THE CONTEST OF MEANING

The MIT Press
Cambridge, Massachusetts
London, England

THE CONTEST OF MEANING:

Critical Histories of Photography

edited by

RICHARD BOLTON

Fifth printing, 1996
First MIT Press paperback edition, 1992

This book was set in Perpetua and Futura by Graphic Composition, Inc. and printed and bound in the United States of America.

Library of Congress Cataloging-in-Publication Data

The Contest of meaning : critical histories of photography / edited by Richard Bolton.
 p. cm.
 Includes bibliographies and index.
 ISBN 0-262-02288-5 (HB), 0-262-52169-5 (PB)
 1. Photography, Artistic—History and criticism. I. Bolton, Richard, 1956–
TR642.C66 1989
770'.9—dc19

Douglas Crimp, "The Museum's Old/The Library's New Subject," is a revised version of an essay published originally in *Parachute* 22 (Spring 1981).

Christopher Phillips, "The Judgment Seat of Photography," was published originally in *October* 22 (Fall 1982).

Benjamin H. D. Buchloh, "From Faktura to Factography," was published originally in *October* 30 (Fall 1984).

Abigail Solomon-Godeau, "The Armed Vision Disarmed: Radical Formalism from Weapon to Style," was published originally in *Afterimage* 11:6 (January 1983).

Catherine Lord, "What Becomes a Legend Most: The Short, Sad Career of Diane Arbus," was published originally in *Exposure* 23:3 (Fall 1985).

Deborah Bright, "Of Mother Nature and Marlboro Men: An Inquiry into the Cultural Meanings of Landscape Photography," is a revised version of an essay published originally in *Exposure* 23:4 (Winter 1985).

Sally Stein, "The Graphic Ordering of Desire: Modernization of a Middle-Class Women's Magazine, 1914–1939" was published originally in *Heresies* 18 (1985).

Jan Zita Grover, "Dykes in Context: Some Problems in Minority Representation," is published here for the first time.

Carol Squiers, "The Corporate Year in Pictures," was published originally in *Manhattan, inc.* (July 1985).

Esther Parada, "C/Overt Ideology: Two Images of Revolution," was published originally in *Afterimage* 11:8 (March 1984).

Richard Bolton, "In the American East: Richard Avedon Incorporated," was published originally in *Afterimage* 15:2 (September 1987).

Rosalind Krauss, "Photography's Discursive Spaces," was published originally in *Art Journal* 42 (Winter 1982).

Martha Rosler, "in, around and afterthoughts (on documentary photography)" is a revised version of an essay published originally in *Martha Rosler: 3 Works* (Halifax: The Press of the Nova Scotia College of Art and Design, 1981). The version published here also incorporates the essay "Notes on Quotes," published originally in *Wedge* 2 (Fall 1982).

Allan Sekula, "The Body and the Archive," is a revised version of an essay published originally in *October* 39 (Winter 1986).

C O N T E N T S

How is photography used to promote class and national interests?

What are the politics of photographic truth?

RICHARD BOLTON

Introduction

The Contest of Meaning:
Critical Histories of Photography

We no longer need to argue for photography's acceptance as a form of art. Since its invention, enormous personal and institutional energy has been devoted to legitimizing the medium; in fact, during most of the key moments of modernist photography, the *production* of photography and the *promotion* of photography have been inseparable. In the United States alone, one thinks of Alfred Stieglitz with his galleries and *Camerawork,* Minor White and *Aperture,* the artists and educators at the Institute of Design, and Beaumont Newhall, Edward Steichen, and John Szarkowski at the Museum of Modern Art. Such enthusiastic promotion has borne much fruit, and photography is now a respected member of the museum and the marketplace.

We no longer need to argue for the establishment of a distinct history of photography. The study of photography has gained acceptance as a separate discipline within the academy; as a result, the medium now has an official pedigree that provides practitioners and enthusiasts alike with inspiration and a sense of identity. Here too analysis has been joined to the promotion of the medium, and the resulting tale has exerted enormous influence on research, exhibition practice, reputations, market values, and photographic production itself. This history has also given direction and legitimacy to the many photographic programs now commonly found in art schools and university art departments.

Yet there remains a fundamental controversy about the terms of photography's success. Photography no longer behaves like a clumsy *arriviste;* its confident manner gives the impression that the major questions haunting the medium have been resolved. This is, however, far from the case, for many compromises have been made along the road to success. Institutional memory is quite selective, and it is no accident that the social function of photography and the social role of the photographic artist have been ignored. This anthology has been compiled to explore these important but neglected aspects of photography's place in the world. By critically examining prevailing beliefs about the medium and

by raising questions about photography's relationship to society, the writers included here suggest important new ways to explain the history of photography. This history is seen to be much more than the march of great (male) geniuses and their progeny: photography is considered as a part of a large social, economic, and intellectual landscape. By analyzing the material, institutional, and ideological influences on photographic practice, these writers create a new understanding of the dynamics of modernist photography and, more importantly, of the role of the photograph within *modernity,* within the modernization that has transformed twentieth-century life. These essays describe not only the politics of photographic representation, but also the politics of meaning itself.

The accepted version of photographic practice, forged for posterity in the 1950s and 1960s, is a limited construction based in the formalist values of late modernism. Historians and curators during that time worked quite deliberately to *narrow* photography. They emphasized the autonomy of the image and set about to define the "norms" of the medium, the intrinsic technological and visual properties of the photograph. They selected a common set of characteristics from a diverse set of images and brought scores of conflicting photographers and photographs under the jurisdiction of a universal history. The social and political issues raised by industrial application and plebeian function were ignored—it was instead given to art photography to provide an unsullied articulation of photography's common characteristics. One recalls John Szarkowski's famous list of these norms in his book *The Photographer's Eye;*[1] his introduction, which summarized the basic agenda of late-modern formalism in photography, was also succinct: "This book is an investigation of *what photographs look like, and why they look that way.* It is concerned with photographic *style* and with photographic *tradition*"[2] (emphasis added). Through Szarkowski's book and other like-minded efforts, the late-modern art photograph was elevated to a universal type, its ontogeny supposedly recapitulating the phylogeny of all photographic production.

But the intrinsic and universal properties of the photograph have never been established with complete satisfaction. An examination of formalism itself reveals marked differences between early-twentieth-century Soviet practice, Bauhaus photography, the photographic practices taught at the Institute of Design, and the practices promoted by the Museum of Modern Art; compare, for example, the work of such pivotal figures as Alexander Rodchenko, Alfred Stieglitz, László Moholy-Nagy, Minor White, and Harry Callahan. Even without an examination of other photographic approaches, diversity *within* formalism raises serious doubts about the existence of universal photographic form. That such heterogeneity has generally been ignored is an indication of the absolutism that fuels the field of photography and that informs its uncomplicated official history. Advocates of late modernism successfully regulated photographic meaning, and confirmed their own authority over the field in doing so. As a result, traditional photographic history offers us a myth of origin that emphasizes homogeneity and continuity and ignores disruptions and change. We have a history of the agreements within photography, but not of the disagreements. We are told, quite falsely, that all photographs, beyond their many and often radical differences, aspire to the same objective—the medium itself.

It would, of course, be simplistic to attribute the shortcomings of photographic history and practice to the photographic establishment alone. The loss of a radical modernism has become apparent in every form of cultural practice, and thus photographic formalism

bespeaks much larger conditions within modernity. The disruptions and challenges posed by modernist invention have been assimilated into the status quo; once-radical methods for producing alternative reality have become apolitical means for reproducing dominant reality. Despite the utopian and anarchic desires that fueled modern art, its lasting impact seems to have been on commodity production, mass media, and other means of social control. Its greatest accomplishment can be found in the public's adjustment to the new productive and reproductive apparatuses of twentieth-century life. This dissolution of radical practice was encouraged further by a changing political climate in the United States. By the end of the 1950s, conservatism and anticommunism had done much to discourage interest in socially motivated artistic production (and, of course, political radicalism generally). By the time of photography's great success in the 1970s, the "universality" of an apolitical fine art practice and history was widely accepted.

But despite the streamlining of photographic meaning and the broader depoliticization of artistic experience, we can still uncover the complex social history of the photographic medium. First of all, we can reexamine contrasting claims about photography's role in public life. It was once said that photography would serve democracy, helping to construct a modernist *polis* by providing a means of speech accessible to a wide number of participants. But photography also offered a means of social control: the camera's capabilities for documentation and surveillance were vital to the attempt to build a regulated society. We can also reexamine photography's contradictory relationship to material experience. The medium seemed to offer an uncritical, even emphatic, assertion of everyday life, preserving subtle nuances of the most humdrum moments. Photography seemed to endow material life with spiritual value, proposing a harmony with technology that was seldom realized in day-to-day experience. But the camera also introduced a profound disruption of everyday life: photographic technology made the familiar seem strange, helping photographers challenge the commonplace. For every claim about the transparency and obviousness of the photograph, there can be found an opposing claim emphasizing the difficult language introduced by the photograph, a language based in the liberties of framing, montage, juxtaposition, and surreality.

It seems that wherever we look in photography, we find contradictory impulses and opposing aims. The wide range of photographic applications raises the possibility that photography has no governing characteristics at all save adaptability. Here is a medium that has been used repressively (e. g., police photography), honorifically (portrait photography), as a means of contest and revolution (in constructivism and dada), as a marketing device (advertising photography), and as a means of both liberal and governmental reform (as in the photography of the Farm Security Administration). Certain practices preserve the status quo and others strive to overthrow it; it is possible to find in the medium contributions to both the domination and the liberation of social life.

But the ubiquity of the photograph, the multiplicity of its uses, and the contradictory goals of photographic practice are seldom raised as issues in modernist photographic history. The writers included in this volume address these neglected problems; they look beyond the glossy narratives of photographic history and discover a medium transformed, even deformed, by the twists and turns of technology, history, and ideology. Photography's complexity is revealed through a judicious consideration of context: the discussions here of art photography, news reportage, advertising and fashion illustration, erotic photography, the photography of subcultures, geographical survey photography, documentary photography, and police photography emphasize the constraints and ambitions of each

particular mode of production. This attention to the broad sweep of photographic production, and to the historical and ideological particulars within various strands of production, has helped these writers define many alternatives to the dominant history of the medium.

Despite the disagreements with late-modern formalism shared by these writers, the lines of questioning developed in this book *do* have a basis in artwork from this period, specifically in the conceptual and minimal art of the 1960s and 1970s. Some of this work tried to reestablish a critical modernist practice by emphasizing the context of presentation, whether in the museum, the landscape, public space, or the art publication. Some commentators, most notably Michael Fried, saw in this effort the corruption of modernism, the injection of theatricality inappropriate to the art experience. But for many this emphasis on the situation of the observer was a positive development; work came to question the role of the audience and the institutional constraints applied to meaning. It came to be recognized that meaning could not be determined without a close examination of the social conditions of production and reception. The resulting analyses drew upon many philosophical and interdisciplinary perspectives—phenomenology, literary criticism, semiotics, hermeneutics, marxism, feminism, psychology, and works by Russian formalists, Walter Benjamin, Jacques Lacan, Roland Barthes. Other histories of modernism were elaborated, histories that contradicted prevailing views by emphasizing the critical role of the modernist object. These reevaluations of artistic practice provided ways for art to be carried outside the hermetic world of late formalism and integrated into the social and political arena.

From these new perspectives, the photographic image had little independent meaning. Of course, the "narrative poverty" of the photograph had been discussed before, even by formalists. But formalists wanted to celebrate this poverty, making it the cornerstone of a *laissez-faire* and completely subjectivist approach to interpretation. In reaction to this, critical artists and writers argued that the narrative poverty of the photograph creates an *illusion* of neutrality. They argued that meaning is instead established through interpretive conventions that exist outside of the image—conventions that are socially and institutionally constructed and that serve an ideological function. These conventions are often self-effacing, helping to naturalize a system of beliefs. To understand the workings of ideology, these claims to nature must be taken apart, their historical and social dimensions revealed.

Consequently, the writers in this book challenge the certainties of late-modern formalism and the foundational beliefs of many other systems of interpretation. Finding little that is natural in the relationship between seeing and meaning, they find nothing inevitable in our society's art practices. This does not lead them to argue for the absolute relativism of interpretation; instead, they work to understand how meaning is affected by the exercise of power. A relativist understanding of the open-ended, "polysemic" nature of the photograph is useful, but absolute interpretations still exist in the world. Institutions continue to legitimize certain viewpoints and to marginalize others. By examining the politics of these institutional acts, these writers develop an understanding of meaning as a contest, created out of opposition and negotiation. Intellectual production is here given an activist role, charged with the development of new forms of social experience and a new social basis for art.

Readers may hear echoes of recent postmodern theory in many of the arguments in this book. It would take another volume to address these theories; let it be said simply

that these writers exemplify a *politicized* postmodernism. They share within postmodernism an awareness of social critique, of the historicity of form, and of the political context of creation. These concerns are not shared by all postmodernists; some postmodern practices actually *reinforce* the late-modern separation of culture and society, advocating an ahistorical approach to quotation and a decontextualized use of the mass media and commodities. Such positions are exactly opposite to the critical postmodernism advocated by the writers in this book. These conflicts within postmodernism are important ones, but they must remain in the background of the arguments offered here.[3]

Photography has been a crucial influence on Western consciousness since the invention of the medium 150 years ago, and it continues to exert great influence today. The photograph continues to be a primary source of information about both the world and ourselves; it remains crucial to advertising and marketing and, hence, to our commodity system; it works with other forms (such as film and video) to thicken our visual environment. This thoroughly cultural formation called photography is now a part of our nature. The terrible rift experienced in the nineteenth century, the upheaval introduced by photography into the order of information and reality, has been assimilated. We no longer worry about our society rushing "like Narcissus, to contemplate its trivial image on the metallic plate"; we now consider it quite natural to do so. To gain a critical understanding of our complicated relationship to photography, we must not only analyze art photography, but also such photography first within the context of *all* photographic production, then within the context of information production, and then within the context of *social* production. For art photography is one small part of the extensive history of technological communication and the technological organization of reality. The writers in this book offer their arguments with these larger contexts in mind.

What are the social consequences of aesthetic practice?

The first subject addressed in this anthology is the construction of art photography itself. It is the gradually developed *exclusivity* of art photography that most concerns these writers; the essays in this section describe the politics of canon formation and the refinement of the restrictive practices of late modernism. The political dynamics of early modernism provide an important contrast to late modernism; for many artists, the question of form during this time was part of a larger question about the role of the artist in society. Aesthetic questions were political questions. But after the triumph of late modernism, considerations of the political basis of modernism were pushed aside. As the formal attributes of these early practices were absorbed into the status quo, an apolitical practice gradually gained the upper hand.

In his essay "The Museum's Old/The Library's New Subject," Douglas Crimp describes the *episteme* of modernism, the way in which modernism has restructured knowledge itself. He is interested in the effects that classification systems have upon meaning and, particularly, in the way that the museum works as a classification system. Crimp uses the formation of the photographic collection at the New York Public Library to demonstrate how the museum has succeeded in separating the photograph from its subject, thus triumphing over the library. As Crimp notes, the establishment of photographic practice as a pure category has required other ways of understanding to be "dismantled and destroyed."

In "The Judgment Seat of Photography," Christopher Phillips charts further the "museum's emergence as orchestrator of meaning." Utilizing Walter Benjamin's famous dis-

tinction between cult value (where the magical aura of the artwork is emphasized) and exhibition value (where demystified communication with the audience is stressed), Phillips develops a comprehensive analysis of the history of photographic curation at the Museum of Modern Art. Phillips shows that, despite great differences in its many curatorial approaches, the museum, even when it has emphasized exhibition value, has always moved photography closer to an apolitical and auratic formalism.

In his essay "From Faktura to Factography," Benjamin Buchloh describes an important shift within the practice of early-twentieth-century avant-garde photography. *Faktura,* a critical examination of representation that stressed the material conditions of production, is shown to give way finally to *factography,* the attempt to speak without ambiguity to a mass audience through an easily understood iconography. Buchloh's analysis reveals the social and political context of both modernist self-reflexivity and photomontage; in addition, he provides us with an important example of the often complicated relationship between modern art and its audience.

Abigail Solomon-Godeau offers a panoramic view of the changes in modernist practice in her essay "The Armed Vision Disarmed: Radical Formalism from Weapon to Style." After describing positions within the radical formalism of Soviet practitioners early in this century, she follows the trajectory of these views through the Neue Sachlichkeit and Bauhaus movements in Germany, to their American manifestation at the Institute of Design in Chicago. Solomon-Godeau shows how a politically motivated formalism, conceived of as a weapon, was progressively rewritten into a style. Through "a certain amount of historical legerdemain," late-modernist photographic history has ignored this transformation of radical formalism, emphasizing "tradition and continuity rather than . . . rupture and change."

How does photography construct sexual difference?

One of the most significant developments of the last ten years has been the emergence of a feminist critique of photographic practice. One of the strengths of this critique has been its large compass; this anthology, for example, includes feminist arguments that address documentary and landscape photography, mass media communication, and subcultural practice. These writers argue more than the need for the equal presence in the art world of work by women (although this is certainly raised as an issue); they examine the ways in which the female is configured as a subject. These essays explain how sexual difference is constructed across various registers of representation; further, the essays reveal how the formalism encouraged in modern photography has helped to obscure the complex subject positions that inform sexual identity.

In "What Becomes a Legend Most: The Short, Sad Career of Diane Arbus," Catherine Lord describes the ways that the legend of Diane Arbus has been constructed through exhibition practice, romantic biography, and the control exerted over her reputation by the Arbus estate. Lord examines the sexual and artistic stereotypes at work in the Arbus persona and shows that Arbus's reputation as a freak, as an abnormal but blessed artist, prevents any understanding of the larger context of her work. This distortion of Arbus is encouraged, Lord emphasizes, by the art world's "continued valorization of individual artistic genius" and "the excision of photography from meaningful political or social contexts."

In "Of Mother Nature and Marlboro Men: An Inquiry into the Cultural Meanings of Landscape Photography," Deborah Bright discusses the impact of formalism on the pho-

tographic depiction of landscape. She asserts that formalist photographers often portray the landscape as untainted by political and social circumstances, so creating a formalist view of nature itself. This view of nature in turn depends upon certain assumptions about human nature, particularly sexual difference: nature remains a feminine presence, seen through male eyes. As an alternative, Bright argues for an understanding of landscape as "a human organization of space, a historical construction rather than an immutable essence."

The role of women's magazines in early modernist culture is described by Sally Stein in "The Graphic Ordering of Desire: Modernization of a Middle-Class Women's Magazine, 1914–1939." These magazines are shown to be an important link between industrial production and domestic reproduction. Stein argues that "before World War II, magazines served a central role in developing the visible materiality of consumer culture" and in developing domestic efficiency. Through an analysis of both the content and form of these magazines, she traces the ground shared by the rationalization of domestic consumption and the scientific management of the workplace promoted by the industrial engineers of that time.

Yet another process of interpretation is discussed by Jan Zita Grover in her essay "Dykes in Context: Some Problems in Minority Representation." Grover examines photographs used by lesbians to establish sexual identity. Arguing that the photograph is a complicated speech act, she shows how these particular images can be read in one way by the subculture that produces them and in another way by those within dominant culture. The various readings generated by the circulation of these images demonstrate for Grover the contingent rather than the essential nature of interpretation. Images are "locuses of contending discourses," and members of a subculture must work to "transform the materials and values of dominant culture for [their] own purposes."

How is photography used to promote class and national interests?

Mainstream photographic history offers no analysis of the effects of power on representation. In fact, it encourages the opposite understanding, instilling the belief that all forms of the photographic image are neutral and above ideology. Advertising, fashion, and news photography are thus easily transformed into art images, recontextualized through the logic of photographic history. But photography serves society as an important form of mass communication; and as the essays in this section make clear, this ties photography to the promotion of class and national interests, to the agendas of the patrons of communications. That is, photography is not immune to ideological effects, and the refusal to consider these effects strengthens the role of photography as a voice for the status quo.

Carol Squiers discusses the way photography is employed for public relations purposes. Her essay "The Corporate Year in Pictures" examines the 1984 annual reports of several well-known corporations. Many of these companies had to describe crises and public relations disasters in their reports, and Squiers shows the ways in which they tried to "minimize the negative and maximize the positive" for their shareholders. Photography played an important role in these rearrangements of reality. Photographic formalism proved an effective tool for shifting attention away from unpleasant news about earnings, corporate accidents, unsafe products, and labor problems.

In "C/Overt Ideology: Two Images of Revolution," Esther Parada examines the way

national experience and identity are constructed through news reportage. Reminding us that "a newspaper, like a photograph, is a reflection of a hierarchy of attention," Parada examines two very different versions of the Nicaraguan revolution. The *New York Times* provides one example; Parada shows how photographs, text, and advertisements are used covertly in this paper to construct a view of Latin America as an irrational and violent Other. Within Nicaraguan media, Parada discovers a second view of the revolution, a view that is more overtly ideological by American standards, but that conveys vital insights about Nicaragua missing from "objective" American reports.

My contribution to the anthology, "In the American East: Richard Avedon Incorporated," explores the relationship between art, photography, and commodity production. An analysis of Avedon's recent work reveals how art production in general and photographic documentary in particular have been affected by the fashion and entertainment industries. The essay describes how the logic of advertising "unites and governs all forms of sign production in present-day capitalism," and how museums and the art press collaborate in extending this logic to artmaking. Under the twin guise of fine art and advertising, Avedon's photographs effectively reassert the inequalities that inform labor relations.

What are the politics of photographic truth?

The essays in the last section of the book discuss the construction of the photographic witness and the construction of photographic truth. The photograph is not sufficient evidence by itself; an interpretive structure must be established—naturalized—before a stable and believable meaning can be read into the documentary image. These essays describe how interpretive structures are tied to the intended *use* of the image; that is, photographic truth is considered as a function of instrumentality. The analysis of photographic truth thus leads to an analysis of power, and our understanding of documentary photography is shown to depend upon our understanding of its social and political aims.

In "Photography's Discursive Spaces," Rosalind Krauss examines the impact of art history on our interpretation of nineteenth-century photographic practice. Many of these early photographs were not intended as artistic statements, and Krauss shows the extent to which these works were determined by the expectations of empirical science, topography, and record-keeping. These circumstances of production and meaning have been ignored by photographic historians as they confine photography within another discursive space; these historians work "to dismantle the photographic archive—the set of practices, institutions, and relationships to which nineteenth-century photography originally belonged—and to reassemble it within the categories previously constituted by art and its history."

Martha Rosler, in her essay "in, around, and afterthought (on documentary photography)," discusses how documentary has been used to describe the powerless to the powerful. She examines the origins and limits of liberal documentary and the "cultural myth of objectivity" that informs such work. Rosler points out various ways in which documentary can actually *supplant* social activism; as an alternative, she raises the possibility of a documentary practice based on a politically sensitive strategy of quotation. The practice of quotation "represents a refusal of socially integrated, therefore complicit, *creativity*"; this approach may help to short-circuit the ideological closure that generally characterizes documentary.

In "The Body and the Archive," Allan Sekula describes the "double system" of representation within photography. The photograph can be used to honor or repress its subjects, to either complement the "ceremonial presentation of the bourgeois *self*" or "establish and delimit the terrain of the *other*." In this way, the photograph is seen to aid in the construction of social and moral hierarchies. Sekula finds an important early example of the repressive potential of photography in its use by the police for identification purposes. He describes the sociological and scientific beliefs that informed the photographic surveillance of the criminal and shows how these beliefs provided the logic for the arrangement of the photographic archive of criminal "types." This concept of the archive is shown to be fundamental to our understanding of photographic meaning.

This book includes key essays from a still-developing critique of established photographic history and practice. It offers an examination of various subject positions and interpretive dynamics that affect the meaning of photography. Obviously, important parts of this critique are missing from this book. This collection is intended to be provocative rather than exhaustive, and issues and writers that have not been represented will no doubt occur to the reader. There are, for example, no essays on the representation of race. This should be an important part of the argument developed here, but this issue has yet to receive sufficient attention within photography's critical community. It also cannot be emphasized too strongly that this book contains only American voices. This anthology was conceived to be precisely that—a summary of arguments in the United States—but this decision was not intended to imply American dominion over these issues.[4]

Important reforms no doubt lie ahead, but any recognition of the politics of representation will require a recognition of the importance of politics itself. Arguments for change in the art world, and for change in the history and interpretation of art, also imply the need for change in the world beyond the institutions of art. But how much can art actually change society? The pessimistic responses that this recurring question usually receives indicate just how far we have adjusted our expectations, how much we have accepted the separation of culture and society promoted by late modernism. But a better question might be: how can art *best* change society? After all, most artists hope to create change; few actually work self-consciously to further the status quo. Most positions within modernism have at some point been considered "radical"—even the much-criticized strategy of autonomy. How, then, do we determine the best ways to create change?

Perhaps it is obvious, but few think that this radical practice will be achieved by creating a persuasive art that inspires "the masses" to action. In fact, as one might guess from the arguments in these essays, the rhetoric and realism such persuasion requires would be met with great suspicion. Instead, politicized photographic practices and histories must grow out of critical thinking, and they must encourage critical thinking in others. This critical thinking, however, cannot be seen as yet another autonomous process; it must be wedded to a political context, provided with a material and social forum. It is hoped that this book will bring us one step closer to such an understanding of art. A socially motivated, critical practice will undoubtably have its limits, but we have yet to approach them. As of today, when asked how much art can change society, we can answer with confidence: "Much more than it does."

1 These norms were "the thing itself," "the detail," "the frame," "time," and "vantage point." Szar-kowski's inclusion of "the thing itself" may sound like a concession to content, and to a world outside the image, but his discussion in this book reduces content to a formal problem. John Szarkowski, *The Photographer's Eye* (New York: The Museum of Modern Art, 1965).

2 Over the years, Szarkowski has emphasized work in which the solipsism of the photographer and the "narrative poverty" of the image guarantee the articulation of the formal traits of the medium. (At one point in the development of his position, in the exhibition *Mirrors and Windows,* Szarkowski appeared to give up his checklist of formal necessities in favor of the descriptive innocence of the photograph. *Mirrors and Windows* seemed to advocate an untroubled transparency that could be used for both descriptive and self-expressive ends, but the exhibition really did not stray far from the celebration of narrative poverty and subjectivity that has characterized the rest of Szarkowski's curatorial work.) Changes within Szarkowski's position, and particularly the narrowing of the for-malist canon, can be seen by comparing two artists championed by Szarkowski—Lee Friedlander, supported by Szarkowski early in both of their careers, and William Eggleston, a late-comer to the museum. Friedlander's work is far more complex: although his work certainly helped create a style of street photography, Friedlander also used the urban landscape to say something about the rela-tionship between his own alienation and the nature of urban experience. Eggleston, on the other hand, photographs anything and everything, inviting arbitrariness as a way of eliminating content entirely to better focus on style. His work perfectly illustrates (and offers no challenge to) Szar-kowski's curatorial arguments.

3 Readers interested in general discussions about postmodernism should see Brian Wallis, ed., *Art After Modernism: Rethinking Representation* (New York and Boston: The New Museum of Contempo-rary Art and David R. Godine, 1984); Hal Foster, ed., *The Anti-Aesthetic: Essays on Postmodern Culture* (Port Townsend: Bay Press, 1983); Hal Foster, *Recodings: Art, Spectacle, Cultural Politics* (Port Town-send: Bay Press, 1985); Douglas Kahn and Diane Neumaier, eds., *Cultures in Contention* (Seattle: The Real Comet Press, 1985); John Thackara, ed., *Design After Modernism: Beyond the Object* (London and New York: Thames and Hudson, 1988); and the journals *October, Wedge, Zone, camera obscura, Afteri-mage, Ten.8, Block, Social Text, New German Critique,* and *New Left Review,* among others.

4 On the issue of race, readers should see Henry Louis Gates, Jr., ed., *"Race," Writing, and Difference* (Chicago: University of Chicago Press, 1986); James Clifford, *The Predicament of Culture: Twentieth Century Ethnography, Literature, and Art* (Cambridge: Harvard University Press, 1988); James Clifford and George Marcus, eds., *Writing Culture: The Poetics and Politics of Ethnography* (Berkeley: University of California Press, 1986); and Sander Gilman, *Difference and Pathology: Stereotypes of Sexuality, Race, and Madness* (Ithaca: Cornell University Press, 1985). Also not addressed in this anthology is the construction of the gay male as Other; see Simon Watney, *Policing Desire: Pornography, AIDS, and the Media* (Minneapolis: University of Minnesota Press, 1987). The issue of pornographic representa-tion is addressed in Kate Ellis, Nan Hunter, Beth Jaker, Barbara O'Dair, Abby Tallmer, *Caught Looking: Feminism, Pornography & Censorship* (Seattle: The Real Comet Press, 1987).

Many additional arguments relevant to the issues in this anthology can be found in Victor Burgin, *Between* (London: Basil Blackwell Limited, 1986); Victor Burgin, *The End of Art Theory: Criti-cism and Postmodernity* (Atlantic Highlands: Highlands Press International, Inc., 1986); Victor Burgin, ed., *Thinking Photography* (London: Macmillan, 1982); Allan Sekula, *Photography Against the Grain: Essays and Photo Works 1973–1983* (Halifax: The Press of the Nova Scotia College of Art and De-sign, 1984); Benjamin Buchloh and Robert Wilkie, ed., *Mining Photographs and Other Pictures 1948–1968* (Halifax: The Press of the Nova Scotia College of Art and Design, 1983); Rosalind Krauss, *The Originality of the Avant-Garde and Other Modernist Myths* (Cambridge: The MIT Press, 1985); Jo Spence, *Putting Myself in the Picture* (London: Camden Press, 1986); and Judith Williamson, *Decoding Advertising: Ideology and Meaning in Advertising* (London: Marion Boyars, 1978).

**What are the social consequences
of aesthetic practice?**

$\dfrac{2}{3}$

The Museum's Old/
The Library's New Subject

All the arts are based on the presence of man, only photography derives an advantage from his absence.

Andre Bazin, "The Ontology of the Photographic Image"

For the fiftieth anniversary of the Museum of Modern Art, William S. Lieberman, sole survivor of the founding regime associated with the directorship of Alfred Barr, mounted the exhibition *Art of the Twenties.* The exhibition's subject was presumably chosen not only to celebrate the decade in which MoMA was born, but also because it would necessarily draw upon every department of the museum: film, photography, architecture and design, drawings, prints and illustrated books, as well as painting and sculpture. Indeed, a major impression left by the show was that aesthetic activity in the 1920s was wholly dispersed across the various media, that painting and sculpture exercised no hegemony at all. The arts then clearly on the ascendant, not only in Paris but more tellingly in Berlin and Moscow, were photography and film, agitprop posters, and other functionally designed objects. With only a few exceptions—Miró, Mondrian, Brancusi—painting and sculpture appear to have been very nearly usurped. Duchamp's *Large Glass*—not, of course, in the exhibition—may well be the decade's most significant work, and one is hard pressed to define its medium in relation to traditional categories.[1]

Art of the Twenties was all the more interesting and appropriate for the museum's anniversary year because it came at the end of another decade in which painting and sculpture had been displaced by other aesthetic options. And yet, if it is possible to assess the 1970s as a time of the demise of traditional painting and sculpture, it is equally possible to see it as the decade of an extraordinary resurgence of those modes, just as the 1920s can be understood as a time of extreme conservative backlash in the arts—when, for example, after the radical achievement of analytic cubism, Picasso returned to traditional representation in his so-called neoclassical period.[2] That radical moves should be accompanied by or cause retrenchment is not surprising, but the degree to which such retrenchment is currently embraced and applauded, even to the extent of obscuring whatever advances have been made, is alarming.

In MoMA's annual report for its jubilee year, the museum's president and director give less attention to *Art of the Twenties* than to two of the year's other major events, both of which helped create the first substantial operating surplus in the museum's history. These were the sale, after many legal and public-relations difficulties, of the museum's "air rights" to a real estate developer for $17 million as the most crucial aspect of the museum's expansion program; and the biggest blockbuster the museum had ever staged, *Pablo Picasso: A Retrospective,* which boasted nearly a thousand artworks and over a million visitors. One other celebratory event was singled out by the museum's top officials as of particular importance: the exhibition of photographs by Ansel Adams, one of the founding fathers of MoMA's Department of Photography—the first such department in any art museum, as they proudly point out.

The big real estate deal, the blockbuster retrospective of this century's leading candidate for the title "artistic genius," the fêting of the best-selling living photographer (a print of Adam's *Moonrise, Hernandez, New Mexico* recently sold for $22,000)[3]—the significance of the conjunction of these events can hardly be lost on anyone forced to cope with the social realities of the current New York art world.[4] In comparison, the importance of *Art of the Twenties* begins to pale; perhaps the exhibition must after all be seen merely as the swan song of the museum's first era and of the show's curator, who subsequently moved to the Metropolitan Museum.

The notion of art as bound by and deeply engaged in its particular historical moment, as radically deflected from the age-old conventions of painting and sculpture, as embracing advanced technologies for its production—all of this could apparently be swept aside by a notion of art as bound only by the limitations of individual human genius. Modern art could now be understood as art had seemingly always been understood, as embodied in the masterpieces invented by the master artist. *Picasso*—the man's signature adorned the T-shirts of thousands on the streets of New York that summer, evidence, one supposes, that they had attended the spectacle and were proud of it, proud to have thus paid homage to genius. But these T-shirt-clad museum goers were themselves part of another spectacle, the spectacle of response. The myths, the clichés, the platitudes, the *idées reçues* about artistic genius—appropriately signified by this *signature*—were never so resoundingly reaffirmed, not only by the mass media, from whom it was to have been expected, but by the museum itself, by curators, dealers, critics, and by artists. The very suggestion that there might be something suspicious, perhaps regressive, about this response was dismissed as misanthropic naysaying.

A short five-years earlier, in a text on contemporary art intended for art-school audiences, I had written that Duchamp had replaced Picasso as the earlier twentieth-century artist most relevant to contemporary practice. Now, it seems, I'd have to eat those words. In a special "Picasso Symposium" devoted to responses to the MoMA retrospective, *Art in America* asked various art-world personalities to give their views. Here is that of the recently successful painter Elizabeth Murray: "Picasso is the avant-garde artist of our time. . . . He truly says you can do anything."[5] Her fellow painter, the former critic Bruce Boice, elaborates upon the same point:

Picasso seems to have had no fear. He just did whatever he wanted to do, and obviously there was a lot he wanted to do. . . . For me to speak about what I find so astounding about Picasso is to speak of what is most fundamental to being a painter. Being a painter should be the easiest thing in the world because there are and can be no rules. All you have to do is do whatever you want to do. You can just, and you must, make everything up.[6]

This, then, is the lesson of Picasso. There are no constraints, whether these are construed as conventions, languages, discourses, ideologies, institutions, histories. There is only freedom, the freedom to invent at will, to do whatever you want. Picasso is the avant-garde artist of *our* time because, after so much tedious discussion about history and ideology, about the death of the author, he provides the exhilarating revelation that we are free after all.

This creative freedom fantasized by contemporary artists and confirmed for them by the spectacle of a thousand Picasso inventions is seconded by the art-historical community. A typical, if hyperbolic response is that of John Richardson, writing in the favored organ of the U.S. literary establishment, the *New York Review of Books*.[7] Calling Picasso "the most prodigious and versatile artist of all time," Richardson rehearses the biography of artistic genius from its beginnings in the transcendence of the mere child prodigy by "an energy and a sensibility that are astonishingly mature" through the "stylistic changes that revolutionized the course of twentieth-century art" to the "poignant" late works, with their "mixture of self-mockery and megalomania." Richardson's assessment is perhaps uncharacteristic in only one respect. He claims that "up to the day of Picasso's death in 1973 the power was never switched off."

Absolutely characteristic, though, is Richardson's view that Picasso's is a subjective art, that "the facts of his life have more bearing on Picasso's art than is the case with any other great artist, except perhaps van Gogh." And so we don't miss the meaning of any of these great works, Richardson insists that "every crumb of information should be gathered while there is time. In no other great life are the minutiae of gossip so potentially significant."[8]

It is, then, as if Duchamp's ready-mades had never occurred, as if modernism's most radical developments, including Picasso's own cubist collage, had never taken place, or at least as if their implications could be overlooked and the old myths of art fully revivified. The dead author has been reborn; he has returned with his full subjective power restored—as the contemporary artist puts it—to make it all up, to do whatever he wants. Duchamp's ready-mades had, of course, embodied the proposition that the artist invents nothing, that he only uses, manipulates, displaces, reformulates, repositions what history has given him. This is not to divest the artist of the power to intervene in, to alter or expand discourse, only to dispense with the fiction that power arises from an autonomous self existing outside history and ideology. The ready-mades propose that the artist cannot *make,* but can only *take* what is already there.

It is precisely upon this distinction—the distinction between making and taking—that the ontological difference between painting and photography is said to rest. The director of MoMA's Department of Photography, John Szarkowski, states it simply enough:

The invention of photography provided a radically new picture-taking process—a process based not on synthesis but on selection. The difference was a basic one. Paintings were *made* . . . but photographs, as the man on the street puts it, were *taken*.[9]

But MoMA's jubilee photographer, Ansel Adams, is uncomfortable with this predatory view of photography. How could the artist Adams wants to call a "photopoet" be a common thief?

The common term "*taking* a picture" is more than just an idiom; it is a symbol of exploitation. "*Making* a picture" implies a creative resonance which is essential to profound expression.

My approach to photography is based on my belief in the vigor and values of the world of nature—in the aspects of grandeur and of the minutiae all about us. I believe in growing things, and in the things which have grown and died magnificently. I believe in people and in the simple aspects of human life, and in the relation of man to nature. I believe man must be free, both in spirit and in society, that he must build strength into himself, affirming the "enormous beauty of the world" and acquiring the confidence to see and to express his vision. And I believe in photography as one means of expressing this affirmation, and of achieving an ultimate happiness and faith.[10]

There is really less contradiction of Szarkowski's position in Adams's Sierra Club humanism, however, than there appears. For in both cases it is ultimately a matter of faith in the medium itself to act as just that, a *medium* of the artist's subjectivity. So, for example, Adams writes:

A great photograph is a full expression of what one feels about what is being photographed in the deepest sense, and is, thereby, a true expression of what one feels about life in its entirety. And the expression of what one feels should be set forth in terms of simple devotion to the medium—a statement of utmost clarity and perfection possible under the conditions of creation and production.[11]

Compare Szarkowski:

An artist is a man [sic] who seeks new structures in which to order and simplify his sense of the reality of life. For the artist photographer, much of his sense of reality (where the picture starts) and much of his sense of craft or structure (where the picture is completed) are anonymous and untraceable gifts from photography itself.[12]

By construing photography ontologically, as a medium of subjectivity, Adams and Szarkowski contrive a fundamentally modernist position for it, duplicating in nearly every respect theories of modernist autonomy articulated earlier in this century for painting. In so doing, they ignore the plurality of discourses in which photography has participated. Everything that has determined its multiple practice is set aside in favor of *photography itself*. Thus reorganized, photography is readied to be funneled through a new market, ultimately to be housed in the museum.

Several years ago, Julia van Haaften, a librarian in the Art and Architecture Division of the New York Public Library, became interested in photography. As she studied what was then known about this vast subject, she discovered that the library itself owned many books containing vintage photographic prints, especially from the nineteenth century, and she hit upon the idea of organizing an exhibition of this material culled from the library's collections. She gathered books illustrated with photographs from throughout the library's many different divisions, books about archaeology in the Holy Land and Central America, about ruined castles in England and Islamic ornament in Spain; illustrated newspapers of Paris and London; books of ethnography and geology; technical and medical manuals.[13] In preparing this exhibition, the library realized for the first time that it owned an extraordinarily large and valuable collection of photographs—for the first time, because no one had previously inventoried these materials under the single category of photography. Until then the photographs had been so thoroughly dispersed throughout the library's extensive resources that it was only through patient research that Julia van Haaften was able to track them down. And furthermore, it was only at the time she installed

her exhibition that photography's prices were beginning to skyrocket on the market. So although now books with original plates by Maxime du Camp or Francis Frith might be worth a small fortune, ten or fifteen years ago they weren't even worth enough to merit placing them in the library's Rare Books Division.

Julia van Haaften now has a new job. She is director of the New York Public Library's Photographic Collections Documentation Project, an interim step on the way to the creation of a new division to be called Art, Prints, and Photographs, which will consolidate the old Art and Architecture Division with the Prints Division, adding to them photographic materials culled from all other library departments.[14] These materials are thus to be reclassified according to their newly acquired value, the value that is now attached to the "artists" who made the photographs. Thus, what was once housed in the Jewish Division under the classification "Jerusalem" will eventually be found in Art, Prints, and Photographs under the classification "Auguste Salzmann." What was Egypt will become Beato, or du Camp, or Frith; Pre-Columbian Middle America will be Désiré Charnay; the American Civil War, Alexander Gardner and Timothy O'Sullivan; the cathedrals of France will be Henri LeSecq; the Swiss Alps, the Bisson Frères; the horse in motion is now Muybridge; the flight of birds, Marey; and the expression of emotions forgets Darwin to become Guillaume Duchêne de Boulogne.

What Julia van Haaften is doing at the New York Public Library is just one example of what is occurring throughout our culture on a massive scale. And thus the list goes on, as urban poverty becomes Jacob Riis and Lewis Hine; portraits *of* Delacroix and Manet become portraits *by* Nadar and Carjat; Dior's New Look becomes Irving Penn; and World War II becomes Robert Capa; for if photography was invented in 1839, it was only *discovered* in the 1960s and 1970s—photography, that is, as an essence, photography *itself*. Szarkowski can again be counted on to put it simply:

The pictures reproduced in this book [*The Photographer's Eye*] were made over almost a century and a quarter. They were made for various reasons, by men of different concerns and varying talent. They have in fact little in common except their success, and a shared vocabulary: these pictures are unmistakably photographs. The vision they share belongs to no school or aesthetic theory, but to photography itself.[15]

It is in this text that Szarkowski attempts to specify the particulars of this "photographic vision," to define those things which are particular to photography and to no other medium. In other words, Szarkowski's ontology of photography makes photography a *modernist* medium in Clement Greenberg's sense of the term—an art form that can distinguish itself in its essential qualities from all other art forms. And it is according to this view that photography is now being redefined and redistributed. Photography will hereafter be found in departments of photography or divisions of art and photography. Thus ghettoized, it will no longer primarily be *useful* within other discursive practices; it will no longer serve the purposes of information, documentation, evidence, illustration, reportage. The formerly plural field of photography will henceforth be reduced to the single, all-encompassing *aesthetic.* Just as, when paintings and sculptures were wrested from the churches and palaces of Europe and consigned to museums in the late eighteenth and early nineteenth centuries, they acquired a newfound autonomy, relieved of their earlier functions, so now photography acquires *its* autonomy as it too enters the museum. But we must recognize that in order for this new aesthetic understanding to occur, other ways of understanding photography must be dismantled and destroyed. Books about Egypt will literally be torn apart so that photographs by Francis Frith may be

framed and placed on the walls of museums. Once there, photographs will never look the same. Whereas we may formerly have looked at Cartier-Bresson's photographs for the information they conveyed about the revolution in China or the Civil War in Spain, we will now look at them for what they tell us about the artist's style of expression.

This consolidation of photography's formerly multiple practices, this formation of a new epistemological construct in order that we may now *see* photography, is only part of a much more complex redistribution of knowledge taking place throughout our culture. This redistribution is associated with the name *postmodernism,* although most of the people who use the name have very little idea what, exactly, they're naming or why they even need this new name. In spite of the currency of its use, *postmodernism* has thus far acquired no agreed-upon meaning at all. For the most part, it is used in only a negative sense, to say that modernism is over. And where it is used in a positive sense, it is used as a catch-all, to characterize anything and everything that is happening in the present. So, for example, Douglas Davis, who uses the term very loosely, and relentlessly, says of it:

"Post-modern" is a negative term, failing to name a "positive" replacement, but this permits pluralism to flourish (in a word, it permits *freedom,* even in the marketplace). . . . "Post-modern" has a reactionary taint—because "Modern" has come to be acquainted with "now"—but the "Tradition of the New" requires a strong counter-revolution, not one more forward move.[16]

Indeed, counterrevolution, pluralism, the fantasy of artistic freedom—all of these are, for many, synonymous with postmodernism. And they are right to the extent that in conjunction with the end of modernism all kinds of regressive symptoms are appearing. But rather than characterizing these symptoms as postmodernist, I think we should see them as the forms of a retrenched, a petrified, reified modernism. They are, I think, the morbid symptoms of modernism's demise.

Photography's entrance into the museum on a vast scale, its revaluation according to the epistemology of modernism, its new status as an autonomous art—this is what I mean by the symptoms of modernism's demise. For photography is not autonomous, and it is not, in the modernist sense, an art. When modernism was a fully operative paradigm of artistic practice, photography was necessarily seen as too contingent—too constrained by the world that was photographed, too dependent upon the discursive structures in which it was embedded—to achieve the self-reflexive, entirely conventionalized form of modernist art. This is not to say that no photograph could ever be a modernist artwork; the photographs in MoMA's *Art of the Twenties* show were ample proof that certain photographs could be as self-consciously about photographic language as any modernist painting was about painting's particular conventions. That is why MoMA's photography department was established in the first place. Szarkowski is the inheritor of a department that reflected the modernist aesthetic of Alfred Stieglitz and his followers. But it has taken Szarkowski and *his* followers to bestow retrospectively upon *photography itself* what Stieglitz had thought was achieved by only a very few photographs. For photography to be understood and reorganized in such a way is a complete perversion of modernism, and it can happen only because modernism has indeed become dysfunctional. Postmodernism may be said to be founded in part upon this paradox: that it is photography's revaluation as a modernist medium that signals the end of modernism. Postmodernism begins when photography comes to pervert modernism.

8 | 9

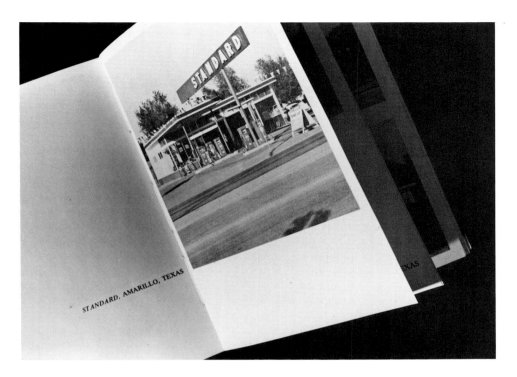

Ed Ruscha, *Twentysix Gasoline
Stations,* 1962 (Photo: Louise
Lawler, 1987)

If this entry of photography into the museum and the library's art division is one means of photography's perversion of modernism—the negative one—then there is another form of that perversion which may be seen as positive, in that it establishes a wholly new and radicalized artistic practice that truly deserves to be called postmodernist. For at a certain moment photography enters the practice of art in such a way that it contaminates the purity of modernism's separate categories, the categories of painting and sculpture. These categories are subsequently divested of their fictive autonomy, their idealism, and thus their power. The first positive instances of this contamination occurred in the early 1960s, when Rauschenberg and Warhol began to silkscreen photographic images onto their canvases.[17] From that moment forward, the guarded autonomy of modernist art was under constant threat from the incursions of the real world that photography has read-mitted to the purview of art. After over a century of art's imprisonment in the discourse of modernism and the institution of the museum, hermetically sealed off from the rest of culture and society, the art of postmodernism begins to make inroads back into the world. It is photography, in part, that makes this possible, while still guaranteeing against the compromising atavism of traditional realism.

Another story about the library will perhaps illustrate my point. I was once hired to do research for an industrial film about the history of transportation, a film that was to be made largely by shooting footage of still photographs; it was my job to find appro-priate photographs. Browsing through the stacks of the New York Public Library where books on the general subject of transportation were shelved, I came across the book by Ed Ruscha entitled *Twentysix Gasoline Stations,* a work first published in 1963 and consisting of photographs of just that: twenty-six gasoline stations. I remember thinking how funny

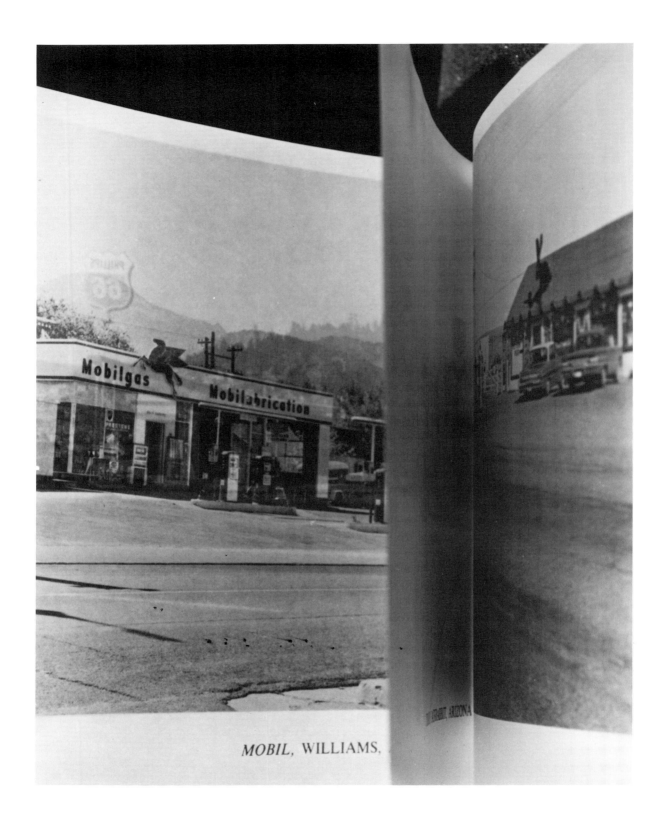

MOBIL, WILLIAMS,

Ed Ruscha, *Twentysix Gasoline
Stations,* 1962 (Photo: Louise
Lawler, 1987)

it was that the book had been miscatalogued and placed alongside books about automobiles, highways, and so forth. I knew, as the librarians evidently did not, that Ruscha's book was a work of art and therefore belonged in the art division. But now, because of the considerations of postmodernism, I've changed my mind; I now know that Ed Ruscha's books make no sense in relation to the categories of art according to which art books are catalogued in the library, and that that is part of their achievement. The fact that there is nowhere within the present system of classification a place for *Twentysix Gasoline Stations* is an index of its radicalism with respect to established modes of thought.

The problem with the view of postmodernism which refuses to theorize it and thereby confuses it with pluralism is that it lumps together under the same rubric the symptoms of modernism's demise with what has positively replaced modernism. Such a view has it that the paintings of Elizabeth Murray and Bruce Boice—clearly academic extensions of a petrified modernism—are as much manifestations of postmodernism as Ed Ruscha's books—just as clearly replacements of that modernism. For Ruscha's photographic books have escaped the categories through which modernism is understood just as they have escaped the art museum, which arose simultaneously with that modernism and came to be its inevitable resting place. Such a pluralist view of postmodernism would be like saying of modernism at its founding moment that it was signaled by both Manet *and* Gérôme (and it is surely another symptom of modernism's demise that revisionist art historians are saying just that), or, better yet, that modernism is both Manet and Disdéri, that hack entrepreneur who made a fortune peddling photographic visiting cards, who is credited with the first extensive commercialization of photography, and whose utterly uninteresting photographs hang, as I write this essay, in the Metropolitan Museum of Art in an exhibition whose title is *After Daguerre: Masterworks from the Bibliothèque Nationale*.

Barnes:
• a photograph is always invisible- it Is not what we see -
it carries its referent w/ it always.
• cannot be separated - "windowpane & landscape."

→ but modernism wants to make photographs that are
~~about photographs~~. about photographs.

1 Rosalind Krauss has persuasively argued the case for thinking of the *Large Glass* as a kind of photo-graph; see "Notes on the Index: Seventies Art in America," *October* 3 (Spring 1977), pp. 68–81.

2 For a detailed discussion of this between-the-wars reaction in relation to the recent return to representational painting, see Benjamin H. D. Buchloh, "Figures of Authority, Ciphers of Regression," *October* 16 (Spring 1981), pp. 39–68.

3 Just as this essay originally went to press in the spring of 1981, a mural-size print of *Moonrise* was sold at auction for over $70,000. Ansel Adams died in 1984.

4 For an important discussion of the relations between real estate development and the art world, see Rosalyn Deutsche and Cara Gendel Ryan, "The Fine Art of Gentrification," *October* 31 (Winter 1984), pp. 91–111.

5 Lawrence Alloway, Bruce Boice, Elizabeth Murray, et al., "Picasso: A Symposium," *Art in America* 68: 10 (December 1980), p. 19.

6 Ibid., p. 17.

7 John Richardson, "Your Show of Shows," *New York Review of Books* 27: 12 (July 17, 1980), pp. 16–24.

8 For a critique of the prevailing view of Picasso's art as autobiography, see Rosalind Krauss, "In the Name of Picasso," *October* 16 (Spring 1981), pp. 5–22.

9 John Szarkowski, "Introduction to *The Photographer's Eye,*" in Peninah R. Petruck, ed., *The Camera Viewed: Writings on Twentieth-Century Photography* (New York: E. P. Dutton, 1979, vol. 2), p. 203.

10 Ansel Adams, "A Personal Credo," *American Annual of Photography* 58 (1948), p. 16.

11 Ibid., p. 13.

12 Szarkowski, pp. 211–12.

13 See Julia van Haaften, " 'Original Sun Pictures': A Check List of the New York Public Library's Holdings of Early Works Illustrated with Photographs, 1844–1900," *Bulletin of the New York Public Library* 80: 3 (Spring 1977), pp. 355–415.

14 See Anne M. McGrath, "Photographic Treasures at the N.Y.P.L.," *AB Bookmans Weekly,* January 25, 1982, pp. 550–60. As of 1982 the photography collection, of which Julia van Haaften is the *curator,* was integrated into what is now called the Miriam and Ira D. Wallach Division of Art, Prints, and Photographs.

15 Szarkowski, p. 206.

16 Douglas Davis, "Post-Everything," *Art in America* 68: 2 (February 1980), p. 14. Davis's notion of freedom, like that of Picasso's fans cited earlier, is the thoroughly ideological one which recognizes no such problematic constraints as class, race, gender, etc. It is therefore highly telling that when Davis thinks of freedom, the first thing that springs to his mind is "the marketplace." Indeed, the notion of freedom perpetuated here is the Reagan-era version of it, as in "free" enterprise.

17 For further discussion of this founding moment of postmodernism, see my essay "On the Museum's Ruins," in Hal Foster, ed., *The Anti-Aesthetic: Essays in Postmodern Culture* (Port Townsend, WA: Bay Press, 1983), pp. 43–56.

12 | 13

My ideal is to achieve the ability to produce numberless prints from each negative, prints all significantly alive, yet indistinguishably alike, and to be able to circulate them at a price no higher than that of a popular magazine or even a daily paper. To gain that ability there has been no choice but to follow the path that I have chosen.

Alfred Stieglitz, catalogue preface to his exhibition at the Anderson Galleries, 1921

The Judgment Seat of Photography

Photography, at least from the inception of Fox Talbot's negative/positive technique, would seem the very type of what Jean Baudrillard has recently called the "industrial simulacrum"—his designation for all of those products of modern industrial processes that can be said to issue in potentially endless chains of identical, equivalent objects.[1] Duplicability, seriality, "copies" that refer back to no "original": these are the hallmarks of Baudrillard's "order of simulacra." They are, as well, precisely those characteristics one might ascribe to photography as the principal source of the mass imagery that ceaselessly circulates throughout the global *société de consommation*.

This perspective, needless to say, is considerably at odds with the institutional trends that have, in recent years, borne photography triumphantly into the museum, the auction house, and the corporate boardroom. A curious denial—or strategic avoidance—of the fact of photography's sheer multiplicity informs much of today's authoritative discussion of the medium. Consider the assertion of the present director of the Museum of Modern Art's Department of Photography that "a photographic print is a much less predictable product than a print from an engraving or an etching plate," or his assurance that the likelihood of a photographer's being "able truly to duplicate an earlier print is very slight." [2]

This passage from multiplicity, ubiquity, equivalence to singularity, rarity, and authenticity seems conveniently to account for the kind of closure effected by photography's gradual reconstitution as an art and as the museum's natural and special object of study. When we turn, however, to consider the institutional setting in which this transformation might be said principally to have taken place, we quickly discover the process to have been more complex and equivocal than suspected. I speak, of course, of the MoMA Department of Photography, which for nearly half a century, through its influential exhibitions and publications, has with increasing authority set our general "horizon of

expectation" with respect to photography. MoMA's assimilation of photography has indeed proceeded, on the one hand, through an investing of photography with what Walter Benjamin called the "aura" of traditional art—accomplished, in this case, by revamping older notions of print connoisseurship, transposing the ordering categories of art history to a new register, and confirming the workaday photographer as creative artist. But equally important has been the museum's considerable effort to reappropriate, on its own terms, those very aspects of photographic reproducibility believed by Benjamin to signal the aura's demise.

The cultural transformation of photography into a museum art provides, and in no small degree, an ironic postscript to the thesis that Benjamin elaborated in his 1936 essay "The Work of Art in the Age of Mechanical Reproduction." And it is for that very reason that I shall retain, in the background of the discussion that follows, the pair of terms "cult value" and "exhibition value." Their opposition provides the basis for Benjamin's claim that "that which withers in the age of mechanical reproduction is the aura of the work of art." [3]

This oft-cited fragment compresses into aphorism a rich and ingenious argument, one by now sufficiently familiar to require no full-scale treatment here. In brief, Benjamin proceeded from what he saw as a historical distinction between two modes of reception of art. Cult value was rooted in art's origins in religious/magical ritual, whence the unique presence manifested in the aura of the work of art. Exhibition value involved the gradually changing function of the work of art as it became portable and (later) duplicable— thus, the passage from the fixed fresco or mosaic of the Renaissance to the mobile "public presentability" of easel painting. Tracing these two modes to modern times, Benjamin described a secularized cult value that revealed itself in a preoccupation with the singularity and the physical authenticity of the treasured art object. Here, moreover, religious mystery was progressively displaced by the mysteries of creative genius and eternal value, mysteries whose meaning could be interpreted to art's public only through the mediations of the art expert and the connoisseur. In this view—and Benjamin is writing during his least ambiguously Marxist phase—the aura of the secular work of art, the "unique phenomenon of a distance however close it may be," is disclosed as a function of its embeddedness in the constraining discourse that bourgeois society calls cultural tradition.

But tracing the course of exhibition value in similar fashion to the present, Benjamin saw in the nineteenth century's perfection of technically precise reproduction media such as photography and film the opportunity not only to prise art from its cultural constraints, but also to transform radically its traditional functions. As the singular original gave way to a plurality of increasingly precise copies, so would the previously unbridgeable gap between art and its audience give way to universal availability and accessibility. Hence, Benjamin anticipated a "dissolution" of the aura, a proliferation of meanings, in short a "tremendous shattering of tradition." It is here that the Marxist thread of his discourse emerges explicitly, for Benjamin welcomed the desacralization of the work of art, the "liquidation" of cultural tradition, as clearing the way for a radical critique of bourgeois society. In particular, he identified photography and film—forms conceived as inherently reproducible—as the indispensable instruments of such a critique, since they promised to introduce new modes of perception and analysis in ways immediately comprehensible to a mass public.

Now while the last decade has seen a remarkable renewal of interest in those facets of Benjamin's thought that I have so schematically outlined, there has been a notable absence

(at least in America) of a corresponding reexamination of the shrewdest criticism it origi-
nally received—that of Theodor Adorno. After reviewing what he called Benjamin's "ex-
traordinary study," Adorno nonetheless voiced a strong skepticism in regard to its
argument. By setting up an enabling opposition between cult value and exhibition value,
privileging the latter, and representing it as an unequivocally positive agent of change,
Adorno felt that Benjamin had lapsed into a technological determinism. The techniques
of reproducibility, Adorno claimed, having arisen wholly within the framework of the
capitalist order, were not to be so easily disentangled from their role in the functioning of
that order. If the historical processes that Benjamin condensed under the rubric exhibi-
tion value were not, in fact, incompatible with the values of bourgeois culture, they could
not fulfill the conveniently one-sided role that Benjamin wished them to play. Of the
relation between the traditional forms of high art and the new technical modes, Adorno
insisted, "Both bear the scars of capitalism, both contain elements of change. . . . Both are
torn halves of full freedom, to which however they do not add up."[4]

One can only share Adorno's belief that Benjamin's undeniably pioneering effort carries
more than a trace of the social and technological romanticism so evident in Germany
between the wars, evident in figures as diverse as Brecht and Moholy-Nagy. With this
proviso, however, and aware of the utopian aspect of exhibition value, we can see Benja-
min's two modes of reception as providing a useful starting point for the consideration of
a remarkable process: the way in which photography—the medium believed by Benjamin
to have effectively overthrown the "judgment seat" of traditional art[5]—has in turn been
subjected to the transfiguring gaze of art's institutional guardian: the museum.

From the time of MoMA's opening in 1929, photography received the museum's nodding
recognition as one branch of modernist practice, doubtless spurred by MoMA director
Alfred H. Barr, Jr.'s awareness of the photographic activity of the European avant-garde.
The first showings of photography at the museum resulted, however, from the intermit-
tent enthusiasm of Lincoln Kirstein, then one of the most active members of the MoMA
Junior Advisory Committee. It was Kirstein who, with Julian Levy, in 1932 arranged the
first exhibition to feature photographs (in this case giant photomurals by Steichen and
Berenice Abbott, among others) in *Murals by American Painters and Photographers*. The next
year, Kirstein sponsored the showing of photographs of American Victorian houses by his
friend Walker Evans—a project Kirstein had conceived and personally financed. Until
1935, however, the date of Beaumont Newhall's arrival as librarian (replacing Iris Barry,
who now headed the new Film Department), no MoMA staff member spoke with author-
ity for photography's interests.[6]

Newhall's exhibition *Photography 1839–1937* is usually cited as a crucial step in the
acceptance of photography as a full-fledged museum art. Considered from a slightly dif-
ferent perspective, it also emerges as an important link in the series of four great didactic
exhibitions staged at MoMA during 1936–38; the others were Barr's *Cubism and Abstract
Art* (1936) and *Fantastic Art, Dada, and Surrealism* (1936), and the retrospective *Bauhaus:
1919–1928* (1938). Together, these exhibitions demonstrated MoMA's influential moderni-
zation of what had come to be known among museum professionals as the "aesthetic
theory of museum management."[7] The central tenets had at first been spelled out in the
dramatic reorientation of the Boston Museum of Fine Arts three decades earlier. At that
time the educational role of art museums had been sharply distinguished from that of

Installation view of *Murals*
by American Painters and
Photographers, MoMA, 1932
(Permission of The Museum of
Modern Art, New York)

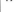

history or science museums. Rather than provide useful information or technical instruc-
tion, the art museum was increasingly directed toward the service of "joy not knowl-
edge." That is, it began to serve as *vade mecum* to aesthetic appreciation; it became a
treasure house of "eternal" monuments of art, the guarantor of art's continuous tradition.
Like Barr, Newhall had been schooled in the essentials of this approach—connoisseurship
and rigorous art-historical scholarship—in the famous museum seminars led by Paul
Sachs at Harvard's Fogg Art Museum.[8] By the mid-1930s, MoMA's refinement of these
methods—through the rationalization of collection building, the augmentation of the
role of the research library, and the extension of scholarly commentary to exhibition
catalogues—accounted in part for its reputation in museum circles. The four exhibitions
of 1936–38—with their vast installations, exhaustive documentation, and ambitious cata-
logue essays—carried the process one step further. They sought to impart a convincing
retrospective order to their heterogeneous domains, and, by so doing, to confirm MoMA's
claim as the preeminent institutional interpreter of modern art and its allied movements.

Turning again to *Photography: 1839–1937,* we can see that Newhall's exhibition is
frankly uninterested in the old question of photography's status among the fine arts;
rather, it signaled MoMA's recognition that implicit in photography's adoption by the Eu-
ropean avant-garde was a new outlook on the whole spectrum of photographic applica-
tions. The approach of photography's centenary year provided reason enough to stage in
America the kind of far-reaching examination that had been common in Germany, for
example, for over a decade. Newhall's exhibition—comprising more than eight hundred
catalogued items grouped according to technical processes (daguerreotypy, calotypy, wet-
plate, and dry-plate periods) and their present-day applications (press photography, infra-
red and X-ray photography, astronomical photography, "creative" photography)—clearly

seems guided more by Moholy-Nagy's expansive notion of *fotokunst* than by Stieglitz's *kunstphotographie*.[9] Moholy was, indeed, one of Newhall's principal advisers and "teachers" before the exhibition. Stieglitz, on the other hand, who still insisted on the utter opposition of fine-art and applied photography, not only declined to cooperate with Newhall, but also refused to allow his later photographs to be represented.[10]

Without resorting to devices as overtly didactic as Moholy's eight "varieties of photographic vision," Newhall nevertheless conceived the exhibition primarily as a lesson in the evolution and specialization of photographic techniques; the work of Muybridge, Atget, Stieglitz, and Anschutz, for instance, was presented under the rubric of dry-plate photography. The scope of the exhibition, its organization primarily along technical lines, and Newhall's refusal to make the expected pronouncement on photography's place among the fine arts—together these represented a notable departure from the usual practice of an American art museum. Lewis Mumford raised the question in the *New Yorker*:

Perhaps it is a little ungrateful for me to suggest that the Museum of Modern Art has begun to overreach itself in the matter of documentation. . . . What is lacking in the present exhibition is a weighing and an assessment of photography in terms of pure aesthetic merit—such an evaluation as should distinguish a show in an art museum from one that might be held, say, in the Museum of Science and Industry. In shifting this function onto the spectator, the Museum seems to me to be adding unfairly to his burden.[11]

Mumford notwithstanding, we need only to look more closely into Newhall's catalogue essay to locate the emerging signs of MoMA's reordering of photography along lines consistent indeed with the conventional aims of the art museum. In Newhall's long essay (the seed of his subsequent *History of Photography*), we find an explicitly articulated program for the isolation and expert judging of the "aesthetic merit" of photographs—virtually any photograph, regardless of derivation. Newhall's method here seems to me directly related to that of Alfred Barr in his *Cubism and Abstract Art*, published the previous year. Barr's famous flow charts of the various "currents" of modern painting depended on an admittedly formalist supposition: the existence of a self-enclosed, self-referential field of purely aesthetic factors, untouched by the influence of any larger social or historical forces. What is explicit in Barr (and what provoked, by way of rejoinder, Meyer Schapiro's "Nature of Abstract Art") reappears *sub rosa* in Newhall. Drawing on the earlier, overwhelmingly technical histories of photography (those of Eder and Potonniée, in particular), Newhall outlined photography's history primarily as a succession of technical innovations—independent, for all intents and purposes, of developments in the neighboring graphic arts or painting—that were to be assessed above all for their aesthetic consequences.

How were these aesthetic factors to be isolated? Newhall found the key in the purist/ formalist appeal to those qualities somehow judged to be irreducibly intrinsic to a given medium or, in Newhall's words, "generic to photography."[12] In this case, "In order that . . . criticism of photography should be valid, photography should be examined in terms of the optical and chemical laws which govern its production."[13] On this basis, and taking his cue, I suspect, from Barr's well-known opposition (in *Cubism and Abstract Art*) of the "two main traditions of abstract art," Newhall likewise located two main traditions of aesthetic satisfaction in photography: from the optical side, the *detail,* and from the chemical side, *tonal fidelity*. This "schism" is found "to run through the entire history of photography"[14] from the daguerreotype (detail) and calotype (tonal mass) to the modern high-resolution products of the view camera and the less precise but graphically more

forceful images of the miniature camera. The creative application of these primary qualities consists, for Newhall, in the recognition of "significant" detail and in the arrangement of "large simple masses" or a "fine range of shimmering tones."[15]

The aims of this method, as specified in the preface added to the next year's revised edition, were "to construct a foundation by which the significance of photography as an esthetic medium can be more fully grasped."[16] The limits and constraints of these aims are nowhere more clearly revealed than in Newhall's remarks on the nineteenth-century French photographer Charles Marville. Marville had, in the 1860s, documented the condemned sections of old Paris before they were razed to make way for Haussmann's boulevards. For Newhall, Marville's photographs can be considered "personal expressions" principally by virtue of the photographer's "subtle lighting and careful rendition of detail."[17] Having once established this priority, any social/historical residue can be unobtrusively rechanneled as nostalgia—in Newhall's words, "the melancholy beauty of the condemned and vanished past."[18]

The appearance at MoMA, three years before the founding of a full department of photography, of this rudimentary way of "looking at photographs," seems in retrospect the real point of interest in Newhall's 1937 exhibition. By carefully limiting his attention to what he later codified as the "relationship of technique to visualization,"[19] Newhall opened the door to a connoisseurship of photographs that might easily range beyond the confines of art photography, yet still avoid the nettlesome intermediary questions raised by the photographic medium's entanglement in the larger workings of the world.

Newhall never fully explored the implications of such a method; by 1940, when he was named the museum's curator of photography (the first time any museum had created such a post), he had already redirected his interests to what he conceived as photography's creative, rather than practical or applied, side. In his "Program of the Department," he now called for the study of photography to be modeled on that of literature, conventionally conceived: as the examination "under the most favorable conditions, of the best work that can be assembled."[20] In practice, this involved a new dependence on the connoisseur's cultivated, discriminating taste; on the singling out of the monuments of photography's past; on the elaboration of a canon of "masters of photography"; and on a historical approach that started from the supposition of creative expression—in short, an art history of photography. For the sources of this reinscription of photography within the traditional vocabulary of the fine arts, we must look not only to Newhall, but also to the two others who presided with him over the inception of the department: the collector David Hunter McAlpin and the photographer Ansel Adams.

Signs of this reinscription were already clear in 1938, when Newhall's earlier essay reappeared, revised, as *Photography: A Short Critical History.* Where Moholy-Nagy might be seen as the guiding spirit of 1937, now Stieglitz was firmly installed as *genius loci:* a new dedication rendered homage to Stieglitz, and one of his photographs was reproduced as frontispiece. More revealing was the disappearance of that section of the earlier essay in which Newhall (echoing Moholy) had scored the dependence of Stieglitz's Photo-Secession group on the models of genre painting and pointed out that its members' production of prints had been "arbitrarily limited, in spite of the fact that an inherent characteristic of photography is its ability to yield infinite identical prints."[21] In its place there now appeared a paean to Stieglitz as visionary, which revolved around the claim that "the step to modern art was logical and direct, for Stieglitz and the group were alive to every type of revelation through pictures."[22]

Newhall's new alignment with such a transcendent claim of modernist photography, rather than with the more openly functionalist claims of the "new vision," can be seen as one means of attracting the support necessary to establish a full department at MoMA. The key step was the involvement—thanks to Newhall's friend Ansel Adams—of David Hunter McAlpin, a wealthy stockbroker related to the Rockefeller family, whom Stieglitz had groomed as a collector of photographs. It was McAlpin who initially agreed to provide funds for the museum to purchase photographs, and he was subsequently invited to join the MoMA board as the founding chairman of the Committee on Photography. In 1940 it was McAlpin who arranged to bring Ansel Adams to New York as vice-chairman of the new department, to join Newhall in organizing its first exhibitions.[23]

Looking at the first exhibition staged by Newhall and Adams, *60 Photographs: A Survey of Camera Esthetics,* and reading the texts that accompanied it, one finds a number of markers set in place to delimit the kinds of photographs with which the new department would be concerned. Quick to appear are notions of rarity, authenticity, and personal expression—already the vocabulary of print connoisseurship is being brought into play. The collector David McAlpin introduced the theme of the rarity of the photographic original:

The history of painting, sculpture, and the other arts . . . is widely accessible to all. By reason of the perishable nature of plates, films, and prints, original photographic material is scarce. Much of it has disappeared. What remains is scattered, its whereabouts unknown.[24]

Newhall, elaborating upon this idea, broached the possibility of a rarity of still greater degree:

From the prodigious output of the last hundred years relatively few great pictures have survived—pictures which are personal expressions of their makers' emotions, pictures which have made full use of the inherent characteristics of the medium of photography. These living photographs are, in the fullest sense of the word, works of art.[25]

Having indicated the narrowing scope of his interests, Newhall went on to imply a comparative system of classification of photographic prints, one ultimately enabling him to suggest the way in which the question of authenticity might be addressed. Physical authenticity could be referred back to considerations of technical process, which had figured so prominently in his 1937 essay; *60 Photographs* allowed Newhall to emphasize his expert familiarity with the special characteristics of calotypes, albumen prints, platinum prints, direct photogravures, palladio-types, chloride prints, bromide prints, and so on. But a more subtle test of authenticity was the degree to which a photograph might be enveloped, without incongruity, in the language and categories usually reserved for fine art. Thus Newhall called attention to the photographic interpretation of such traditional genres as landscape, portraiture, and architectural studies. Further, a way of placing photographs according to the degree and direction of visual stylization was suggested, along an axis bounded by the terminals of "objective" and "abstract" renderings.

But the chief claim made for the work presented in *60 Photographs* was this: "Each print is an individual personal expression."[26] As the ultimate guarantee against the charge that the photographic process was merely mechanical, this claim presents no special difficulty when made, as it was here, on behalf of photographers like Stieglitz, Strand, Weston, Sheeler, and Walker Evans—self-conscious modernists all. The stakes are somewhat different, however, when the same claim is extended to earlier photographs made in a variety of circumstances and for a variety of reasons. And it is here, I think, that we may look to Ansel Adams for the first flowering of a practice that reappears, in the tenure of

John Szarkowski, as a crucial feature of MoMA's critical apparatus: the projection of the
critical concerns of one's own day onto a wide range of photographs of the past that were
not originally intended as art.

Not surprisingly, Adams undertook a modernist rereading of the work of the
nineteenth-century wet-plate photographers of the American West in the light of the
post-Stieglitz "straight" aesthetic. Just before his move to New York in 1940, Adams
(with Newhall's help) organized a large exhibition in San Francisco that highlighted such
early western photographers as Timothy O'Sullivan, William Henry Jackson, Jack Hillers,
and Carleton Watkins. By confirming his attention to questions of photographic tech-
nique and the stylistics of landscape (and pushing to the margins the very different cir-
cumstances that had called these photographs into being), Adams was able to see in them
"supreme examples of creative photography," belonging to one of the medium's "great
traditions" [27]—needless to say, his own. The same pronounced shift in the "horizon of
expectation" brought to earlier work is evident as well in the essay, "Photography as an
Art," that Newhall contributed to the same catalogue. In it he redrew the boundaries of
art photography to accommodate the Civil War documentation of the Brady group. Ad-
mitting that the photographs had been made "without any implied esthetic intent," he
claimed them for art on the grounds that they seemed, to him, undeniably "tragic and
beautiful" and that they specifically prefigured the concerns of latter-day documentary
stylists like Walker Evans and Berenice Abbott.[28] These Civil War and early western pho-
tographs were brought together at MoMA two years later, beginning their long rehabilita-
tion as independent, self-contained aesthetic objects.

To a remarkable degree, the program of nearly thirty exhibitions mounted by the MoMA Department of Photography from 1940–47 anticipates what has emerged only in the last decade as the standard practice of other American museums.[29] The exhibitions centered on historical surveys (*French Photographs—Daguerre to Atget*, 1945), the canonization of masters (*Paul Strand,* 1945, and *Edward Weston,* 1946), and the promotion of selected younger photographers (Helen Levitt and Eliot Porter, 1943; Henri Cartier-Bresson, 1947). Typically the photographs were presented in precisely the same manner as other prints or drawings—carefully matted, framed, and placed behind glass, and hung at eye level; they were given precisely the same status: that of objects of authorized admiration and delectation. In this museological mise-en-scène, the "outmoded" categories of artistic reception that Walter Benjamin had expected photography to brush aside—"creativity and genius, eternal value and mystery"—were displaced onto a new ground and given new life. Photography—an admittedly narrow range of it, initially—was laid out on an institutionalized interpretative grid and made the object of expert aesthetic judgment. Moreover, by extending the axes of this grid—formalist reading, the presupposition of creative intent, the announced preciousness of the photographic print—it was conceivable that a related order might eventually be imposed on the outlying regions of photography's past.

One may reasonably wonder, then, seeing that Newhall's curatorial policies so clearly anticipate today's uncontested norm, why, in the summer of 1947, MoMA's trustees canceled their support for those policies, named the sixty-eight-year-old Edward Steichen as director of the photography department, and accepted Newhall's sudden resignation.

Simply put, it seems clear that Newhall's exhibition program failed equally to retrieve photography from its marginal status among the fine arts and to attract what the museum could consider a substantial popular following. While Barr's exhibitions, *Cubism and Abstract Art* among them, were instrumental in creating a flourishing market for modern painting and sculpture, thereby confirming MoMA's status as an important art-world tastemaker, Newhall's photography exhibitions had no comparable effect. A striking index of photography's marginality can be found in a curious 1941 MoMA showing called *American Photographs at $10,* which offered for sale limited-edition prints by the photographers who figured most prominently in Newhall's emerging canon—Stieglitz, Weston, and Adams, among them. The language in which the prints were presented all but confessed the absence of an audience attuned to the proclaimed transcendent aims of modernist art photography:

The exhibition and sale is an experiment to encourage the collecting of photographs for decoration and pleasure. Once a photographer has worked out a suitable relationship between grade of paper, exposure and development to make one fine print, he can at the same time make many more of identical quality. Thus the unit cost can be lowered.[30]

More seriously, Newhall's insistent championing of photography as fine art drew the open hostility of that section of the photographic press that claimed to speak for the nation's millions of amateurs: the department was called "snobbish," "pontifical," and accused of being shrouded in "esoteric fogs."[31] In light of the museum's desire for funds for expansion in the mid-1940s, the declaration of John A. Abbot, vice-president of the museum's board, that MoMA intended actively to seek the "support of the photographic industry and photography's vast and devoted following"[32] clearly spelled trouble for Newhall. In Newhall's later recollection:

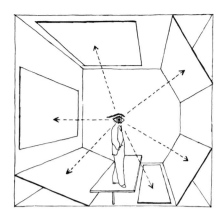

Herbert Bayer, Diagram of
extended vision in exhibition
presentation, 1930

Suddenly I was told by the director that the Trustees had decided to appoint Edward Steichen as the Director of Photography. I'd felt that I could not work with Steichen. I respected the man, I knew the man pretty well by this time. I just didn't see that we could be colleagues. It was as simple as that. My interests were increasingly in the art of photography; his were increasingly in the illustrative use of photography, particularly in the swaying of great masses of people.[33]

The approach that Newhall had mapped out at MoMA survived, of course: as an influential text (his *History of Photography,* first published in 1949[34]) and in an important institutional enclave (the George Eastman House, whose first director he became). Nevertheless, the next fifteen years at MoMA were marked by Steichen's inclination not to give a "hoot in hell"[35] for photography conceived as an autonomous fine art.

In his 1947 study of the former Bauhaus artist/designer Herbert Bayer, Alexander Dorner offered this ironic conception of the classically conceived exhibition gallery:

The gallery shows works of art containing eternal ideas and forms in an equally immutable framework of space which itself has grown out of the absolute immutability of the inner form. . . . The visitor . . . is supposed to visit a temple of the eternal spirit and listen to its oracle.[36]

Announcing to his American audience that the age of art forms such as these was at an end, Dorner hailed the Bauhaus for its "explosive transformation of the very idea *art*"; in language strikingly similar to Walter Benjamin's he described the situation brought about by the decline of traditional art forms as one "bursting with energies which, once set to work in the practical context of life, might well influence life on a tremendous practical scale."[37]

Bayer's own contrasting idea of the aims of the modern exhibition descended from El Lissitzky's revolutionary use of repetitive photographic/typographic clusters in the late 1920s, mediated by the Bauhaus's rationalization of Lissitzky's techniques in the 1930s. Bayer called on the modern exhibition to apply all of the techniques of the "new vision" in combination with color, scale, elevation, and typography—all of these to serve, moreover, a decidedly instrumental end. The modern exhibition, he wrote,

. . . should not retain its distance from the spectator, it should be brought close to him, penetrate and leave an impression on him, should explain, demonstrate, and even persuade and lead him to a planned and direct reaction. Therefore we may say that exhibition design runs parallel with the psychology of advertising.[38]

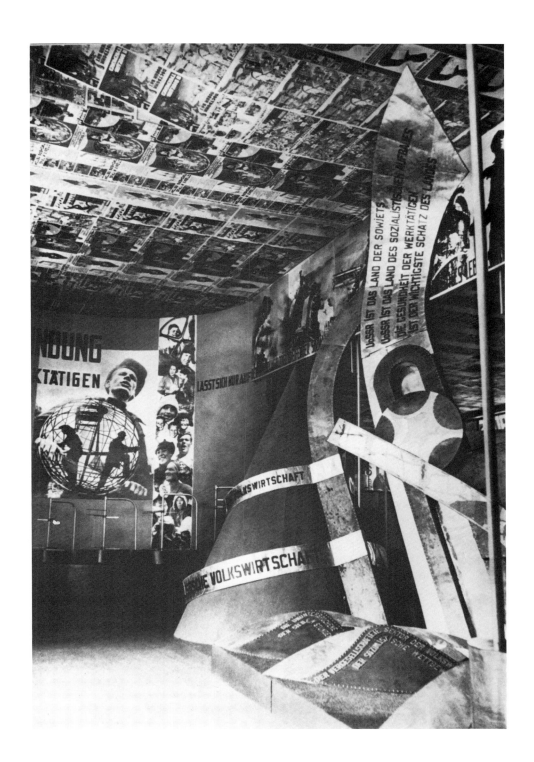

El Lissitzky, Soviet Pavilion,
International Hygiene
Exhibition, Dresden, 1930

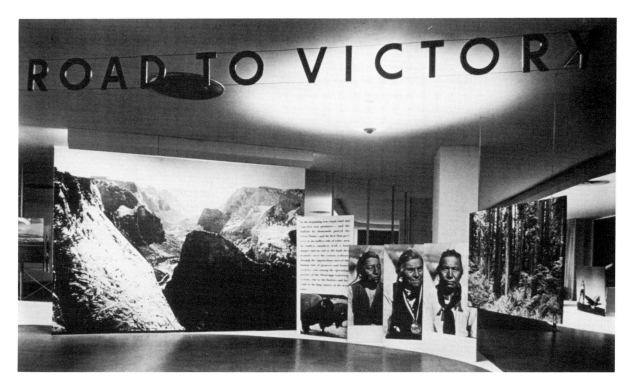

Road to Victory, view of
MoMA installation by Herbert
Bayer, 1942 (Permission of
The Museum of Modern Art,
New York)

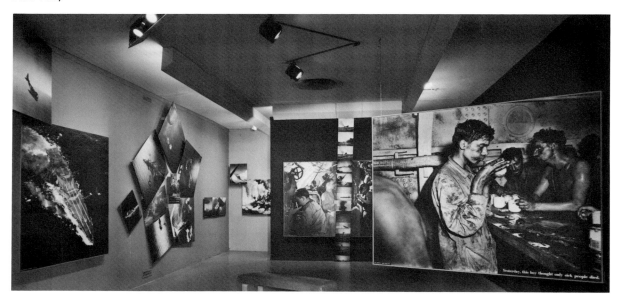

Power in the Pacific, view of
MoMA installation by George
Kidder Smith, 1945 (Permission
of The Museum of Modern Art,
New York)

In the Germany of the 1920s and early 1930s, this turn of emphasis could well be seen as essential to the rapid education of a backward public to the complexities of an emerging technological culture; such, of course, was one of the overriding themes of the entire Bauhaus project. But these principles, transported to the America of the postwar period, proved quite readily adaptable to very different ends—particularly when used to shape the extravagant thematic exhibitions that marked Steichen's years at MoMA.

Now it might seem that Steichen—one of the founders of the Photo-Secession and, with Stieglitz, one of the first promoters of European modernist art in America—was uniquely fitted to fulfill Newhall's efforts to consolidate a place for fine-art photography within the museum. But since the 1920s Steichen's ambitions had carried him far beyond the confines of art photography: his portrait and fashion photography for *Vanity Fair* and *Vogue* brought him personal celebrity and fortune, and during his service in the U.S. Navy in World War II he learned the enormous power of quasi-documentary reportage aimed at the home-front audience. It was with this knowledge that, in 1942, he first came to MoMA:

During the war I collected photographs and organized an exhibition called "Road to Victory," and it was that exhibition which gave ideas to the board of directors of the Museum. Here was something new in photography to them. Here were photographs that were not simply placed there for their aesthetic values. Here were photographs used as a force and people flocked to see it. People who ordinarily never visited the museum came to see this. So they passed the proposition on to me that I keep on along those lines.[39]

The impact of *Road to Victory* depended largely on the ingenious installation devised for Steichen by Herbert Bayer, who had left Germany in 1938. Spectators were guided along a twisting path of enormous, freestanding enlargements of documentary photographs—some as large as ten by forty feet. This arrangement was calculated to produce a visual narrative that combined the most dramatic devices of film and *Life*-style photojournalism. In *PM* the photographer Ralph Steiner wrote, "The photographs are displayed by Bayer as photographs have never been displayed before. They don't sit quietly on the wall. They jut out from the walls and up from the floors to assault your vision."[40] The exhibition attracted immense crowds and critical plaudits, as did its 1945 successor, *Power in the Pacific.*

It was in just this direction, and in this style, that Steichen was invited to continue at MoMA after the war: rather than contest the peripheral status of art photography, he was to capitalize on photography's demonstrably central role as a mass medium that dramatically "interpreted" the world for a national (and international) audience. That the museum harbored such an interest seems peculiar only if one ignores MoMA's extensive wartime program, in which the museum's prestige was directed toward the "educat[ion], inspir[ation], and strengthen[ing of] the hearts and wills of free men in defense of their own freedom."[41] Later—as Eva Cockcroft has shown—after carrying out a number of wartime cultural missions for Nelson Rockefeller's Office of Inter-American Affairs, MoMA emerged as one of the principal actors in the cultural Cold War.[42] In welcoming Steichen to MoMA in 1947, Rockefeller (then president of MoMA's board) served notice that the Department of Photography's concerns would no longer be confined to the aesthetic realm:

Steichen, the young man who was so instrumental in bringing modern art to America, joins with the Museum of Modern Art to bring to as wide an audience as possible the best work being done throughout the world, and to employ it creatively as a means of interpretation in major Museum exhibitions where photography is *not the theme but the medium through which great achievements and great moments are graphically represented.*[43]

One can, with Allan Sekula, see productions like *The Family of Man* as exercises in sheer manipulation; but one can also see in their enthusiastic reception that familiar mass-cultural phenomenon whereby very real social and political anxieties are initially conjured up, only to be quickly transformed and furnished with positive (imaginary) resolutions.[44] From this standpoint, in *Korea: The Impact of War* (1951), doubts about dispatching American soldiers to distant regional battles are acknowledged (in a careful juxtaposition of the photographs of David Douglas Duncan), only to be neutralized in an exhibition setting that emphasized stirring images of American military might. In the same way, the global patriarchical family proposed as utopia in *The Family of Man* (1955) stands to gain considerably when set as the only opposing term to the nightmare image of atomic destruction. And *The Bitter Years* (1962)—coming at the height of the superpower war of nerves over Cuba and Berlin—consciously revived (for the first time in two decades) and reinterpreted the FSA's Depression-era photographs as an inspirational demonstration of the "fierce pride and courage which turned the struggle through those long bitter years into an American epic."[45]

While one could profitably examine such exhibitions as Barthesian "mythologies," ritual reenactments and carefully channeled resolutions of Cold War anxieties, I wish to call attention to the form in which they were conceived and circulated. For the underlying premise at work is that of the ultimate availability and duplicability of photographs—a notion believed to have revolutionary implications in the 1930s, but now reappropriated and domesticated in a later and very different set of circumstances. To prise photographs from their original contexts, to discard or alter their captions, to recrop their borders in the enforcement of a unitary meaning, to reprint them for dramatic impact, to redistribute them in new narrative chains consistent with a predetermined thesis—thus one might roughly summarize Steichen's operating procedure.[46] Furthermore, beginning as early as the 1942 *Road to Victory,* each of these thematic exhibitions was conceived not as a single presentation, but as a set of multiple "editions" of varying physical dimensions intended to circulate—in the manner of motion pictures or magazines—throughout the United States and the world. Thus, by the mid-1950s, MoMA's initial press release anticipated that *The Family of Man* would open simultaneously in New York, Europe, Asia, and Latin America, thereafter to travel globally for two years.[47]

The successful application of such techniques entailed, of course, two major factors: the all-but-total disappearance of the individual photographer within the larger fabric, and a disregard of the supposed personal-expressive qualities of the "fine print."[48] The photographers complied, for the most part, signing over to the museum the right to crop, print, and edit their images. In this way, the potential void left, at one level, by the abandonment of Newhall's main tenets—the photographer as autonomous artist, the original print as personal expression—was promptly filled at another by the museum's emergence as orchestrator of meaning. One would by no means be mistaken in seeing Steichen as MoMA's glorified picture editor, sifting through thousands of images from different sources and recombining them in forms reflecting the familiar mass-cultural mingling of popular entertainment and moral edification.[49]

This slippage of the photographer from the status of autonomous artist to that of illustrator of (another's) ideas marked the entire range of Steichen's exhibitions at MoMA; and it was not confined to the giant thematic shows that constituted its most visible aspect. The young photographers, however, who came of age just after World War II and looked to the mass-circulation magazines for their livelihood generally understood illustration as the condition of photography. The most renowned artist-photographers at this

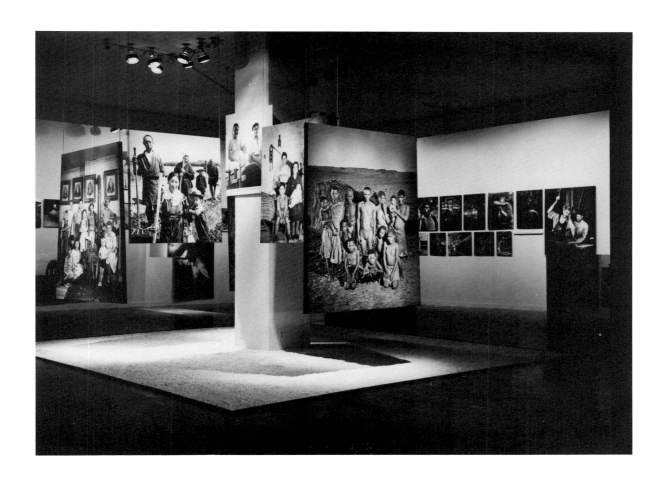

The Family of Man, view of
MoMA installation by Paul
Rudolph, 1955 (Permission of
The Museum of Modern Art,
New York)

CHRISTOPHER PHILLIPS

Installation view of *Forgotten Photographers*, MoMA, 1951 (Permission of The Museum of Modern Art, New York)

Installation view of *Abstraction in Photography*, MoMA, 1951 (Permission of The Museum of Modern Art, New York)

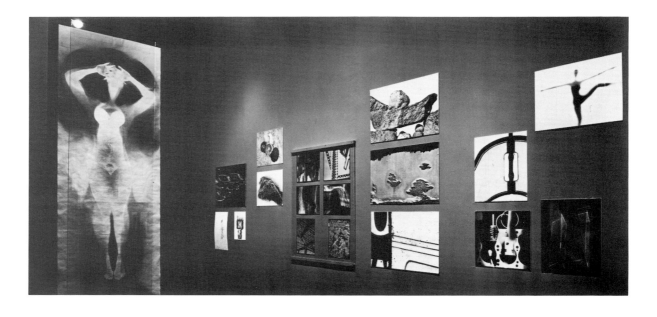

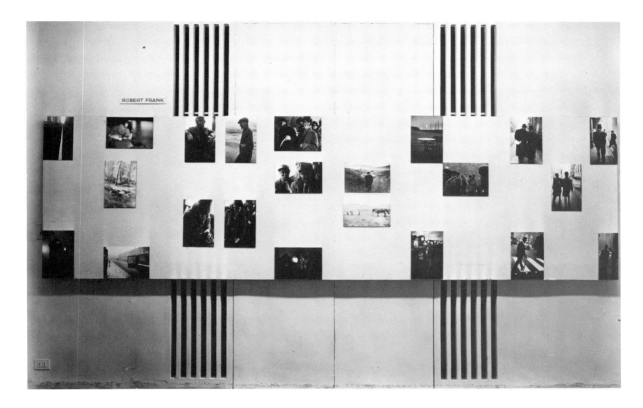

time could expect to sell their work for no more than fifteen to twenty-five dollars per print.[50] Irving Penn was surely not alone in his insistence (at the 1950 MoMA symposium, "What Is Modern Photography?") that "for the modern photographer the end product of his efforts is the printed page, not the photographic print. . . . The modern photographer does not think of photography as an art or of his photograph as an art object."[51]

This view could only be reinforced by the presentation of photographs in the MoMA galleries. Under Steichen, the typical gallery installation resembled nothing so much as an oversized magazine layout, designed to reward rapid scanning rather than leisurely contemplation. Too frequently, the designer's hand appeared to greater advantage than the photographer's eye. Even in exhibitions of "creative" photography, the preciousness of the fine print was dramatically deemphasized. Prints were typically shown flush-mounted on thick (nonarchival) backing board, unmatted, and without benefit of protective glass. In addition, one could from time to time expect to encounter giant color transparencies, commercial press sheets, and inexpensive prints from color slides.

It should not be thought that fine-art photography of the kind that Newhall had sponsored vanished entirely from the MoMA galleries—it did not. It was, however, acknowledged as a tiny band on the photographic spectrum, at a time when Steichen—an adept auto-publicist—encouraged a view of himself as the grandfatherly "dean" of *all* photog-

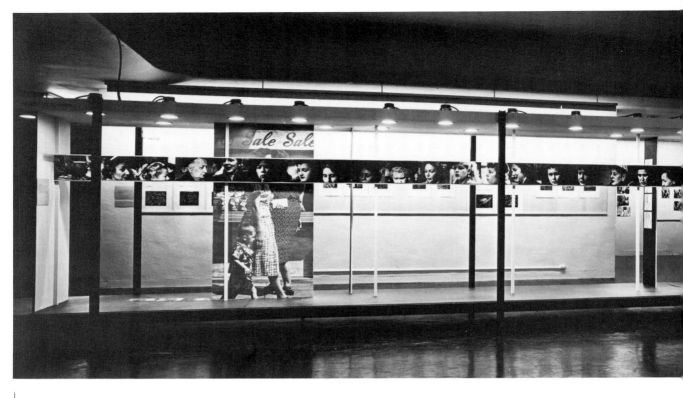

raphy and MoMA as its institutional monitor. Soon after his arrival at the museum, for example, he let it be known that "he want[ed] to gather under his wing the 200,000 of America's amateurs . . . and teach them something about making pictures. Later on he want[ed] them to send the pictures to him for sorting and cataloguing."[52] He subsequently organized large survey exhibitions treating diverse special topics like news photography (1949), color photography (1950), and abstraction in photography (1951)—this last juxtaposing "creative" work with analogous scientific work. Such exhibitions never raised the question of the artistic status of any branch of photography. Rather, they demonstrated that all photography, if properly packaged, could be efficiently channeled into the currents of the mass media. Indeed, during this period magazine inserts and syndicated newspaper interviews largely replaced exhibition catalogues.

Two irregular series of smaller exhibitions clearly showed the limitations of Steichen's approach when applied to the handling of historical and serious contemporary photography. Photography's past was acknowledged in a number of so-called "flashback" exhibitions interspersed between the larger shows. These surveyed the work of the Photo-Secession (1948), nineteenth-century French photography from the Cromer Collection of the George Eastman House (1949), and the work of Stieglitz and Atget, shown together in 1950. But in the absence of extensive magazine coverage, exhibition catalogues, or critical writing, these exhibitions attracted little attention and left virtually no trace.[53]

More significant were the many small exhibitions organized to illustrate various photographers' treatments of a given theme, defined, of course, by Steichen. The best known were the five installments of *Diogenes with a Camera* (1952–61), in which a great many photographers presented the results of their ostensible search for truth—the whole notion, one may suppose, a remnant of the claims previously made for art photography's

Installation view of *Diogenes with a Camera*, MoMA, 1952 (Permission of The Museum of Modern Art, New York)

incorporation of transcendent values. Gradually these exhibitions fell prey to Steichen's sentimental and moralizing tendencies; so much so that in 1962, when he wished to pair two of his favorites, Harry Callahan and Robert Frank, in a final *Diogenes,* Frank flatly refused to exhibit under that title.[54]

The photographic values that Steichen consistently encouraged remained those of the glossy picture magazines: emotional immediacy, graphic inventiveness, avoidance of difficulty. Photographers who chose to explore what were defined as peripheral areas—whether of a social or an aesthetic nature—quickly faced loss of access to what had become (thanks in part to Steichen's proselytizing) a mass audience for photography. Callahan and Frank were typical of the ambitious younger photographers whose reputations benefited from their regular inclusion in MoMA exhibitions, but who nonetheless eventually chafed at the constraints of the mass-media model imposed on all of the work presented there. Callahan's rigorous formalist side was never shown to advantage, nor was his extensive work in color; as he later remarked of his exhibitions at MoMA during those years, "It was always a Steichen show. Always."[55] In the same way, the poignant, romantic Robert Frank whose work appeared at MoMA resembled only slightly the photographer whose corrosive social vision informed *The Americans*—a book that defined itself in opposition to the reigning norms of *Life* magazine and professionally "committed" photojournalism. ("I do not like the adoration of grand old men," was Frank's later, testy dismissal.[56])

At a time, then, when most American art museums still considered photography well beyond the pale of the fine arts, a peculiar set of circumstances allowed Steichen effectively to establish MoMA as the ultimate institutional arbiter of the entire range of photographic practice. In dissolving the categories by means of which Newhall had sought to separate fine-art photography from the medium's other applications, Steichen under-

Installation view of *Harry
Callahan*, MoMA, 1977
(Permission of The Museum
of Modern Art, New York)

mined the whole notion of the "cult value" of the fine print. In the process he attracted a wide popular following for photography as a medium and won for it (and for himself) the regular attention of the mass press. The price exacted at MoMA was the eclipse of the individual photographer and the subordination of his or her work to the more or less overtly instrumental demands of illustration. This was the situation inherited by Steichen's successor in 1962.

A survey of the installation views of MoMA's photographic exhibitions from the early 1960s to the present induces a dizzying realization of the speed of photography's cultural repackaging. Steichen's hyperactive, chock-a-block displays metamorphose before one's eyes into the cool white spaces of sparsely hung galleries. Mural-sized enlargements shrink to conventional proportions, and the eccentric clustering of photographs of wildly assorted dimensions gives way to an orderly march of prints of utterly uniform size. The fine-art accoutrements of the Newhall years—standard white mattes, wooden frames, and covering glass—quickly reappear. With no knowledge of the particulars of John Szarkowski's program as director of MoMA's Department of Photography, one could easily surmise that the museum's claims for photography's "cult value" had been dusted off and urgently revived.[57] What one could not infer, of course, is the extent to which those claims resounded beyond the museum's walls to a rapidly proliferating network of galleries, collectors, critics, and arts administrators, all specializing, in one way or another, in photography.

The barbed title of his first exhibition, *Five Unrelated Photographers* (1962), announced that although Steichen had personally chosen him as his successor, Szarkowski was no acolyte. It gradually became apparent that Szarkowski, trained as an art historian, held no affection for Steichen's casting of photography in the role of social instrument and "universal language." Instead, he represented an aestheticizing reaction against Steichen's identification of photography with mass media. While deploring the "graphic gymnastics" of latter-day photojournalism, however, he showed equally little interest in the "artistic" alternatives at hand, in the photomysticism of Minor White or the expressive abstraction of

Aaron Siskind. Szarkowski noted "incipient exhaustion" in the bulk of the photographs of the past decade, adding, "Their simplicity of meaning has—not to put too fine a point on it—often verged on vacuity." [58]

What Szarkowski sought, rather than a repetition of Newhall's attempt to cordon off a "high" art photography more or less independent of the medium's everyday uses, was the theoretical salvaging of photography in its entirety from the encroachments of mass culture. He wished, on this account, to redefine the medium's aesthetic nature in such a way as to set it on an irrevocably autonomous course. At a time when most excursions into photography's history still followed the narrow genetic-biographical path evidenced in Newhall's *Masters of Photography* (1958) and shared its emphasis on "the unmistakable authority of genius," Szarkowski turned to quick advantage the presumption (inherited from Steichen) that the MoMA Department of Photography might address any of the medium's multiple facets. From this institutional salient, he was able to set about reconstructing a resolutely modernist aesthetic for photography and remapping a "main tradition" in order to legitimize it. [59]

Even before coming to MoMA Szarkowski had clearly indicated the direction his search for a usable tradition would take. In 1958, linking his own ambitions as a photographer to the precedents set in the previous century by Brady, O'Sullivan, and Jackson, he proclaimed, 'I want to make pictures possessing the qualities of poise, clarity of purpose, and natural beauty, as these qualities were achieved in the work of the good wet-plate photographers." [60] In 1967, five years after arriving at MoMA, he elaborated on the same theme. In the essay "Photography and Mass Media" he sharply distinguished the work of these nineteenth-century photographers from the "flabbiness" of media-age photography and its ostensibly creative offshoots. These latter he faulted as "less and less interested in clear observation," which was what he felt photography's true vocation to be.

> During photography's first century it was generally understood . . . that what photography did best was to *describe* things: their shapes and textures and situations and relationships. The highest virtues of such photographs were clarity of statement and density of information. They could be read as well as seen; their value was literary and intellectual as well as visceral and visual. [61]

With such an agenda—realistic description without overt prescription—Szarkowski could view with equanimity the impending collapse of photojournalism in the early 1970s. Assuming more and more the role of aesthetic guide, he recommended as models to younger photographers the works of Atget, Sander, and Frances Benjamin Johnston—all "deliberate and descriptive," and "constructed with the poise and stability which suggest Poussin or Piero." Such pictures, he advised, "are not only good to look at, they are good to contemplate." [62]

Szarkowski's ambitious program for establishing photography in its own aesthetic realm has been set forth explicitly in no single work, but arrived at piecemeal in a series of slender essays over the last twenty years. His project has followed, I think, three main lines. These include: (1) the introduction of a formalist vocabulary theoretically capable of comprehending the visual structure (the "carpentry") of any existing photograph; (2) the isolation of a modernist visual "poetics" supposedly inherent to the photographic image; and (3) the routing of photography's "main tradition" away from the (exhausted) Stieglitz/Weston line of high modernism and toward sources formerly seen as peripheral to art photography.

The formalist theme first appeared in *The Photographer's Eye* (1964), in which Szarkowski presented a selection of photographs—both celebrated and anonymous—that epitomized for him the visual characteristics intrinsic to photography. Reworking John Kouwenhoven's thesis (outlined in the 1948 *Made in America*) that the American artistic tradition could be conceived as the interplay of native ("vernacular") and European ("cultivated") strains, Szarkowski offered a list of photography's basic formal elements that drew equally on what Kouwenhoven had called the American "respect for optical reality" and the essentially European concern for coherent, self-sufficient form. His five characteristics—the detail, the thing itself, time, the frame, and the vantage point—provided not only a checklist that could be held up to any photograph for the cool appraisal of its organizing logic, but also a range of stylistic alternatives that were explicitly regarded as "artist's choices."

Interestingly, Szarkowski's concern with locating photography's formal properties signaled no incipient move toward abstraction. The formal characteristics he acknowledged

Installation view of *New Documents*, MoMA, 1967 (Permission of The Museum of Modern Art, New York)

were all modes of photographic *description:* instead of stressing (as had Clement Greenberg in his formalist essays on painting) the necessary role of the material support in determining the essential nature of the medium, Szarkowski wished to reserve unexamined for photography that classical system of representation that depends on the assumed transparency of the picture surface.[63] Thus the delimitation of formal elements could prove no end in itself, but only set the stage for a move to the iconographic level.

The central text in this regard is the curious *From the Picture Press* (1973), an investigation of the formal and iconographic properties of the "millions of profoundly radical pictures" that have filled the pages of the daily press. The enabling assumption here—one with important consequences for Szarkowski's whole aesthetic enterprise—is that of the "narrative poverty" of the photograph, a notion first broached in *The Photographer's Eye.* In essence, this entails the view that, considered strictly in terms of the visual descriptions inscribed within the picture frame, an individual photograph can, at best, give a "sense of the scene" but can never convey a larger narrative meaning. For Szarkowski, it does not follow that one ought to seek a supplement to the image beyond the frame. (What is at stake, after all, is the self-sufficiency of the photograph.) He recommends, instead, a particular mode of transformation of pictorial content: "If photographs could not be read as stories, they could be read as symbols."[64] Selecting a number of press photographs from the files of the *Daily News* (with the help of Diane Arbus and Carole Kismaric), *From the Picture Press* provided an admittedly witty exercise in aesthetic reprocessing. Separated from their original contexts and their original captions, organized into iconographic categories ("ceremonies," "disasters," and the like), the images could now be savored for their surprising conjunctions of formal coherence and narrative ambiguity. They could be seen, in Szarkowski's words, as "short visual poems—they describe a simple perception out of context."[65] It is significant that the vocabulary of indeterminacy used thus to characterize the poetics of imagery duplicates that already familiar throughout the range of modernist art and literature: "As images, the photographs are shockingly direct, and at the same time mysterious, elliptical, and fragmentary, reproducing the texture of experience without explaining its meaning."[66] Moreover (as becomes clear in a later essay), Szarkowski finds these the essential qualities built into the images produced

Installation view of *The Work of Atget: Old France*, MoMA, 1982 (Permission of The Museum of Modern Art, New York)

by the photographic medium; in this way photography can be claimed to produce its own, inherently modernist "new pictorial vocabulary, based on the specific, the fragmentary, the elliptical, the ephemeral, and the provisional."[67]

Szarkowski's distribution of emphases—falling, as I have indicated, on the transparency of photography's representational apparatus, the formal/stylistic elements peculiar to its descriptive system, and its ready-made modernist pictorial syntax—finally prepares the ground for the emergence of an aestheticized authorial "voice" proper to photography. In the work of Gary Winogrand, Diane Arbus, Lee Friedlander, and William Eggleston, for example—Szarkowski's "heirs of the documentary tradition"[68]—the adoption of the unmanipulated "invisible" style of documentary initially links their work to that aspect of the classical system of representation that posits (in Louis Marin's words) that "nobody is speaking; it is reality itself that speaks." But the new critic/connoisseur is on hand to certify the presence of the artist and to provide expert guidance to the formal strategies of concealment through which the artist-photographer (to quote Marin on the reverse face of the classical paradigm) "inscribes himself as the center of the world and transforms himself into things by transforming things into *his* representations." These "contradictory axioms" of the classical system operate with considerable force in photography and, in Szarkowski's scheme, ultimately to the advantage of the artist-photographer. Thus his insistence that even though at first Winogrand's pictures may seem the uninflected "mechanical utterance of a machine,"

As we study his photographs, we recognize that although in the conventional sense they may be impersonal, they are also consistently informed by what in a poem we would call a voice. This voice is, in turn, comic, harsh, ironic, delighted, and even cruel. But it is always active and distinct—always, in fact, a narrative voice.[69]

Admittedly, this postulation of a unitary authorial "voice" makes it possible to reckon critically with those contemporary artist-photographers who (proceeding along the familiar modernist route that Shklovsky called the "canonization of peripheral forms") have chosen to mimic the unperturbed stability of nineteenth-century topographic photographs or to adopt the snapshot's seemingly unpremeditated jumbling of visual events as a metaphor for the fragmented, elusive quality of modern life. More subtly than Newhall's

emphasis on "personal expression," it restores the presence of the artist through a reading
method that makes it possible to see Eggleston's laconic photographs, for instance, pri-
marily as "patterns of random fact in the service of an imagination—not the real
world."[70] But whatever its value as a critical procedure for valorizing the work of one
privileged sector of today's art photography, it provides at the same time a powerful ratio-
nale for the systematic rereading, along precisely the same lines, of the photographs of
the past. Unfortunately, since photography has never been simply, or even primarily, an
art medium—since it has operated both within and at the intersections of a variety of
institutional discourses—when one projects a present-day art-critical method across the
entire range of the photography of the past, the consequences are not inconsiderable.
Nor, given the prevailing winds of today's art market, are they likely to be disinterested.
Thus, for example, the critic Ben Lifson's automatic reinterpretation of Robert Capa's
politically committed Spanish Civil War reportage as a self-conscious "experimenting
with photographic syntax." For Lifson, Capa's redemption for an aestheticized photo-
graphic tradition can proceed only by means of his transformation into an artist/author
whose photographs can be safely read as a "fiction of his own creation."[71]

Such selective and reductive readings are, however, sanctioned by Szarkowski's concep-
tion of photography's past and its "central tradition." He writes: "Most of the meanings
of any picture reside in its relationships to other and earlier pictures—to tradition."[72]
But turning away from Newhall's lineage of successive individual "masters," he redirects
attention to those photographers who "chose not to lead photography but to follow it,
down those paths suggested by the medium's own eccentric and original genius."[73] Al-
though echoing Eliot's insistence (in "Tradition and the Individual Talent") that the poet
has not a personality but a medium to express and that the medium's "main current . . .
does not at all flow invariably through the most distinguished reputations," Szarkowski
nonetheless goes far beyond Eliot's proposed "ideal order" of "existing monuments." His
ideal order theoretically extends to *all* of photography: "Not only the great pictures by
great photographers but *photography*—the great undifferentiated whole of it—has been
teacher, library, and laboratory for those who have consciously used the camera as art-
ist."[74] It would seem, then, that for Szarkowski historical practice should consist of the

sifting of fragments and shards, and their reordering as a privileged representation of moments in the unfolding of photography's main tradition. If, as Edward Said has suggested, the proper vehicle for the display of such fragments is the chrestomathy, we can see in *Looking at Photographs* (1973), Szarkowski's most widely read book, a connoisseur's collection of photographic fragments ordered by and encased in his own richly allusive prose.

One further consideration remains. Szarkowski's comparison of the bulk of the photographic production of the nineteenth and early twentieth centuries to an "untended garden"[75] and a "genetic pool of possibilities"[76] hints that, indeed, he regards the development of photography as "something pretty close to an organic issue."[77] Reaching for a suitable analogy, he likens his search for photography's main tradition to "that line which makes the job of curator rather similar to the job of a taxonomist in a natural history museum."[78] Can one say, then, that Szarkowski conceives of photography as endowed with an essential nature, determined by its origins and evident in what he calls an "evolutionary line of being"?[79]

Such would appear to be the case, at least on the basis of MoMA curator Peter Galassi's 1981 exhibition *Before Photography,* which sought to give substance to Szarkowski's conjecture that photography was "like an organism . . . born whole."[80] Galassi's slim but ambitious catalogue had two aims: to portray photography as the legitimate (albeit eccentric) offspring of the Western pictorial tradition and to demonstrate that it was born with an inherent "pictorial syntax" that forced originality (and modernism) upon it. In stressing photography's claims as the heir to the system of one-point linear perspective, Galassi argued that the advent of photography in 1839 issued not from the juncture of multiple scientific, cultural, and economic determinations but from a minor tendency in late-

Installation view of *Before
Photography*, MoMA, 1981
(Permission of The Museum
of Modern Art, New York)

eighteenth-century painting. It was this tendency (evident primarily in hitherto-
unremarked landscape sketches), notable for an embryonic pictorial syntax of "immediate
synoptic perception and discontinuous forms," that somehow "catalyzed" photography
into being. The larger point of this peculiar argument is that while photography incorpo-
rated what has been called here the classical paradigm of representation, the new me-
dium was incapable of taking over painting's conventional pictorial language. For,
according to Galassi, "the photographer was powerless to compose his picture. He could
only . . . take it."[81] By reason of this "unavoidable condition," originality was forced, not
simply on the photographer, but on the medium itself. In this way, what Szarkowski else-
where referred to as the "monstrous and nearly shapeless experiment" of photography's
first century can be seen as the unbidden working out of the "special formal potentials"
of photography's inherent and singular syntax of the specific, the fragmentary, the ellipti-
cal, and so on. Incarnated in the work of "primitives" (Szarkowski's term) like Brady and
O'Sullivan, this "new pictorial language" awaited its recognition and appropriation by
self-conscious artist-photographers like Walker Evans, Lee Friedlander, or Robert Adams.

Thus endowed with a privileged origin—in painting—and an inherent nature that is
modernist *avant la lettre,* photography is removed to its own aesthetic realm, free to get
on with its vocation of producing "millions of profoundly radical pictures." As should be
apparent, this version of photographic history is, in truth, a flight from history, from
history's reversals, repudiations, and multiple determinations. The dual sentence spelled
out here—the formal isolation and cultural legitimation of the "great undifferentiated
whole" of photography—is the disquieting message handed down from the museum's
judgment seat.

1 Jean Baudrillard, *L'Echange symbolique et la mort* (Paris: Editions Gallimard, 1976), pp. 85–88.

2 John Szarkowski, "Photography and the Private Collector," *Aperture* 15:2 (Summer 1970), n.p.

3 Walter Benjamin, "The Work of Art in the Age of Mechanical Reproduction," trans. Harry Zohn, in *Illuminations* (New York: Schocken Books, 1969), p. 223.

4 Quoted in Susan Buck-Morss, *The Origin of Negative Dialectics* (New York: Free Press, 1977), p. 149. The Adorno-Benjamin correspondence has been published in *Aesthetics and Politics* (London: New Left Books, 1977). A discussion of Benjamin's use of "cult value" and "exhibition value" can be found in Pierre V. Zima, "L'Ambivalence dialectique: Entre Benjamin et Bakhtine," *Revue d'Esthétique* (1981), pp. 131–40. Benjamin's friend Brecht detected a lingering theological tone in the concept of the aura, calling it, in his *Arbeitsjournal,* "all mysticism, mysticism, in a form opposed to mysticism. . . . it is rather ghastly" (Buck-Morss, p. 149).

5 Walter Benjamin, "A Short History of Photography," trans. Stanley Mitchell, *Screen* 13:1 (Spring 1972), p. 6.

6 Kirstein was the author of what was apparently the museum's first major statement on the subject, "Photography in the United States," in Holger Cahill and Alfred H. Barr, Jr., eds., *Art in American in Modern Times* (New York: Reynal and Hitchcock, 1934). The essay was based on a talk given as part of a series of MoMA-sponsored coast-to-coast broadcasts introducing the American radio audience to modern painting, sculpture, architecture, photography, and film.

7 Certainly a major factor in this movement was the proliferation of art reproductions. The issue of copies (public education) versus originals (aesthetic appreciation) came to a head at the Boston Museum of Fine Arts over the purchase of plaster casts of original marbles and ultimately led to the resignation of the museum's director, Edward Robinson. For a full account of that museum's subsequent formulation of the "religion" of art, see Benjamin Ives Gilman, *Museum Ideals* (Cambridge, Mass., 1918).

8 Sachs, in addition to his incalculable influence on the emerging American museum profession, more particularly served as the principal academic presence on the committee convened by Mrs. John D. Rockefeller, Jr., in 1929 to draw up plans for a Museum of Modern Art. Sachs long remained an important member of MoMA's board.

9 Newhall's exhibition follows precisely along the lines of the series of large photography exhibitions held in Germany from 1925 until the early 1930s, as described by Ute Eskildsen, "Innovative Photography in Germany between the Wars," in *Avant-Garde Photography in Germany 1919–39* (San Francisco: San Francisco Museum of Modern Art, 1980). These joint showings of scientific, commercial, and creative "new vision" photography and film placed the camera at the center of the postwar technological aesthetic in Germany and should be seen as forming part of the background of Walter Benjamin's writings during this period.

10 For an indication of the position of Stieglitz's die-hard followers regarding photography outside the fine-art tradition, see R. Child Bayley's remarkably brief "Photography Before Stieglitz," in *America and Alfred Stieglitz* (New York: The Literary Guild, 1934), pp. 89–104.

11 Lewis Mumford, "The Art Galleries," *The New Yorker,* April 3, 1937, p. 40.

12 Beaumont Newhall, *Photography: 1839–1937* (New York: The Museum of Modern Art, 1937), p. 41.

13 Ibid., p. 41.

14 Ibid., p. 44.

15 Ibid., pp. 43–44. This duality was already a commonplace in the 1850s, as evidenced in Gustave

Le Gray's preface to his *Photographie: Traité nouveau* of 1852. For a contemporary "inquiry into the aesthetics of photography" along the same line, see James Borcomon, "Purism versus Pictorialism: The 135 Years War," in *Artscanada* 31:3–4 (December 1974).

16 Beaumont Newhall, *Photography: A Short Critical History* (New York: The Museum of Modern Art, 1938), p. 9.

17 Newhall, *Photography: 1839–1937,* p. 48.

18 Ibid. Newhall was aware of the very different method at work in Gisèle Freund's *La Photographie en France au dix-neuvième siècle* (Paris: Monnier, 1936), which he cites. The validity of his own method must have seemed self-evident, for the possibility of alternative procedures is nowhere acknowledged.

19 Beaumont Newhall, "Program of the Department," *The Bulletin of the Museum of Modern Art* 8:2 (December–January 1940–41), p. 4.

20 Ibid.

21 Newhall, *Photography: 1839–1937,* p. 64.

22 Newhall, *Photography: A Short Critical History,* p. 64.

23 Newhall's account can be found in the interview included in Paul Hill and Thomas Cooper, *Dialogue with Photography* (New York: Farrar, Straus and Giroux, 1979), pp. 389–90.

24 David H. McAlpin, "The New Department of Photography," *The Bulletin of the Museum of Modern Art* 8:2 (December–January 1940–41), p. 3.

25 Newhall, "Program of the Department," p. 2.

26 Beaumont Newhall, "The Exhibition: Sixty Photographs," *The Bulletin of the Museum of Modern Art* 8:2 (December–January 1940–41), p. 5.

27 "Above all, the work of these hardy and direct artists indicates the beauty and effectiveness of the straight photographic approach. No time or energy was available for inessentials in visualization or completion of their pictures. Their work has become one of the great traditions of photography." Ansel Adams, introduction to *A Pageant of Photography* (San Francisco: San Francisco Bay Exposition Co., 1940), n.p.

28 Beaumont Newhall, "Photography as an Art," in *A Pageant of Photography,* n.p.

29 Any assessment of Newhall's department must bear in mind the complicated comings and goings that marked the war years. On Newhall's departure for military service, his wife Nancy became acting curator. The next year saw Willard Morgan (husband of the photographer Barbara Morgan) named director of the department, an arrangement that lasted only one year. And in 1942 and 1945 Edward Steichen was brought in to stage spectacular patriotic exhibitions.

30 Wall label for *American Photographs at $10,* visible in an installation view filed in the MoMA archive. As the history of the Julian Levy Gallery during the 1930s made evident, the market for original photographs was never strong enough to support even one gallery specializing in photography.

31 Bruce Downes, "The Museum of Modern Art's Photography Center," *Popular Photography* (February 1944), p. 85.

32 Ibid., p. 86.

33 Newhall interviewed by WXXI-TV, Rochester, 1979, transcript pages 27–28.

34 In light of the increasing awareness of the problematic role played by narrative representation in historiography (see, for example, Hayden White's "Interpretation in History," *New Literary History* 4:2 [Winter 1973]), it deserves to be noted that the narrative strategy of Newhall's 1949 *History* was devised with the aid of a Hollywood scriptwriter, Ferdinand Reyner. See Hill and Cooper, *Dialogue with Photography,* pp. 407–8. In Newhall's words, "*The History of Photography* was deliberately planned with the help of a storyteller."

35 "When I first became interested in photography, I thought it was the whole cheese. My idea was to have it recognized as one of the fine arts. Today I don't give a hoot in hell about that" (Steichen on the occasion of his ninetieth birthday, as reported in the *New York Times,* March 19, 1969).

36 Alexander Dorner, *The Way Beyond "Art": The Work of Herbert Bayer* (New York: Wittenborn, Schultz, 1947), pp. 107–8. Dorner was the former director of the Landes Museum in Hanover, Germany, for whom El Lissitzky had designed special rooms for the exhibition of abstract art in 1925. After emigrating to the U.S., he joined the faculty of the Rhode Island School of Design.

37 Dorner, *The Way Beyond Art,* p. 15.

38 Herbert Bayer, "Fundamentals of Exhibition Design," *PM* (December–January 1939–40), p. 17. *PM* (Production Manager) was the publication of New York's Laboratory School of Industrial Design.

39 Edward Steichen, "Photography and the Art Museum," in *Museum Service* (Bulletin of the Rochester Museum of Arts and Sciences) (June 1948), p. 69.

40 Ralph Steiner, in *PM* (May 31, 1942). The Edward Steichen Archive, MoMA. A more complete account of the *Road to Victory* exhibition can be found in my "Steichen's 'Road to Victory,'" *Exposure* 18:2 (Fall 1980).

41 Quotation from John Hay Whitney, then president of MoMA's board, cited in Russell Lynes, *Good Old Modern* (New York: Athenaeum, 1973), p. 233.

42 Eva Cockcroft, "Abstract Expressionism: Weapon of the Cold War," *Artforum* 12:10 (June 1974), pp. 39–41.

43 "Edward Steichen Appointed Head of Photography at Museum of Modern Art," undated 1947 MoMA press release, The Edward Steichen Archive, MoMA, italics added. Rockefeller notes, in conclusion, "I am particularly pleased that the enlarged program for the Department, headed by Mr. Steichen, has the endorsement and support of the photographic industry."

44 See Allan Sekula, "The Traffic in Photographs," *Art Journal* 41:1 (Spring 1981), pp. 15–25. See also Fredric Jameson, "Reification and Utopia in Mass Culture," *Social Text* 1 (1979), pp. 139–48.

45 "A Talk with Steichen," *WPAT Gaslight Revue* 8:2 (October 1962), p. 40.

46 In the 1942 *Road to Victory,* for example, the dramatic turning point of the exhibition hinges on the juxtaposition of a photograph of the Pearl Harbor explosions with a Dorothea Lange photograph of a grim-visaged "Texas farmer" who is made to say, in caption, "War—they asked for it—now, by the living God, they'll get it!" Examining the original Lange photograph in the MoMA Archive, one finds this very different caption: "Industrialized agriculture. From Texas farmer to migratory worker in California. Kern County. November, 1938." For similar instances involving recropping, see Ulrich Keller, "Photographs in Context," *Image* (December 1976), pp. 1–12.

47 "Museum of Modern Art Plans International Photography Exhibition," MoMA press release, January 31, 1954. The Edward Steichen Archive, MoMA.

48 This was the point of Ansel Adams's main complaint. "The quality of the prints—of all his exhibits of this gross character—was very poor. . . . If a great Museum represented photography in such a style and quality, why bother about the subtle qualities of the image and the fine print?" (Ansel Adams, correspondence with this writer, January 30, 1980).

49 "The Family of Man" can be seen to spring directly from the series of photoessays supervised by picture editor John G. Morris for the *Ladies' Home Journal* in 1947. "People Are People the World Over" used photojournalists like Robert Capa and Larry Burrows to present the everyday lives of families from twelve countries, on the premise that "the family is still the basic building block of society."

50 At the MoMA Christmas print sale of 1951, one could buy photographs by Weston, Ansel Adams, Frederick Sommer, Charles Sheeler, and Berenice Abbott, among others, for ten to twenty-five dollars. At this particular sale, Harry Callahan (7), outsold Weston (5). The virtual nonexistence of a market for original photographs underlay the continuing difficulties of Helen Gee's Limelight Gallery, from 1954–61 the only New York gallery to regularly feature photography; see Barbara Lobron, "Limelight Lives," *Photograph* 1:3 (1977), pp. 1–3. As late as 1962, at the time of Steichen's retirement, Harry Callahan could expect to receive five dollars for each print purchased by the museum.

51 Quoted in "What Is Modern Photography," *American Photography* (March 1951), p. 148. The symposium included statements by Penn, Margaret Bourke-White, Gjon Mili, Ben Shahn, Walker Evans, and Charles Sheeler, among others. Each participant, however, was limited to a five-minute statement, in order that the proceedings might be carried to a "Voice of America" radio audience.

52 Gilbert Bayley, "Photographer's America," *New York Times Magazine,* August 31, 1947, p. 39.

53 According to Newhall's count of selected publications on the history of photography from 1900 to 1970, the 1950s saw fewer than half as many publications in this area than had the 1930s. The 1960s, on the other hand, witnessed a dramatic increase, more than doubling the number of publications of the 1930s. Newhall's compilation was made available at the Photographic Collectors' Symposium, George Eastman House, October 1978.

54 Frank agreed to show his work minus the *Diogenes* label. But "Modern Art Museum officials were dismayed over the number of beatniks—about 80 of them—who crowded in the swank, private opening of Robert Frank's new photography exhibit. There wasn't much the museum could do about it, though. The beats were Frank's friends." *New York Daily News,* March 5, 1962. The Edward Steichen Archive, MoMA.

55 Jacqueline Brody, "Harry Callahan: Questions," *Print Collectors' Newsletter* (January–February 1977), p. 174. A good discussion of Callahan's relation with Steichen can be found in Sally Stein, "Harry Callahan: Works in Color/The Years 1946–1978," in the exhibition catalogue *Harry Callahan: Photographs in Color/The Years 1946–1978* (Center for Creative Photography, 1980).

56 Robert Frank, "Letter from New York," *Creative Camera* (July 1969), p. 234.

57 The MoMA archive holds a full selection of installation views from the early 1930s to the present. These provide an invaluable record of the ways art has been presented to the public over the last half century.

58 John Szarkowski, "Photography and Mass Media," *Aperture* 13:3 (1967), n.p.

59 Andreas Huyssen distinguishes modernism from avant-garde by means of the relation of each to artistic tradition, with modernism devising more and more hermetic strategies to preserve art's realm of autonomy, and avant-garde as the embodiment of postauratic antitradition. See "The Search for Tradition: Avant-Garde and Postmodernism in the 1970s," *New German Critique* 22 (Winter 1981), pp. 23–40. In this light, see Hilton Kramer's uncomprehending "Anxiety about the Museumization of Photography," *New York Times,* July 4, 1976, in which he castigates Szarkowski for "providing a haven for the anti-art impulse."

60 John Szarkowski, *The Face of Minnesota* (Minneapolis: University of Minnesota, 1958). The book's format—short informal essays paired with single photographs—anticipated Szarkowski's MoMA productions. Two years earlier, Szarkowski had attracted attention with his Guggenheim-sponsored book *The Idea of Louis Sullivan,* featuring his own photographs of Sullivan's buildings and a short, lyrical essay. His photographs served as his initial point of contact with both Newhall and Steichen.

61 Szarkowski, "Photography and Mass Media."

62 Ibid. It seems worthwhile to note that of the two illustrations introduced to underline his point, only one (a carefully staged tableau by Frances Benjamin Johnston) is a photograph. The other—connecting Szarkowski's pictorial concerns to an older, more prestigious tradition—is Poussin's *The Arcadian Shepherds.* Using just this painting as his object of commentary, Louis Marin has recently provided a remarkable analysis of the contemplative process in question here, as well as a partial "history of reading" in the visual arts. What Marin calls the post-Renaissance classical system of representation, founded on one-point linear perspective and the assumed transparency of the picture plane, permits two simultaneous and contradictory readings: (1) as a duplication or immediate mirroring of objects or scenes; or (2) as (someone's) representation of those scenes or objects. As we will see, for Szarkowski the operation of these contradictory modes is a precondition for the emergence of what he calls the "narrative voice" in modernist art photography. See Marin, "Toward a Theory of Reading in the Visual Arts: Poussin's *The Arcadian Shepherds,*" in Suleiman and Crosman, eds., *The Reader in the Text* (Princeton: Princeton University Press, 1980), pp. 293–324. Also see Craig Owens's valuable commentary in "Representation, Appropriation, and Power," *Art in America* (May 1982), pp. 9–21.

63 See Victor Burgin's commentary in "Photography, Phantasy, Function," *Screen* 21:1 (1980). As suggested by his emphasis on pure photographic description, Szarkowski has shown little interest in work in which the photographer's "hand" figures prominently or work that explicitly calls photography's means of representation into question (as with Michael Snow or Jan Dibbets). As curator of the Department of Photography in the late 1960s and early 1970s, Peter Bunnell covered these areas to some extent in exhibitions like *Photography as Printmaking* (1968) and *Photography into Sculpture* (1970). Bunnell directed considerably more attention than Szarkowski to the connoisseurship of the "fine print," especially to the "subjective mannerisms, in part directed by techniques and materials, which render each print unique and which, in the last analysis, place man as the actual medium of expression." ("Photography as Printmaking," *Artist's Proof* [New York: Pratt Graphics, 1969], p. 24).

64 John Szarkowski, *The Photographer's Eye* (New York: The Museum of Modern Art, 1965), n.p. Benjamin, of course, in "A Short History of Photography," cites Brecht on the necessity of constructing a supplement to the photographic image. And Dorothea Lange, in *An American Exodus,* conceives the documentary mode as depending on what she calls a "tripod" of meaning furnished by the relation of the image, the caption, and the text.

65 John Szarkowski, *From the Picture Press* (New York: The Museum of Modern Art, 1973), p. 5.

66 Ibid., p. 6.

67 John Szarkowski, *William Eggleston's Guide* (New York: The Museum of Modern Art, 1976), p. 6. Elsewhere Szarkowski links photography to the modern literary imagination. Writing of Crane's *The Red Badge of Courage,* he calls it a "profoundly photographic book" and speculates that Crane had "surely known" the Brady photographs. As Szarkowski describes the "thousands of Civil War photographs that survive," we see "only bits of machinery, records of destruction, a bit of a forest where a skirmish had occurred, and little knots of grey clad men, living or dead, waiting for a revelation of the larger meanings of the conflict." He describes Crane's book, similarly, as "the personal trial of one ignorant participant, seen from so close a perspective that large patterns are invisible" (Szarkowski, "American Photography and the Frontier Tradition"). Presumably Crane or Szarkowski might have found the same effect in Stendhal, writing well before the invention of photography.

68 "The heirs of the documentary tradition have redirected that idea in the light of their own fascination with the snapshot: the most personal, reticent, and ambiguous of documents. These photographers have attempted to preserve the persuasiveness and mystery of these humble, intuitive camera records, while adding a sense of intention and visual logic" (John Szarkowski, wall label introducing "Photography: New Acquisitions," April 1970). Winogrand, Arbus, and Friedlander had already shown together in the exhibition *New Documents* (1967).

69 John Szarkowski, "American Photography and the Frontier Tradition," *Symposion über Fotografie* (Graz, Austria: Forum Stadtpark, 1979), p. 107.

70 Szarkowski, *William Eggleston's Guide,* p. 8.

71 Ben Lifson and Abigail Solomon-Godeau, "Photophilia: A Conversation about the Photography Scene," *October* 16 (Spring 1981), p. 107. Describing the work of Robert Capa in the same language he might employ for that of, say, Gary Winogrand, Lifson brings to mind a 1970 MoMA exhibition called *Protest Photographs.* Staged just after the mass protests that greeted the American invasion of Cambodia, the exhibition presented a number of prints push-pinned to the wall, as if they had just been rushed over from the photographers' darkrooms. One might have thought that here was a contemporary reflection of the concerns that animated photographers like Capa. On closer inspection, however, the photographs were revealed as exercises in virtuosity by Winogrand, Burk Uzzle, and Charles Harbutt—all using demonstration sites as an arena for what Szarkowski (writing elsewhere of Winogrand's formal bent) called "the recognition of coherence in the confluence of forms and signs."

72 John Szarkowski, *New Japanese Photography* (New York: The Museum of Modern Art, 1974), p. 9.

73 Szarkowski, "American Photography and the Frontier Tradition," p. 99.

74 Szarkowski, *The Photographer's Eye,* n.p.

75 Szarkowski, *Looking at Photographs* (New York: The Museum of Modern Art, 1973), p. 11.

76 Quoted in Maren Stange, "Photography and the Institution: Szarkowski at the Modern," *Massachusetts Review* 19:4 (Winter 1978), p. 701.

77 Ibid.

78 Ibid., p. 698.

79 Ibid., p. 701.

80 Szarkowski, *The Photographer's Eye,* n.p.

81 Peter Galassi, *Before Photography* (New York: The Museum of Modern Art, 1981), p. 17. Three generally critical reactions to Galassi's argument are developed in S. Varnedoe's "Of Surface Similarities, Deeper Disparities, First Photographs, and the Function of Form: Photography and Painting after 1839," *Arts Magazine* (September 1981); Joel Snyder's review in *Studies in Visual Communications* 8:1 (1982); and Abigail Solomon-Godeau's "Tunnel Vision," *Print Collectors' Newsletter* 12:6 (January–February 1982). Only the last attempted to establish the connection between Galassi's effort and Szarkowski's critical position.

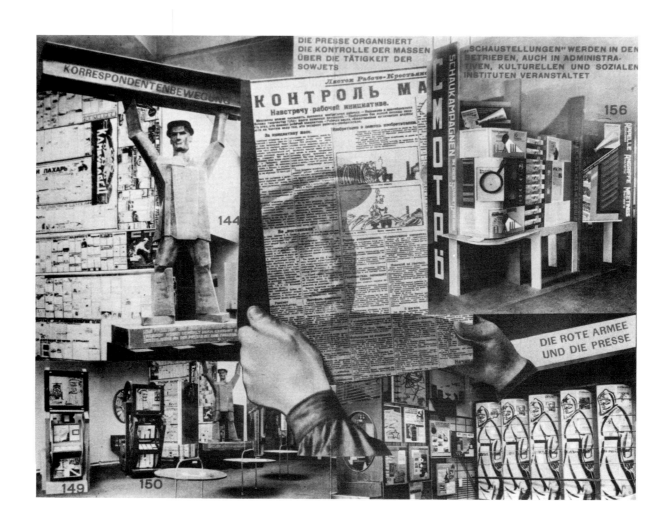

El Lissitzky, photomontage for
catalogue accompanying
Soviet Pavilion at *Pressa*
exhibition, Cologne, 1928

From Faktura to Factography

As the first director of the Museum of Modern Art, Alfred Barr largely determined the goals and policy of the institution that was to define the framework of production and reception for the American neo-avant-garde. In 1927, just prior to the founding of the museum, Barr traveled to the Soviet Union. This was to have been a survey journey, like the one he had just completed in Weimar Germany, to explore current avant-garde production by artists working in the new revolutionary society. What he found there, however, was a situation of seemingly unmanageable conflict.

On the other hand, he witnessed the extraordinary productivity of the original modernist avant-garde (extraordinary in terms of the number of its participants, both men *and* women, and in terms of the variety of modes of production: ranging from Malevich's late suprematist work through the Laboratory Period of the constructivists, to the Lef Group and the emerging productivist program, as well as agitprop theater and avant-garde films screened for mass audiences). On the other hand, there was the general awareness among artists and cultural theoreticians that they were participating in a final transformation of the modernist vanguard aesthetic, as they irrevocably changed those conditions of art production and reception inherited from bourgeois society and its institutions. Then, too, there was the growing fear that the process of that successful transformation might be aborted by the emergence of totalitarian repression from within the very system that had generated the foundation for a new socialist collective culture. And last of all, there was Barr's own professional disposition to search for the most advanced, modernist avant-garde at precisely the moment when that social group was about to dismantle itself and its specialized activities in order to assume a different role in the newly defined process of the social production of culture.

These conflicting elements are clearly reflected in the diary that Barr kept during his visit to the Soviet Union:

. . . went to see Rodchenko and his talented wife. . . . Rodchenko showed us an appalling variety of things—suprematist paintings (preceded by the earliest geometrical things I have seen, 1915, done with compass)—woodcuts, linoleum cuts, posters, book designs, photographs, kino set, etc. etc. He has done no painting since 1922, devoting himself to the photographic arts of which he is a master. . . . We left after 11 p.m.—an excellent evening, but I must find some painters if possible.[1]

But Barr was no more fortunate in his search for painting during his visit with El Lissitzky: "He showed also books and photographs, many of them quite ingenious. . . . I asked whether he painted. He replied that he painted only when he had nothing else to do, and as that was never, never."[2]

And, finally, in his encounter with Sergei Tretyakov, it became clear that there was a historical reason for the frustration of Barr's expectations. For Tretyakov enunciated the position these artists had adopted in the course of transforming their aesthetic thinking in relation to the emerging industrialization of the Soviet Union: the program of productivism and the new method of literary representation/production that accompanied it, *factography*. "Tretyakov," Barr's diary tells us, "seemed to have lost all interest in everything that did not conform to his objective, descriptive, self-styled journalistic ideal of art. He had no interest in painting since it had become abstract. He no longer writes poetry but confines himself to reporting."[3]

This paradigm-change within modernism, which Barr witnessed from the very first hour, did not make a strong enough impression on him to affect his future project. He continued in his plan to lay the foundations of an avant-garde art in the United States according to the model that had been developed in the first two decades of this century in western Europe (primarily in Paris). And it was this perseverance, as much as anything else, that prevented, until the late 1960s, the program of productivism and the methods of factographic production from entering the general consciousness of American and European audiences.

In 1936, when Barr's experiences in the Soviet Union were incorporated in the extraordinary exhibition *Cubism and Abstract Art,* his encounter with productivism was all but undocumented. This is particularly astonishing since Barr seems to have undergone a conversion toward the end of his journey, one that is not recorded in his diary but that he publicly expressed upon his return in "The Lef and Soviet Art," his essay for *Transition* published in the fall of 1928. Surprisingly, we read in this article, illustrated with two photographs of Lissitzky's exhibition design for the 1928 *Pressa* exhibition in Cologne, the following rather perspicacious appraisal of the ideas and goals of the Lef Group:

The *Lef* is more than a symptom, more than an expression of a fresh culture or of post-revolutionary man; it is a courageous attempt to give to art an important social function in a world where from one point of view it has been prostituted for five centuries. The *Lef* is formed by men who are idealists of Materialism; who have a certain advantage over the Alexandrian cults of the West—the *surréaliste* wizards, the esoteric word jugglers and those nostalgics who practice necromancy over the bones variously of Montezuma, Louis Philippe or St. Thomas Aquinas. The *Lef* is strong in the illusion that man can live by bread alone.[4]

But western European and American interests in the modernist avant-garde refused to confront the implications seen so clearly by Barr. Instead, what happened at that moment, in the process of reception, was what had been described in 1926 by Boris Arvatov, who along with Alexei Gan, Sergei Tretyakov, and Nikolai Tarabukin made up the group of productivist theoreticians. Arvatov wrote about the painters who refused to join the productivists, "Those on the Right gave up their positions without resistance. . . . Either

they stopped painting altogether or they emigrated to the Western countries, in order to astonish Europe with home-made Russian Cézannes or with patriotic-folkloristic paintings of little roosters."[5]

It is against this background that I want to pursue the following questions: Why did the Soviet avant-garde, after having evolved a modernist practice to its most radical stages in the postsynthetic cubist work of the suprematists, constructivists, and Laboratory Period artists, apparently abandon the paradigm of modernism upon which its practice had been based? What paradigmatic changes occurred at that time, and which paradigm formation replaced the previous one?

For the sake of detail and specificity I will limit myself in what follows to a discussion of only some aspects of the respective paradigms that generated the crucial concern for *faktura* in the first period and that made *factography* the primary method in the second period of Russian avant-garde practice.

Faktura was first defined in the Russian context in David Burliuk's futurist manifesto, "A Slap in the Face of Public Taste," of 1912, and in Mikhail Larionov's "Rayonnist Manifesto" of the same year. In the works of Malevich in 1913–19 *faktura* was a major pictorial concern, as it was at that time for painters such as Lissitzky, Popova, and Rozanova, who had their origins in synthetic cubism and who had been profoundly influenced by Malevich's suprematism. Further, it remained the central concept in the nonutilitarian objects produced by Rodchenko, Tatlin, and the Stenberg brothers, sometimes referred to as the Laboratory constructivists. During an extremely hectic period of approximately seven years (1913–20), the essential qualities of *faktura* were acquired step by step and developed further by the individual members of that avant-garde.

By 1920 it seemed to them that they had brought to their logical conclusion all the major issues that had been developed during the preceding fifty years of modernist painting. Therefore the central concern for a self-reflexive pictorial and sculptural production was abandoned after 1920—gradually at first, then abruptly—to be replaced by the new concern for factographic and productivist practices that are indicative of a more profound paradigmatic change.

Faktura

Attempts are being made in the recent literature to construct a genealogy for the Russian vanguard's concern for *faktura,* claiming that it originates in Russian icon painting. Vladimir Markov's 1914 text "Icon Painting"—after Burliuk and Larionov the third to address *faktura* explicitly—had established this specifically Russian source, arguing that "through the resonance of the colors, the sound of the materials, the assemblage of textures (*faktura*) we call the people to beauty, to religion, to God. . . . The real world is introduced into the icon's creation only through the assemblage and incrustation of real tangible objects and this seems to produce a combat between two worlds, the inner and the outer."[6]

But the specifically Russian qualities of *faktura* are nonetheless challenged by other details of this production. For the religio-transcendental function assigned by Markov to the term *faktura* is just too close to the essential pursuit of collage aesthetics as defined in 1914 by, for example, Georges Braque. Braque argued, "That was the great adventure: color and shape operated simultaneously, but they were completely independent of each other." Similarly, Tatlin's request in 1913 that "the eye should be put under the control of touch" is too close to Duchamp's famous statement that he wanted to abolish the supremacy of the retinal principle in art. And, in the contemporaneous discussions of the

Alexander Rodchenko, *Oval Hanging Construction (Surfaces Reflecting Light)*, 1921

term, any references to specifically Russian or religious functions are too rapidly jettisoned to maintain the credibility of Markov's argument. Already in 1916 Tarabukin wrote a definition of *faktura* that would essentially remain valid for the entire period of Laboratory constructivism to follow. "The form of a work of art," he declared, "derives from two fundamental premises: the *material* or medium (colors, sounds, words) and the *construction,* through which the material is organized in a coherent whole, acquiring its artistic logic and its profound meaning."[7]

What qualifies the concern for *faktura* as a paradigmatic feature (differentiating it at the same time from previous concerns for facture in the works of the cubists and futurists in western Europe) is the quasi-scientific, systematic manner in which the constructivists now pursued their investigation of pictorial and sculptural constructs, *as well as* the perceptual interaction with the viewer they generate. The equation between colors, sounds, and words established by Tarabukin was no longer the neoromantic call for *synaesthesia* that one could still hear at this time from Kandinsky and Kupka. Running parallel with the formation of structural linguistics in the Moscow Linguistic Circle and the Opoyaz Group in Petersburg in 1915 and 1916 respectively, the constructivists developed the first systematic phenomenological grammar of painting and sculpture. They attempted to define the separate material and procedural qualities by which such constructs are constituted with the same analytic accuracy used to analyze the *interrelationships* of their various functions—what Saussure would call the syntagmatic axis—which are equally relevant for the constitution of a perceptual phenomenon. Furthermore, they addressed the apparatus of visual sign production, that is, production procedures as well as the tools of these procedures. It was precisely the systematic nature of this investigation that led Barr in 1927 to see "an appalling variety of things" in Rodchenko's work.

When, in 1920–21, Rodchenko arrived more or less simultaneously at his sculptural series *Hanging Construction* (a series subtitled *Surfaces Reflecting Light*) and at the triptych *Pure Colors: Red, Yellow, Blue,* he had developed to its logical conclusion that separation of color and line and that integration of shape and plane that the cubists had initiated with such excitement. With some justification he declared, "This is the end of painting. These are the primary colors. Every plane is a plane and there will be no more representation." [8]

Even at this point in Rodchenko's development *faktura* already meant more than a rigorous and programmatic separation of line and drawing from painting and color, more than the congruence of planes with their actual support surface, more than emphasizing the necessary self-referentiality of pictorial signifiers and their contiguity with all other syntagmatic functions. It already meant, as well, more than just the object's shift from virtual pictorial/sculptural space into actual space. We should not take the reference to *Surfaces Reflecting Light* as anything less than an indication of the potential involvement of these artists with materials and objects in actual space and the social processes that occur within it.

Faktura also meant at this point, and not for Rodchenko alone, incorporating the technical means of construction into the work itself and linking them with existing standards of the development of the means of production in society at large. At first this happened on the seemingly banal level of the tools and materials that the painter employs—shifts that still caused considerable shock thirty years later with regard to Pollock's work. In 1917 Rodchenko explained his reasons for abandoning the traditional tools of painting and his sense of the need to mechanize its craft:

Thenceforth the picture ceased being a picture and became a painting or an object. The brush gave way to new instruments with which it was convenient and easy and more expedient to work the surface. The brush which had been so indispensable in painting which transmitted the object and its subtleties became an inadequate and imprecise instrument in the new non-objective painting and the press, the roller, the drawing pen, the compass replaced it. [9]

The very same conviction about laboratory technology is concretized in Rodchenko's systematic experimentation with pictorial surfaces as *traces* or immediate results of specific procedures and materials: metallic and reflective paint are juxtaposed with matte gouaches; varnishes and oil colors are combined with highly textured surfaces.

It is this techno-logic of Rodchenko's experimental approach that seems to have prevented aesthetic comprehension for even longer than did Duchamp's most advanced work of 1913, such as his *Three Standard Stoppages* or his ready-mades. With its emphasis on the material congruence of the sign with its signifying practice, on the causal relationship between the sign and its referent, and its focus on the *indexical* status of the sign, Rodchenko's work has defied a secondary level of meaning/reading. [10]

Further, this emphasis on the *process qualities* of painting was linked to a serially organized configuration, a structure that resulted as much from the commitment to systematic investigation as from the aspiration toward science with which artists wanted to associate their production. It is this nexus of relationships that tied these essential features of the modernist paradigm eventually to the socially dominant modes of control and management of time and perceptual experience in the Soviet Union's rapidly accelerating process of industrialization.

Faktura is therefore the historically logical aesthetic correlative to the introduction of industrialization and social engineering that was imminent in the Soviet Union after the revolution of 1917. For that reason *faktura* also became the necessary intermediary step

within the transformation of the modernist paradigm as we witness it around 1920. When in 1921 A. V. Babichev, the leader of the Working Group for Objective Analysis (of which Rodchenko and Stepanova were members), gives a definition of art production, his statement is strikingly close to ideas of Taylorism, social engineering, and organized consumption, as they became operative at that time in both western European and American society. "Art," he wrote, "is an informed analysis of the concrete tasks which social life poses. . . . If art becomes public property it will organize the consciousness and psyche of the masses by organizing objects and ideas."[11]

Finally, the notion of *faktura* already implied a reference to the *placement* of the constructivist object and its interaction with the spectator. To emphasize spatial and perceptual contiguity by mirror reflection—as hinted in Rodchenko's project for constructions whose reflective surfaces would mirror their surroundings—means, once again, to reduce the process of representation to purely *indexical* signs[12]: matter seemingly generates its own representation without mediation (the old positivist's dream, as it was, of course, that of the early photographers). Contiguity is also incorporated in the *kinetic* potential of Rodchenko's *Hanging Constructions,* since their movement by air currents or touch literally involves the viewer in an endless phenomenological loop made of his or her own movements in the time/space continuum.

In the discussions of the Group for Objective Analysis from 1921, *construction* was defined as the organization of the kinetic life of objects and materials which would create new movement. At such it had been juxtaposed with the traditional notion of *composition,* as Varvara Stepanova defines it:

Composition is the contemplative approach of the artist in his work. Technique and industry have confronted art with the problem of construction as an active process, and not a contemplative reflection. The "sanctity" of a work as a single entity is destroyed. The museum which was a treasury of this entity is now transformed into an archive.[13]

If these lines sound familiar today it is not because Stepanova's text had considerable impact on the thinking and practice of her peers, but rather because, more than ten years later, precisely the same historical phenomenon is described and analyzed in a text that is by now rightfully considered one of the most important contributions to twentieth-century aesthetic theory. I am speaking, of course, of Walter Benjamin's 1935 essay "The Work of Art in the Age of Mechanical Reproduction," and the following excerpt might be compared with Stepanova's 1921 statement:

What they [the dadaists] intended and achieved was a relentless destruction of the aura of their creations, which they branded as reproductions with the very means of production. . . . In the decline of middle-class society, contemplation became a school for asocial behavior; it was countered by distraction as a variant of social conduct. . . . [Dada] hit the spectator like a bullet, it happened to him, thus acquiring a tactile quality. . . . (Thus the dada work restores the quality of tactility to the art of the present day, a quality which is important to the art of all periods in their stages of transformation.)[14]

The historical observations by Stepanova and their subsequent theorization by Benjamin have another correlative in the work of Lissitzky from the period 1925–27. Already in 1923 in his *Prounenraum* for the Grosse Berliner Kunstausstellung, Lissitzky had transformed tactility and perceptual movement—still latent in Rodchenko's *Hanging Construction*—into a full-scale architectural relief construction. For the first time, Lissitzky's earlier claim for his *Proun-Paintings,* to operate as transfer stations from art to architecture, had been fulfilled.

El Lissitzky, *Cabinet of Abstract Art,* Hannoversches Landesmuseum, Hannover, 1926. Installation view shows aluminum relief walls and corner cabinet with movable panel. Works on display by Lissitzky, Schlemmer, and Marcoussis.

El Lissitzky, *Floating Volume,* 1919. Installed in El Lissitzky's *Cabinet of Abstract Art.* The two views indicate change from white to black depending on viewer's position.

It was, however, not until 1926, when he designed and installed in Dresden and Hannover what he called his *Demonstration Rooms*—room-sized cabinets for the display and installation of the nonrepresentational art of his time—that one finds Stepanova's analysis fully confirmed in Lissitzky's practice. The vertical lattice relief-construction that covers the display surfaces of the cabinet and that changes value from white, through gray, to black according to the viewer's position clearly engages the viewer in a phenomenological exercise that defies traditional contemplative behavior in front of the work of art. And the moveable wall panels, carrying or covering easel panels on display, to be shifted by the viewers themselves according to their momentary needs and interests, already incorporate into the display system of the museum the function of the archive that Stepanova predicted as its social destiny. In the late 1920s Lissitzky wrote a retrospective analysis of his *Demonstration Rooms,* and once again it is crucial to compare his ideas with those of both Stepanova and Benjamin in order to realize how developed and current these concerns actually were in the various contexts:

Traditionally the viewer was lulled into passivity by the paintings on the walls. Our construction/design shall make the man active. This is the function of our room. . . . With each movement of the viewer in space the perception of the wall changes; what was white becomes black, and vice versa. Thus, as a result of human bodily motion, a perceptual dynamic is achieved. This play makes the viewer active. . . . The viewer is physically engaged in an interaction with the object on display.[15]

The paradox and historical irony of Lissitzky's work was, of course, that it had introduced a revolution of the perceptual apparatus into an otherwise totally unchanged social institution, one that constantly reaffirms both the contemplative behavior and the sanctity of historically rooted works of art.

This paradox complemented the contradiction that had become apparent several years earlier when Lissitzky had placed a suprematist painting, enlarged to the size of an agitational billboard, in front of a factory entrance in Vitebsk. This utopian radicalism in the formal sphere—what the conservative Soviet critics later would pejoratively allude to as formalism—in its failure to communicate with and address the new audiences of industrialized urban society in the Soviet Union, became increasingly problematic in the eyes of the very groups that had developed constructivist strategies to expand the framework of modernism. It had become clear that the new society following the socialist revolution (in many respects a social organization that was comparable to the advanced industrial nations of western Europe and the United States at that time) required systems of representation/production/distribution which would recognize the collective participation in the actual processes of production of social wealth, systems which, like architecture in the past or cinema in the present, had established conditions of *simultaneous collective reception.* In order to make art "an informed analysis of the concrete tasks which social life poses," as Babichev had requested, and in order to "fill the gulf between art and the masses that the bourgeois traditions had established," as Meyerhold had called for, entirely new forms of audience address and distribution had to be considered. But around 1920 even the most advanced works among the nonutilitarian object-constructions—by Rodchenko, the Stenberg brothers, Tatlin, and Medunetsky—did not depart much further from the modernist framework of bourgeois aesthetics than the point of establishing models of epistemological and semiotic critique. No matter how radical, these were at best no more than a negation of the perceptual conventions by which art had previously been produced and received.

With sufficient historical distance it becomes clearer that this fundamental crisis within the modernist paradigm was not only a crisis of representation (one that had reached its penultimate status of self-reflexive verification and epistemological critique). It was also, importantly, a crisis of audience relationships, a moment in which the historical institutionalization of the avant-garde had reached its peak of credibility, from which legitimation was only to be obtained by a redefinition of its relationship with the new urban masses and their cultural demands. The Western avant-garde experienced the same crisis with the same intensity. It generally responded with entrenchment in traditional models—the "Rappel à l'ordre"—and the subsequent alignment of many of its artists with the aesthetic needs of the fascists in Italy and Germany. Or, other factions of the Paris avant-garde responded to the same crisis with an increased affirmation of the unique status of a high-art avant-garde, trying to resolve the contradictions of their practice by reaffirming blatantly obsolete conventions of pictorial representation. In the early 1920s the Soviet avant-garde (as well as some members of the de Stijl group, the Bauhaus, and Berlin dada) developed different strategies to transcend the historical limitations of modernism. They recognized that the crisis of representation could not be resolved without at the same time addressing questions of distribution and audience. Architecture, utilitarian product design, and photographic factography were some of the practices that the Soviet avant-garde considered capable of establishing these new modes of simultaneous collective reception.[16] Arvatov gives a vivid account of the gradual transition from the modernist position in the Russian avant-garde to the factographic and utilitarian aesthetic:

The first to retire were the expressionists, headed by Kandinsky, who could not endure extremist pressure. Then the suprematists, headed by Malevich, protested against the murder of the sanctity of art, since they were convinced of the complete self-sufficiency of art. They could not comprehend any other form of art production but that of the easel. . . . In 1921 the Institute for Artistic Culture, which had once united all the Left artists, broke up. Shortly thereafter the Institute started to work under the banner of productivism. After a long process of selection, after an obstinate fight, the group of nonrepresentational constructivists crystallized within the group of the Left (Tatlin, Rodchenko, and the Obmochu-Group), who based their practice on the investigation and treatment of real materials as a transition to the constructive activity of the engineer. During one of the most important meetings of the Inchuk a resolution was passed unanimously to finish off with the self-sufficient constructions and to take all measures necessary in order to engage immediately with the industrial revolution.[17]

Photomontage: Between Faktura and Factography

The relatively late discovery of photocollage and montage techniques seems to have functioned as a transitional phase, operating between the fully developed modernist critique of the conventions of representation, which one sees in constructivism, and an emerging awareness of the new need to construct *iconic* representations for a new mass audience. Neither Lissitzky nor Rodchenko produced any photocollage work before 1922; and only as late as 1919—when these artists had already pushed other aspects of postcubist pictorial and sculptural problems further than anyone else in Europe (except, of course, for Duchamp)—did the collage technique proper enter their work at all. It seems credible that in fact Gustav Klucis, a disciple of Malevich and a collaborator with Lissitzky, was the first artist to transcend the purity of suprematist painting by introducing iconic photographic fragments into his suprematist work in 1919, the very date that Heartfield and Grosz, Hausmann and Höch have claimed as the moment of their invention of photomontage.

Since by 1919 photomontage was widespread and commonly used in both advertising and commercial photography, the question of who actually introduced the technique into the transformation of the modernist paradigm is unimportant.[18] What is far more crucial is in what way the artists (who might very well have simultaneously "discovered" the technique for their own purposes quite independently of one another) related to the inherent potential and consequences of the reintroduction of (photographic) iconic imagery at precisely the moment when mimetic representation had seemingly been dismantled and definitively abandoned.

Announcing his claims to priority, Klucis also underlines the essential difference between the Soviet type of photomontage and that of the Berlin dadaists when he writes in 1931:

There are two general tendencies in the development of photomontage: one comes from American publicity and is exploited by the Dadaists and Expressionists—the so called photomontage of form; the second tendency, that of militant and political photomontage, was created on the soil of the Soviet Union. Photomontage appeared in the USSR under the banner of LEF when non-objective art was already finished. . . . Photomontage as a new method of art dates from 1919 to 1920.[19]

The hybrids that Klucis, Lissitzky, and Rodchenko created with their first attempts at collage and photomontage reveal the difficulty of the paradigmatic transformation that is inherent in that procedure and the concomitant search, in the period 1919–23, for a solution to the crisis of representation. But beyond this, they suggest where the answer to these questions would have to be found, and they define the qualities and functions which the new procedures that legitimize iconic representation would have to offer. At the same time, it would seem that these artists did not want, on the one hand, to sacrifice any of the supreme modernist virtues they had achieved in their pictorial and sculptural work: the transparency of construction procedures; the self-referentiality of the pictorial signi-

Alexander Rodchenko, *Ticket No. 1,* 1919

Alexander Rodchenko, photomontage for *Pro Eto,* 1923

fying devices; the reflexive spatial organization; and the general emphasis on the tactility, that is, the constructed nature of their representations. But, on the other hand, photocollage and photomontage reintroduced into the aesthetic construct—at a moment when its modernist self-reflexivity and purification had semiotically reduced all formal and material operations to purely indexical signs—unlimited sources for a new *iconicity* of representation, one that was mechanically produced and reproduced, and therefore—to a generation of media utopians—the most reliable. Looking at the photomontage work of 1923, such as Rodchenko's series *Pro Eto* or Hausmann's work, one might well wonder whether the exuberance, willfulness, and quantity of the photographic quotations and their juxtapositions were not in part motivated by their authors' relief at having finally broken the modernist ban on iconic representation. This was in extreme contrast to the Parisian vanguard's collage work, in which iconic representation ultimately reappeared but which never made use of photographic or mechanically reproduced iconic images.

But the rediscovery of a need to construct iconic representations did not, of course, result primarily from the need to overcome the strictures of modernism. Rather it was a necessary strategy to implement the transformation of audiences that the artists of the Soviet avant-garde wanted to achieve at that time. "Photomontage," an anonymous text (attributed by some scholars to Rodchenko) published in *Lef* in 1924, not only traces the historic affiliation of photomontage's conglomerate image with the strategies of advertising, juxtaposing photomontage's technique and its iconic dimension with the traditional techniques of modernist representation, but also introduces the necessity of *documentary* representation in order to reach the new mass audience:

By photomontage we understand the usage of the photographic prints as tools of representation. The combination of photographs replaces the composition of graphic representations. The reason for this substitution resides in the fact that the photographic print is not the sketch of a visual fact, but its precise fixation. The precision and the documentary character give photography an impact on the spectator that the graphic representation can never claim to achieve. . . . An advertisement with a photograph of the object that is being advertised is more efficient than a drawing of the same subject.[20]

Unlike the Berlin dadaists who claimed to have invented photomontage, the author of this *Lef* text does not disavow the technique's intrinsic affiliation (and competitive engagement) with the dominant practices of advertising. Quite the contrary, the author seems to invite that competition by defining photomontage from the start as an agitational tool that addresses the Soviet Union's urban masses. It is with this aspect in mind that the practitioners of photomontage could not accept the confinement of the medium to the forms of distribution they had inherited from collage: forms limited by the single, rectangular sheet of paper, its format, scale, and size of edition entirely determined by the most traditional studio notions of unique, auratic works of art.

While (with the exception of the work of John Heartfield) most western European photomontage remains on the level of the unique, fabricated image—paradoxically folding into the singularity of this object fragments of a multitude of technically reproduced photographic images from mass-cultural sources—the strategies of the Soviet avant-garde seem rather rapidly to have shifted away from a reenactment of that historical paradox. The productivist artists realized that in order to address a new audience not only did the techniques of production have to be changed, but the forms of distribution and institutions of dissemination and reception had to be transformed as well. The photomontage technique, as an artistic procedure that supposedly carries transformative potential *qua*

Kurt Schwitters, *Untitled
(Der Sturm)*, 1919

El Lissitzky, photomontage for
catalogue accompanying
Soviet Pavilion at *Pressa*
exhibition, 1928

procedure, as the Berlin dadaists seem to have believed, therefore, in the work of Rodchenko and Lissitzky, becomes integrated as only *one* among several techniques—typography, advertising, propaganda—that attempted to redefine the representational systems of the new society.

From Modernism to Mass Culture

In 1926 Lissitzky developed a theory of contemporary art production that not only associated aesthetic practice with the needs of audience and patron class as prime determinants of the forms that production would assume, but also linked standards of modernist practice to distribution developments occurring in other communications media: books, graphic design, film. Although his beliefs were buoyed by the same naive optimism toward the enlightening power of technology and the media that would ten years later limit the ultimate relevance of Walter Benjamin's essay, Lissitzky's is not a mere "machine aesthetic." Rather, it is an attempt to establish an operative aesthetic framework that could focus attention simultaneously on the existing needs of mass audiences and on the available techniques and standards of the means of artistic production. Like Benjamin in his later essay, Lissitzky considers aesthetic forms and their procedures of production in the light of history rather than in terms of universal categories. Yet unlike Benjamin, he perceives the ensuing transformations as a product of needs and functions rather than as a result of technological changes. The text is important for the clarification of Lissitzky's motivation in the following years, as he decided to abandon almost all traditional forms of graphic and photographic, let alone painterly or sculptural, production and to concentrate exclusively on those practices that establish the new "monumentality"—the conditions of simultaneous collective reception:

It is shortsighted to suppose that machines, *i.e.,* the displacement of manual by mechanical processes, are basic to the development of the form and the figure of an artifact. In the first place it is the consumers' demand that determines the development, *i.e.,* the demand of the social strata that provide the "commissions." Today this is not a narrow circle anymore, a thin cream, but everybody, the masses. . . . What conclusions does this imply in our field? The most important thing here is that the mode of production of words and pictures is included in the same process: photography. . . . [In America] they began to modify the relation of word and illustration in exposition in the direct opposite of the European style. The highly developed technique of facsimile electrotype (half-tone blocks) was especially important for this development; thus photomontage was born. . . . With our work the Revolution has achieved a colossal labor of propaganda and enlightenment. We ripped up the traditional book into single pages, magnified these a hundred times, . . . and stuck them up as posters in the streets. . . . The innovation of easel painting made great works of art possible, but it has now lost its power. The cinema and the illustrated weekly have succeeded it. . . . The book is the most monumental art form today; no longer is it fondled by the delicate hands of a bibliophile, but seized by a hundred thousand hands. . . . We shall be satisfied if we can conceptualize the epic and the lyric developments of our times in our form of the book.[21]

The degree to which Lissitzky focused at that time on the question of audience as a determinant of form, and on the perspective of creating conditions for simultaneous collective reception, becomes even more obvious in the essay's at-first surprising equation between the reading space of the printed page and the space of dramatic experience in the theater. According to Lissitzky the page (and its traditional layout and typography) shares conventions of confinement with the theater—the peep-show as he calls it— where the spectator is separated from the performers, and the spectator's gaze is contained—as in traditional easel painting—in the central perspective of the proscenium stage. The revolutionary transformation of book design ran parallel in Lissitzky's work to

the revolution of the theatrical space, for example, as he would produce it in 1929 for Meyerhold's theater and its central, open-stage construction. Already in his 1922 book *Of Two Squares* (reading lessons for children, as he called it), he said that "the action unrolls like a film" and the method of typographical montage generates the tactility of experiencing the reader's movement through time and space.[22]

This integration of the dramatic experience of theatrical/cinematographic space and the perceptual experience of static signs of graphic/photographic montage and typography is successfully achieved in 1928 in Lissitzky's first major exhibition project for the International Press Exhibition, *Pressa,* in Cologne. Not surprisingly, we find on the first page of the catalogue that Lissitzky created to accompany the design of the USSR Pavilion the announcement, "Here you see in a typographic kino-show the passage of the contents of the Soviet Pavilion."[23]

Rather than thinking of Lissitzky's involvement with the design of exhibitions merely as a task-oriented activity that remains marginal to the central concerns of his work (as have most authors considering these projects), it seems more adequate to see them, along with Lissitzky's subsequent involvement with the propaganda journal *USSR in Construction,* as a logical next step in the development of his own work, as well as in the radical transformation of modernist aesthetics and art production as it had been occurring within the Soviet avant-garde since 1921 and the rise of productivism. We have no reason to doubt the sincerity of one of the last texts Lissitzky wrote, shortly before his death in 1941, a table of autobiographical dates and activities, where the entry under the year 1926 reads, "In 1926 my most important work as an artist began: the design of exhibitions."[24]

In 1927 Lissitzky had been commissioned to install his first "commercial" exhibition design in the Soviet Union, the exhibition of the Polygraphic Union, a relatively modest project in Moscow's Gorky Park. Unlike the 1926 design for the *International Contemporary Art Exhibition* in Dresden, or the cabinet design for the Hannover Landesmuseum in 1927, this project was conceived and produced as a set for a trade show rather than an exhibition of contemporary art; furthermore, it was the result of the collaboration of a group of artists.

Klucis, the "inventor" of photomontage, Lissitzky's colleague and disciple from Vitebsk, where both had struggled to come to terms with the legacy of Malevich's suprematism in 1919–20, was one of the collaborators in the project, as was Salomon Telingater, later to emerge as one of the major figures in the revolution of Soviet typographic design. It is in the catalogue of this exhibition—a book design project that was jointly produced by Lissitzky and Telingater—that we find Lissitzky's essay "The Artist in Production."

This text is not only Lissitzky's own productivist manifesto (Rodchenko and Stepanova's text, officially entitled "Productive Manifesto," had appeared already in 1921, and Ossip Brik's manifesto "Into Production" had appeared in *Lef* in 1923), but it is also the text in which Lissitzky develops most succinctly his ideas about the uses of photography in general and the functions of photomontage in particular:

As a result of the social needs of our epoch and the fact that artists acquainted themselves with new techniques, *photomontage* emerged in the years following the Revolution and flourished thereafter. Even though this technique had been used in America much earlier for advertising, and the dadaists in Europe had used it to shake up official bourgeois art, it only served political goals in Germany. But only here, with us, photomontage acquired a clearly socially determined and aesthetic form. Like all other great art, it cre-

ated its own laws of formation. The power of its expression made the workers and the Komsomol circles enthusiastic for the visual arts and it had great influence on the billboards and newspapers. Photomontage at its present stage of development uses finished, entire photographs as elements from which it constructs a totality.[25]

Lissitzky's 1927 text not only traces an astonishingly clear history of the technique of photomontage and its origins in advertising technology, but also gives us a clear view of his awareness that the functions of the technique within the historical context of the Soviet avant-garde are entirely different from that of the Berlin dadaists, that the technique is only valid if it is bound into the particular needs of a social group. That is to say, he disavows photomontage as a new artistic strategy that has value *qua* artistic operation and innovational mode of representation/production. The nucleus of the inherent potential of photomontage, that is, the production of iconic, documentary information, already addressed in the anonymous text from *Lef* of 1924, is fully developed in Lissitzky's definition of the functions of the technique in 1927: the morphology of the products of that technique has changed substantially by comparison with its original manifestations in 1919–23. Those features that the technique of photomontage had inherited from its origins in collage and the cubist critique of representation were gradually abandoned. Also abandoned was the overlap of photomontage with the techniques of modern advertising. These techniques seemed to have generated, in the dada context, the extreme procedures of juxtaposition and fragmentation by which the origins in advertising were inverted and where the constructed artificiality of the artifact destroyed the mythical nature of the commodity. This shift became apparent in the gradual return to the *iconic* functions of the photograph, deleting altogether the *indexical* potential of the photograph (as still visible in Lissitzky's photograms of the 1920s) as well as the actual indexical structure of the agglomerated fragments of the photomontage itself, where the network of cuts and lines of jutting edges and unmediated transitions from fragment to fragment was as important, if not more so, as the actual iconic representation contained within the fragment itself.

Thus *faktura,* an essential feature of the modernist paradigm that underlay the production of the Soviet avant-garde until 1923, was replaced by a new concern for the *factographic* capacity of the photograph, supposedly rendering aspects of reality visible without interference or mediation. It was at this moment—in 1924—that Rodchenko decided to abandon photomontage altogether and to engage in single-frame still photography, which transforms montage through the explicit choice of camera angle, the framing of vision, the determinants of the filmic apparatus, and the camera's superiority over the conventions of human perception. In Lissitzky's essay this change is clearly indicated in the phrase arguing that "photomontage in its present stage of development uses finished entire photographs as elements from which it constructs a totality." From this we see that homogeneity in the single print is favored over fragmentation, iconic representation of an absent referent is favored over the indexical materiality of the trace of a verifiable process, tactility of the construction of incoherent surfaces and spatial references is exchanged for the monumentality of the camera angle's awesome visions and the technological media optimism that it conveys. Yet while it is evident that at this moment the premises of the modernist paradigm were vacated, and that a programmatic commitment to new audiences entirely changed the nature of artistic production, it seems no more appropriate to neglect or condemn as *propaganda* Lissitzky's or Rodchenko's work from this period (nor their subsequent involvement with Stalin's State Publishing House in the 1930s) than it would be to condemn certain surrealist artists (those in particular

who developed what Max Ernst was to call the technique of the "painted collage") as being responsible for providing advertising's visual and textual strategies, operative to this very day.

Between Photomontage and Propaganda: The *Pressa*

Partially as a response to his first successful exhibition design in Moscow in 1927, a committee chaired by Anatoly Lunacharsky decided to ask Lissitzky (together with Rabinowich, who later withdrew from participation) to design the Soviet Pavilion at the forthcoming *International Exhibition of Newspaper and Book Publishing* in Cologne, the first exhibition of its kind. Since the decision of the committee was made on December 23, 1927, and the exhibition was to begin in the first week of May 1928, Lissitzky and his collaborators had four months to plan and produce the design of the exhibition. Apparently just two days after the committee had appointed him, Lissitzky submitted a first general outline that foresaw the formation of a "collective of creators" with himself as the general coordinator of the design. Among the approximately thirty-eight members of the collective, only a few, among them the stage designer Naumova, had previously participated in exhibition design and the decoration of revolutionary pageants.[26] The largest group within the collective consisted of agitprop graphic designers, shortly thereafter to become some of the most important graphic designers of the Soviet avant-garde. The majority of the 227 exhibits were produced and assembled in the workshops for stage design in the Lenin Hills in Moscow. The other elements were designed in Moscow as well, but produced and assembled in Cologne under the supervision of Lissitzky and Sergei Senkin, who had traveled to the site of the exhibition to supervise and install the Soviet Pavilion.

The centerpiece of the exhibition was in fact the large-scale photomontage that Lissitzky had designed with Senkin's assistance. This *photofresco,* as Senkin called it, measured approximately seventy-two by eleven feet and depicted, in constant alternation of camera angles, of close-ups and long-shots, the history and importance of the publishing industry in the Soviet Union since the Revolution and its role in the education of the illiterate masses of the newly industrialized state. Thus the photofresco, *The Task of the Press Is the Education of the Masses* (its official title), functioned as the centerpiece of an exhibition that was devoted to documenting the achievements of the Revolution in the educational field for a skeptical, if not hostile western European public.

The actual structure of the photofresco followed the strategies that Lissitzky had laid out in the essay that accompanied the catalogue of his first exhibition design in 1927. Large-scale photographic prints were assembled in an irregular grid formation and the visual dynamic of the montage resulted from the juxtaposition of the various camera angles and positions, but no longer from a jagged linear network of seams and edges of heterogeneous photographic fragments.

While the scale and size of the photomontage—it was installed on the wall at a considerable height—aligned the work with a tradition of architectural decoration and mural painting, the sequencing of the images and their emphatic dependence on camera technology and movement related the work to the experience of cinematic viewing, such as that of the newsreel. In their mostly enthusiastic reviews, many visitors to the *Pressa* exhibition actually discussed the theatrical and cinematic aspects of the photofresco. One critic reminisced that one went through "a drama that unfolded in time and space. One went through expositions, climaxes, retardations, and finales."[27] Reviewing both the

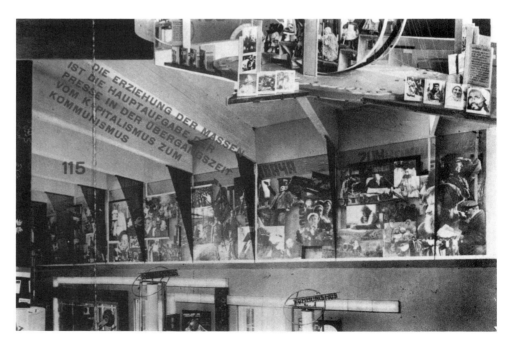

El Lissitzky (in collaboration
with Sergei Senkin),
photofresco in *Pressa*
exhibition, 1928

Dresden *Hygiene Exhibition* design by Lissitzky and the Cologne *Pressa* design, a less well-disposed critic still had to admit the design's affiliation with the most advanced forms of cinematic production:

The first impression is brilliant. Excellent the technique, the arrangement, the organization, the modern way it has been constructed. . . . Propaganda, propaganda, that is the keynote of Soviet Russian exhibitions, whether they be in Cologne or in Dresden. And how well the Russians know how to achieve the visual effects their films have been showing us for years![28]

Even though Lissitzky did not meet Dziga Vertov until 1929 (inaugurating a friendship that lasted until Lissitzky's death in 1941), it is very likely that in 1927–28 he was drawing not only upon the collage and montage sources of cubism, dadaism, and constructivism, but equally upon the cinematic montage techniques that Vertov had used in the first *Kino-Pravda* films, and used still more daringly and systematically in his work after 1923.

In his manifesto "We," published in *kinofot* in 1922 and illustrated by a compass and ruler drawing by Rodchenko from 1915, Vertov had called film "an art of movement, its central aim being the organization of the movements of objects in space." Hubertus Gassner speculates that this manifesto had considerable influence on Rodchenko, as well as the constructivists, and led him away from drawing and painting into the photographic montage production that Rodchenko published two issues later in the same journal.[29] It seems, however, that Vertov only voiced a concern that, as we saw above in several instances, was very much at the center of the constructivist debate itself, to make "construction" and "montage" the procedures that would transform the passive, contemplative modes of seeing. Sophie Küppers argues that it was Vertov who learned the montage technique from Lissitzky's earliest experiments with the photogram and the photomontage, and that it was primarily Lissitzky's transparency technique and the double exposure as photographic montage technique that left a particularly strong impression on Vertov's own work in the mid-1920s. Only in the later work produced by Lissitzky for the magazine *USSR in Construction* can we recognize, according to Küppers, the influence of Vertov's *Kino-Pravda*.

In spite of the obvious parallels between the cinematographic montage and the photomontage, and leaving aside the question of historical priority and influence, it is important to clarify in this context the specific differences that existed between the mural-sized photomontages and exhibition designs of Lissitzky and the montage of Vertov's *Kino-Pravda*. Clearly the still photograph and the new photomontage, as Lissitzky defined it, offered features that the moving imagery of the film lacked: aspects of the same subject could be compared and contrasted and could be offered for extensive reading and viewing; complicated processes of construction and social transformation could be analyzed in detailed accounts that ran parallel with statistics and other written information; and the same subject could, as Rodchenko argued, be represented "at different times and in different circumstances." This practice of "realistic constructivism" as the critic Gus called Lissitzky's exhibition design, had in fact wrought a substantial change within collage and photomontage aesthetics. What in collage had been the strategy of *contingency,* by which material had been juxtaposed, emphasizing the divergence of the fragments, had now become the *stringency* of a conscious construction of documentary factographic information.

In an excellent recent study of Russian constructivism, Christina Lodder has argued that it was the failure of the constructivists actually to implement their productivist program (due to shortage of materials, lack of access to industrial facilities, disinterest on the

part of the engineers and administrators of the State manufacturing companies) that drove these artists into the field of typography, publication and poster design, agitational propaganda, and exhibition design.[30] The emergence of a strong antimodernism, backed by the Party as a result of Lenin's New Economic Policy in 1921, required the return to traditional values in art and laid the foundations for the rise of socialist realism. Lodder argues that it was as a result of these changes and as an attempt at competition with these reactionary forces that Lissitzky's and Rodchenko's work at that time employed iconic, photographic representation and abandoned the radical syntax of the montage aesthetic. The problem with this criticism, however—as with all previous rejections of the later work of Rodchenko and Lissitzky—is that criteria of judgment that were originally developed within the framework of modernism are now applied to a practice of representation that had deliberately and systematically disassociated itself from that framework in order to lay the foundations of an art production that would correspond to the needs of a newly industrialized collective society. Because, as we have seen, these conditions required radically different production procedures and modes of presentation and distribution, any historical critique or evaluation will have to develop its criteria from *within* the actual intentions and conditions at the origin of these practices.

Lissitzky's exhibition design does overcome the traditional limitations of the avant-garde practice of photomontage and reconstitutes it within the necessary conditions of simultaneous collective reception that were given in the cinema and in architecture. Further, in his new practice of montage, Lissitzky incorporated the method of "systematic analytical sequence," as Tretyakov was to define it shortly afterward. Tretyakov wrote in 1931 that the photographer/artist should move from the single-image aesthetic to the systematic photographic sequence and the long-term observation:

If a more or less random snapshot is like an infinitely fine scale that has been scratched from the surface of reality with the tip of the finger, then in comparison the photoseries or the photomontage lets us experience the extended massiveness of reality, its authentic meaning. We build systematically. We must also photograph systematically. Sequence and long-term photographic observation—that is the method.[31]

Modernism's Aftermath

In spite of the fact that even the most conservative international newspapers reported enthusiastically on Lissitzky's *Pressa* design, and that he received a medal from the Soviet government in recognition of the success of this project as well as having been named an honorary member of the Moscow town Soviet, he seems to have been personally dissatisfied with the results. This is evident in a letter that he wrote on December 26, 1928, to his Dutch friend, the de Stijl architect J. J. P. Oud. "It was a big success for us," he mused, "but aesthetically there is something of a poisoned satisfaction. The extreme hurry and the shortage of time violated my intentions and the necessary completion of the form—so it ended up being basically a theater decoration."[32]

We will, however, find in neither Lissitzky's letters nor his diary entries any private or public disavowal of or signs of regret about having abandoned the role of the modernist artist for that of the producer of political propaganda in the service of the new Communist state. Quite the opposite: the letters we know Lissitzky to have written during the years of his subsequent involvement with both the design of exhibitions for the government and his employment by Stalin's State Publishing House on the magazine *USSR in Construction* clearly indicate that he was as enthusiastically at work in fashioning the prop-

aganda for Stalin's regime as were Rodchenko and Stepanova, who were at that time involved in similar tasks. Clearly Lissitzky shared the naive utopianism that also characterized Walter Benjamin's later essay, an optimism that Adorno criticized in his response to the text:

Both the dialectic of the highest and the lowest [modernism and mass culture] bear the stigmata of capitalism, both contain elements of change. . . . Both are torn halves of an integral freedom, to which however they do not add up. It would be romantic to sacrifice one to the other, either as the bourgeois romanticism of the conservation of personality and all that stuff, or as the anarchistic romanticism of blind confidence in the spontaneous power of the proletariat in the historical process—a proletariat which is itself a product of bourgeois society.[33]

But it is also clear by now that both Lissitzky's and Benjamin's media optimism prevented them from recognizing that the attempt to create conditions of a simultaneous collective reception for the new audiences of the industrialized state would very soon issue into the preparation of an arsenal of totalitarian, Stalinist propaganda in the Soviet Union. What is worse, it would deliver the aesthetics and technology of propaganda to the Italian Fascist and German Nazi regimes. And only a little later we see the immediate consequences of Lissitzky's new montage techniques and photofrescoes in their successful adaptation for the ideological needs of American politics and the campaigns for the acceleration of capitalist development through consumption. Thus, what in Lissitzky's hands had been a tool of instruction, political education, and the raising of consciousness was rapidly transformed into an instrument for prescribing the silence of conformity and obedience. The "consequent inrush of barbarism" of which Adorno speaks in the letter to Benjamin as one possible result of the undialectical abandonment of modernism was soon to become a historical reality. As early as 1932 we see the immediate impact of the *Pressa* project in its adaption for the propaganda needs of the Fascist government in Italy. Informed by the members of the Italian League of Rational Architecture, in particular Bardi and Paladini (who was an expert on the art of the Soviet avant-garde), the architect Giuseppe Terragni constructed an enormous mural-sized photomontage for the *Exposition of the Fascist Revolution*.[34] It would require a detailed formal and structural analysis to identify the transformations that took place within photomontage aesthetics once they were put to the service of Fascist politics. It may suffice here to bring only one detail to the attention of the reader, a detail in which that inversion of meaning under an apparent continuity of a formal principle becomes apparent, proving that it is by no means simply the case of an available formal strategy being refurbished with a new political and ideological content.

The detail in question is the representation of the masses in Terragni's photomural, where a crowd of people is contained in the outlines of a relief shaped like the propeller of a turbine or a ship. Clearly it was one of the most difficult tasks, in constructing representations for new mass audiences, not only to establish conditions of simultaneous collective viewing, but further, actually to construct representations of the masses themselves, to depict the collectivity. One of the most prominent examples of this necessity is an early photomontage poster by Klucis, which in fact seems to have been so successful that Klucis used the same visual configuration for two different purposes.[35] The subject of the poster in both versions is the representation of political participation in the decision-making processes of the new Soviet state. In Klucis's poster participation is encouraged by an outstretched hand within which hundreds of faces are contained: thus the individu-

Gustav Klucis, photomontage
poster (version one), 1930

Gustav Klucis, photomontage
poster (version two), 1930

ation resulting from the participation in political decisions and subordination under the
political needs of the collectivity seem to be successfully integrated into one image. In
Terragni's photomural the same structure has been deployed; this time, however, the
overall form of the outstretched hand of the voting individual is replaced by the outlines
of the machine (the propeller, the turbine) which contains the image of the masses of
people. And it is clear that the Fascist image means what it unknowingly conveys: that
the subordination of the masses under the state apparatus in the service of the continued
dominance of the political and economic interests of the industrial ruling class has to be
masked behind the image of technological progress and mastery. Abstracted as it is, how-
ever, from the interests of those who are being mastered, it appears as an image of ano-
nymity and subjugation rather than one of individual participation in the construction of
a new collective.

It is significant that the principles of photomontage are completely abandoned once
the technique of the photomural is employed for the propaganda purposes of the German
fascists. In the same manner that they had discovered Eisenstein's films as a model to be
copied for their purposes (Leni Riefenstahl studied his work thoroughly for the prepara-
tion of her own propaganda movies), they had also recognized that the achievements of
the Russian artists in the field of exhibition design could be employed to serve their needs
to manipulate the urban and rural masses of Germany during the crisis of the post-
Weimar period. When the German Werkbund, which had just been turned into a fascist
organization, put together a popular photography show in 1933 called *The Camera*, the
organizers explicitly compared their exhibition design with that of the Russians (without,
of course, mentioning Lissitzky's name):

John Heartfield, *All fists have been clenched as one*, photomontage cover for special issue against fascism of *Arbeiter Illustrierte Zeitung* 13:40 (1934)

If you compare this exhibition with the propaganda rooms of the Russians that received so much attention during the last years, you will instantly become aware of the direct, unproblematic, and truly grandiose nature of the representation of reality in this room. These pictures address the spectator in a much more direct manner than the confusion of typography, photomontage, and drawings. . . . This hall of honor is so calm and grand that one is almost embarrassed to talk any longer about propaganda in this context.[36]

To erase even the last remnant of modernist practice in photomontage, the seams and the margins where the constructed nature of reality could become apparent—and therefore its potential for change obvious—had now become a standard practice in totalitarian propaganda, and construction was replaced by the awe-inspiring monumentality of the gigantic, single-image panorama. What had once been the visual and formal incorporation of dialectics in the structure of the montage—in its simultaneity of opposing views, its rapidly changing angles, its unmediated transitions from part to whole—and had as such embodied the relationship between individual and collectivity as one that is constantly to be redefined, we now find displaced by the unified spatial perspective (often the bird's-eye-view) that travels over uninterrupted expanses (land, fields, water, masses) and thus naturalizes the perspective of governance and control, of the surveillance of the rulers' omnipresent eye in the metaphor of nature as an image of a pacified social collective without history or conflict.

It remains to be determined at what point, historically as well as structurally, this reversal takes place within the practices of photomontage during the 1930s. Unification of the image and its concomitant monumentalization were—as we saw—already operative in Lissitzky's work for the *Pressa* exhibition. These tendencies were of considerable importance for the success of his enterprise. And according to Stepanova's own text,

Giuseppe Terragni,
photomontage mural for the
*Exposition of the Fascist
Revolution,* 1932

Photomural at the German
Werkbund exhibition *Die
Kamera,* Berlin, 1933

Rodchenko abandoned photomontage principles as early as 1924, replacing them by
single-frame images and/or series of single-frame images with highly informative docu-
mentary qualities. At what point these factographic dimensions turned into the sheer
adulation of totalitarian power, however, is a question that requires future investigation.
That this point occurs within Rodchenko's work, if not also in Lissitzky's for the journal
USSR in Construction is a problem that modernist art historians have tried to avoid by
styling these artists as purist heroes and martyrs who had to sacrifice their commitment
to the spiritual realm of abstract art by their enforced involvement with the state. A
revision of this comforting distortion of history is long overdue. It is a distortion that
deprives these artists—if nothing else—of their actual political identity (their commit-
ment to the cause of Stalinist politics was enthusiastic and sincere and came unforced, as
is evident from the fact that an artist such as Tatlin, who did not work for the state
agencies, continued to live his private, if economically miserable, existence without ha-
rassment), as it deprives us of the understanding of one of the most profound conflicts
inherent in modernism itself: that of the historical dialectic between individual autonomy
and the representation of a collectivity through visual constructs. Clearly the history of
photomontage is one of the terrains in which this dialectic was raised to the highest
degree of its contradictory forces. Thus it is not surprising that we find the first signs of a
new authoritarian monumental aesthetic defined through the very rejection of the legacy
of photomontage in favor of a new unified imagery. In 1928 Stepanova could still trace
this terrain's development through an apparently neutral political terminology in charac-
terizing the climax of the productivist factographic position:

Within its short life, photomontage has passed through many phases of development. Its
first stage was characterized by the integration of large numbers of photographs into a
single composition, which helped bring into relief individual photo images. Contrasts in
photographs of various sizes and, to a lesser extent, the graphic surface itself formed the

connective medium. One might say that this kind of montage had the character of a planar montage superimposed on white paper ground. The subsequent development of photomontage has confirmed the possibility of using photographs as such . . . the individual snapshots are not fragmented and have all the characteristics of a real document. The artist himself must take up photography. . . . The value of the photograph itself came to assume primary importance; the photograph is no longer raw material for montage or for some kind of illustrated composition but has an independent and complete totality.[37]

But two years later, from within the Soviet Russian reflection upon the purposes and functions of the technique of photomontage itself we witness the rise of that concern for the new monumentality and heroic pathos that was the prime feature of the German fascist attack on the legacy of photomontage quoted above. In 1930, in his text "The Social Meaning of Photomontage," the critic O. L. Kusakov writes,

. . . the solution to the problem of the proletarian, dynamic photomontage is inherently connected to the simultaneous solution of the question for a monumental style, since the monumentality of the tasks of the construction of socialism requires a heroic pathos for the organization of the consciousness of the spectators. Only in a successful synthesis of dynamics and monumentality—in conjunction with the constitution of a dialectical relationship between the levels of life—can photography fulfill the functions of an art that organizes and leads life.[38]

Thus it seems that Babichev's original, utopian quest and prognosis for the future functions of a postmodernist factographic art to become "an informed analysis of the concrete tasks which social life poses," one that will "organize the consciousness and psyche of the masses by organizing objects and ideas," had become true within ten years' time, although in a manner that was perhaps quite different from what he had actually hoped for. Or we could say that the latent element of social engineering, inherent in the notion of social progress as a result of technological development which art could mediate, had finally caught up with modernism's orientation toward science and technology as its underlying paradigms for a cognitively and perceptually emancipatory practice.

This historical dialectic seems to have come full circle in Rodchenko's career. In 1931 he worked as artist-in-residence on the site of the construction of the White Sea Canal in order to document the heroic technological achievements of the Stalin government and to produce a volume of photographic records. But apparently in the first year alone of his stay more than a hundred thousand workers lost their lives due to inhuman working conditions. While it is unimaginable that Rodchenko would not have been aware of the conditions that he photographed for almost two years, his subsequent publications on the subject project only a grandiose vision of nature harnassed by technology and the criminal and hedonistic impulses of the prerevolutionary and counterrevolutionary personality mastered through the process of reeducation in the forced labor camps of the White Sea Canal.[39]

While it is undoubtedly clear that at this time Rodchenko did not have any other choice than to comply with the interest of the State Publishing House if he wanted to maintain his role as an artist who participated actively in the construction of the new Soviet society (and we have no reason to doubt this to be his primary motive), we have to say at least that by 1931 the goals of factography had clearly been abandoned.

However, the contempt meted out from a Western perspective at the fate of modernist photomontage and factographic practice in the Soviet Union during the 1930s or at its transformation into totalitarian propaganda in fascist Italy and Germany seems historically inappropriate. For the technique was adapted to the specifically American needs of ideo-

Alexander Rodchenko, two
pages from the magazine
USSR in Construction 12
(December 1933), special issue
on the construction of the
Stalin Canal

Overprinted caption in
photograph reads: "In the
course of twenty months
almost twenty thousand skilled
workmen were trained in forty
trades. They were all ex-
thieves, bandits, kulaks,
wreckers, murderers. For
the first time they became
conscious of the poetry of
labor, the romance of
construction work. They
worked to the music of
their own orchestras."

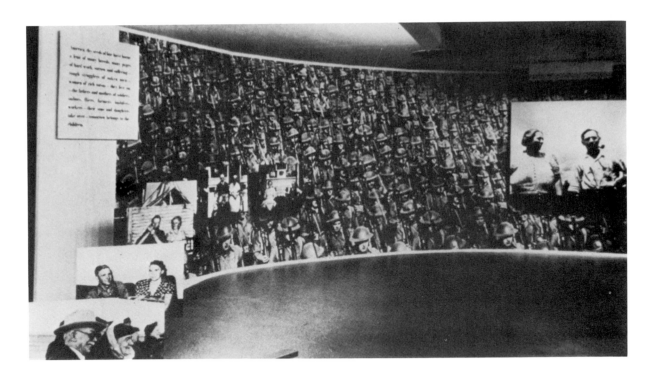

Herbert Bayer, photomural for
Edward Steichen's exhibition
Road to Victory at the Museum
of Modern Art, New York,
1942

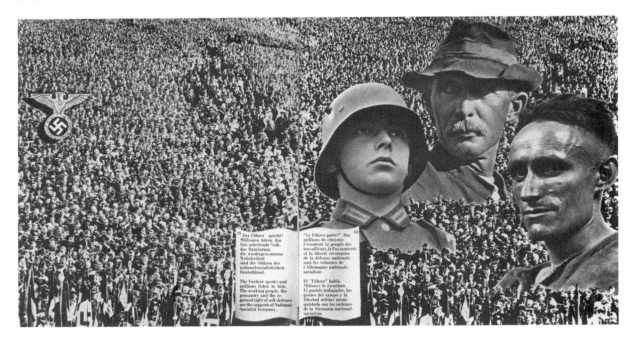

Herbert Bayer, photomontage
for brochure accompanying
the exhibition *Deutschland
Ausstellung,* Berlin, 1936

logical deployment at the very same moment. Once again, the tradition of photomontage itself had first to be attacked in order to clear the ground for the new needs of the monumental propaganda machines. Here is Edward Steichen's American variation on the theme of an antimodernist backlash in favor of his version of a "productivist" integration of art and commerce in 1931:

The modern European photographer has not liberated himself as definitely [as the American commercial photographer]. He still imitated his friend, the painter, with the so-called photomontage. He has merely chosen the *modern* painter as his prototype. We have gone well past the painful period of combining and tricking the banal commercial photograph. . . . It is logical therefore that we find many modern photographers lined up with architects and designers instead of with painters or photographic art salons.[40]

Ten years later Steichen staged his first project at the Museum of Modern Art, the exhibition *Road to Victory*. Once again its propagandistic success depended almost entirely, as Christopher Phillips has shown, on a debased and falsified version of Lissitzky's exhibition designs.[41] In this case it was Herbert Bayer who provided American industry and ideology with what *he* thought Lissitzky's ideas and practice had attempted to achieve. Bayer was well suited to this task, having already prepared an elaborate photomontage brochure for the National Socialists' *Deutschland Ausstellung* of 1936, staged to coincide with the Berlin Olympics. When asked by Christopher Phillips about his contribution to this project for the Nazis, Bayer's only comment was, "This is an interesting booklet insofar as it was done exclusively with photography and photomontage, and was printed in a duotone technique."[42] Thus, at the cross section of politically emancipatory productivist aesthetics and the transformation of modernist montage aesthetics into an instrument of mass education and enlightenment, we find not only its imminent transformation into totalitarian propaganda, but also its successful adaptation for the needs of the ideological apparatus of the culture industry of Western capitalism.

1 Alfred Barr, "Russian Diary 1927–1928," *October* 7 (Winter 1978), p. 21.

2 Ibid., p. 19.

3 Ibid., p. 14.

4 Alfred Barr, "The Lef and Soviet Art," *Transition* 14 (Fall 1928), pp. 267–70.

5 Boris Arvatov, *Kunst und Produktion* (Munich: Hanser Verlag, 1978), p. 43. All translations from the German, unless otherwise noted, are my own.

6 Yve-Alain Bois, in his essay "Malévich, le carré, le degré zéro," *Macula* 1 (1976), pp. 28–49, gives an excellent survey of the original discussion of the question of *faktura* among the various factions of the Russian avant-garde. More recently Margit Rowell has added references such as Markov's text, quoted here, that had not been mentioned by Bois. In any case, as Bois has argued, it is pointless to attempt a chronology since the many references to the phenomenon appear simultaneously and often independently of one another.

 As early as 1912 the question of *faktura* is discussed by Mikhail Larionov in his "Rayonnist Manifesto," where he calls it "the essence of painting," arguing that the "combination of colors, their density, their interaction, their depth, and their *faktura* would interest the truly concerned to the highest degree." A year later, in his manifesto "Luchism," he argues that "every painting consists of a colored surface, its *faktura* (that is, the condition of that colored surface, its timbre) and the sensation that you receive from these two aspects." Also in 1912 we find David Burliuk differentiating between "a unified pictorial surface A and a differentiated pictorial surface B. The structure of a pictorial surface can be I. *Granular*, II. *Fibrous*, and III. *Lamellar*. I have carefully scrutinized Monet's *Rouen Cathedral* and I thought 'fibrous vertical structure.' . . . One can say that Cézanne is typically *lamellar*." Burliuk's text is entitled "Faktura." Bois also quotes numerous references to the phenomenon of *faktura* in the writings of Malevich, for example, where he calls Cézanne the inventor of a "new faktura of the pictorial surface," or when he juxtaposes the *linear* with the *textual* in painting. The concern for *faktura* seems still to have been central in 1919, as is evident from Popova's statement that "the content of pictorial surfaces is *faktura*." Even writers who were not predominantly concerned with visual and plastic phenomena were engaged in a discussion of *faktura*, as is the case of Roman Jakobson in his essay "Futurism," identifying it as one of the many strategies of the new poets and painters who were concerned with the "unveiling of the procedure: therefore the increased concern for *faktura*; it no longer needs any justification, it becomes autonomous, it requires new methods of formation and new materials."

 Quite unlike the traditional idea of *fattura* or *facture* in painting, where the masterful facture of a painter's hand spiritualizes the *mere* materiality of the pictorial production and where the hand becomes at the same time the substitute or the totalization of the identifying signature (as the guarantee of authenticity, it justifies the painting's exchange value and maintains its commodity existence), the new concern for *faktura* in the Soviet avant-garde emphasizes precisely the mechanical quality, the materiality, and the anonymity of the painterly procedure from a perspective of empirico-critical positivism. It demystifies and devalidates not only the claims for the authenticity of the spiritual and the transcendental in the painterly execution but, as well, the authenticity of the exchange value of the work of art that is bestowed on it by the first.

 For the discussion of the Markov statement and a generally important essay on the phenomenon of *faktura*, see also Margit Rowell, "Vladimir Tatlin: Form/Faktura," *October* 7 (Winter 1978), pp. 94ff.

7 Nikolai Tarabukin, *Le dernier tableau* (Paris: Editions Le Champ Libre, 1972), p. 102, cited in Rowell, p. 91.

8 Alexander Rodchenko, "Working with Maiakovsky," manuscript 1939, published in excerpts in *From Painting to Design,* exhibition catalogue (Cologne: Galerie Gmurzynska, 1981), pp. 190–91.

9 Alexander Rodchenko, exhibition pamphlet at the exhibition of the Leftist Federation in Moscow, 1917, cited in German Karginov, *Rodchenko* (London: Thames and Hudson, 1975), p. 64.

10 The terminological distinction is of course that of C. S. Peirce, as Rosalind Krauss has first applied it to Duchamp's work in her essay "Notes on the Index," *October* 3 and 4 (Summer and Fall 1977).

11 A. V. Babichev, cited in Hubertus Gassner, "Analytical Sequences," in *Alexander Rodchenko,* ed. David Elliott (Oxford: Museum of Modern Art, 1979), p. 110.

12 Krauss, "Notes," *passim.*

13 Varvara Stepanova, quoted in Camilla Grey, *The Russian Experiment* (New York: Thames and Hudson, 1971), pp. 250–51.

14 Walter Benjamin, "The Work of Art in the Age of Mechanical Reproduction," in *Illuminations,* trans. Harry Zohn (New York: Schocken Books, 1969), p. 238. The last sentence of this quotation, set into parenthesis, is taken from the second version of Benjamin's essay (my translation).

15 El Lissitzky, "Demonstrationsräume," in *El Lissitzky,* ed. Sophie Lissitzky-Küppers (Dresden: VEB-Verlag der Kunst, 1967), p. 362.

16 The problem of the creation of conditions of simultaneous collective reception is dealt with in an essay by Wolfgang Kemp, "Quantität und Qualität: Formbestimmtheit und Format der Fotografie," *Foto-Essays zur Geschichte und Theorie der Fotografie* (Munich: Schirmer/Mosel, 1978), pp. 10ff.

17 Arvatov, *Kunst,* p. 43.

18 The two essays that trace the history of photomontage in the context of the history of photography and the history of emerging advertising technology are Robert Sobieszek, "Composite Imagery and the Origins of Photomontage," Part I and II, *Artforum* (September–October 1978), pp. 58–65 and pp. 40–45. Much more specifically addressing the origins of photomontage in advertising techniques is Sally Stein's important essay, "The Composite Photographic Image and the Composition of Consumer Ideology," *Art Journal* (Spring 1981), pp. 39–45.

19 Gustav Klucis, Preface to the exhibition catalogue *Fotomontage* (Berlin, 1931), cited in Dawn Ades, *Photomontage* (London/New York: Pantheon, 1976), p. 15.

20 Anonymous, *Lef* 4 (1924), reprinted in *Art et Poésie Russes* (Paris: Musée national d'art moderne, 1979), pp. 221ff (my translation).

21 El Lissitzky, "Unser Buch," in *El Lissitzky,* pp. 357–60.

22 Yve-Alain Bois, "El Lissitzky: Reading Lessons," *October* 11 (Winter 1979), pp. 77–96.

23 Lissitzky, *Katalog des Sowjet Pavillons auf der Internationalen Presse-Ausstellung* (Cologne: Dumont Verlag, 1928), p. 16.

24 Lissitzky, *Proun und Wolkenbügel* (Dresden: VEB Verlag der Kunst, 1977), p. 115.

25 Lissitzky, "Der Künstler in der Produktion," *Proun,* pp. 113ff.

26 For a detailed description of the history and the procedures of the work for the *Pressa* exhibition design, see Igor W. Rjasanzew, "El Lissitzky und die *Pressa* in Köln 1928," in *El Lissitzky,* exhibition catalogue (Halle [GDR]: Staatliche Galerie Moritzburg, 1982), pp. 72–81.

27 Ibid., p. 78.

28 Ibid., p. 79.

29 Hubertus Gassner, *Rodchenko Fotografien* (Munich: Schirmer/Mosel, 1982), p. 121.

30 Christina Lodder, *Russian Constructivism* (New Haven: Yale University Press, 1983).

31 Sergei Tretyakov, "From the Photoseries to the Long-Term Photographic Observation," in *Proletarskoje Foto* IV (1931), p. 20, reprinted in German translation in *Zwischen Revolutionskunst und Sozialistischem Realismus,* ed. Hubertus Gassner and Eckhart Gillen (Cologne: Dumont Verlag, 1979), pp. 222ff.

32 Lissitzky, *Proun,* p. 135.

33 Theodor W. Adorno, Letter to Walter Benjamin (London, March 18, 1936) reprinted in *Aesthetics and Politics* (London: New Left Books, 1977), pp. 120ff.

34 Herta Wescher wrote in 1968 in her history of collage that P. M. Bardi's work *Tavola degli orrori* had been modeled upon Lissitzky's montage work published in Western journals. For Paladini, Wescher argues, the relationship was even more direct since he had been born in Moscow of Italian parents and had developed a strong interest in the Soviet avant-garde. In response to the exhibition of the Soviet Pavilion at the Venice Bienale in 1924, he published a study *Art in the Soviet Union* (1925). See Wescher, *Collage* (Cologne: Dumont Verlag, 1968), pp. 76ff.

35 Gustav Klucis's first version of the photomontage poster in 1930 reads, "Let us fulfill the plan of the great projects," and it was an encouragement to participate in the five-year plan of 1930. The second version of the poster is identical in its image of an outstretched hand which in itself contains a large number of outstretched hands and an even larger number of photographic portraits, but this time the inscription exhorts the women of the Soviet Union to participate in the election and decision-making process of their local soviets. This poster seems to have also had an influence on John Heartfield, who transformed Klucis's outstretched hand into an outstretched arm with a fist, giving the salute of the Communist International under the slogan, "All fists have been clenched as one," on the cover of the *AIZ* 40 (1934). Here, as well as in Klucis's and Terragni's work, the image of the masses is contained in the synecdochic representation. In Klucis's and Heartfield's photomontages it is, however, the synecdoche of the human body as a sign of active participation, whereas in the Terragni montage it is the synecdoche of the machine that subjugates the mass of individuals. The inscription in Terragni's photomontage mural reads accordingly, "See how the inflammatory words of Mussolini attract the people of Italy with the violent power of turbines and convert them to Fascism."

36 Kemp, *Foto-Essays,* p. 14.

37 Stepanova, "Photomontage" (1928), English translation in *Alexander Rodenchenko,* ed. Elliott, pp. 91ff.

38 O. L. Kusakov, "Die soziale Bedeutung der Fotomontage," *Sovetskoe Foto* (Moscow, 1930), no. 5, p. 130. Quoted from the German translation in *Zwischen Revolutionskunst und Sozialistischem Realismus,* pp. 230ff.

39 Gassner makes a first attempt at assessing these facts with regard to Rodchenko's career at large in his doctoral thesis on the artist, "Rodchenko-Fotografien," especially pp. 104ff, and n. 475. The problem is, however, that he seems to base his information on the working conditions at the White Sea Canal and the number of victims on the "testimony" of Alexander Solzhnytsyn's writings, clearly a source that would have to be quoted with extreme caution in a historical study. The main work on Lissitzky's, Rodchenko's, and Stepanova's collaboration with Stalin's State Publishing House remains to be done.

40 Edward Steichen, "Commercial Photography," *Annual of American Design* (New York, 1931), p. 159.

41 Christopher Phillips, "The Judgment Seat of Photography," *October* 22 (Fall 1982), pp. 27ff (reprinted in this volume), provides detailed information on Steichen's history and practice of exhibition design at the Museum of Modern Art in New York. Allan Sekula's essay, "The Traffic in Photographs" (reprinted in *Modernism and Modernity* [Halifax: The Press of the Nova Scotia College of Art and Design, 1983]), gives us the best discussion of the *Family of Man* exhibition by Steichen and also touches upon the issues of exhibition design in general.

42 I am grateful to Christopher Phillips for providing me with this information and for his permission to quote from his private correspondence with Herbert Bayer, as well as for lending me the brochure itself. *Deutschland Ausstellung 1936* was also published as an insert in the design magazine *Gebrauchsgraphik* (April 1936).

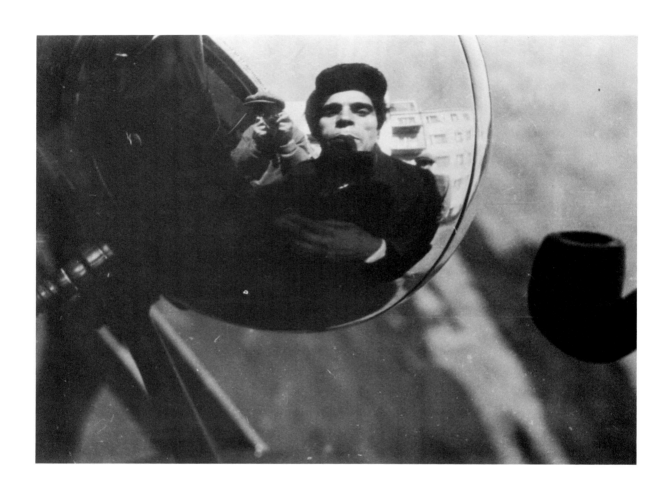

Alexander Rodchenko,
Chauffeur, 1933 (Collection,
The Museum of Modern Art,
New York)

The Armed Vision Disarmed:
Radical Formalism from Weapon
to Style

Art photography, although long since legitimated by all the conventional discourses of fine art, seems destined perpetually to recapitulate the rituals of the *arriviste*. Inasmuch as one of those rituals consists of the establishment of suitable ancestry, a search for distinguished blood lines, it inevitably happens that photographic history and criticism are more concerned with the notions of tradition and continuity than with those of rupture and change. Such recuperative strategies may either take on photography *toute entière,* as in the Museum of Modern Art's exhibition *Before Photography,* which attempted to demonstrate that photography was engendered from the body of art, or selectively resurrect the photography of the past, as in the case of the publication and exhibition by Stieglitz of the work of Hill and Adamson and Julia Margaret Cameron to emphasize the continuity of a particular aesthetic. Although a certain amount of historical legerdemain is occasionally required to argue that *a* evolves or derives from *b,* the nature of photography makes such enterprises relatively easy. An anonymous vernacular photograph may look quite like a Walker Evans, a Lee Friedlander may closely resemble a Rodchenko; put side by side, a close, but specious, relationship appears obviously, *visually* established.

Nowhere is the myth of continuity more apparent than in the recent Aperture offering *The New Vision,* which traces the fortunes and fruits of the Chicago Institute of Design, or, as John Grimes puts it in his essay, "The New Vision in the New World."[1] Although the leitmotif of the book—both in the Grimes essay as well as in Charles Traub's "Photographic Education Comes of Age"—is the enduring presence and influence of the Founding Father (and his founding principles), it is perfectly evident that a substantial amount of the photography to have emerged from the I.D. has little in common with the production, much less the ethos, of the Dessau Bauhaus. In fact, on the evidence of the work reproduced, I would venture to say that much of the photography to have emerged from the Bauhaus of the diaspora is more closely allied to indigenous currents in Ameri-

can art photography than to the machine-age ethic that informed Moholy's thinking.

Such reflections are suggested, among other things, by the concluding sentence in the book's first (unsigned) essay, "A Visionary Founder: László Moholy-Nagy," which reads as follows: "The Utopian dream Moholy worked for never became a reality, despite his dedication and energy, but his new vision was a powerful legacy, especially for photographers, who could see their 'mechanical' art as the means for objective vision, optical truth, and personal enlightenment." [2] Objective vision and optical truth were indeed linchpins of Moholy's program for photography, even as early as 1925. Personal enlightenment, however, was a notion utterly uncountenanced in Moholy's thinking, and the quotes around the world "mechanical"—the precise attribute which made the camera a privileged imagemaking technology in the Bauhaus scheme of things—are an obvious signal of a profound *volteface.*

The problems raised by the kind of photographic history proposed in *The New Vision* are compounded by what appears to be a general confusion as to the notion of formalism in photography. Most photographic cognoscenti, when asked what type of photography is represented by the I.D. at least up to the early 1970s, will respond that it represents the "Chicago School," or "formalism," by which is intended a label that will describe such disparate photographers as Harry Callahan, Aaron Siskind, Ray Metzker, Art Sinsabaugh, Barbara Blondeau, or Kenneth Josephson. To the degree that formalism has undergone (I would argue) the same kinds of permutations and ruptures as did the Bauhaus/I.D. itself, it seemed a useful project to trace generally the radical formalism of Rodchenko as it was disseminated into Weimar *fotokultur* and its additional transformations as it was absorbed and modified in Moholy's practice, within the institution of the Bauhaus. Finally, I was curious to see how the formalism of Aaron Siskind and some of the later graduates of the I.D. related to that of their European forebears. That this forty-year period traces the change from an explicitly political and aggressively antiexpressionist production to its virtual antithesis is implicit testimony that photograph, like all social production, is not merely the vessel, but is itself constitutive, of ideology.

"All art," wrote George Orwell, "is propaganda, but not all propaganda is art." The radical formalist photography forged in the Soviet Union in the span of years immediately before and for several years after the Russian Revolution disclaimed all aesthetic intent and instead defined itself as instrumental in nurturing a new, collective consciousness. "Art has no place in modern life," wrote Alexander Rodchenko in the pages of *Lef* in 1928: "It will continue to exist as long as there is a mania for the romantic and as long as there are people who love beautiful lies and deception. Every modern cultured man must wage war against art as against opium." [3] Refusing the appellation of art and embracing the medium as an ideal instrument for perceptual renewal and social progress, the photographic work of Alexander Rodchenko and El Lissitzky has nonetheless come to signify more as art than as revolutionary praxis. Despite their having whole-heartedly consecrated their work as propaganda, we view them now as having been—preeminently—artists. In this *a posteriori* aesthetic recuperation is inscribed a second death of radical Russian photography: its first was effected in its native society by official suppression; its second was determined by its rapid assimilation in Western Europe and the United States—a victim, one might say, of its own success. Diffused and defused, photographic strategies invented in the service of revolution were quickly conscripted for other uses, other ideologies. It is this

latter fate that I wish to discuss here, in part because it reveals so clearly the profound mutability of photographic practice in general and in part because the fortunes of formalist photography itself provide a paradigm of aesthetic institutionalization—from the barricades to the Academy (so to speak) in less than three generations.

This particular migration is by no means limited to photography, or even formalist photography. Leo Steinberg's observation that the "rapid domestication of the outrageous is the most characteristic feature of our artistic life, and the time lapse between shock received and thanks returned gets progressively shorter"[4] fairly describes the history of radical art movements in the twentieth century; no art practice has yet proved too intractable, subversive, or resistant to be assimilated sooner or later into the cultural mainstream. Examination of the transformations that occur when a given art movement or idea traverses frontiers and oceans, as well as time, is instructive for the way it compels recognition of the essential instability of meaning in cultural production. This is nowhere more conspicuous than in the passage of photography from one society and context to another. Thus, while a historical understanding of the goals, conditions, and determining factors that produced constructivist and productivist photography can be obtained from any book on the subject, the ability to perceive a Rodchenko photograph or an El Lissitzky photomontage as their contemporaries did is lost to us as though it were centuries rather than decades separating us from their images.

The radical formalism that structured the new Soviet photography had little to do with the Anglo-American variety that propelled the photography of Alfred Stieglitz, Paul Strand, et al. toward a fully articulated modernist position, although there were common grounds in the two formalisms—shared convictions, for example, that the nature of the medium must properly determine its aesthetic and that photography must acknowledge its own specific characteristics. Deriving ultimately from Kantian aesthetics, Anglo-American formalism insisted above all on the autonomy, purity, and self-reflexivity of the work of art. As such it remained throughout its modernist permutations an essentially idealist stance. Such concepts, as well as related notions of immanence and transcendence, with the parallel construct of the promethean artist, were, however, anathema to the Russian formalists. Resolutely opposed to all metaphysical systems, the Russian literary critics who provided the theoretical basis for the movement focused their attention on a systematic investigation of the distinguishing components of literature: those elements, qualities, and characteristics that defined literature *as such*.[5] The radical nature of this critical enterprise lay in its strict materialism, impersonality, and anti-individualism, all essential aspects of constructivist and productivist practice. The key concept of *ostranenie*—the making strange of the familiar—developed by Victor Shklovsky in 1916, was conceived for literary purposes, but it had obvious applications to photography. The defamiliarization of the world effected in prose and poetry, the renewal and heightening of perception that was understood to be a primary goal of literature, had its natural analogue in the ability of the camera to represent the world in nonconventional ways. Revolutionary culture required new forms of expression as well as new definitions of art, and the camera—both film and still—and its operator served as ideal agents of this new vision.

But while the art photography simultaneously emerging in New York posited a modernist aesthetic that insisted on photography as a medium of subjectivity—even while acknowledging its mechanical attributes—radical practice in both the Soviet Union and Germany rejected absolutely the notion of the artist's function as the expression of a

privileged subjectivity. This repudiation of subjectivity, personality, and private vision was linked not only to revolutionary tenets of collectivism and utilitarianism, but also to the widespread reaction against expressionism—"a culture of mendacious stupidity," in Raoul Hausmann's assessment. One did not, in fact, require Marxist credentials to reject expressionism: futurism, de Stijl, Zurich and Berlin dada, suprematism, and of course, constructivism, all in one form or another defined their agendas in opposition to expressionist culture, for its atavism, utopianism, and emotionalism were antithetical to the critical and socially oriented art movements that emerged after World War I. Moreover, the antitechnological stance of expressionism was totally at odds with the passionate enthusiasm for technology and urbanism—all that comprised the machine-age ethos—which was to figure so prominently in both Weimar and Soviet culture.

For an artist like Alexander Rodchenko, not yet thirty at the time of the October Revolution, the internal logic of constructivism as well as the imperatives of revolutionary culture led inevitably to a repudiation of easel painting. "The crushing of all 'isms' in painting was for me the beginning of my resurrection," wrote Rodchenko in 1919. "With the funeral bells of color painting, the last 'ism' was accompanied to its grave, the lingering last hopes of love are destroyed, and I leave the house of dead truths. Not synthesis but analysis is creation."[6] A few weeks after the last "laboratory" exhibition of the Moscow constructivists in 1921 ($5 \times 5 = 25$), the twenty-five young artists, including Rodchenko (whose work was represented in the exhibition by his three "last paintings"— three painted surfaces, one red, one yellow, and one blue), renounced "pure pictorial practice" altogether, and instead embraced a wholly materialist orientation—productivism. Osip Brik, the formalist critic and theoretician closely linked to both Rodchenko and the poet Vladimir Mayakovsky, wrote yet another of the many obsequies for easel painting: "We are practitioners—and in this lies the distinctive feature of our cultural consciousness. There is no place for the easel picture in this consciousness. Its force and meaning lie in its extra-utilitarianism, in the fact that it serves no other function than 'caressing' the eye."[7] Although in part a resolution to the "crisis of images" represented on the one hand by the absolutism of Malevich's *White on White* of 1918, and on the other by the effective closure of Rodchenko's "last paintings," productivism signaled

a kind of return to the earth after the long cosmic flight of Malevitchian suprematism and the super-specialization in which nonobjective art was recklessly engaged in the years 1915–1918. In fleeing the labyrinth of extreme theorization, the productivists hoped . . . to lead art back into the heart of society.[8]

Indeed, it was precisely this intense engagement with the larger society at hand, as well as the belief that the artist must function as an active, sociopolitical being, that contrasted so dramatically with the almost ritualistically alienated stance of the expressionist artist. "The aim of the new art," wrote Ilya Ehrenburg in 1921, "is to fuse with life,"[9] and productivist texts abound with exhortations that the artist turn from the museum to the street, from the studio to the factory. Echoing Mayakovsky ("The streets our brushes/the squares our palettes") Rodchenko proclaimed:

Non-objective painting has left the Museums; non-objective painting is the street itself, the squares, the towns and the whole world. The art of the future will not be the cozy decoration of family homes. It will be just as indispensable as 48-storey skyscrapers, mighty bridges, wireless, aeronautics and submarines which will be transformed into art.[10]

The productivists' stance was thus not so much anti-art, their more excited polemics notwithstanding, as it was opposed to the ghettoization of art as an activity of the privileged few for the production of luxury items. With the renunciation of easel painting, Rodchenko turned his attention to the range of materials, technologies, and practices that collectively constituted a reconciliation of creative energies with the felt needs of Soviet society. These activities were, perforce, those that existed in the public sphere: the design of exhibitions and pavilions (including the Worker's Club for the Soviet Pavilion at the 1925 Paris *Exposition des Arts Decoratifs,* which introduced the work of the Russian avantgarde to western Europe), furniture, textile, theater, typographic and graphic design, including posters, book covers, and advertising,[11] and, from 1924 on, photography.

Rodchenko's photography drew equally from notions derived from the formalist circle, presumably through people such as Brik and Sergei Tretiakoff, and from the precepts of productivism itself. Of the former influence, the concept of defamiliarization has already been cited. Additionally, Roman Jakobson's concept of the "laying bare of the device"—the inclusion within the work of art of those material or formal elements that reveal its construction—was readily assimilable to a new photography practice. Much of Rodchenko's most innovative photography from the 1920s is notable for its refusal of "naturalized," conventionalized viewpoints, the insistence that it was a camera lens and not a window pane that yielded the image. Worm's-eye, bird's-eye, oblique, or vertiginous perspectives relate not only to a strategy of defamiliarization, but also to an affirmation of the apparatus itself as the agent of this vision. Making the point even more emphatically are photographs by Rodchenko, such as *Chauffeur—Karelia 1933,* in which the photographer himself is contained in the image. Returning to the observation made at the beginning of this discussion—that photographic practices employed in one historical moment may have their significance altogether transformed when employed in another—it should be noted that Rodchenko's presence in the photograph has infinitely more to do with Dziga Vertov's inclusion of the filmmaking process in *The Man with the Movie Camera* than it does with Lee Friedlander's self-referencing devices.[12] What is being stressed is the manifest presence of the means of production, and an implicit rejection of the notion of the photograph as either transparent or neutral.

The productivist influences on Rodchenko's photography thus derived more from the mechanical-technical attributes of the medium than from its purely formal possibilities. The camera was obviously a fundamentally democratic instrument; it was easily mastered, produced multiple images relatively cheaply, and represented (like the airplane or the radio tower, both powerful and pervasive symbols of technological promise) speed and science, precision and modernity. Most suggestive to Rodchenko, however, was the realization that the camera performed in an aggregate, analytic way rather than in a unitary, synthetic one. Rodchenko's statement that creation was analysis, not synthesis, was based on his understanding that contemporary reality could not be apprehended in essentializing syntheses. In "Against the Synthetic Portrait, for the Snapshot" (1928), Rodchenko argued, "One has to take different shots of a subject, from different points of view and in different situations, as if one examined it in the round rather than looked through the same key-hole again and again"—a notion equally central to the practice of the cubists. Posterity's physical knowledge of the historical Lenin would be known, Rodchenko added, not by a single exemplary oil painting, but through the hundreds of photographs taken, Lenin's letters and journals, and the memoirs of his associates. Thus, Rodchenko concludes, "Don't try to capture a man in one synthetic portrait, but rather in lots of snapshots taken at different times and in different circumstances!"[13]

By the early 1930s, if not before, the photographic formalism pioneered by Rodchenko
fell increasingly under attack. Leon Trotsky himself had spearheaded the attack against
the Opoyaz group (the literary formalists) in 1925 with *Literature and Revolution.* The
laissez-faire cultural policy of the cultural commissar Lunacharsky, which had sustained
the extraordinary production of the avant-garde, did not long survive him. *Novy Lef,* in
whose pages Rodchenko's photographs and photomontage had appeared, for which he
had written, and which had published Brik and Tretiakoff, suspended publication in 1930,
and the field was eventually left to *Proletarskoe Foto* and the photographic equivalent of
socialist realism. Rodchenko, unlike many of his avant-garde companions of the revolu-
tionary period, survived Stalinism, retaining his position as dean of the metalwork faculty
at Vkhutein. In 1936, submitting to antiformalist pressure, he declared himself "willing to
abandon purely formal solutions for a photographic language that can more fully serve
(the exigencies) of socialist realism";[14] four years later he returned to easel painting. In
the space of about fifteen years, Russian formalism had passed from an officially tolerated,
if not sanctioned, art practice, conceived as a tool in the forging of revolutionary con-
sciousness, to an "elitist," "bourgeois," "decadent," and "counterrevolutionary" practice
that condemned those who employed it to exile, silence, repudiation, or death.

But in the few years before the photographic formalism exemplified by Rodchenko
was more or less effectively exterminated in the Soviet Union, it thrived, albeit in trans-
figured form, within the photographic culture of Weimar Germany. The diagonal compo-
sitions, suppressed horizons, tipped perspectives, bird's-eye and worm's-eye views, serial
portraits, extreme close-up portraits, and various technical experiments with the medium
had become, by 1930, relative commonplaces in that range of German photographic prac-
tice encompassing the popular press, advertising, photographic books, and exhibitions, as
well as the work of the photographic avant-garde. While much of this photographic ac-
tivity tends to be unreflectively clumped within general categories such as the Neue Sach-

Martin Munkacsi, *A Field
Full of Children, Kissingen,
Germany*, 1929 (Collection,
San Francisco Museum of
Modern Art)

lichkeit or the New Vision (so-called by Moholy-Nagy), I am here concerned with that photography which had most thoroughly been informed by the Russian model. And while in the cultural crucible of Weimar Germany it is difficult to disentangle the skeins of influence, the various forces that acted upon each other and cumulatively formed the *fotokultur* acknowledged by the late 1920s, it is nonetheless clear that the 1922 Soviet Art exhibition that took place in Berlin had an immense—and immediate—influence. For the German left, still in disarray after the abortive 1918 revolution, the range of Russian art therein represented was greeted as a frontline communiqué of vanguard practice. To the twenty-seven-year-old Moholy-Nagy, an exile from the Hungarian White Terror (as were his compatriots George Lukács and Belá Balazs) then painting in a dadaist/abstract-geometrical vein, the constructivist work in the exhibition struck with the force of revelation. Reporting on the show for *MA* (Today), the Hungarian futurist publication, Moholy wrote: "This is our century . . . technology, machine, Socialism . . . Constructivism is pure substance. It is not confined to the picture frame and pedestal. It expands into industry and architecture, into objects and relationships. Construction is the socialism of vision."[15]

In terms of photography and photomontage, it was El Lissitzky who was most active in disseminating the new formalist photography. Through the trilingual magazine *Veshch/Gegenstand/Objet,* which he published with Ehrenburg, as well as his organization and design of such exhibitions as the extraordinary Cologne *Pressa,* Russian formalist photography was siphoned into the pluralist brew of German photography. Any precise tracing of the course of the formalist photography theorized and practiced by Rodchenko and El Lissitzy as it was assimilated into German photography must await closer study. But bearing in mind that the function and ideology of such photography were integrally bound together, one can begin to distinguish important divergences by the time the New Vision photography became a dominant force.

With the earliest introduction of Russian experimental photography, which is generally dated to the early 1920s, German photography was divided among the pictorialism of the camera clubs, the rapid expansion of photography in the illustrated press and advertising (a function of new developments in camera technology, for example, smaller cameras and faster film), and the use of photomontage by the left avant-garde (Raoul Hausmann, Hannah Hoch, John Heartfield, George Grosz, and others). Throughout the 1920s, German photography was in effect cross-fertilized by radical Russian photography, so that by 1929 and the Deutsche Werkebund *Film und Foto* exhibition—a veritable *summa* of the New Vision—various constitutive elements of Soviet work had been absorbed and, depending on the particular practice involved, transfigured. Essentially, the formalism imported into Weimar Germany became splintered into different, occasionally overlapping, components. Thus, for example, the use of a vertical rather than horizontal perspective, which was for Rodchenko one particular optical strategy of *ostranenie*—an implicitly political notion—was widely employed in Germany. There it signified, among other things, the modernity, urbanism, and technological glamour of elevators, skyscrapers, airplanes, and cranes. "We all felt a demonstrative enthusiasm for lifts, jazz and radio towers,"[16] wrote Hans Joachim in 1930, and, of course, some of Moholy's best-known photographs from the 1920s were aerial views shot from the Berlin radio tower. For Rodchenko, who had also made aerial photographs from the Moscow radio tower, the tower itself was "a symbol of collective effort."

Indeed, the entire repertoire of Russian formalist photography was intended as the optical analogue to revolution—quite simply a revolutionizing of perception to accord

with the demands of a revolutionary society. Although the romance of technology and urbanism was fully a part of the Soviet culture, it was, at least in the early 1920s, closer to wishful thinking than reality; this was, after all, a barely industrialized society devastated by revolution, civil war, and foreign invasion, that required the services of Armand Hammer to manufacture its pencils.

The formal innovations of Russian photography were nowhere more thoroughly grasped or intensively exploited than in the burgeoning and sophisticated German advertising industry. In his important essay on the photography of the Neue Sachlichkeit, Herbert Molderings discussed the implications of this phenomenon:

If we consider the "new vision" in the context of its economic and social functions, what the historical content of the "new realism" is, becomes clear. Along with heavy industry, the machine which was its substratum and the new architecture which was its result, "neo-realist" photography discovered the world of industrial products, and showed itself as a component of the aesthetic of commodities in a double sense, affecting both production and distribution. Such photographers as Burchartz, Renger-Patzsch, Gorny, Zielke, Biermann and Finsler discovered that an industrial product develops its own particular aesthetic only when the serial principle, as the general basis of manufacture, becomes pronouncedly visible.[17]

It requires but a single intermediary (photographic) step to the commodity fetish:

Commodities also came to be shown from a different point of view, directly linked with the needs of advertising. The development of *Sachfotographie*—the photographing of individual objects—is recognized as an important achievement of photography in the twenties. . . . Objects hitherto regarded as without significance are made "interesting" and surprising by multiple exploitation of the camera's technical possibilities, unusual perspectives, close-ups and deceptive partial views. . . . The advertising value of such photographs consists precisely in the fact that the objects are not presented functionally and contain a promise of mysterious meaning over and beyond their use-value: they take on a bizarre unexpected appearance suggesting that they live lives of their own, independent of human beings. More than all the fauvist, cubist, and expressionist paintings, it was applied photography which modified and renewed the centuries-old genre of the still-life from the bottom up. It created the actual still-life of the twentieth century: pictorial expression of commodity fetishism.[18]

In the work of Albert Renger-Patzsch (preeminently the photographs contained in the 1928 *Die Welt ist Schön*), elements that are coeval, if not derived from Russian formalism, are collapsed into the older, Kantian conception: the belief that governing laws of form underlay all the manifestations of nature, as well as the works of man, and that the revelation of these structures yields both significance and beauty. Thus, on the one hand, images of machinery, modern building materials, architecture, textures, and details, photographed to reveal "that it is possible to regard a machine or an industrial plant as no less beautiful than nature or a work of art";[19] on the other hand, images of landscape, animals, and people, photographed to display and underline "that which is typical of the species."[20] The nature of this enterprise is not only essentializing but symbolic, a point made with some emphasis by Carl Georg Heise, who wrote the preface to *Die Welt ist Schön*:

They [Renger-Patzsch's finest photographs] . . . are true symbols. Nevertheless we should not forget that it is basically nature and created life itself which bears within it symbolic power of this kind, and that the work of the photographer does not create symbols but merely makes them visible! . . . The last picture is of a woman's hands, raised, laid lightly over one another. Who can fail to recognize the symbolic character of this picture which speaks with an insistence far more powerful than words![21]

Hein Gorny, Untitled, c. 1928
(Collection, San Francisco
Museum of Modern Art)

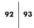

László Moholy-Nagy, *From
the Radio Tower, Berlin*, 1928
(Collection, The Museum of
Modern Art, New York)

Walter Benjamin immediately grasped the implications of Renger-Patzsch's photography and was concerned to distinguish it from both progressive avant-garde practice as exemplified by Moholy-Nagy and from the work of Sander, Blossfeld, or Krull:

Where photography takes itself out of context, severing the connections illustrated by Sander, Blossfeld or Germaine Krull, where it frees itself from physiognomic, political and scientific interest, then it becomes *creative*. The lens now looks for interesting juxtapositions; photography turns into a sort of arty journalism. . . . The more far-reaching the crisis of the present social order, the more rigidly its individual components are locked together in their death struggle, the more has the creative—in its deepest essence a sport, by contradiction out of imitation—become a fetish, whose lineaments live only in the fitful illumination of changing fashion. The creative in photography is its capitulation to fashion. *The world is beautiful*—that is its watchword. Therein is unmasked the posture of a photography that can endow any soup can with cosmic significance but cannot grasp a single one of the human connexions in which it exists, even where most far-fetched subjects are more concerned with saleability than with insight.[22]

It was, however, in the Bauhaus that all the myriad facets of formalist photography were systematically appropriated, theorized, and repositioned with respect to the range of practice and application that functioned pedagogically, artistically, and commercially. In much the same way that Weimar Germany itself was a cultural transmission station, the Bauhaus in its various incarnations, and through its influential propagandists and productions (exhibitions, books, product design, architecture, typography, etc.) was a powerful cultural disseminating force. With respect to photography, it is Moholy who is the crucial figure, even though photography was only taught as a separate course in the Bauhaus in 1929, and then not by Moholy, but by Walter Peterhans.

Moholy had become friends with El Lissitzky in 1921, a year that witnessed the Russian influx into Berlin: Mayakovsky, Osip and Lily Brik, Ilya Ehrenburg, as well as artists like Pevsner, Gabo, and Kandinski (hired to teach at the Bauhaus), who although opposed in various ways to the productivist wing were nonetheless the standard-bearers of the new Soviet art. By the following year, Moholy was making photograms with his wife Lucia and producing photomontages. He was also independently repeating much of the same theoretical program as the productivists. Thus, in 1922, the year of his one-man show at the Sturm gallery, he included a group of elementarist compositions, which like Rodchenko's last paintings signaled not only a rejection of easel painting and its accompanying ethos of originality and subjectivity, but also the positive embrace of mechanical methods of production. Moholy described his project in strictly matter-of-fact terms:

In 1922 I ordered by telephone from a sign factory five paintings in porcelain enamel. I had the factory's colour chart before me and I sketched my paintings on graph paper. At the other end of the telephone the factory supervisor had the same kind of paper divided into squares. He took down the dictated shapes in the correct position.[23]

The following spring, Walter Gropius, the director of the Bauhaus, hired Moholy to become an instructor in the metalwork shop, making him the exact counterpart of Rodchenko at Vkhutein. Moholy's arrival signified one of the first decisive shifts within the Bauhaus away from the earlier expressionist, utopian orientation aptly symbolized by Lionel Feininger's woodcut logo for the prospectus (a Gothic cathedral), under which Gropius proclaimed, "Architects, sculptors, painters, we must all go back to the crafts." The atmosphere of the Weimar Bauhaus prior to the departure of Johannes Itten was almost the exact opposite of the functionalism and technologism associated with its later attitudes. The emphasis on crafts and artisanal methods of production in the curriculum was accompanied by vegetarianism, a vogue for oriental religions, and the occasional tenure of

94 | 95

itinerant crackpots. Although consecutively expelled from the cities of Weimar, Dessau, and finally Berlin and considered by the more conservative elements of local governments to be a very hotbed of bolshevism, the radical left tended to view the Bauhaus program with a certain amount of contempt. The evaluation of *Starba,* the leading Czechoslovakian architectural periodical, was not atypical:

Unfortunately, the Bauhaus is not consistent as a school for architecture as long as it is still concerned with the question of applied arts or "art" as such. Any art school, no matter how good, can today be only an anachronism and nonsense. . . . If Gropius wants his school to fight against dilettantism in the arts, if he assumes the machine to be the modern means of production, if he admits the division of labor, why does he suppose a knowledge of crafts to be essential for industrial manufacture? Craftsmanship and industry have a fundamentally different approach, theoretically as well as practically. Today, the crafts are nothing but a luxury, supported by the bourgeoisie with their individualism and snobbery and their purely decorative point of view. Like any other art school, the Bauhaus is incapable of improving industrial production; at the most it might provide new impulses." [24]

By 1923, however, the Bauhaus had undergone a fairly substantial change of direction. No longer "A Cathedral of Socialism," but rather, "Art and Technology—-A New Unity," was the credo. Notwithstanding the fact that the important international journals such as *De Stijl* and *L'Esprit Nouveau* still considered the Bauhaus too individualistic, decorative, and arty, Gropius was resolved to make the Bauhaus a force in architecture, industrial design, and contemporary art. The change of direction and the implementation of

Gropius's ideas became fully established only after the Bauhaus's expulsion from Weimar and its reestablishment in Dessau, housed in the landmark buildings that Gropius himself had designed.

Given Moholy's patron-saint status in the history of modern photography, and his undeniable importance in the dissemination of his particular variety of formalism, it is important to remember that Moholy never thought of himself as a photographer—certainly never referred to himself as such—and that much of his enthusiasm for photography was predicated (at least in the 1920s) on his conviction that the machine age demanded machine-age art: functional, impersonal, rational. Formalism for Moholy signified above all the absolute primacy of the material, the medium itself. Thus if photography, and indeed a photographic processes including film, was defined by its physical properties—the action of light on a light-sensitive emulsion—formalism could be distilled into a bare-bones recipe for the creation of exemplary works. Written out of this equation was not only any notion of a privileged subjectivity (in keeping with progressive avant-garde theory), but even the camera itself: "It must be stressed that the essential tool of photographic procedure is not the camera but the light-sensitive layer." [25]

Moholy's codification of the eight varieties of photographic seeing in his 1925 Bauhaus book *Painting, Photography, Film* indicates to what degree his assimilation of Russian formalist photography tended toward a more purely theoretical and abstract rather than instrumental or agitational conception of "camera vision":

1. Abstract seeing by means of direct records of forms produced by light; the photogram . . .
2. Exact seeing by means of the fixation of the appearance of things: reportage.
3. Rapid seeing by means of the fixation of movement in the shortest possible time: snapshots.
4. Rapid seeing by means of the fixation of movements spread over a period of time . . .
5. Intensified seeing by means of: (a) micro-photography; (b) filter-photography . . .
6. Penetrative photography by means of X-rays: radiography . . .
7. Simultaneous seeing by means of transparent superimposition: the future process of automatic photomontage.
8. Distorted seeing . . . [26]

Whereas the technical and formal possibilities of photography were for Rodchenko, too, a wedge to prise open conventionalized and naturalized appearance, a visual device against classical representational systems, for him these constituted specific strategies in the service of larger ends. In Weimar Germany the photographic production oriented toward those ends was to be primarily that of the photomontagist John Heartfield, whose means, needless to say, were not those of the formalists. To the degree that "camera vision" became itself a fetishized concept in Weimar culture, the political implications of Russian formalist photography were sheared away from the body of New Vision photography.

Moholy's embrace of photography, like Werner Gräff's or Franz Roh's, did not in any way distinguish between the uses, intentions, and contexts of photographic production, having thus the dubious distinction of anticipating contemporary critical and curatorial practice by a good forty years. In exhibitions such as the seminal *Film und Foto* and in publications such as Roh's *Foto-Auge* or Gräff's *Es kommt der neue Fotograf!* scientific, advertising, documentary, aerial, art and experimental, even police photography, were enthusiastically thrown together into an aesthetic emporium of choice examples of camera vision. Moholy's championship of photography, like that of his contemporaries, had finally more to do with the widespread intoxication with all things technological than it did

with a politically instrumental notion of photographic practice. The camera was privileged precisely *because* it was a machine, and camera vision was privileged because it was deemed superior to normal vision. Herein lay the total reversal of terms that had historically characterized the art versus photography debate. "The photographic camera," wrote Moholy, "can either complete or supplement our optical instrument, the eye."[27]

Within the Bauhaus scheme of things, particularly in its Dessau days, photography existed as one of a number of technologies for use in the training of designers. Throughout the 1920s Gropius sought to establish the Bauhaus as a source of production as well as ideas or designers. In 1926 a limited company was set up by Gropius with a group of businessmen and the participation of some labor unions for the commercial handling of Bauhaus designs and products. Although the *politique* of the later Bauhaus remained collectivist, anti-individualist, and of course, emphatically functionalist, these were not necessarily radical positions within the political spectrum of the Weimar Republic. Moreover, the Bauhaus Idea—it was referred to as such at the time—envisioned a society made better through the works of the architects, designers, and craftsmen it produced. This, then, was the legacy that Moholy carried when he resurrected the New Bauhaus on the distinctly American terrain of the city of Chicago.

Within his own career Moholy had traveled from the pronouncedly avant-gardist, revolutionary milieu of the *MA* group, and later, the constructivist circle around El Lissitzky, to that of an emigré artist and educator whose activities between 1937 and his death in 1946 were dominated by his efforts to reconstitute the Bauhaus and the values it represented in a time and place light years removed from the culture and politics of Weimar Germany.[28] The contradictions that *Starba* had identified in the Weimar Bauhaus between the demands of industry and the conditions of craft, between the different assumptions governing the production of art and the practice of applied arts, remained problematic in the American version. These contradictions underlie the conflicts that seem regularly to have arisen between the expectations and assumptions of the New Bauhaus's initial sponsors (The Chicago Association of Arts and Industries, a consortium of businessmen, and Walter Paepcke, who was one of the principal supporters of the school until 1946) and Moholy's determination to transplant the Bauhaus Idea with as little compromise as possible. Similarly, these contradictions surfaced with every subsequent change of director, staff, enrollment, and student profile. While the curriculum of the I.D. remained basically comparable to its earlier German version (e.g., the first year foundation course, the experimentation with various media, etc.), the nature of photographic teaching (and practice) became in time a distinct and discrete aspect of the I.D. whose function was less linked to the imperatives of the industrial age than it was to those notions of art production that had preceded the establishment of the I.D. in America by twenty years. Added to that was the fact that America after the Second World War was hardly a hospitable environment in which to transplant even the *bien-pensant* leftism of the Dessau Bauhaus, and that American artists and photographers were in the process of implicitly or explicitly repudiating the politically and socially oriented practice of the previous decade, whose most developed expression had been in documentary form. How then was photographic formalism understood and expressed at the I.D.? Was there, we might ask, a new inflection to formalism which made it substantially different from its earlier incarnations and might be seen to link Arthur Siegel, Harry Callahan, and Aaron Siskind? And what, if anything, made the I.D.-based formalist practice similar to, or different from, the indigenous American variety—that is, purist, straight photography—exemplified by Paul Strand after 1915 and the f/64 group in the following years?

Reflecting back on the various sea changes to which Russian photography had been subjected in Germany, what seems most conspicuous was the tendency to separate out various components of radical formalism and to factor them into different discursive functions: seriality, unusual close-ups, and graphic presentation of the object were, as we have seen, promptly assimilated to advertising photography; defamiliarizing tactics such as unconventional viewpoints and the flattening and abstracting of pictorial space all became part of a stylistic lexicon available to commercial photographers, art photographers, designers, and photojournalists—a lexicon, it should be added, that had assimilated surrealist elements as well. In a general way, formalism had become a stylistic notion rather than an instrumental one, an archive of picture-making strategies that intersected with a widely dispersed, heroicized concept of camera vision. In the work of Bauhaus and Bauhaus-influenced photographers, one of the most durable legacies of Russian photography was the continued emphasis placed on experimentation. It was this latter characteristic that made I.D. photography rather different from American art photography of the 1950s and 1960s. Whether through the encouragement of color photography or through the various workshop exercises utilizing photograms, light modulators, multiple negatives, photo-etching, collage, and so on, I.D. photography encompassed a broad range of photographic technologies and experimentation that distinguished it somewhat from the dominant purist notions of East and West Coast art photography.

By the early 1950s, as the I.D. became more firmly established and as the photography program gradually took pride of place in the curriculum—becoming, in fact, its principal attraction—the native circumstances and conditions of American photography were themselves acting on the I.D. For Moholy, the pedagogical system of the I.D. was conceived literally as a training program, a vocational system that would prepare designers, architects, and photographers to go into the world and in some vague, utopian sense transform it. The enormously gifted Herbert Bayer, designing exhibitions, books, posters, and typography, employed by Walter Paepcke on the advertising series "Great Ideas Of Western Man" for the Container Corporation of America, was the very model of what Moholy intended his alumni to become and accomplish. But after the initial influx of G.I. Bill students who studied at the I.D. with the expectation of working as commercial photographers or professional photojournalists, the gulf between commercial or applied photography and the progressively rarified approach to photography coming out of the I.D. widened. And although Arthur Siegel (who had been one of the first photography teachers hired by Moholy) moved back and forth between professional photojournalism, teaching stints, and his personal work throughout his career, this was to prove more the exception than the rule.

What eventually emerged from the I.D. as model careers for serious photographers were those of Henry Holmes Smith, Harry Callahan, and Aaron Siskind; that is to say, teachers of future generations of art photographers who would themselves end up teaching photography and, to a greater or lesser extent, pursuing their own photographic destinies within an expanding university and art school network. This alone would have constituted a significant shift away from the Bauhaus Idea, inasmuch as up to that point the *raison d'être* of the institution was the implementation of its program in the world of industry, design, and manufacturing. Indeed, the very notion of the artist-photographer producing images for a knowledgeable or peer audience was essentially at odds with the dynamic, public, and functionalist concept of photography sanctioned by the German Bauhaus.

Aaron Siskind, *San Luis Potosi,*
Mexico, 1961 (Permission of
the Visual Studies Workshop)

Between 1946—the year of Moholy's death—and 1951, when Harry Callahan hired Aaron Siskind, the assumptions and principles governing photographic production at the I.D. were already being inflected and altered as much by the American cultural climate as by the rather different goals and ideas of the American staff hired by Moholy. Arthur Siegel, who ran the photography department between Moholy's death and 1949, was in certain respects the transitional figure, having one foot in the Moholy camp and the other in a subjectivized, privatized approach to the medium. Published statements by Siegel are such a jumble of the two approaches that it is difficult to distill what he actually meant. Here, for example, is Siegel on his first tenure at the I.D.:

My job, develop a four-year course of study for photographers. (With the help and hindrance of many students and teachers, I tried to weave the threads of European experimental and painting-oriented photography into the American straight technique of object transformation.) This attitude became a web of problems, history, and technique that, together with the whole environment of the school, provided an atmosphere for the gradually unfolding enrichment of the creative photographer. . . . Harry Callahan and Aaron Siskind carry on the rich teaching tradition that I inherited from Moholy-Nagy, Kepes, and others. . . . For if the fifties of photography had lyrical songs, part of the notes originated at the Institute of Design.[29]

Although it is difficult to pinpoint precisely when the nominally formalist framework of the I.D. came to incorporate that very subjectivity which had been previously excoriated,

Kenneth Josephson, *Season's Greetings,* 1963 (Collection, The Museum of Modern Art, New York)

Siegel's "personal" work as well as his statements suggest that this shift in emphasis was well in place by the end of the 1940s. It is worth mentioning too that in Siegel's work one finds technical experimentation with the medium coupled with a rather ghastly self-expressive intent, illustrated by projects such as the series of color photographs made in 1951 collectively entitled *In Search of Myself* and undertaken, as John Grimes indicates, at the suggestion of Siegel's psychoanalyst.

Harry Callahan's arrival at the I.D. in 1946 (hired by Moholy himself, shortly before his death) could only have confirmed this direction. A self-taught photographer for whom photography was, according to John Szarkowski, "a semi-religious calling" [30] and whose exposure to Ansel Adams and his work in 1941 was both revelation and epiphany ("Ansel is what freed me"), [31] Callahan was as far removed from the machine-age ethic of Bauhaus photography as anybody possibly could be. As early as 1941, with photographs such as the calligraphic study of reeds in water (*Detroit, 1941*), Callahan was single-mindedly developing a body of work that would probably have been little different had he never set foot in Chicago. Characterized by a consistent and intensely personal iconography (the fact and body of his wife and model Eleanor) and great elegance and purity of design and composition, Callahan's photography had more in common with the work of Minor White, or even Stieglitz, than it did with Moholy's. Although one could argue that certain kinds of work Callahan produced after coming to Chicago—the collages, multiple exposures, series, and superimpositions—were the result of his exposure to Moholy's ideas and the I.D. environment, some of this experimentation had in fact preceded his arrival. In any case, few would dispute that Callahan's influence on the future orientation of the I.D. photography program was immense. Beyond any consideration of the direct influence of his photographs was the fact that he came to exemplify the committed art photographer; equally aloof from marketplace or mass media, content to teach and serve his muse. "The interior shape of private experience" [32] coupled with a rigorous concern for formal values effectively constituted Callahan's approach to photography, and this, more than any of Moholy's theoretical formulations, constituted the mainstream of American art photography through the 1960s.

That a subjectivized notion of camera seeing should have come to prevail at the I.D. by the 1940s is not surprising. Reflecting on the political and cultural climate of America in the ten years following World War II, it seems inevitable that the last remaining tenet of radical formalism to have survived the ocean crossing—and I refer here to the belief that the camera was a mechanical (no quotes), objective, impersonal, and rational device fully in keeping with the imperatives of technological society—should be finally engulfed by the dominant ethos of art photography. Surely one of the significant factors shaping all noncommercial photography by the end of the decade was that certain kinds of documentary practice had become politically suspect. The influential and politically left New York Photo League was included in the Attorney General's list of subversive organizations by 1947, and many documentary photographers felt that their very subject matter made them politically vulnerable.

Discussing this period in her essay "Photography in the Fifties," Helen Gee gives a particularly suggestive example in the case of Sid Grossman, the director of the Photo League's school and an acknowledged radical:

Remaining virtually in hiding, afraid of the "knock on the door" he complained of no longer feeling free to work on the streets. He escaped as often as he could, seeking the solitude of Cape Cod. His work between 1948 and the time of his death in 1955 . . . shows a clean break, a complete change in subject matter. From the lively images of rambunctious teenagers on Coney Island beaches he moved to contemplative scenes of sea and sand in Provincetown, a change which appears to be more psychological than geographic. While an extreme example of a shift from a documentary approach to a reflective, interior response to the world, it is symbolic of a change in sensibility that affected American artists, either consciously or unconsciously, during the decade of the fifties.[33]

It is interesting in this light to return to the Szarkowski essay on Callahan, which subtly suggests that Callahan's stature as an artist was somehow reinforced by his refusal of the social documentary mode: "Activist photography in 1941 seemed new, important, and adventurous, and there was a market for it. Nevertheless, Callahan was not interested. For him, the problem was located at the point where the potentials of photography and his own private experience intersected. . . . His attitude toward this question has not changed."[34]

But well before the machinery of HUAC, McCarthyism, and the Cold War had been put in place, American art culture was shifting away from agitprop production and the Popular Front program of solidarity with the masses toward the postwar embrace of an international modernism whose legatees and avant-garde elite were the abstract expressionist painters of the New York School.[35] For many American art photographers who had in various way accommodated themselves and/or modified their work to accord with the concerns of the Depression years,[36] the later depoliticizing of American culture truly constituted a return to normalcy. The battle to legitimate photography as art had been consistently waged in terms of the camera's ability to express the subjectivity and unique personal vision of the photographer, and with the postwar valorization of individualism, detachment, and originality, art photographers returned again to their historic agenda.

It is against this background that we need to survey what, *faute de mieux,* we might consider the Callahan-Siskind "high formalist" period at the I.D., which may be said to have started in 1951 when Callahan hired Siskind after becoming head of the photography department in 1949. In an article on Chicago photography, Andy Grundberg points out that the two men "overthrew or redirected much of Moholy's emphasis,"[37] although I am inclined to think that the process had begun under Siegel, or in any case before Siskind's arrival. Grundberg further points out that

As enrollment increased and a graduate degree program was added, the New Bauhaus curriculum was de-emphasized. The preliminary course, which mimicked Moholy's original progression in the medium—from photograms to paper negatives, multiple exposures, out-of-focus images, etc.—was retained but lost some importance. Callahan and Siskind both resisted emphasizing experimental techniques (Callahan: "I didn't care anything about solarization and negative prints . . ."; Siskind: "I had no interest at all in the Bauhaus philosophy. I found all that experimentalism stuff a little uncongenial to me.").[38]

The surprise is that the tradition of technical experimentation, including the mixing of media, remained as strong as it did in the post-Moholy I.D. But inasmuch as Callahan and Siskind were for the ten-year period between 1951 and 1961 the dominant photographic influences in the school—both through their teaching and the prestige of their work—it is evident that whatever vestiges remained of the earlier concept of formalism were entirely eclipsed by the subjectivization of vision championed and practiced by both

men. It might be noted, too, that art photography of the early 1950s is exemplified by Minor White, Frederick Sommer (who spent a year at I.D. while Callahan was abroad on a grant), and Ansel Adams, and that *Aperture,* with White as its editor, was conceived in 1952.

In retrospect, Aaron Siskind seems so perfectly to represent the cultural and photographic adjustment of the period that one is tempted to say that had he not been born he might well be invented. It is not only in the fact of Siskind's shift from the social documentary work of his Photo League days to the virtual abstractions of 1944 that one sees the magnitude of the larger social transformation (Siskind, after all, continued to teach documentary photography at the I.D. for years), but in his assimilation of Clement Greenberg's doxology of modernism—the *ne plus ultra* of Anglo-American formalism—as the theory and ground of his work. "First and emphatically," wrote Siskind in his "Credo" of 1956, "I accept the flat picture surface as the primary frame of reference of the picture."[39] And two years later: "As the language or vocabulary of photography has been extended, the emphasis on meaning has shifted—shifted from what the world looks like to what we feel about the world and what we want the world to mean."[40] This interiorized, *purified* notion of art making is, of course, closely linked to notions current among the New York School artists with whom Siskind was allied both by friendship and dealer (he exhibited from 1947 to 1957 at the Charles Egan Gallery). In the same way that among abstract painters action was redirected from the political field to the field of the canvas, Siskind's arena became circumscribed. "The only other thing that I got which reassured me from the abstract expressionists," said Siskind in a 1973 interview,

is the absolute belief that this canvas is the complete total area of struggle, this is the arena, this is where the fight is taking place, the battle. Everybody believes that, but you have to really believe it and work that way. And that's why I work on a flat plane, because then you don't get references immediately to nature—the outside world—it's like drawing.[41]

What is striking about Siskind's enterprise is not simply that he produced photographs that look like miniature monochrome reproductions of Klines or Motherwells—if one believes a photograph to be like a drawing, why not?—but that the heroicizing of self-expression is so absolute as to border on the parodic. That more than an enthusiastic conversion to Greenbergian formalism was involved in Siskind's rejection of the documentary mode (a mode which in no way precludes formalist preoccupations, *vide* Walker Evans and Siskind himself) is suggested by Siskind's photographs of *writing,* and political writing at that.

I've done a lot of them [torn political posters]. You may have seen some, they're big political slogans in huge letters, put on walls, and then someone comes along and paints them out and they make these marvelous forms. . . . That goes back to 1955, but since then I've found many more and the interest has gotten more complex, in that I began to realize to some extent that they are political. I wasn't interested in the politics. . . . I was interested in the shapes and the suggestability of the shapes.[42]

It is tempting to see in the very extremity of this refusal of political meaning in the world a double displacement: first, in the effacement of the specifically political text, and second, in the conflation of abstracted form with transcendent meaning.

That the formalism espoused by Callahan or Siskind derives from aesthetics rather than criticism is obvious, and that it relates more to the mainstream currents in American art photography should be equally so. Somewhere between these two notions of for-

Barbara Blondeau, Untitled,
1971 (Permission of the Visual
Studies Workshop)

malism lies Bauhaus photography: responsive to certain aspects of revolutionary thought,
but functioning within a developed, capitalist society on the verge of fascist consolidation.

Most of what is now meant by "Chicago School" or specifically, "I.D. photography," is
the work of photographers who emerged during the 1960s (exceptions would include Art
Sinsabaugh, who graduated in the 1940s; Richard Nickel, who graduated in 1957; and
Ray Metzker, class of 1959). Neither Siskind nor Callahan seemed to have exercised direct
influence on their students' production, at least in the sense of their students' work re-
sembling their own. Rather, the influence would appear to center around the assertion—
provided as much by example as exhortation—that art photography, at its highest level,
represented the expression of a privileged subjectivity, and the use of the formal and
material properties of the medium to express that subjectivity. Given that radical formal-
ism had been launched with a blanket repudiation of such notions, there is finally very
little that remains to link Russian photography with the productions of the I.D. The
pedagogic formalism which was developed and refined throughout the 1950s and 1960s
provided I.D. photographers with certain kinds of building blocks, frameworks, struc-
tures—or, at the most trivial level, *schticks*—which, in a general sort of way, do consti-
tute a recognizable look. The emphasis on "problem solving," the concept of series,
interior framing devices, and other self-reflexive strategies, emphasis on the design ele-
ment in light and shadow and positive and negative space, dark printing, certain types of
subject matter, technical experimentation, are all identifiable aspects of I.D. formalism.
This type of work, and the precepts that inform it, have in turn been widely dissemi-
nated, largely because most art photographers end up teaching new generations of art

photographers. With the quantum leap in photographic education that occurred in the mid to late 1960s (the number of colleges teaching photography expanded from 228 in 1964 to 440 in 1967), as well as the growth of a photography marketplace, I.D. photography was further validated.

There is, of course, no fair way to generalize about the range of work made by as many (and disparate) photographers as Thomas Barrow, Linda Connor, Barbara Blondeau, William Larson, Joseph Jachna, Ray Metzker, Kenneth Josephson, Barbara Crane, Art Sinsabaugh, Joseph Sterling, Charles Swedlund, Charles Traub, Jerry Gordon, and John Wood, to name only the ones I am familiar with. I would however, venture to say that at its best, as in Josephson's *History of Photography* series, it is intelligent, witty, and interesting, and at its worst—or average, for that matter—it reveals only the predictable results of a thoroughly academicized, pedagogical notion of formalism.

And although I am compelled to admit that in comparison to what passes for formalist art photography nowadays the I.D. photographers cited above seem blazing stars in the firmament, this can only be considered as damning with faint praise. The basic issue is whether I.D. formalism, or any other, for that matter, has not become a *cul-de-sac*. The I.D. tradition of experimentation and serial work notwithstanding, what one sees over and over again is a recapitulation of various devices and strategies which exist as guarantors of sophistication and mastery, but which rarely exceed the level of academic, albeit accomplished, exercises. Inasmuch as so many of these photographers are clearly serious, intelligent, and committed to their art, I wonder at what point they may begin to question whether the concerns of art photography might extend beyond the creative or the self-reflexive? As the tumbrels for the photography boom begin to be heard in the land, as the markets that have supported post-1960s art photography begin to collapse, the body of art photography produced in the past twenty years will be subject to ever more rigorous criticism. The formalism which sustained the best work of a Callahan or a Siskind has run its course and become useless either as pedigree or infrastructure. Walter Benjamin's prescient warning on the results of the fetishizing of the creative seems as applicable to present-day art photography as it was to the photography of Renger-Patzsch and his milieu, which had, at very least, the gloss of newness.

NOTES

1 *The New Vision: Forty Years of Photography at the Institute of Design,* (Millertown, NY: Aperture, 1982), p. 10. I would like to acknowledge the great help, both bibliographic and conceptual, given me by Christopher Phillips. I would also like to thank Charles Traub for furnishing additional information on the I.D.

2 Ibid., p. 10.

3 Alexander Rodchenko, "Against the Synthetic Portrait, for the Snapshot" (1928), cited in *Russian Art of the Avant-Garde: Theory and Criticism 1902–1934,* ed. and trans. John E. Bowlt (New York: The Viking Press, 1976), p. 167.

4 "Contemporary Art and the Flight of its Public," in Leo Steinberg, *Other Criteria* (Oxford: Oxford University Press, 1979), p. 5.

5 The comparison is often drawn between the critical method of the Russian formalists and the contemporary work of the American New Critics. Addressing this correspondence, Frederic Jameson has written: "While both the American and Russian critical movements are contemporaneous with a great modernistic literature, although both arise in part in an attempt to do theoretical justice to that literature, the Formalists found themselves to be contemporaries of Mayakowsky and Khlebnikov, revolutionaries both in art and politics, whereas the most influential literary contemporaries of the American New Critics were called T. S. Eliot and Ezra Pound. This is to say that the familiar split between avant-garde art and left-wing politics was not a universal but merely a local, Anglo-American phenomenon." *The Prison House of Language* (Princeton: Princeton University Press, 1972), p. 44.

6 Alexander Rodchenko, "From the Easel to the Machine," cited in *Rodchenko and the Arts of Revolutionary Russia,* ed. David Elliott (New York: Pantheon Books, 1979), p. 8.

7 Osip Brik, "From Pictures to Textiles," in Bowlt, p. 245.

8 Andrei B. Nakov, "Le Retour au Materiau de la Vie," in *Rodchenko* (Paris: Arc 2, Musee d'Art Moderne de la Ville de Paris, 1977), n.p., my translation.

9 Cited in Bowlt, p. 152.

10 Alexander Lavrentiev, "Alexander Rodchenko," in Elliot, p. 26.

11 Discussing the advertising work produced by the artistic partnership of Mayakowsky and Rodchenko, Szymon Bojko has indicated, in effect, why this advertising practice may not be compared with the advertising industry of Weimar Germany, or the U.S.: "The need for visual advertising appeared as a result of the coexistence on the national scene of the nationalised and private sectors. The real sense of NEP advertising was not so much commercial, since there was still a scarcity of goods, but for propaganda purposes. The aim was to stress the dominating role of the nationalised commerce and services. In this way Mayakowsky understood the advertising and he wrote propaganda poems and slogans for it. . . . All Moscow was dominated by products of the partnership who signed themselves as 'advertising constructors'." Szymon Bojko, "Productivist Life," in Elliott, p. 81.

12 The influence of Dziga Vertov on Rodchenko was immense, as indeed it was on most of the radical Russian artists. Rodchendo worked with Vertov on several projects, including designing the titles for *The Man with a Movie Camera* and posters for Vertov's *Kino-Pravda.*

13 Both quotes are from Bowlt, p. 167.

14 Cited in *Rodchenko.*

15 Cited in John Willett, *Art and Politics in the Weimar Period: The New Sobriety, 1917–1933* (New York: Pantheon Books, 1978), p. 76.

16 Cited in Herbert Molderings, "Urbanism and Technological Utopianism: Thoughts on the Photography of the Neue Sachlichkeit and the Bauhaus," in *Germany: The New Photography, 1927–1933,* ed. David Mellor (London: Arts Council of Great Britain, 1978), p. 89.

17 Ibid., p. 92.

18 Ibid., p. 93.

19 Carl George Heise, preface to *Die Welt ist Schön,* in ibid., p. 9.

20 Ibid., p. 10.

21 Ibid., p. 14.

22 Walter Benjamin, "A Short History of Photography," in ibid., p. 72.

23 Cited in Reyner Banham, *Theory and Design in the First Machine Age* (Cambridge: The MIT Press, 1981), p. 313.

24 Karel Teige, cited in *Bauhaus 1919–1928,* ed. Herbert Bayer, Walter Gropius, and Ise Gropius (New York: Museum of Modern Art, 1952), p. 91.

25 László Moholy-Nagy, "Photography is the Manipulation of Light," reprinted in Andreas Haus, *Moholy-Nagy: Photographs and Photograms* (New York: Pantheon Books, 1980), p. 47.

26 Cited in *The New Vision,* pp. 16–17.

27 Moholy-Nagy, *Painting, Photography, Film,* (Cambridge: The MIT Press, 1969), p. 28, originally published as *Malerai, Fotographie, Film,* Vol. 8, Bauhausbuchen. For a suggestive and provocative discussion of the implications of the prevalent view of the camera as supplement to optical vision, see Rosalind Krauss, "Jump Over the Bauhaus," *October* 15 (Winter 1980).

28 Between Moholy's departure from the Bauhaus in 1928 and his appointment as director of the New Bauhaus in Chicago, it seems probable that his politics, ambitions, and art practice were all variously transformed. In Amsterdam, where he initially emigrated in 1934, he worked primarily as an advertising photographer and a design consultant. Supported by Sir Herbert Read, he moved to London the following year, where he designed window displays for Simpson's of Piccadilly and worked as a graphic designer for British Royal Airlines and London Transport. He also designed the (never used) light decoration for Alexander Korda's film *The Shape of Things to Come* and produced three photographically illustrated books.

29 Arthur Siegel, "Photography Is," *Aperture* 9:2 (1961), n.p. This special issue, "Five Photography Students from the Institute of Design, Illinois Institute of Technology," contained portfolios by Ken Josephson, Joseph Sterling, Charles Swedlund, Ray K. Metzker, and Joseph Jachna.

30 *Harry Callahan,* edited with an introduction by John Szarkowski (Millerton, NY: Aperture in association with the Museum of Modern Art, 1976), p. 12.

31 Ibid., p. 11.

32 Ibid.

33 Helen Gee, *Photography of the Fifties: An American Perspective* (Tucson: The Center for Creative Photography, 1980), p. 5.

34 Szarkowski, p. 9.

35 For a detailed discussion of the de-Marxification of the American intelligentsia, and the rapprochement of the abstract expressionist program with postwar liberalism, see Serge Guilbaut's "The New Adventures of the Avant-Garde in America," *October* 15 (Winter 1980).

36 I am thinking here, for example, of Walker Evans's two-year association with the FSA, Berenice Abbott's WPA-funded documentation of *Changing New York,* and Paul Strand's involvement with Frontier Films.

37 Andy Grundberg, "Photography, Chicago, Moholy, and After," *Art in America* 64:5 (September–October 1976), p. 34.

38 Ibid., p. 35.

39 Aaron Siskind, "Credo," in *Photographers on Photography,* ed. Nathan Lyons (New York: Prentice-Hall, 1966), p. 98.

40 Aaron Siskind, from "Photography as an Art Form," an unpublished lecture delivered at the Art Institute of Chicago (Nov. 7, 1958), printed in Lyons, p. 96.

41 Aaron Siskind, "Thoughts and Reflections," interview in *Afterimage* 1:6 (March 1973), p. 2.

42 Ibid.

W h a t B e c o m e s A L e g e n d M o s t :
T h e S h o r t , S a d C a r e e r o f D i a n e A r b u s

Meanwhile, please get me permissions, both posh and sordid. . . . The more the merrier. We can't tell in advance where the most will be. I can only get photographs by photographing. I will go anywhere.[1]

Diane Arbus to
***Esquire,* 1959**

If history weighs like a nightmare on the brains of the living, it's only natural that the living try to shake off sleep altogether. Or so I explain what a young photographer told me, not very long ago, about his work—large color pictures of the inhabitants of one of Southern California's rural ghettos. His photographs, in my reading, were resolutely beautiful, obsessively formalistic, and, despite the titillated inclusion of those physical and psychological problems which the poor cannot afford to conceal, uninformative.

Which I said, awkwardly, confusing diplomacy with verbiage.

"Well," he retorted, "other people want to know what a white middle-class kid like me is doing ripping off his subjects."

"What do you tell them?" I asked.

"I photograph them *because* they're weird. They're not like me. And if you're thinking that I'm as bad as Diane Arbus, I'm not. She fucked people like that. I don't."

I laughed—as much at the effort to combat guilt with photo history as at finding myself conned into the moral indulgences racket. Still, the photographer's remark stayed with me, a symptom of the dilemmas of documentary photography as well as an omen of the current state of Arbus lore, of the nightmare that weighs upon the brains of those for whom the 1960s, the decade when Arbus made the photographs that made her a legend, are for all practical purposes the property of a dead generation. Guilt in search of a pedigree causes ideological hairsplitting; nightmares, Marx might also have mentioned, recur.

This particular nightmare is of a woman turned into a legend that won't turn back into history. And therefore one has to ask what the history is, and why the woman could become a legend. What was made of Diane Arbus? What is her legacy? What does she mean, this woman whom every photographer knows with the passion of fascination, or denunciation, or both at once, this woman who can be incorporated into such extraordinary rationalization, this woman said to have "redefine[d] both the normal and abnormal

in our lives," to have changed "the character of photography," to have "altered the terms of the art she practiced," to be "blessed with . . . the essential skill of an original artist"? What does she *mean,* a photographer who has become enough of a legend in nonspecialist households that her most famous photographs can sell in soft-sculpture versions on the Christmas market, that she herself might become the subject not just of an off-Broadway play, but of an MGM feature film, starring perhaps Diane Keaton, perhaps even Barbra Streisand?

Someone told me a story about an inveterate liar and I didn't know whether to believe it. It's the same with what I am about to tell you. Above all, I do not want to make you cry.[3]
Diane Arbus, 1966

Woman then stands in patriarchal culture as a signifier for the male other, bound by a symbolic order in which man can live out his phantasies and obsessions through linguistic command by imposing them on the silent image of woman still tied to her place as bearer of meaning, not maker of meaning.[4]
Laura Mulvey, 1975

The neutral outline, the biography of the woman and the artist, is easily enough traced. Diane Arbus was born in 1923 in New York City. Her father, David Nemerov, was the son of Jewish immigrants from Kiev; he would eventually own Russek's Fifth Avenue, the rather flashy fur and women's clothing store founded by his father-in-law. Arbus's childhood surroundings were affluent—large apartments on Park Avenue and Central Park West, trimmed with such requisites as servants, governesses, and summer camps. Arbus later called the scene "nouveau." She received an excellent formal education at the progressive Ethical Culture and Fieldston schools, as did her older brother, the poet Howard Nemerov, and her younger sister, René Sparkia, a sculptor of decorative plastic-topped tables, among other things. Arbus graduated from Fieldston in 1940, but chose not to attend college.[5]

In 1941 she married Allan Arbus; she was eighteen, he was twenty-three. They had met when she was thirteen and he was a pasteup boy in Russek's advertising department. It had been a romance of which the Nemerovs did not at first approve. The Arbuses would have two daughters—Doon, born in 1945, and Amy, born in 1954. In 1946, after Allan had been discharged from the army, where he received photographic training, the Arbuses began to work together in fashion photography. They started with Russek's account, the moral support of David Nemerov, and perhaps some financial backing from the Arbus family.[6] Diane Arbus conceived the approach to be taken in the photographs; Allan Arbus did the actual shooting. At first, they lived by a sort of monetary brinksmanship, but gradually they became more successful, and their work appeared in magazines such as *Seventeen, Glamour,* and *Vogue.*

Diane Arbus, who had been photographing outside the fashion business since at least 1943, grew to hate the studio routine. She quit in 1956, after bursting into tears when a dinner guest asked her to describe her day. She went to study with Alexey Brodovitch, art director of *Harper's Bazaar,* but detested his workshops. Then, in 1957, she began two years of study with the photographer Lisette Model. It proved a turning point, as well as the beginning of an intense friendship. By 1959 Arbus was taking her work to magazine editors. Between the summer of 1959 and 1960, she moved, with her two daughters, to a separate apartment; the Arbuses remained friends and divorced in 1969.[7]

In 1960 the first Arbus portfolio appeared in print: *Esquire* published six photographs, with an accompanying text, intended to reveal the extremes of New York life. Arbus was

thirty-seven. In 1961 five "eccentrics" appeared in *Harper's Bazaar,* again with a short Arbus text.[8] Arbus received Guggenheim fellowships in 1963 and 1966. A few of her photographs of "American rites, manners, and customs," as she described her Guggenheim project, were exhibited at the Philadelphia College of Art in 1966, along with those of other Guggenheim photography fellows from the years 1937 to 1965.[9]

Arbus had first shown her work to John Szarkowski, director of the photography department at New York's Museum of Modern Art, in 1962. Though he included three of her pictures in his *Recent Acquisitions* for 1965, her big break came in 1967, when Szarkowski included thirty-two of her portraits in *New Documents.* Lee Friedlander and Garry Winogrand were also included in the exhibition, but Arbus received a room of her own and most of the attention—from the *New York Times* to *Newsweek.* The latter tabbed her as a photographer of "the margins of society" and quoted a remark of hers that would become part of the lore: "Freaks were born with their trauma. They've already passed it. They're aristocrats."[10] In 1967 she also exhibited at the Fogg Museum, in Cambridge, Massachusetts.

That is the extent of Arbus's public career as an artist during her lifetime. Between 1967 and July 1971, when she committed suicide at the age of forty-eight, she neither exhibited her photographs nor published more of what might be called her personal work, though her magazine assignments continued to appear.

In July 1972 Walter Hopps included Arbus in the Venice Biennale, making her the first American photographer ever to be represented there. In October 1972 Doon Arbus published a short tribute to her mother in *Ms.* magazine.[11] Whatever Doon's good intentions in rendering such an homage, the *Ms.* text added fuel to the legend. It also provided advance publicity for the MoMA retrospective which would open that November and for the accompanying Aperture monograph, edited by Doon and Marvin Israel, former art director of *Harper's Bazaar* and a close friend of Diane Arbus. The text in the monograph consisted of Arbus's own words, drawn from a highly edited version of a master class she taught at Westbeth in 1971, with a few inserts from a 1969 interview with Studs Terkel.[12]

More than a quarter of a million people saw the Arbus retrospective—*before* it left MoMA to tour the United States, Canada, Japan, Australia, and New Zealand, from whence it returned in 1979, having been installed in a total of forty-three museums and galleries. The monograph has sold over a hundred thousand copies and is now in its tenth edition; the retrospective was discussed everywhere, with varying degrees of acumen and information.[13]

In 1974 Marvin Israel published a one-page homage to Arbus that added the memories of another intimate to the legend. By the following year, critical attention had begun to subside in volume. In 1975, then, for all practical purposes, the cult was running on highly edited evidence: the tributes by Doon Arbus and Marvin Israel, the 112 prints shown in the MoMA retrospective, of which 39 were printed posthumously, and, for the real addicts, those early *Esquire* and *Harper's* portfolios.[14]

In 1977 the Helios Gallery in New York mounted a show of 108 Arbus photographs. Most were the classics from the MoMA retrospective; on public view for the first time, however, were many early photographs: smaller 35 mm. images that had preceded the trademark 2¼ inch negatives enlarged to 16 by 20 inches; a Coney Island series from 1958–60; a series on female impersonators from 1962; and photographs of a Southern country doctor and his patients commissioned by *Esquire* in 1968. In 1980 *Picture Magazine* devoted an entire issue to seventeen Arbus photographs, which the editors claimed, inac-

curately, had hitherto been unpublished. The issue coincided with exhibitions at the Robert Miller Gallery, New York, and the Fraenkel Gallery, San Francisco. No text whatsoever accompanied the photographs, a renunciation of critical pretensions which the editors explained away as gracefully as possible: "Since PICTURE is primarily concerned with the photographic image and the fidelity of its reproduction, we have acceded to the preference of the Estate of Diane Arbus that this monograph be published without accompanying text."[15]

In 1984 appeared two large, if not major in the ideal sense of the term, books on Arbus. Patricia Bosworth's *Diane Arbus* is the unauthorized biography. *Diane Arbus: Magazine Work,* edited by Doon Arbus and Marvin Israel, with text by Thomas Southall, is a sanctioned version of one aspect of Arbus's career. (I should say here that Thomas Southall, in his acknowledgments, generously thanks me for my help, which consisted of discussing with him the existence of correspondence between Arbus and Peter Crookston.) Southall's book serves as the catalogue for an exhibition of ninety-two prints which will travel to fourteen cities in the United States. The Arbus legend still holds sway: the catalogue had to be reprinted, due to popular demand, even in its prepublication stage.[16]

Clearly, it's difficult to preserve an entirely objective tone, and I haven't explained what all the fuss is about, much less what Diane Arbus might *mean.*

I think I have a slight corner on something about the quality of things. It's very subtle, and I don't know if it's world shaking, but it's just I guess I've always had a terrific conceit, and one of my conceits is that when I was young I used to think that I was kind of . . . not a lodestone exactly . . . more like that I was the perfect temperature, the perfect thermometer for the times.[17]
Diane Arbus, 1969

The preoccupation with the individual artist is symptomatic of the work accomplished in art history—the production of an artistic subject for works of art. The subject constructed from the art work is then posited as the exclusive source of meaning—i.e., of 'art', and the effect of this is to remove 'art' from historical or textual analysis by representing it solely as the 'expression' of the creative personality of the artist. Art is therefore neither public, social, nor a product of work. Art and the artist become reflexive, mystically bound into an unbreakable circuit which produces the artist as the subject of the art work and the art work as the means of contemplative access to that subject's 'transcendent' and creative subjectivity.[18]
Griselda Pollock, 1980

Patricia Bosworth is as convenient an entry point as any. Having previously "done" Montgomery Clift, she is now cashing in on another haunted soul. She covers not even everything I have summarized thus far, at much greater length. Aurelia Plath could have produced this biography, had she not found another calling: it is a dreadful book—badly written, sloppily edited, interminable. Bosworth had no inkling of the rationale for documented sources, no ideas about biography, no discernible notion of why anyone might want to read a biography of an artist, nothing but a nodding acquaintance with the history of photography, and no grasp of historiography, which is, after all, the basic issue here. Five years of interviews have spawned this breathless accretion of facts, laced with so many dubious facts, or pointless facts, that even the verifiable facts, to say nothing of the important facts, become tarnished. Unfortunately, so few "facts" on Arbus have been released—the photographs having been left to speak for themselves (which photographs are celebrated for doing badly)—that this book will doubtless sate the appetite of the curious and the careless.

As I said, it is difficult to remain neutral, but then my objective is history, not neutral-ity, and they are not to be confused. A coward about nightmares, I dissect the Bosworth book to reveal hagiography gone berserk.

Leaving aside the more complicated issues of methodology, Bosworth's job as a biogra-pher was to inform herself, as broadly as possible, about Diane Arbus's life, working envi-ronment, and family background. She did not succeed, although this was not entirely her fault. She seems to have read some but not all of the printed material on Arbus; one can't really tell, for the book has no bibliography.[19] She interviewed or corresponded with, she says, about two hundred people, but she had little help from Lisette Model and none at all from Allan, Doon and Amy Arbus, Richard Avedon, and Marvin Israel.[20] Since these individuals were of pivotal importance in Arbus's adult life, it is not surprising that the sections on her childhood are more reliable. Bosworth did have the cooperation of Ger-trude and Howard Nemerov, Renée Sparkia, and a few key teachers at the Fieldston School.

But more reliable is not *reliable*. Bosworth's internal model of narrative prose, I sus-pect, is something like the gothic novel—an amalgam of description, dates, and dialogue that moves the hypnotized consumer down the path of vicarious pleasure to a formulaic climax. Should there be a lull in the action (due to a paucity of character motivation, or the need to plod through establishing data before getting back to twists in the romance), why, writers have their secrets: ladling on the adjectives, injecting psychological asides to win sympathy for boring but necessary personages, creating small moments of pseudo-suspense, even just skipping the dreary dates. That's the formula. Arbus's life, and art appreciation at its most syrupy, fit it perfectly.

Bosworth apparently thinks, or was told, or convinced her editors, that in the interests of eliminating pedantry from a book aimed at a "general" audience, she need only reveal the source of material framed by quotation marks. This "rule" lets her get away with a lot, for she can indulge herself in description while picking and choosing dialogue (the only thing, after all, which ever appears between quotation marks in the conventional novel).

Thus, selecting two early pages (12–13) at random, we learn, directly from Howard Nemerov, that David Nemerov was "power-using," that Howard and Diane felt "pro-tected, privileged," that they sometimes had physical fights, that Howard had no theories "as to how or why we became what we became." We learn directly from Diane Arbus that she thought her father was "something of a phony." These are the hard facts. We also learn, in quotes, from an unnamed, uncited "Nemerov cousin" (all rules, even nonrules, are made to be broken) that "Howard doted on Diane" and that she was "gorgeously intuitive," while he was "intellectual." We learn, in quotations, from an unnamed, uncited Russek's "buyer" that "If you got in David Nemerov's way, he'd walk all over you." We learn, not in quotes, but from the loquacious narrator, that David Nemerov could be both "charming" and "brutal," that Howard and Diane were inseparable, that they ate in si-lence, that Diane was once frightened by a French goat, that Howard and Diane were "obedient, well-behaved little children," that they hated being compared, that Diane's motto, which she read on a nickel and said every night at bedtime, was "In God We Trust," and that Howard was "strong and quiet and so handsome she liked to just look into his face."

Disregarding entirely the notion of *significant* facts (a goat?—even a *French* goat . . .), Bosworth has managed to sneak in some heady stuff. The information directly attribut-

able to Arbus and her brother conveys only their feeling of having been privileged children, a certain ambivalence toward their father, and Howard's reluctance to theorize about the past (or more likely, considering Nemerov's work, his distaste for facile explanation). The undocumented information, the information attributable by default to the imaginative faculties of Patricia Bosworth, conveys paternal "brutality" and a doting brother-sister couple who manifest the perfect male/female division of roles—even, in the sister's mooning, a certain physical attraction.

This is highly suggestive material, introduced by innuendo. It is the staple of Bosworth's technique, and though I have neither the space nor the stamina to analyze the entire book in such detail, I would like to outline certain problematic issues which arise from Bosworth's amateur psychologizing. Inscribed in the compilation of minutiae which constitutes this biography (the number of cats Robert Frank had, Lisette Model's lifelong devotion to her husband, Howard Nemerov's opinion of Hamilton College, Allan Arbus's knack for finding affordable Manhattan housing, Diane Arbus's penchant for ratty fur coats and *Jules et Jim* . . .) are notions of women, art, and history which should not be left unremarked. I am making these notions explicit precisely because Bosworth is *not* the only photographic commentator who abides by them. She is a grossly irresponsible writer, but the ideas she carries to excess infect most versions of photographic history, and, certainly, most interpretations of Arbus's work.

There is, to start with, the character constructed to explain how the Diane Arbus who began as the coddled daughter of *nouveau riche* Jewish parents ended as the Diane Arbus who followed transvestites home to seedy hotels and frequented nudist camps in New Jersey. Bosworth's solution has the elegance of tradition: blame the woman.

The problems were there all along. Not only did the teenage Arbus dote upon her brother, she also fantasized about committing incest with her father (p. 27; Bosworth does not reveal how she divined Arbus's desires) and wore her future husband's underwear, or so Bosworth says "the salesladies" at Russek's informed her (p. 38). ("The salesladies" remain anonymous; did Bosworth really track down more than one?) Bosworth soon observes that Arbus did not shave her legs and that, in rebellion "against her parents' preoccupations with cleanliness . . . [she] chose to wear no deodorant" (p. 39; no source is given for this data on the artist's grooming habits). Moving up to the early married years, we learn not merely about an early affair Arbus fell into and the high frequency of the Arbuses' lovemaking (p. 98; a friend's memory of something Diane Arbus had said), but that among Diane Arbus's "dark and perverse" sexual fantasies was rape (p. 94; just something Arbus once confided to another friend, unnamed this time). We learn (p. 102) that it may not after all be true that Doon was conceived on the sand dunes of East Hampton. (Why bring it up then? A little extra *frisson*? A weakness for bad puns?) Shortly before the birth of the Arbuses' second child, we learn (p. 106) that Arbus "particularly enjoyed menstruating—when her womb cramped up, when warm, wet blood coursed between her thighs." (A source for this revelation? Why bother to ask?)

We are then told about Arbus's grief when her husband fell in love with another woman (p. 153; attributed to a friend who prefers to use a pseudonym), and it is suggested that "a succession of very attractive women" seemed at home in the Arbus studio (p. 175; a neighbor's recollection). The story thus moves naturally, the forces of retribution having been deployed—after all, it was Diane Arbus who had first been unfaithful—to her haunting the subway at all hours, cultivating a "palpable" erotic rapport with a Mexican dwarf (p. 193; Bosworth's interpretation of the well-known photograph of said),

acting out her bisexuality (p. 205; the hypothesis of the filmmaker Emile de Antonio, who felt uncomfortable accompanying Arbus and two other women to the movies), concluding that one-night stands were "terrific sex" (p. 206; no source), and taking pleasure in her increasingly "aggressive" sexuality (ibid.). The saga is interspersed with chatty anecdotes about Arbus's dalliances, sexual and otherwise, with her various subjects.

In sum, Diane Arbus was weird. She may have started out as a nice Jewish girl, but it obviously takes more than family. Women, or rather this construction, "Diane Arbus," can only go so far in the quest for meaningful lives. Otherwise they end up demonstrating that they are, as it has always been said, whores. Or creatures of insatiable sexual appetites. Beings who cannot transcend the physical. Freaks.

This raises the second problematic motif in Bosworth's book: class. Because if Arbus had been just an ordinary female freak who cleaned houses, say, for a living, the story wouldn't have the same charm. Arbus was brought up to know better. Whatever her actual financial situation as an adult, therefore, she could somehow always have *afforded* to know better. From this derives a useful dramatic tension, especially in the bookselling trade: the really interesting freaks, Arbus's famous pronouncement to the contrary, aren't born with their trauma—*they create it.*

Again, this is a subtext inscribed (or, more accurately, interred) in the accretion of detail: the furs and the chauffeurs and the governesses and the piano lessons and the trips to Europe and the dancing classes and the white gloves and the psychoanalysts and the smoking jackets and the dinners and the "baroque" furniture meticulously recounted. In general, price tags are the only thing missing, though Bosworth tosses them in whenever she can.[21] It doesn't really matter. Whatever the total, it signifies money. And money, *nouveau* though it be, fascinates Bosworth. She would probably have been happier had the Nemerovs been Guggenheims, but sometimes one has to make do. Thus, even after business mistakes and the Great Depression had cost David Nemerov a considerable sum, Bosworth never fails to lavish attention on the objects with which he chose to reduce his remaining capital (e.g., a Palm Beach residence). When the budget won't stretch far enough, she simply flashes back to the good old days.

But money propels the story in contradictory ways. On the one hand, it lends color, a sort of romantic cachet, as if, this being America, high income demonstrated a spiritual predisposition to the exceptional. On the other hand, those very same dollars are used to prove an *arriviste* vulgarity, the egregious conflation of money with social rank that induces the purchase of a Rodin ashtray, crimson carpets, or reproduction of French antiques. The important thing, however, is that to Diane Arbus thereby accrue the benefits of both a white-gloves-and-governesses nature and the rejection of conspicuous-consumption nurture. One or the other of the dual impulses can be invoked when convenient, particularly since the sage operates without the benefit of an analytical framework incorporating the notion of class. ("Classy," an adjective which attaches itself with some frequency to David Nemerov, is not the same thing.)

Beyond the level of anecdote and a few paragraphs of cultural history, Bosworth ignores the economic, social, and political milieu of the Eastern European and Russian Jews who arrived in New York shortly before the turn of the century and there rose to wealth. In Bosworth's history, that class is demoted to a tribe: the Nemerovs, Arbus's Fieldston schoolmates, Richard Avedon, and Marvin Israel are virtually the only members, and their folklore is used to reinforce the preestablished struggle between the romantic and the vulgar. This set-up allows Bosworth to take the best of both possible worlds and win a

quick shortcut to real class. It works like this. Though Arbus, in crude financial terms, was downwardly mobile, her transcendence of the "humiliatingly gross kingdom"[22] she inherited meant a corresponding upward mobility of the mind—a return, if you will, to the spiritual *function* of white-gloves-and-governesses breeding. Arbus rebelled against money to become an aristocrat.

And that, in turn, would not be particularly interesting (who, really, gives a damn about impoverished nobility?) unless it meshed so perfectly with the rehashed romanticism that determines the notion of an artist to which Bosworth subscribes. In brief, great art exudes directly from the lonely souls of those endowed with a unique vision. By definition and from birth, this type of soul is cursed to the exact degree it is blessed. It's a simple exchange-value formula: if this type of soul didn't cater to society's instruction, edification, delight, and occasional enrichment, society would deem it pathological, or, if the soul wasn't lucky enough to be born into at least the middle class, ignore it. Omitted from this schema are several crucial elements: the circumstances which enable the production of art, the production of art as a form of work, and the artist as a social being.

Bosworth, in her breathless fashion, takes the romantic construction of the artist well past the point of absurdity: true aristocrats of the spirit (read "artists") must die. Adopting the strategy of classical hagiography, Bosworth goes back as far as she can to find, or invent, miracles. Always, Arbus had "longed to scrutinize the perverse, the alienated, the extreme" (p. 130; no source). When she was a toddler, she identified herself with the underdog, the outsider, seeing "herself in [small children]—isolated creatures, secretly raging" (p. 15; no source). When she encountered derelicts as a teenager, she identified "with these strange, sad people's isolation—their aloneness" (p. 30; no source). Concomitantly, she had long wanted to be a "great sad artist" (p. 51; an unfinished autobiography).

The parade of relatives, friends, acquaintances, and bystanders who serve afterwards to mirror the glare of genius reinforce the theme of Arbus's attraction to extremes, invariably remarking on her talent, brilliance, vision, and genius. Some go so far as to say she was a goddess. The spiritual virtues, laboriously compiled, overwhelm; the end, presumably the price of wanting so much, is foreshadowed with an equally heavy hand. Alexey Brodovitch admonishes Arbus that the period of creativity seldom lasts more than eight years (p. 123). A lover recalls, with emotion, that one afternoon in bed he saw Arbus's face turn into a death's-head (p. 95). Finally, we are told, in "terror over her increasing responsibilities" and "to perfect her art," Arbus cut herself off from friends and admirers (p. 311). She was "lonely, she was alone—and she would fall into despair" (p. 312). The suicide follows shortly, along with the—well, "vulgar" is the accurate word—report of a rumor that Arbus photographed herself dying.

The nominal point of this soap opera, difficult as it may be to remember, is the elucidation of an artist's career. In fact, however, the only contexts beyond the personal provided for Arbus's descent into doom are silly accounts of the New York art world and photographic history. In the former, to paraphrase one of Bosworth's more detailed renditions (p. 145), assorted abstract expressionists dance all night and play the bongos to illustrate artistic vitality and good cheer in the 1950s. In the latter, Bosworth's ignorance of photographic history is perhaps best demonstrated by quoting in its entirety the only passage which might be said to represent her theoretical overview (pp. 123–24):

Now that she was freer, Diane began a study of photography back to the world's first photograph: by Joseph Niepce, a view from the window of his blurred French garden circa 1826. [Were nineteenth-century gardens blurry, or was that the impressionists?] In time Diane would become familiar with the dreamy nineteenth-century portraiture of Julia Cameron, with Mathew Brady's documentation of Civil War battlefields. She would read about Paul Strand's switch from pictorialism to Cubist-inspired photographs in the 1920s; she would study Lewis Hine's powerful pictures of children working in coal mines. Hine's bleak images would impress her more than Stieglitz's gorgeous cloud formations. Stieglitz believed that photographs could be metaphorical equivalents of deep feelings. He also believed that the fine print, the excellently made photograph, was the criterion of a good photograph. Diane did not believe that. Which is why she responded to the work of her contemporaries Louis Faurer and Robert Frank, who were experimenting with outrageous cropping and out-of-focus imagery. But Diane was even more impressed by Lisette Model's studies of grotesques, especially the grotesques of poverty and old age which she documented with almost clinical detachment.

When needed later to liven up the facts, some of these same luminaries, joined by Weegee and Avedon, make cameo appearances and quick exits. They personalize the sort of history in which Arbus flirts with the decisive moment and then converts to the more "real" snapshot aesthetic, works in her darkroom with "trays holding strange-smelling chemical solutions" (p. 67), and makes "lovely still-lifes" (p. 120), or pictures which are metaphors for "the emptiness and pretension of her past (p. 198).

One could go on and on about Bosworth's ignorance[23] and her predilection for morbid smut. The point, however, is that the book is a closed circle. Bosworth's lack of training in either photography or conventional art history simply makes blatant the usual tautologies of the monograph *genre:* the life generates significance for the art, which is in turn referred back to the life. Unconstrained by academic etiquette, Bosworth takes the usual interpretation of Diane Arbus to its logical extremes. The photographs are "explained" by constructing Arbus herself as a freak, and their power, from which derives their value as art, is legitimated by her suicide.

Compared to this, *Diane Arbus: Magazine Work* is a relief, unmarred by adjectival hyperbole or so much as a hint of sensationalism. Quite the contrary, it is introduced by what can best be described as an apology for the sensation caused by the 1972 Aperture monograph. According to the editors, Doon Arbus and Marvin Israel, the monograph, "as a depiction of [Arbus's] career, for which is has since been held accountable, is misleading." Thus another monograph, a scholarly one this time, intended to combat the exaltation of the Arbus oeuvre as mysterious, inexplicable, introduced into the world, like Athena, fully formed. *Magazine Work,* we are told in the editor's introduction, "is about work as a process rather than a series of isolated achievements and about the evolution of a distinctive photographic style that grew out of ingenuity, eclecticism, and the simple necessity of getting the job done." Though some of Arbus's commercially produced pictures are now considered her "personal" work and were included in the MoMA retrospective— *Widow in Her Bedroom, New York City, 1963; Mother Holding Her Child, New Jersey, 1967; Brooklyn Family on Sunday Outing, 1966; Family on Lawn One Sunday, Westchester, 1968;* and *King and Queen of a Senior Citizen's Dance, N.Y.C., 1970*[24]—the goal here is to untangle the commissioned and the voluntary in order to illustrate the background for the development of the more important artistic achievements. The 1972 monograph, in Doon Arbus's and Marvin Israel's minds, contains some of her "best work." Still, the magazine photographs are "of interest in themselves, and constitute an experience that contributed a great deal to the development of her style, her technique, and the way she thought about photographs and subject matter."[25]

Despite this rather awkward separation, which Thomas Southall partially redresses in his text, *Magazine Work* is unquestionably, commendably useful. It contains more reliable information than anything yet published on Arbus, including reproductions of most of her commercially commissioned projects, a bibliography of all her published photographs, and crucial texts that were never printed (e.g., on nudists and on Hubert's Museum). Most of all, it is useful for Southall's careful, factual essay. He brings in a significant amount of primary source material, quoting extensively from Arbus material in the *Esquire* archives as well as from her correspondence with Peter Crookston, with whom she began working in 1967, when he was deputy editor of London's *Sunday Times Magazine,* and with whom she continued working after he became editor of *Nova* in 1969. Moreover, Southall uses footnotes, doesn't gush, and utters not a syllable about cursed souls. Instead, within the bounds of conventional photohistory, he tries to establish a material base for Arbus's production in the spheres of art and journalism, though obviously focusing on the latter, particularly the expectations and requirements of Arbus's editors. He traces the evolution of specific projects, and he addresses, to a limited extent, Arbus's earnings and economic requirements.

Southall argues that Arbus's entry into the magazine world of the early 1960s came exactly at the time when various publications were redefining journalism, promoting a more personal, more upbeat, catchy style to compete with the encroachments of television. It was the decade of the "New Journalism," and the search for a new image was on. Though Arbus had never before been published, Harold Hayes, assistant to the publisher of *Esquire,* was sufficiently taken with her portfolio to consider assigning her *all* the pictures for a special issue on New York. (*Esquire* backed down to the six portraits in "The Vertical Journey.") It is also an indication of the priority placed on a novel style that *Harper's Bazaar* immediately took "The Eccentrics" when *Esquire* killed the project. Arbus continued to work with these two magazines, as well as with *Show, Glamour, The New York Times Magazine, Essence, Harper's Magazine, Holiday,* and, after 1967, the London *Sunday Times Magazine* and *Nova.*

The *New Documents* exhibition in 1967 brought Arbus much attention, but with the exception of her projects for Crookston, no tangible boost in assignments. After 1969 her assignments began to decline, in part because of staff changes at various publications that eliminated the personal contacts upon which Arbus had relied. Southall, however, suggests an equally important reason:

In the early 1960s, some editors regarded Arbus as someone who could be used to gain the trust of a subject who might have been defensive when confronted by a photographer with a more established reputation. By the end of the 1960s, Arbus's style had become well known. Additionally, it certainly did not help her to have the public, potential sitters, and editors increasingly associate her work with controversial subjects.[26]

It was at this juncture that Arbus tried other ways to make money: teaching, printing a portfolio of her pictures (she sold five at $1000 apiece), applying for grants (she received none after her 1966 Guggenheim), taking on related projects (notably the preliminary research for MoMA's *Beyond the Picture Press*), and thinking, at the urging of the French publisher Robert Delpire, about doing a book.

Magazine's Work's Diane Arbus is very different from the Diane Arbus of the first monograph, to say nothing of Bosworth's Arbus—which is in no way surprising, since a correction of the myth was the explicit intention of the *Magazine Work* editors. The revised Diane Arbus is a working woman. Dramas of husband, children, separation, and

divorce do not figure in the freelance bustle. The pampered childhood is ignored; the word "suicide" is not used. Rebellion, innate perversity, the seduction of extremes, a woman's quest for sexual and personal liberation, or any other psychologistic theorizing are likewise omitted. This Diane Arbus has a job to do—hustling assignments, getting things down in writing, charming editors (and she was marvelously, wittily persuasive), compromising about ideas, arguing over money, worrying about the next project. This Diane Arbus, an unquenchable source of story leads, pursues everything from midgets to skeleton collectors with the same diligence and equanimity. For her, distinctions between art and commerce are not always functional: it helped as much to have a press pass to get to The Mystic Barber as it did to the Daughters of the American Revolution, whether or not one project brought a page fee and the other didn't.

The idea was to photograph and get the work out. Hopefully, money would thereby come in, and even if its actual arrival caused aesthetic twinges ("When I make money on a photograph I immediately assume it's not a good photograph"[27]), they hardly seem to have deterred Arbus. There is no evidence that she ever lost time worrying about whether to submit her personal work to a magazine or to an art museum. Indeed, she appears to have been supremely untroubled by combining the two spheres, as the separation was even pertinent to her, exhibition opportunities being scarce before the market boom in the late 1960s. Instead, one gets the impression from *Magazine Work* that the world lacked room enough for Arbus' boundless energy. *No* distribution mechanism could have accommodated her projects. Like all good artists of yore, this Diane Arbus is on the move, and neither she nor Southall ever paused to wonder where she is going, or why.

But the operative myth here—sober though Southall is, responsible to dates and external constraints and stylistic developments—is once again basically the notion of art as a closed system. Facts are marshaled to enhance a reputation already established, not to question or transform it. This may well be less a matter of Southall's inclinations than a happy coincidence of Aperture's publishing philosophy and the wishes of the Estate of Diane Arbus. If any one thing characterizes the former, it is the valorization of individual artistic genius by the excision of photography from meaningful political or social contexts. As to the Estate, if any one thing has been abundantly evident in the fourteen years since Arbus's death, it is the policy of maintaining strict control over scholarly, critical, or curatorial texts as a price for rights to both literary and visual material. The control has meant an artistic reputation unsullied by any substantial injections of new data or by *critical* analysis effectively backed by visual material. Even given this new monograph, what compels attention is not how much more we now know about Arbus, but how much remains to be learned. Leaving aside, for example, notes and other unpublished texts, Arbus left behind 7500 rolls of contact-printed film, as well as about 1000 *finished* prints. No more than 400 of the latter, at a charitable estimate, have been made available by the estate.[28]

In *Magazine Work* both Aperture and the Estate of Diane Arbus provide supporting information about someone already impeccably credentialed as a Great Photographer. It is not in the interest of either party to examine the credentials themselves, much less the mechanisms of certification. Thus, excellent though Southall's text is in its *genre,* the result is a new monograph that lacks any substantially new reading of Arbus's career. Ironically, this makes *Magazine Work* much duller than its subject. Precisely because the book is scholarly without confronting the act of writing history, *Magazine Work* fuels the legend without considering the circumstances which enabled the legend, without even wondering whether those old nightmares will recur.

1 Letter to Robert Benton, art director of *Esquire* (*c.* October 1959), quoted in Thomas W. Southall, "The Magazine Years: 1960–1971," in *Diane Arbus: Magazine Work,* ed. Doon Arbus and Marvin Israel (Millerton, NY: Aperture, 1984), p. 156, hereafter referred to as *Magazine Work.*

2 I quote Anonymous, the Knopf copywriter who provided the dustjacket blurb for *Diane Arbus: A Biography,* by Patricia Bosworth (New York: Knopf, 1984), and, respectively, from the dustjacket of *Magazine Work,* Peter Bunnell, Hilton Kramer, and John Szarkowski. In 1978 Esther Luttikhuizen marketed as soft sculptures both *Identical Twins* and *Prom Couple* (*New York Times,* November 20, 1978). Arbus, Marilyn Monroe, Billie Holiday, Virginia Woolf, Janis Joplin, and Sylvia Plath were the subjects of the 1974 play *Disquieting Muses* reviewed in the *New York Times,* February 21, 1974). MGM, which bought the rights to the Bosworth book, reportedly asked Diane Kurys, of *Entre Nous,* to direct the feature. See *New York Times,* January 29, 1984, and Liz Smith in the *Daily News,* June 20, 1984, for more trade gossip.

3 Diane Arbus, "Hubert's Obituary: Or This Was Where We Came In," unpublished text, 1966, *Magazine Work,* p. 80.

4 Laura Mulvey, "Visual Pleasure and Narrative Cinema," *Screen* 16:3 (Autumn 1975), p. 7.

5 Unless otherwise indicated, the information in this section is drawn from my entry for Diane Arbus in *Notable American Women: The Modern Period,* ed. Barbara Sicherman and Carol Hurd Green (Cambridge: Harvard University Press, 1980). The information about Renée Sparkia's career is taken from Bosworth, pp. 117–19.

6 Bosworth (p. 68) says that David Nemerov provided only a fraction of the equipment he had promised; she offers no documentation for the statement. In Allan Arbus's account, David Nemerov helped them enormously. (Interview with the author, September 12, 1977.) In Howard Nemerov's version, Allan Arbus "from early on after the War felt fashion photography as a burden, part entailed by his family's staking him to all that expensive equipment when he got out of the Army." (Letter to the author, October 28, 1977.)

7 Confusion remains about all these dates in the late 1950s. Bosworth dates Arbus's study with Model to 1958; Allan Arbus (ibid.) to 1959; Southall to 1957. The latter date, given Southall's access to Arbus's records, seems the most reliable. It is not clear when Diane Arbus actually moved to her own apartment. Southall doesn't mention it; Bosworth fudges it. Arbus had moved, certainly, by the early months of 1960.

8 "The Vertical Journey: Six Movements of a Moment within the Heart of the City," *Esquire* (July 1960), pp. 102–7, and "The Full Circle," *Harper's Bazaar* (November 1961), pp. 133–37, 169–73.

9 Documentation for the exhibition was provided by Allan Porter, "The John Simon Guggenheim Memorial Foundation: Fellows in Photography, 1937–1965," *Camera* (April 1966). There had been, then, a total of 30 fellows. Lest 1937 seem an arbitrary date, remember that it was the year the first Guggenheim was awarded to a photographer, who happened to be Edward Weston.

10 "Telling It As It Is," unsigned, *Newsweek* (March 20, 1967), p. 110. *Newsweek* also codified the nice-rich-girl-courts-danger motif: "I'm a little foolhardy rushing in to explore all these freaky things, but dangers of violence—rape, murder—are more moving and less frightening than making a living at fashion photography." In addition, Jacob Deschin reviewed the show for the *New York Times* (March 5, 1967); Chauncey Howell for *Women's Wear Daily* (March 2, 1967); Max Kozloff for *The Nation* (May 1, 1967); and Marion Magid for *Arts Magazine* (April 1, 1967).

11 Doon Arbus, "Diane Arbus: Photographer," *Ms.* (October 1973), pp. 43–53.

12 A transcript of the class is in the archives of the Visual Studies Workshop, Rochester, NY. The

Terkel interview (December 1969) is in the archives of WFMT, Chicago, and is quoted here courtesy of WFMT.

13 *Picture Magazine* 16 (1980), provides these statistics. Robert Stevens's "The Diane Arbus Bibliography," *Exposure* 15:3 (September 1977) is an invaluable, annotated summary of Arbus's press coverage.

14 Marvin Israel, "Diane Arbus," *Creative Camera* (May 1974), pp. 164–73. See also Peter C. Bunnell, "Diane Arbus," *Print Collectors Newsletter* 3:6 (January-February 1973), p. 130.

15 *Picture Magazine* 16 (1980). The claim of a scoop is not, strictly speaking, true: at least two of the photographs had been published in mass-circulation magazines, as opposed to the art press: though the photographs appear untitled in *Picture,* Arbus had photographed Mrs. T. Charlton Henry and Amy Arbus for *Harper's Bazaar.* See *Magazine Work,* pp. 31, 70–71.

16 Douglas Davis, "Two Faces of Arbus," *Newsweek* (October 22, 1984).

17 Terkel interview.

18 Griselda Pollock, "Artists, Mythologies and Media—Genius, Madness and Art History," *Screen* 21:3 (1980), pp. 58–59.

19 In scanning Bosworth's footnotes, I found no mention of, for example, Susan Sontag's "Freak Show," *New York Review of Books* (November 15, 1973), revised and reprinted as "America, Seen through Photographs, Darkly," in *On Photography* (New York: Farrar, Straus and Giroux, 1977), or Hollis Frampton's "Incisions in History/Segments of Eternity," *Artforum* (October 1974).

20 Bosworth cites an interview she conducted with Model, but she seems to rely mostly on an unpublished, undated interview conducted by Phillip Lopate.

21 Symptomatically, Bosworth never fails to remind us, with ghoulish precision, of lost investment opportunities in the photo print market: for example, if you'd bought a Model for $15.00 in the mid-50s, it would be worth $1000 now (p. 127).

22 Terkel interview. Arbus uses the phrase to describe Russek's, and, by implication, the entire milieu in which she grew up.

23 Anne W. Tucker, in "Arbus Through the Looking Glass," *Afterimage* 12:8 (March 1985), pp. 9–11, is quite clear about Bosworth's factual errors.

24 In addition, the nudist camp photographs were commissioned, partially paid for, and unpublished by *Esquire,* which also commissioned, and did not publish, a series that yielded *Tattooed Man at a Carnival, Albino Sword Swallower at a Carnival,* and *Girl in Her Circus Costume* (*Magazine Work,* pp. 164–65, 170). Arbus, judging from her correspondence with Peter Crookston, also tried to sell him on rephotographing the "Jewish giant" that eventually yielded one of her better-known images.

25 *Magazine Work,* p. 5.

26 "The Magazine Years: 1960–71," *Magazine Work,* p. 170.
Terkel interview.

28 The figures on Arbus's output are from *Magazine Work,* p. 5. The following letter from Doon Arbus to Prentice-Hall is in the archives of the Museum of Modern Art, New York: "It is very important to me that my mother's photographs be seen as photographs in the context of her own work and those of other photographers, and not as illustrations. Therefore, I have consistently refused to allow them to be reproduced in connection with any books or articles dealing with any subject other than photography itself." (Doon Arbus to Helen Maertens, July 2, 1975). As I have noted, the Estate of Diane Arbus gave reproduction rights to *Picture Magazine* in exchange for the withholding of a text. A related situation is Shelley Rice's "Essential Differences: A Comparison of the Portraits of Lisette Model and Diane Arbus," *Artforum* 18:9 (May 1980), pp. 66–71, which appeared without any illustrations. Ingrid Sischy offered the following editorial explanation: "There are no illustrations of work by Diane Arbus or Lisette Model to accompany the following analysis by Shelley Rice because permission would be granted only on the condition that the article be read before a permission decision could be reached. *Artforum* is not willing to accomodate compromising stipulations."(p. 66). Sischy's stand was rare; most art publications will go to any length to avoid printing straight text.

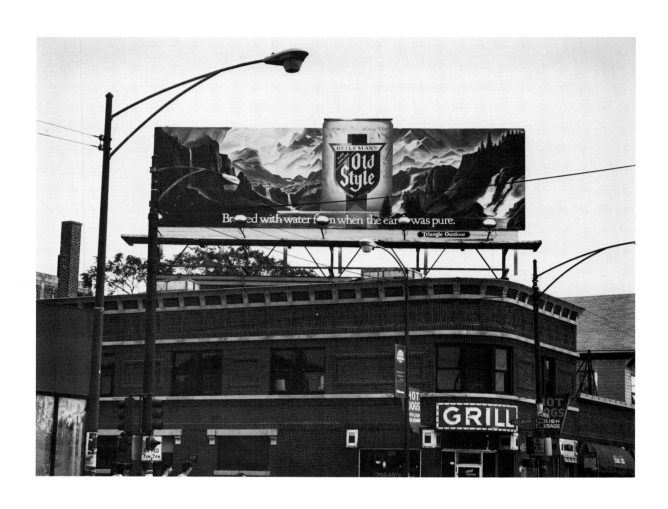

Deborah Bright, Billboard,
Belmont and Halsted, Chicago,
1985

DEBORAH BRIGHT

Of Mother Nature and Marlboro Men:
An Inquiry into the Cultural Meanings
of Landscape Photography

I suspect no
landscape,
vernacular or
otherwise, can be
comprehended
unless we perceive it
as an organization
of space; unless we
ask ourselves who
owns or uses the
spaces, how they
were created and
how they change.

J. B. Jackson[1]

Landscape photography has been enjoying a spectacular resurgence in the coffee table/
art book press. During 1984 alone, glossy tomes such as *Landscape as Photograph, Edward
Weston's California Landscapes, The Essential Landscape, Second View,* and *An American Field Guide*
piled off the presses and into the bookstores. In addition, the Spring 1985 issue of *Aper-
ture* was given over to the topic "Western Spaces."

Why landscape *now?* A few conjectures come to mind: it is certainly true that among
educated, middle-class audiences, landscape is generally conceived of as an upbeat and
"wholesome" sort of subject which, like Mom and apple pie, stands indisputably beyond
politics and ideology and appeals to "timeless" values. This would sit well in our current
conservative cultural climate, where images of the land (conceptual, historical, or literary)
from Lakes Tahoe to Wobegon are being used to evoke the universal constancy of a geo-
logical and mythic America seemingly beyond present vicissitudes.

But this is too simple an explanation—images of landscape cannot be perceived
simply as an antidote to politics, as a pastoral salve to lull us back to some primordial
sense of our own insignificance. Nor should they be regarded simply as the loci of our
modernist pleasure in arrangements of material objects in ironic constellations—found
"happenings" for the lens whose references to the worlds beyond the frame rivet all at-
tention on the sensibility of the artist.

These two prevalent constructions of landscape remind us that "landscape" as a sub-
ject of visual representation is a distinctly modern phenomenon. The taxonomic term
"landscape" comes from Western art history and refers to a genre of painterly practice
that gathered momentum and prestige only in the seventeenth and eighteenth centuries.
In the aristocratic classical tradition of painting, landscapes were principally fields for
noble action—carefully cultivated gardens suited to the gods and heroes who populated
them. With the rise in the seventeenth century of the merchant bourgeoisie in Holland, a
new sort of landscape emerged—a seemingly more "natural" landscape that celebrated

property ownership: the working water- or windmill, the merchant ship at anchor, the farmer's field, the burgher's estate. English landscape painting in the eighteenth century followed the Dutch model, though it supplanted the formulaic quality of earlier genre painting with scientific accuracy that reflected the increasing prestige and achievements of empirical science and its offspring, technology. The word *landscape,* in English, initially referred specifically to Dutch paintings and only later denoted the broader idea of a view or prospect.[2]

Whether noble, picturesque, sublime or mundane, the landscape image bears the imprint of its cultural pedigree. It is a selected and constructed text, and while the formal choices of what has been included and excluded have been the focus of most art-historical criticism to date, the historical and social significance of those choices has rarely been addressed and even intentionally avoided.

To take an example, the "small-town American" landscape of mass-circulation graphic illustration signifies more than a generic place idealized by Norman Rockwell. It also connotes a semi-rural golden age, a psychological center from which a ruling middle-class minority draws its symbolic identity and nationalistic context—its ideology:

In this generalized image Main Street is the seat of a business culture of property-minded, law-abiding citizens devoted to "free enterprise" and "social morality," a community of sober, sensible, practical people. The Chamber of Commerce and the Protestant churches are naturally linked in support of "progress" and "improvement." For many people over many decades of our national life this is the landscape of "small town virtues," the "backbone of America," the "real America."[3]

Despite its cultural dominance, this is a landscape in which the major portion of the nation's populace—its urban natives and refugees (including blacks, Hispanics, homosexuals, Jews)—finds no positive reflection but instead oppression.

Thus, whatever its aesthetic merits, every representation of landscape is also a record of human values and actions imposed on the land over time. What stake do landscape photographers have in constructing such representations? A large one, I believe. Whatever the photographer's claims, landscapes as subject matter in photography can be analyzed as documents extending beyond the formally aesthetic or personally expressive. Even formal and personal choices do not emerge *sui generis,* but instead reflect collective interests and influences, whether philosophical, political, economic, or otherwise. While most art historical/curatorial scholarship has concentrated on the artistic genius of a select few (and the stake in so doing is obvious), it is time to look afresh at the cultural meanings of landscapes in order to confront issues lying beyond individual intuition and/or technical virtuosity. The sorts of questions we might ask concern what ideologies landscape photographs perpetuate; in whose interests they were conceived; why we still desire to make and consume them; and why the art of landscape photography remains so singularly identified with a masculine eye.

In the late-nineteenth-century United States, after the "Indian problem" had been brutally solved and the frontier ceased to exist, a veritable Cult of Wild Nature flourished, having undergone several evolutionary phases since the continent's discovery by white Europeans. This was characterized by a nostalgia for the red-blooded rigors of a pioneer life that had become obsolete. As with many significant movements in American cultural life, this one emerged from a pragmatic alliance of liberal reform and commercial interests: the first epitomized in the Progressive Movement's precept that the "nature experi-

126 | 127

Ronald Reagan at the "Rancho
del Cielo," California, 1976
(Photo: Michael Evans/Sygma)

ence" was a desirable antidote to the unhealthy urban life, and the second in the creation
of a middle-class tourist market, first by the railroads and later by the automobile
interests.

In the same spirit, efforts to create pockets of arcadian nature in the cities through the
institution of landscaped parks and nearby forest preserves reflected an upper-crust culti-
vated taste for aestheticized nature and that class's conviction that such garden spots
could elevate the aspirations and manners of the immigrants and workers who used
them. In concert with these programs, wilderness areas began to be claimed and named
as refugees of timeless order in a changing world—"God's gift to the American
people"—to be preserved as a legacy for future generations.

The religious overtones in the American attitude toward these wilderness areas is un-
mistakable. As Kenneth Erickson has pointed out, these landscapes were and still are
truly ceremonial in nature, requiring both a code of personal conduct for users (park
rules and regulations) as well as ritualized expressions of devotion ("pilgrimages" made on
certain holidays and the compulsion to take snapshots of the conventional shrines of Na-
ture). The role of visual icons as both talismans of the original "experience" and prompt-
ers for renewed inspiration seems obvious in such a context.[4]

In 1908 sixty-nine thousand tourists went to worship in the eleven national parks.
Twenty years later, the figure had climbed to three million. What kind of landscapes were
these tourists so eager to gaze upon? As one historian describes it:

They were not impressed by wilderness itself. They looked instead for the unique, the
spectacular, or the sublime, drawing their standards from stereoscopic views, picture
postcards, railroad advertising, magazine illustrations, Romantic literature and landscape
art. Scenic beauty was an art form, and its inspiration a preconditioned experience.[5]

The railroads competed ruthlessly for the nature-tourist's dollar by trumpeting the unique visual enchantments of their respective routes. The federal government published popular National Park Portfolios during the 1920s, which prepared the general public for its first views of Yellowstone and Yosemite.

As automobile travel became widespread in the 1920s, the Park Service's Landscape Architecture Division engineered the wilderness to accommodate the new mobility with planned roads and numbered scenic turnoffs, sited and designed to conform to conventional pictorial standards. Nature was redesigned, we might say, for middle-class convenience and efficiency. With the active participation of government and private enterprise, wilderness scenery became good business. In this enterprise, photography rapidly surpassed other modes of graphic illustration to play a central role in merchandizing landscape for public consumption:

Sprawling enlargements, reminding prospective travellers of distant attractions, were spread like murals across the walls of ticket offices in smoky Eastern cities.[6]

These views became the established "standards" against which all future visual records of these landscape-spectacles would be measured. It was these "mechanical reproductions" of the chosen shrines that lured tourists into making the journey to find the Real Thing.[7]

The advent of motion pictures, particularly the Western, created a public taste for spectacular scenery used as a backdrop for thrilling dramas. The cowboy movie was firmly established as a genre by the 1920s and succeeded as no other form in masculinizing the western landscape. "Away up in the Canadian Rockies, amid the mighty forces of Nature, a man must be a man even to survive," read the press release for James Oliver Curwood's *The Valley of Silent Men* (1922)[8]; another of his press releases touted a film as "A Supreme Test of Manhood That Shows What Real Character Is. It Surpasses Belief and Overwhelms Our Sense of the Beautiful."[9] These larger-than-life celluloid landscapes

Joe Benson, n.d.

were mirrored at a humbler level in the roadside attractions of Western tourist land-scapes and became as well a marketing strategy for selling everything from cigarettes to presidents. Like Philip Morris's Marlboro Man, today a white-hatted Reagan rides his horse or chops wood for the camera on his Santa Barbara ranch, a rugged individualist drawn up to specs by Central Casting.

In the American consciousness, then, the western landscape has become a complex construct. It is the locus of the visually spectacular, culled from the total sum of geo-graphic possibilities and marketed for tourist consumption. For liberal conservationists, it represents the romantic dream of a pure, unsullied wilderness where communion with Nature can transpire without technological mediation, a dream that has been effectively engineered out of most modern experience. Once considered the essential ingredient in character formation, Nature has become commodified; its benefits can be bought and sold in the form of camping fees, trail passes, and vacation packages at wilderness resorts. As geographer J. B. Jackson has pointed out, we come in contact with Nature on a tight, highly structured schedule—holidays and weekends—which is determined not by the change of seasons, but by the routines of urban work.[10] This Nature has been designed to help us absorb its "benefits" as efficiently as possible: tourist literature and park displays ensure that we are exposed to the peak experiences at the site (sight).

For others, the western landscape is the repository of the vestiges of the Frontier, with its mythical freedom from the rules and strictures of urban social contracts—a place where social Darwinism and free enterprise can still operate untrammeled, where tract houses can sprout in the waterless desert. As one pundit put it, "For Americans, true freedom is not the choice at the ballot box but the opportunity to create a new world out of nothing: a Beverly Hills, a Disneyland, a Dallas, a Tranquility Base."[11]

Repressed or unexpressed among these mythical landscapes that conventional photog-raphy and Hollywood cinema have served so well is a landscape that cannot be defined strictly by aesthetic or geographical categories. The sort of landscape I am referring to, and which I think photographers might have a stake in revealing, is that landscape which J. B. Jackson has called "a field of perpetual conflict and compromise between what is established by authority and what the vernacular insists on preferring."[12] A landscape, in other words, whose construction by culture is made explicit—indeed, whose construc-tion is made the very subject of photographic investigation.

Beauty, preservation, development, exploitation, regulation: these are historical matters in flux, not essential conditions of landscape. The political interests that landscape organi-zation reveals are subjects that the practice of landscape photography has not clearly ad-dressed. Before I speculate on strategies photographers might use to reveal landscape's cultural construction, it would be useful to assess some of the inadequacies in traditional landscape photography.

The dominant landscape aesthetic in museum/gallery photography was self-consciously established as an offshoot of the American purist/precisionist movement in art during late 1920s and 1930s. A second, West Coast landscape school, founded by Edward Weston and continued more popularly by Ansel Adams and Eliot Porter, represented the contin-ued taste for the picturesque sublime from nineteenth-century European and American painting. This aesthetic was premised on an identification between a mythical Eden and the American landscape and was well suited to the conservative social climate of a post-World War II United States basking in its reborn Manifest Destiny as a world superpower. Popular Sierra Club publications, such as Porter's *In Wilderness Is The Preservation of the*

World (1962), celebrated the same sanitized conception of the natural world that Walt Disney promoted in his wildlife films. Porter anchored his vision in literature, specifically the nineteenth-century American Transcendentalists, whose ideal of a uniquely American wilderness proposed a landscape where deity could be touched through intuition.

The publication of *Aperture* (begun in 1952) and Minor White's eclectic reworking of Stieglitz's Equivalent provided artistic landscape photography with something resembling a theoretical base. Borrowing heavily (via Steichen) from the turn-of-the-century Symbolists, Stieglitz defined a photographic Equivalent as a metaphor for the vision or feeling of the artist rather than as a transcriptive record of the subject. However, as Andy Grundberg has succinctly pointed out,

For all its virtues in making us engage photographs more closely and complexly, the aesthetic of the Equivalent . . . has one major shortcoming: after asserting that an apparently transparent image of the world is imbued with an individual vision or feeling, it has difficulty defining what that vision or feeling is. Used as a critical instrument, the theory of Equivalence is unable to determine any intended meaning in a photograph. But as a credo, it has served as the dominant aesthetic of American photographic modernist practice.[13]

For Minor White, Ansel Adams, and their generation of art photographers, intuition and expression were the central issues, not visual form. Thus *Aperture* could routinely publish portfolios as stylistically diverse as those of Robert Frank and Frederick Sommer, for "the final form of the image was of less importance than its evocative meaning."[14] It was on this slippery beachhead that the *Aperture* forces were eventually challenged and overwhelmed by John Szarkowski's curatorial juggernaut in the 1960s and 70s.

As a landscape photographer and as modernist photography's most influential tastemaker, Szarkowski used landscape photographs extensively to shape and bolster his assertions about photography's essential "nature." Employing a formalist vocabulary peculiar to his reading of photography ("vantage point," "detail," and "frame"), Szarkowski invoked the work of selected nineteenth-century landscape photographers as evidence for his theory of form. In keeping with his notion of photography as a medium with its own irrepressible forms, he proffered these photographers as "naifs" through whom landscape could be represented photographically without regard for the pictorial formulae of European painting. Szarkowski referred to Timothy O'Sullivan, that seasoned professional, as "a mutant, native talent," displaying the "kind of natural grace by which a great dancer or singer seems possessed."[15]

In addition to its patronizing tone, such writing sheds no light on the historical circumstances in which O'Sullivan's photographs were produced. Significant issues of patronage, audience, means of reproduction and distribution are neatly elided in favor of a formal theory applied equally to any body of photographs from any historical time and place. Plucked from their historical world of contracts, commissions, stereographs, and stubborn Senators, nineteenth-century photographers like O'Sullivan are thus rehabilitated as the sires of a bloodline of artistic photographers legitimized by a powerful American cultural institution, the Museum of Modern Art, and its provincial satellites: the Art Institute of Chicago, the Corcoran, the Walker, and now the Getty.

Szarkowski's scholarly legerdemain was nowhere more evident than in his protégé Peter Galassi's much-ballyhooed thesis project, *Before Photography* (1981). Here again, land-

scape imagery of extraordinary obscurity, culled from both nineteenth-century painting and photography, is used to establish a legitimating art-historical pedigree for "photographic seeing." As Abigail Solomon-Godeau put it with her customary bluntness, selective raids on the art history slide library can be used to support any proposition, no matter how absurd. The practice of obscuring historical contexts permits a curatorial theorist to construct a specious history that s/he then tautologically claims to have discovered.

In the area of landscape photography in particular. Szarkowski's influence seems to have been particularly crippling. As recently as 1981, he published *American Landscapes,* a slender *catalogue raisonée* of photographs from the museum's permanent collection. His brief introductory essay amounts to a roll call of the canonical masters, beginning with Civil War photographers and ending with Frank Gohlke, a designated heir. In some ways, this publication makes far more explicit the limitations of Szarkowski's vision of photography than other, more ambitious catalogues and exhibitions. There is, for example, the question of sexism in dominant curatorial practice: of the forty photographers included in *American Landscapes,* only two are women—Laura Gilpin and Dorothea Lange—both of whom are dead.[16] Each is represented by a single image, while male counterparts such as Harry Callahan and Edward Weston are represented by three and four pictures, respectively. Lange's inclusion seems forced in other ways as well, for her images of landscape are rare and she meant them to be read in context with her images of human activity and the extensive texts she and Paul Taylor wrote to accompany them.

Perhaps no exhibition and catalog were more influential on the course of landscape photography during the past decade than *New Topographics: Photographs of a Man-altered Landscape,* organized by William Jenkins for the George Eastman House in 1975. The aesthetic position enunciated by Jenkins pitted the nine photographers represented (only one woman—half of the Bechers—was included) against both the kitschy Kodachrome versions of wilderness immoralized on postcards and calendars and the touchy-feely Nature worship of the Minor White crowd, which perennially haunts the fringes of art photography.

The *New Topographics* photographers—Robert Adams, Lewis Baltz, the Bechers, Joe Deal, Frank Gohlke, Nicholas Nixon, John Schott, Stephen Shore, and Henry Wessel, Jr.—shun all the conventional norms of beauty and sentiment to which art and kitsch landscape photography appeal. Rather, they present themselves as self-consciously knowing "naifs," artless artists working within the tradition Szarkowski has constructed for those nineteenth-century expeditionary photographers who worked "without precedent," *without style.* For Jenkins and his photographers, however, "there is little doubt that the problem at the center of this exhibition *is* [my italics] one of style."[17]

In speaking for the photographers he curated (and Robert Adams and Lewis Baltz must have squirmed just a bit at this), Jenkins claims that while their photographs convey "substantial amounts of visual information," they are *intentionally* about what is in front of the lens, which he defines as above all *an aesthetic arrangement,* having nothing to do with the cultural meaning of those references. He quotes Robert Adams:

By Interstate 70: a dog skeleton, a vacuum cleaner, TV dinners, a doll, a pie, rolls of carpet. . . . Later, next to the South Platte River: algae, broken concrete, jet contrails, the smell of crude oil. . . . What I hope to document, though not at the expense of surface detail, is the Form that underlies this apparent chaos.[18]

LOOKING NORTH FROM MASONIC HILL TOWARD QUARRY MOUNTAIN

"I want my work to be neutral and free from aesthetic or ideological posturing."
LEWIS BALTZ

Lewis Baltz in *Landscape:*
Theory, 1980

But there is no Form outside of representation. Formal orders are human arrange-ments and perceptions, not given essences. Though Jenkins asserts that the photogra-phers "take great pains to prevent the slightest trace of judgment or opinion from entering their work," these representations (no less that those from other landscape tradi-tions) are charged with meanings that derive from the race, class, gender, and personal histories of these photographers, which are in turn transmitted to an audience with its own nexus of social and psychic predispositions.

The paradoxical fact that many critics and photographers regard the work of the New Topographers as moving beyond formalist to social critique has more to do, I think, with the impoverished expectations of what passes for social criticism in art than with any theoretical positions assumed by the artists in question. All acquiesce to the notion Szar-kowski advanced in *Looking at Photographs*—that "photographs describe everything but explain nothing." [19] Jenkins reiterates the substance, if not the economy, of the dictum:

The important word is *description* for although photography is thought to do many things to and for its subjects, what it does first and best is describe them. [20]

While it may be true that individual photographs are laconic—that they "explain noth-ing"—the contexts in which they are produced, distributed, and consumed explain much about how we are to interpret them, including the knotty question of their relationship to the subjects they describe.

As an example, the uses of Stephen Shore's landscape photographs provide a fascinat-ing case study of how different contexts can invite radically different readings of the same image. During the American Bicentennial, the Smithsonian Institution invited architect/theorist Robert Venturi to organize a theme exhibition on cultural symbolism in the American vernacular landscape. The resulting exhibition and catalog, *Signs of Life: Symbols in the American City* (1976), prominently featured Shore's large-format color photographs of small-town and suburban landscapes. One of these had appeared the previous year in Jenkins's *New Topographics;* another reappeared seven years later in Shore's own mono-graph, *Uncommon Places* (1983). In Venturi's *Signs of Life,* Shore's photograph of a small Dutch colonial style cottage in a neatly manicured suburban setting appears with the following caption printed beneath it:

Decorated house fronts are suburban billboards with flags and eagles, foundation plant-ing, doors, porches, roofs and walls, windows, grills, shutters and ornaments as part of the symbolic content. [21]

In the *New Topographics* catalog, the identical photograph is captioned, "West Avenue, Great Barrington, Massachusetts, 1974." This laconic place-and-date appellation follows the formula for titling landscape photographs shown and reproduced within art contexts. (Its intentionally nonspecific formula does not customarily include the street name, but in this instance perhaps it sounded more "topographic.") The modernist premise underlying this second title is, of course, that one does not make photographs *of* things or events, but rather makes pictures to see forms in flat arrangements with their own internal co-herence. Making any reference to the world outside the frame beyond the title is deemed superfluous, if not downright distracting.

This refusal of historical context is taken to its extreme by Shore in his own book, *Uncommon Places.* In *Signs of Life,* Venturi's caption of Shore's photograph of a town thor-oughfare reads, "On Main Street, the buildings of one era are transformed by the signs of the next." In Shore's fine-art monograph, the identical photograph is reproduced with no caption or adjacent image of any sort—only a page number. An index at the back of the

modern/classical—
avoid personal—
Its just about form
and tone and
composition. Not
social/political etc.

book refers each photograph's page number to the conventional formula of place and date. Nothing textual (and thus contextual) is allowed to distract the viewer from an appreciation of the photograph as pure visual form; anything reminding us of the historical contingency of the photographer and/or his subject is rigorously eliminated.

But art venues invariably use external devices to control our reception of a photograph. Mats and frames, neutral walls, discreet labels, high rents, and the gallery hush provoke a palpable reverence before the images, even before we've inspected them closely. In catalogs and monographs, the high seriousness of the images reproduced is constructed through the inclusion of each photographer's resumé. Thus in *New Topographics* we read that photographer Robert Adams received both an NEA fellowship and a Guggenheim grant, in addition to being exhibited at the MoMA, while across the page, Adams's photograph automatically "confirms" the credentials of "proven genius" set forth verbally.

I single out Robert Adams because he is the most complex and articulate of the New Topographers and has made no secret of his liberal interest in the social issues surrounding the landscapes he photographs. However, his *logophobia* in the presence of *the image* has resulted in a self-defeating tendency to give lectures and write essays that reveal his passionate feelings about what he photographs while the images themselves remain isolated within museum and gallery spaces whose institutional discourse tends to suppress expression of social concerns.[22] This balkanization of images and text renders both Adams's written essays and photographs weakened statements; it also remands his photographs to the precincts of Art, there to be admired for their "attic restraint," to quote Szarkowski, rather than for their expression of a socially critical point of view.

In a revealing passage in one of his essays, Adams says that one day, after spending weeks making beautiful formal pictures of open-pit mines for a commercial client, he felt impelled to drive eighty miles out of his way to photograph a monument erected by the United Mine Workers to commemorate the massacre of miners and their families by the state militia.

What I wanted *and knew it was hopeless* were pictures of the monument that would somehow indict the new strip mines to the north. But in most cases the miners there were uninterested in a union and were, for all I had been able to discover of their consciences, now themselves probably members of the National Guard.

I was left at the end of the day with a sense of the uncertainty of evil, of the ambiguity of what photography could do with it, and of the fact of my own limited skills. After years with a camera I had wasted still more time trying to do what it apparently was not given me to do [emphasis added].[23]

Adams's twinges of liberal guilt about working for a corporate client in an industry with a violent union-busting history are, in his eyes at least, absolved by his projecting onto "the miners" a conservatism and lack of self-interest comparable to that of their bosses— "they were uninterested in a union and were . . . now themselves probably members of the National Guard." Adams's abortive pilgrimage to the monument and his recounting of how he tried to make an incriminating picture (and failed) get him off the hook, justify his limitations, and make him look like the good liberal he is—"It apparently was not given me to do." One might ask, *given by whom? God? Nature? John Szarkowski?* Who told Robert Adams he could not make photographs "that would somehow indict the new strip mines to the north"?

Furthermore, for what is Adams indicting the strip mines? Corporate greed? Boomtowns? Immigrant workers? Ravaging the landscape? Even though he does not reveal the

precise nature of his distress, any number of indictable situations could be documented photographically, accompanied by explanatory texts and, particularly with Adams's national reputation, published in forums that reached his intended audience(s).

Adams's most recently published attempt to address a "social issue" while still fetishizing the purely visual is *Our Lives and Our Children, Photographs Taken Near the Rocky Flats Nuclear Weapons Plant* (1984). *Our Lives and Our Children* provides an excellent case study of the poverty of dominant art photographic practice in speaking to specific, material concerns.[24] Photographs seeking to construct social concerns without reference to their status as historical objects become diminished by their "universalized" status as art objects. It should be obvious that modern patron-institutions (cultural, corporate, governmental), all justifiable targets of social critique, have a vested interest in keeping art and the critical discourse surrounding it free from overt politics. As Allan Sekula, Hans Haacke, Douglas Crimp, and others have demonstrated, art institutions have been successful in accomplishing this task, both through action—control of funding, endowments, curatorial practice, art-historical scholarship, etc.—and through self-representation—the conventional wisdom that the separation of art and politics is just plain "common sense," that the museum, like Art itself, is about timeless and universal concerns.[25]

Returning to landscape, what can photographs of landscapes tell us about how we construct our sense of the world? A comparison of two bodies of landscape photographs made in the same period, of similar subject matter, and addressing similar social concerns will demonstrate the difference between landscape work committed to questioning the conventions of landscape photography and an art photography that merely perpetuates or dissolves them into barren irony. Every critic who has assessed John Pfahl's widely published portfolio *Power Places* has expressed astonishment and some confusion about his apparent lack of political consciousness in making such lush, large-format, *beautiful* pictures of nuclear power plants. Even those who are quite at home with traditional art photographs seem a bit nonplussed when confronted with Pfahl's serene impression of Three Mile Island, reflected in the still, quiet waters of the Susquehanna River early on a sunny morning.

Exhibited without any statement that might anchor his images for the viewer, the photographs bespeak a kind of romantic nostalgia for the picturesque landscape; power plants, like rock formations or ancient trees, can be objects of beauty—the sublimity of the modern atom by the shores of ancient seas. Pfahl's photographs elicit other readings as well: that "energy" is "natural" and found in every landscape; that human exploitation of resources is universal and necessary, even in the most primordial, picturesque settings, and so on. As social responses to the issues raised by nuclear-energy development, such readings play squarely into the hands of utilities management, which uses very similar visual images to make precisely these points in corporate propaganda.

If setting up a "dissonance" between the romantic pastoralism of the landscapes and the potentially dangerous power plants within them was Pfahl's intended strategy, it is not carried through consistently, for he photographs nonhazardous *power places* such as hydroelectric facilities and dams with identical concerns for beauty and formal control. One suspects other motives at work here, namely marketing strategies in the art-collecting world. It is worth recalling that Robert Freidus, Pfahl's New York dealer, has stated explicitly that the "theme portfolio" is the cornerstone of his art-photography selling suc-

Lisa Lewenz, *Three Mile Island Calendar*, 1984

cess.[26] By combining conventionally beautiful photographs of socially-loaded subjects with a fashionably ambiguous high-tech/political/ecological theme, the work was highly marketable without offending any potential buyer—a corporate client in the energy industry, for example.

In contrast, Lisa Lewenz's *Three Mile Island Calendar* (1984) uses photographs of that power plant within a very consciously constructed political context, wittily appropriating the vernacular Christmas-calendar format as a foil for her serious message. Instead of the conventional Kodachromes of mountain's majesty, we see TMI photographed in gritty black and white from the homes of nearby residents. On the calendar itself, in addition to traditional famous anniversaries and birthdates, Lewenz adds dates of significance to the history of atomic energy, creating oddly provocative juxtapositions. For example, along with "Father's Day" we read, "Radioactive Iodine released by Dresden-2 reactor, Chicago, 1970" or "U.S. Supreme Court rules: NRC can OK nuclear plant without waste study, 1983." Her inclusion of landscapes *within* the frame of people's homes makes explicit the lurid connection between what lies *out there* and the privacy of our homes. Rather than the fantasy of a landscape world *beyond* society, or only marginally related to society, Lewenz creates an analysis of landscapes as a social production.

By mass-producing her calendar and selling it for an affordable six dollars instead of issuing her photographs as limited-edition, archivally printed art objects priced in the hundreds or thousands, Lewenz makes clear the precedence of the informational over the aesthetic. She also opens up distribution to audiences who would never enter a museum or gallery. It goes without saying that Pfahl makes much more money at what he does

A VISION OF NATURE

ADAMS
PORTER
STIEGLITZ
STRAND
WESTON
WHITE

than Lewenz; he is a "success" in current art-world terms and reaps the rewards of
steady academic employment and visiting-artist gigs. But Lewenz's calendar demonstrates
a successful attempt at moving beyond art photography's limited, inbred audience and its
ironic/aesthetic detachment from "life," to using landscape images for articulating a clear
position on both formal and social issues while reaching a wider public.

Other sorts of positions that might be articulated in landscape photography include
land use, zoning, the workplace, the home. Women, I think, have a special stake in docu-
menting this sort of "social landscape"—one that is quite different in nature from the
"social landscape" delineated in the mid-1960s by Nathan Lyons in his exhibition of that
title for the Eastman House. Most landscapes that are used primarily by women—the
house, shopping centers, beauty parlors, laundromats, etc.—are designed by men for
maximum efficiency and/or to promote consumerism among women. Only recently has
the history of an architecture by women for women been rediscovered and advanced.
Such an architecture would fundamentally redesign living spaces and workspaces with
women's needs in mind—for example, communal day care, private work areas away from
family demands, and easy access to other women through horizontal social networks.[27]
Such a sense of order-in-space could be analyzed in a feminist landscape photography.

Women might also recoup landscape photography for themselves in response to its
present character as a male preserve in art photography. The image of the lone, male
photographer-hero, like his prototypes, the explorer and hunter, venturing forth into the
wilds to capture the virgin beauty of Nature, is an enduring one.[28] Even those modernist
topographers who point their Deardorffs, Sinars, or Linhofs at "the works of Man" (as in

a Man-altered Landscape, to use Jenkins's words, or *The Hand of Man Upon The Land,* to borrow one of David Plowden's headings) fit that archetype. Weston, Porter, Caponigro, Strand, Plowden, Tice, Clift, both Adamses, Baltz, Deal, Divola, Klett—the roster of landscape photography's acknowledged masters could go on and on.

Where are the women? As my comments on Szarkowski hint, their work has been systematically excluded from surveys of landscape photography at major museums. Five years ago, Lustrum Press published *Landscape: Theory*[29] as part of its ongoing "Theory" series, wherein well-known photographers attempt to explain, with varying degrees of success, what they do. From "A" (Adams) to "W" (Weston), all ten of the photographers profiled in *Landscape: Theory* were men.

And the beat goes on: the Spring 1985 *Aperture* survey of Western landscape photography featured the portfolios of eleven men, NASA (which may as well count as a twelfth!), and one woman, Marilyn Bridges. In April 1985 a major landscape exhibition tellingly titled *A Vision of Nature* was mounted by the Photography Department of The Art Institute of Chicago. The curator not only excluded women from his retrospective, but set up a dubious historical account promoting the genius of the six masters represented—Adams (A.), Porter, Stieglitz, Strand, Weston, and White. No less than Marlboro Country, American landscape photography remains a reified masculine outpost—a wilderness of the mind.

Some women landscape photographers, like Linda Connor, have protested the exclusion of women from the canon, but instead of challenging the structures of canon-formation per se, they offer what amounts to an essentialist theory of women's landscape imagery, one that posits a more intimate, emotional response to Nature because women somehow have more affinity with It. According to Connor, women don't possess the acquisitive, manipulative, territorial instincts of men, and this comes through in their pictures of landscape. Additionally, she asserts that women's childbearing capacity "makes an enormous difference" in how they perceive themselves and their relationship to the world, although she doesn't reveal any specifics.[30]

Ironically, this construction appeals to an old, pancultural assumption that has been used throughout history to devalue women and their cultural production. It holds that because a woman is more involved with the "natural" functions of reproduction and nurture, she is "closer to nature" than men. The insidious corollary to this posits that the male's lack of such "natural" creativity causes him to create "artificially" through the mediums of technology and symbols. Consequently, maleness and male activities are more highly valued (and this is universally true) for their consciousness and artifice: men *choose* to interact with nature and bend it to their will, while women simply *are* nature and cannot define themselves in opposition to it.

Feminist anthropologists like Sherry B. Ortner have demonstrated how these constructions and their implications operate as universal givens for men *and* women in their perceptions of gender difference.[31] And psychologist Nancy Chodorow has argued convincingly that this notion of sexual difference is not innate; that it is inculcated within the structure of the family, where gender roles are taught to children by both example and representation at many levels.[32] Rather than further perpetuating these restrictive notions about women's special relationship to nature, feminist photographers might well use their work to subvert conventional masculine constructions of the wilderness and the Marlboro Man.[33] Merely supplementing the limited canonical notions of landscape photography with an-Other, equally limited and ahistorical, may have the short-term effect of

138 | 139

populating the walls of "women's spaces" with a certain easily identifiable style of work, but, as was the case with the first phase of feminist painting in the early 1970s, it will only serve to create new sexist stereotypes or entrench old ones more deeply.

Rather than accepting established art-historical models of landscape photography or looking for alternative but equally universalized "norms" to replace them, it seems worthwhile to examine instead other disciplines such as urban planning, landscape architecture, and geography. In these disciplines, the environment is approached analytically; photographic evidence is used to make focused cultural statements. Such work, most notably the writings of geographer J. B. Jackson, has already exerted some influence within the photographic community, particularly in the Southwest, his base of operations. The inventive approaches of urban planners like Kevin Lynch and Robert Venturi, who consider the city as primarily a visual space, or the probing essays of cultural geographer David Lowenthal on the significance of cultural memorials, or the extensive use of photographs and visual material by Grady Clay in his book *Close Up: How to Read The American City*—all of these can stimulate reflection on how the landscape is a human organization of space, an historical construction rather than an immutable essence.

Art photographers fear that in such "analytical" approaches the photograph might lose its primacy of place to a written text, should the two ever be joined. It seems as though part of the Faustian bargain to elevate photography to status of "art" has exacted a decree that written texts be forever banished from the vicinity of the visual image—that photographs present themselves in the same contentless depoliticized way as modernist paintings have embraced since the 1930s. Ironically, such concessions were instituted in the name of preserving "the integrity of the image," the price being the integrity of history! As was pointed out earlier, recent art-historical scholarship has engaged in a wholesale effort to rid historical photographs of their historical functions (has ripped them out of the books and magazines) and presented them instead as autonomous works of art by original geniuses.[34]

It follows, too, that most college-level art photography programs do not include theory[35] and history courses that would require students (1) to formulate coherent statements about what they are doing and why and (2) to write around their photograph(ing). Rather, the student is taught to conceive of him/herself as, in effect, a post-literate Eye that makes photographs "to see what things look like photographed," to paraphrase modernism's most-lionized master, the late Garry Winogrand. Small wonder, then, that most art-photography teachers and students are unprepared for and hostile toward any methodology that demands accountability for what is being shown *in* their photographs in terms of discourses other than that of a disinterested formalism.

If we are to make photographs that raise questions or make assertions about what is *in* and *around* the picture, we must first be aware of what the ideological premises are that underlie our chosen mode(s) of representation. Such awareness will structure the aesthetic, editorial, and technical decisions that are made with the goal of communicating ideas in a provocative (and yes, creative!) way. As part of this program, a reassessment of the museum/gallery system is in order. Many artists have found it necessary to seek other venues for their work. Should the rare fate of "art fashionability" befall the photographer engaged in socially committed work, s/he must be vigilant about protecting the work from being removed from its own history—from having its captions removed, its tape recorder unplugged, or its sequence jumbled. It goes without saying that any issue-

oriented work becomes transformed by history and loses its immediacy with time, but this is no justification for abandoning the work's current cultural task to the first (or highest) bidder.

Landscape art is the last preserve of American myths about Nature, Culture, and Beauty. It is no accident that its resurgence in popular and highbrow art is taking place during a right-wing political period in which big business has virtually free rein over the social and physical environment. Photographs of the strong forms of a Chicago or Pittsburgh blast furnace say nothing about the tragedy of massive unemployment in the Rust Belt or the profit motive of a corporation that rends the social fabric of a company town. How shocking would it be for U.S. Steel chairman David M. Roderick to have a Weston, a Sheeler, or a Plowden hanging on the wall of his corporate headquarters? Or former Interior Secretary Donald Hodel an Eliot Porter? The regrettable truth is that most "art lovers" wouldn't bat an eye, but instead congratulate the CEO and the Secretary on their good taste, their support of the arts—confident that art was doing its cultural work, "beautifying and elevating" our *personal* lives!

Landscape has been appropriated by our cultural establishment as "proof" of the timeless virtues of a Nature that transcends history—which is to say, collective human action. For most photographer-artists, landscape has been reduced to a locus for the experience of the isolated individual. In the words of Lewis Baltz:

The landscape . . . seems more a set of conditions, a location where things and events might transpire rather than a given thing or event in itself; an arena or circumstance within which an open set of possibilities might be induced to play themselves out.[36]

But landscape needn't serve either of these dominant constructions. If we are to redeem landscape photography from its narrow, self-reflexive project, why not openly question the assumptions about nature and culture that it has traditionally served and use our practice instead to criticize them? Landscape is not the open field of ideological neutrality that Baltz fancies it to be. Rather, it is a historical construction that can be viewed as a record of the material facts of our social reality and what we have made of them.

N O T E S

1 J. B. Jackson, "Concluding with Landscapes," *Discovering the Vernacular Landscape* (New Haven: Yale University Press, 1984), p. 150.

2 John Stilgoe, *Common Landscape of America, 1580 to 1845* (New Haven: Yale University Press, 1982), p. 24.

3 D. W. Meinig, "Symbolic Landscapes," *The Interpretation of Ordinary Landscapes,* ed. D. W. Meinig, (Oxford: Oxford University Press, 1979), p. 167.

4 Kenneth A. Erickson, "Ceremonial Landscapes of the American West," *Landscape* 22:1, p. 39.

5 Peter J. Schmitt, *Back To Nature: The Arcadian Myth in Urban America* (New York: Oxford University Press, 1969), p. 155.

6 Ibid., p. 148.

7 See Dean MacCannell, *The Tourist: A New Theory of the Leisure Class* (New York: Schocken Books, 1976) p. 45: "It is the mechanical reproduction phase of sacralization that is most responsible for setting the tourist in motion of his journey to find the true object."

8 Schmitt, *Back to Nature,* p. 150.

9 Ibid., p. 151.

10 J. B. Jackson, "A Puritan Looks at Scenery," *Discovering the Vernacular Landscape,* p. 63.

11 Frederick Turner, "Cultivating the American Garden," *Harpers,* August 1985, p. 50.

12 J. B. Jackson, "Concluding with Landscapes," p. 148.

13 Andy Grundberg, "Ansel Adams: the Politics of Natural Space," *The New Criterion* (November 1984), p. 150.

14 Jonathan Green, "Aperture in the Fifties: The Word and the Way," *American Photography: A Critical History 1945 to the Present* (New York: Harry N. Abrams, 1984), p. 71.

15 Jonathan Szarkowski, *American Landscapes* (New York: The Museum of Modern Art, 1981), p. 7.

16 For a succinct summary of the systematic discrimination against women by the photography establishment, see Catherine Lord, "A Thorn is a Thorn is a Thorn," *Exposure* 22:2 (Summer 1984), p. 40.

17 William Jenkins, "Introduction to *The New Topographics,*" reprinted in *Reading Into Photography,* ed. Thomas Barrow et al. (Albuquerque: University of New Mexico Press, 1982), p. 51.

18 Ibid., p. 55.

19 John Szarkowski, *Looking at Photographs* (New York: The Museum of Modern Art, 1973), p. 72. Szarkowski ascribes these words to Henri Daumier, the French visual satirist whose devastating cartoons lampooned the Louis-Philippe government and the bourgeoisie. One can only surmise that Daumier spoke with sarcasm—to mock photography's limitations as a means to reveal political truths. Alas for Szarkowski and the modernists, this has become its great virtue.

20 Jenkins, "Introduction," p. 53.

21 Robert Venturi, *Signs of Life: Symbols in the American City* (Washington, D.C.: The Smithsonian Institution, 1976).

22 See Martha Rosler, "Lookers, Buyers, Dealers, and Makers: Thoughts on Audience," *Exposure* 17:1 (Spring 1979), pp. 10–25. Reprinted and revised in Brian Wallis, ed., *Art After Modernism* (New York: The New Museum of Contemporary Art, 1984), pp. 311–39.

23 Robert Adams, *Beauty in Photography* (New York: Aperture, 1981), p. 66.

24 For a trenchant review of *Our Lives and Our Children,* see Abigail Solomon-Godeau, *Exposure* 22:3 (Fall 1984), p. 53.

25 See Marx and Engels, *The German Ideology,* 3rd revised edition (Moscow: Progress Printers, 1976), pp. 68–69. For the ruling class "is compelled . . . to present its interest as the common interest of

all the members of society, that is, expressed in ideal form: it has to give its ideas the form of universality, and present them as the only rational, universally valid ones."

26 Michelle Bogre, "Robert Freidus," *American Photographer* (November 1984), p. 72.

27 See Gwendolyn Wright, *Building The Dream: A Social History of Housing in America* (Cambridge: The MIT Press, 1981). Also, Dolores Hayden, *The Grand Domestic Revolution* (Cambridge: The MIT Press, 1981), and *Re-designing the American Dream* (New York: Norton, 1984).

28 Peter Beard comes to mind as a contemporary figure who literally combines the personae of great white hunter and great white photographer.

29 *Landscape: Theory* (New York: Lustrum Press, 1980).

30 Charles Desmarais, "Linda Connor," *CMP Bulletin* 2:2 (1983), p. 12.

31 Sherry B. Ortner, "Is Female to Male as Nature Is to Culture?" *Women, Culture and Society,* ed. Rosaldo and Lamphere (Palo Alto: Stanford University Press, 1974), p. 67.

32 Nancy Chodorow, "Family Structure and Feminine Personality," *Women, Culture and Society,* p. 43.

33 See Christopher L. Salter, "The Cowboy and the City: Urban Affection for Wilderness," *Landscape* 27:3 (1983), p. 43.

34 See Douglas Crimp, "The Museum's Old/The Library's New Subject," *Parachute* 22 (Spring 1981), pp. 32–37, reprinted in this volume, and Griselda Pollock, "Artists Mythologies and Media—Genius, Madness, and Art History, *Screen* 21:3 (1980).

35 As Simon Watney points out, in the average art-photography program "theory' is almost . . . invariably understood as a *technical* category, covering the study of sensitometry, photo-chemistry, and so on." Simon Watney, "Photography-Education-Theory," *Screen* (January-February 1984), p. 67.

36 Lewis Baltz, "Landscape Problems," *Aperture* 98 (Spring 1985).

SALLY STEIN

The Graphic Ordering of Desire: Modernization of a Middle-Class Women's Magazine, 1919-1939

In the 1920s study *Middletown,* a Muncie, Indiana, housewife gave this account of her reading habits:

I just read magazines in my scraps of time. I should so like to do more consecutive reading but I don't know of any reading course or how to make one out.[1]

A key phrase here is the "scraps of time," the sense of fragmented leisure time which characterized women's work in the home. This woman was still describing her activity with magazines as "reading," but she was clearly distinguishing between this form of reading and the more continuous reading required of traditional literature. It won't ever be possible to know exactly what she was getting from magazines; but if we are to begin to comprehend the kinds of messages transmitted and the reasons for the medium's enormous appeal in this century, we need to develop new methods of conceptualizing the content and construction of the modern women's magazine.

The magazine's use of texts implies a fairly rational mode of apprehension. It would be inaccurate, however, to describe most magazine reading as a straight, linear process; though often referred to as a "book" by editors, the typical magazine is not organized along a single continuum. By sandwiching within its covers a variety of discrete texts, the magazine invites us to pick and choose, to move backward as well as forward, in a way that suggests that we not only will the process to continue by physically turning the pages (distinctly different from the more passive modes of radio and television reception), but that we also "freely" negotiate a "personal" path through the magazine labyrinth.

We do enjoy considerable freedom in determining our experience with magazines, and, as the testimony of the Muncie housewife suggests, the flexibility of the magazine format is one of the chief reasons for its popularity as a modern mass-communication form. Moreover, a regular magazine reader develops a routine to avoid perpetual distraction. This technique of "reading with blinders" is a logical response to the amount of visual diversion incorporated in the modern magazine.

The magazine forces us to discipline our focus in much the same way that modern highway driving cultivates split-second timing. But if we employed perfect tunnel vision while driving, the value of billboards would be nil. Any description of the highway that focused exclusively on the road would fail to address the way this form of mobility allows us to achieve specific destinations while constantly recharging our desire for less immediately attainable ends. The car encloses us, the road directs us, and these conditions made ads especially welcome as points of reference and as emblems of our long-term goals.

The picture magazine was refined at the same time that the commercial roadscape was being developed. Both forms of communication reflect the same impulse in the history of corporate capitalism to mobilize consumption at a national level. But unlike recent studies of car culture and "the strip," the magazine has rarely been studied as a unified cultural artifact. Studies of magazines have usually treated literary texts, or editorial images, or ads, as independent entities and have proceeded to analyze their meanings divorced from their original context. This strategy flattens our conception of the way magazines came to be assembled and then received. For these elements certainly are not apprehended in isolation; rather, images and texts, ads and editorial matter, are each designed to work off each other within the larger ensemble of the magazine.[2]

Historians and sociologists have often referred to the phenomenal increases in ad revenues in the post-World War I era as an index of change in the traditional women's magazine.[3] But the statistics alone say very little about the character of these changes or the way the magazine remained a coherently structured text, a social product whose value derived in part from the way it organized its diverse collection of materials. Thus I am interested in the specific ways new graphic techniques—color, photography, serial cartoons—were orchestrated in a more dynamic layout to sustain the reader's interest *and* to draw the reader closer to the marketplace. My stress on the changing material aspects of the magazine is not intended to promote a formalist analysis per se. Rather I hope to bring home the point that the women's magazine in the twentieth century, though continuing to include lengthy literary texts, was becoming a predominantly visual experience, constructing an audience of spectators and, by extension, consumers.

The *Ladies' Home Journal* provides a good case study of the reshaping of the nineteenth-century women's magazine into its familiar twentieth-century format. For half a century beginning in the 1890s, it was the most successful women's publication, leading in advertising revenues and circulation figures. In its prime, numerous editors and writers published detailed "inside" accounts of the magazine's operation. Most important is the fact that the *Journal*'s enormous success did not rest upon a fixed formula but involved especially aggressive innovation beginning around World War I—a good twenty years before that moment generally thought of as the birth of the modern picture magazine. Indeed the more familiar success story of *Life* magazine—born in 1936 with all the fanfare of complete originality—represents a relatively late development, based largely on the earlier transformation of the women's magazine.

In order to understand why women's magazines were revamped especially early in this century, we need to consider the impact of changes in two social spheres: that of industrial production and that of domestic reproduction. These spheres were never wholly separate, but in this period the two became closely synchronized, and women's magazines played an important mediating link in that process.

With the late-nineteenth-century emergence of monopoly capitalism, factory work changed drastically. Industrial consolidation led to larger workplaces, assembling far more

workers at a single site, thereby leading to new ways of organizing manufacturing processes. The foreman's traditional authority was rapidly preempted by a new breed of professionally trained industrial engineers. With stopwatches in hand, these men entered the shop floor to study all details of the established production techniques with the objective of transforming craft skills into a series of simple, endlessly repeatable tasks. By "deskilling" work, the efficiency experts promised to break shop floor resistance. Logically, production rates would soar, for it would now be possible to exploit far more efficiently the mass of common laborers who—lacking long-developed craft skills—were far more vulnerable to constant monitoring, thus easily pressured to increase output.

To Frederick Winslow Taylor goes most credit for promulgating the initial principles of "scientific management." However, the general process of industrial rationalization came to be popularly associated with Henry Ford's introduction of the assembly line in 1914, which allowed Ford to hire thousands of unskilled workers at the unprecedented rate of five dollars per day. The increased pay rate was easily matched by an unprecedented rate of production (and profit). The justly famous output of Ford's assembly line constituted a truly massive demonstration of the value of efficiency.[4]

Of course, middle-class women had little direct involvement with factory work, but their work within the home changed quickly with the advent of scientific management. On two distinct levels, rationalization altered the character of housework. Materially, monopoly capital quickly discovered that marketing specialists were as essential as industrial engineers, for accelerated production would yield no profits if consumption were not also systematically managed. Ideologically, the rhetoric of efficiency had such appeal for the middle class (including feminists like Charlotte Perkins Gilman), that a variant on the discourse of "scientific management" soon became part of the rhetoric directed at women.[5]

But there was a fundamental contradiction in the burgeoning discourse of "domestic efficiency." Scientific management in the factory offered wage incentives in exchange for accelerated production. Domestic efficiency experts, on the other hand, avoided the issue of money, since they maintained the sanctity of women's domestic labor as a labor of love. Without the wage motive, other stimuli had to be developed to promote interest in higher standards for housework in conjunction with the use of new machinery and products. Born-again housework had many attributes of a spiritual revival, taking hold in direct relation to the decline of actual managerial work and autonomy in the home.[6] And as in many faiths that do not address basic contradictions, signs were a necessary form of sustenance on the road to salvation.

Extremely sophisticated graphics appeared early in this discourse. An illustration from Mrs. Christine Frederick's 1913 home efficiency tract, appropriately titled *The New Housekeeping,* stands as a prototype of a new kind of communication in which a variety of visual and literary codes—text, drawing, photo—are neatly combined to suggest that a feast for the eyes could be produced by means of "efficiency" (signified by the business file adapted to the kitchen) rather than by time, effort, and money.[7] If it seems that I am reading too much into this composite image, one need only note the title of Frederick's subsequent publication—*Meals that Cook Themselves* (1914).

Frederick's career path is even more revealing of the interests best served by the rationalization of housework. Following her first book on domestic efficiency, she became an associate editor for the *Ladies' Home Journal,* a position she held until the mid-1920s, when she began to work free-lance, advising manufacturers and retailers on the best sales

Illustration from Mrs. Christine
Frederick's *The New
Housekeeping,* 1913, facing
p. 150

CROWN ROAST OF LAMB WITH PEAS AND
STEAMED WAFFLE POTATOES

Select parts from two loins of lamb containing from seven
to eleven ribs in each. Scrape the flesh from the bone between
the ribs, as far down as the lean meat and trim off the back-
bone. Keep the ribs on the outside, shape each piece in a
semi-circle and sew together to form a crown. Tie securely.
Cover each chop bone with a thin strip of salt pork to prevent
burning. Dredge with flour, sprinkle with salt and pepper,
and roast for an hour and a half until tender throughout.
Remove the cubes of fat and replace with paper frills. Serve
on a hot platter, with green peas in the centre of the crown,
and steamed waffle potatoes around the base.

Specimen recipe card with illustration, from
Filing Cook Book
The New Housekeeping Filing Cook Book

148 | 149

strategies for capturing the women's market. Thus, if initially she was committed to pro-
viding women with more efficient domestic skills, the distinction between skills and com-
modities was then attenuated in the commercially sponsored forum of the women's
magazine, and the distinction was completely abandoned by the time she wrote her last
book, *Selling Mrs. Consumer* (1929).

In the same period that Frederick's career advanced along these lines, the women's
magazines were themselves rationalized as marketing vehicles, providing an optimal con-
text in which to sell new domestic commodities by constructing a paradoxical vision of
housework: scientifically reducible to its component parts yet containing still an irreduc-
ible quality of romance. The format could be made to mirror the compartmentalization of
domestic tasks, while supplying instruction in all phases of this minutely detailed work.
The magazine neatly categorized performance standards in matters of dressing, decorat-
ing, cleaning, cooking, child-rearing . . . and the repairing of home and marriage if con-
stant attention proved to be insufficient. And unlike conventional instruction manuals, it
provided a constant stream of promises—false promises, or at least inflated ones—of
personal benefits that would result from tending new machines and using new materials.
What these promises lacked in substance, they made up for in vividness—the kind of
tantalizing but tawdry incentive proposed by the industrial engineer Frederick Winslow
Taylor in his discussion of the "scientific management" of young, low-paid, female factory
workers: "encouragement either in the form of personal attention from those over them
or an actual reward in sight as often as once an hour."[8]

Of course, since they were underwritten by advertisers, magazines were well suited to
construct an extended visual argument for the rewards of modern domesticity. They had
another advantage over isolated treatises on "scientific management" of the home. Given

their periodic appearance, the magazines were an especially effective means of inculcating new habits and standards. Once a month, the drilling and instructions were repeated in slightly different form, and each repetition was accompanied by a new representation of the rewards—exactly the type of "scientific pedagogy" advocated by the industrial psychologist Lilian Gilbreth in 1914: "Associations . . . lapse more slowly the older they are and the oftener they have been reviewed by renewed memorizing."[9]

The mappings presented in Venturi, Scott Brown, and Izenour's *Learning from Las Vegas* far surpass photographs or any other conventional representations in providing a schematic overview of the signifying structure of the commercial strip. I sought a comparable form to conceptualize the totality of a single magazine issue, with the idea of then comparing changes at five-year intervals in the use and structuring of various graphic elements of the *Journal* between 1914 and 1939. By "exploding" the magazine into a synchronically viewed series of double pages—each double page being represented by a vertical bar in which the right-hand page appears above the center line (representing the "gutter" or "spine" of the magazine) and the left-hand page below—patterns of communication emerge that would have been experienced less consciously when the magazine is looked at page by page.

Though I ended up making a series of graphs on the changes between 1914 and 1939 in the use of photography, color printing, and narrative picture sequences, I began simply by charting the breakdown of editorial and advertising space in each issue. Editorial space is shaded; advertising space is white. These first diagrams should not be mistaken for an economic breakdown of publishing costs, but they do indicate how the advertising basis of the magazine was reflected (and to some extent concealed) in the allocation of space within an issue.

Between 1914 and 1939, the ratio of advertising to editorial space remained relatively constant at 45 percent, but there are noticeable changes in the distribution of advertising material during this period. The front of the *Journal* always contained a disproportionate amount of editorial pages, a format designed to emphasize the weight of editorial matter. Over twenty-five years, the solid block of editorial material was somewhat pushed back, allowing more full-page ads to appear on the opening pages. By 1939 advertising was so culturally pervasive that it was unnecessary to confine it to the back pages. By 1939 *Fortune* was a decade old and had made a trademark of its gallery of full-page ads at the front of each issue. In comparison with contemporary magazines like *Fortune* and *Vogue*, the *Journal* still led with editorial emphasis, so that the reader was made conscious immediately of an authoritative voice that presumably organized the following contents with her best interests in mind.

The lines running in and out of the bar graph trace the internal "page flow"—the way texts are broken up and continued elsewhere in the magazine. The interruption of articles may appear to the average reader as a commonplace if inconvenient occurrence, but the resulting movement back and forth also serves as a form of entrapment. Thus the reader will find it considerably more difficult to confine her time and attention to a single article. She is forced to flip through the rest of the magazine in order to pursue her immediate interests.

The historical evolution of a maze-like page flows is readily seen here. In 1914 less than one half of the editorial space was thus interwoven; the rest was allowed to stand as isolated pieces of text. A marked change occurred between 1914 and 1919, when many more direct routes were established from the front, beginning at page 7, to the middle of

October 1914

October 1919

October 1924

October 1929

page 3
page 1
cover
inside cover
page 2
page 267
inside back cover
spine/gutter
back cover
page 268

October 1934

continued from previous issue
page 3
page 1
cover
inside cover
page 2
page 155
inside back cover
spine/gutter
back cover
page 156

October 1939

page 3
page 1
cover
inside cover
page 2
page 121
inside back cover
spine/gutter
back cover
page 122

Editorial copy
Advertising copy
Continuity lines

Ladies' Home Journal, October 1939, p. 11

the magazine, though the last thirty pages were not so integrated. By 1924 the constructed flow began on page 3 and extended almost to the back of the issue, although some portions of the magazine continued as isolated islands. The same held true in 1929, when a prodigious labyrinth between front and back was created, still leaving portions of the magazine unconnected. In the Depression years of the 1930s, when the *Journal* shrank from the gargantuan size of the October 1929 issue, the process of interweaving almost all the editorial contents was finally realized. Moreover, the 1939 page flow was achieved with fewer large jumps—as indicated by only twelve external links in the chart—so that the flow itself was more continuous. Thus, while the typical magazine reader of this period may have believed that the magazine could be consumed piecemeal, in "scraps of time," the diagrams reveal that the magazine was being redesigned to consume an extended period of time.

At the same time that the magazine succeeded in connecting almost all of its interior pages, there were considerably fewer texts explicitly leading to or from earlier or later issues. While this helped create a more integrated, overall text, serialization was not abandoned completely. By 1939 advertising literature stressed the desirability of newsstand sales (supposedly attracting impulse shoppers), which would have been bolstered by dramatic serialization. Accordingly, in the October 1939 issue the most gripping narrative—illustrated to underscore the title "Another Woman" by positioning the wife precariously at the right-hand edge of the page—breaks off exactly when the wife is

confronted with the necessity of getting a divorce. In case the reader failed to sustain concern for the wife's plight through the rest of the issue, the editor's closing column, "Journal's End" (equating the magazine with a kind of journey) reminded the reader that this cliff-hanger would not be resolved until the next month. Serialization, therefore, was being used more sparingly, and its use indicated those topics thought to be most compelling for *Journal* readers. But it still served a strategic function in insuring the month-to-month loyalty of the magazine reader.

The same set of graphs also reveals a major change in layout within the double-page spread. As early as 1919, a marked shift appeared in the placement of editorial material in relation to ads. In 1914, between pages 60 and 99, two narrow bars of editorial columns floated in a sea of ads. By 1919 these columns were pushed together at the center of the double page. By the 1939 issue, excepting the inside cover and inside back pages, which commanded higher ad rates, there was some portion of editorial matter at the front of each double spread. Thus, over a twenty-five-year period, a system of layout emerged that anchored the bulk of advertising to a constant editorial presence at its center. In effect, there was always an editorial voice reminding the reader of the "educational" value of the magazine.

Though it is difficult to uncover an articulated philosophy that determined these changes in layout (the art directors rarely published articles on their work), a similarly paternalistic ideology is apparent when comparing other choices made by the art directors between 1929 and 1939. Two covers, ten years apart, have an almost antithetical message. The 1929 mother-as-mature-flapper relies for its effect upon the state of amazement conveyed by the pint-sized child and pet collie at her side. In contrast, the woman on the October 1939 cover has obviously relinquished her pedestal. Whatever she has lost in terms of high fashion she has "gained" in terms of direct resemblance to her daughter, moving toward the other ideal of mother-as-older-sister. And she is really "moving," animated in a way that seems directly to encourage her child to master difficult balance problems like bike-riding. We can assume from the line "The Magazine Women Believe In," which has been added to the *Journal* logo, that trust has become a crucial selling point. The reader can trust what she learns in the *Journal* in the same way that the daughter, though still tottering, seems assured of a safe upbringing.

The theme of supervised mobility depicted in the cover graphic, as well as the motherly tone of the "Journal's End" column, suggests that in the late 1930s the magazine was consciously projecting an image of itself as a vicarious trip, while providing many assurances that the viewer would travel safely. Guided though this journey may have been, a final look at these graphs indicates that it hardly shielded the reader from overexposure to the continuous lure of advertisements. On the contrary, the development of a systematic layout principle with a continuous editorial thread meant that even if one chose to look only at editorial features, one would not miss a single double page, and therefore not a single ad. Moreover, the same graphs also indicate that the full-page spreads and clusters of page spreads which characterize the front of the magazine were replaced by smaller and smaller blocks of columns toward the back, where the editorial content thinned out and was constantly interspersed with advertising. A parallel format is the late-night televised movie (pre-cable, or VCR ad-zapping), which, as it progresses, is cut at shorter and shorter intervals, interrupted by increasingly brief ads. If a compelling program has been established, the viewer stays tuned all the same and even grows to accept this format as part of an evening's entertainment.

Ladies' Home Journal, October 1929, cover

Ladies' Home Journal, October 1939, cover

The *Journal* was always an illustrated magazine, but the predominant modes of illustration changed significantly in this period. While photographic reproductions gradually replaced a large portion of the traditional drawings, color printing was introduced with great fanfare and quickly became the most privileged visual rhetoric of the women's magazine.

As early as the December 1911 issue, the editorial column on the first page of the *Journal* held out the idea of a color-filled magazine as a sort of promissory note which would accrue to the loyal reader: "No feature we have ever introduced in the magazine has met with the satisfaction expressed over our color pages. This has encouraged us to add to the number." What also encouraged the publisher in this novel venture was the prospect of increased ad revenues; once color's mass appeal had been established, advertising readily paid the higher page rates for this proven method of commanding the reader's attention.

While the volume of color work rose most sharply between 1914 and 1919, the number of color pages continued to expand long after the initial novelty had worn off. The editorial page of the October 1929 issue headlined the magazine's new use of color photography, a technology developed quite obviously to accommodate new marketing strategies. After a decade of successful marketing based on color ads, the assembly lines of the late 1920s began turning out goods in assorted shades. If the consumer needed any encouragement to buy these novel commodities, advertisers were quick to insinuate that the colorless life was not worth living. The prize for the most desperate attempt to keep abreast of the color craze belongs to Kodak; six years before the photographic manufacturer was able to offer amateurs a practical color film, it had already conceded the priority of capturing color in 1929 when the conventional, black box camera was refinished in a variety of hues, to serve as "Fashion Accents . . . for Picture Takers that Reflect the Rainbow."

The Depression left its mark on both the content and physical features of the magazine. During the 1930s the overall length of the magazine, which had expanded greatly from 1914 to 1929, shrank back to the 1914 size. However, while the number of color pages per issue decreased, the proportion of color to black and white remained strong. A large number of advertisers continued to invest in color, though the need for economy was evident in the number of ads that began utilizing a dramatic genre of black-and-white photography. Notwithstanding the rise of straight black-and-white photography in the 1930s women's magazine, the decrease in volume of color printing was somewhat obscured by a marked change in the positioning of color pages between 1934 and 1939. A body of color images was still featured at the crucial beginning of each issue, with smaller runs of color at the middle and again at the very end of the *Journal*—thus maintaining the image of the magazine as a luxurious commodity in its own right.

As the color page in the Depression came to represent a more serious investment, we can assume that it was designed to be as arresting as possible. To appreciate fully the way these brilliant color images figured as "occasions" within the reading process, we would need to study the variety of color images within the extended flow of magazine material. A reading of a single page is insufficient; at most it would demonstrate that the graphic artists of the 1930s were as adept with the grammar of diverse graphic codes as was the anonymous artist who illustrated the 1913 domestic efficiency book. What is needed is a sequential reading (optimally, a *number* of serial readings since, as discussed earlier, the magazine did not work by a single continuum). Though space does not permit a review

Ladies' Home Journal, October
1939, pp. 20, 21

Ladies' Home Journal, October
1939, pp. 22, 23

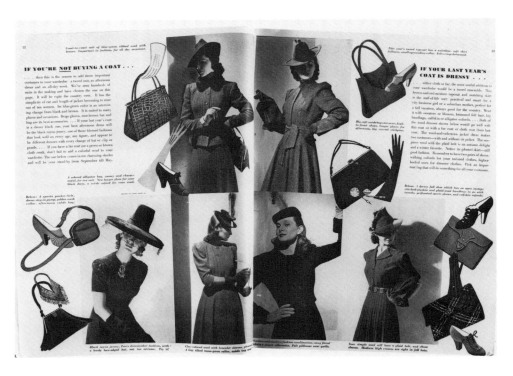

of an entire magazine issue, a look at only a selected run of pages might suggest the way a montage principle was increasingly at work in the cumulative meanings produced by the magazine.

In the run of six pages of editorial fashion in the October 1939 *Journal,* the first pair of pages was geared to the high-fashion market. The layout was sophisticated in its fanning diagonals and bold, alternating pattern of black-and-white and color photos. The second spread was aimed at women with less money who could only afford to spruce up with accessories. The double page still used color printing to feature the Fall shades for hand-bags, shoes, and gloves: however, the models themselves were pictured in black and white. The intended selling point was hardly difficult to grasp: a bright note of color provided by a new bag would do wonders, as demonstrated by the graphic effect of small colorful accents on an otherwise monochrome page. The final fashion spread was devoted to women with even less money. Its color scheme was the most resolutely gay, and, with its stress on "feminine" floral colors, was a return to stylized, diminutive figure sketches. Here photography was reserved for the color portrait closest to center, montaged with a second photo of an ornate gilt frame and compared in the caption to a Joshua Reynolds painting. Though more than a little surreal in its effect, the art historical reference, brought up-to-date in "living color," was clearly intended to lend a pseudo-aristocratic dignity to women without means but with the considerable time, skill, and ambition to remain "in fashion" by sewing their own clothes from patterns.

On these three double pages of editorial fashion, the use of type and graphics ranged from the contemporary, "modernist" style of *Vogue* to a modified version of traditional pattern book illustrations. In other words, each of these three spreads spoke to a different strata of the magazine's somewhat diversified readership. But the consistent fact of color

Ladies' Home Journal, October 1939, pp. 24, 25

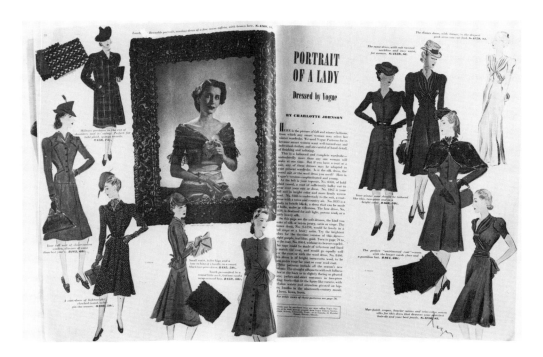

on all three double spreads at the heart of the editorial section of the magazine glossed over these differences, thus conveying the editor's conviction that all the readers assigned the same high value to beauty, implying further that the ideal of glamour was democratic and unifying.

While the run of editorial fashion pages achieved a tight coherence, the graphic codes were articulated just as clearly in the endless juxtapositions in each issue between nominally unrelated ads and editorial columns, pictures, and texts. Consider the interaction between the last full-page editorial column and the fairly typical studio ad in color facing it. The column asked whether men were more adventurous, and thus more fulfilled than women, in their choice of hobbies. The headlined query was set in cool, cyan blue type—the one spot of color on this page. Directly below the headline, scenes of men at play were presented by means of black-and-white photography for added documentary authority. The implication was that women should follow their examples, without acknowledging that a young mother with children, trying also to redecorate her home and "keep herself up," had enough on her hands without worrying about upgrading her hobbies. But any anxiety aroused by invidious comparisons with men's pastimes was resolved as soon as the eye moved to the right. Nothing documented on the left matched the sheer vividness of the well-ordered table on which the brilliant RITZ crackers package served as both central ornament and principal source of nourishment.

Of course, many of these editorial/ad juxtapositions were not calculated—though my research so far in publishing and advertising archives indicates that ad agencies sought to control the placement of their ads and, conversely, that magazines tried their utmost to maintain agency goodwill by "sensitive" layout. No matter how calculated, the recurrence

Ladies' Home Journal, October
1939, pp. 74, 75

of these meaningful juxtapositions suggests a new form of cultural communication. This subject needs further study, but for now I would propose that the separate but integrated codes of color and black and white enhanced the magazine in two noneconomic ways: formally, such divisions provided a dynamic rhythm to the flow of the magazine; functionally, the magazine became a richer vehicle for this diversity, fulfilling the consumer's desire for both Truth and Beauty and maintaining the illusion that these were easily distinguishable categories of experience.

Having devoted considerable space to the importance of long-term changes in format and color, I would be misrepresenting the Depression-era women's magazine if I failed to note a different type of innovation in magazine advertising of the 1930s. Not only was this innovation particular to the Depression years, but it signaled the limits of the magazine as a perfectly rationalized marketing vehicle as compared with emerging modern media. Throughout this analysis, I have tried to suggest the strength of various graphic appeals by describing the page or the ad as "speaking" to the magazine reader. In a discussion of visual effects, the expression invites charges of mixing metaphors. I have used it deliberately, for the idea arguably informed most of the conscious changes in the magazines; moreover, by the 1930s the idea of the "speaking" graphic was achieved in a fairly literal sense as well.

Throughout the 1920s a common mode of selling was the personality endorsement. In women's magazines, film stars and "sociolites" most frequently appeared in this role, in the form of chatty "direct testimony" along with a photographic portrait. This recipe had the virtue of human interest, but the product itself was often upstaged. A 1924 ad for laundry soap attempted to resolve this contradiction by replacing the standard portrait

Ladies' Home Journal, October
1939, pp. 100, 101

and testimony with a picture of pastel baby clothes accompanied by the headline, "If Clothes could talk . . . ," which was followed by the pitch, "We Want Fels Naptha!" A dramatic form was still needed, but the objective was clear.

In the same period that the sound film replaced the silent, a new genre of printed ad began to replace the older testimonial. The hallmarks of this genre were speech balloons and a serial strip form, emphasizing terse dialogue and abbreviated sequential activity that revolved around the product. Though similar in look to newspaper comics, probably radio ads were as influential a source for this trend (the ad agencies after all were creating many of the popular radio programs of the 1930s, programs that moved seamlessly from entertainment to product endorsement). In some cases, these cartoons may have provided a visual guide to audio ads women were hearing with growing regularity on radio. Whether or not they were exact transcriptions of radio ads, they certainly anticipated the storyboards for condensed dramas—consisting largely of close-ups—which would make their debut as televised commercials.

Though radio competed with magazines for audiences and advertising money, the two media were quite complementary. While no magazine could match the perfect continuity of commercial broadcast radio programming, a flow which could accompany the practice of housework, radio was unable to reveal the "look" of a commodified, modernized domestic world. Thus before World War II, magazines served a central role in developing the visible materiality of consumer culture. Furthermore, the murky antinomies of modernized women's magazines—between editorial and advertising copy, between "pleasurable" color and "instructive" monochrome images and text, between the rhetoric of "scientific" housework and the rhetoric of romance—trained the female viewer for the distinctive flow of messages delivered by the predominant cultural institution of the postwar era: television.

Far more work needs to be done on the continuity between these two forms of mass culture, which have had a profound affect upon, and appeal for, women. We need to comprehend better the ways these institutional forms structure meaning. We also need to pursue the *actual* and *differing* ways these messages are received—how they are integrated into a larger complex pattern of experiences and also how they are resisted (at least partially) because of their inconsistency with the logic of our experiences.

1 Robert and Helen Lynd, *Middletown* (New York, 1956), p. 235.

2 The present article, published originally in *Heresies* 18 (1985), draws upon research papers written as a graduate student at Yale University, in Nancy F. Cott's seminar on women's studies, and in Jules Prown's seminar on material culture. In looking for a method with which to analyze the changing structure of women's magazines, I found little specifically on magazines or print media in general; on the other hand, recent work on related issues of commercial culture challenged me to pursue this theme, especially the innovative study of the strip coauthored by Robert Venturi, Denise Scott Brown, and Steven Izenour, *Learning from Las Vegas* (Cambridge, Mass., 1977), and Raymond Williams's more critical cultural analysis of the "flow" of television, *Television: Technology and Cultural Form* (New York, 1977). Since writing my first version of this article, a considerable body of new work on reception *vis-à-vis* the "flow" of modern commercial media has been produced: in particular, the collectively produced series of videotapes by Paper Tiger Television, which offers critical (and also witty) readings of a wide range of contemporary periodicals (see Martha Gever, "Meet the Press: On Paper Tiger Television," *Afterimage* 11:4 [November 1983], pp. 7–11); Tania Modleski's study of the tradition of commercial women's culture spanning Gothics to Soap Operas (though omitting women's magazines), *Loving with a Vengeance* (Hamden, CN, 1982); and Nick Browne's recent article, "The Political Economy of the Television (Super) Text," *Quarterly Review of Film Studies* 9:3 (Summer 1984), pp. 174–82, pursues the issues raised by Raymond Williams's earlier work on television. For this version, I am greatly indebted for editorial assistance to Lucy Lippard and Allan Sekula.

3 See for example, Robert S. Lynd with the assistance of Alice C. Hanson, "The People as Consumer," in *Recent Social Trends in the United States* (New York, 1933), pp. 871–74.

4 See David Montgomery, *Workers' Control in America: Studies in the History of Work, Technology and Labor Struggles* (Cambridge, 1979), especially, pp. 122–27; Loren Bartiz, *The Servants of Power* (New York, 1965), pp. 28–54; and Harry Braverman, *Labor and Monopoly Capital* (New York, 1974).

5 On Gilman's contradictory position regarding efficiency and the transformation of traditional women's work, see Dolores Hayden, "Charlotte Perkins Gilman and the Kitchenless Home," *Radical History Review* 21 (March 1980), pp. 225–47.

6 Ruth Schwartz Cowan explores these issues in "The Industrial Revolution in the Home: Household Technology and Social Change in the Twentieth Century," *Technology and Culture* 17 (1976), pp. 16, 21–23, and at greater length in her later book, *More Work for Mother* (New York, 1983).

7 For a more detailed discussion of this composite illustration, see my earlier essay, "The Composite Photographic Image and the Composition of Consumer Ideology," *Art Journal* (Spring 1981), pp. 39–45.

8 Frederick Winslow Taylor, *The Principles of Scientific Management* (New York, 1915), p. 94.

9 Lilian Gilbreth, *The Psychology of Management* (New York, 1914), p. 246.

Dykes in Context: Some Problems
in Minority Representation

Dykography

Two stories:

When I first realized that I could describe myself as a lesbian, I read everything that I could on the subject. After all, I was in training as a young scholar, and library research was the single area of human experience with which I felt entirely comfortable. What was happening to me in my everyday life, on the other hand, was terrifying, if also exhilarating, so I took refuge from it in the library. I was also curious to see what life as a lesbian would hold for me—to investigate, imaginatively, what my future as a lesbian might be. Books being histories, accumulations of experience over time, I thought then that they could answer my questions.

The future, it turned out, looked pretty grim: like everyone else's, my first literary encounter with lesbianism was Radclyffe Hall's *The Well of Loneliness* (1925), from which I learned that self-renunciation and noble suffering (which, like most women, I had already learned at my mother's knee) were the most that I could aspire to. Curiously, I felt a far larger frustration with this book's *form* than with its moral position: it offended me aesthetically. It was a far clumsier novel—less erotically or intellectually satisfying—than those I had come to love and analyze as an undergraduate English honors student. It upset me—this was my first experience of the lesbian's marginality—that I should somehow have to settle for novels that I would otherwise find uninteresting, simply because they were the only ones peopled with lesbian lives. This discontent is still a problem for me twenty-two years later, though I recognize how fortunate I am that this is the strongest experience of marginality I have had.

My second brush with published sapphistry was a peculiar book of popular sociology by a male author, Jess Stearn. *The Grapevine* purported to examine the lives of a broad cross section of lesbians in America, c. 1964.[1] Once I had finally worked up enough courage to walk up to a counter at the University of California bookstore and brazenly

buy it, I read the book eagerly. What I discovered from Stearn was that we were, all of us, damned: some more colorfully than others, some more thoroughly than others, but all damned nonetheless. In his many anecdotal portraits of lesbians across different ages, classes, professions, and regions, Stearn made several things all too clear: fidelity was unlikely, alcoholism probable, promiscuity endemic, loneliness inevitable, and alternatives unthinkable.

Now here's the catch, the whole point of my bringing this up: it was very important to me that my sister, who is eighteen months younger than I, understand something about this new identity of mine. And being an earnest young scholar, and having unearthed this book that (given my own inexperience) seemed to represent exhaustively the world I was now entering, I sent *The Grapevine* off to my sister. I intended it as a sort of teaching aid to the primary text of my new identity as a lesbian. I was twenty years old.

Looking back on this, it surprises me that my sister didn't contemplate a swift mercy killing. Of course, I had no idea then how awful a representation of lesbian lives *The Grapevine* was; in a sort of paradoxical and finally transformative reading, I both accepted its image of lesbians and ignored its gruesome moral in favor of the vivid sense of connection it gave me to women I longed to know. It was 1965, and there were no women's centers, no women's bookstores, no women's publishers as there would be five years later. I was young, I was guiltless, and all the horrors Jess Stearn described lay (if at all) in my future. Beyond adulation of the San Francisco Mime Troupe's guerilla theater, I was innocent of a politics. So though I did think it odd that a man should have authored a book about lesbian lives, it was difficult for me to see precisely where the problem lay, since the conclusions Stearn drew were identical to those of the only lesbian author I knew of: Radclyffe Hall.

Soon I discovered the popular novels of Ann Bannon and Claire Morgan, and Djuna Barnes's elegant and very literary novel *Nightwood.* Though of varying degrees of interest in the formal terms by which I had been taught to read and value literature, their subtexts matched those of Hall and Stearn: lesbian lives were doomed.

My second story:

In Phoenix twelve years later, a woman I worked with bought her lover a book of photographs for her twenty-seventh birthday. Rita showed me the book after she found it at a mall one day on her lunch hour. It was a book of gauzily-diffused nudes—two elegant-looking women seemingly engaged in lesbian lovemaking: *Sappho,* by J. Frederick Smith.[2] *Playboy, Penthouse, Hustler,* and other men's magazines frequently run similar sorts of photographic features: medium-range and close-up shots of naked or exotically dressed women in close embraces, kissing, coiling about each other like serpents, the crotch or breasts of one of them always curiously pointed, not at the other, but toward the camera and the absent but implied presence of a (male) viewer.

Rita looked at me with such visible pride in her purchase that I did not tell her what I thought of her book. After all, who was I to tell her what she should and shouldn't find erotic, whom she should or shouldn't support through her book buying? But it made me terribly sad to think that that book's distinctly male fantasies about lesbian eroticism should have been the only thing Rita could find in book form that approximated her own sexual focus.

This second incident took place in 1977. Between then and now a number of lesbian institutions have been instrumental in the production and distribution of lesbian photographic representations. These images circulate through publications like the late *Blatant*

Image, Sinister Wisdom, Conditions, Heresies, Thirteenth Moon, On Our Backs, through women's centers and alternative galleries, and through the wonderfully complex informal networks that lesbians—feminist and otherwise—have developed throughout the United States and Canada.

Yet I am confronted with a discomforting paradox—rueful, dykey, not politically correct. It is this: that for all our seeming gains in having created our own visual representations—our own visual identity, you might say—something valuable has been lost as well as gained. Those older representations—the illustrated book covers of lesbian pulp paperbacks in the 1940s–60s, the covers of *The Ladder*—despite their fictitiousness, their sexual stereotyping, acknowledged desire, acknowledged the power of lesbian sexuality in a way that much contemporary lesbian self-representation does not.

This is not a conclusion I reach lightly or without great reluctance. I have cross-examined myself: am I simply nostalgic, as if often the case with members of a once-embattled, now partially tolerated or assimilated subculture, for the days when to belong was also to be a social outlaw, a member less of a culture than of a cult? Am I succumbing to that treacherous fantasy of a now-dead organic community, which, as Raymond Williams has wisely reminded us, is already "always gone"? Or am I perhaps yielding to the ubiquitous fantasy of the middle-aged—finding the period of my own youth more exciting, more stimulating (after all, it was mine) than the present?

All of these speculations are partially true for me. In addition, though, and this is partly the focus of my essay, I think that much of our current self-representation has been effected at the expense of our sexuality, or at any rate of its representation. In seeking to represent the female sexual outlaw, the dyke, as a whole person, many photographers have ceased imag(in)ing her as a hole person.

As I have said, I neither reached this conclusion lightly nor am I pleased by it, but I do think it important to explore, no less for those of you engaged in other struggles of self-representation than for lesbians. For although what I have written thus far may appear to present a merely local problem—perhaps even a purely personal one—I think otherwise: what I am exploring here is the problematic interplay between culturally prevalent forms and what are intended as oppositional practices, between what is expected of us by our own and by dominant groups, between what we are willing to grant ourselves and others of our own/their expectations.[4]

The Hole in Space

My focus is the work of a number of lesbian photographers who make photographs for a variety of communities. In 1984 I placed an advertisement in the summer and fall issues of *Afterimage* seeking lesbian images. The advertisement read:

Submit papers, proposals, slides: On Problems of Representation in Lesbian Photography, for possible exhibition/publication in 1985–86 and for presentation at the 1985 Society for Photographic Education national conference in Minneapolis.

I also wrote to a number of lesbian photographers and lesbian publications that used photographs, explaining the project in detail. In response, I received ten initial query letters and slides for consideration. Through the informal lesbian networks nationwide, I received an additional seven letters and several sets of slides; I also viewed work at the Lesbian Herstory Archives in New York and solicited/discussed a number of photographers' work by phone. Although my notice stated that September 15, 1984, was the cut-off date, I continued to receive work for well over a year, the last from a woman in Waniassa, Australia. Of such is this invisible empire constructed.

It seems important to stress at the outset that Western lesbianism as a cultural identity is itself a product of capitalism and industrialization. Though same-sex love is as old as history, its expression as an exclusive sexual and personal identity in Western societies—an identity whereby its adherents identity ourselves as lesbian and live much of our adult lives exclusively with or among other women-loving women—is peculiar to the late nineteenth and twentieth centuries. Large cities and workplaces have created the conditions of social mobility, population density, and (relative) economic security necessary for lesbians to find each other and to create institutions for ourselves (and likewise, they have made it possible for our enemies to identify us through the growing visibility of our practices and institutions).[5]

In the earliest phase of this process, lesbians produced little in the way of publications or other vehicles for visual imagery. When lesbianism was represented visually, it was largely from without, by men speaking from and for dominant culture: one thinks immediately of the pornographic films, peep shows, and photographic card sets of commerce, the lesbian masquerade of the classical Hollywood film, the Parisian photographs of Brassai.

Lesbian visual self-representation in the early twentieth century was limited largely to noncommercial artwork undertaken and distributed informally, from hand to hand, within lesbian subcultures: snapshots made with amateur cameras, private lesbian paintings and photographs by privileged, well-known artists and self-taught amateurs, and later, voluntary labors-of-love like The Daughters of Bilitis's monthly magazine *The Ladder* (1956–72). So far as I know, there were few commercial enterprises involving production, distribution, and exhibition of images from within lesbian communities until very recently.[6] In this sense, what self-generated images we do have from the first sixty-odd years of this century exist not as commercial commodities but as personal mementoes, private or collective expressions of regard and friendship. They existed, in other words, outside the standard practices of commercial production and circulation, and, as such, their content was not determined primarily by the dominant culture's market values and methods. Alongside them books and images produced primarily to satisfy a heterosexual male market, like *Warped Desire, Sappho,* and *The Grapevine,* have also been collected and treasured by lesbians, their homophobic contents read transformatively and positively, as I had read them in my youth.

By the end of the 1960s, the United States's largest generation had come to adulthood in a wartime boom economy. Alongside the early civil rights movement and partially growing out of a resurgence of feminist and New Left theory and practice, lesbian and gay liberation movements appeared, creating a host of institutions catering to lesbian and gay desire for self-identified culture: community newspapers (such as *The Lesbian Tide, The Advocate, The Body Politic,* New York *Native,* San Francisco *Sentinel,* and *Bay Area Reporter*), magazines (*Sinister Wisdom, Heresies, Thirteenth Moon, Christopher Street*), publishing houses (Spinster's Ink, Daughters, Inc., Naiad Press; significantly, there were fewer gay presses than lesbian ones, a fact attributable at least in part to the easier time that gay men *as men* still have in publishing their manuscripts with mainstream publishers), theater, political organizations, churches and synagogues, singing societies, orchestras, and on.

These subcultural institutions ranged from community-based, not-for-profit collectives to profit-making, capitalist ventures. *The Lesbian Tide* (1971–80) of Los Angeles, for example, was published by an editorial collective that struggled throughout its existence to put out a newspaper combining local and national news and images of interest to lesbi-

ans. In contrast, the gay male *Advocate,* published first in the Bay Area and now in Los Angeles, was from its founding intended as a profit-making newspaper run along editorial and advertising lines identical to those of dominant culture's newspapers. The contradictions inherent in circulating and consuming sometimes identical images within such radically different publishing contexts will return to haunt us later.

In any case, both within mainstream and lesbian/gay subcultures, rising personal, social/political expectations and the proliferation of lesbian and gay cultural institutions in the 1970s and 1980s produced a wide variety of uses and meanings for photographs, our main concern here.[7] This demand for images of lesbians and gays—transcriptive photographs for news-reporting purposes, traditional portraits of couples and individuals, pornographic photographs for the rapidly growing gay (and more lately lesbian) commercial porno industry, "corrective" life-style images for both lesbian/gay and straight audiences—coincided with and has been affected by feminist theory and criticism, as these have successively and variously defined themselves.

One of the most remarkable effects of feminist examinations in the 1970s of the ways women have been visually represented is a widespread, reactive move away from representation of the female body and female sexual experience. This is more true of visual than of literary and performance representations, and we need to understand why. As Rosalind Coward has noted, "speaking about sexuality, and a preoccupation with sexuality, is not in and of itself progressive," but neither, for that matter, is silence on the subject. What one might bear in mind, however, is that either reaction—a speaking out or a silence—is bound to be taken several ways, according to who is doing the interpreting. Both dominant and subcultural messages can be read variously, even contradictorily, for they are read by at least two different constituencies: an intended or *internal* audience and an accidental or *external* one. Both messages share a number of values/meanings for their audiences—members of subcultures are, after all, informed outsiders, understanding the meanings/values attributed to mainstream cultural messages as well as producing their own more limited ones. But the reverse is not also true: heterosexual men and women, for example, are not likely to understand the specific erotic valences of much lesbian and gay sexual imagery.

We need to recognize the problems inherent in serving and interpreting two cultural "masters," rather than stimatizing the sign-ers as hypocritical or inconsistent. The latter reaction, unfortunately, is the more common one around the subjects of both lesbian silence *and* lesbian celebration of sexuality, with both outside and inside critics condemning either the presence or absence of lesbian erotica. A further problem is that, as is common in criticism of visual artifacts, too much attention is paid to what lies within the frame and too little to the establishing contexts that surround it. This is even more the case when the photographs in question circulate within the forms of modernist high culture, wherein photographs are commonly treated primarily as formal arguments.

In the case of the much commented upon antisexuality of much politically active lesbian writing and photography in the 1970s, one can see the downplaying of sexuality as a gesture of accommodation toward the heterosexual world of dominant culture, not only as a correction (reaction) to the prevailing male construction of the lesbian as perversely and exclusively sexual, but also as the price of being able to work alongside otherwise discomforted straight women (the "lesbianism means making your primary emotional bonds with other women" tack, which drops out sexuality as one of the engines of lesbian culture identity) on political issues affecting us all—ERA, abortion reform, child

custody, equal pay, the continued genderization of the job market, and so on.[8] Within lesbian communities as well, sexuality has been frequently downplayed as the price consciously paid for community. (The emergence in the 1980s of open lesbian s/m communities argues for the possibility of sex as a bonding rather than atomizing practice.) Within lesbian-feminist subculture, however, the same period also saw the production of a great deal of writing and image-making addressing sexuality directly: *The Cunt Coloring Book, Blatant Image,* the graphics of Tee Corinne, Barbara Hammer's films, Samois's s/m theory/ practice manuals, Pat Califia's prose, and more.

This brings us to one of the two central problems I can see in writing about lesbian, gay, or other minority photographs: defining what it is that defines them as lesbian, gay, latino, or whatever. Is a *lesbian photograph* an ontological entity, or does it gain its classificatory status through use, nomination, or what? *Whose* use or nomination? Such questions bring us squarely to a consideration of what it means to represent a subject in photographs.

Where We Come From

I remember that in 1972 two women came into my social circle and brought their instamatics. They were feminists and "just out" and brought their Kodaks to our parties and took snapshots. . . . We were embarrassed. All of us too shy to say, "No. Stop. Don't take pictures here. Don't take pictures of lesbians. Of us. It isn't allowed." Those of us who vividly remembered photographs being used against lesbians in court, those of us who had ever heard of a custody battle for our children just stopped coming to the parties. The rest of us somehow stayed and survived. We didn't make them stop taking pictures and for the first time since childhood I had pictures of myself. No myself-at-the-folks-passing-for-straight but of myself.[9]

What does it mean to re-present oneself visually as a gay or lesbian person? Does it produce something like the coverage one finds in a middle-class, dominant-culture magazine like *Time, Newsweek, Life,* where gays—at least post-Stonewall, pre-AIDS gays—were conventionally depicted as clean-cut, shiny-haired, Land's-End *citizens with a difference*? Is it similar to the coverage one finds in a working-class, dominant-culture magazine like *National Enquirer* or *The Star,* where gays wear silver-lamé jockstraps, linesman's boots, and little else, and lesbians T-shirts with cigarette packs (hard) rolled in our shirtsleeves? Or the depictions in, say, middle-class, mainstream gay publications like *Christopher Street* and *The Advocate,* where gay men are usually Caucasian, handsome, moustached, short-haired, palpably middle-class consumers? Or *Blue Boy* or *Honcho*—"hot and hunky" (hairless/ hairy)? Lesbians: which representation has greater authority for you: the wanton woman in Victoria's Secret underwear or leather in *On Our Backs* or the jockettes in a photographs of GAA softball players printed in a local bar guide or gay city newspaper? Any of these? All? None?

Obviously, we must ask ourselves a second question, not simply about which cultural institution's representations have authority or resonance or credibility, but *for whom:* for the Moral Majorian seeking proof for his contempt; for a parent of a gay seeking evidence that gay lives can be (almost) happy, (almost) normal; for a gay person living a closeted or isolated life, eager for evidence that others of her or his sex, class, race, sexual preference exist as openly gay; for a concerned straight person attempting to understand—to see— something about a gay friend's culture; for a gay or straight fantasy, turn-on, turn-off, daydream, nightmare. This question is in turn complicated by all that we know of ourselves: each of these distinctive audiences lives within us as well; we are no more homogenous as identities than a stadium full of voters.

The point is that any visual representation is initially addressed through a cultural medium possessing greater or lesser authority to a particular constituency, for whom it may possess a greater or lesser degree of authenticity. As it moves beyond this primary audience, however, it acquires other meanings, other statuses. This is a condition of circulation that no one can afford to ignore. Images in the mass-circulation media, for example, possess a power that is rarely successfully challenged precisely *because* their widespread distribution posits them as representations of widely (and thus popularly) held values. Such images—in the form of advertising, editorial, public service, fashion, sport, or photojournalistic photographs—gain much of their power through the (seeming) simplicity of their means, which seek to limit possible readings in favor of central, market-desirable one(s).

What part of us produces images we might call lesbian? I can see many problems with the sampling of photographs with which I attempt to raise this question. It is heavily weighted toward women self-consciously allied with art/academic photographic institutions (the advertisement in *Afterimage* partially assured that). From my review of the holdings of the Lesbian Herstory Archives and the negatives and prints by many lesbian photographers that I found through other channels, I believe the vast majority of lesbian images are of the record-making variety. Whether recording domestic/private activities or public events in which lesbians figure, such photographs present us with a photographic practice that is specifically lesbian not in its attitudes to issues of representations of sexual and social difference and the contexts in which the work is encountered, but rather in its content: it records social occasions in the lives of women living as lesbians—demonstrations, vacations, concerts, festivals, parties. It does so in a manner identical to that of other social groups, making such photographs lesbian only in the sense that the people recorded therein are self-identified as lesbian.

Rosalind Coward has made a distinction between women's novels and feminist novels that seems useful here:

It is important to distinguish between [women's] novels . . . not in order to designate one text as progressive in a crude moralistic way—far from it—but because with the increase of feminist involvement in cultural politics we cannot leave unasked the question of how representations work. . . .

Feminism can never be the product of the identity of women's experiences and interests—there is no such unity. Feminism must always be the alignment of women in a political movement with particular political aims and objectives. It is a grouping unified by its political interests, not its common experiences.

Finally, I think it is only if we raise . . . questions of the institutions, politics of those institutions, the representations produced and circulated within those institutions and the assessments of those representations that we can make any claim at all to a "feminist reading." [10]

This is no idle distinction. We can profit here from observing the vicissitudes of one of the most consistent arguments running through lesbian-feminist literary theory—namely, the question of whether or not there is anything intrinsic to the writing of lesbians that proposes their prose or poetry *as* lesbian and the larger question that points to: whether to define the field of inquiry on the basis of its presumed essence or its operations.

The field of lesbian literature, for example, has been largely defined in terms of authors' biographies (Jane Rule's 1975 *Lesbian Images*), stylistics (Barbara Smith's 1977 article, "Towards a Black Feminist Criticism" [11]), creative energy (Adrienne Rich's 1979 essay, "It Is The Lesbian In Us" [12]). The biographical approach has the obvious advantage of grounding the field of inquiry in something highly tangible—the known practices and

affectional values of a writer—but it is likely at the same time to be highly reductive, since the biographical details of many authors' lives are unknowable and, more important, do not map simply and reflexively onto a person's art practices. A stylistic, *écriture féminine* approach privileges a particular use of language as if it were *essentially* lesbian rather than a subversive literary strategy equally available to men and women of any sexual identity. Similarly, the proposal that female creative energy is intrinsically lesbian produces a category—lesbian writing—that is so all-inclusive as to be useless for defining a field for inquiry.[13]

My tactic is instead one that arises from the specific historical formations of contemporary urban lesbian-feminism. The field I survey here is one comprised of photographs produced for distribution within the cultural institutions of lesbian subculture and secondarily within mainstream gallery settings, where (art-) accredited lesbians sometimes exhibit their work.

This resolves the question of whether or not to include private record-keeping photographs. Fascinating as they are, they are not intended to, nor do they, circulate through institutions that allow them opportunities to propose themselves as lesbian representations.[14] The photographs I was sent, on the other hand, as well as many that I found in archives, were intended and used within the subculture's institutions—its periodicals, postcards, posters, books, slide shows, and exhibitions. Within these venues, photographs propose certain things about lesbians: the ways we look, behave, *are*. It is these propositions I will address in this paper.[15]

There is no way to know if the photographs I received are representative of politicized lesbian photographic activity as a whole. Nor do I know if it is possible to draw any conclusions from the work that would apply across the field of U.S. lesbian photography. I make no claims to do so.[16]

As a critic, I can see any number of problems in proffering a personal reading of these photographs. The danger is always that such a reading will be so idiosyncratic—compounded out of my private concerns, my inevitably personal and partial consciousness of art and cultural histories, political convictions, and the peculiarly epicene conclusions that the very act of writing produces—that it will serve no purpose other than to clarify certain things for me, at the same time reenforcing for the reader a widely held notion that critics' concerns are too unworldly to constitute anything but a curious form of entertainment.

The most readily available alternative to such a privatized critical reading is the communications model or sociological or audience-response reading based upon quantitative studies of viewers'/readers' reactions to work. This, I think, also has its limitations: the kinds of questions *askable* under such models are limited to fairly simple and reductive ones, as are the possible replies.

What I hope to do here is to steer a middle course between the extremes of a highly personal and highly quantitative approach. I have shown the work I will be discussing to audiences ranging from a single viewer to a seminar group in feminist theory and criticism to a convention audience of approximately two hundred people. In all instances, I have been struck by the similarity of people's initial reactions to the reproductions I used to contextualize current lesbian photographs—that is, the pulp images common in men's magazines and fiction of the 1930s-60s. In contrast, reactions to the self-representations of lesbians differed markedly from audience to audience.[17]

I went to reflect on the material practices of a few lesbian photographers operating simultaneously within two contexts: dominant American culture and urban lesbian-feminist subculture, each of which makes some things easy to do, some difficult, some all but impossible. This is true at the levels of production, distribution, and exhibition of photographs. Though the range and number of lesbian photographers considered here is narrow, I hope that my discussion will prompt wider and deeper investigations, not only by lesbians but by any people who have not spoken through representation but rather have been spoken for.

We will begin by looking at the ways lesbians have been represented in the dominant culture's images, since these are the ones against which lesbian self-representations have primarily been produced and positioned. Happily, this isn't a particularly difficult task to perform: such images are everywhere, forming part of our mass-media image world.

Commercial depictions of lesbians have concentrated exclusively on sexual identity as a function of sexual activity. Lesbians, I need hardly add, are in turn identifiable solely through their sexual activity with one another: a tautological identity. The notion that the model demonstrating a refrigerator, working out on a home-fitness machine, or modeling lingerie might also be a lesbian is unthinkable within the set of assumptions wherein such commercial representations operate, for the lesbian can be identified *as such* only through her sexual activities vis-à-vis another woman (perhaps a lesbian, quite possibly "a victim," since the "true" lesbian is popularly coded as predatory and male-like)—or, to be more accurate, *pre*-activity: at least one of the lesbians in much popular pulp imagery is commonly depicted as still *a woman:* she waits, she yearns, but she doesn't do much. If we look, for example, at the covers of pulp paperbacks depicting lesbian relationships in the 1940s-60s, we find that in these little worlds we are represented as exclusively sexual beings. Typically, we find a couple situated on or near a bed or an open door, with all that

Cover illustration, *Warped* (New York: Beacon Books, 1955)

Cover illustration, *Warped Desire* (New York: Beacon Books, 1960)

those symbols commonly imply of sexual transgression or exploration. Like the pornographic treatment of lesbians in *Penthouse* and *Hustler,* these depictions conventionally pair blonde and brunette, blonde and redhead. Unlike contemporary male fantasy fodder, however, which pairs similarly made-up models of comparable body type, these pulp paperbacks make explicit allusion to butch-femme dichotomies: what were popularly conceived of as "male" traits are attributed to one partner (short hair, tailored clothes, piercing stare, wiry, boyish build, dominating position above and behind partner), while the other is commonly depicted as exaggeratedly feminine (*en deshabille*—peignoir, brassiere or slip, frilly underpants—long hair, modestly downcast glance).[18]

As in male pornography, the "ethereal" blonde is portrayed as passive and feminine—the innocent victim (femme)—while the "earthy" brunette or redhead is active and masculine—overtly sexual (dominating butch). In looking at twenty-four pulp fiction covers from the Maida Tilchen Lesbian Trash Paperback Collection at the Lesbian Herstory Archives (New York), I found that 63 percent of the illustrations employ dominant/dominated subject positions; 67 percent play a short-haired, boyish butch against a long-haired femme; 88 percent employ a blonde-brunette/blonde-redhead pairing. Such consistency testifies to the marketing potency of these (supposed) signifiers of lesbian eroticism, which in turn suggests the publishers' projection of signifiers potent to *male desire* onto the lesbian. That is, most of the social and sexual differences encoded in these illustrations say more about male illustrators'/editors'/readers' concerns with imposing marks of gender difference on the objects of their desire than they do about lesbian lives.[19] Here, I might add, I am not invoking the putative authority of (my) lesbian experience as a corrective to male representations. Rather, I am interested in the differences between dominant cultural stereotypes of a subculture and that subculture's own stereotypes.[20] The consistency with which *all* audiences can read signifiers intended for primarily male producers/consumers contrasts markedly with the limited ability of heterosexual audiences to interpret quite another set of images produced by lesbian-feminist photographers primarily for lesbian audiences—which only tells us again what we already know in other ways: that subcultures are informed outsiders of dominant (here, of course, male) culture, understanding the signs of its desire very well, in ways that are not true in reverse.[21]

Whenever I show these pulp book covers to audiences, reactions are invariably amused and positive, whether those audiences are primarily heterosexual or gay or lesbian or lesbian-feminist. There is an undeniable pleasure to be found in these images, in the exercise of viewers' ability to read propositions about male desire so clearly; for when the images are presented in large numbers, their fixations become obvious. They also offer the pleasure of nostalgia: a removal of that contemporary ambiguity about sexual identity that makes their comforting male-female polarity appear artless and lost—desirable. But what seems most remarkable about them *in our current image climate* is the very overtness and insistence of their sexual interest. The rapacious gazes, the body postures, the sexually-coded costumes and setting, and the texts propose a narrative of (masculinized) female sexual heat that is missing in *Hustler*'s or *Penthouse*'s versions of lesbian sexuality, where the fantasy's contents, soft focus, and static, iconic presentations remove the depicted activities from the everyday.

In contrast, the pulp paperback covers place their subjects in bars, streets, college-girl bedrooms, thereby situating desire in everyday life. Pulp titillation appears to have moved male fantasy materials from quotidian encounters with the sexually exotic and challenging to a leisure-world, passive consumption; from the representation of aggressive lesbian

sexuality to a "softer," more abstract contemporary version. This change in fantasy images coincides with the very real visibility of active heterosexual female and lesbian sexuality just outside the covers of these magazines.

If we turn to visual representations of the lesbian within lesbian subcultural settings, we find a different story. It is compounded of practical applications of feminist (primarily film) theory and of modernist photographic theory and practice as taught and learned within the colleges and universities where so many lesbian photographers learn their craft and aesthetic values—values that do not necessarily serve the historical moment of their intended or accidental audiences as they might hope.

Increasingly in the 1970s, feminist literary and film theory stressed the problematic nature of any representation of the female person. The first and more obvious problem with female representation was that historically women's identity and image have been cut to the measure of male desire. How, feminists have asked, can women re-present ourselves in ways that do not fall into the conventions (and thus the ideology that those conventions partially both mediate and represent) of a patriarchal construction of femininity?

Two principal positions have emerged in response to this question. What has been termed the essentialist position poses a sort of bedrock femininity, long repressed by patriarchal institutions and discourses, which might rise up and reassert itself as we women grope out way into a female-centered consciousness, from which we can then speak our own femininity. Criticism proceeding from this position assumes, whether explicitly or implicitly, the existence of an authoritative *feminine* experience that can speak for and to women and against the constructions that men have placed on women's experience.[22] That this position is ahistorical and metaphysical has become increasingly obvious. If the principal barrier to "true" femininity could be identified as extrinsic—men and their culture—and the solution therefore simple—women's culture—then Valhalla should have arrived in certain separatist urbane enclaves by 1972. It didn't. Our own Problems with Women clearly were deeper than the dominance of men's culture.

As feminists increasingly incorporated psychoanalytic theory into our analyses of cultural patterns, and as the rifts between white, middle-class, heterosexual feminists and lesbians, poor women, and women of color became more visible, a second position arose. It saw femininity as itself a psychic and social construction, as a constantly shifting, fractured identity, taking on meaning principally as a structuring absence—the absence of masculinity, that symbolic/social presence around which all other gendered identities revolve—that defines itself in relation to or reaction against various historical masculinities. How and to what extent meaning is determined by (which) masculinity is an issue preliminary to any questions of interpretation, however.

As Ann Kaplan has noted, the "essentialist/anti-essentialist debate is important since the position one takes determines one's feminist methodology: it will affect the kinds of questions one asks and the kinds of knowledge one uses."[23] Even within a single structuring paradigm, there can be enormous differences in interpretation. For example, I can point out the differences between Abigail Solomon-Godeau's and my own readings of the issues raised by Frankie Mann's attire in Connie Hatch's "Adapt," the second segment of Hatch's slide-tape trilogy *Serving the Status Quo: Stories We Tell Ourselves, Stories We Tell Each Other*. Both of us operate out of an assumption that personal identities are culturally forged rather than genetically programmed, but one of us is heterosexual and one lesbian-feminist. I believe that this difference leads to according Mann's clothing different

meanings, different values. For Abigail, Mann's "masculine" haircut and clothes constitute a "central contradiction that emerges" between Mann's "expressed revulsion for all that constitutes the signs and attributes of masculinity and her assumption of a relatively butch persona."[24] This interpretation assumes that Mann's lesbianism is constructed primarily through reference to signifiers of *masculinity*,[25] which in our culture include short hair, tailored shirts, and slacks.

However, it is equally possible to begin with the proposition—an argument central to much lesbian-feminist struggle—that such attributes are signifiers whose cultural meaning(s) is equally determined by the (sub)culture in which they are activated, that their play within subculture partially evacuates their prior or parallel meanings elsewhere. That is, if we consider Mann's "relatively butch persona" not in terms of "socially constructed gender roles that patriarchy has manipulated for its own ends" (Kaplan, p. 235) but in the lesbian's own terms, then Mann's no-nonsense clothing, haircut, makeup-free face and physical ease, far from representing "nothing so much as the adolescent male colonizing physical space" (Solomon-Godeau, p. 135), may with equal plausibility signify a claiming of *human* physical and social power denied women through conventionally "feminine" dress and deportment, which is the construction that I and many other (nonessentialist) lesbian writers have placed on the significance of clothing.[26] Put in other terms, what stands in one context as signifier of masculinity becomes, to those viewing it from within another, signifier of the non-conventionally female or as the unconventionally female— the lesbian.

The important thing to note here, since I see it as a way out of the dilemma also posed by the photographs under consideration, is that as signs move away from their culturally specific "climate," they become constituted as signifiers pointing to new meanings. What may appear retrograde or progressive, unsophisticated or sophisticated, obscure or blatant depends primarily on the climate for or within which the sign is produced/circulated and the expectations set for it. I therefore quarrel with a commonly held position within much feminist cultural, film, and literary criticism in the late 1970s-early 1980s, here enunciated by Mary Ann Doane in relation to film, as far too generalizing and pessimistic in its assumptions about the audience's probable reception of images of women:

Cinematic images of woman have been so consistently oppressive and repressive that the very idea of a feminist filmmaking practice seems an impossibility. The simple act of directing a camera toward a woman has become equivalent to a terrorist act.[27]

Such a position seems unduly pessimistic about the limitations imposed by dominant cultural forms or producers and readers, both as subjects of dominant culture and as possible subjects of subcultures as well. Though sophisticated, it is functionally a model of text production and consumption that leaves no possibility for transformative creation or reception. Instead, it suggests that we are stuck inside a culture that so inscribes patriarchy that the most we as feminists can hope for is to content ourselves with the fissures, the holes, the absences, and the silences within patriarchal discourses.[28]

In contrast to this scenario, subcultures—lesbians, gays, and other minorities—have regularly transformed the materials and values of dominant culture for our own purposes. Doane et al.'s pessimistic scenario is a historical one that may indeed reflect an impasse in narrative cinema for some middle-class European/North American white feminist practitioners and theorists, but it has little to say to the rest of us, who have yet to be self-represented cinematically, photographically, *at all*. Without in any way intending to dis-

in rhetoric it has become that - but what is the reality- is there one ?

miss the enormous problems in re-presenting female, much less lesbian, sexuality, I none-theless reject the model that much recent feminist literary and film criticism calls for, a model whose authenticity is guaranteed by its supposed transparency of interest in and attention to the medium's technical/formal apparatus.[29] Such a model is of little practical use outside of those academic and avant-garde circles where formal innovations are considered central to efforts of liberation.

The Heart of the Matter

The pedagogical question crucial to Lacan's own teaching will thus be: *Where does it resist? Where does a text (or a signifier in a patient's conduct) precisely make no sense, that is, resist interpretation? Where does what I see*—and what I read—*resist my understanding? Where is the ignorance*—the resistance to knowledge—*located? And what can I thus learn from the locus of that ignorance? How can I interpret out of the dynamic ignorance I analytically encounter, both in others and in myself? How can I turn ignorance into an instrument of teaching?*[30]

Is there anything that is not w/in the structure?

I turn now to the photographs I was sent, found, collected during the last several years. This is not intended as a formal analysis but rather as an inquiry into the cultural work they do. Unless we begin to understand the complex constraints on lesbian photographers in the face of both subcultural and mainstream values and practices, we run the risk of dismissing their work as "unadventurous," "old-fashioned," "not-on-the-cutting-edge," and other art-in-a-vacuum pronouncements. It is crucial to understand that the conditions under which work makes its way into the world operate to make some work likely, some possible, some virtually unthinkable, some makeable but unshowable. This is what interests me—that point of intersection between what the producer makes or attempts to make and the world that receives it.

In her important study of the nineteenth-century American novel, *Sensational Designs,* Jane Tompkins explained that her "assumption in each instance has been that the text is engaged in solving a problem or a set of problems specific to the time in which it was written, *and that therefore the way to identify its purposes is not to compare it to other examples of the genre,* but to relate it to the historical circumstances and the contemporary cultural discourse to which it seems most closely linked."[31] Tompkins's assumption and method seem equally applicable to the matter at hand—an elucidation of the cultural work of lesbian-feminist photographs. But I am conscious that to address the photographs in this way flies in the face of most photographers' and readers' expectations of what will get said about them.

Those of us who are interested in photographs nominated as "personal" or "art" images are accustomed to hearing them discussed formally, which is a heritage of photography's arrival in the academy in the late 1960s, when the simplest way of paving over the painful differences among images and their readers—and to claim for them the seriousness of modern art—was to discuss them using agreeably vague and democratic terms like *intensity, originality, genius, formal purity, line, movement.*[32]

Being aware of the tyranny of readers—and my own—expectations about such matters, I have found myself resisting writing what might be thought the central section of this article, namely, a consideration of the photographs themselves. Even that phrase, *photographs themselves,* seems to privilege the images as the heart of my project.

My resistance has taken a classic form: it has taken me over a year to write this section of the article, and even as I write, even as you read it, the slide between an honorable (expected) intention and what I am in fact doing is evident: the prefatory material I

consider critical to a discussion of the photographs has extended itself indefinitely, pivoting endlessly around what may appear to you as a hole, a vacuum. I feel an anticipatory guilt toward the photographers who sent me their work, trusting that I would *analyze* it, only to find that I am doing something quite different; I feel a similar anxiety about my readers, who expect no less; and yet (*Yes, but. . . .*) I am convinced otherwise. There is a reason for resisting the expected here, something to be learned from it. Wrapping and rewrapping the photographs in these many layers of historical circumstance seems the only way I can shape what would otherwise be an unsatisfying and academic approach to them.

Analyzing the formal strategies deployed in these photographs would "explain" only how a particular representation is constructed visually; and it is the representation *as a sign, an argument* in the world, that interests me. This emphasis points us away from that enclosure measured by what lies within each photograph's frame, the province of most academic criticism of photographs; it points us instead to a field constituted very differently: the concrete, historical sites *in which the photographs are encountered* by different people, sites where they establish their meanings.[33] Thought about this way, both the presences and absences in these photographs become more lucid: we can read images as sites of consensus or resistance to cultural prescriptions/proscriptions, as locuses of contending discourses, such as those of academic art photography and dominant and subcultural politics, rather than as isolated acts of individual creativity.

Central to all these photographers' work is a conviction that it is a positive act to represent lesbian lives, that, in the words of Tee Corinne, "The images we see, as a culture, help define and expand our dreams, our perceptions of what is possible. Pictures of who we are help us visualize who we can be."[34]

Who the *we* that is speaking and spoken to is, of course, a core problem to this statement as well as to the picture-making that follows from it. The *we* the seven photographers discussed below use to position themselves within lesbian subcultures varies widely, as do the *we*'s addressed. But in teasing out those *we*'s, the rationales, strengths, and limitations of these different approaches become more understandable.

All of the photographers I discuss here work against something of a vacuum in lesbian self-imagining. During the 1950s and 1960s, when the oldest of them were in their childhood and adolescence, these photographers had access to few representations of dykes from within our own communities; the images with the widest circulations appeared in *The Ladder,* a long-running lesbian monthly produced by the national organization The Daughters of Bilitis.[35]

Two things about *The Ladder*'s graphics are particularly striking for viewers in these post-Stonewall, (hopefully not post-) feminist days: their emphasis on the dyke-beneath-the-lady—the tomboy hiding behind, or hopelessly striving to emulate, the "feminine" woman—and a gender differentiation as implacable as that supposed to obtain in heterosexual social relations: short-haired, flat-shoed, pants-wearing women eyeing or hand-in-hand with longer-haired, high-heeled, skirted femmes.

Lived experience is far more complicated than any representations of it can ever be, and I well remember the dilemmas that these images referred to in my own and others' lives, and how untidy and inconsistent our solutions to them were. The connection between such images and our experiences was wistful, romantic, and very allusive. It was the product of an era in which even to speak about our lesbianism *among ourselves* was to court personal and public disaster: the magazine was mailed anonymously and its cover

Cover illustration, *The Ladder* 2:1 (October 1957)

Cover illustration, *The Ladder*, n.d.

art was sufficiently allegorical to make its subject matter a puzzle piece to "outsiders."

Joan E. Biren (JEB) of Washington, D.C., Tee Corinne of Sunny Valley, Oregon, Nancy Rosenblum of Los Angeles, and Danita Simpson of Detroit are lesbian photographers whose work has been produced and distributed largely for lesbian audiences. With the exception of Corinne, their circulating work is dominated by formal and informal portraits, many of them of women alone, signed by their occupation or public identity (Rosenblum's *Betsy Skidmore, 29, tennis instructor; Jean Pittman, 30, furniture maker;* JEB's portraits in *Eye to Eye*). By removing the most conventional marker of lesbianism—another woman who reminds the viewer of the lesbian's sexual choice—such images propose lesbianism as a social or essential identity rather than exclusively a sexual one. Inclusion of names, ages, and occupations emphasizes the subjects' being-in-the-world, filling in the social absences in prior representations for both lesbians and other audiences. At the same time, by positioning these socialized subjects within an avowedly lesbian context—a book or slide show on lesbian people/lesbian identities—distributed through primarily lesbian communities, these photographs remind us of the dual nature, sexual and social, of their subjects.

Even the formal portraits of couples in these photographers' work appear as repudiations of a preeminently sexual identity: it is their stability as social units that is emphasized. Unlike male-produced images of lesbians—and here I confess that I must compare apples and oranges, for I'm talking about formal portraits on the one hand and porn on the other[36]—these photographs all but eliminate the sexual components. Unlike pulp paperback covers, *Penthouse* or *Hustler* spreads, Rosenblum's, Simpson's, and Biren's photo-

178 | 179

Nancy Rosenblum, *Betsy Skidmore, 29, tennis instructor,* 1983

Nancy Rosenblum, *Jean Pittman, 30, furniture maker,* 1980

Joan E. Biren (JEB), *Building the Boardwalk for the Differently-abled,* 1983

Joan E. Biren (JEB), from *Nice Jewish Girls,* 1982

Danita Simpson, *Donna and Suzie,* n.d.

Danita Simpson, *Sara and Sally,* n.d.

graphs avoid seduction, overt sexuality, and hierarchical organization of the subjects (as those have been conventionally defined in formal portraiture). Where women touch at all, it is in a friendly, nonerotic manner. Particularly in Simpson's case, there is as much information about the couples' domestic settings as about them; the comfortable clutter of their living rooms (not a bedroom or boudoir in sight) invites us to speculate about taste and personality rather than sexual practices.

Yet the claim of "this is what is" sits uneasily in light of other decisions evident in the photographs. The subjects seem to be placed for the sake of the framing: chairs pulled into centers of rooms, uncluttered backgrounds. Most of the subjects look directly into the camera, they rarely or barely smile, and their bodies are composed, at rest. (Rosenblum's use of the 4 × 5 camera and Simpson's use of medium format with great depth of field make relatively long exposures necessary, which partially explains the static quality of these portraits.) Their formality attests to the status these photographers aspire to: the making of propositions about what is desirable (home, furniture, pets, lives in common) rather than signs of what has been permanently achieved. The positive reactions such photographs meet with when circulated outside the particular communities of the women pictured (as in JEB's nationally circulating slide shows) but still within lesbian subculture attests to the ways in which such photographs function culturally for lesbian viewers: as evidence that coupledom, domestic stability, and single lesbianhood can be achieved.

The photographs circulate primarily within lesbian settings—women's centers, coffee-house galleries, books from women's presses—where they function primarily as signs of the emergence and new public-ness of lesbian subculture, their intended audiences. But these are not the only viewers the photographs have, nor the only reactions possible to them. In contrast, nonlesbian audiences may be struck by a variety of other qualities in the images: their formal conventionality, as if photographic portrait strategies hadn't altered since 1915; a nineteenth-century technique imposed on a distinctly late-twentieth-century social phenomenon, the urban, "out" lesbian couple or individual; their romanticism—lesbian life, whether singly or in couples, portrayed as a self-satisfying, orderly, above all *stable* existence (a quality that these portraits share with other formal portraits, though not one commonly credited to lesbian lives).

The situation with Simpson's bar photographs is somewhat different, pointing up the confusions that result when subcultural images circulate outside their primary "terrain." Made for her master's degree project at Wayne State University, these portraits followed a shooting/editing strategy common to both art photographers (Lee Friedlander, Garry Winogrand, Larry Fink) and amateurs—party pictures taken under very low lighting conditions in which the image reveals itself only during the microsecond illumination of the electronic flash and later in the printed images themselves.

For Simpson, this almost-random method of shooting functioned as a guarantee that "the images are not voyeuristic—for it's impossible to be such with an electronic flash in a darkened bar." [37] Such an ethical concern with the motivations or consequences of shooting, however naive or displaced it may be, differentiates the lesbian photographer's position and dilemma in chronicling her community and circulating images of it beyond that community from the position of art photographers bringing the same methods to bear on mainstream social events. This isn't to say that I think Simpson's photographs are comparable to those of Friedlander and company in formal inventiveness or visual complexity, the criteria by which those images are customarily judged. To do so is to miss my

Danita Simpson, Untitled, n.d.

point entirely: criteria of meaning alter as one reads from specific community to specific community. In this case, Simpson attempted to have it two ways—to make photographs that were specifically recognizable within an art/academic context as kin to Friedlander et al.'s as well as within her own lesbian community.

Her method and site produced a spontaneity and casualness that her black-and-white portraits do not; what these qualities mean, however, depends on who is doing the reading. For a lesbian audience, the bar means darkness, drinking, flirtation, public declarations of affection, sexual interest, sexual identity, aggression. The images that arise from these conditions read for lesbian audiences as explicit celebrations of sexuality between women. For an art/academic audience, these emphases are replaced by technical and formal considerations: the color balance of the printing, the pleasing ambiguity (or displeasing literalness) of the image. Such criteria can serve interests at pains to ignore lesbian issues, as Simpson herself discovered (see below).

The strategies at work in the majority of photography courses in art schools, liberal arts colleges, and universities make it easy for instructors and students to find ways around discussing the cultural meanings (such as the sexual or political content) in photographs. It is the dubious achievement of an institutional emphasis on formal strategies and material techniques that leaves the sociocultural balance of power addressed *by students* in their work unknowledged and therefore undiscussed by their mentors. This, I emphasize, is not purely a function of instructors' or institutions' timidity, racism, homophobia, or sexism: it is equally a sign of the dreadful structural limitations of a pedagogical method that consigns everyone's social propositions to the edge of consideration, that colludes with much else in our culture to aestheticize uncomfortable questions about and challenges to how power operates in the world. Students work within a formalist/technical system that is the dominant one in formal education today. The students' own concerns, on the other hand, particularly those of feminists, gays and lesbians, and other minorities, are frequently emergent challenges to as well as reactions against dominant culture's forms and concerns.[38] There is a constant slide within individual practitioners between the forms and values of mainstream culture and those they invent or inherit from their own, smaller communities. I see such pulls, such contradictions, in the photographs presently under discussion. The very ambiguity of Simpson's bar pictures allows them to be easily read in ways that cause straight audiences less difficulty; the rhetoric of academic art photography encourages the seeking of private, idiosyncratic meaning on the grounds that photographs are an index of individual sensitivity (and, in a case like this, of collective social resistance). These are values that lesbian photographers both embrace and reject, like everybody else.

Tee Corinne, also academically trained as an artist (MFA, Pratt Institute, 1968), makes positive-image photographs of lesbians—"lifestyle or culturally evocative/variant" images—and formal portraits, many of which have been used as book-cover illustrations and back-of-book author's portraits. She has, however, also published a large number of explicit sexual images and what she terms "sexually symbolic" images.

Corinne's need to protect the subjects of her portraits has figured significantly in determining what work she felt she could do:

I chose lesbian writers who were public or "out" about their affectional preferences and who used lesbianism as the subject of their texts. I felt that these women could afford to be part of my project and could benefit from the attention.[39]

The slippage between "beautiful images" and "beautiful women" is clearer in Corinne's best-known photographs, her "sexually symbolic" images, which obscure those practices and body parts that are most tabooed, most problematic, through technical feints: solarizations, flipped negatives, multiple images. A muted voice and near invisibility, in one sense, are preserved here: the dreamlike condensations and displacements block or slow down an explicit sexual reading. Corinne's use of a "distanced, universalized and romanticised [*sic*]"[47] approach to female sexuality, drawing upon a long tradition of "feminine" iconography, gives her work a currency outside lesbian communities that the other work I've discussed doesn't have: her "sexually symbolic" images have appeared in the heterosexual journal of soft erotica *Yellow Silk* as well as in the (more) rough-sex lesbian journal *On Our Backs*. Though the impetus for Corinne's approach to sexual imagery might stem in part from political and social concerns for her primarily lesbian subjects/audience, the images neither challenge nor address lesbian sexuality explicitly.

In her portraits and life-style images, however, Corinne has produced a body of work that looks squarely at lesbian identity. Its ways of doing so are sufficiently subtle as to be perhaps invisible to many outside viewers: how revolutionary could it be (as is the case with her cover illustration for *Toothpick House*, published by Naiad Press) to see two women embrace enthusiastically on the cover of a book?

If you need to think about the answer to that question, consider the work of Lynette Molnar, which I first saw while serving as a juror of photography grants for a state arts council. The discussion about Molnar's work, which culminated in a compromise whereby I could unilaterally give money to her project over the objections of the other two jurors, is a good object lesson in some of the problems that subcultural work encounters when it attempts to make its way into the larger world.[48]

Molnar's *Familiar Names and Not-so-familiar Faces* consists of a series of photomontages in which images of the photographer and her female lover are stripped into existing reproductions: a Nikon ad, the Ward and June Cleaver family of *Leave It To Beaver*. The montage is deliberately not very convincing: it is quite obvious that the two figures have been imported from some other world and pastiched into these mainstream settings. The scale and the repetitiveness of the same figures embracing in a variety of commercial settings enforce the artificiality of the insertion, producing a sense that this is an act of defiance, a clumsy and not altogether successful fusion of two different universes. Anyone living the life of an informed outsider will recognize that this is precisely the position that we occupy—culturally and politically, if not economically. Molnar's work struck me as a clever objectification of both the aspiration and reality of the uncloseted lesbian.

The reaction of the other two arts council jurors was very different. Looking at the work primarily *in terms of what lay within the frame,* they rejected it on the basis of its technical flaws ("She hasn't even varied the size of the two female figures"; "The figures don't look as if they are really integrated into the scene") and formal deficiencies ("Why didn't she change the pose of the two figures? It's too repetitive").[49] When I objected that these seeming limitations became challenges and virtues, given the paucity and distortions of most images depicting lesbians, my fellow jurors' resistance took the form I've described above: *We're judging photographs, not social revolutions.* And of course photographs are never instruments in/of social revolutions: they exist in a world apart.[50]

The misunderstanding Molnar encountered in taking her work before the general public, even though they "read" fluently to members of her subculture, is a common experience among lesbian photographers addressing lesbian issues in work that they exhibit

If this is what a beginner can do with a Nikon FG, imagine what you could do with a little practice.

Lynette Molnar, from *Familiar Names and Not-so-Familiar Faces*, 1985

Kaucyila Brooke, Untitled,
1984

Kaucyila Brooke, Untitled,
1984

outside their communities. Danita Simpson had similar experiences, as did Kaucyila Brooke. Brooke's work is highly metaphoric. She creates tableaux that reject the pretext of representing her subjects' "lives," employing them instead as actors. The darkly printed images are, she says, about relationship: "some of the ways our nurturing fostering community can at times hold us back." [51] Brooke rejects the need expressed by Biren, Rosenblum, and Simpson to represent positive images to the lesbian community: "I decided early on that I need not present propaganda of an idealised lesbian life-style." Instead, she concentrates on metaphorical reconstructions of various relationship patterns—jealousy, possessiveness, extreme romanticism—as she perceives them at work in her community.

The work functions efficiently inside the subculture for which it is made, in part because of the seeming authenticity of her actors' postures, gestures, looks, and personal styles. But the very qualities that helped authorize the work for lesbian viewers worked against it when she showed the work outside that community, in a Tucson art gallery. The signifiers of her actors' lesbianism were interpreted by mainstream audiences as signifiers of something else—masculinity:

Because many of the women that I photograph exist outside the culturally defined norms already[,] they do not exhibit the posturing, posing, gazing and costuming usually used to distinguish one sex from the other. . . . Sometimes the uninitiated het[erosexual] viewer thinks that the women in my pictures are in fact men. [52]

Again, the problem is not one of misinterpreting the entire sign—the metaphorical content—of the image but rather the gender identification to which Brooke intended that content to refer. And despite the clearly *staged* nature of Brooke's photographs, issues of confidentiality made it impossible to include several of the images I wished to use to illustrate this essay. Identification *as a participant* in these images, Brooke wrote, could severely damage several of her subjects' lives. [53] Of how many identities in the United States today could it be said that portraits and staged tableaux could cause damage? Should it be any surprise that so little photography addressing lesbian issues and identity is in circulation?

Susan Maney's *Two Women Fall in Love by the Sea* circumvents this difficulty by using found images. The work takes two forms: an album of postcards, snapshots, and greeting cards assembled over handwritten captions and wall-sized photomontage panels with text. The scraps of narrative in the piece move back and forth across space and time: Florida, Europe, family homes in the northeast United States. At least three generations of female couples enjoy themselves under the same tropical skies and exotic tree. *Two Women* invests its subjects with a (magical) tradition and history: real, historical couples (for so the snapshot photographs propose) occupy those cottages, hold hands for the camera, walk upon that beach. By placing her real couples in imaginary (lesbian) relationships and (imaginary) landscapes, Maney asks several questions about sexual identity and the nature of photographs' truth-telling: Were the women these snapshots refer to actually lesbians? What would have constituted marks of lesbianism in their class, their era, their locale? What are the elements in Maney's use of these photographs and in the photographs' content that allows us to read them as lesbian images now?

As fanciful as Maney's work is, its content reads much less ambiguously for mainstream (art) audiences than the seemingly more straightforward work discussed earlier. Partially this is because Maney uses text, which identifies her concerns poetically but clearly. Partially it is the work's form, which is both familiar to and problematic for most adults: the family album with its gulf separating life-as-seen-in-snapshots and life as

she knew it
had to be a
secret

As if there was only one world, and it was flat.

Susan Maney, from *Two
Women Fall in Love by the
Sea*, 1985

lived.[54] Maney goes beyond questions of reality and appearance as they raise themselves in every family (that happy family beaming in front of the new Buick; that car Dad bought just before he and mother split up and that he rode away in) to include questions about sexual identity. But she does so in a way that provides the pleasures of gallery art—with complexity of form, huge scale, color, gallery sponsorship. Her work can do this in part because of the assumptions Maney can make about her primarily art-gallery audiences— their supposed willingness to approach the work as a puzzle, as a personal expression to be decoded. The pleasures associated with visiting galleries do not frequently include confrontations with lesbian content—to date, *sexual difference* has ventured no further off the curatorial track than male and female heterosexuality—[55] so the danger to Maney's academically sophisticated work lies precisely in the likelihood of its lesbian content being ignored in favor of its formal inventiveness.

Getting Around

This brings us to the question of what sites for exhibiting lesbian photographs are possible and what meanings attach to the choice of site(s). Particularly in the case of an outlaw minority's self-representations, we must distinguish carefully among the various possible audiences and sites of reception in exploring what work the images do.

There are basically three ways that lesbian still photographs circulate beyond small circles of friends. The first is through the institutions created by lesbian-feminist communities: women's centers; coffeehouses; literary, art, and political journals; community newspapers; alternative gallery spaces; and the *ad hoc* "production companies"—groups of local women who agree to undertake the production of traveling slide shows, films, and lectures. These institutions are primarily not-for-profit, collectively run ventures, and their primary, sometimes exclusive, audiences are women. This eliminates several problems for producers of lesbian imagery: the need to safeguard the privacy of subjects and to make the terms of the work comprehensible to an extra-subcultural audience, one that does not necessarily share the producer's and primary audience's values. At the same time, it introduces what some producers see as another problem: the possibility of marginalizing their work, of limiting its possible audiences.

The second method for distributing lesbian imagery is through mainstream art/academic gallery systems. Since the early to mid-1970s, there have been a sufficient number of traditional and alternative gallery settings—college/university, library, community center, not-for-profit experimental, artists' co-op, and mainstream commercial—to provide at least an illusion of access to photographers. And in fact several of the photographers who sent me work do show their photographs in such settings. At times there is even overlap in these venues: for example, in Chicago two of the artists' cooperative galleries are run by women's, and largely feminist, committees. In terms of the services and spaces provided, there is often little difference between what is offered at the not-for-profit and commercial galleries of an American city.

For image producers, the difference between these two systems lies in the mechanisms through which each system builds and reaches its audiences and the composition of those audiences. In mainstream gallery settings, the audience is primarily heterosexual and, while assumed to be liberal, presumably does not share the producer's view of lesbianism as a positive identity. Nor does a mainstream gallery setting promote the sorts of expectations that lesbian-feminist or other minority cultural settings usually do: that the work will be discussed in that setting, that it is indeed there *to provoke discussion*. Museum, gal-

lery, and library settings often set up the opposite set of expectations: the work is there to be savored privately; the print on the wall is its producer's end-product, not a step along the way to some collective (however temporary) resolution of personal and social issues.[56] Thus although the photographer who chooses to exhibit lesbian work in traditional settings gains access to a wider audience than she would have within lesbian-feminist settings, she is likely to claim it at the expense of one level of meaning in the work: its exploration of sexual identity. Because she cannot protect her subjects' identities in a mainstream setting, she may have to compromise or limit her depictions to subjects who are entirely "out" in their lesbianism or obscure identifying marks in her subjects. If she regards her work as a form of speaking to straight audiences, she may also find herself, as several women who sent me work stated they did, engaging in a self-censoring that screens out those aspects of lesbian identity most likely to be offensive to a heterosexual audience.

The third method of distributing work is one that is only now developing: commercial magazines and videotape services with reproduction and distribution capabilities far exceeding the artisanal output of photographers distributing their work through galleries and informal lesbian networks. Where a single, highly successful lesbian-feminist photographer taking her slide show on the road may reach five thousand women in a year, a single issue of On Our Backs claims to reach ten thousand subscribers per issue.[57] This method of distribution, in turn, presents its own limitations: in a magazine organized for commercial survival, much less profitability, the images that get published will be those the editors feel have the greatest probability of selling space to advertisers and selling copies to individual consumers. Like photographs in traditional gallery spaces, images in a lesbian commercial publication or videotape are distributed to a relatively uncontrolled audience, so protecting the identity of models, for example, cannot be an issue.

To a much greater degree than makers of heterosexual photographs, the producers of lesbian images must foresee, plan, and control not only the production but also the distribution of their images. This is so because there are so many possible negative social repercussions to a woman's being represented *as a lesbian*. That is, although a woman might, for example, readily permit herself and her child to be photographed and the image exhibited or published as a representation of, say, "a single parent and child," the same photograph shown or published as part of a series on "lesbian mothers" could easily open her to child-custody battles; to censure at work, among friends or family; to religious shunning; or to problems with immigration status, complications with pending lawsuits, and so on.[58] From the point at which she decides to photograph subjects as lesbians, the lesbian photographer is making political choices that affect the social well-being of her subjects as well as herself. Thus her plans for producing the photographs are frequently integrated from the beginning with a plan for distributing or exhibiting them that will ensure her subjects' (relative) privacy.

This relatively untrodden ground was addressed in the first issue of the late *The Blatant Image* (1981), which as a primarily lesbian-oriented periodical devoted to feminist photography published several sample releases reflecting the complex social implications of lesbian self-identification. In the one created by Tia Cross, women could grant permission for their likenesses to appear in any or all mass-market publications, feminist publications, lesbian publications. They could also choose to be identified as lesbians in any of the categories or in none. Ruth (Ikeler) Mountaingrove's release explicitly limited her rights to produce subjects' images only in "magazines, books, and newspapers connected with the Women's Movement and/or in exhibits or in private sale to individual women."

Lynda Koolish's release provided room for the subject to specify the uses that she would agree to.[59] As an alternative, JEB, author of *Eye to Eye: Portraits of Lesbians* (Glad Hag Books, 1979), distributes her work primarily in the form of slide shows, a decision that partially solves the problem of limiting access to sympathetic audiences:

You have to be responsible to the women in your images—or people end up feeling as if they've lost control. One of the problems of the distribution—and we're a very mobile community—is that I don't work at the pace where I can take a photograph one moment and use it the next. Sometimes it's six years later. I've had people sign my release and say, "You can use this picture anywhere but Cincinnati."

JEB has structured her slide show containing images of nudity and explicit sexual acts so that those images appear in the second hour, at which point men in the audience are asked to leave: "I figure that after an hour they're probably ready to leave anyway. And it's important that my subjects feel that their privacy is being protected."[60]

JEB came to photography from New Left politics, which may account in part for her sophisticated understanding of the implications of various distribution and exhibition vehicles in structuring audience responses:

Part of the definition of Lesbian photography that I am offering depends upon the photograph being viewed in a context "continuous with that from which the camera removed it"; for example, in our homes, women's centers and Lesbian bars and restaurants. In this way the photograph will be comprehensible as Joanne Kerr has explained, "because of the reference to shared experience, rather than shared knowledge of artistic convention."[61]

Like many feminist and oppositional filmmakers and photographers, JEB found it necessary to develop new methods of getting her work circulated and discussed and has relied chiefly upon informal or alternative networks. Her book *Eye to Eye* was self-published and distributed, as is her new one[62]; her slide shows are produced by women who undertake the responsibility for local production in their own communities and find space, do publicity, and build audiences. Under such circumstances, audiences come not just to look but to stay and discuss what they have seen, thus making the viewing experience different from what it would be in a conventional gallery. Art-making and viewing are continuous with everyday life and are used to celebrate and analyze community, both in the representations being exhibited and in the interactions between audience and producer. This is quite different from most audiences' expectations of what viewing art is for. In this respect, Biren's work raises the same issues that Annette Kuhn has identified in feminist filmmaking:

The objective of working with audiences is to effect some transformation in the passive receptivity characteristic of spectator-text relations in dominant cinema, rather perhaps than simply to create another mass audience for a different kind of film. Work with audiences might therefore involve active efforts to make films available for distribution, to work in unexpected or unfamiliar ways—to render them accessible to audiences and to generate debates around cinematic representation.[63]

The chief disadvantage to such a method of distribution is the flipside to its principal advantage: audiences can be built up only slowly and in small numbers. Mass-distribution routes, such as through periodicals and electronic media, are possible only in a limited sense. No women's presses publish four-color work (one of the reasons JEB decided upon slide shows was so that she could exhibit her color work); reproductions are usually few and poor in quality; series of photographs are commonly broken up and scattered through the text as illustrations rather than grouped together, where they could constitute an argument of their own.[64] Electronic media, because of the high capital costs of

[handwritten margin note:] Is that contra part of the conception of the work—that necessitates a constant painting of the two (limits its distribution) and this is almost impossible in repr. because the image takes of—separates from its origins (is appropriated).

equipment and post-production, and distribution channels even narrower than those for still photographs, are the province of art/academic work and commercial erotica—both subsidized media in their own ways.

Some of the photographers I dealt with have rejected the material limitations of the undercapitalized women's presses and alternative exhibition sites in favor of venues chosen for the very conventionality of their audience and programming. Madge Matteo, for example, chose to exhibit her work in mainstream art/photography galleries rather than principally gay/lesbian ones[65] out of a belief that traditional gallery audiences are "fairly intellectual" and thus ready to be confronted by "intimate and tender" portraits of gays and lesbians. Her task, as she sees it, is one of education, of "reaching out to the straight world."[66]

Some of the costs of such a strategy are obvious. Although Matteo began photographing gays/lesbians in 1978 and ended up with hundreds of subjects, in 1981 she had to "weed out" images of anyone not willing to have his or her image exhibited before the mixed audiences she wanted to reach. She ended up with fifty-seven subjects. "Your picture isn't going to do me any good because I can't show it," she found herself telling people, "I want to show my work where I want to show it."

A second, and perhaps more far-reaching cost of the decision to exhibit in mainstream galleries is the narrowed range of what lesbian-feminist photographers conceive as acceptable subjects and treatment. As Matteo notes:

I hoped that my photographs could serve as an early step toward overcoming stereotypes toward homosexuality. I reasoned that the demonstration of personal behavior and emotional interactions between homosexuals might overcome a slight degree of ignorance on the part of my viewers.[67]

Such theoretical acceptance was contingent upon avoiding what she termed "stereotypes—flaming queens, flannel-shirted lesbians. . . . I didn't want to reinforce straight stereotypes. . . . I don't want our culture to be reflected that way."[68] Danita Simpson has expressed similar thoughts about the work she showed in art galleries:

I viewed my work as an opportunity to provide positive reinforcement in a society that simultaneously negates and exploits our lifestyle. This leads to the second reason—that of public education. I feel that individuals fear and hate that which they don't understand. By viewing my work, I hope to combat the homophobia prevalent in our society. If people begin to realize that lesbians are "everyday" folk . . . perhaps acceptance will replace hatred.[69]

In Simpson's case, self-censuring took the form of "as a matter of principle declin[ing] photographing the women in black leather with rings through their nipples."[70]

Simpson's color photographs made in women's bars record what most urban lesbians would recognize as sexual exuberance and cruising; but among larger audiences, the photographs' meanings were apparently lost, overlooked, or deliberately misunderstood:

Evidence of how far we have to go was demonstrated when my work was shown as part of my MFA project. Individuals were not quite sure what they were looking at—was this simply women in a bar or portraits of "friends"? Not one review of the show dared say images of lesbians. Were they really unsure (they don't look like dykes?) or were they just afraid of putting that word—lesbian—in print? Someday, perhaps, these questions won't be of concern.[71]

For the time being, however, these questions are of concern. If representations of lesbian lives can be addressed/dismissed as "life-style" photographs, with all the illusionistic par-

194 | 195

Abigail. Sb resists this argument because Diff.

ity that phrase evokes, if representations of lesbian people must exclude women whose appearance might match heterosexual gallery-goers' most negative stereotypes of lesbians, then it seems to me that we have won at best a pyrrhic victory.

More important, such strategies do not address the level at which stereotypes themselves are constructed—in ideology, that "imaginary relationship of individuals to their real conditions of existence."[72] Looked at this way, we must recognize that a stereotype, whether positive or negative, performs cultural work that reinforces existing social relations; this cannot simply be undone by offering another stereotype in its place—the gay/ lesbian as a WASP/Jew/hispanic/black/Asian with a difference—unless the new one provides a more compelling and satisfying explanation.[73] In the case of dominant culture's stereotypic notions of lesbians, the asexuality of so much recent "public" lesbian portraiture does not effectively challenge or replace mainstream beliefs ("lesbians are women who make it with other women"; "lesbians are women who look like/wish they were men") with socially useful alternatives ("lesbians are women who look like everybody else," "lesbians are amiable, capable-looking women").

[handwritten: cannot one manufactured identity with another.]

We must ask ourselves whether a gallery setting—by which I mean that serene, white- or gray-walled secular temple where no one talks in a normal tone of voice, where few people crowd together, and where heated discussion is generally unknown—can provide the appropriate site for producing any of the reactions that lesbian photographers express a wish to produce. John Berger, Hans Haacke, and Martha Rosler have all undertaken studies of art gallery visitors,[74] and though their methods and interrogations differed, their projects produced similarities: visitors to galleries represent a narrow segment of the American and British public; they are socially and politically more liberal (as well as financially better off) than average; they tend to be people who are themselves professionally involved in the arts; they see the gallery as a site apart from the messy contingencies of everyday life. When these perceived characteristics of gallery audiences and spaces are combined with the "educated" gallery-goer's expectation that modern art will provide her/him with a "purely" aesthetic experience, there is little likelihood that gallery audiences expect or are willing to participate in a communal experience that demands they rethink social categories (dyke, faggot) that have served the status quo very well.[75] In fact, Danita Simpson's experience would suggest that rather than confront difficult social categories, viewers in a traditional gallery setting may instead overlook or deny the very presence of those categories, as happened when her photographers were ambiguously and evasively characterized as "life-style" images.

By the same token, the distance established in modernist art settings between Art and everyday life also contributes to a visitor's qualified acceptance of *outré* imagery within a gallery setting; there is, after all, comparatively little social threat to visual proposals far removed from the world in which the viewer habitually lives.[76] Even more important, Berger, Haacke, and Rosler have confirmed what we all suspected and must factor in as the most critical problem in showing minority imagery to majority viewers: the work reaches a very small (if socially and culturally powerful) audience confirmed in its own sense of liberality, and I question the value of tailoring our self-representations to the cut of such an audience's sensibilities. If doing so means having to factor *out* "the women in black leather with rings through their nipples," the "flaming queens [and] flannel-shirted lesbians," we need to ask ourselves at what price we are seeking acceptance—and to whom we are conceding the right to authorize it.[77]

Afterword

In the last few years there has been an enormous amount of discussion and activity within lesbian and lesbian-feminist communities on sexual expression—a public reclaiming of the open, raw sexuality that so captivates audiences viewing those old pulp paperbacks I described earlier. Lesbian video production companies (Blush Productions, Tiger Productions) make and distribute lesbian porn cassettes; *On Our Backs* has grown and encountered competition (*Bad Attitude*); lesbian s/m, once a polarizing and largely stigmatized practice in lesbian/feminist communities, now has what amounts to institutional status—regularly announced rap groups, classes, meetings, and socials in most large U.S. cities.[78]

I haven't discussed any of these welcome signs of sexual pleasure, confidence, and experimentation in this essay. What I have sought to explore here instead have been the structuring *absences* and *negativities* that have played so large a role in determining lesbian image-making until recently—absences of money for production and distribution, absences of wide audiences and sites for exhibition; negations of personal identity, security, and pride fostered by mainstream culture—and the inventiveness and resolution with which lesbian photographers have resisted institutionalized homophobia and gynophobia.

1 *The Grapevine* (New York: Macfadden-Bartell, 1965).

2 *Sappho: the Art of Loving Women* (New York: Crown Books, 1975).

3 Williams is speaking, in *Culture and Society, 1780–1950* (1953), of the persistence of the idea of past societies better integrated, more peaceful and happy, than the present: utopias projected not into the future but into the past. "This is, I think," he says, "a surrender to a characteristically industrialist, or urban, nostalgia—a late version of medievalism, with its attachments to an 'adjusted' feudal society. If there is one thing certain about 'the organic community,' it is that it has always gone" (p. 259). As a sexual and therefore something of a social outlaw (being female rounding out the triple estrangement from dominant cultural values), I of course favor a somewhat more giddy version of utopia—Monique Wittig's, perhaps—but as a historian, I think I do not confuse Wittig's fantasy with the 1950s and 1960s, when I grew up in San Francisco.

4 Raymond Williams's idea on transformations/contestations within culture, first advanced in *The Long Revolution* (1961) and discussed further in *Raymond Williams: Politics & Letters* (London: New Left Books, 1979), p. 146, is useful here: "One should not underestimate the degree of internal transformation within the apparent continuity of these immensely prolonged belief-systems. Every key crisis in the society as a whole provoked great conflict in the system, which responded with reinterpretation, redistribution of emphasis, in many cases even positive denial. These responses then tended to form new configurations of residual, dominant and emergent religious feeling [he is discussing developments within Christianity from the Middle Ages through the Industrial Revolution.] *The result is typically a simultaneity of multiple different relations between the presumed belief-system and the actually operative social system*."

5 John D'Emilio, "Capitalism and Gay Identity," in *Powers of Desire: The Politics of Sexuality,* ed. Ann Snitow et al. (New York: Monthly Review Press, 1983), p. 105; see also Jeffrey Weeks, "Capitalism and the Organisation of Sex," *Homosexuality: Power and Politics* (London: Allison and Busby, 1980), pp. 11–20. For a more politicized analysis of gay/lesbian ghettoization, see Tom Waugh and Chuck Kleinhaus, "Gays, Straights, Film and the Left: A Discussion," *Jump Cut* 16 (1977), reprinted in *Jump Cut: Hollywood, Politics, and Counter-Cinema,* ed. Peter Steven (New York: Praeger, 1985), p. 282.

6 Tee Corinne has found lesbian images made in Paris for the erotic book industry in the early twentieth century, but has little information about their makers. Corinne, letter to JZG, 6 November 1985. See Christina Cassidy, "A Short History of Lesbian Publications," *Native* (New York), July 28, 1986, pp. 22–23; Fran Koski and Maida Tilchen, "Some Pulp Sappho," *Margins* 223 (1975), pp. 41–45, for a similar overview on pulp novels.

7 I take it as a premise of the analysis that follows that photographs have no discernible intrinsic meaning; like fluids, they take their shape or meaning from the contexts in which they are placed or found. This proposal is discussed at length below.

8 Adrienne Rich's 1976 talk, "It is the Lesbian in Us . . .", delivered at a panel meeting of the Women's Commission and Gay Caucus of the Modern Language Association, is a perfect case in point. Her use of the term *lesbian* in this talk pointed at emotional bonding between women at the expense of the explicitly sexual: "That reality was nothing *so simple and dismissible* as the fact that two women might go to bed together" (my emphasis). In her afterthoughts on the talk, Rich states, "One lesbian asserted that if 'the lesbian in us' was to become a figurative term, she, as a woman who had been oppressed for physically expressing her love for women, wanted another name for who she was. . . . I was trying to invoke . . . the self-chosen woman, the forbidden 'primary intensity' between women, and also the woman who refuses to obey, who has said 'no' to

the fathers." *On Lies, Secrets, and Silence: Selected Prose, 1966–1978* (New York: W. W. Norton, 1979), p. 202. For a historical survey of feminist and lesbian accommodations/challenges to dominant constructions of sexuality, see Jeffrey Weeks, *Sexuality and its Discontents: Meanings, Myths and Modern Sexualities* (London: Routledge & Kegan Paul, 1985), esp. chapters 2 and 8. Weeks is the most consistently perceptive critic of ideas about sexual identity writing in English today.

9 Carol Seajay, "Visual Conceptions: A Review of Two Slide Shows," *Off Our Backs* (March 1980), pp. 18–19.

10 "This Novel Changes Lives': Are Women's Novels Feminist Novels? A Response to Rebecca O'Rourke's Article 'Summer Reading,' " *Feminist Review* 3 (1980), pp. 56, 63. See also Annette Kuhn on the distinctions between films made by women and feminist films, the latter incorporating "the crucial determinants of their reception: . . . the institutional context within which they are positioned" into their practice. *Women's Pictures: Feminist and Cinema* (London: Routledge & Kegan Paul, 1982), p. 195.

11 *Conditions: Two* (1977).

12 Rich, *On Lies, Secrets, and Silence*.

13 For a practical guide to, if not a theoretical overview of, lesbian feminist literary criticism, see Bonnie Zimmerman, "What Has Never-Been: An Overview of Lesbian Feminist Criticism," *Making a Difference: Feminist Literary Criticism,* ed. Gayle Greene and Coppélia Kahn (London: Methuen & Co., 1985), pp. 177–210. An elegant example of lesbian-feminist literary criticism can be found in Catherine R. Stimpson's "Zero Degree Deviancy: The Lesbian Novel in English," *Critical Inquiry* 8:2 (1981), repr. in *Writing and Sexual Difference,* ed. Elizabeth Edel (Chicago: University of Chicago Press, 1982), pp. 243–59. See also, the lesbian issue of *Signs* 9:4 (Summer 1984).

14 An exception to this is the National Lesbian Slide-show Competition, held biannually by Horizon, a lesbian social club in Binghampton, NY, to which Joan E. Biren of Washington, D.C. drew my attention in a lengthy phone conversation. According to Biren, many of the entries are made up of snapshots, which would propel these images into the class that I am trying to outline here. Conversation with JZG, 4 November 1985. Another possible exception is the bar bulletin board, where the authenticity and value of snapshots *as lesbian documents* is guaranteed by the social institution in which they circulate.

15 In a more essentialist formula for defining lesbian photography, JEB, "The Photographer and the Viewer," *Blatant Image* (1980), p. 54, states that making photographs for showing in lesbian venues "allows us to share our life experiences through our art" in contrast to "making images for non-Lesbian audiences," which "forces us to make different images because we must rely so heavily on the common experience of art to communicate."

Biren addresses the difficulties of her definition both here and at greater length in a revision of this article published in *Studies in Visual Communication:* "We could discuss which (if either) is a Lesbian photograph: the picture of a flower I made for my (non-Lesbian) mother's birthday present or male photographer Skrebenski's book cover portrait of Lesbian author Rita Mae Brown? But consideration of these questions is so new that I believe we will gain the most by focusing on the most clearly Lesbian situation first" (p. 85).

16 JEB, who has conducted lesbian photography workshops throughout the United States for the past several years, remarked that most of the representations of lesbians that she sees at her workshops and traveling slide shows are snapshots made by people with no training or identification as photographers. As this essay you are reading expands (as I intend it to), I shall address such snapshot work, some of which can be found in the Lesbian Herstory Archives in New York and in other gay and lesbian history archives. I hope to analyze the kinds of cultural work such images do for their makers and primary viewers.

17 In the smallest groups, as one would expect, people's reactions were more subtle and complex than in large groups. The seminar group (mixed lesbian and heterosexual female feminists), for example, had both the time to reflect upon their reactions to the images and the habit of "reading against the grain," which comes more vividly into play under the expectations of a theory/criticism seminar. The large audience, on the other hand, enjoyed the peculiar momentum large groups have in responding en masse.

18 See Michael Norday, *Warped* (New York: Beacon Books, 1955); Sheldon Lord, *The Sisterhood* (New York: Softcover Library, 1970); Guy des Cars, *The Damned One* (New York: Pyramid Books, 1956); Carol Emery, *Queer Affair* (New York: Universal Publishers, 1957); Kay Addams, *Warped Desire* (New York: Beacon Books, 1960); Nan Keene, *Twice As Gay* (n.p.: After Hours Book, 1964); Fletcher Flora, *Strange Sisters* (New York: Pyramid Books, 1960); John Dexter, *Dyke Diary* (San Diego: Candid Reader/Corinth, 1967); Carla Josephs, *The Off-Limits World* (New York: Domino Books, 1965); Sheldon Lord, *21 Gay Street* (New York: Midwood Enterprises, 1967). These and over three hundred more paperback novels make up the Maida Tilchen Lesbian Trash Paperback Collection at the Lesbian Herstory Archives, New York. See also Gene Damon [Barbara Grier,] "The Lesbian Paperback," *Tangents* 1:9 (June 1966), pp. 4–7; 1:10 (July 1966), pp. 13–15, for a history of lesbian mass-market fiction in the United States.

19 Or maybe the object of desire is closer to hand: another man, whose desirability needs to be projected onto a woman. See Eve Kosofsky Sedgwick, *Between Men: English Literature and Male Homosexual Desire* (New York: Columbia University Press, 1985).

20 Cf. T. E. Perkins, "Rethinking Stereotypes," in *Ideology and Cultural Production,* ed. Michele Barrett et al. (London: Croom Helm, 1979), pp. 135–59; p. 141: "The strength of a stereotype results from a combination of three factors: its 'simplicity'; its immediate recognisability (which makes its communicative role very important), and its implicit reference to an assumed consensus about some attribute or complex social relationships. Stereotypes are in this respect prototypes of 'shared cultural meanings'. They are nothing if not social. It is because of these characteristics that they are so useful in socialisation—which in turn adds to their relative strength." I am indebted to Simon Watney for introducing me to this article.

See also Sander Gilman, "What are Stereotypes and Why Use Texts to Study Them?" in *Difference and Pathology: Stereotypes of Sexuality, Race, and Madness* (Ithaca: Cornell University Press, 1985), pp. 15–35, for a psychoanalytical exploration of stereotypes that provides a base and balance to Perkins's sociological reading.

21 This doesn't mean that heterosexual men—or for that matter, gay men—cannot find images of lesbians arousing. What I'm getting at is the fact that we understand the springs of male desire in a way that they do not appear to understand the sources of ours.

22 This position is exemplified by many critical essays and anthologies analyzing literary and film images of women, particularly a number written in the late 1960s to mid-1970s. Kate Millett's *Sexual Politics* (1969) is the *ur*-text here; it was followed in feminist literary studies by *Images of Women in Fiction: Feminist Perspectives,* ed. Susan Koppelman Cornillon (Bowling Green, OH: Bowling Green University Press, 1972), *Feminist Literary Criticism: Explorations in Theory,* ed. Josephine Donovan (Lexington: The University Press of Kentucky, 1975), and *The Authority of Experience: Essays in Feminist Criticism,* ed. Arlyn Diamond and Lee R. Edwards (Amherst: The University of Massachusetts Press, 1977), and in feminist film studies by Marjorie Rosen, *Popcorn Venus: Women, Movies and the American Dream* (New York: Coward McCann & Geoghegan, 1973), and Molly Haskell, *From Reverence to Rape: The Treatment of Women in the Movies* (New York: Holt, Rinehart & Winston, 1973).

23 Ann Kaplan, "The Hidden Agenda: Re-Vision: Essays in Feminist Film Criticism," *camera obscura* 13/14 (1985), pp. 235–36.

24 "Reconstructing Documentary: Connie Hatch's Representational Resistance," *camera obscura* 13/14 (1985), pp. 135–37.

25 *Masculinity* is not itself a metahistorical category either, for that matter; when opposing it to femininity, we should also be aware that in current usage it also subsumes a great many other classes: heterosexual, European/Northern, Christian or of Christian descent; and usually bourgeois, politically and/or culturally.

26 See Joan Nestle, "Butch-Femme Relationships: Sexual Courage in the Fifties," *Heresies* 12 (1981), pp. 21–24. For references to further lesbian discussion on the significance of masculine signifiers, see Nestle, "The Fem Question," *Pleasure and Danger: Exploring Female Sexuality,* ed. Carole S. Vance (London: Routledge & Kegan Paul, 1984), pp. 239–40, n. 1. See also Tee Corinne's remarks below.

27 Mary Ann Doane, "Woman's State: Filming the Female Body," *October* 17 (1981), p. 21. For other examples of this position, see Elizabeth Cowie, "Women, Representation and the Image," *Screen Education* 23 (1977), pp. 15–23; Claire Johnston, "The Subject of Feminist Film Theory/Practice," *Screen* 21:2 (1980), pp. 27–34; Laura Mulvey, "Visual Pleasure and Narrative Cinema," *Screen* 16:3 (1975), repr. Brian Wallis, ed., *Art After Modernism: Rethinking Representation* (New York: The New Museum, 1984), pp. 361–73.

28 The most eloquent statements of this strategy are by French feminists Hélène Cixous, Luce Irigaray, Xaviere Gauthier, and the Julia Kristeva of *Desire in Language* (U.S. 1980). Readily available excerpts from their work can be found in *New French Feminisms: An Anthology,* ed. Elaine Marks and Isabelle de Courtivron (New York: Schocken Books, 1981).

29 The most vigorous challenges to the Lacanian psychoanalytic/semiotic/*écriture feminine* theorization of text formation and reception have come from the left: Christine Gledhill, "Developments in Feminist Film Criticism," *Quarterly Review of Film Studies* (1978), rev. and repr. in Mary Ann Doane et al., *Re-Vision: Essays in Feminist Film Criticism* (Frederick, Md.: American Film Institute/University Publications of America, 1984); Stuart Hall, "Recent Developments in Theories of Language and Ideology: A Critical Note," in *Culture, Media, Language: Working Papers in Cultural Studies, 1972–79* (London: Hutchinson/Centre for Contemporary Cultural Studies, University of Birmingham, 1980), pp. 157–162; Richard Dyer, *Stars* (London: British Film Institute, 1979), *Gays and Film* (London: British Film Institute, 1977), and "Male Gay Porn: Coming to Terms," which appeared in *Jump Cut* along with a number of other articles arguing for transformative readings and uses of pop-cult materials. *Jump Cut* and its writers, most notably Chuck Kleinhans and Julia Lesage, have been central to the challenges to what Stuart Hall calls "screen theory" in the U.S.

30 Shoshana Felman, "Psychoanalysis and Education: Teaching Terminable and Interminable," *Yale French Studies* 63 (1981), pp. 30–31. Emphases are Felman's.

31 Tompkins, *Sensational Designs: The Cultural Work of American Fiction 1790–1860* (New York: Oxford University Press, 1985), p. 38.

32 A much-discussed parallel situation obtained in teaching literary history and criticism in the immediate post-World War II era to a generation of college students (GIs) lacking any other social cement than their common experience in the armed services. See Richard Ohmann, *English in America* (New York: Oxford University Press, 1976); Raymond Williams, *Politics and Letters* (London: Verso, 1981), pp. 80–83, 241–42; *Re-Reading English,* ed. Peter Widdowson (London: Methuen., 1982).

33 The notion that a photographic image's meaning or use is primarily adducible from what lies within its frame is one of the most durable ideas perpetuated by academic discourse on photography. Like popularized New Criticism in academic literature programs, formalist criticism of photographs serves to pave over the very real differences among viewers (differences of sex, race, class, education), to mystify art production, and to diffuse or obscure any political content intended by the photographs' maker. This is an aspect of academic criticism that is not lost on students; see, for example, the comments of Doreen, a third-year student at Columbia College, Chicago, in J. Z. Grover, "Putting Feminism in the Classroom," *Exposure* 23:2 (Summer 1985), pp. 26–27. In saying this, I recognize the historical role played by analytic criticism in legitimizing the academic study of photography; what makes its use maddening today is the refusal of its practitioners to recognize it as a historical rather than universal practice—a critical strategy that may have outlived its usefulness.

34 Corinne, "Lesbian photography—a personal and public exploration" (unpublished manuscript, 1985), p. 1.

35 For a detailed description of *The Ladder,* see Gene Damon and Jan Watson, *Index to The Ladder* (Reno: The Ladder, 1974).

36 If there are male photographers out there making portraits of lesbian couples outside of bed, won't you please come forward? I'd hate to mischaracterize your work.

37 Simpson, letter to JZG, 6 October 1984.

38 See Griselda Pollock, *"Art, Art School, Culture,"* *Block* 11 (Winter 1985–86), pp. 8–18, and Simon Watney, "Photography-Education-Theory," *Screen* (London) 25:1 (January-February 1984), pp. 67–72.

39 Corinne, "Some thoughts and questions about—and a few personal solutions to—problems of lesbian photography" (mimeograph, n.d.), p. 3.

40 Corinne, "Lesbian photography—a personal and public exploration" (mimeograph, n.d.), p. 6.

41 If, like me, you suspect that *life-style* has come to be a codeword for *queer,* I'd love to hear from you: how far back can you trace this usage? Partially as an homage to Raymond Williams's *Keywords,* partially because the concept is so useful, I would like to write a gay/lesbian *Keywords; life-style* would figure in it prominently, I suspect.

42 Corinne, "Lesbian photography," p. 4.

43 Ibid.

44 Ibid.

45 Corinne, "Some thoughts and questions," p. 2.

46 Coward, "Sexual Violence and Sexuality," *Feminist Review* 11 (1982), p. 11.

47 Corinne, "Lesbian photography," p. 2.

48 Jurors' deliberations are frequently confidential; in this case, the state—Ohio—has a sunshine law covering the council's grant deliberations, so our arguments were carried out before an audience of about forty photographers and other members of the public. I thus feel no scruples about mentioning the substance of this incident.

49 I recorded these comments in my notes on the jurying; 12 April 1985.

50 Molnar has since produced these images as greeting cards, which are sold through lesbian channels.

51 Brooke, letter to JZG, 31 October 1984.

52 Ibid.

53 Brooke to JZG, July 1987.

54 The most eloquent and extended discussion of the contradictions inherent in most domestic photography can be found in Jo Spence, *Putting Myself in the Picture: A Political Personal and Photographic Autobiography* (London: Camden Press, 1986). See also J. Z. Grover, "Jo Spence," *Afterimage* (February 1988).

55 For example, the New Museum's *Difference* show (Fall 1985), curated by Kate Linker, which Martha Gever (editor, *The Independent*) succinctly characterized as the "*same old difference* show."

56 Moreover, work that proposes itself as *about* social issues (in its presentation or treatment of controversial subject matter) is unlikely to be given exhibition in traditional galleries to begin with, unless its treatment can be annexed to artistic categories like genius, daring, nightmare—the stuff of marketing.

57 Given the magazine formula of five readers per copy, this means that *On Our Backs* reaches approximately fifty thousand readers each quarter, easily exceeding the reach of other distribution methods within lesbian subculture.

58 I would like to thank JEB for her eloquent description of the wide variety of social repercussions she has met with in the experience of her portrait subjects.

59 *The Blatant Image* 1 (1981), p. 89.

60 JEB, conversation with JZG, 4 November 1985.

61 JEB, "Lesbian photography—Seeing Through Our Own Eyes," *The Blatant Image* 1 (1981), p. 52. The quotations, respectively, are from John Berger's *About Looking* (New York: Pantheon, 1980) and Joanne Kerr's unpublished doctoral dissertation "Art and Community: a Sociological Study of Contemporary Feminist Art" (University of California, Irvine, 1980).

62 *Making a Way: Lesbians Out Front* (Washington, D.C.: Glad Hag Books, 1987), distributed by Spinster's Ink.

63 Kuhn, *Women's Pictures: Feminism and Cinema,* p. 191.

64 JEB, conversation with JZG, 4 November 1985.

65 Matteo has also shown her photographs in a gay/lesbian photography exhibition in San Francisco.

66 Matteo, unpublished paper (n.d.), p. 6.

67 Matteo, conversation with JZG, 5 November 1985.

68 Ibid.

69 Simpson, letter to JZG, 4 September 1984.

70 Simpson, letter to JZG, 6 October 1984.

71 Simpson, letter to JZG, 4 September 1984. Included with this letter was an undated newspaper review by Khristi Sigurdson commenting on Simpson's bar photographs: "Other mediums represented include a series of *candid lifestyle photographs* by Danita Simpson. Simpson captures scenes of everyday life with a blunt but humane eye. Each leaves a sharp, clear image, not unlike that of photographic luminary Ansel Adams" (italics mine).

72 Louis Althusser, "Ideology and Ideological State Apparatuses (Notes toward an Investigation), [1970]," in *Lenin and Philosophy and Other Essays* (London: New Left Books, 1971), p. 162. An important discussion of the impact of ideological formations on women and students, both germane to my discussion, is Judith Williamson's "How does girl number twenty understand ideology?" *Screen Education* (London) 40 (Autumn/Winter 1981–82), pp. 8–87.

73 *Cf.* Perkins, "Rethinking Stereotypes," *op. cit.*

74 Berger, *Ways of Seeing,* Hans Haacke, "John Weber Gallery Visitors' Profiles 1 and 2 [1972]," *Framing and Being Framed* (Halifax: The Press of the Nova Scotia College of Art and Design, 1975), pp. 15–36, 39–58; Martha Rosler, "Lookers, Buyers, Dealers and Makers: Thoughts on Audience," *exposure* 17:1 (Spring 1979), revised in Brian Wallis, ed., *Art after Modernism,* pp. 311–339.

75 Particularly now that because of AIDS there is a greater need for sexual scapegoats than before. See Nancy Krieger and Rose Appleman, *The Politics of AIDS* (Oakland, CA: Frontline Pamphlets, 1986); Richard Goldstein, "The Uses of AIDS," *Village Voice* (5 November 1985), pp. 25–27; Simon Watney, *Policing Desire: Pornography, AIDS, and the Media* (London: Methuen, 1987; Minneapolis: University of Minnesota Press, 1987); Watney, "The Rhetoric of AIDS," *Screen* (London) 27:1 (January-February 1986), pp. 72–85; and Cindy Patton, *Sex and Germs: The Politics of AIDS* (Boston: South End Press, 1985).

76 Robert Mapplethorpe's *success de scandale* photographs of gay male fist-fucking and s/m sexual practices fall into this category.

77 This is all too reminiscent of the scrambling for crumbs that other sexual minorities have experienced; for example, the controversy in the mid to late 1970s among political gay men about drag queens, whose giddy visibility appeared to threaten the new and always-perilous tolerance that urban, white, middle-class gays (most notably in San Francisco and New York) were beginning to build in their city enclaves. Should political gays disavow their screaming sisters as betrayers of the revolution in order to construct an image of gays as responsible and butch, or should they see drag queens as the "cutting edge" of the gay movement, bellwethers for tolerance on the part of both the subculture and the dominant culture?

78 See *What Color is your Handkerchief? A Lesbian S/M Sexuality Reader* (Berkeley: SAMOIS, 1979); *Coming to Power,* edited by members of SAMOIS (Boston: Alyson Publications, Inc., 1981; rev. ed. 1982); and the feminist anti-s/m, anti-porn rejoinder *Against Sadomasochism,* ed. Robin Ruth Linden, Darlene R. Pagano, Diana E. H. Russell, and Susan Leigh Starr (East Palo Alto, CA: Frog in the Well, 1982). The imbroglio in the last two years over anti-porn ordinances spearheaded by Andrea Dworkin and Catherine MacKinnon and countered by anti-anti-porn feminists from F.A.C.T. (Feminist Anti-Censorship Task Force) are part of this story as well. In late 1986 F.A.C.T. published a book of porn photographs, *Caught Looking: Feminism, Pornography, and Censorship* (republished Seattle: Real Comet Press, 1987): "We chose images that are both strong and appealing. We also included images that would impart a history of the envisioning of sex. And, ultimately, like all consumers of pornography, we chose those images we found erotically powerful, the pictures that turned us on. . . . Consider for yourself the pleasures of looking and imagining."

How is photography used to promote class and national interests?

The Corporate Year in Pictures

The H. J. Heinz Company is very, very, very pleased. Last year [1984] marked its twentieth consecutive year of financial growth. Growth that owed a lot to the tomato. Or rather to the 1.3 million tons of tomatoes that Heinz bought in 1984. Which appear in more than five hundred of their products. And constitute about 30 percent of their annual sales. And translate into fifty million gallons of tomato paste. Enough tomato paste to fill 335 residential homes of 24,000 cubic feet each. A lot of paste from a fruit that most Americans thought was poisonous until 1820, although some more forward-looking Americans were eating ketchup in New Orleans as early as 1779.

Where can one obtain these and similar facts? In Heinz's 1984 annual report, of course, a ninety-six-page extravaganza with such gorgeously thick, glossy paper and such splendidly rich picture reproductions that an ordinary book publisher must weep in frustration at the sight of so monumentally expensive and commercially impractical a publishing feat. And as if that weren't enough, Heinz commissioned or bought tomato-related artworks by eleven different artists and reproduced the works in the report, along with photographic portraits of the artists accompanied by their musings on themselves and their art. Heinz paid over eight dollars per book for this tomato celebration, more than double what the average annual costs and four times what an inexpensive annual costs.

Heinz and more than ten thousand other companies produce annual reports because the SEC and the New York Stock Exchange legally require a specific type of financial accounting from public companies once a year. But the facts and figures and graphs and charts in the back of the book don't account for the high publishing expense. Rather, it's the designing and illustrating and photographing and printing, especially of the "picture story" at the front of the book, that make for the big price tag. And although there is considerable variety in the way annuals look and the stories they tell, it's clear that many different kinds of problems can be resolved, dissolved, dispersed, or transformed depend-

ing on how the pictures and design are handled. It's one time when a corporation can tell its own version of reality with no pesty journalists or unfriendly outsiders interpreting the information. But no one agrees on what the picture section is, or should be, about. For everyone who thinks the "creative" Heinz approach is "great," there is at least one, like Smith Barney food analyst Ronald Morrow, who'll retort: "It's ridiculous."

The annual report publishing business is a multibillion-dollar industry. Average totals for a finished report range from $250,000 to $800,000, although a number run over the $1 million mark. The most respected of the graphic designers who specialize in annual reports estimate that annuals account for anywhere from 18 to 65 percent of their total output. "We have occupied a position as professionals: our product is design. We are talking the language of the business community and that's why they're comfortable with us," says designer Bennett Robinson, chairman of Corporate Graphics, the New York firm that did the Heinz report. "Designers have chosen to be aligned with business," explains Richard Danne of Danne & Blackburn, another Manhattan design company. "And designers are selected more now on the basis of their knowledge of how business works. . . . Good design firms are definitely considered part of the inside team."

Over the past twenty years the annual has evolved from a purely financial statement into a multipurpose communications vehicle. "An annual report has, in varying degrees, eight or ten audiences," says designer Arnold Saks, who has done work for companies such as Alcoa, RCA, and United Technologies. "The major audience is shareholders and the professional audience—the financial community. There's also an internal audience, people inside the company. And a peer-group audience—the people on the chairman's mailing list."

How can one book function as a general public relations and sales tool both inside and outside the company? It falls to the designer to include enough information to satisfy this tremendously disparate audience and to make dramatic, exciting, believable, coherent, and aesthetically pleasing whatever news a company wants to communicate—no matter how diffuse, dull, or bad it may be. "From the company's point of view, what's riding on the report is: almost everything," observes Danne. "Problems are built into annual report work," explains Peter Harrison, designer and partner at Pentagram, a firm that produces some of the most innovative annuals. "It's a very sensitive area; what the company stands for, what they did that year. You have to be diplomatic. You have to present, negotiate, and sell. You have to be flexible and intelligent and bring a clear, reasonably calm influence to the report process. And you have to manage things well and stick to budgets."

First the designer sits down and listens to the client. Anthony Russell, president of his own design firm, starts by asking, "What's the story this year? What's different this year than last? Maybe it's the end of a large capital-spending program, or there's a problem overseas or a problem internally. Was it a good year or a bad year?" A concept based on what the company wants to focus on is agreed upon and then a layout or mock-up is done. At that point the designer knows what kind of photographs (or illustrations) will be needed. "The photography is very important in an annual. It's the most effective, real, believable way of telling a story. To a large degree the annual depends on the success of the photography," says Russell. "There are probably twenty or so really reliable, terrific annual report photographers. People like Bruce Davidson, Burk Uzzle, or Burt Glinn are so terrific that you're lucky if you can get one of them."

Annual report photographers seem to divide into two groups: the great mass who do competent but undistinguished pictures that communicate the "corporate look," and the much smaller number who bring artistic or journalistic skills to the process. "I try not to

do reports where someone says go to factory A and shoot machine B," says Burt Glinn, who worked for many years as a photojournalist. "Our photographers often sit in on company meetings," explains Richard Danne. "Burt Glinn was expected to come up with basic research for the Bristol-Myers report. But the conditions are all dictated to the photographer ahead of time: all verticals or all strip horizontals. They'd rather have a sense of what's expected of them—including the size, orientation, agreement on lenses and lighting—beforehand." "I don't get calls to just go out and shoot annual reports," says Neal Slavin, a photographer who does editorial and artistic work as well. "The people who call me work on a certain conceptual level, and I'm usually in on the early stages of thinking about the book."

All annual reports have a concept. The difference between those done by good designers and photographers and those done by mediocre talents is the degree of aesthetic sophistication achieved in telling the company's story. A working definition of "concept" in annual report design might be: the ability to convert problems into images of solution and to make corporate success look honest, hard won, and well deserved.

The 1984 Warner Communications Inc. report is a good example. Warner underwent a radical restructuring of its business in 1984, selling off a number of divisions including the Atari home computer and home video game sector, which caused nearly $586 million in net losses for the year. What the report focused on was what it called Warner's "biggest asset": its talent pool. Neal Slavin was asked by Pentagram to shoot portraits of some of Warner's directors, actors and actresses, musicians, authors, and television personalities in black and white, which is somewhat unusual for an annual. As Richard Danne observes, "There's a real company bias against black and white. They feel it's not rich enough."

One of the traditional strategies of companies having trouble is to do a black-and-white report: it looks more modest and costs less to print. But black and white has good qualities that color doesn't, and designers are pushing for it more and more. "There's an honesty about black and white, a reality," Arnold Saks says. "Black and white is the *only* reality." Most of all, black and white has a crisp, steely authority that color can't touch, a quality Slavin achieved in the Warner portraits. "I worked very closely with Peter Harrison and Susan Hochbaum [of Pentagram]," says Slavin. "There was a series of endless discussions, endless experimentation. . . . We had several problems because we were photographing celebrities and they have to be dealt with in a certain way. Plus Peter wanted pictures that said something, not just standard press pictures."

For the average shareholder, the picture section of the book is much more visible and understandable than the detailed financial section at the back. In visual terms, the problematic parts of the Warner story were consigned to the oblivion of the text, while the money-making film, music, and publishing divisions were applauded, along with the broadcast and cable sector, which lost less money in 1984 than it had in 1983. Thus, an equivalence was drawn between the current money-makers and the potential money-makers. The report also contained one of the few genuinely humorous pictures in any annual report: Chevy Chase wearing his traditional quasi-self-effacing smirk standing in front of a half-painted backdrop. It makes you wonder if the only way to purposely inject humor into annual reports is to hire comedians.

An even more beautiful black-and-white report was done for another company that has seen better days. Schlumberger reported lower earnings for the first time in twenty years in 1983, and although earnings were up 10 percent in 1984, they still didn't match

Portrait of Chevy Chase from
the 1984 annual report of
Warner Communications
(Photo: Neal Slavin)

the 1982 levels. Designed by Milton Glaser Inc. and photographed by John Gruen, the report exudes an understated elegance that makes many other annuals look loud and unruly by comparison. With the exception of a small picture essay on a Schlumberger acquisition, the report is illustrated by still lifes of precision machinery used in the oil and computer industries, and in gas, water, and electricity measurement and control. Isolated against plain dark grounds, the burnished metal objects are framed to create nearly abstract compositions. Unlike other high-tech or energy companies, which generally go for a kind of jazzy glamour or a wide-lens muscularity in their pictures, these images project a cool, distant accuracy. Indeed, they hark back to Paul Strand's high modernist beauty-of-machinery pictures from the 1920s and are printed in a warm, rich black and white worthy of any Museum of Modern Art book. Even though nothing can mitigate the report's repeated admission of flat revenues, the pictures and the overall design offer a visually classy reassurance that business will undoubtedly be picking up soon.

If a company can't make its annual report pictures look like art, the next best thing is to put art right into the pictures. The Chase Manhattan Corp. had a bad year, too, with earnings $24 million below 1983. But Chase also owns one of the world's major corporate art collections, which was started in 1959 and now contains about ten thousand pieces. For the past twenty-five years that art has decorated the boardrooms, lobbies, and office walls of Chase's more than three hundred offices worldwide. This year it decorates the annual report, where it is used as a backdrop for group portraits of executives. One of the rejected ideas for the report was to showcase the art itself and to show banking going on all around it, an approach that probably would have shown some intriguing clashes between art and life—or at least between art and banking.

Cover of the 1984 annual report of Schlumberger Limited, showing a four-armed high-resolution dipmeter (Photo: John Gruen)

Double-page spread from the
1984 annual report of The
Chase Manhattan
Corporation, showing three
Chase executives in front of
work of art by Sol Lewitt
(Photo: Burt Glinn)

beyond the borders of the United States. Says Consumer Banking executive Arthur F. Ryan: "In consumer banking you look for a good fit, in the neighborhood and around the world. The scope of Chase's banking experience is global. And our technological capabilities, coupled with the understanding we've developed of consumer needs in the United States and places such as Hong Kong, Panama, and Puerto Rico, make us a good fit in many locations around the world."

In Hong Kong and Singapore, where Chase already has established a consumer market presence, automated teller machines were added in 1984 to Chase's roster of consumer services. And Chase is building its consumer banking capabilities in other locations worldwide.

Technology
Over the past five years, Chase has invested half a billion dollars in technology.

These telecommunications systems, microcomputer capabilities, and other investments link Chase's bankers and the increasingly sophisticated products they've created to customers around the globe. The system gives Chase's customers instant access to everything from precious metals prices in distant cities to the status of their accounts receivable.

Chase's investment has produced one of the premier electronic banking networks in existence. But in today's banking environment, preeminence

Instead, these casually formal pictures show Chase executives in conversation. The executives appear to like and trust one another and to be willing members of a close-knit, top-notch team. They're not actually engaged in banking itself, which might show them to be tense or puzzled or shouting into the phone. Rather, they sit or stand in tidy spaces defined by expanses of expensive-looking art, as if this rarefied atmosphere protects and coddles them while they get on with the important business of increasing bank profits.

J. P. Morgan & Co. Inc., by contrast, had a very good year, with earnings passing the $500 million mark for the first time. Many strategies might have been used to portray their record year; Morgan chose to use this report to congratulate themselves on their employees' volunteer activities and the company's philanthropy, the latter having cost it over $5 million in 1984, or about one percent of its net income. The enormously diverse activities Morgan supports range from a New York health-education institution and a Brooklyn neighborhood-development program to the Council on Foreign Relations, the Johns Hopkins University School of Advanced International Studies, and the Museum of Modern Art in Brussels, which received a "significant contribution . . . to help acquire works by American artists," although why the exportation of American culture to Western Europe is a philanthropic gesture is anybody's guess, since American culture seems to get all around the world quite nicely on its own. Morgan mentions so many funds, awards, and grants given to so many different programs and institutions that it's difficult

to imagine how far its $5 million could have gone in helping any one of them. But the magic of pictures helps to equalize all charitable gestures: a class of Queens kindergarteners learning to brush their teeth and a group of Belgian executives admiring a museum are both given the same importance.

Following right on the heels of the corporate-largesse portion is a section double its size on the individual volunteer activities of Morgan's employees. Morgan's employees presumably decide what to donate their free time to, although Morgan maintains a list of volunteer activities for them to choose from, such as tour guide on the decommissioned aircraft carrier *Intrepid,* which is currently parked in the Hudson River on Manhattan's West Side. Laid out almost exactly like the corporate section, with no definitive visual break, the employee section reads as one continuous part of a greater corporate story. Although it seems as if Morgan wanted to applaud its thoughtful employees, it instead ends up visually appropriating them into its own charitable fable.

Special-interest annual reports are not limited to charitable activities, though. For the past ten years Bristol-Myers has devoted the better part of the illustrated section of its report to a full-color "scientific" article. This year the theme was the central nervous system, and it involved some vigorous leaping from one laboratory to another around the country, from Johns Hopkins to Yale to the University of Texas Medical School, in the process of giving a broad explanation of state-of-the-art research on maladies such as Alzheimer's disease, depression, and schizophrenia. The section is devoted solely to "pure research" issues, with two pages devoted to Bristol-Myers's own research and products for the central nervous system following immediately after it, illustrated by more modest pictures and printed on paper of a different color. This strategy rightly distinguishes Bristol-Myers's interest from the more general sweep of scientific work, but it also indicates, perhaps unwittingly, a sense that Bristol-Myers is somehow humbled before the great selfless endeavors of SCIENCE.

Top annual report photographer Burt Glinn, who has been doing Bristol-Myers annual reports for a decade, calls these scientific essays "very challenging . . . terrific to work on." In this case the essay was written by Maya Pines, a free-lance science writer. Glinn used it as a starting point, knowing that "one thing leads to another. We knew that Dr. Raichle in St. Louis was doing very valuable research with the PET scan. So I went out to see what they were doing. . . . While I'm there I'm constantly asking questions, trying to find out what else they're doing. . . . I saw this pair of glasses with red lights in them and asked what they did. I knew they would make a good picture. They weren't doing that experiment that day so I asked how they'd set it up. I did a reenactment. But it wasn't changed one bit from what would normally have been done. I lit the thing for dramatic effect. It was done in a cluttered room, and I kept it against a plain blue background."

The caption doesn't indicate that the picture has been set up, but then most set-up or reenacted pictures in annual reports aren't identified as such, just as they aren't indicated in editorial or reportorial contexts either. Perhaps the notion that there's a split between simulation and reality in annual report photographs is absurd or at least beside the point: the reality you see in these pictures is the reality the company wants you to see. At Merck & Co., for instance, a four-month work stoppage at eight of its plants is discussed in the report. But the picture that's published alongside this fairly common bit of news shows a Merck scientist participating in (yet another) company volunteer program at a New Jersey high school. In terms of the big picture and the current economy, labor disputes seem somewhat more "real" than volunteer programs, but it's a reality that has been little place in an annual report.

Double-page spread from the 1984 annual report of the Bristol-Myers Company, showing photic stimulating device (Photo: Burt Glinn)

...in excess of the neurotransmitter dopamine in their brain cells. Victims of Parkinson's disease, by contrast, do not have enough of that chemical. Other neurotransmitters appear to be at low levels in depressed patients.

Doctors therefore treat such patients by attempting to adjust their chemical imbalances. The drugs generally used to treat mental disorders work through the receptors for specific neurotransmitters, either by enhancing the effects of these natural brain chemicals or by blocking them.

"You can think of the receptor as a button," says Dr. Michael Kuhar, a Johns Hopkins professor of neuropharmacology and neuroscience who specializes in receptor mapping. "Chemicals come and push that button and things happen: an emotional experience, a constriction of blood vessels, or a release of gastric acid." These chemicals can be either natural neurotransmitters or drugs which mimic their effects.

Drugs used to treat schizophrenia, for instance, fit into—and block—the brain's receptors for the neurotransmitter dopamine. Parkinson's patients, on the other hand, are given L-dopa, a substance which is converted into dopamine in the brain. Patients suffering from depression are often given drugs that increase the availability of the neurotransmitters serotonin and norepinephrine. Manic-depressive illness can be controlled with lithium, which modulates the activity of a number of neurotransmitters, including dopamine, preventing both emotional highs and lows.

It has only been in the past 15 years, with the development of special radioactive and fluorescent chemicals, that scientists have been able to trace the paths of various neurotransmitters in brain tissue. Such studies have produced a new kind of map of the brain, based on function, as well as structure.

"The brain is like no other organ," says Dr. Goodwin of the NIMH. "There's no way you can take a sample of brain tissue and have it mean anything, as you could with a liver biopsy, where you assume that the rest of the liver is roughly the same." Brain cells, he explains, can be understood only in their living context. "A liver cell is a liver cell. But in the brain, the only functional meaning of cells lies in their relationship to each other," he says. "We used to just grind up tissue to study its chemistry. Now we can see a picture of the actual anatomy of the brain."

This picture is revised almost daily, as scientists continue to discover new brain chemicals. A decade ago, only a handful of neurotransmitters was known. Today, about 50 have been identified, and researchers believe they are on the trail of hundreds more. Not all these chemicals have a direct effect on nerve cells. Some, for instance, seem to act as modulators, altering the cell's response to other neurotransmitters.

"We used to think that one could talk of one neurotransmitter and one type of behavior," recalls Dr. Seymour Kety of the NIMH, a pioneer in research on brain metabolism. "We thought there was one neurotransmitter involved in hostility, and another one involved in passivity, one in sleep and another in wakefulness. But what we're looking at in

*Right: A photic stimulating device is placed on a patient before a PET scan measures the activity of vision-related parts of his brain.
Bottom: Dr. Frank Duffy, of the Harvard Medical School, helped develop the BEAM system, which provides colored pictures of a brain's abnormalities.*

"The brain is like no other organ. There's no way you can take a sample of brain tissue and have it mean anything, as you could with a liver biopsy, where you assume that the rest of the liver is roughly the same."

10 11

Labor issues did surface in a surprising picture in Bethlehem Steel Corp.'s annual report, however. Replacing the picture that traditionally accompanies the chairman's letter—a portrait of a smiling, self-confident CEO posed in his art-hung office—is a picture of an apprehensive, grim-faced Don Trautlein, Bethlehem Steel's chairman. Seated next to him is Lynn Williams, the president of the United Steelworkers of America. The occasion is a meeting of the Steel Advisory Committee in Washington, D.C., set up by the Reagan administration and composed of members of government, labor, and industry, who got together to discuss such issues as "unfairly traded steel imports," employment, and productivity. The rest of the pictorial section gives a more standard, optimistic assessment of Bethlehem's future possibilities, after another year of losses in 1984, and ends with another curious, labor-related picture: three Bethlehem steelworkers being shown through a customer's plant as part of a program to "help them develop a better understanding of the customer's need for on-time delivery of quality products." Visually, the report leaves the impression that *workers,* not imports, are the industry's biggest headache.

The steel industry's problems have been around for a while, and various strategies will continue to be used to solve them. But what about the occurrence of immediately disastrous, or at least serious, problems? "We'd advise confronting it head-on, like Johnson & Johnson did with the Tylenol problem in '82," says Bennett Robinson. Anthony Russell agrees. The Johnson & Johnson report, he says, "was a masterful piece of public relations." And what happens when a client doesn't want to face a problem directly? "I once

did a report for a company that had a big industrial accident they tried to cover up,"
Russell comments. "I quit. I thought it was immoral. I never did any more work for
them."

The 1982 "Tylenol" annual report, of course, was the one that dealt with the fact that
seven people in the Chicago area died from mysteriously poisoned capsules of Tylenol.
Johnson & Johnson was forced to spend $100 million removing Tylenol from store shelves
(and in the process found two more poisoned bottles). The upper right corner of the
plain tan cover of the 1982 report was cut out to show a small picture of a Tylenol bottle
and box, along with the peculiarly euphemistic inscription "An Eventful Year." Opening
the cover revealed that the Tylenol picture was just one of fifteen small images repro-
duced next to the legend "The Tylenol tragedy had a profound impact, but it was only
one event in a remarkable year." (This kind of understatement is the real forte of the
annual report. No matter how bad the circumstances, the annual's job is to minimize the
negative and maximize the positive.) The letter to shareholders dealt with the poisonings,
especially with the company's quick response to it, and the first double-page spread in
the illustrated section showed a McNeil Consumer Products Company worker at a con-
veyor belt full of new tamper-resistant Tylenol packages. Everything from the cover to
the opening pages broadcast a fearless confrontation of the problem and portrayed a
company that had pulled together and solved it, at least from a business point of view.

A much larger tragedy occurred in 1984—the pesticide gas leakage at Union Carbide India Ltd.'s plant in Bhopal. Unlike Johnson & Johnson, Union Carbide did not feature the disaster on the plain white cover of its report. It waited until the letter to stockholders on page 2 to mention it. Facing the letter is a traditional-looking portrait of chairman Warren M. Anderson and president Alec Flamm. It is printed on a sober gray ground and headed "Multinational companies and host countries alike must begin the work of absorbing the lessons of Bhopal in a constructive way," which seems to be a way of saying that Union Carbide isn't taking all the blame for this nightmare. Following this is a two-page essay, "After Bhopal," a discussion of the ramifications of the leak on the chemical industry in terms of uniform safety legislation, responsibility, and so forth. There is no mention of deaths or injuries or of how the leak occurred. There are no pictures of Bhopal or of the methyl isocyanate plant in West Virginia closed temporarily by Union Carbide after the leak. A segment review of the company's various divisions begins right after the Bhopal essay, illustrated on each right-hand page by neatly laid out still-life pictures representing Union Carbide products, which are assembled in tasteful, semi-abstract compositions. Everything looks clean, small, benign, and almost jewellike, in direct contradiction to the enormous, poisonous mess in India. Under the circumstances the aestheticized coldness of these pictures is almost shocking. Shocking, but not surprising: the annual is a vehicle of extremely limited expressive and informational power, meant primarily to reassure stockholders, and at that this book did a well-mannered if not masterful job.

A problem of less life-threatening and more potentially amusing dimensions was the power struggle at United Technologies between chairman and CEO Harry Gray and former president Robert Carlson, who was forced to resign in September 1984. Allegations by Carlson that Gray had bugged his home and office, along with the leaking of a confidential report about a possible takeover of Allied Corp. by United Technologies, caused a sensation in the press and the financial community. Gray's apparently great power within the company allowed him not only to retain power but to use the 1984 report to publicize his continuing preeminence, despite the fact that he is now past retirement age. He appears on the report's cover, in the corporation's senior-management team portrait on page 2, and in the first double-page spread, which is entitled, appropriately, "Profit" and which kicks off twelve pages illustrating the company's corporate credo in large, symbolic photographs. This may not be a record number of photographed appearances for a CEO in a single annual report, but the rest of the pictures do look quite barren without Gray's cherry countenance. (United Technologies might, in fact, consider capitalizing on Gray's photogenic proclivities by offering a line of signature products free to preferred stockholders: the Harry Gray Slimline Legal Pad Protector or the Harry Gray Executive Shoehorn.)

While it is unusual for a CEO to market himself in his company's annual report, it's not at all novel for a company to demonstrate the aggressive marketing of its products, like the Coca-Cola Company does in its 1984 report. More than in other annuals, the pictures in Coke's look lie advertisements. They are totally set up, using models, stylists, and location scouts. Shot by prominent annual-report photographer Bruce Davidson, the pictures are slick and thoroughly professional. They also show how American corporations are striving to homogenize the entire world into an American colony consuming American products.

Still life from the 1984 annual
report of the Union Carbide
Corporation (Photo: Jerry
Sarapochiello)

Cover of the 1984 annual report of the United Technologies Corporation, showing chairman Harry Gray (Photo: Gary Gladstone)

218 | 219

In the soft-drink section of the report the people in the picture are supposed to represent Americans, Japanese, Mexicans, and Britons. But all of the models look like variations of Americans. Only when you read the caption do you realize that the Asian woman in the powder blue running suit represents Coke's sugar-free market in Japan. Even the Americans shown represent a current marketing fantasy: yuppies, in apparent ecstasy, with their Diet Cokes on their fancy boat. The overweening message in the text is that Coke has pursued and will continue to pursue aggressive marketing tactics, especially to increase the international per capita soft-drink consumption, which is "only 15 percent of the U.S. level." Coca-Cola hammers home its strategy in talk about growth areas, growth potential, expanding markets, effective merchandising and advertising, and greater vending-machine "penetration." After all of that, the last caption in the soft-drink section tells us that Coke markets "a variety of products that respond to local consumer demand." Perhaps in their 1985 annual Coke will lead off with a picture of the citizens of Thailand "demanding' a drink of Mello Yello.

In the mid-1970s the investor relations firm Georgeson & Co., Inc. did a study showing that 40 percent of the stockholders surveyed spent five minutes or less with annual report. Annual report designers and photographers seem dedicated to delivering exactly what their clients want, in the most creative way possible. If readers still spend an average of only five minutes with an annual report, then perhaps we should ask that age-old question: What do corporations want? Is what they want too bland, too polite, too one-dimensional, and too unreal, especially in a world of familiar daily scandals, of greenmail, bank failures, insider-trading deals, and big-league brokerage houses defrauding backwater banks? Or is five minutes just right to convey a happy-faced, well-tailored story of corporate cheer? Ten minutes might stimulate questions and doubt. And that just wouldn't do.

The man [*sic*] who is capable of dreaming and transforming his dreams into reality is a revolutionary. . . . The man who is capable of loving and of making his love an instrument of change is also a revolutionary. In this sense, a revolutionary is a dreamer, a lover, a poet; because one cannot be a revolutionary without tears in one's eyes, without tenderness in one's hands. . . .

We have dreamed with Samuel Santos, the Minister of Reconstruction of Managua [capital of Nicaragua, heavily damaged by the 1972 earthquake and the 1979 Somoza bombing] of the union of our two great lakes [Lakes Managua and Nicaragua], of the rebirth of the fish [killed off by pesticide runoff from cotton fields] . . . of jets of water over the fertile fields of the Pacific, of a long *malecon* [lakefront boulevard] lined with fruit trees, with children, with lovers, with flowers. . . . [1]

Tomás Borge
Nicaraguan Minister of the Interior

The aggressive forces in Central America are clandestine and take advantage of the social and economic problems of the region. They hide behind and within movements for genuine social progress and emerge openly to grab power after the fighting has stopped. In Nicaragua a popular revolution to overthrow one dictatorship led to the seizure of power by another, and the new Nicaraguan regime is becoming a Soviet satellite. . . . Liberals should not doubt that [certain] factions [of Salvadoran rebels] seek to establish the kind of Leninist totalitarianism that exists today in Nicaragua, Cuba, and the Soviet Union.[2]

Jack Kemp
Member of the House of Representatives,
Republican, New York
Consultant to the President's Commission
on Central America

C / O v e r t I d e o l o g y :

T w o I m a g e s o f R e v o l u t i o n

The two views of revolution in Central America quoted here were voiced by leaders from two countries that are worlds apart historically, culturally, politically. We have heard the report of the Kissinger commission on Central America[3] (which Kemp advised), but we have not heard the voice of Tomás Borge. In November 1983 our State Department denied him a visa to enter the United States. Borge, whose country is besieged by counterrevolutionary forces supported by the U.S., intended to speak with numerous government officials and private groups here to defend the survival of his government. Our government claims its action was intended to deprive him of a "propaganda platform." The American Civil Liberties Union has charged that the State Department's action was part of an "unconstitutional pattern of actions designed to deny Americans access to information challenging the Administration's position."[4]

On the following pages I will examine our images of Nicaragua and Central America (I include Central America—primarily El Salvador, Guatemala, and Honduras—because our attitudes and actions in relation to these countries are virtually inseparable from our responses to Nicaragua), shaped not through blatant suppression of free speech, as in Borge's case, but through the more subtle and more consistent mechanisms or conventions of "objective" news reporting in the United States. I will compare some material I gathered in Nicaragua (texts and pictures from Nicaraguan publications as well as excerpts from the interviews and images of or by photographers, citizens, and officials there) with *New York Times* articles on Nicaragua during the period I was there, July 29–August 17, 1983. I gave a workshop in high-contrast darkroom techniques in Managua at the invitation of the Union of Photographers (UFN), a section of the Sandinista Association of Cultural Workers (ASTC).[5]

Views from the United States

I choose the *New York Times* for my analysis because I believe it provides the most thorough and influential daily coverage of Latin America available throughout the U.S. My

argument might be more easily made were I to look at smaller or more sensationalized local papers, whereas the *Times* is widely regarded as authoritative and credible. Many *Times* stories are comparatively long and therefore apparently comprehensive. Most are researched and written by the *Times*'s staff reporters, who are generally conscientious in citing their sources. The *Times* also regularly features letters and opinions by figures well known in their respective fields, representing a range of political views. In addition, the *Times*'s design contributes to its image of balance and objectivity. Even the paper's format signifies serious content, unlike the convenience packaging of tabloids. By eschewing colored inks and excessive use of photographs or seductive graphics, by employing staid serif typefaces (predominantly) and relatively uniform headline size, the *Times* maintains a conservative, scholarly look. Nevertheless, despite its appearance and its reputed authority, the *Times* gives us very little information about constructive developments in Nicaragua or other Central American countries.

Perceptual bias and some degree of ethnocentricity may be inevitable in any society in any part of the world. What is so disturbing about the information system in the United States is that we maintain the illusion of receiving objective information and that, on the basis of this (mis)information, most American citizens support or at least tolerate our government's massive military expenditures and interference in other countries in the name of protecting our "vital interests." This has meant that the most powerful nation in the world continues to perpetrate devastating sabotage, both economic and military, against the Sandinista government in Nicaragua as well as thwarting radical change in Central America over the years.[6]

"All the News That's Fit to Print" is the *Times* banner motto, but we must ask how "news" and "fit" are defined. Notions of objective journalism founder on the fact that journalists, editors, and publishers manifest and foster ideological bias in their selection of facts from the infinite spectrum of global, national, and local happenings and in their choice of commentators—sources—on those happenings, no matter how accurate those sources may be. A newspaper, like a photograph, is the reflection of a hierarchy of attention, a system of values, whether consciously or unconsciously articulated. Overwhelmingly, our newspapers' sources for foreign affairs information are officials of the American government, reciting their claims and actions, either in Washington, D.C. or abroad. Accordingly, the government sets the agenda for the focus of our attention, even though certain reporters sometimes challenge specific assertions or government decisions.

Indeed, a Marxist media analyst would conclude that news under a capitalist system reflects the ideas of the ruling class; that even though news reporters are "highly moral and responsible professionals who do the best they can to avoid being manipulated,"[7] they have unconsciously adopted the establishment's point of view; that much of what is published is actually generated by the public relations mills of various political leaders, government agencies, business managers, and other representatives of ruling interests.[8] Whether or not one adopts a Marxist position, common sense tells us that ownership and advertising configurations influence media content.

Certainly the competitive capitalist system encourages news reporting that resembles sensationalized entertainment. As an editor from ABC has admitted regarding film footage selection, "If you can show someone being blown sky high, it can almost compete with prime time for ratings."[9] These distortions are compounded by an absence of history or serious analysis in news presentations and by fragmentation of the unfolding processes of social reality into digestible daily units. Even the continuity which might accumulate from a series of such day-by-day units is unsustained as media attention shifts. Researcher

and corporate advisor John Naisbitt contends that the "news hole," the amount of space devoted to news in a given newspaper, is a closed system which, for economic reasons, changes very little. Therefore, social issues emerge and fade in the press as social concerns in this country shift, or appear to shift. Naisbitt observes that in the early 1970s, for instance, "As the column inches of environmental news increased, news about civil rights decreased—on a one-to-one, line-by-line basis. One yielded as the other gained."[10]

Our apprehension of information is influenced significantly, if subliminally, by context—in the case of newspapers, length, position, and juxtaposition on the page and within an entire issue, including relationships to other articles, photographs, and advertising.

The following pages present excerpts from nine issues of the *New York Times,* plus a page from the *Wall Street Journal* and one from the *Chicago Tribune.* The entire front page of each issue of the *Times* and parts or all of selected interior pages are reproduced, together with an index of all Central American news stories, editorials, letters, and opinion essays in that particular issue. However, my commentary on each issue is intended only to examine the ideological bias in the supposedly objective *news* portion of these papers.

New York Times, July 29, 1983

"House Votes Down Effort to Weaken Ban on Covert Aid" (1:6, 4:2)
Washington, D.C., special to the *New York Times,* by Steven V. Roberts

"House Vote on Cutting Off Covert Aid to Nicaraguan Rebels" (4:3)
Washington, D.C., AP

"Rebels Said to Abandon Useful Ploy in Salvador" (4:1)
San Salvador, special to the *New York Times,* by Charles Mohr

Op-Ed

"Latin Officials Meet in Peace Bid" (4:2), Panama, AP

Op-Ed

"The Sandinista Puzzle" (23:1), by Tom Wicker
"Reaching a Synthesis for Salvadoran Policy" (23:2), by Jack Kemp

There seems to be considerable coverage of Nicaragua/Central America here, but the two articles on Nicaragua are filed in Washington and actually describe actions and attitudes of the House of Representatives toward administration policy. A close reading of the article on El Salvador, although filed in San Salvador, the capital of the country, reveals that statements about Salvadoran guerrilla tactics come almost exclusively from official Western or U.S. sources there: "an American adviser said," "a U.S. military expert said," "A Salvadoran infantry colonel agreed that," "a military analyst there attributed," etc. The only voice of a Latin leader quoted in the paper is that of Costa Rican president Luis Alberto Monge, who "criticized the presence of 19 U.S. Navy ships patrolling off Nicaragua's Pacific and Atlantic coasts: 'We don't like it . . . We don't believe it contributes to progress toward pacification. . . .'" Monge's statement appears in the brief AP report from Panama, mildly (and misleadingly) titled "Latin Officials Meet in Peace Bid."

There are two photographs on page four related to Nicaragua, but again neither one shows us anything about the state of affairs in that country. Instead we see two Representatives discussing the House vote on Nicaragua and New York police gently removing from the United Nations a protestor against U.S. military involvement in Central America.

Two other photographs and headlines relating to international news in the *Times* emphasize the prevalence of violence in *other* parts of the world. The wounded Turkish ambassador in Lisbon, victim of Armenian terrorism, reads messages of condolence. A photograph of protesting Sikhs on page five accompanies the headline "Lynchings Bring Wild West to India," followed by a detailed account of the rise of vigilante justice in that country.

New York Times, July 30, 1983

"White House Says U.S. Will Still Aid Nicaragua Rebels" (1:6, 3:1)
Washington, D.C., special to the *New York Times,* by Philip Taubman

"Castro Proposes Accord to Curb Arms to Latins" (1:5, 2:3)
Washington, D.C., special to the *New York Times*

"Nicaraguan Rebel Criticizes Vote" (2:3)
Tegucigalpa, Honduras, special to the *New York Times*

"Vote on Aid Cutoff: A House Divided and Confused" (3:1)
Washington, D.C., special to the *New York Times,* by Steven V. Roberts

"Costa Rica, Latin Haven, Worries About the Price" (4:1)
San Jose, Costa Rica, special to the *New York Times,* by Barbara Crossette

Op-Ed
"Bolivar's Ideals and 1983," by Robert P. Matthews

This issue of the *Times* again focuses on Washington's attitudes toward Nicaragua and Central America, although Fidel Castro's remarks on the Central American situation, based on a CBS interview with him, are given prominence as are, to a lesser degree, those of Nicaraguan rebel leader Edgar Chamorro Coronel, interviewed in Tegucigalpa, Honduras. The lengthy article about Costa Rica describes the country as uniquely peaceful in Central America but omits any historical analysis of why it has remained so. Given the current confusion over American policy toward Nicaragua (see article on p. 3), wouldn't responsible journalism better serve the public by running a detailed article or series of articles on political, social, and economic conditions in Nicaragua? However, no such articles appeared in the *Times* during this period when Nicaragua was often in the news.

The use of photographs in this issue of the *Times,* especially those on page one, follows a pattern I find common in newspapers in the United States: images of Third World countries generally depict some violent event or even give the impression that violence is an ongoing condition, as in the caption (lower right photo): "Rioting Continues in Sri Lanka. Looters yesterday in Colombo, the capital city, rummaging through debris from a burned store. At least 33 people were killed in new violence and 300 were arrested." But there is no story on page one; only ten paragraphs into the story, on page three, are we offered a political rationale for this violence. Such attention to violence in Sri Lanka is particularly ironic on a day when a leading front-page story and graphic package (two photos and a map) describe the basing of a seven-ship Navy group at Staten Island. This massive military force (a battleship, a cruiser, three destroyers—two carrying guided missiles—and two frigates) is not presented as a destructive force, as evidence of the power of U.S. intimidation. On the contrary, politicians are quoted as ecstatic about the boost to the local economy.

In other words, the unstated message conveyed by photographs in conjunction with text is one reinforced often in our society: *our* military might or exercise of power is somehow clean, rational, even constructive, while violence in the dimly perceived Third World countries is irrational, cyclical, random, involving personal assault, hatred, fanaticism—in short, physically and emotionally messy.

This brings us to a larger issue, our denial of ideology. The majority of North Americans have never experienced the kinds of political/social conflict which bring an existing order fundamentally into question.[11] Therefore it is extremely difficult for us to grant legitimacy to the kind of ideological passion or violent action associated with revolutionary movements. Assuming our system to be benevolent and natural, that is, non-ideological, we do not perceive the flexing of our own military muscle as violent, but we readily label those who challenge our power or threaten established power in other countries as subversives or terrorists.

Ironically, we have not forgotten our own American Revolution. Witness the costumed guard on page five—parading in a farewell ceremony for a retiring Brigadier General—

but that revolution has been routinely sanitized or commercialized. We have no sense of ourselves as a rag-tag band of armed subversives comparable to today's Third World revolutionaries.

New York Times, August 3, 1983

"Reagan Asserts He Is Optimistic on Latin Peace" (1:5, 6:5)
Washington, D.C., special to the *New York Times,* by Philip Taubman

"General Details U.S. Role in Maneuvers in Honduras" (6:1)
Washington, D.C., special to the *New York Times,* by Richard Halloran

Letters
"Central America: A Peace Option" (22:4)
"Wilson's Opposition to Mexico's Huerta" (22:6)

Op-Ed
"Reagan's Path to War" (23:5), by John B. Oakes

The use of photographs in a newspaper such as the *Times* contributes to our sense of the United States as civilized and rational in a second way: no matter what the news content, a good proportion of the photographs in the *Times* are head shots or head-and-shoulder shots of our leaders—white, male officials, clean-shaven and well-groomed, wearing suits, white shirts, and ties, shown individually or in friendly discussion. Although the story on page seven about a governors' meeting in Maine is titled "Economic Policy Splits Governors," the two pictures of governors on page one establish an amiable tone. The two unsmiling senators shown on page six leaving their meeting with President Reagan about Central America ("optimistic on peace") suggest the earnestness with which our leaders pursue peaceful solutions. This photo hardly hints at the massive military operations described in the adjacent article, "General Details U.S. Role in Maneuvers in Honduras": three battalions of Hondurans trained in anti-guerrilla tactics by Army Special Forces, Navy Seals, and Air Force Special Operations; an American naval battalion (the Seabees) scheduled to extend an airfield to accommodate C-130 transports for American troops and supplies; 120 Green Berets training Salvadoran troops; etc.

In the *Wall Street Journal,* which carries no news photographs, the prominent use of photographs in advertisements carried by the paper reinforces the rational image I have described. The Honeywell ad shown here (August 2, 1983, p. 11) addresses the problem of "control and efficiency slip[ping] away, replaced by mounting 'PC Pandemonium,' " and suggests that technology, together with genial negotiations between white men in business suits, will solve the problem.

New York Times, August 4, 1983

"Pentagon Reports Encounter at Sea with Soviet Ship" (1:1, 4:1)
Washington, D.C., special to the *New York Times,* by Richard Halloran

"Stone Briefs Reagan on Trip: 3 Democrats Seek Troop Curb" (4:1)
Washington, D.C., special to the *New York Times,* by Philip Taubman

"Salvadoran Guerrillas Return to a Key Province" (4:1)
San Vicente, El Salvador, special to the *New York Times,* by Charles Mohr

"U.S. Quarantine of Cuba Is Recalled" (4:1)

Op-Ed
"Latin Marshall Plan?," by J. Robert Schaetzel (25:1)

The encounter of a Soviet freighter (bound for Nicaragua's port of Corinto) with an American destroyer is major news in this issue, warranting a story, two photographs, and a map on page one. One might say that Nicaragua is in the news again, but we still learn nothing about Nicaragua—goals, activities, controversies occurring within the country. However, the *Times* augments what it considers to be an important news story—a confrontation between the superpowers on the high seas—with special supplementary material: a historical reference comparing this incident to the 1962 quarantine of Cuba, and consultation with three specialists (one academic, two practicing lawyers) on international or maritime law (on p. 5). The historical and scholarly perspectives thus provided are valuable. It is unfortunate that support/research material comparable to that lavished on this Soviet-U.S. incident is not regularly available regarding small Central American countries. Certainly our present giant military commitment there, to say nothing of the $80

billion aid program proposed by the Kissinger commission, warrants the closest critical scrutiny of the U.S. government's assumptions about and interests in these countries.

Still more curious is a note within the story about the Soviet ship explaining how it made the U.S. press. The Defense Department acknowledged the incident at sea only after the Soviet ship arrived in port, "and the Soviet captain had informed the Nicaraguan Government and the Cuban press agency, Prensa Latina. The Associated Press picked up the Prensa Latina report in Mexico City, causing Pentagon officials to scurry for several hours to produce a press release." This demonstrates the tenuous or capricious connections between an occurrence and its recognition or publication as a newsworthy event. It also indicates the importance of multiple news agencies, representing a variety of interests, in defining and capturing the range of events.

New York Times, August 5, 1983

"Shultz Says Fleet Does Not Pursue Latin Showdown" (1:6, 3:6)
Washington, D.C., special to the *New York Times,* by Philip Taubman

"Salvador Rebels Urged by Allies to Seek Accord" (1:5, 3:2)
Managua, Nicaragua, special to the *New York Times,* by Marlise Simons

"Bonn Contrite Over Activist Who Spilled Blood on General" (2:3)
Bonn, special to the *New York Times,* by James Markham

"U.S. Warships Will Meet Soviet Vessels in Latin Zone" (3:1)
Washington, D.C., special to the *New York Times,* by Richard Halloran

Washington Talk
"CIA: Intra-Agency Rifts Laid to Nicaraguan Operation" (8:3)
Washington, D.C., special to the *New York Times,* by Philip Taubman

Op-Ed
"Irony in Honduras," by Tom Wicker (23:5)

It appears that this issue of the *Times* presents a fairly broad range of information about Nicaragua/Central America. At least in addition to Shultz's statement about American intentions in the area there is an article filed from Managua which quotes extensively from "leftist sources" regarding pressure by Cubans and Nicaraguans on the Salvadoran guerrillas to seek a political settlement. Still, the focus of this article from Managua is an issue defined by the Reagan administration: the Cuba–Nicaragua–El Salvador revolutionary connection/threat. Why not examine instead the historical, cultural, and linguistic ties between these Central American countries that would tend to make them natural allies with related political attitudes? Washington again sets the news agenda.

The single photograph used in connection with the Central American stories (Shultz and Motley of the State Department with the Senate Foreign Relations Committee) concentrates as usual on our officials, the controlling players in this situation. The lead photo on page one represents another genre of news photography: the rituals of benevolent royalty. This "Birthday Tribute for Queen Mother" is also one of the few occasions in which we see women on (or near) the front page of the *Times*. Women are rarely pictured as participants in weighty world affairs, but their presence—often in the role of gracious hostess or philanthropic matron—lightens, lends dignity, glamour, a reassuring sense of stability, that is, hierarchy, to an otherwise hectic scene, a world in upheaval.

Comparing two stories in this issue again highlights the American double standard in attitudes toward violence. On one hand we have a prominent item describing West German Foreign Minister Genscher's apology to Secretary of State Shultz for blood spilled on a U.S. Lieutenant General's uniform. This *symbolic* violence by a German (Hesse Green) activist protesting the U.S. buildup in Honduras and U.S. missiles in Central Europe is described by Genscher as inexcusable and unworthy. On the other hand, the *Times*'s "Washington Talk" story on the CIA's "Nicaraguan Operation," a euphemism for the *actual* violence, is reported with emphasis on the "intra-agency rift," the bureaucratic tensions between professionals who collect and analyze information and those who run the "largest paramilitary effort mounted by the CIA since the Vietnam War."

Chicago Tribune, August 5, 1983

"Latin Exercises Backed" (1:2, 2:1)
Washington, D.C. *Chicago Tribune,* by John Maclean

"New Push for Talks in Salvador" (2:1)
Managua, Nicaragua, *New York Times* News Service

"U.S. Cancels Nicaraguan Loan of $7.5 Million for Schools" (2:1)
Managua, Nicaragua, AP

Editorial
"The Caribbean Supermarket" (18:1)

Op-Ed
"The Risks of Brinksmanship" (19:3), by Flora Lewis

A brief comparison of the *Times* front page with the *Chicago Tribune* front page for the same date (space limitations prevent more extensive comparisons with a greater variety of newspapers and other media) shows the *Tribune* to have a less sober format—greater variation in typefaces and sizes, snappy use of color (red, blue, and yellow) in the banner and charts, more evidence of women (one in the entertainment preview box). But the basic news hierarchy is not dissimilar: Secretary Shultz's defense of troop presence in Central America given top billing, the Lavelle EPA scandal, miscellaneous local issues, and

again the Queen Mother's Birthday. The *Times* undoubtedly covers a greater variety of international news in greater depth. The *Tribune* story "New Push for Salvador Talks," for instance, is a shorter version (cut approximately 40 percent) of the same *Times* story. There is no coverage of the Bonn apology or the CIA rift. One item in the *Tribune,* on the U.S. cancellation of an education loan for Nicaragua, did not appear in the *Times,* but it provides no information on or any way of assessing education in Nicaragua.

New York Times, August 8, 1983

"Shultz Vows No Attack on Nicaragua" (3:2)
Washington, D.C., AP

Washington Talk
"When Is a Foreign Interest 'Vital'?" (8:3)
Washington, D.C., special to the *New York Times,* by Leslie Gelb

Op-Ed
"Bigger Peril," by Sally Shelton (17:1)
"A Dictator or Something," by Tom Wicker (17:5)

The August 8 *Times* has little news on Nicaragua/Central America compared to the others examined so far. The single related story, "Shultz Vows No Attack on Nicaragua," which is, more accurately, about Shultz's pronouncements rather than Nicaragua, raises several questions. Why does the headline implying the peaceful intentions of the United States contradict the text: "He made it clear that the Administration intended to press forward with its plans, covert and otherwise, to stop Nicaraguan support for rebel movements in El Salvador and elsewhere in Central America"? The story could as well be titled "Shultz Intransigent on Nicaragua." Why does the Reuters article, "Castro Rebuts U.S. Officials," which is run under the same title, not merit a separate headline? Apparently, editorial decisions about what and how to cover a given topic or region are somewhat capricious or inconsistent, even though an overall ideological pattern is evident.

News, photographs, and advertising on the first three pages of this issue again contrast our rational, civilized society with Third World instability or violence, reflecting what Bill Whitman, an American priest, has aptly called our "First World consciousness." There are two UPI photos (pp. 1 and 3) of the aftermath of a bombing in Beirut, a city that has come to be identified with endless, incomprehensible violence: the bombings [on August 5 and 7] appear to have had no other immediate objective than to kill as many civilians as possible. Such violence is not without precedent in Lebanon."

The other two pictures on page one show attractive, white male Americans—one a golf star, winner of the PGA tournament, the other a teenage computer whiz who's making lots of money. This latter story of the triumph of free enterprise is placed next to an article on the Soviet Union's stern punishment of shirkers. A similarly attractive white male (depicted in wash drawing) on page three wears "the ultimate light jacket" in an ad from the Men's Shop of Lord and Taylor. The very existence of the product advertising that flows through the pages of the *Times,* offering the promise of success and distinction, creates an impression of well-being, of well-stocked comfort—much like strolling through a prosperous neighborhood or window shopping on Fifth Avenue—and reinforces the image of civilized American society conveyed in the news columns.

New York Times, August 9, 1983

"Guatemalan Army Topples President in a Brief Battle" (1:6, 6:1)
Guatemala, UPI

"U.S. Is Wary on Coup but Also Hopeful" (6:1)
Washington, D.C., special to the *New York Times,* by Philip Taubman

"Latins Should Settle Conflict without the U.S., Paris Says" (6:1)
Paris, AP

"Guatemalan Communique on Chief's Ouster" (6:1)
Guatemala, AP

"In Command in Guatemala: Oscar Humberto Mejía Victores" (6:4)
Mexico City, special to the *New York Times,* by Richard J. Meislin

"Guatemala at a Glance" (6:3)

"Kissinger Commission Plans First Meeting on Wednesday" (6:6)
Washington, D.C., Reuters

Editorial
"Hairs in the Guatemalan Soup" (26:1)

Op-Ed
"Test Castro to Learn if He Would Negotiate" (27:1), by Joseph Sisco
"Weigh Impeachment in an Illegal War" (27:5), by Don Edwards

The chief event relating to Central America in this issue is the coup in Guatemala, with Defense Minister Oscar Humberto Mejía Victores replacing Brigadier General José Efraín Ríos Montt as President. In addition to the story on page one, the *Times* devotes almost an entire page to the coup (see p. 6). The brief background on the history, geography, population, and economy of the country, titled "Guatemala at a Glance," bears close examination because it is presented without a byline or attribution, as neutral fact. Bringing this kind of historical perspective to current events is important but is lacking in most newspapers. The objectivity of such surveys is illusory, however, and their value therefore questionable. Consider the description of recent Guatemalan history:

Modern times have brought chronic political instability marked by military coups, terrorist violence, human rights violations, election frauds and the suspension of constitutional rights. Left wing guerrillas and right wing vigilante groups known as death squads have disrupted life with terrorist attacks and political murders since the '60's.

"Modern times" seems to be the agent of "chronic political instability." The disruption from the right and left are made to seem equal. This bias against "extremists" in either direction and the equation of their violent activities is another unexamined assumption of our simplistic world mythology.

Only at the end of this article, under the heading "Economy," is there a hint of any underlying cause of chronic instability. It occurs in a single sentence following the list of Guatemala's agricultural and industrial products: "Two-thirds of the arable land is controlled by two percent of the people." There is no reference whatsoever to the significant role of the United States in Guatemalan history, although this is well documented elsewhere.[12] Curiously, the *Times*'s lead editorial of the day, "Hairs in the Guatemalan Soup," makes this point: "With the encouragement of the U.S., the (Guatemalan) armed forces have decreed themselves the wielders and judges of power. That attitude was powerfully reinforced in 1954 when the CIA helped topple an elected leftist Government in the name of anti-Communism. The coup . . . opened the way for a procession of unstable military tyrannies." Is it in the name of brevity or objectivity that the factual version of this same history in "Guatemala at a Glance" tells us so little?

New York Times, August 10, 1983

"Guatemala Lifts Curb on Freedoms" (1:5, 4:5)
Guatamala, special to the *New York Times,* by Richard J. Meislin

"Salvador and Vietnam: Parallels Drawn in U.S. Role in Two Wars, But Major Differences
Can Also Be Found" (1:3, 4:1)
San Salvador, special to the *New York Times,* by Charles Mohr

"Military Forces Stretched Thin, Army Chief Says" (1:2, 3:1)
Washington, D.C., special to the *New York Times,* by Richard Halloran

"Salvador Parties Back Vote Delay" (4:1)
San Salvador, special to the *New York Times*

"Guatemalan's Remarks Applauded by the U.S." (4:3)
Washington, D.C., special to the *New York Times,* by Philip Taubman

"Moscow Blames Washington for the Coup in Guatemala" (4:5)
Moscow, AP

Letters
"Central American Quandary" (three letters) (24:4)
"In Nicaragua, Signs of Rights Abuses" (24:6)

Again the disparity between headlines and/or photographs and text is striking. The impression conveyed by both headlines on Guatemala, for example, suggests the country is on the threshold of a new era of freedom. However, within the text of the Taubman article we find that it is not just a purported return to democracy that is being applauded but that "Officials at the Defense Department and the Central Intelligence Agency . . . hope that General Mejía Victores will give Guatemala a more active role in American-sponsored activities in Central America." At the end of the article we learn that Representative Clarence Long, chairman of the House Appropriations Subcommittee, was particularly offended by the refusal of General Mejía Victores "to acknowledge that there had been rights abuses involving Guatemala's Indians." Further, we discover that, although "Congress . . . has refused to approve a resumption of military aid to Guatemala . . . on

the ground that [its] rights record remains poor," the CIA has been providing "covert aid to Guatemala during the last two years to assist in the campaign against leftist guerrillas."

Page three of this issue is another study in picture/text dissonance: the top photo shows the smoldering remains of a terrorist incident in Ireland, while the page is bordered with ads sporting glamour, luxury, brilliance, "beyond the imagination"—"the American look," courtesy of B. Altman, Bergdorf Goodman, Lord and Taylor, Saks Fifth Avenue, and Tiffany and Co. In the center of the page, the discussion of our military commitments, continued from page one, is illustrated with two photographs showing two respectable members of the defense establishment, both concerned about the mismatch between our military budget and strategy. The actual inventory of American military force around the globe is staggering: in brief, AWACS are in Saudi Arabia, Iceland, Okinawa, Egypt, the Sudan. Five and one half of the Army's sixteen divisions are in Europe, one in South Korea, a brigade in Panama. . . . Several battalions are in Egypt for the Bright Star exercise of the rapid deployment force. Smaller units will do similar training in the Sudan and Somalia. Still more maneuvers have occurred or will occur shortly: 3,500 American soldiers with Thai troops, 17,000 in Germany, 900 with Japanese troops, 5,500 with Honduran troops. Beyond this, the Special Forces have 440 trainers in more than fifteen other countries on any given day, and our aircraft carriers (in battle groups that include a cruiser, several destroyers, and frigates) are deployed around the world—in the Atlantic, western Pacific, and Indian oceans and in the Caribbean and Pacific off the coast of Nicaragua.

New York Times, August 13, 1983

"Mexican Pressing Nicaragua on Oil" (3:1)
Mexico City, special to the *New York Times,* by Marlise Simons

"Latin Panel Ends Talk" (3:1)
Washington, D.C., AP

"Guatemala and U.S.: Reagan Gaining Support for Policies from New Central American Leader" (3:5)
Mexico City, special to the *New York Times,* by Richard J. Meislin

"Salvadoran Amnesty Program to Expire Monday" (3:2)
San Salvador, special to the *New York Times,* by Michael Wright

"Salvadoran Panel to Meet Rebels" (4:5)
San Salvador, special to the *New York Times*

"Reagan Praises Hispanic-American Unit" (8:1)
Tampa, Florida, special to the *New York Times,* by Francis X. Clines

"Excerpts from President's Address to Hispanic-American Business Group" (8:1)
Tampa, Florida, AP

The front page of this issue, with a photo and article on Third World violence (in Chile), also has a photograph of President Reagan greeting a retired Vietnam War hero at the U.S. Hispanic Chamber of Commerce in Tampa, Florida. Another photograph of enthusiastic flag-waving Cubans at the conference along with extensive coverage of Reagan's speech to the Hispanic group fills about 60 percent of page eight. This should be recognized as a prestigious and generous forum for the President's domestic political maneuvering to promote support of his Central American policies. He mixes "lavish praise of the Hispanic communities" with denigration of Fidel Castro's Cuba as "the economic basket case of the hemisphere." He loses no opportunity to repeat the litany of his Cold War charges, linking the Soviet Union, Cuba, and insurgent movements throughout the hemisphere. How is the American public to assess our foreign policy, laced with these Cold War assumptions, on the basis of such weighted reporting?

Granted, the foregoing is not an in-depth scientific sampling; nevertheless, looking at these nine issues of the *Times* randomly chosen over a sixteen-day period, certain patterns can be noted. Fully half of the thirty-six news stories related to Central America come from Washington, D.C.—the executive, legislative, or Pentagon beats—without counting the two articles about Reagan with Hispanic-Americans in Florida. As I indicated earlier, even stories filed in Central America often feature American military or diplomatic personnel there.

Five of these nine issues feature front-page photographs of violence or the aftermath of violence in Third World countries (Lebanon, Chad, Sri Lanka, Chile). Out of a total of twenty-nine front-page photographs, eight portray white male Americans (one entertainer, one computer whiz kid, three sports figures, the rest government officials); there are two male Latins, both administration "allies" (the new President of Guatemala and a Hispanic-American Vietnam War hero), two black males (one athlete and the President of Zaire, also our "ally" against Libya), and two white females (a TV news anchorwoman and the Queen Mother with relatives).

Clearly, the *Times* is heavily establishment oriented in its news reporting, which means that, ideologically speaking, it reinforces the status quo. This allows the administration to orchestrate its speeches, press conferences, and other public activities using the press as its promotional vehicle.

If it is true that in its editorial or opinion section the *Times* is frequently critical of the administration; eight out of nine op-ed essays relating to Central America in these nine papers take issue to some degree with Reagan's policies there, as do the majority of letters printed. The most radical of these critiques, Tom Wicker's "Sandinista Puzzle" or

William Sloan Coffin's eloquent "Nicaragua Is Not an Enemy" (*New York Times*, July 31, 1983, p. A19:1) emphasize Sandinista pluralism. Even these articles do not consider the possibility that a government adhering to Marxist principles and cultivating ties with other socialist countries might be legitimate, constructive, and appropriate for that country.

In other words, despite the fact that the American press has been attacked for being left wing,[13] the spectrum of media dialogue in the United States is still shifted far to the right. There are as few forums for Marxist ideas in our mass media as there are for capitalist notions in the Communist press we condemn for imposing its ideological bias on the news. We might note that the Federal Communication Commission's guidelines concerning the Fairness Doctrine, which mandates balanced coverage by broadcasters of "controversial issues of public importance," state that "it is not the Commission's intention to provide time to Communists or to the Communist viewpoint."[14]

If in our cultural arrogance or political narrowmindedness we will not listen to Nicaraguan revolutionary voices, why must we heed people like Stone, Shultz, and Kissinger, who spend scarcely one day of their whirlwind Central American tours in Nicaragua? There are North American technicians, religious workers, and scholars with years of research and experience who could provide the press with more thorough and accurate analyses.

I am not proposing a Marxist government for the United States, nor do I condone censorship or human rights abuses in Nicaragua or any revolutionary society. These countries are not above criticism, nor do they pretend to be. But it is not our business to change them. As responsible Americans we should recognize our *own* ideological biases, identify the forces in *this* country that discourage significant change, and understand how these are reinforced by *our* sources of information.

Views from Nicaragua

Although I was aware of a general pattern of U.S. intervention in Latin American affairs, until quite recently I was unfamiliar with the sordid details of that history in regard to Nicaragua. In 1855 an American adventurer named William Walker arrived in Nicaragua with fifty-eight cronies, declared himself president, and reestablished slavery. In 1912, prompted by our designs on the region as an alternate canal route, we sent in the U.S. Marines. In 1914 we "negotiated" the Bryan-Chamorro Treaty giving the United States exclusive canal rights. Our Marines maintained a more or less continuous presence in Nicaragua until 1933, despite fierce resistance organized by peasant leader and national hero Augusto Sandino during the period 1927–33. When American troops under Sandinista pressure finally evacuated the country, they created and left behind a surrogate force, the Nicaraguan National Guard, headed by Anastasio Somoza García. Lured by hypocritical peace overtures, Sandino was assassinated in 1934 on Somoza García's orders.

Because of the parallels with U.S. Central American intervention today, I feel a sickening sense of *déjà vu* when I read Carleton Beals's vivid account of his experiences in Central America in the 1930s. Beals, the only U.S. journalist who succeeded in locating and interviewing Sandino during his insurrectionary struggle, wrote a book called *Banana Gold*.[15]

Some of the first Nicaraguan
National Guard being
reviewed by a United States
officer, Ocotal, Nicaragua,
1927

Beals on U.S. presence/pressure in Honduras

I lunched [in Tegucigalpa, Honduras] with Eugenia Torres, a Mexican elocutionist. . . . She told me that the Honduras Minister of Education . . . had ordered her point-blank not to recite several patriotic poems of Froylán Turcios, the Sandino representative [in Honduras] "because we are on very good terms with the Americans just now."

On very good terms—the bait being the semi-promise of a loan (which never materialized) on the strength of which the government was busy giving away concessions to American companies. Most of the Honduras army was massed on the Nicaraguan frontier to prevent supplies from reaching Sandino. . . . The press of Tegucigalpa printed only unfavorable and abbreviated news concerning Sandino—orders of the government.[16]

On the U.S. Press in Nicaragua

At the time I arrived in Managua, a number of special correspondents had arrived on the scene. Prior to that all the news had been sewed up in the customs office. Mr. Clifford D. Ham, American [customs] collector for fourteen years, represented the United Press and his assistant, Mr. Irving Lindberg, the Associated Press. Customarily, these were the only two important newspaper men on the scene, thus insuring that only the strictest official versions would be sent out to the American public. . . .

Fortunately, by the time I had arrived, the Sandino revolt had attracted various newspaper and movie men. There was, at the time, a standing offer of fifty thousand dollars to any one who would bring in five yards of film of Sandino's soldiers in action. The Associated Press now had, in addition to Lindbergh, an elderly individual whom the organization had definitely retired to Panama but who was now rushed up to Nicaragua, an honest though simple-minded gentleman, physically quite incapable of rustling around in the heat for the facts, so that most of his work was done by the other correspondents. Mr. Denny, of a New York daily, an unusually brilliant reporter, had been sent down to Bluefields (town on Nicaragua's Atlantic Coast) on a battleship and then had been carried across to Managua in an army plane. He confided to me that in view of these and other courtesies he had dared not send out a single word which was not "official."[17]

On the Sandino Legend

The simple folk with whom we talked here were all agog over Sandino. He had become ubiquitous. He had been seen here; he had been seen there. At night he had gone stalking along a ridge, god of the universe. Later I found the same mythology was believed everywhere I went in Nicaragua. At many a low doorstep I sat and talked over a *jícara* [gourd cup] of chica corn beer, or a glass of yellowish palm wine; and there was no place Sandino had not been seen. He had fired the imagination of the humble people of Nicaragua. In every town Sandino had his Homer. He was of the constellation of Abd-el-Krim, Robin Hood, Villa, the untamed outlaws who knew only daring and great deeds, imbued with the tireless persistence to overcome insurmountable odds and confront successfully overwhelming power. His epos will grow—in Nicaragua, in Latin America, the wide world over. For heroes grow ever more heroic with time.[18]

Today Sandino's image, along with that of Carlos Fonseca, one of the three founders of the Sandinista Revolutionary Front in 1961, is a haunting presence in Nicaragua. Although this nationalist imagery is dominant, there are also important Marxist and Christian influences in the country, manifest in the words and pictures of Che Guevara, Fidel Castro, Marx, Lenin, Jesus, and Pope John Paul II, among others, on posters, in publications, etc.

Father Ernesto Cardenal, the Jesuit priest and poet who is Nicaragua's Minister of Culture, claims that "Nicaragua is the first [country in the world] where it doesn't matter whether one is Marxist or not, just as in civilized countries it doesn't matter whether one is Jewish or Protestant or Catholic. . . . In this Revolution in many cases no one even knows who is what.[19]

238 | 239

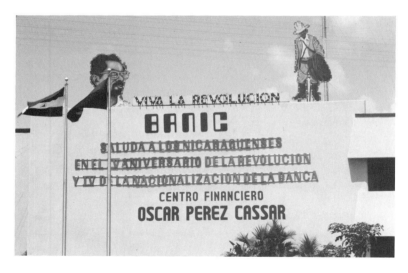

Images of Carlos Fonseca (left) and Sandino (right) atop a bank building in Managua (Photo: Esther Parada)

Sister Mary Hartmann, a North American nun from Altoona, Pennsylvania, has lived for twenty-one years in Nicaragua and is now executive director of the National Commission for the Promotion and Protection of Human Rights.[20] She helped me to understand the seemingly paradoxical coexistence of Christianity and Marxism in Nicaragua.

Mary Hartmann: I didn't come down here with the mentality I have now. I came down with the idea I was going to bring this rich American heritage to these people, and I guess it wasn't until I began living with them, listening to them, possibly suffering with them, that I understood that they have so much to give and it's *their own story, their own*

history that they're making. What also helped to change me was the renovation of the Church itself with Vatican Two, the Medellin doctrine, in which they told us we had to incarnate ourselves into the life of the poor. So that's what we attempted to do. I lived six or seven years with one of the families in the barrios [the Riguero area of Eastern Managua]. Those were the years immediately before the insurrection . . . seeing firsthand the repression of the people, the young men. We had about ninety young people in our youth club, and less than half of them lived to see the victory day.

[American officials who visit] come from lives that have been very, very well protected. They're here for twenty-four or forty-eight hours and they'll go back with the idea that "we know the situation in Nicaragua." They haven't lived in the shoes of the poor. Their interviews are with people who are opposed to the Revolution—which is OK—people more like themselves: the Chamorros, the Robelos [prominent upper-class families in Nicaragua], who see that their way of living has been threatened by the victory of the poor here. It's very, very hard for the poor to be heard, as it has been for centuries.[21]

Nicaraguan revolutionary leaders place major importance on the role of culture. Indeed the redefinition of culture is part of their revolutionary program. Reciprocally, leading Latin American writers and other intellectuals have expressed solidarity with revolutionary movements and governments in the hemisphere, particularly that of Nicaragua. Colombian Gabriel García Márquez, accepting the 1982 Nobel Prize for literature, linked the creativity of Latin American writers to the profound impulse for radical social change among Latin Americans in general. He would undoubtedly chide North Americans, as he did Europeans, for their failure to comprehend the depth of this drive for autonomy.

Gabriel García Márquez: Why is the originality so readily granted us in literature so mistrustfully denied us in our different attempts at social change? Why think that the social justice sought by progressive Europeans for their own countries cannot also be a goal for Latin America, with different methods for dissimilar conditions? No: The immeasurable violence and pain of our history are the result of age-old inequities and untold bitterness, and not a conspiracy plotted 3000 leagues from our homes. But many European leaders and thinkers have thought so, with the childishness of old-timers who have forgotten the fruitful excesses of their youth; as if it were impossible to find another destiny than to live at the mercy of the two great masters of the world [the United States and the Soviet Union]. This, my friends, is the very scale of our solitude.[23]

Noted Argentine writer Julio Cortázar, author of *Hopscotch* and "Blow Up," which was the basis for the movie, has vividly described the expanded notion of culture he finds in revolutionary Nicaragua.

Julio Cortázar: Here one immediately has the sensation that the government has from the very beginning, expanded the concept of culture, has removed the somewhat elegant varnish which has, for example, in western Europe, pushed the world culture onto the street as if it were a fruit or ice cream vendor's cart. They have placed it in the hand and mouth of the people with the simple and cordial gesture with which one would offer a banana. . . . And if my food metaphor is perhaps awakening the appetite of some of you, I will extend it by saying that in Nicaragua everything which is, can be, or will become culture does not seem like an autonomous component of [the] social diet, does not seem like salt or sugar which is added to give more flavor or seasoning to a meal. I feel that here food and culture are the same thing, in that [culture] is not the privilege of those who write well or who sing well or paint well.[23]

This ideal of a people's culture, a nonelitist culture such as Cortázar describes, has been articulated repeatedly by Nicaraguan leaders.

Ernesto Cardenal: In the first place [our culture should be] revolutionary because our cultural struggle is to transform society, to transform it into another society where one man is not exploited by another. . . .

And culture should be *democratic,* so that the great majority have access to it; and not only access to our national culture; but also to universal culture. And so that our people are not only consumers of culture . . . but also producers of culture. And this does not mean that we will lower culture so that it is within reach of the people, but rather that we will raise the people to the most excellent in culture. . . .

And culture should be *popular* . . . which is to say it should never be an elitist culture. . . .

And culture should be *national,* which means to define, develop, discover (one could continue with more verbs) our national identity and our history, taking into account the regions of the country—Palacagüina, Telpaneca, MuyMuy, Matiguás, Kuringuás. And taking into account that we have three national cultures, three national languages.[24]

My brief involvement with the Sandinista Association of Cultural Workers confirmed the strength of support for culture in Nicaragua. Headquartered in Managua in the gracious Casa Fernando Gordillo, named for a Nicaraguan poet who died in 1967, the ASTC is composed of seven unions or subsections representing painters, photographers, writers, musicians, dancers, theater and circus performers. While its functions overlap with those of the Ministry of Culture in terms of promoting cultural activities, its chief aim is to support artists—to further the professionalization of their work and assist them in practical matters such as housing, benefits, etc. The center's luxuriantly planted courtyard is a popular gathering spot for artists, who also use the library, gallery, classrooms, and dance studio there. Members of the National Union of Photographers represent a cross section of Nicaraguan society in terms of wealth, class, ethnic origins, education. Women are an active presence in the organization; for instance, the two one-person shows sponsored by the UFN since its founding in 1982 were by women: Claudia Gordillo and Margaret Randall.

The thirty-five members of the UFN pool their resources to organize local exhibitions[25] and order photographic supplies (these are now almost impossible to obtain in Nicaragua and must be gotten through contacts in other countries). They critique each other's work, discuss prices for free-lance sales, arrange lectures and workshops. Luis Morales, executive director of the UFN and the Union of Plastic Artists, told me that UFN members are preparing portfolios which will be sold to solidarity groups in five European countries, Mexico, and the United States.

Nicaraguan photographers benefit from the importance accorded culture within the country. In their role as cultural workers, they are integrated into the fabric of society and do not function as marginalized artists. I was impressed, for instance, with the fact that their photographs are regularly reproduced in *Ventana,* the Saturday cultural supplement of the FSLN newspaper *Barricada,* even though, as photographers were quick to point out, the reproduction quality and layout leave much to be desired.

On the other hand, the notion of photography as a form of personal expression is new in Nicaragua, and because UFN photographers all work as photojournalists, free-lancers, designers, or lab technicians, they have less time to pursue personal projects than they would like. They are also frustrated by the scarcity of materials and the lack of books, lectures, and other educational opportunities. Such problems, which any small country remote from large metropolitan centers inevitably faces, are intensified in Nicaragua by the enormous foreign debts inherited from the Somoza regime and severely compounded by current economic and military pressures from the United States.

Daniel Ortega: On Scarcity

When the U.S. cuts off loans to Nicaragua, when the U.S. pressures European . . . [or] Latin American countries which are helping Nicaragua not to continue with that aid, all the creative capacity of our population is affected. . . . It's incredible, but there are moments in which we don't have certain basic elements for our . . . artisans or our painters, such as paint . . . which has to be imported, which we cannot produce here. . . .

Foreign exchange [currency] is needed and we don't have it. This is a reality of which we must be totally clear, because this obliges us, as Nicaraguans . . . to make rational use of the materials which we are able to import, to use them in solidarity so that everyone can have at least a little of what we are able to import. This also obliges us to use our ingenuity, to make what we can here in Nicaragua.[26]

Twenty-eight year old Claudia Gordillo, photojournalist for the FSLN newspaper *Barricada*, is one of the best known photographers in Nicaragua, partly because in 1982 her work sparked a prolonged ideological debate over the role of art in the Revolution. Her one-woman exhibit as the Casa Fernando Gordillo, including an extended series on the crumbling Cathedral of Managua, was reviewed by fellow *Barricada* photojournalist Rudolf Wedel. He claimed that although Gordillo was "a master of development, printing and composition . . . her work was empty and dehumanized—formalist photography which expresses nothing except perhaps the interior world of the artist."[27] The following week an emphatic response to Wedel's criticism came from Gioconda Belli, a poet who works with the Ministry of Culture.

Page from *Ventana* with photograph by Claudia Gordillo, from her series on the Cathedral of Managua

242 | 243

Members of the militia relaxing in the war zone, by Claudia Gordillo

Gioconda Belli: On Revolutionary Aesthetics

These images are not only aesthetically beautiful, they are saying something. They show a temple, which was a symbol and a point of reference of old Managua, being slowly devoured by time. . . . If this does not speak to comrade Wedel, it is not a problem of the exhibit. . . . There are those who think that art, in order to be revolutionary, must be explicit. . . . This is an implicit underestimation of the people. . . . In regard to the second claim, that Gordillo's work does not express anything except the interior world of the artist . . . it appears to us that this is a supremely dangerous and confusing claim. The Revolution absolutely does not deny the interior world of a person. The collectivity is formed of individuals, every one of them with an interior world. Every individual who creates does so from his/her interior world. . . . By the same token no one's interior world arises out of nothing; it is a product of one's social existence and, of course, it cannot be said that it only has meaning for the individual.[28]

Although UFN photographers have produced many photos reflecting militant attitudes or the actual mobilization of Nicaraguans against counterrevolutionary aggression, I saw no indication that artistic expression is limited to social realist content. In fact diversity is seen as an antidote to colonial and imperial influences.

Daniel Ortega: "The Revolution does not impose formulas. . . ."

If we have any advice to give to artisans it is that they develop their imaginations, their creativity as they see fit, to try to release all that was accumulated and oppressed. . . . [They should] do this without any sense of obligation . . . to be in good standing with the Revolution; because we will be in good standing in the measure in which we are able to be creative, ever more creative . . . to break with all dependent mentalities. . . . [I]n this manner we will be fighting against the colonialist forms which, from the cultural point of view, tried to crush our identity.[29]

Rosario Murillo (Secretary General of the ASTC): The Sandinista Front has been extremely careful [to avoid imposing artistic norms]. It's one thing to put my talent as a writer at the service of the Revolution—to write reports, interviews, news articles. My personal work is something else altogether. In this I have absolute liberty. The same is true for a painter. . . . Photographers must learn to make the same distinction.[30]

Almost every photographer I met, male or female, had spent time in the war zone—the northern border area—either as a photo correspondent or on militia duty. Artists in other media—musicians, theater people, dancers—have sent performance troups to the combat area. Four *Barricada* photographers (Claudia Gordillo, Leonardo Barreto, Mario Tapia, and Rudolf Wedel) collaborated with reporters on a book, issued July 1983 in honor of the fourth anniversary of the Revolution, titled *Corresponsales de Guerra: Testimonio de Cien Días de Sangre, Fuego y Victorias* (War Correspondents: Testimony of a Hundred Days of Blood, Fire, and Victories). It records their combat impressions in the frontier regions between March and June 1983.

This book, published by *Barricada*, makes no pretense of neutrality. Captions accompanying the photos brook no ambiguity in describing heroes (those who defend the Revolution) and villains (the criminal or bestial Somocistas who attack it). Few societies would respond any differently to such murderous attacks, but it is distressing to see that nuances of perception and language become yet another casualty of counterrevolutionary U.S. pressure—particularly in a Revolution which has been as open and generous in its vision and action as this one.

In his introduction to *Corresponsales de Guerra*, Commandante Carlos Núñez Tellez characterizes the function of the newspaper *Barricada:* "to inform and educate the people, to mobilize the masses for the fulfillment of tasks required by the Revolution." He describes

"After the enemy. This combatant runs to seek a new position. His expression portrays the degree of conscience and patriotic commitment with which our people assume the defense of the Revolution." From *Corresponsales de Guerra.* (Photograph: Leonardo Barreto)

Barricada, August 4, 1983

the origins of today's *Barricada* in the clandestine press or "journalism of the catacombs," which was an important means of communication and education for those struggling against the Somoza dictatorship before 1979.

The fact that *Barricada* has become the establishment or official press[31] does not remove conflict from its pages. These reflect the struggle to defeat external enemies and to solve internal problems. However, it does not make sense to analyze *Barricada* the way I have approached the *New York Times,* challenging its assumption of objectivity. *Barricada* does not conceal the fact that it represents a definite viewpoint. It is not moderate verbally. It is fundamentally identified with violence as indicated in the paper's banner, showing a person with a rifle at the barricades. This image of violence signifies resistance to oppression, an attitude forged over decades of struggle and hardened now by U.S. support of counterrevolution.

Barricada's partisan position does not preclude coverage of the considerable controversies occurring within the country. The ideological debate inspired by Gordillo's photographs is one example; the August 4, 1983, *Barricada* provides more. There are articles on Council of State[32] discussions, actions, and hearings regarding a national wage policy (1:1,

5:1), the problem of low academic performance (1:2, 5:1), a projected social service law for university graduates (1:5), strategies of self-sufficiency in food production (3:1), and protection of the rights of political parties (7:1).

Both photos and texts in this issue feature people from all levels of Nicaraguan society: Miskito Indians convicted of counterrevolutionary activities released from an experimental prison farm (1:5, 5:4), bakery employees demanding the removal of an abusive manager (14:1), women meat vendors listening to new sales regulations designed to ensure more equitable distribution of meat (7:5), a committee of Mothers of Heroes and Martyrs of the Revolution meeting with representatives of the Permanent Peoples' Tribunal (7:2), homage to the administrator of a coffee processing plant killed in ambush by counterrevolutionaries (1:1, 5:4). In comparison, the opposition newspaper *La Prensa* focuses more on the activities of the upper classes and the church hierarchy.

In the United States we hear much about Soviet and Cuban influence in Central America, particularly Nicaragua, but the significant presence of North and South Americans and Europeans is almost totally ignored. In this issue of *Barricada* I found no pictures or articles about Soviets, Cubans, or people from any socialist country for that matter, who are in Nicaragua. There are, however, photos with an article about energy ministers from Uruguay, Barbados, and Brazil, who arrived for the Ninth Annual Conference of the Committee of Ministers of the Latin American Energy Organization (OLADE) (1:4). There are six representatives of a Dutch solidarity group who have brought a donation of photographic and design materials to Nicaragua (7:1). There are agronomists from four Latin American countries (Peru, Ecuador, Bolivia, and Venezuela) in Nicaragua for the Second Encounter of Agropecuarian (agriculture and fishing) Research and Development (14:1).

The literacy primer *El Amanecer del Pueblo* (The Dawn of the People), published by the Vice-Ministry of Adult Education (part of the Ministry of Education), is another publication that is overtly political. Sergío Ramírez Mercado (one of three members of the Junta of the Government of National Reconstruction), vigorously defends the ideological orientation of this primer in his address to the National Literacy Crusade Brigade.

Sergío Ramírez Mercado: We Will Alphabetize in Order to Change

. . . [A]n apolitical primer, a primer without words such as PEOPLE, STRUGGLE, LIBERATION, REVOLUTION, CARLOS FONSECA, SANDINO, SANDINISTA FRONT, would be a primer that would continue the ideological manipulation of the people.

. . . We are through with empty phrases in Nicaragua. . . . When the Revolution speaks of the people, it is referring to the people of flesh and blood who with their sweat, their effort, their sacrifice, proud of their humility, aware of their origins, have made the richness of this country, have planted the earth of this country. We are not speaking of the people in the abstract, we are speaking of the people—humble, oppressed—which has raised itself once and forever, which took arms once and for always, and has now arrived in power. . . .

In place of EGOISM we will write SOLIDARITY; in place of EXPLOITATION we will write JUSTICE; in place of OPPRESSION we will write LIBERATION; and REVOLUTION, REVOLUTION, as many times as it is necessary to make REVOLUTION, to learn REVOLUTION, to transmit REVOLUTION, to write REVOLUTION![33]

This approach to education might be seen as manipulative, as encouraging the recitation of a kind of catechism of revolutionary ideas. Or it can be seen as relating education to the needs, concerns, and cultural background of the Nicaraguan people. The fact that many of the literacy teachers are peasants or workers who themselves have recently learned to read suggests to me that this educational method allows what Paulo Friere calls "dialogical encounter," or *conscientizaçaõ*—a Portuguese word meaning critical con-

LECCIÓN 15

1. Observemos y comentemos:

vigilancia

69

The text for lesson 15 in *Amanecer del Pueblo* translates: "Revolutionary vigilance is everyone's task."

LECCIÓN 25

1. Observemos y comentemos:

Xilonem

128

Lesson 25 translates: "Xilonem represented the goddess of corn for our ancestors."

sciousness-raising or learning to perceive social, political, and economic contradictions and to take action against oppressive aspects of one's reality. As Freire points out, this process "does not lead men [sic] to 'destructive fanaticism.'" On the contrary, by making it possible for them to enter the historical process as responsible subjects [those who know and act, as opposed to objects] . . . it enrolls them in the search for self-affirmation and thus avoids fanaticism."[34]

Empowering the poor and the illiterate plus a renewed attention to indigenous cultural traditions are among the revolutionary goals that have captured the imagination of other artists is Nicaragua.

Adriana Angel, a Colombian who now lives in Managua, is a free-lance photographer and member of the UFN. Her work includes documenting a variety of cultural events for the Ministry of Culture and a photo series on the mask makers of Masaya. She collaborated with the Luisa Amanda Espinoza Nicaraguan Women's Association (AMNLAE) in organizing an exhibition of photographs of women, and she now wants to develop a photo essay on a particular Nicaraguan woman, Doña Maria Medina Pavón, her friend and former servant. Adriana feels that Doña Maria's life exemplifies the new options for the poor that the Revolution has introduced.

Adriana Angel: The time came when our daughter wasn't home all day; we put her in a daycare center. So I told Doña Maria that we wouldn't need her. I felt that we could take over the responsibilities of the house, because, among other things, the contradiction was bothering me: the exploitation of one woman by another. I also felt a little uncomfortable dismissing her, since she had been left by her husband with six children. But we had a very good relationship.

She's a woman who's done everything. She's a campesino; she's harvested coffee, cut cotton, taken care of children, worked in the market, worked as a street vendor. She's a woman of thirty-four years, but looks more than forty.

Adriana Angel, *Yesterday and Today*, 1982

Adriana Angel, *Chontales* (a
religious festival), 1982

Rosanna Lacayo, from a series
of portraits by women

Doña Maria Medina: Before [the Revolution] we didn't have a school. I had to leave my kids alone all day while I worked. Now there are more schools. Before we women went to take care of other people's kids—to wash, iron, cook, clean their houses, water their gardens, run errands, run to the market—while our kids were alone all day. I came home to sleep if I could, but I was gone all day, seven days a week, working. This happened with many people and it still happens, but not so much.

I worked to organize quite a few women. In 1980–81 the union [of domestic workers] was formed in this area of Pancasán with about three hundred women, and they began to protest to their employers. They started to demand shorter work hours and more pay. The union continues but I don't belong to it any more because now I work for the Ministry of Education cleaning and belong to a different union.

EP: ... In my country people say that the CDS exercises too much control over others, that one can't have a private life.

DMM: As far as I'm concerned, I think that it's a good thing that people are controlled, especially in regard to food. There were people here who hoarded food, who had a whole leg of meat in their refrigerator, good meat, and the market was empty—only bones for the poor. Now this has been stopped. Now a few people can't just go off with the best. Each person has a ration card [for staples].[35]

A photographer and filmmaker for the Nicaraguan Film Institute (INCINE), Rossana Lacayo comes from an upper-class Nicaraguan family and was educated at private schools in the United States. Her portraits include some striking images of women and a series on a circus clown. She is also interested in documenting Nicaraguan folk traditions. Shown here is one of her photos from the Santo Domingo procession of July 31, 1983 (celebrating the patron saint of Managua) as it was published in *Ventana* and as she later modified it in the high-contrast workshop I taught.

Rosanna Lacayo, work from
high-contrast workshop,
original photograph of Santo
Domingo procession

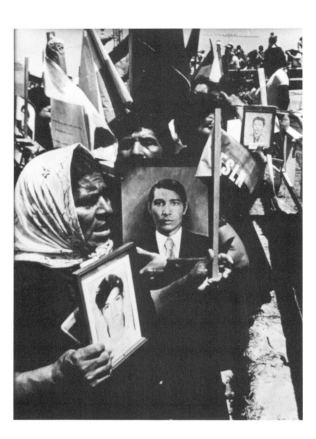

Margarita Montealegre, *Marcha de las Madres* (commemorating children killed by counterrevolutionaries)

Two other women photographers active in Managua are Margarita Montealegre and Cordelia Dilg. Although she comes from the Nicaraguan upper class, Margarita has a passionate commitment to the goals of the Revolution. Studying photography at the International Center for Photography in New York City (in 1981) strengthened her technical skills, but she realized that her attitude toward photography was fundamentally different from that of most American students and teachers she met. While they urged her to draw upon her personal feelings and experiences as a source for her work, she has found that the political and social documentary is most important for her.

Cordelia Dilg is a photographer from West Berlin who has lived in Nicaragua for the last three years. Her work is widely published and seen in Nicaragua, both in newspapers and in official government brochures such as *The Dawning of Nicaragua*, published in several languages by the Department of Political Education and Propaganda (DEPEP). Her observations are those of a European deeply but not uncritically committed to the principles of the Revolution.

Cordelia Dilg: I've always had the problem of not being able to work continuously here because of money problems. I can't live from what I earn here. I sell some photos to DEPEP. I give away photos which are published in *Ventana*. So I have to sell photos in Germany. I could do much more if, for example, I could stay two months or half a year in one village, then spend a month printing the work and finally send it off. But there's no money in this, so what do I do? Stay in Managua running after events.

Another problem is that in Germany, some bourgeois magazines publish my photos—*Der Spiegel, Zeit.* Once they published a very long, very bad article with my photos and after that I said, "I'm not ever going to send them photos again [because of their distortion]. A picture of Tomás Borge speaking forcefully—the way that one does when one feels something strongly—is presented as if he were a dictator. This wasn't my photo; I

didn't take a picture of him as a dictator. There are certain photos that I'll never send to Germany because I know they'll be used in an absolutely false context. For example, pictures of children with weapons—I know ahead of time what the caption would be: "cannon fodder."[36]

Another "outsider" with a strong commitment to the Revolution is North American writer and photographer Margaret Randall. From the late 1960s until 1980, she lived in Cuba, where she wrote a number of books on women in revolutionary situations; in 1980 she moved to Nicaragua. Her most recent book, *Sandino's Daughters: Testimonies of Nicaraguan Women in Struggle,*[37] combines her skills as writer, interviewer, and photographer in bringing together the stories of peasant, working-class, professional, and bourgeois women in relation to the Revolution.

Margaret Randall: I think the gap between theory and practice in Nicaragua is the war. In spite of the war there's an amazing amount of attention given to artistic expression, an importance placed on it and money spent on it—out of a scant national budget.

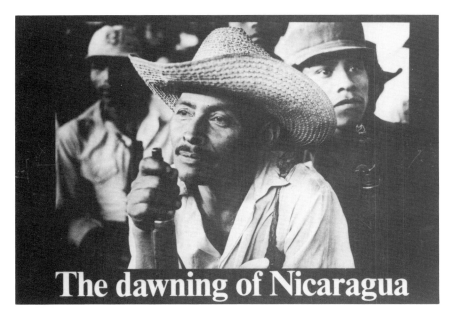

Cordelia Dilg, cover for *The Dawning of Nicaragua*

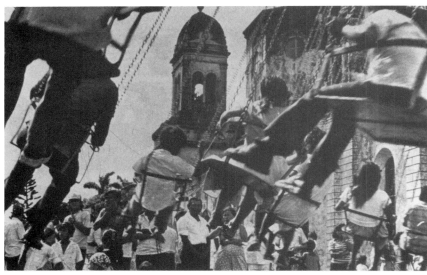

Cordelia Dilg, Untitled

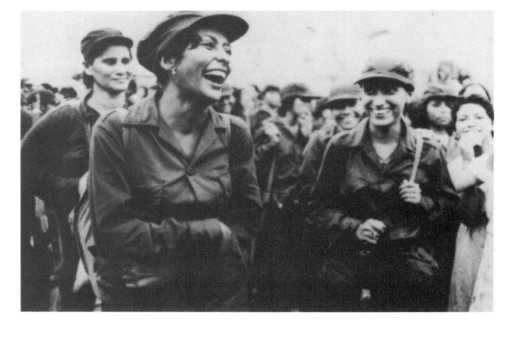

252 | 253

EP: It seems to me that when artists who've been fighting the system are able to function within it, their role is very different. It becomes a kind of homage developing a certain kind of iconography within the Revolution, and there is a danger of becoming colorless or stereotyped.

MR: It's true that you have a sense of celebration in a situation such as Nicaragua where a people's revolution has been won and is being defended at a tremendously high cost. When you consider the figures: 50,000 dead during the two years before the triumph of the Revolution, and an estimated 350,000 killed by Somoza and his Guard during the forty-two years of his dictatorship, that's not including the people who died of malnutrition and curable diseases—curable deaths. Those are two realities. There was a reality of oppression; there is a reality of celebration. I don't feel that there is a stereotype here.

There may be a sameness in the photography that comes from a whole combination of superimposed things such as lack of time, the fact that most photographers here don't work full time as photographers. There are those who work full time for newspapers, but they aren't doing their own work.[38]

Another active UFN photographer is Olga Martha Montiel, who currently serves as director of international relations with the Ministry of Culture. Unfortunately, I was not able to meet her while I was in Nicaragua because she was doing militia duty at the time. The UFN has not yet organized a systematic archive of members' work which would have allowed me to make slides of her photographs.

One of the most interesting uses of photography in Nicaragua today is in *fotonovelas* (photo novels). Traditionally in Latin American countries *fotonovelas,* like soap operas, have appealed to reactionary tendencies—reinforcing consumerism, sexism, and the Cinderella fantasies of their readers.[39] However, in the weekly *El Tayacán,* a Christian revolutionary magazine published in Managua, photographer Celeste Gonzales conceives, directs, and photographs stories or parables dealing with religion, labor, literacy, and similar issues.

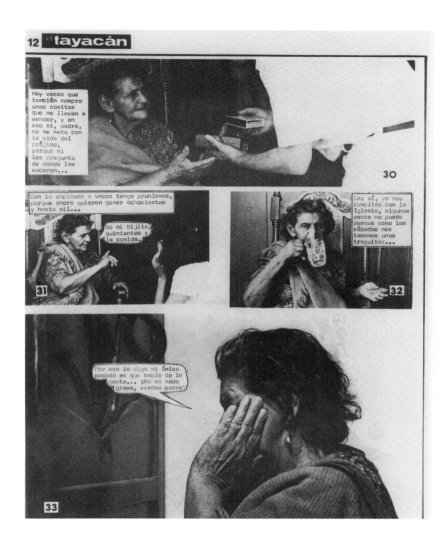

Final page of *fotonovela* "Doña Clo Cuecho," by Celeste Gonzalez. The translated text reads: (30) "There are times when I buy a few things which they bring to me to sell; and in this case, father, I don't poke my nose in other people's business." (31) "Sometimes I have problems with my servant, who wants to earn eight hundred (pesos) or even a thousand. . . ." "No, my dear, just five hundred and your food." (32) But certainly I'm faithful about Church, except for once in a while, when I can't make it—those Saturdays when I have a few too many drinks . . ." (33) "So I tell you that my only sin is gossiping about people. . . . That's not so serious, is it father?"

An example is the story of "Doña Clo Cuecho,"[40] a hypocritical churchgoer who details all her neighbors' faults to the local priest, but only reluctantly admits her own sins as a mean-spirited usurer/pawnbroker. The story is followed by a full-page analysis of the meaning of the "manipulation of religion," defined as "the use of religious figures or articles to support a cause which is not God's cause." In another story, "Chemita y el Trabajo"[41] (Chemita and His Work), a boy's elaborate fantasies of winning the lottery and gaining power through wealth lead him to an awareness of the power of his own labor. This is followed by a page of discussion on the meaning and dignity of labor, with quotes from Bertolt Brecht, John Paul II, French theologian Teilhard de Chardin, and Karl Marx.

Government publications also frequently employ a lively mix of photography, cartoons, and texts for didactic purposes. What is unusual about *Abriendo Surco* (Breaking Ground), a book about the progress and problems of an agricultural cooperative published by the cooperative training institute of the Agrarian Reform Office, is that it, too, is a cooperative effort. Agrarian reform representatives taped and recorded the stories and opinions of the members. The process of making the book, as well as the process of forming the cooperative, become part of the story, which ends with a series of questions for readers to ask themselves in examining their cooperative efforts.

Two excerpts from "Chemita y el Trabajo": (top) "And Chemita became the rock. 'Now neither the rays of the sun, not the rain can do anything to me. I'm the most powerful." (bottom) "One day a man came to work close by."

Excerpts from *Abriendo Surco*. The texts translate: (top) "Enrique Martinez is one of those who returned. 'Actually I withdrew and was working alone, thinking that was better.'" (bottom) "Of course, we also have a board to organize our work well; this means that we all elect those who can best serve in these positions."

The Ministry of Culture explicitly states its openness to "international cooperation . . . across ideological frontiers as long as . . . [it] contributes to our identity and preserves our national sovereignty and self-determination."[42] There are numerous examples. Most obvious to me was the enthusiasm and affinity for experimentation with high-contrast techniques in my workshop. During my stay I met people from England, Sweden, Spain, Italy, France, and the United States who worked in Managua as advisors or university teachers in areas as diverse as physics, nutrition, and ceramic mural design. They represented only a fraction of the foreigners welcomed in the country.[43] Poetry workshops sponsored by the ministry expose their members to Greek, Chinese, Japanese, and North American poets.[44] Iván García, director of the Sandinista Television System, has described the diversification of TV programming, which was 80 percent North American before the Revolution but now includes Mexican, French, Brazilian, Cuban, Soviet, East German, and Bulgarian—as well as Nicaraguan—material.[45]

Statistics on the Ministry of Culture's exchange programs with various countries between 1980 and 1982 have been compiled in the following categories: scholarships and internships for Nicaraguans in foreign countries (34.5%); exhibits, performances, movie festivals, sports events (31%); technical advising (20.69%); and materials and equipment (13.8%).[46]

Donations—either materials and equipment or technical assistance—received by Nicaragua during the same period supported projects such as libraries, cultural publications, children's theater, musical education, crafts programs, research on ethnic minorities, and preservation or restoration of historic sites and artifacts. We find that by far the largest of these contributions have come from western Europe: the Low Countries (the Netherlands and Belgium, $702,000), Austria ($546,000), West Germany ($332,000), and from UNESCO ($120,000). France, Switzerland, Venezuela, Ireland, Bulgaria, Korea, England, the OAS, the Soviet Union, and Mexico contributed amounts under $100,000 each.[47] The ministry also listed bilateral exchange agreements without monetary value with Venezuela, Cuba, Mexico, the Soviet Union, Bulgaria, and France.[48]

Uriel Molina, *Cultural brigade in the war zone*

Based on this material and my personal experience, it seems clear to me that Nicaragua is a country where ideological positions are articulated as a means of fostering social change. However, it is not a monolithic society. Nicaraguans are interested in taking what is useful from many sources, adapting what is relevant from many models—including North American ones—to reconstruct their lives. But *they* must choose, and *we* must come to acknowledge how overwhelming and destructive our political and cultural domination has been, and continues to be, for countries that have not secured their own political autonomy and cultural identity.

256 | 257

The Parrots

My friend Michel is the officer in
 charge of Somoto,
there, by the border with Honduras,
where they caught, he told me,
 contraband parrots
about to be exported to the United States
where they would learn to speak English.
There were one hundred eight-six parrots,
 and forty-seven had already died in their cages.
And he returned them to the place from
 which they had come
And just as the truck was arriving at
 a place called "The Plains"
close to the mountains where the parrots once lived
(the mountains seemed huge behind those plains)
the parrots became agitated and began to
 flap their wings,
pushing against the walls of their cages.
And when the cages were opened
they all flew like arrows toward their mountains.
That's just what the Revolution did with
 us, I think:
took us out of the cages in which we
were being carried off to speak English.
And sent us back to the land from which we
 had been pulled.
The green *compas* like parrots
 gave back to the parrots their green mountains.
But forty-seven had died.[49]

Ernesto Cardenal

1 From "Art as Heresy," a speech delivered on January 18, 1981, at the opening of the Second National Marathon of Poetry at Rubén Darío's birthplace, Ciudad Darío, on the occasion of the 114th anniversary of the poet's birth, published in *Hacia una Política Cultural* (Toward a Cultural Policy) (Managua, Nicaragua: Ministry of Culture, 1982), p. 65. Unless otherwise noted, the translations are mine.

2 Jack Kemp, "Reaching a Synthesis for Salvadoran Policy," *New York Times,* July 29, 1983, p. 23. Kemp's assertion reveals an abysmal ignorance of Nicaraguan history, since the Sandinista movement (FSLN) founded in 1961, which is now in a leadership position in the Nicaraguan government, spearheaded and sacrificed many of its members to the revolutionary struggle against Somoza.

3 See "Key Sections from Study of Latin Regions by Reagan Panel," *New York Times,* January 12, 1984, pp. A14–16.

4 "ACLU Assails Visa Denial to Latins," *New York Times,* December 1, 1983, p. 8.

5 The original contact for this trip was made by Magnum photojournalist Susan Meiselas. I paid my own transportation costs; the ASTC paid my living expenses there.

6 For a history of U.S. intervention in Central American political and economic affairs, see Walter LeFeber, *Inevitable Revolutions: The U.S. in Central America* (New York: W. W. Norton, 1983); Penny Lernoux, *Cry of the People: The Struggle for Human Rights in Latin America — The Catholic Church in Conflict with U.S. Foreign Policy* (Middlesex, England: Penguin Books Ltd., 1982); and Eduardo Galeano, *Open Veins of Latin America: Five Centuries of the Pillage of a Continent* (New York: Monthly Review Press, 1971).

7 Arthur Asa Berger, *Media Analysis Techniques* (Beverly Hills: Sage Publications, 1982), p. 150.

8 This synopsis of Marxist media theory is derived from Berger's outline of that particular theory within the context of a general discussion of various media analysis methodologies.

9 Jane Mayer, "Combat Cameramen Look for 'Bang Bang' to Win TV Ratings," *Wall Street Journal,* October 20, 1982, p. 1.

10 John Naisbitt, *Megatrends: Ten Directions Transforming Our Lives* (New York: Warner Books, 1982), pp. xxv–xxvi.

11 Louis Hartz, quoted in "The Media Go to War — From Vietnam to Central America," by Dan Hallin, in *NACLA Report on the Americas* 17:4 (July/August, 1983), p. 22. I am indebted to this article for refining my analysis of media coverage of Central America.

12 Several excellent sources for information about Guatemalan history and U.S.–Guatemalan relations are: *Guatemala,* edited by Susanne Jonas and David Tobis (New York: North American Committee on Latin America, 1974); three issues of *NACLA Report on the Americas:* 14:1 (January/February 1980), 17:1 (January/February, 1983), and 17:2 (March/April 1983); Stephen Schlesinger and Stephen Kinzer, *Bitter Fruit* (Garden City, NY: Anchor Press/Doubleday, 1983); and *Guatemala in Rebellion: Unfinished History,* edited by Jonathan Fried, Marvin Gettelman, Deborah Levenson, and Nancy Peckenham (New York: Grove Press, 1983).

13 See, for instance, Franky Schaeffer, *A Time for Anger: The Myth of Neutrality* (Westchester, IL: Crossway Books, 1982). Schaeffer makes a convincing case against press objectivity from a right-wing position.

14 Hallin, p. 10.

15 Carleton Beals, *Banana Gold* (Philadelphia: J. B. Lippincott, 1932), n.p.

16 Ibid., p. 191.

17 Ibid., p. 276–77.

18 Ibid., pp. 300–1.

19 Ernesto Cardenal, interview in Managua with Mark Cooper, Pacifica Program Service, Los Angeles, June 1981.

20 Nicaragua was the first Latin American country to respond to the 1980 United Nations recommendation that all governments establish such commissions.

21 Interview with the author, Managua, August 16, 1983. I have made a few minor editorial changes in this and other interviews.

22 Gabriel Garcia Márquez, excerpt from his Nobel lecture, reprinted in the *New York Times,* February 6, 1983, p. D17.

23 Julio Cortázar, "Esta Revolución Es Cultura" (This Revolution Is Culture), lecture given upon receiving the 1983 Rubén Darío Order of Cultural Independence; published in *Areito* 9:34 (1983), pp. 17–20.

24 In addition to Spanish, Miskito, and Sumo, English is spoken on the Atlantic coast, which was subject to British colonial influence. Ernesto Cardenal, "Culture: Revolutionary, Popular, National, Anti-Imperialist," speech given at the opening of the First Assembly of Cultural Workers in the Palace of Heroes of the Revolution, Managua, February 25, 1980; published in *Hacia una Política Cultural,* pp. 179–85.

25 Three major exhibitions organized by the UFN were, "Los Rostros de America" (Faces of America, 1982), the "1983 National Photography Competition," and a show documenting the cultural brigades in the war zone, with work by Adriana Angel, Uriel Molina, and Oscar Cantarero (1983).

26 Daniel Ortega, "Revolution Is Creativity, Imagination," address to the Encounter of Nicaraguan Artisans, November 22, 1981; published in *Hacia una Política Cultural,* pp. 83–89.

27 Rudolf Wedel, "Art for Whom? The Cathedral of Managua and Other Images," *Barricada,* August 22, 1982, p. 7.

28 Gioconda Belli, "Ideological Debate: An Old Discussion which Should Take New Directions," *Barricada,* September 5, 1982, p. 3. The debate continued over a month airing the views of a number of writers.

29 Ortega, "Revolution is Creativity."

30 Interview with author, August 16, 1983, Managua.

31 "Official organ of the FSLN" is part of the paper's logo. There are two other daily newspapers in Managua, *El Nuevo Diario* and *La Prensa.* The former is pro-government, the latter is anti-Sandinista and has been censored by the government on numerous occasions.

32 The Council of State is Nicaragua's representative body with fifty-one members drawn from thirty-two national organizations, including political parties, popular organizations such as the women's organization (AMNLAE) and the organization of neighborhoods (CDS), unions, professional associations and the churches, and private enterprise. The Council shares legislative power with the Junta for the Government of National Reconstruction. For a detailed account of this governmental process, see *Now We Can Speak: A Journey through the New Nicaragua,* by Frances Moore Lappé and Joseph Collins (San Francisco: Institute for Food and Development, 1982). This book and another by the same authors and publisher, *What Difference Could a Revolution Make? Food and Farming in the New Nicaragua,* are the most lucid accounts I have read by North Americans of the Nicaraguan revolutionary process.

33 Sergío Ramírez Mercado, "We Will Alphabetize in Order to Change," address delivered March 13, 1980, in Managua; published in *Hacia una Política Cultural,* pp. 131–35.

34 Paulo Freire, *Pedagogy of the Oppressed* (New York: Herder and Herder, 1972), p. 20.

35 Interview with author, August 6, 1983, Managua.

36 Interview with author, August 7, 1983, Managua.

37 Margaret Randall, *Sandino's Daughters: Testimonies of Nicaraguan Women in Struggle* (Toronto/Vancouver: New Star Books, 1981).

38 Interview with author, August 16, 1983, Managua.

39 See Comelia Butler Flora and Jan L. Flora, "The Fotonovela as a Tool for Class and Cultural Domination," in *Latin American Perspectives,* 5:1 (Winter 1978), pp. 134–50.

258 | 259

40 *El Tayacán* 2:58 (June 13, 1983), pp. 5–7, 10–13.

41 *El Tayacán* 2:54 (April 30, 1983), pp. 11–15.

42 *Hacia una Política Cultural,* p. 315.

43 According to my host, Swedish audio-visual specialist Lazaro Bildt, there were fifteen thousand non-Central American foreigners (Europeans, North and South Americans) in Nicaragua as of July 1982.

44 Ernesto Cardenal described these workshops at a press conference at the United Nations, New York City, November 30, 1983.

45 Iván García, "Four Years of Problems, Efforts and Achievements in Television," *Ventana,* July 30, 1983, pp. 2–4.

46 *Hacia una Política Cultural.*

47 Ibid., pp. 306–9. I have calculated the value of these donations based on the official exchange rate of ten cordobas to the dollar.

48 One should keep in mind that Nicaraguan involvement with socialist countries does not necessarily reflect ideological or cultural affinities, but rather relates to more favorable loan terms or monetary policies offered by these countries.

49 Translation, by Robert Cohen, published with his permission.

In the American East:

Richard Avedon Incorporated

Working up a sweat is no longer in style. That is to say, *labor* is not in style: the deindustrialization of our economy is said to be at hand. Here is a new age—postindustrial, postalienation, posteconomic despair. We have discovered the magic and play of the office; our days are filled with enchanting encounters with microcoordinated friends. We have discovered economic salvation in computer software, artificial intelligence, corporate takeovers, investment planning, and the spectacles of advertising and entertainment. From this day forward, capital will be generated through the production and distribution of signs, or more purely, by the reconfiguration of money itself. We will concentrate on floppy disks, fiber optics, credit cards, and advertising copy while ignoring the social implications of these products. For these implications have been lost in the rhetoric of the information economy and in the abstraction of the signs themselves. Our well-dressed data blind us to larger concerns.

Many American cities, facing the decline of heavy industry, found a cure in postindustrial magic, and the rest of the United States now strives to mirror this success. But this new economy is an imaginary one, constructed by rhetoric; the basic political realities of this economy go unacknowledged. First of all, no matter how complete the revolution seems, hard labor has not been eliminated. It merely has been shifted out of sight, to Mexico, Taiwan, and other countries where wages are low and unions nonexistent. Secondly, heavy industry still plays an important role in many regions of the United States, even if such industry *is* treated as an embarrassment. Further, it must be pointed out that much of the growth in the information economy is the result of increased Defense Department spending. And most importantly, it should be recognized that a pernicious class structure accompanies this new economy, a structure that privileges the managerial class and the elite at the expense of the hourly wage-earner, the poor, and the less educated. In fact, the new economy has been accompanied by a general resurgence of authority across the board in business and government. Upon close examination, we find that the power base of America's postindustrial society is precisely the conservative business class currently in power.

Examine, for example, how citizens of lesser means have been treated in this new economy. Armed with "laws" of economics that justify higher unemployment as the natural cost of economic recovery, the Reagan administration and the American business community have attempted to establish a permanent class of unemployed and underemployed Americans. The original alibi for this action, the famous "trickle-down" theory, claimed that the lower class would eventually benefit from the increased wealth of the upper class. Currently, the difficulties of the lower class are alleviated through statistical manipulation, or by ignoring the issue entirely. But as political theorist Göran Therborn has pointed out, economic stability did *not* require the creation of this marginalized class.[1] As Therborn shows, statistical comparisons of the economic conditions of all developed countries over the last twenty years demonstrate no inevitable connections between inflation, recovery, and unemployment. Therborn, however, did notice that countries with strong policy commitments to full employment in place prior to the most recent world recession found ways to keep unemployment low throughout and after this recession. It seems that each government's commitment to employment made all the difference.

Obviously, no commitment of this nature exists in the United States. Instead, we are offered the fantasy of high tech, a fantasy that obscures the real social consequences of postindustrial production. Capitalism seems more heroic than ever—information commodities seem to generate spontaneously from deep within the system, bodied forth as evidence of the utopia to come. We are surrounded by the corporate sublime, by the promise of a new age of pure information and pure capital. Communication seems boundless, and we count on its speed and abundance to bring about a better world. But in spite of this plentitude, we have only a narrow understanding of the world. For behind this information economy, and behind our information itself, can be found the same viewpoint, the same class, the same owners. Competing opinions and conflicting realities have been excluded from the postindustrial revolution.

The present condition of art can tell us much about the nature of communication in our "new" society. Artists have always been the "entrepreneurs" of sign production; throughout this century they have contended with competition from the mass media. Strategies for survival have usually counted on art to function as a critical space, a place where temporary, *strategic* autonomy can be found. It is this critical space that we are in danger of losing entirely. For in the information economy, a monopoly on sign production has been encouraged—a monopoly on human communication. Corporations affect more and more information; this includes not only newspapers and television, but art exhibitions as well.[2] This corporate influence is reflected not only in direct ownership of information, but also in the very form communication takes. Communication has become infused with the powerful and fascinating *effects* of advertising. These effects not only sell products; they also threaten to overwhelm substantive discourse entirely, affecting the content of everything from news broadcasts to presidential elections. Advertising (and within advertising, fashion) is now the master discourse; its logic unites and governs all forms of sign production in present-day capitalism. Art, which has long contested the media's ambition to be the sole voice of authority, is engaged in a fight for its life, in a fight for its relevance as a means of communication. But the media seem more powerful, and art has begun to serve as the research and development department for the information industries. Discoveries in art are quickly put to use in public relations, sales, and entertainment. As a result, art, fashion, and advertising have become impossibly interwoven; careers like Richard Avedon's (and Irving Penn's and Bruce Weber's and Robert Mapplethorpe's) appear to be the rule rather than the exceptions.

Richard Avedon
photographing Jimmy Lopez,
Sweetwater, Texas, 6/15/79
(Photo: Laura Wilson)

The problem of labor in the new information economy, and the conflict between art and mass media, are both apparent in Richard Avedon's most recent work, "In the American West." In 1979, Avedon began what would become a five-year project photographing the marginal and dispossessed citizens of the West, the "men and women who work at hard uncelebrated jobs, the people who are often ignored and overlooked." [3] In this project, economic obsolescence is photographed by someone who well understands the logic of obsolescence in our society; the marginalized class of postindustrialism is transformed by postindustrial sign production. In the first section below, I will examine how Avedon incorporates and refashions this marginalized class, and how he rewrites our concept of labor in the process. In the second section, I will analyze the way these pictures have been used by museums and corporations; this will reveal how art is utilized in the information economy for public relations purposes.

Fashioning Labor

Avedon's photographs owe their effectiveness to his style, to an approach established through years of photographic encounters with the beautiful and the well known. Avedon eliminated evidence of specific locations in the West by placing his subjects in front of a seamless studio backdrop; he diminished the sculpturing effects of light by photographing his subjects in shadow. Three-dimensionality was also reduced through the use of a narrow depth of field, while the surface of the subject was emphasized through the use of an 8 × 10 camera. The subject was exaggerated further through elaborate printing, and the negatives were even opaqued (with red lipstick, of all materials!) to remove even the slightest tones from the white backgrounds. The final prints are large, and some are gigantic, calling still more attention to the photographic effects.

Avedon has gone to this trouble because he wants us to find meaning in the photographs solely through clues in the subjects' appearance. He has emphasized the ugliness and sloppiness we'd least expect to see; Avedon's "realism" is achieved by depicting the awkwardness and bad taste suppressed in more glamorous photographs. But we can learn little else about the subjects. By decontextualizing these idiosyncrasies, and by blowing them out of proportion, Avedon renders the subject mute. The subjects—detailed, delineated, floating before emptiness—become hieroglyphs, ciphers. The photograph seems like a message without a purpose, a supercharged fragment of reality lost in space.

Avedon seems to expect his subject to be communicated to the audience sheerly through photographic fidelity and visceral impact; the image is to transform the exhibition space with spellbinding, absolute presence. Such an approach might be considered part of contemporary neoexpressionism, but the more obvious source of pictures like these is tabloid photography, as practiced by Weegee years ago and by many television news programs today. In the tabloid approach, disaster is best communicated through a striking and horrible image: it is thought that communication is facilitated by this intense, simulated version of the original. But this visual horror goes hand in hand with voyeurism and fascination, and so seldom leads to understanding. In fact, the end result of the fantasia of the media is complete solipsism, a passive state full of sensation without content. Reality becomes but a series of phantasms, formed through the intensity and univocality of the media.

Avedon, of course, would say this differently: "The surface is all you've got. You can only get beyond the surface by working with the surface."[4] "A portrait is not a likeness. The moment an emotion or fact is transformed into a photograph, it is no longer a fact but an opinion. . . . All photographs are accurate. None of them is the truth."[5] "This is a fictionalized West. I don't think the West of these portraits is any more conclusive than the West of John Wayne or Edward Curtis."[6]

These remarks would seem to make any consideration of the work as documentary impossible. But Avedon also wants to hold on to the truth and transparency of the image, no matter how manipulated it may be. He wants us to feel "that everything embodied in the photograph simply happened, that the person in the photograph was always there . . . was not even in the presence of a photographer."[7] And judging from press releases and news articles, many other people think of this work as a documentary record of the western United States.[8] Avedon sets up the clash between objective and subjective—between description and self-expression—that haunts much documentary. This conflict is often a part of what we now consider to be the bad faith of much documentary: claims about the value of self-expression obscure the manner in which relations of power inform representation, the way the privileged represent the reality of another class. Avedon's approach appears to fit the description of such bad faith; he seems to exploit members of a lower class for the edification of his own, rationalizing this as a form of fiction.

But perhaps it is not this simple. Another argument that has been made for this work tries to clear up the problem of motive and responsibility. It has been said that these pictures work *archetypically,* eschewing specific analysis so that fundamental truths about human experience can be revealed. This perspective on Avedon's work was offered by Adam Gopnik in a recent seminar with Avedon.[9] Gopnik explained Avedon's entire lifetime of work as a search for "fundamental human types, fundamental creatures of his psyche." Much as "Chaplin and Shakespeare" composed stock companies, Avedon has

Cover of exhibition brochure,
Amon Carter Museum, Fort
Worth, Texas, 1985

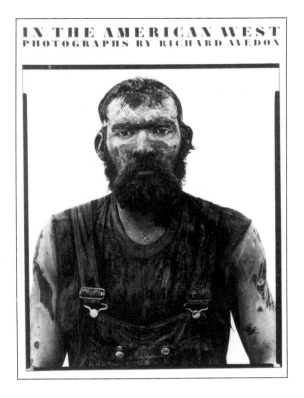

constructed "a pantheon of mythical types." These types can be recognized in Avedon's editorial fashion photography, his advertising work, his celebrity portraits, and his "portraits of ordinary people"; the original circumstances and use of each image do not appear to matter. Gopnik gave the following examples of "Avedon types": the "Botticelli maiden" (a "plaintive oval-faced beauty"), the "androgynous gentleman" (who is "elegantly slumping" and "heavy lidded"), the "high-strung matron" ("full of intelligence and nervous poise, posed on the brink of a crack-up"), and the "Beckett tramp" (a "philosopher-comedian"). One illustrated example will suffice: the "androgynous gentleman" can be seen in Avedon's famous portrait of Galanos, the fashion designer, and *David Beason, shipping clerk* (1981), a picture from "In the American West."

Gopnik's analysis seems exactly right, and this is what is exactly wrong with Avedon's work. Gopnik's analysis works because Avedon's portraits have so little specificity: these "fundamental truths" have only to do with how people *look*. We are asked to ignore the social differences between each subject and picture in favor of "universal" typologies based upon superficial resemblances. Gopnik does not mention that this approach necessarily requires a belief in the neutrality of photographic representation and faith in the physiognomic truths the camera has been said to record. But few still hold these beliefs; most people acknowledge in some way the prejudices of photographic representation. Avedon himself claims to share this skepticism of photographic truth, yet he is willing to use this discredited belief to make his case. In fact, he pushes photographic truth and the logic of physiognomy to hyperbolic extremes; he revels in skepticism by simulating and exaggerating devices he admits are exhausted. We are left with photographs that cannot provide understanding but that still offer a voyeuristic charge.

The logic of typology is carried to the point of absurdity in these western portraits. Everyone looks the same. Avedon has made the work powerful through consistent use of various formal devices, and particularly through the repetition of the subjects' look, a

look that is direct, uncomfortable, awkward, grim. Through photography Avedon constructs a single type; united by the look of alienation stand drifters and waitresses, factory workers and grave diggers, meat packers and the mentally ill, jail prisoners and the co-presidents of the Loretta Lynn Fan Club. This alienation is made to include individuals not immediately considered marginal: a scientist, a physical therapist, a pastor, a practical nurse, a beekeeper. His approach is reminiscent of police photography—in the police photograph, one cannot help but look like a criminal; the format itself communicates guilt. Avedon has asked, "If I reveal that the portraits of the American West were actors, meticulously cast, would it diminish or enhance them as works of art?"[10] It would do neither. Avedon has treated his subjects as actors anyway; their appearance owes everything to his control.

But Gopnik points out that this is *Avedon's* company; these individuals have been filtered through Avedon's unique personality. Put another way, it could be said that Avedon has attempted to construct stereotypes that explain his own experiences. In his recent book *Difference and Pathology,* Sander Gilman describes how stereotypes are formed by subjective experience.[11] Gilman claims that we construct stereotypes to control our fears of the unknown—the Other. But while all stereotypes originate in this manner, not all work the same way. Healthy stereotypes are those that we use as temporary coping mechanisms; we modify or discard them when confronted by the specifics of experience. Pathological stereotypes, on the other hand, are not open to change. They are imposed upon the unknown; the Other is defined in rigid terms to better control it. We attempt to naturalize the pathological stereotype; we claim that this stereotype is universal. The healthy stereotype, then, respects difference and the complexities of experience, the unhealthy one denies difference, imposing itself upon the world.

From "In the American West," and from many of his other photographs, we can see that Avedon has the same fears many of us have: fears of pain, disease, corruption, aging, death. Avedon's work is monumentally elegiac—life erodes before the camera. The subject, however, never challenges these stereotypes, never renders them specific. The great consistency of Avedon's work is derived from his unwillingness to see human experience as manifested in anything but style. But labor, decay, and death do not exist as generalized types, nor as style; they exist in history and in specific social realities.

What social meaning can we discover in the type Avedon has constructed for the western pictures? The consistency of this type leads us to assume the existence of an entire class. However, we are at a loss to determine any consistent economic or social circumstances that unify these subjects; the class is constituted solely through the project itself. In other words, Avedon builds the illusion of a class through the evenhandedness of his approach, the uniformity of his interpretation, and through overarching metaphors (such as the inclusion of photographs of slaughtered animals). We are then asked to accept this class as a truthful version of the lower class that *does* exist in America. In Avedon's lower class, however, there are no political causes, only natural ones. Marginalization is just another part of the human condition; alienation knows no history. Labor is never rewarding; it only renders the laborer tired and stupid. Dress and taste are genetically determined. The American West is a primitive place: work is done in the elements with the entire body, rather than with the fingers at a computer console or in a studio with a beautiful model. These messages are not just *fictions;* they compose a fantasy of the most pernicious kind, a fantasy that smacks of social Darwinism and the Reaganite restructuring of classes. Behind Avedon's control of the subject can be found the control of an entire class.

Again, Avedon would describe these shortcomings differently, as the inevitable circumstances of portraiture: "A portrait photographer depends upon another person to complete his picture. The subject imagined, which in a sense is me, must be discovered in someone else willing to take part in a fiction he cannot possibly know about. My concerns are not his. We have separate ambitions for the image. His need to plead his case probably goes as deep as my need to plead mine, but the control is with me."[12] And Avedon would also protest that he made great efforts not to exploit his subjects. He provided a picture and a signed copy of the book to everyone who sat for him, and he invited everyone to the show. Many of the subjects came to the opening and to a public discussion at the Amon Carter Museum, Fort Worth, Texas (exhibition dates, September 14–November 17, 1985); during that discussion several of them stated that they did not feel exploited, but instead were honored to be a part of this project. One sitter, Billy Mudd, went so far as to say that seeing his portrait was the most profound moment of his life. As Irvin Lippman of the Amon Carter later described it, Mudd "saw this photograph in the museum and said that he has literally been looking for himself for years, and finally found himself in the museum. . . . [He said] that he had finally felt that God was speaking through his eyes." Lippman also told the story of Richard Wheatcroft, another of Avedon's sitters, who stood up at the discussion and said that "he was proud to be American, and this is how America looks." Lippman described the audience reaction to this remark: "This audience of sophisticates from the Metroplex [Dallas/Fort Worth] began to applaud. I mean, this is the first time that they had applauded truck drivers and coal miners—people were in tears by the end of that."[13] These heroic tales are meant to convince us of the classless, transcendental nature of art: The uncultured can experience the epiphany of the museum; the cultured can learn about the dignity of all people.

But did Avedon's subjects really understand his project and the system within which it exists? This is *not* to question the intelligence of the subjects, but it must be recognized that the understanding of art and the art system is not universal, even within a single culture (even among artists themselves). In fact, art appreciation is closely tied to class identity, and it is very unlikely that Avedon's subjects had much experience with art prior to their encounter with him. Certainly, for these people to be recognized by members of a more powerful class, by the class that controls history, would be considered an honor; Avedon, after all, deliberately chose the unsung and the uncelebrated. But this happiness at being recognized should not be mistaken for an understanding of the exploitation that occurs in the production of history and culture. Was it clearly explained to these people that the art system and the economic system would place more value upon their images than upon their lives? Was it clearly explained to each of them that their image would sell for more than some of them earn in a year, or in two? Were they told that, had they been less dirty, or less debilitated, or had they better taste, or better posture, they might not have been chosen to be photographed? Do Avedon's subjects truly understand that the project has given them new occupations in a new economy, employing them as signs of the dispossessed?

Avedon points out that there is no truth in photographs, that his work is fiction, but this does not alleviate social responsibility. For there *is* truth in life; there are real social conditions and real oppressions. The exercise of power creates such truth. The artist can either confront art's inability to address the realities of power, or the artist can work to institutionalize solipsism. Avedon, and the institutions that support him, have chosen the latter path.

more effective advertising photographer in this regard. "I'd like to merge my portraits of Americans with my knowledge of television advertising to bring a reminder of humanity to computers, oil companies, Detroit. It could be explosive." This would require the use of realistic images to create

a deeper approach to advertising, showing that there are problems that exist in the world, and that advertisers should not . . . ignore that these problems exist. . . . For instance, in a beer advertisement, if a photographer or director would focus on the difficulties facing the American worker instead of them sitting around guzzling beers and just hanging around, I strongly believe that the workers would respond to this approach and the ads would be very successful. . . . As an advertiser, one should try to make the statement that "I respect your life and I think my product can make a difference and help you." The upbeat approach is creatively used up, no longer effective. It's bad advertising because it's not believable.[16]

It would not be oversimplifying these remarks to say that Avedon is advocating using workers' alienation to sell them products that come from the very system that caused this alienation. In a very real way, Avedon's project in the American West was a trial run for a new advertising approach. It should not surprise us, then, that these pictures became fashionable. As the Boston exhibition of the work reveals, there are ways to put this alienation to work for the economic system.

The (Cash) Registers of Representation

Photography as such has no identity. Its status as a technology varies with the power relations which invest it. Its nature as a practice depends on the institutions and agents which define it and set it to work. . . . It is a flickering across a field of institutional spaces. And it is this field we must study, not photography as such.
John Tagg, "The Burden of Representation: Photography and the Growth of the State"[17]

> The ICA Council and Filene's
> invite you to a
> straight shootin' showdown hoedown
> The Wild Cactus Ball
> Saturday, April 25
> 9:30 p.m. to 2:00 a.m.
>
> Are you ready for the West? Are you set for the wide open spaces? It's all here at The Wild Cactus Ball. So dust off your ten-gallon hat and swing to the tunes of the Ed Peters Orchestra or sway to the western rhythms of Secrets. Set a spell in the Shotgun Saloon and sing along with our player piano. Join in the square dancing at The ICA Corral and chow down at our hot and spicy chuckwagon.
>
> So come on down, get to reeling, get the feeling . . . slip under the wonder of The Wild Cactus Ball.
>
> Special Guest of Honor: Richard Avedon

From a publicity poster announcing a fund-raiser for the Institute of Contemporary Art in Boston, held on the occasion of Avedon's "In the American West."

Art has become a growth industry; artworks are among the most elegant products of the entertainment system. Even critical works can be transformed by this system, becoming mere choices in a parade of upper-class commodities. The government has encouraged this situation by emphasizing "private sector" funding for the arts. Corporations have responded not only by funding art for others, but also by funding art for themselves; corporations have become important collectors, influencing the kind of work made and seen. Such is the condition of corporate culture: art as distraction, art as investment. But

patronage alone does not build a corporate culture. As we have already discussed, through the diminished distance between art and advertising, art has become a subsidiary of the information monopoly. Art, fashion, and advertising have come to share the same logic, and often the same signs. Avedon's studio is a case in point. As a company known as "Richard Avedon Incorporated," it produces both art and fashion, as well as the public relations services required by Avedon's work.

We have seen how "In the American West" fashions labor; now we will see how the work becomes a part of fashion. It would be an understatement to say that this work has been popular. The show has been a full-blown media spectacle—a public relations director's dream. It makes sense that Avedon would attract such attention; he is, after all, a major force in the media, helping to shape the public's opinion of companies, products, and magazines. Avedon is "media-savvy"; he understands how to get the public's attention, and so it is no surprise that magazines and television stations fell all over one another to cover the show. All the Condé Nast publications "fell in line"[18] with enthusiastic coverage, and most other publications treated the show as a "cultural event," declining critical analysis. The contents of press releases were repeated *ad infinitum* across newsstands and airwaves, and the pictures were reproduced everywhere. Almost every large circulation magazine in the United States covered the show at the Amon Carter. Articles or reviews appeared in the *New York Times, Newsweek, Time, New York, Atlantic, Popular Photography, Arts, Art in America, Artnews, Artforum, Aperture, Vanity Fair, Vogue, GQ, Rolling Stone,* and *Travel and Leisure;* opinions were offered by such well-known writers as Douglas Davis, Vicki Goldberg, Dore Ashton, Thomas McGuane, and Larry McMurtry. Hiro photographed Avedon for *Vanity Fair,* and Irving Penn photographed him for *Vogue.* Gene Shalit interviewed him on *Today,* and television coverage was extensive at every stop on the exhibition's tour. Even *Spirit* (the magazine of Southwest Airlines) and the *Dallas/Fort Worth Home and Garden* got into the act; *Texas Monthly* devoted twenty-two pages and its front cover to the work. In short, Avedon is a star of the media, and the media did not let him down. And as the media waxed prolix, the crowds poured in. The show set attendance records at the Amon Carter (fifty thousand saw the show there) and at other stops on the tour.

Publicity was coordinated and controlled by Avedon, the Amon Carter, and Abrams, Avedon's publisher. Irvin Lippman, publications and public affairs officer for the Amon Carter, spoke revealingly of their work, on a panel called "Tailor-Made PR." He noted that "the press bought the whole package"; in fact, their public relations work was so successful that the show did not receive substantial criticism until the exhibition left the Amon Carter.[19] Lippman attributed this subsequent criticism to a loss of control over publicity. "When Avedon, and I think the museum, was in control of the PR, there was generally a very positive response by the press. When the press went into the exhibition unattended, as they did at the Corcoran [Gallery, in Washington, D.C., December 7, 1985–February 16, 1986], there was sometimes not as positive a comment made."[20] Lippman was not very specific about all the ways the media were controlled; certainly, standard efforts were made to find favorable reviewers, supply them with easily digested information, and so forth. Less typical approaches included press conferences at each stop of the tour (these conferences no doubt short-circuited critical reviews, encouraging reporters to write instead about Avedon's journey and the show as *events*); Avedon even reviewed many stories prior to publication, to correct "misquotes." At times, this control

seems to have bordered on the obsessive: In Boston, for instance, Avedon even insisted on determining the way his work was portrayed in the museum's newsletter. The exhibition was described using a text copywritten by Avedon, with a layout and typefaces he approved.

Yet for all of this attention to public relations, "In the American West" is in no way an anomaly. It is merely a clever twist to the blockbuster approach, now a basic part of museum strategy. The blockbuster must be packaged in a way that maximizes media attention but minimizes criticism. This approach usually requires emphasizing the artist as a heroic figure. As museums take up marketing strategies, the product they promote is further joined to the logic of the market; and so the commodification of the work is inevitable. But unlike some museums, the Amon Carter had a very specific reason to mount this campaign. The museum actually commissioned "In the American West," supporting Avedon and his assistants for five years while this work was produced. In exchange for their support, the museum received a full set of prints—124 in all. The museum thus had an economic stake in the success of the show; negative reviews could affect the value of their Avedon holdings. As things went, the museum did very well. These pictures currently sell for $14,000 each; besides obtaining a reputation as a museum willing to take risks, the Amon Carter gained an Avedon collection worth about $1.7 million.

How did the work fare in Boston? First, some remarks about the city itself: Boston, like many other coastal cities, has accepted completely the rhetoric of the new economy and has worked for years to become a model postindustrial city. Once plagued by empty factories and a shrinking work force, the city is now in the midst of a booming recovery. Here is the city of the future, filled with computer firms, publishers, advertising agencies, and services; the town even has become an attractive site for prime-time television shows. Boston has fared this transition better than some cities; the state tries to keep unemployment low and provides unemployment compensation and job training. But Boston remains a city divided; poor neighborhoods south of Boston recently attempted to secede from the city, hoping to gain control over their real estate and their destinies. Even in Massachusetts, the recovery has not been extended to everyone; the marginalized class central to the conservative agenda still exists.

"In the American West" was exhibited in Boston at the Institute of Contemporary Art, a museum with a low-key public profile, known for sponsoring progressive, often political, sometimes difficult work. The ICA has undertaken many significant projects in the past, even offering the public a critique of the museum's own institutional effects.[21] This curatorial approach was not accepted easily in Boston, and the museum has sustained years of criticism to achieve the prominence it now enjoys. The exhibition at the ICA was sponsored by Filene's, an established, fashionable Boston department store that is a part of the Federated chain. This collaboration between progressive institution and status quo corporation was successful, revealing, and as we shall see, troubling. Specifically, we shall see how easily Avedon's pictures can be positioned in the landscape of the new economy; through this example, we will see how art and art institutions in general can be incorporated into this economy.

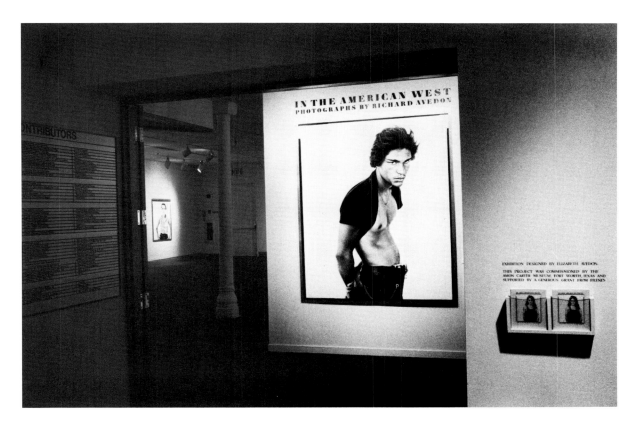

Installation view of *In the
American West*, Institute of
Contemporary Art, Boston,
1987

As in other cities, media attention was extraordinary, thrusting Avedon, as well as the
ICA, into the spotlight. Every major television station, newspaper, and magazine in the
city announced the exhibition, reviewed the show, or interviewed the artist. The town's
major paper, the *Boston Globe,* ran no fewer than seven pieces on the exhibition, including
an initial story on the show's corporate sponsor ("Filene's Underwrites ICA's Avedon Ex-
hibit," February 8, 1987), a society-page report on the opening ("Avedon's West Hits the
East," February 23, 1987), a review of the show ("Avedon's 'West': Exploitation or Art?"
February 24, 1987), *two* interviews with the artist, and letters to the editor. Due in large
part to this attention, the ICA enjoyed record attendance. Exhibitions at the ICA average
five thousand visitors per show, but Avedon brought in twenty-seven thousand. The mu-
seum wisely held a membership drive during this time and was able to increase its mem-
bership base by one-third. Reports have it that the gallery staff barely found time to wipe
away fingerprints on walls, let alone tend to normal business. Such public interest begs to
be taken seriously, as no doubt it will be by the ICA Board of Directors—a board in part
composed of corporate and media moguls in the Boston area. What kind of pressure will
exist to create more blockbusters in the future? Will the ICA become another leisure-
time amenity for the citizens and tourists of the "New Boston," sacrificing its hard-won
position as a critical institution?

These are not just idle questions. One glance at the way the corporate sponsor of the show appropriated both institution and artwork into its marketing strategy, and so into the information economy of the New Boston, provides sufficient cause for worry. Filene's was extraordinarily generous; the ICA had never experienced corporate sponsorship of this magnitude before, and, in fact, Filene's had never before sponsored an art exhibition. When the possibility arose to show "In the American West" at the ICA, David Ross, director of the ICA, approached Filene's with the hope of receiving their support. (While Ross was a curator at the University of California at Berkeley, he worked on a retrospective of Avedon's work that enjoyed sponsorship by Macy's. This gave him the idea to approach Filene's.) In the final arrangement, the ICA paid for the actual installation of the show; Filene's paid all remaining expenses, mounted a promotional blitz for the show, and hosted a fund-raiser. (Additional corporate support was received from the Revlon Corporation, and it should be noted that the normally staid Harvard threw its support behind the exhibition as well.[23])

Filene's donated $100,000 worth of print advertising to the effort, to publicize both the show and corporation's sponsorship; Filene's also mentioned the show in advertisements not directly related to the promotion. The company mailed an announcement of the show to 250,000 Filene's credit card holders in their monthly bills, offering reduced admission and membership rates. The exhibition's informational brochure was written by an ICA curator, edited by Avedon, and printed by Filene's; the brochure was distributed both in the store and in the museum. Such a promotional onslaught was unusual for the ICA, to say the least. The museum does almost *no* advertising, for it cannot afford it— advertisements usually appear in space donated in the city's weekly arts and leisure newspaper; design work on these ads is donated as well. The store's extensive campaign penetrated major Boston magazines and newspapers that the ICA never reaches, allowing the museum, in Ross's words, to "reach a tremendously diverse audience," so helping the ICA transcend its "forbidden," difficult reputation.[23]

But Filene's did not stop there. They used the show as the basis of a sales campaign for western wear. Taking a "destinational" approach (to quote their press release), the show combined posters from the show with mannequins in western landscapes throughout the store. Street-level display windows juxtaposed fashionable clothing with different images from "In the American West" and quotes from Avedon. Avedon's portrait of Sandra Bennett, dressed in Lee coveralls, mixed it up with models wearing Calvin Klein and Guess? wear in a catalogue entitled "Feeling ready for the West." Charlotte Brewer, Filene's vice president of marketing, explained the promotion in this way: "The American 'West' theme is an ideal attitudinal and visual concept to showcase today's rugged, earthy denims and chambray with the soft sensuality of cotton petticoats and camisoles that reflect a spirit of early pioneering days. . . . This fantasy with the American West is always with us, but surges every so often as a major fashion statement."[24] Indeed.

Even these projects did not exhaust Filene's promotion department. The store commemorated the show yet again with "Features," an "amateur portrait photography competition in celebration of the art of photography." Grand prize was—you guessed it—a trip to the American West, to the Sheraton Tucson El Conquistador Golf and Tennis Resort in Tucson, Arizona. Still going strong, Filene's sponsored a fundraiser for the ICA, "The Wild Cactus Ball." This benefit, which featured Avedon as guest of honor, served up western food and music to participants wearing black tie or western dress. Events included a celebrity hat auction, a chili cook-off, and (in the words of one reporter) "two

Photograph of *In the American West* opening, published in the *Boston Ledger*, February 21–27, 1987 (Photo: Roger Farrington)

Filene's official publicity photograph from the "Wild Cactus Ball" benefit, 1987

gals in black outfits, shouldering leather holsters, slinging Tequila bottles with crossed 'gun belts' of shot glasses . . . offering guests 'shooters.' "[25] Tickets for the fête ranged from $40 to $350; the high contribution offered the donor admission to a Benefactors Dinner and the Ball itself, as well as a limited-edition Gyorgy Kepes photograph (Kepes being one of Boston's own), and "an opportunity to sponsor a Boston artist to attend the Ball."

Installation view of *In the American West*, Institute of Contemporary Art, Boston. View shows *Sandra Bennett, twelve year old, Rocky Ford, Colorado, 8/23/80*, among other images.

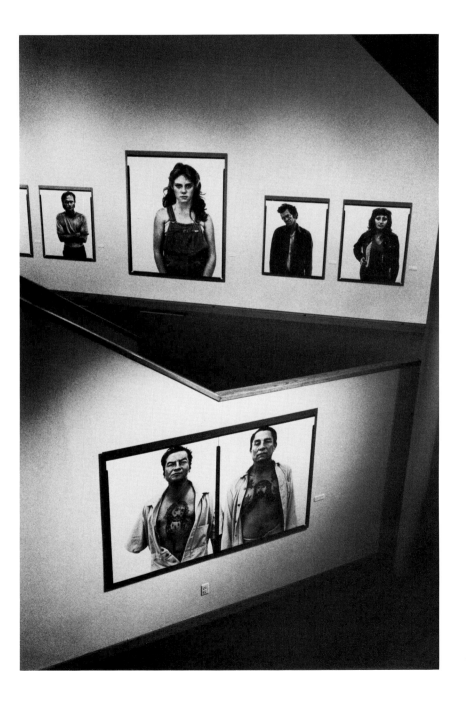

Cover of the book *In the
American West* (New York:
Harry N. Abrams, Inc., 1985)

Poster, Amon Carter Museum,
1985

Advertisement for the Boston
run of the exhibition *In the
American West*

Cover and page spread from
Feeling ready for the West,
Filene's Spring 1987 catalogue

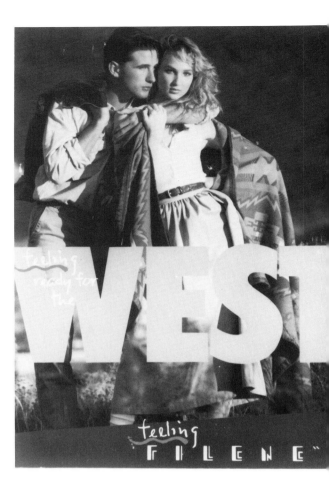

278 | 279

One thing that is immediately apparent when reviewing various materials from this project is the use of Avedon's *Sandra Bennett, 12 years old* (1980). This image recurs so frequently that it has become the logo for the project. It can be found on the cover of Avedon's book, in many articles about the work, and in most of the publicity material associated with the show. This picture is an obvious choice for the promotional needs of all concerned, since it is the least confrontational picture in the project. A more controversial picture might have ruptured a carefully built, expensive media image by contradicting the institutions' own advertising, or by creating embarrassing juxtapositions *in situ* with other advertising or editorial information. The moral issue of the promotion—the use of images of the dispossessed to create public images for the artist, the company, and the museum—would become obvious. "Advertising is advertising is advertising," as Ross noted in my conversation with him. The museum wanted only to bring the audience into the museum; they wanted confrontation to take place in the gallery rather than in the media. And Filene's, of course, wanted to bring people into the store. *Sandra Bennett* was a particularly appropriate image for their purposes. First of all, none of the other pictures in the show could be joined as easily to the department store's carefree slogan "Feeling Filene's." Secondly, *Sandra Bennett* speaks to one of the store's target audiences. Given Avedon's approach, the young girl can be used to symbolize the unfashionable young

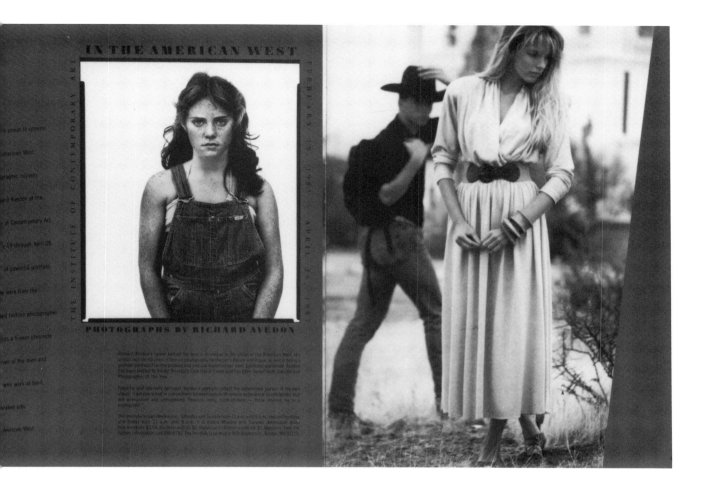

woman, waiting to be transformed by the store. Here is a first result of Avedon's advice to use more realistic images for a "deeper approach to advertising." (It is interesting to note that the picture can form this identification with the target audience and also enunciate the distance and superiority of the remaining eastern audience.) Finally, there is a margin of safety gained through the use of this picture. The appearance of this image in so many different places assures audience familiarity; because of this repetition, the audience is less likely to examine each specific context of presentation. This, too, is to everyone's benefit should an unfavorable juxtaposition occur.

It is also interesting to note how the "logo" effect is carried into the exhibition. The show, designed by Elizabeth Avedon, the photographer's daughter-in-law, capitalized on the recognizability of *Sandra Bennett* built through media exposure. The image was placed in the center of the first gallery seen upon entering the building; for emphasis, the image was printed larger than the others in that gallery. The other main entrance to the show was marked by *Juan Patricio Lobato, carney* (1980). another picture used (although less frequently) to publicize the show. And since there is no clear separation between the sales area and the exhibition spaces of the ICA, viewers were treated to the duplication of these images on books and posters available for sale. The work thus assisted in its own promotion. Even in the museum, Avedon's work was accompanied by its duplication in the media.

Page from the *Sunday Boston Globe Magazine,* April 5, 1987, "The interview: Richard Avedon," by D. C. Denison

By D.C. Denison

The interview

Richard Avedon

"Not everyone is a suitable subject for a portrait by me."

Richard Avedon is a photographer. We spoke at the Institute of Contemporary Art, where his exhibit of portraits, "In the American West," is on display through April 26.

You don't look through the lens when you're taking a portrait. Why not?
My kind of portrait is dependent on an interchange between myself and the sitter. I guess all portraiture is. If the photographer's face is covered by a camera, it means that the subject is relating to a machine, not another person. The portraits I do are very much about the sitter's response to me. I have to draw from them the quality I'm looking for.

So where do you stand when you're shooting a portrait?
I stand right next to the lens. I can imagine the difference between my eyes and the lens, which is infinitesimal. Then I can work as if the camera isn't there. That's very important. It's the only way

D. C. DENISON IS A BOSTON-BASED WRITER.

I have of directing a photograph.

What were your preconceptions of the West, before you started this project?
Probably the same as yours: John Wayne movies, Marlboro men. Every American man has grown up with some definition of masculinity that's embedded in the American West. You start with cowboys and Indians, and you end up with Marlboro men. I discovered that that West has nothing to do with the West of today, if it ever did.

What were you looking for in your subjects?
What you see on the walls of the ICA now. I have a certain style of portraiture that's defined by the graphic elements of the portrait and the people I choose. Not everyone is a suitable subject for a portrait by me. It's similar to the way in which you could say, "She looks like a Modigliani." In the same way, if you see this exhibit, you'll see what an Avedon portrait looks like.

You've often referred to your photographs as "fictions." Why?
The line between fiction and fact is crucial in anything to do with photography. There has never been an art in the history of the world as dependent on that distinction. For example, if you were writing about me, I could say, "That's not me, that's what Denison thinks," or if I was painted, I could say, "That's not me, that's a deKooning." But with a photograph, you can never say that you weren't there. So that implies a certain truth. On the other hand, anything edited is a lie. The minute you edit this tape you're not telling the truth about me. You can do anything you want with this tape. And photography is the most deceptive in that regard, because the person is right there in the picture.

How many people did you photograph for this project and not use?
There were about 600 people that I photographed and didn't use. But there were hundreds of thousands, probably millions, who were looked at and rejected. I spent a tremendous amount of time

walking through fairs and oil fields and truck stops staring at people, looking for someone who had in his face a quality that I could express myself through.

I read that your mentor, Alexey Brodovitch, used to say, "Produce something that startles." Do you still follow that?
No. He said that in relation to monthly magazine work, where it's necessary to surprise and startle. But no, I think that in my portrait work I don't do anything to startle at all. The discipline is to do as truthful and as deep a portrait as is possible to make. For me it's been a lifetime of digging deeper, into myself and the people who have posed for me.

How much fashion work do you do?
I photograph the covers of three Conde Nast magazines: *Vogue, GQ,* and *Self.* That's the only editorial work I do. I really make my living as an advertising photographer. The new Revlon campaign, Calvin Klein television commercials, Chanel television commercials — I direct them and co-write them.

So you play more of a conceptual role?
Right. Most of the time now I'm hired to invent an image for a company, and then execute it.

What do you think about when someone is taking your picture?
I'm surprised at how quickly I become an object. I never know what the photographer is thinking or wants from me, but I just lend myself. I'm always amazed at how generous people who pose for me are with their selves, with a capital "S." I try to do the same. I wait to be led, and I'm interested in what photographers do with my face.

The photographs I've seen make you look more severe than you are in person.
Being an artist demands severity of all kinds. The smile is a kind of mask. So is horsing around for the camera. Those ruses arrived with the snapshot. The true meaning hidden in a face is revealed in repose. ●

2

Here we see all the components of a public relations strategy working together. The work of art is treated as an empty vessel, used alternately to promote the artist, the museum, and the corporate sponsor. The work, from its inception, is produced according to a logic that makes this appropriation possible. The aesthetic approach of art history and the criticism-cum-entertainment of the art journalist also work to support and encourage this appropriation. The audience, well versed in the logic of information, respond as they will to the affirmation of the class structure in which they live. The potentially critical space of art, and the museum itself, provide public relations support for the dominant class, and assist in the naturalization of circumstances and beliefs that empower this class.

During our interview, Ross claimed that it was courageous of Filene's to support the Avedon exhibition. Most corporations would prefer to contribute to nonspecific operating expenses, thus establishing a general identification with the institution. In this way they gain from the prestige of the institution without risking the failure of a specific show. Ross noted that the message of Avedon's "In the American West" might be anticonsumerist; the corporation thus ran a risk. But as we have seen, the artist, the museum, and the corporation did everything possible to eliminate readings of this work that would directly criticize the American system.

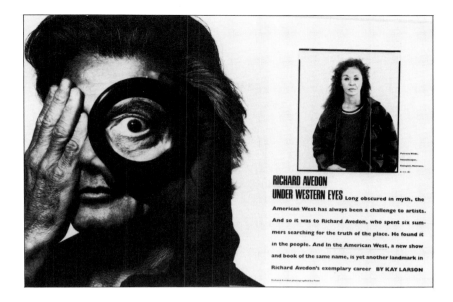

RICHARD AVEDON
UNDER WESTERN EYES Long obscured in myth, the American West has always been a challenge to artists. And so it was to Richard Avedon, who spent six summers searching for the truth of the place. He found it in the people. And In the American West, a new show and book of the same name, is yet another landmark in Richard Avedon's exemplary career BY KAY LARSON

Roland Barthes argued famously that the photograph is polysemic, that it has no single independent meaning, but many possible meanings depending upon context and use. But Barthes also understood that, just as a social context makes certain readings possible, it can make other readings *im*possible. Institutions authorize certain meanings and dismiss, even silence, others. Thus there is a politics of interpretation that one contends with immediately, whether one knows it or not. To interpret a photograph, or any cultural object, is to negotiate a sea of choices already made.

I have described how this work provides *control* over the dispossessed, and how institutions have *managed* the work to prevent possible critical interruption. We have seen how the artist rewrites alienation into a form acceptable to the status quo, and how institutions have rewritten the work still further, turning the subjects of the work into entertainment and consumerist frisson. Ross mentioned that there may indeed be an irony here between audience, client, and subject, but for him this was not a *great* irony, a "Chekhovian" irony. "The disparities are not pronounced enough to be of great ironic value." This is to say that the subject has been rewritten so many times that *no* irony, not even *aesthetic* irony, remains. The subject has been incorporated into the reality of the dominant class. Yet this very fact introduces enormous *political* irony that we must not allow ourselves to appreciate from a distance, as connoisseurs of despair.

1 Göran Therborn, *Why Some People Are More Unemployed Than Others: The Strange Paradox of Growth and Unemployment* (London: Verso, 1986).

2 The artist Hans Haacke has addressed this issue with great clarity. See Brian Wallis, ed., *Hans Haacke: Unfinished Business* (New York: New Museum of Contemporary Art, and Cambridge: The MIT Press, 1986).

3 Laura Wilson, "Background," in Richard Avedon, *In the American West, 1979–1984* (New York: Harry N. Abrams, Inc., 1985), n.p.

4 Richard Avedon, lecture given during "In the American West" seminar, February 20, 1987, "Learning from Performers Program," Office for the Arts at Harvard and Radcliffe, Cambridge, MA.

5 Richard Avedon, "Foreword," in Avedon, *In the American West,* n.p.

6 Avedon, quoted in press release, "In the American West," Amon Carter Museum, Fort Worth, TX, June 1, 1985.

7 Avedon, "Foreword," *In the American West.*

8 Here, for example, is how Avedon's book of western portraits was described in the publisher's catalogue copy: "Here is western America down and dirty; gritty, tough, brave, sad—real people in real places. Avedon's courage in facing these men and women, in confronting their plight and evoking their terrifying beauty, marks a new dimension in his art. These are no pretty pictures here, no Neiman-Marcus tailoring—not an easy book, this is a profoundly important one."

9 Gopnik, "In the American West" seminar, "Learning from Performers Program."

10 Avedon, "West" seminar, "Learning from Performers Program."

11 Sander Gilman, *Difference and Pathology: Stereotypes of Sexuality, Race, and Madness* (Ithaca: Cornell University Press, 1985).

12 Avedon, "Foreword," *In the American West.*

13 Irvin Lippman, presentation at American Association of Museums conference, New York, 1986. Panel entitled "Three Disciplines, Three Approaches: Tailor-Made PR for Art, History, and Science Museum."

14 Avedon, "West" seminar, "Learning from Performers Program."

15 Dick Hebdige, *Subculture: The Meaning of Style* (London: Methuen, 1979).

16 Tom Weisend, "Avedon's Work 'In the American West' Changes His Opinion of American Ads," *Adweek,* February 23, 1987, p. 6.

17 In *Ten.8* 14 (1984), pp. 11–12.

18 Lippman, "Tailor-Made PR."

19 Two of these critical reviews are particularly incisive. See Stephen Frailey, "Richard Avedon: 'In the American West,'" *Print Collector's Newsletter* (May/June 1986), pp. 50–52; and Max Kozloff, "Through Eastern Eyes," *Art in America* 75:1 (January 1987), pp. 91–97.

20 Lippman, "Tailor-Made PR."

21 See the exhibition catalogue *Dissent: The Issue of Modern Art in Boston* (Boston: Institute of Contemporary Art, 1985).

22 "West" seminar, "Learning from Performers Program."

23 David Ross, interview with author, June 1, 1987. All remaining remarks by Ross are derived from this conversation.

24 Press release for "In the American West," Filene's, Boston, MA, February 23, 1987.

25 Roger Farrington, "ICA Wild Cactus Ball," *Boston Ledger,* May 16–22, 1987.

What are the politics of photographic truth?

Timothy O'Sullivan, *Tufa Domes, Pyramid Lake (Nevada)*, 1868

Photolithograph after O'Sullivan, *Tufa Domes, Pyramid Lake*. Published in King Survey report, 1875.

Photography's Discursive Spaces

Let us start with two images, identically titled *Tufa Domes, Pyramid Lake, Nevada*. The first is a (recently) celebrated photograph made by Timothy O'Sullivan in 1868 that functions with special insistence within the art-historical construction of nineteenth-century landscape photography. The second is a lithographic copy of the first, produced for the publication of Clarence King's *Systematic Geology* in 1878.[1]

Twentieth-century sensibility welcomes the original O'Sullivan as a model of the mysterious, silent beauty to which landscape photography had access during the early decades of the medium. In the photograph, three bulky masses of rock are seen as if deployed on a kind of abstract, transparent chessboard, marking by their separate positions a retreating trajectory into depth. A fanatical descriptive clarity has bestowed on the bodies of these rocks a hallucinatory wealth of detail, so that each crevice, each granular trace of the original volcanic heat finds its record. Yet the rocks seem unreal and the space dreamlike, the tufa domes appear as if suspended in a luminous ether, unbounded and directionless. The brilliance of this undifferentiated ground, in which water and sky connect in an almost seamless continuum, overpowers the material objects within it, so that if the rocks seem to float, to hover, they do so merely as shape. The luminous ground overmasters their bulk, making them instead the functions of design. The mysterious beauty of the image is in this opulent flattening of its space.

By comparison, the lithograph is an object of insistent visual banality. Everything mysterious in the photograph has been explained with supplemental, chatty detail. Clouds have been massed in the sky; the far shore of the lake has been given a definitive shape; the surface of the lake has been characterized by little eddies and ripples. And most important for the demotion of this image from strange to commonplace, the reflections of the rocks in the water have been carefully recreated, so that gravity and direction are restored to this space formerly awash with the vague luminosity of too rapidly exposed collodion.

But it is clear, of course, that the difference between the two images—the photograph and its translation—is not a function of the inspiration of the photographer and the insipidity of the lithographer. They belong to two separate domains of culture, they assume different expectations in the user of the image, they convey two distinct kinds of knowledge. In a more recent vocabulary, one would say that they operate as representations within two distinct discursive spaces, as members of two different discourses. The lithograph belongs to the discourse of geology and, thus, of empirical science. In order for it to function within this discourse, the ordinary elements of topographical description had to be restored to the image produced by O'Sullivan. The coordinates of a continuous homogeneous space, mapped not so much by perspective as by the cartographic grid, had to be reconstructed in terms of a coherent recession along an intelligible horizontal plane retreating toward a definite horizon. The geological data of the tufa domes had to be grounded, coordinated, mapped. As shapes afloat on a continuous, vertical plane, they would have been useless.[2]

And the photograph? Within what discursive space does it operate?

Aesthetic discourse as it developed in the nineteenth century organized itself increasingly around what could be called the space of exhibition. Whether public museum, official salon, world's fair, or private showing, the space of exhibition was constituted in part by the continuous surface of wall—a wall increasingly structured solely for the display of art. The space of exhibition had other features besides the gallery wall. It was also the ground of criticism: on the one hand, the ground of a written response to the works' appearance in that special context; on the other, the implicit ground of choice (of either inclusion or exclusion), with everything excluded from the space of exhibition becoming marginalized with regard to its status as Art.[3] Given its function as the physical vehicle of exhibition, the gallery wall became the signifier of inclusion and, thus, can be seen as constituting in itself a representation of what could be called *exhibitionality,* or that which was developing as the crucial medium of exchange between patrons and artists within the changing structure of art in the nineteenth century. And in the last half of the century, painting—particularly landscape painting—responded with its own corresponding set of depictions. It began to internalize the space of exhibition—the wall—and to represent it.

The transformation of landscape after 1860 into a flattened and compressed experience of space spreading laterally across the surface was extremely rapid. It began with the insistent voiding of perspective, as landscape painting counteracted perspectival recession with a variety of devices, among them sharp value contrast, which had the effect of converting the orthogonal penetration of depth—effected, for example, by a lane of trees—into a diagonal ordering of the surface. No sooner had this compression occurred, constituting within the single easel painting a representation of the very space of exhibition, than other means of composing this representation were employed: serial landscapes, hung in succession, mimed the horizontal extension of the wall, as in Monet's Rouen Cathedral paintings; or landscapes, compressed and horizonless, expanded to become the absolute size of the wall. The synonymy of landscape and wall (the one a representation of the other) of Monet's late water lilies is thus an advanced moment in a series of operations in which aesthetic discourse resolves itself around a representation of the very space that grounds it institutionally.

This constitution of the work of art as a representation of its own space of exhibition is in fact what we know as the history of modernism. It is now fascinating to watch historians of photography assimilating their medium to the logic of that history. For if we ask, once again, within what discursive space does the original O'Sullivan—as I described it at the outset—function, we have to answer: that of the aesthetic discourse. And if we ask what it is a representation *of,* the answer must be that within this space it is constituted as a representation of the plane of exhibition, the surface of the museum, the capacity of the gallery to constitute the objects it selects for inclusion as Art.

But did O'Sullivan in his own day, the 1860s and 1870s, construct his work for the aesthetic discourse and the space of exhibition? Or did he create it for the scientific/topographical discourse that it more or less efficiently serves? Is the interpretation of O'Sullivan's work as a representation of aesthetic values—flatness, graphic design, ambiguity, and, behind these, certain intentions toward aesthetic significations: sublimity, transcendence—not a retrospective construction designed to secure it as art?[4] And is this projection not illegitimate, the composition of a false history?

This question has a special methodological thrust from the vantage of the present, as a newly organized and energized history of photography is at work constructing an account of the early years of the medium. Central to this account is the photography, most of it topographical, originally undertaken for the purposes of exploration, expedition, and survey. Matted, framed, labeled, these images now enter the space of historical reconstruction through the museum. Decorously isolated on the wall of exhibition, the objects can be read according to a logic that insists on their representational character within the discursive space of art, in an attempt to "legitimate" them. The term is Peter Galassi's, and the issue of legitimacy was the focus of the Museum of Modern Art exhibition *Before Photography,* which he organized. In a sentence that was repeated by every reviewer of his argument, Galassi sets up this question of photography's position with respect to the aesthetic discourse: "The object here is to show that photography was not a bastard left by science on the doorstep of art, but a legitimate child of the Western pictorial tradition."[5]

The legitimation that follows depends on something far more ambitious than proving that certain nineteenth-century photographers had pretensions to being artists, or theorizing that photographs were as good as, or even superior to, paintings, or showing that photographic societies organized exhibitions on the model of Establishment salons. Legitimations depend on going beyond the presentation of apparent membership in a given family; they demand the demonstration of the internal, generic necessity of such membership. Galassi wants, therefore, to address internal, formal structures rather than external, circumstantial details. To this end he wishes to prove that the perspective so prominent in nineteenth-century outdoor photography—a perspective that tends to flatten, to fragment, to generate ambiguous overlap, to which Galassi gives the name "analytic," as opposed to the "synthetic" constructive perspective of the Renaissance—was fully developed by the late eighteenth century within the discipline of painting. The force of this proof, Galassi maintains, will be to rebut the notion that photography is essentially a "child of technical rather than aesthetic traditions" and an outsider to the internal issues of aesthetic debate and to show, instead, that it is a product of that same spirit of inquiry *within the arts* that welcomed and developed both "analytic" perspective and an empiricist vision. The radically foreshortened and elliptical sketches by Constable (and

even Degas) can then be used as models for a subsequent photographic practice, which in Galassi's presentation turns out overwhelmingly to be that of topography: Samuel Bourne, Felice Beato, Auguste Salzmann, Charles Marville, and, of course, Timothy O'Sullivan.

And the photographs respond as they are bid. The Bourne of a road in Kashmir, in its steep split in values, empties perspective of its spatial significance and reinvests it with a two-dimensional order every bit as powerfully as does a contemporary Monet. The Salzmann, in its fanatical recording of the texture of stone on a wall that fills the frame with a nearly uniform tonal continuum, assimilates its depiction of empirical detail to a representation of the pictorial infrastructure. And the O'Sullivans, with their rock formations engulfed by that passive, blank, collodion sky, flatten into the same hypnotically seen but two-dimensionally experienced order that characterized the *Tufa Domes* of Pyramid Lake. When viewing the evidence on the walls of the museum, we have no doubt that Art has not only been intended but has also been represented—in the flattened, decoratively unifying drawing of "analytic" perspective.

But here the demonstration runs into difficulty. For Timothy O'Sullivan's photographs were not published in the nineteenth century and their only public distribution was through the medium of stereography. Most of the famous O'Sullivans—the Canyon de Chelly ruins from the Wheeler Expedition, for example—exist as stereographic views, and it was to these that, in O'Sullivan's case, as in William Henry Jackson's, the wider public had access.[6] Thus, if we began with a comparison between two images—the photograph and the lithographic translation—we can continue with a comparison between two cameras: a 9 × 12 plate camera and a camera for stereoscopic views. These two pieces of equipment mark distinct domains of experience.

Stereographic space is perspectival space raised to a higher power. Organized as a kind of tunnel vision, the experience of deep recession is insistent and inescapable. This experience is heightened by the fact that the viewer's own ambient space is masked out by the optical instrument he must hold before his eyes. As he views the image in an ideal isolation, his own surrounds, with their walls and floors, are banished from sight. The apparatus of the stereoscope mechanically focuses all attention on the matter at hand and precludes the visual meandering experienced in the museum gallery as one's eyes wander from picture to picture and to surrounding space. Instead, the refocusing of attention can occur only within the spectator's channel of vision constructed by the optical machine.

The stereographic image appears multilayered, a steep gradient of different planes stretching away from the nearby space into depth. The operation of viewing this space involves scanning the field of the image, moving from its lower left corner, say, to its upper right. That much is like looking at a painting. But the actual experience of this scan is something wholly different. As one moves, visually, through the stereoscopic tunnel from inspecting the nearest ground to attending to an object in the middle distance, one has the sensation of refocusing one's eyes. And then again, into the farthest plane, another effort is made, and felt, to refocus.[7]

These micromuscular efforts are the kinesthetic counterpart to the sheerly optical illusion of the stereograph. They are a kind of enactment, on a very reduced scale, of what happens when a deep channel of space is opened before one. The actual readjustment of the eyes from plane to plane within the stereoscopic field is the representation by one part of the body of what another part of the body (the feet) would do in passing through real space. From this physio-optical traversal of the stereo field derives another difference between it and pictorial space. This difference concerns the dimension of time.

The contemporary accounts of what it was like to look at stereographs all dilate on the length of time spent examining the contents of the image. For Oliver Wendell Holmes, Sr., a passionate advocate of stereography, this perusal was the response appropriate to the "inexhaustible" wealth of detail provided by the image. As he picks his way over this detail in his writing on stereography—in describing, for example, his experience of an E. & H. T. Anthony view up Broadway—Holmes enacts for his readers the protracted engagement with the spectacle demanded by stereo viewing. By contrast, paintings do not require (and as they become more modernist, certainly do not support) this temporal dilation of attention, this minute-by-minute examining of every inch of the ground.

When Holmes characterizes this special modality of viewing, where "the mind feels its way into the very depths of the picture," he has recourse to extreme mental states, like hypnotism, "half-magnetic effects," and dream. "At least the shutting out of surrounding objects, and the concentration of the whole attention which is a consequence of this, produce a dream-like exaltation," he writes, "in which we seem to leave the body behind us and sail away into one strange scene after another, like disembodied spirits."[8]

The phenomenology of the stereoscope produces a situation not unlike that of looking at cinema. Both involve the isolation of the viewer with an image from which surrounding interference is masked out. In both, the image transports the viewer optically, while his body remains immobile. In both, the pleasure derives from the experience of the simulacrum: the appearance of reality from which any testing of the real-effect by actually, physically, moving through the scene is denied. And in both, the real-effect of the simulacrum is heightened by a temporal dilation. What has been called the *apparatus* of cinematic process had, then, a certain protohistory in the institution of stereography, just as stereography's own protohistory is to be found in the similarly darkened and isolating but spectacularly illusionistic space of the diorama.[9] And in the case of the stereograph, as was later the case for film, the specific pleasures that seem to be released by that apparatus—the desires that it seems to gratify—accounted for the instantly wild popularity of the instrument.

The diffusion of stereography as a truly mass medium was made possible by mechanized printing techniques. Beginning in the 1850s but continuing almost unabated into the 1880s, the figures for stereo sales are dizzying. As early as 1857 the London Stereoscopic Company had sold five-hundred thousand stereoscopes and in 1859 was able to claim a catalogue listing more than a hundred thousand different stereo views.[10]

It is in this very term—*view*—by which the practice of stereoscopy identified its object, that we can locate the particularity of that experience. First of all, *view* speaks to the dramatic insistence of the perspectivally organized depth I have been describing. This was often heightened, or acknowledged, by the makers of stereo views by structuring the image around a vertical marker in fore- or middle ground that works to *center* space, forming a representation within the visual field of the eyes' convergence at a vanishing point. Many of Timothy O'Sullivan's images organize themselves around such a center— the staff of a bare tree trunk, the sheer edge of a rock formation—whose compositional sense derives from the special sensations of the *view*. Given O'Sullivan's tendency to compose around the diagonal recession and centering of the *view*, it is not surprising to find that in his one published account of his work as a Western photographer he consistently speaks of what he makes as "views" and what he does when making them as "viewing." Writing of the expedition to Pyramid Lake, he describes the provisions, "among which

may be mentioned the instruments and chemicals necessary for our photographer to 'work up his view.' Of the Humboldt Sink, he says, "It was a pretty location to work in, and viewing there was as pleasant work as could be desired."[11] *View* was the term consistently used in the photographic journals, as it was overwhelmingly the appellation photographers gave to their entries in photographic salons in the 1860s. Thus, even when consciously entering the space of exhibition, they tended to choose *view* rather than *landscape* as their descriptive category.

Further, *view* addresses a notion of authorship in which the natural phenomenon, the point of interest, rises up to confront the viewer, seemingly without the mediation of an individual recorder or artist, leaving "authorship" of the views to their publishers rather than to the operators (as they were called) who took the pictures. Thus, authorship is characteristically made a function of publication, with copyright held by the various companies, for example, Keystone Views, while the photographers remain anonymous. In this sense the phenomenological character of the view, its exaggerated depth and focus, opens onto a second feature, which is the isolating of the object of that view. Indeed, it is a "point of interest," a natural wonder, a singular phenomenon that comes to occupy this centering of attention. This experience of the *singular* is, as Barbara Stafford has shown in an examination of singularity as a special category associated with travel accounts beginning in the late eighteenth century, founded on the transfer of authorship from the subjectivity of the artist to the objective manifestations of nature.[12] For this reason, the institution of the view does not claim the imaginative projection of an author so much as the legal protection of property in the form of the copyright.

Finally, *view* registers this singularity, this focal point, as one moment in a complex representation of the world, a kind of complete topographical atlas. For the physical space within which the "views" were kept was invariably a cabinet in whose drawers were catalogued and stored a whole geographical system. The file cabinet is a different object from the wall or the easel. It holds out the possibility of storing and cross-referencing bits of information and of collating them through the particular grid of a system of knowledge. The elaborate cabinets of stereo views that were part of the furnishing of nineteenth-century middle-class homes as well as of the equipment of public libraries comprise a compound representation of geographic space. The spatiality of the view, its insistent penetration, functions as the sensory model for a more abstract system whose subject also is space. View and land survey are interdetermined and interrelated.

What emerges from this analysis is a system of historically specific requirements that were satisfied by the view and in relation to which *view* formed a coherent discourse. I hope it is apparent that this discourse is disjunct from what aesthetic discourse intends by the term *landscape.* Just as the view's construction of space cannot be assimilated, phenomenologically, to the compressed and fragmented space of what *Before Photography* calls analytic perspective,[13] so the representation formed by the collectivity of these views cannot be likened to the representation organized by the space of exhibition. The one composes an image of geographic order; the other represents the space of an autonomous Art and its idealized, specialized History, which is constituted by aesthetic discourse. The complex collective representations of that quality called style—period style, personal style—are dependent upon the space of exhibition; one could say they are a function of it. Modern art history is in that sense a product of the most rigorously organized nineteenth-century space of exhibition: the museum.[14]

André Malraux has explained to us how the museum, with its succession of (representations of) styles, collectively organizes the master representation of Art. Having updated themselves through the institution of the modern art book, Malraux's museums are now "without walls," the galleries' contents collectivized by means of photographic reproduction. But this serves only to intensify the reductiveness of the process:

Thus it is that, thanks to the rather specious unity imposed by the photographic reproduction on a multiplicity of objects, ranging from the statue to the bas-relief, from bas-reliefs to seal-impressions, and from these to the plaques of the nomads, a "Babylonian style" seems to emerge as a real entity, not a mere classification—as something resembling, rather the life-story of a great creator. Nothing conveys more vividly and compellingly the notion of a destiny shaping human ends than do the great styles, whose evolutions and transformations seem like long scars that Fate has left, in passing, on the face of the earth.[15]

Having decided that nineteenth-century photography belongs in a museum, having decided that the genres of aesthetic discourse are applicable to it, having decided that the art-historical model will map nicely onto this material, recent scholars of photography have decided (ahead of time) quite a lot. For one thing, they have concluded that given images are *landscapes* (rather than *views*), and they are thus certain about the discourse these images belong to and what they are representations of. For another (but this conclusion is reached simultaneously with the first), they have determined that other fundamental concepts of aesthetic discourse will be applicable to this visual archive. One of these is the concept *artist,* with its correlative notion of sustained and intentional progress to which we give the term *career.* The other is the possibility of coherence and meaning that will unfold through the collective body of work so produced, this constituting the unity of an *oeuvre.* But, it can be argued, these are terms that nineteenth-century topographic photography not only tends not to support but in fact opens to question.

The concept *artist* implies more than the mere fact of authorship; it suggests that one must go through certain steps to earn the right to claim the condition of being an author, the word *artist* being somehow semantically connected with the notion of vocation. Generally, "vocation" implies an apprenticeship, a juvenilia, a learning of the tradition of one's craft and the gaining of an individuated view of that tradition through a process that includes both success and failure. If this, or at least some part of it, is what is necessarily included in the term *artist,* can we then imagine someone being an artist for just one year? Would this not be a logical (some would say, grammatical) contradiction, like the example adduced by Stanley Cavell in relation to aesthetic judgments, where he repeats Wittgenstein's question: "Could someone have a feeling of ardent love or hope for the space of one second—*no matter what* preceded or followed this second?"[16]

But this is the case with Auguste Salzmann, whose career as a photographer began in 1853 and was over in less than a year. Little else on the horizon of nineteenth-century photography appeared only to vanish quite so meteorically. But other major figures within this history enter this métier and then leave it in less than a decade. This is true of Roger Fenton, Gustave LeGray, and Henri LeSecq, all of them acknowledged "masters" of the art. Some of these desertions involved a return to the more traditional arts; others, like Fenton's, meant taking up a totally different field such as the law. What do the span and nature of these engagements with the medium mean for the concept of *career?* Can we study these "careers" with the same methodological presuppositions, the same assumptions of personal style and its continuity, that we bring to the careers of another sort of artist?[17]

And what of the other great aesthetic unity: *oeuvre?* Once again we encounter practices that seem difficult to bring into conformity with what the term comprises, with its assumptions that the oeuvre is the result of sustained intention and that it is organically related to the effort of its maker: that it is coherent. One practice already mentioned was the imperious assumption of copyright, so that certain oeuvres, like Matthew Brady's and Francis Frith's, are largely a function of the work of their employees. Another practice, related to the nature of photographic commissions, left large bodies of the oeuvre unachieved. An example is the Heliographic Mission of 1851, in which LeSecq, LeGray, Baldus, Bayard, and Mestral (which is to say some of the greatest figures in early photographic history in France) did survey work for the Commission des Monuments Historiques. Their results, some three hundred negatives recording medieval architecture about to be restored, not only were never published or exhibited by the commission but were never even printed. This is analogous to a director shooting a film but never having the footage developed, hence never seeing the rushes. How would the result fit into the oeuvre of this director?[18]

There are other practices, other exhibits, in the archive that also test the applicability of the concept *oeuvre.* One of these is the body of work that is too meager for this notion; the other is the body that is too large. Can we imagine an oeuvre consisting of one work? The history of photography tries to do this with a single photographic effort produced by Auguste Salzmann, a lone volume of archaeological photographs (of great formal beauty), some portion of which are known to have been taken by his assistant.[19] And, at the opposite extreme, can we imagine an oeuvre consisting of ten thousand works?

Eugène Atget's labors produced a vast body of work, which he sold over the years of its production (roughly 1895 to 1927) to various historical collections, such as the Bibliothèque de la Ville de Paris, the Musée de la Ville de Paris (Musée Carnavalet), the Bibliothèque Nationale, the Monuments Historiques, as well as to commercial builders and artists. The assimilation of this work of documentation into a specifically aesthetic discourse began in 1925 with its notice and publication by the surrealists and was followed, in 1929, by its placement within the photographic sensibility of the German New Vision.[20] Thus began the various partial viewings of the ten-thousand piece archive; each view the result of a selection intended to make a given aesthetic or formal point.

The repetitive rhythm of accumulation that interested the Neue Sachlichkeit could be found and illustrated within this material, as could the collage sensibility of the surrealists, who were particularly drawn to the Atget shopfronts, which they made famous. Other selections sustain other interpretations of the material. The frequent visual superimpositions of object and agent, as when Atget captures himself as a reflection in the glazed entrance of the café he is photographing, permit a reading of the work as reflexive, picturing its own conditions of making. Other readings of the images are more architectonically formal. They see Atget managing to locate a point around which the complex spatial trajectories of the site will unfold with an especially clarifying symmetry. Most often images of parks and rural scenes are used for such analyses.

But each of these readings is partial, like tiny core samples that are extracted from a vast geological field, each displaying the presence of a different ore. Or like the blind men's elephant. Ten thousand pieces are a lot to collate. Yet, if Atget's work is to be considered art, and he an artist, this collation must be made; we must acknowledge ourselves to be in the presence of an oeuvre. The Museum of Modern Art's four-part exhibi-

tion of Atget, assembled under the already loaded title *Atget and the Art of Photography*, moves briskly toward the solution of this problem, always assuming that the model that will serve to ensure the unity for this archive is the concept of an *artist's oeuvre*. For what else could it be?

John Szarkowski, after recognizing that, from the point of view of formal invention, the work is extremely uneven, speculates on why this should be so:

There are a number of ways to interpret this apparent incoherence. We could assume that it was Atget's goal to make glorious pictures that would delight and thrill us, and that in this ambition he failed as often as not. Or we could assume that he began photographing as a novice and gradually, through the pedagogical device of work, learned to use his peculiar, recalcitrant medium with economy and sureness, so that his work became better and better as he grew older. Or we could point out that he worked both for others and for himself and that the work he did for himself was better, because it served a more demanding master. Or we could say that it was Atget's goal to explain in visual terms an issue of great richness and complexity—the spirit of his own culture—and that in service to this goal he was willing to accept the results of his own best efforts, even when they did not rise above the role of simple records.

I believe that all of these explanations are in some degree true, but the last is especially interesting to us, since it is so foreign to our understanding of artistic ambition. It is not easy for us to be comfortable with the idea that an artist might work as a servant to an idea larger than he. We have been educated to believe, or rather, to assume, that no value transcends the value of the creative individual. A logical corollary of this assumption is that no subject matter except the artist's own sensibility is quite worthy of his best attention.[21]

This inching forward from the normal categories of description of aesthetic production—formal success/formal failure; apprenticeship/maturity; public commission/personal statement—toward a position that he acknowledges as "foreign to our understanding of artistic ambition," namely, work "in the service of an issue larger than self-expression," evidently troubles Szarkowski. Just before breaking off this train of thought he meditates on why Atget revisited sites (sometimes after several years) to choose different aspects of, say, a given building to photography. Szarkowski's answer resolves itself in terms of formal success/formal failure and the categories of artistic maturation that are consistent with the notion of oeuvre. His own persistence in thinking about the work in relation to this aesthetic model surfaces in his decision to continue to treat it in terms of stylistic evolution: "The earlier pictures show the tree as complete and discrete, as an object against a ground; as centrally positioned within the frame; as frontally lighted, from behind the photographer's shoulder. The later pictures show the tree radically cut by the frame, asymmetrically positioned, and more obviously inflected by the quality of light that falls upon it."[22] This is what produces the "elegiac" mood of some of the late work.

But this whole matter of artistic intention and stylistic evolution must be integrated with the "idea larger than he" that Atget can be thought to have served. If the ten thousand images form Atget's picture of the larger idea, then that idea can inform us of Atget's aesthetic intentions, for there will be a reciprocal relation between the two, one inside, the other outside the artist.

To get hold, simultaneously, of this larger idea and of Atget's elusive intentions in making this vast archive ("It is difficult," Szarkowski writes, "to name an important artist of the modern period whose life and intention have been so perfectly withheld from us as those of Eugène Atget"), it was long believed to be necessary to decipher the code provided by Atget's negative numbers. Each of the ten thousand plates is numbered. Yet the numbers are not strictly successive; they do not organize the work chronologically; they sometimes double back on each other.[23]

Eugène Atget, *Verrières, coin pittoresque,* 1922 (Collection, The Museum of Modern Art, New York)

For researchers into the problem of Atget's oeuvre, the numbers were seen as providing the all-important code to the artist's intentions and the work's meaning. Maria Morris Hambourg has finally and most definitively deciphered this code, to find in it the systematization of a catalogue of topographic subjects, divided into five major series and many smaller subseries and groups.[24] The names given to the various series and groupings (Landscape-Documents, Picturesque Paris, Environs, Old-France) establish as the master, larger idea for the work a collective picture of the spirit of French culture—similar, we could say, to Balzac's undertaking in the *Comédie Humaine.* In relation to this master subject, Atget's vision can be organized around a set of intentions that are socio-aesthetic, so to speak; he becomes photography's great visual anthropologist. The unifying intention of the oeuvre can be understood as a continuing search for the representation of the moment of interface between nature and culture, as in the juxtaposition of the vines growing beside a farmhouse window curtained in a lace representation of schematized leaves. But this analysis, interesting and often brilliant as it is, is once again only partial. The desire to represent the paradigm nature/culture can be traced in only a small fraction of the images and then, like the trail of an elusive animal, it dies out, leaving the intentions as mute and mysterious as ever.

Eugène Atget, *Sceaux, coin pittoresque*, 1922 (Collection, The Museum of Modern Art, New York)

What is interesting in this case is that the Museum of Modern Art and Maria Morris Hambourg hold in their hands the solution to this mystery, a key that will not so much unlock the system of Atget's aesthetic intentions as dispel them. And this example seems all the more informative as it demonstrates the resistance of the museological and art-historical disciplines to using that key.

The coding system Atget applied to his images derives from the card files of the librar-ies and topographic collections for which he worked. His subjects are often standardized, dictated by the established categories of survey and historical documentation. The reason many of Atget's street images uncannily resemble the photographs by Marville taken a half-century earlier is that both are functions of the same documentary master plan.[25] A catalogue is not so much an idea as it is a mathesis, a system of organization. It submits not so much to intellectual as to institutional analysis. And it seems clear that Atget's work is the *function* of a catalogue that he had no hand in inventing and for which *author-ship* is an irrelevant term.

The normal conditions of authorship that the museum wishes to maintain tend to collapse under this observation, leading us to a rather startling reflection. The museum undertook to crack the code of Atget's negative numbers in order to discover an aesthetic anima. What they found, instead, was a card catalogue.

With this in mind we get different answers to various earlier questions, like the problem of why Atget photographed certain subjects piecemeal, the image of a façade separated by months or even years from the view of the same building's doorway or window mullions or wrought-iron work. The answer, it seems, lies less in the conditions of aesthetic success or failure than in the requirements of the catalogue and its categorical spaces.

Subject is the fulcrum in all of this. Are the doorways and the ironwork balconies Atget's subjects, his choices, the manifest expression of him as active *subject,* thinking, willing, intending, creating? Or are they simply (although there is nothing simple in this) *subjects,* the functions of the catalogue, to which Atget himself is *subject?* What possible price of historical clarity are we willing to pay in order to maintain the former interpretation over the latter?

Everything that has been put forward about the need to abandon or at least to submit to a serious critique the aesthetically derived categories of authorship, oeuvre, and genre (as in *landscape*) obviously amounts to an attempt to maintain early photography as an archive and to call for the sort of archaeological examination of this archive that Michel Foucault both theorizes and provides a model for. Describing the analysis to which archaeology submits the archive in order to reveal the conditions of its discursive formations, Foucault writes:

[They] must not be understood as a set of determinations imposed from the outside on the thought of individuals, or inhabiting it from the inside, in advance as it were; they constitute rather the set of conditions in accordance with which a practice is exercised, in accordance with which that practice gives rise to partially or totally new statements, and in accordance with which it can be modified. [The relations established by archaeology] are not so much limitations imposed on the initiative of subjects as the field in which that initiative is articulated (without however constituting its center), rules that it puts into operation (without it having invented or formulated them), relations that provide it with a support (without it being either their final result or their point of convergence). [Archaeology] is an attempt to reveal discursive practices in their complexity and density; to show that to speak is to do something—something other than to express what one thinks.[26]

Everywhere at present there is an attempt to dismantle the photographic archive—the set of practices, institutions, and relationships to which nineteenth-century photography originally belonged—and to reassemble it within the categories previously constituted by art and its history.[27] It is not hard to conceive of what the inducements for doing so are, but it is more difficult to understand the tolerance for the kind of incoherence it produces.

298 | 299

1 Clarence King, *Systematic Geology,* 1878, is vol. 1 of *Professional Papers of the Engineer Department U.S. Army,* 7 vols. & atlas (Washington, D.C.: U.S. Government Printing Office, 1877–78).

2 The cartographic grid onto which this information is reconstructed has other purposes besides the collation of scientific information. As Alan Trachtenberg argues, the government-sponsored Western surveys were intended to gain access to the mineral resources needed for industrialization. It was an industrial as well as a scientific program that generated this photography, which "when viewed outside the context of the reports it accompanied seems to perpetuate the landscape tradition." Trachtenberg continues: "The photographs represent an essential aspect of the enterprise, a form of record keeping; they contributed to the federal government's policy of supplying fundamental needs of industrialization, needs for reliable data concerning raw materials, and promoted a public willingness to support government policy of conquest, settlement, and exploitation." Alan Trachtenberg, *The Incorporation of America* (New York: Hill and Wang, 1982), p. 20.

3 In his important essay "L'espace de l'art," Jean-Claude Lebensztejn discusses the museum's function, since its relatively recent inception, in determining what will count as Art: "The museum has a double but complementary function: to exclude everything else, and through this exclusion to constitute what we mean by the word art. It does not overstate the case to say that the concept of art underwent a profound transformation when a space, fashioned for its very definition, was opened to contain it." In Lebensztejn, *Zigzag* (Paris: Flammarion, 1981), p. 41.

4 The treatment of Western survey photography as continuous with painterly depictions of nature is everywhere in the literature. Barbara Novak, Weston Naef, and Elisabeth Lindquist-Cock are three specialists who see this work as an extension of the landscape sensibilities operative in American nineteenth-century painting, with transcendentalist fervor constantly conditioning the way nature is seen. Thus, the by-now standard argument about the King/O'Sullivan collaboration is that this visual material amounts to a proof-by-photography of creationism and the presence of God. King, it is argued, resisted both Lyell's geological uniformitarianism and Darwin's evolutionism. A catastrophist, King read the geological records of the Utah and Nevada landscape as a series of acts of creation in which all species were given their permanent shape by a divine creator. The great upheavals and escarpments, the dramatic basalt formations were all produced by nature and photographed by O'Sullivan as proof of King's catastrophist doctrine. With this mission to perform, O'Sullivan's Western photography becomes continuous with the landscape vision of Bierstadt or Church.

There is equal support for the opposite argument: King was a serious scientist, who made great efforts to publish as part of the findings of his survey Marsh's paleontological finds, which he knew full well provided one of the important "missing links" needed to give empirical support to Darwin's theory. Furthermore, as we have seen, O'Sullivan's photographs in their lithographic form function as neutralized, scientific testimony in the context of King's report; the transcendentalists' God does not inhabit the visual field of *Systematic Geology.* See Barbara Novak, *Nature and Culture* (New York: Oxford University Press, 1980); Weston Naef, *Era of Exploration* (New York: Metropolitan Museum of Art, 1975); and Elisabeth Lindquist-Cock, *Influence of Photography on American Landscape Painting* (New York: Garland Press, 1977).

5 Peter Galassi, *Before Photography* (New York: The Museum of Modern Art, 1981), p. 12.

6 See the chapter "Landscape and the Published Photograph," in Naef, *Era of Exploration.* In 1871 the Government Printing Office published a catalogue of Jackson's work, *Catalogue of Stereoscopic, 6 × 8 and 8 × 10 Photographs by Wm. H. Jackson.*

7 The eye is not actually refocusing. Rather, given the nearness of the image to the eyes and the fixity of the head in relation to it, in order to scan the space of the image a viewer must readjust and recoordinate the two eyeballs from point to point as vision moves over the surface.

8 Oliver Wendell Holmes, "Sun-Painting and Sun-Sculpture," *Atlantic Monthly* 8 (July 1861), 14–15. The discussion of the view of Broadway occurs on p. 17. Holmes's other two essays appeared as "The Stereoscope and the Stereograph," *Atlantic Monthly* 3 (June 1859), 738–48; and "Doings of the Sunbeam," *Atlantic Monthly* 12 (July 1863), 1–15.

9 See, Jean-Louis Baudry, "The Apparatus" *Camera Obscura* 1 (1976), 104–26, originally published as "Le Dispositif," *Communications* 23 (1975), 56–72; and Baudry, "Cinéma: Effects idéologiques produits par l'appareil de base," *Cinéthique* 7–8 (1979), 1–8.

10 Edward W. Earle, ed., *Points of View: The Stereograph in America: A Cultural History* (Rochester, NY: The Visual Studies Workshop Press, 1979), p. 12. In 1856 Robert Hunt in the *Art Journal* reported, "The stereoscope is now seen in every drawing-room; philosophers talk learnedly upon it, ladies are delighted with its magic representation, and children play with it." Ibid., p. 28.

11 "Photographs from the High Rockies," *Harper's Magazine* 39 (September 1869), 465–75. In this article *Tufa Domes, Pyramid Lake* finds yet one more place of publication, in a crude translation of the photograph, this time as an illustration to the author's adventure narrative. Thus one more imaginative space is projected onto the blank, collodion screen. This time, in response to the account of the near capsize of the exploration party's boat, the engraver whips the waters into a darkened frenzy and the sky into banks of lowering storm clouds.

12 Stafford writes, "The concept that true history is natural history emancipates the objects of nature from the government of man. For the idea of singularity it is significant . . . that geological phenomena—taken in their widest sense to include specimens from the mineral kingdom—constitute landscape forms in which natural history finds aesthetic expression. . . . The final stage in the historicizing of nature sees the products of history naturalized. In 1789, the German *savant* Samuel Witte—basing his conclusions on the writings of Desmarets, Duluc and Faujas de Saint-Fond— annexed the pyramids of Egypt for nature, declaring that they were basalt eruptions; he also identified the ruins of Peresepolis, Baalbek, Palmyra, as well as the Temple of Jupiter at Agrigento and the Palace of the Incas in Peru, as lithic outcroppings." Barbara M. Stafford, "Towards Romantic Landscape Perception: Illustrated Travels and the Rise of 'Singularity' as an Aesthetic Category," *Art Quarterly,* n.s.1 (1977), pp. 108–9. She concludes her study of "the cultivation of taste for the natural phenomenon as singularity," by insisting that "the lone natural object . . . need not be interpreted as human surrogates; on the contrary, [the nineteenth-century Romantic landscape painter's] isolated, detached monoliths should be placed within the vitalist aesthetic tradition— emerging from the illustrated voyage—that valued the natural singular. One might refer to this tradition as that of a 'neue Sachlichkeit' in which the regard for the specifics of nature produces a repertory of animate particulars" (117–18).

13 For another discussion of Galassi's argument with relation to the roots of "analytic perspective" in seventeenth-century optics and the *camera obscura,* see Svetlana Alpers, *The Art of Describing: Dutch Art in the Seventeenth Century* (Chicago: University of Chicago Press, 1983), pp. 243–44, n. 37.

14 Michel Foucault opens a discussion of the museum in "Fantasia of the Library," in *Language, Counter-Memory, Practice,* trans. D. F. Bouchard and S. Simon (Ithaca: Cornell University Press, 1977), pp. 87–109. See also Eugenio Donato, "The Museum's Furnace: Notes toward a Contextual Reading of *Bouvard and Pécuchet,*" *Textual Strategies: Perspectives in Post-Structuralist Criticism,* ed. Josué V. Harari (Ithaca: Cornell University Press, 1979); and Douglas Crimp, "On the Museum's Ruins," *October* 13 (Summer 1980), pp. 41–57.

15 André Malraux, "Museum without Walls," *The Voices of Silence* (Princeton: Princeton University Press, Bollingen Series 24, 1978), p. 46.

16 Stanley Cavell, *Must We Mean What We Say?* (New York: Scribners, 1969), p. 91, n. 9.

17 Students of photography's history are not encouraged to question whether art-historical models might (or might not) apply. The session on the history of photography at the 1982 College Art Association meeting (a session proudly introduced as the fruits of real scholarly research at last applied to this formerly unsystematically studied field) was a display of what can go wrong. In the paper "Charles Marville, Popular Illustrator: Origins of a Photographic Aesthetic," presented by

Constance Kane Hungerford, the model of the necessary internal consistency of an oeuvre encouraged the idea that there had to be a stylistic connection between Marville's early practice as an engraver and his later work as a photographer. The characterizations of style this promoted with regard to Marville's photographic work (e.g., sharp contrasts of light and dark, hard, crisp contours) were not only hard to see, consistently, but when these did apply they did not distinguish him in any way from his fellows on the Heliographic Mission. For every "graphic" Marville, it is possible to find an equally graphic LeSecq.

18 An example of this is the nearly four miles of footage shot by Eisenstein in Mexico for his project *Que Viva Mexico*. Sent to California, where it was developed, this footage was never seen by Eisenstein, who was forced to leave the United States immediately upon his return from Mexico. The footage was then cannibalized by two American editors to compose *Thunder over Mexico* and *Time in the Sun*. Neither of these is supposed to be part of Eisenstein's oeuvre. Only a "shooting chronology" assembled by Jay Leyda in the Museum of Modern Art now exists. Its status in relation to Eisenstein's oeuvre is obviously peculiar. But given Eisenstein's nearly ten years of filmmaking experience at the time of the shooting (given also the state of the art of cinema in terms of the body of material that existed by 1930 and the extent to which this had been theorized), it is probable that Eisenstein had a more complete sense, from the script and his working conception of the film, of what he had made as a "work"—even though he never saw it—than the photographers of the Heliographic Mission could have had of theirs. The history of Eisenstein's project is fully documented in Sergei Eisenstein and Upton Sinclair, *The Making and Unmaking of "Que Viva Mexico,"* eds. Harry M. Geduld and Ronald Gottesman (Bloomington: Indiana University Press, 1970).

19 See Abigail Solomon-Godeau, "A Photographer in Jerusalem, 1955: Auguste Salzmann and His Times," *October* 18 (Fall 1981), p. 95. This essay raises some of the issues about the problematic nature of Salzmann's work considered as *oeuvre*.

20 Man Ray arranged for publication of four photographs by Atget in *La Révolution Surréaliste*, three in the June 1926 issue and one in the December 1926 issue. The exhibition *Film und Foto* (Stuttgart, 1929) included Atget, whose work was also reproduced in *Foto-Auge* (Stuttgart: Wedekind Verlag, 1929).

21 Maria Morris Hambourg and John Szarkowski, *The Work of Atget: Volume 1, Old France* (New York: The Museum of Modern Art, and Boston: New York Graphic Society, 1981), pp. 18–19.

22 Ibid., p. 21.

23 The first published discussion of this problem characterizes it as follows: "Atget's numbering system is puzzling. His pictures are not numbered in a simple serial system, but in a confusing manner. In many cases, low-numbered photographs are dated later than high-numbered photographs, and in many cases numbers are duplicated." See Barbara Michaels, "An Introduction to the Dating and Organization of Eugène Atget's Photographs," *The Art Bulletin* 41 (September 1979), p. 461.

24 Maria Morris Hambourg, "Eugène Atget, 1857–1927: The Structure of the Work," unpublished Ph.D. dissertation, Columbia University, 1980.

25 See *Charles Marville, Photographs of Paris 1852–1878* (New York: The French Institute/Alliance Française, 1981). This contains an essay, "Charles Marville's Old Paris," by Maria Morris Hambourg.

26 Michel Foucault, *The Archaeology of Knowledge,* trans. A. M. Sheridan Smith (New York: Harper and Row, 1976), pp. 208–9.

27 Thus far the work of Allan Sekula has been the one consistent analysis of the history of photography to attack this effort. See Allan Sekula, "The Traffic in Photographs," *Art Journal* 41 (Spring 1981), pp. 15–25; and "The Instrumental Image: Steichen at War," *Artforum* 13 (December 1975). A discussion of the rearrangement of the archive in relation to the need to protect the values of modernism is mounted by Douglas Crimp's "The Museum's Old/The Library's New Subject," *Parachute* (Spring 1981), reprinted in this volume.

In, around, and afterthoughts
(on documentary photography)

The Bowery, in New York, is an archetypal skid row. It has been much photographed, in works veering between outraged moral sensitivity and sheer slumming spectacle. Why is the Bowery so magnetic to documentarians? It is no longer possible to evoke the camouflaging impulses to "help" drunks and down-and-outers or "expose" their dangerous existence.

How can we deal with documentary photography itself as a photographic practice? What remains of it? We must begin with it as a historical phenomenon, a practice with a past. Documentary photography[1] has come to represent the social conscience of liberal sensibility presented in visual imagery (though its roots are somewhat more diverse and include the "artless" control motives of police record keeping and surveillance). Photo documentary as a public genre had its moment in the ideological climate of developing state liberalism and the attendant reform movements of the early-twentieth-century Progressive Era in the United States and withered along with the New Deal consensus some time after the Second World War. Documentary, with its original muckraking associations, preceded the myth of journalistic objectivity and was partly strangled by it. We can reconstruct a past for documentary within which photographs of the Bowery might have been part of the aggressive insistence on the tangible reality of generalized poverty and despair—of enforced social marginality and finally outright social uselessness. An insistence, further, that the ordered world of business-as-usual take account of that reality behind those images newly seen, a reality newly elevated into consideration simply by *being photographed* and thus exemplified and made concrete.

Jacob Riis, *Hell on Earth,* 1903. Riis commented: "One night, when I went through one of the worst dives I ever knew, my camera caught and held this scene.... When I look upon that unhappy girl's face, I think that the Grace of God can reach that 'lost woman' in her sins; but what about the man who made profit upon the slum that gave her up to the street?" From "The Peril and Preservation of the Home," in *Jacob Riis, Photographer and Citizen,* ed., Alexander Alland, Sr. (Millerton, NY: Aperture, 1974).

In *The Making of an American,* Jacob Riis wrote:

We used to go in the small hours of the morning to the worst tenements . . . and the sights I saw there gripped my heart until I felt that I must tell of them, or burst, or turn anarchist, or something . . . I wrote, but it seemed to make no impression. One morning, scanning my newspaper at the breakfast table, I put it down with an outcry that startled my wife, sitting opposite. There it was, the thing I had been looking for all those years. A four-line despatch from somewhere in Germany, if I remember right, had it all. A way had been discovered, it ran, to take pictures by flashlight. The darkest corner might be photographed that way.[2]

In contrast to the pure sensationalism of much of the journalistic attention to working-class, immigrant, and slum life, the meliorism of Riis, Lewis Hine, and others involved in social-work propagandizing argued, through the presentation of images combined with other forms of discourse, for the rectification of wrongs. It did not perceive those wrongs as fundamental to the social system that tolerated them—the assumption that they were tolerated rather than *bred* marks a basic fallacy of social work. Reformers like Riis and Margaret Sanger[3] strongly appealed to the worry that the ravages of poverty—crime, immorality, prostitution, disease, radicalism—would threaten the health and security of polite society as well as by sympathy for the poor, and their appeals were often meant to awaken the self-interest of the privileged. The notion of *charity* fiercely argued for far outweighs any call for self-help. Charity is an argument for the preservation of wealth, and reformist documentary (like the appeal for free and compulsory education) represented an argument within a class about the need to give a little in order to mollify the dangerous classes below, an argument embedded in a matrix of Christian ethics.

Documentary photography has been much more comfortable in the company of moralism than wedded to a rhetoric or program of revolutionary politics. Even the bulk of work of the U.S. version of the (Workers') Film and Photo League[4] of the Depression era

Lewis Hine, *Cannery Workers Preparing Beans*, c. 1910. From *America and Lewis Hine: Photographs 1904–1940* (Millerton, NY: Aperture, 1977).

Leo Seltzer, *Rent Strike, Upper East Side, New York City, 1933*. Seltzer was a member of the New York (Workers') Film and Photo League. His work in photography and film seems more consistently militant than that of many other members.

shared in the muted rhetoric of the popular front. Yet the force of documentary surely derives in part from the fact that the images might be more decisively unsettling than the arguments enveloping them. Arguments for reform—threatening to the social order as they might seem to the unconvinced—must have come as a relief from the *potential* arguments embedded in the images: With the manifold possibilities for radical demands that photos of poverty and degradation suggest, any coherent argument for reform is ultimately both polite and negotiable. Odious, perhaps, but manageable; it is, after all, social *discourse.* As such, these arguments were surrounded and institutionalized into the very structures of government; the newly created institutions, however, began to prove their inadequacy—even to their own limited purpose—almost as soon as they were erected.

Let us consider the Bowery again, the site of victim photography in which the victims, insofar as they are nov victims of the camera—that is, of the photographer—are often docile, whether through mental confusion or because they are just lying there, unconscious. (But if you should show up before they are sufficiently distracted by drink, you are likely to be met with hostility, for the men on the Bowery are not particularly interested in immortality and stardom, and they've had plenty of experience with the Nikon set.) Especially now, the meaning of all such work, past and present, has changed: the liberal New Deal state has been dismantled piece by piece. The War on Poverty has been called off. Utopia has been abandoned, and liberalism itself has been deserted. Its vision of moral idealism spurring general social concern has been replaced with a mean-minded Spencerian sociobiology that suggests, among other things, that the poor may be poor through lack of merit (read Harvard's Richard Hernstein as well as, of course, between Milton Friedman's lines[5]). There is as yet no organized national Left, only a Right. There is not even drunkenness, only "substance abuse"—a problem of bureaucratic management. The exposé, the compassion and outrage, of documentary fueled by the dedication to reform has shaded over into combinations of exoticism, tourism, voyeurism, psychologism and metaphysics, trophy hunting—and careerism.

Yet documentary still exists, still functions socially in one way or another. Liberalism may have been routed, but its cultural expressions still survive. This mainstream documentary has achieved legitimacy and has a decidedly ritualistic character. It begins in glossy magazines and books, occasionally in newspapers, and becomes more expensive as it moves into art galleries and museums. The liberal documentary assuages any stirrings of conscience in its viewers the way scratching relieves an itch and simultaneously reassures them about their relative wealth and social position; especially the latter, now that even the veneer of social concern has dropped away from the upwardly mobile and comfortable social sectors. Yet this reminder carries the germ of an inescapable anxiety about the future. It is both flattery and warning (as it always has been). Documentary is a little like horror movies, putting a face on fear and transforming threat into fantasy, into imagery. One can handle imagery by leaving it behind. (*It is them, not us.*) One may even, as a private person, support causes.

Documentary, as we know it, carries (old) information about a group of powerless people to another group addressed as socially powerful. In the set piece of liberal television documentary, Edward R. Murrow's *Harvest of Shame,* broadcast the day after Thanksgiving in 1960, Murrow closes with an appeal to the viewers (then a more restricted part of the population than at present) to *write their congressmen* to help the migrant farm workers, whose pathetic, helpless, dispirited victimhood has been amply demonstrated for an

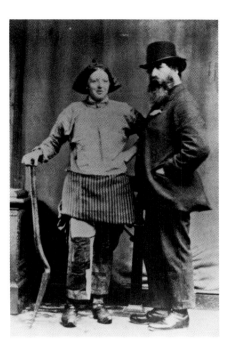

Ellen Grounds, age 22, a "pit broo wench" (pit-brow worker) at Pearson and Knowles's Pits, Wigan, with Munby beside her "to show how nearly she approached me in size." *Carte-de-visite* by Robert Little (or Mrs. Little), Wigan, September 11, 1873. From Michael Hiley, *Victorian Working Women: Portraits from Life* (London: Gordon Fraser, 1979)

hour—not least by the documentary's aggressively probing style of interview, its "higher purpose" notwithstanding—because *these people* can do nothing for themselves. But which political battles have been fought and won by someone for someone else? Luckily, Cesar Chávez was not watching television but rather, throughout that era, was patiently organizing farm workers to fight for themselves. This difference is reflected in the documentaries made by and for the Farm Workers' Organizing Committee (later the United Farm Workers of America, AFL-CIO), such works as *Sí, Se Puede* (Yes, We Can) and *Decision at Delano;* not radical works, perhaps, but *militant* works.

In the liberal documentary, poverty and oppression are almost invariably equated with misfortunes caused by natural disasters: casuality is vague, blame is not assigned, fate cannot be overcome. Liberal documentary blames neither the victims nor their willful oppressors—unless they happen to be under the influence of our own global enemy, World Communism. Like photos of children in pleas for donations to international charity organizations, liberal documentary implores us to look in the face of deprivation and to weep (and maybe to send money, if it is to some faraway place where the innocence of childhood poverty does not set off in us the train of thought that begins with denial and ends with "welfare cheat.")

Even in the fading of liberal sentiments one recognizes that it is impolite or dangerous to stare in person, as Diane Arbus knew when she arranged her satisfyingly immobilized imagery as a surrogate for *the real thing,* the real freak show. With the appropriate object to view, one no longer feels obligated to suffer empathy. As sixties' radical chic has given way to eighties' pugnacious self-interest, one displays one's toughness in enduring a visual assault without a flinch, in jeering, or in cheering. Beyond the spectacle of families in poverty (where starveling infants and despairing adults give the lie to any imagined hint of freedom and become merely the currently tedious poor), the way seems open for a subtle imputation of pathetic-heroic choice to victims-turned-freaks, of the seizing of fate in straitened circumstances. The boringly sociological becomes the excitingly mythological/psychological. On this territory a more or less overt sexualization of the photographic image is accomplished, pointing, perhaps, to the wellspring of identification that may be the source of this particular fascination.[6]

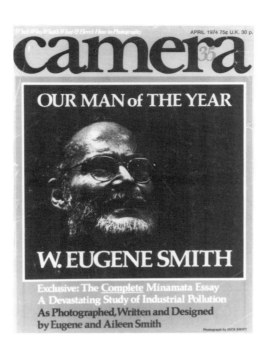

Cover of *Camera 35* (April 1974). Photograph of Smith by Dick Swift.

It is easy to understand why what has ceased to be news becomes testimonial to the bearer of the news. Documentary testifies, finally, to the bravery or (dare we name it?) the manipulativeness and savvy of the photographer, who entered a situation of physical danger, social restrictedness, human decay, or combinations of these and saved us the trouble. Or who, like the astronauts, entertained us by showing us the places we never hope to go. War photography, slum photography, "subculture" or cult photography, photography of the foreign poor, photography of "deviance," photography from the past— W. Eugene Smith, David Douglas Duncan, Larry Burrows, Diane Arbus, Larry Clark, Danny Lyon, Bruce Davidson, Dorothea Lange, Russell Lee, Walker Evans, Robert Capa, Don McCullin, Susan Meiselas . . . these are merely the most currently luminous of documentarian stars.

W. Eugene Smith and his wife Aileen Mioko Smith spent the early 1970s on a photo-and-text exposé of the human devastation in Minamata, a small Japanese fishing and farming town, caused by the heedless prosperity of the Chisso chemical firm, which dumped its mercury-laden effluent into their waters. They included an account of the ultimately successful but violence-ridden attempt of victims to gain redress. When the major court fight was won, the Smiths published a text and many photos in the American magazine *Camera 35*[7]. Smith had sent in a cover photo with a carefully done layout. The editor, Jim Hughes, knowing what sells and what doesn't, ran *a picture of Smith* on the cover and named him "Our Man of the Year" ("*Camera 35*'s first and probably only" one). Inside, Hughes wrote: "The nice thing about Gene Smith is that you know he will keep chasing the truth and trying to nail it down for us in words and pictures. And you know that even if the truth doesn't get better, Gene will. Imagine it!"[8] The Smiths' unequivocal text argues for strong-minded activism. The magazine's framing articles *handle* that directness; they convert *the Smiths* into *Smith;* and they congratulate him warmly, smothering his message with appreciation.

Help preserve the "cultural heritage" of the mudmen in New Guinea, urges the travel editor of the Vancouver *Province*. Why should you care?, he asks; and he answers, to safeguard the value received for your tourist dollar (Canadians also love Disneyland and Dis-

Canadian Club whiskey
advertisement, 1971

Edward S. Curtis, *Hopi Girls*,
c. 1900. Original is gold toned.

Robert Flaherty, c. 1914.
Woman identified as "Allegoo
(Shining Water), Sikoslingmuit
Eskimo Woman, Southern
Baffin Lands," but she may be
a woman named Kanaju
Aeojiealia. Published in March
1915 in a Toronto newspaper,
with the caption, "Our little
lady of the snows . . . makes a
most engaging picture." From
*Robert Flaherty, Photographer/
Filmmaker: The Inuit 1910–
1922* (Vancouver Art Gallery,
1980).

MARTHA ROSLER

From *How to Make Good
Movies* (Rochester, NY:
Eastman Kodak Company,
n.d.)

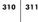

ney World). He is asking for donations to a cultural center. The "mudmen" formerly
made large, grimacing pull-on masks to frighten their opponents in war and now wear
them in adventure ads for Canadian Club ("We thought we were in a peaceful village
until . . ."). The mudmen also appear in the "small room" of Irving Penn's *Worlds in a Small
Room,*[9] an effete mimicry of anthropological documentary, not to mention in photos with
the Queen. Edward S. Curtis was also interested in preserving someone's cultural heritage
and, like other itinerant photographers operating among native North American peoples,
he carried a stock of more or less authentic, more or less appropriate (often less, on both
counts) clothing and accoutrements with which to deck out his sitters.[10] Here, as with
Robert Flaherty a bit later,[11] the heritage was considered sufficiently preserved when cap-
tured within the edges of the photographic record and in the ethnographic costume
shops then being established in museums of "natural" history. In Curtis's case, the photo-
graphic record was often retouched, gold-toned, and bound in gold-decorated volumes
selling for astonishing sums and financed by J. P. Morgan. We needn't quibble over the
status of such historical romances, for the degree of truth in them may (again) be more
or less equivalent to that in any well-made ethnographic or travel photo or film. An
early—1940s, perhaps—Kodak movie book[12] tells North American travelers, such as the
Rodman C. Pells of San Francisco, pictured in the act of photographing a Tahitian, how to
film natives so that they seem unconscious of the camera. Making such photos height-
ened patriotic sentiments in the States but precluded any understanding of contemporary
native peoples as *experiencing subjects* in impoverished or at least modern circumstances; it
even assisted the collective projection of Caucasian guilt and its rationalizations onto the
"Indians" for having sunk so and having *betrayed their own heritage.* To be fair, some respect

Adam Clark Vroman, *Hopi
Towns: The Man with a Hoe,*
1902. From *Photographer of
the Southwest, Adam Clark
Vroman, 1856–1916,* ed. Ruth
Mahood (New York: Bonanza
Books, n.d.).

was surely also gained for these people who had formerly been allowed few images other
than those of abject defeat; no imagination, no transcendence, no history, no morals, no
social institutions, only vice. Yet, on balance, the sentimental pictorialism of Curtis seems
repulsively contorted, like the cariogenic creations of Julia Margaret Cameron or the sac-
charine poems of Longfellow. Personally, I prefer the cooler, more "anthropological" work
of Adam Clark Vroman.[13] We can, nevertheless, freely exempt all the photographers, all
the filmmakers, as well as all the ethnographers, ancillas to imperialism, from charges of
willful complicity with the dispossession of the American native peoples. We can even
thank them, as many of the present-day descendants of the photographed people do, for
considering their ancestors worthy of photographic attention and thus creating a histori-
cal record (the only visual one). We can thank them further for *not* picturing the destitu-
tion of the native peoples, for it is difficult to imagine what good it would have done. If
this reminds you of Riis and Hine, who first pictured the North American immigrant and
native-born poor, the connection is appropriate as far as it goes but diverges just where it
is revealed that the romanticism of Curtis furthered the required sentimental mythifica-
tion of the Indian peoples, by then physically absent from most of the towns and cities of
white America. Tradition (traditional racism), which decreed that the Indian was the ge-
nius of the continent, had nothing of the kind to say about the immigrant poor, who
were both fodder for the Industrial Moloch and a hotbed of infection and corruption.

Or consider a photo book on the teeming masses of India—how different is looking
through it from going to an Indian restaurant or wearing an Indian shirt or sari? We
consume the world through images, through shopping, through eating. . . .

VISA credit card advertisement, 1979. Photo by Elliott Erwitt. Original in color. For the ad campaign, this scene was also restaged, twenty years after Erwitt made these stills, by the producer of a (moving) television commercial.

Your world is waiting and Visa is there.
 120 countries
 2.6 million shops, hotels, restaurants and airlines
 70,000 banking offices
 For traveling, shopping and cash advances . . .
 Visa is the most widely recognized name in the world.
 We're keeping up with you.

This current ad campaign includes photographs taken here and there in the world, some "authentic," some staged. One photo shows a man and a boy in dark berets on a bicycle on a tree-lined road, with long baguettes of bread tied across the rear of the bike: rural France. But wait—I've seen this photo before, years ago. It turns out that it was done by Elliott Erwitt for the Doyle Dane Bernbach ad agency on a job for the French office of tourism in the fifties. Erwitt received fifteen hundred dollars for the photo, which he staged using his driver and the man's nephew: "The man pedaled back and forth nearly 30 times till Erwitt achieved the ideal composition. . . . Even in such a carefully produced image, Erwitt's gift for documentary photography is evident," startlingly avers Erla Zwingle[14] in the column "Inside Advertising" in the December 1979 issue of *American Photographer*—which also has articles, among others, on Bill Owens's at best ambivalent photos of mid-American suburbs, leisure activities, and work ("sympathetic and honest, revealing the contentment of the American middle class," according to Amy M. Schiffman), on a show of the Magnum news-photo agency photos in a Tokyo department store ("soon after the opening [Magnum president Burk] Uzzle flew off to hunt down refugees in Thailand while Glinn remained in Japan, garnering much yen from assignments for the likes of IBM, Seagram, and Goldman Sachs," says E. F.), on Geoff Winningham's photos of Texas high-school football ("Inevitably one can compare him with the legendary Robert Frank, but the difference . . . is that . . . Winningham clearly loves the craziness [more on craziness later] he dwells upon," writes Schiffman), on Larry Clark's photos of Tulsa speed freaks ("A beautiful, secret world, much of it sordid" and "although there is plenty of sex, death, violence, anxiety, boredom . . . there is no polemic apparent . . . so it doesn't really matter whether or not we can trust these photos as documents; to see them as photo-

Elliott Erwitt, on an assignment for the French office of tourism in the 1950s (Agency: Doyle Dane Bernbach). Original in color.

A colonial variant. . . . Photo by Allée Dumanoir, in the Sunday *New York Times* travel section for November 22, 1981, captioned, "Riding home with a French loaf at Capesterre on Basse-terre." Basse-Terre is part of Guadeloupe in the French West Indies. Frank J. Prial's accompanying article, "A Francophile's Guadeloupe," avers that despite U.S. tourism, "thank heaven, everything has remained resolutely French, or at least French-Caribbean."

David Burnett, contact sheet
showing prisoners detained at
the stadium, Santiago, Chile,
September 1973. From
American Photographer
(December 1979).

314 | 315

David Burnett, *Detained
Prisoners,* September 1973.
From *American Photographer*
(December 1979).

graphs, no more and no less, is enough," remarks Owen Edwards). There is a Washington column by James Cassell complaining that "the administration frowns upon inspired photojournalism" and a page on Gamma photographer David Burnett, who arrived in Santiago de Chile a few days after the brutal putsch in 1973. On a government tour of the infamous stadium where people were detained and shot, he and other photographers "noticed a fresh batch of prisoners." Burnett says, "The Chileans had heard many stories about people being shot or disappearing [in a war does one learn of death from hearing stories?] and they were terribly frightened. The haunting gaze of one man in particular, whose figure was framed by two armed soldiers, . . . caught my eye. The picture has always stayed with me." We see a contact sheet and that image enlarged. The article, by Yvette E. Benedek, continues: "Like most agency photographers, Burnett must shoot both color and black and white to satisfy many publications in different countries, so he often works with three Nikons and a Leica. His coverage of the coup . . . won the Overseas Press Club's Robert Capa Award . . . 'for exceptional courage and enterprise.' "

What happened to the man (actually, men) in the photo? The question is inappropriate when the subject is photographs. And photographers. The subject of the article is the photographer. The name of the magazine is *American Photographer*. In 1978 there was a small news story on a historical curiosity: the real-live person who was photographed by Dorothea Lange in 1936 in what became *the world's most reproduced photograph*. Florence Thompson, seventy-five in 1978, a Cherokee living in a trailer in Modesto, California, was quoted by the Associated Press as saying, "That's my picture hanging all over the world, and I can't get a penny out of it." She said that she is proud to be its subject but asked, "What good's it doing me?" She has tried unsuccessfully to get the photo suppressed. About it, Roy Stryker, genius of the photo section of the Farm Security Administration, for which Lange was working, said in 1972: "When Dorothea took that picture, that was the ultimate. She never surpassed it. To me, it was *the* picture of Farm Security. . . . So many times I've asked myself what is she thinking? She has all of the suffering of mankind in her but all of the perseverance too. . . . You can see anything you want to in her. She is immortal." [15] In 1979, a United Press International story about Mrs. Thompson said she gets $331.60 a month from Social Security and $44.40 for medical expenses. She is of interest solely because she is an incongruity, a photograph that has aged; of interest solely because she is a postscript to an acknowledged work of art. Mr. Burnett's Chilean photograph will probably not reach such prominence (I've never seen it before, myself), and we will not discover what happened to the people in it, not even forty-two years later.

A good, reasonably principled photographer I know, who works for an occupational-health-and-safety group and cares about how his images are understood, was annoyed by the articles about Florence Thompson. He thought they were cheap, that the photo *Migrant Mother,* with its obvious symbolic dimension, stands over and apart from her, is *not her,* has an independent life history. (Are photographic images, then, like civilization, made on the backs of the exploited?) I mentioned to him that in the book *In This Proud Land,* [16] Lange's field notes are quoted as saying, "She thought that my pictures might help her, and so she helped me." My friend the labor photographer responded that the photo's publication caused local officials to fix up the migrant camp, so that although Mrs. Thompson didn't benefit directly, others like her did. I think she had a different idea of their bargain.

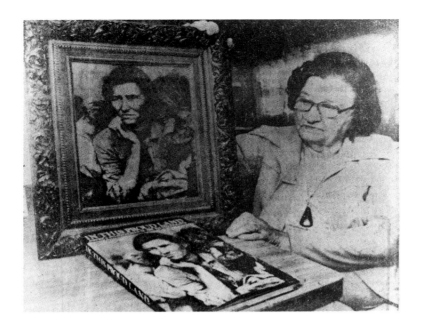

Associated Press
(photographer unknown),
Florence Thompson in her
trailer home with a framed
copy of her photo and the
book *In This Proud Land.* From
Los Angeles Times, November
18, 1978.

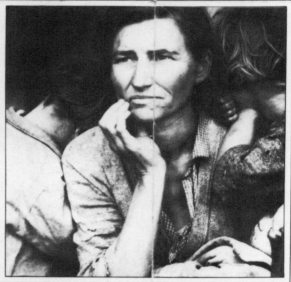

Recorder of an Era

Early in 1979, American Photographer
mounted as impressive portfolio of
Dorothea Lange. Accompanied by text
illustrating Lange's rise to notoriety
as one of the foremost documentary
photographers of her time, the "Migrant
Mother" sequence is considered perhaps
the most effective icon of the 1930s. It
accomplishes the prime purpose of
government photography: to provoke
action. Lange, under assignment from the
Farm Security Administration (FSA), took
these photographs in March 1936 as she
drove by a destitute peapickers camp in
Nipomo, California. Lange approaches
from 40 feet, finally focusing on the
mother's face.

Dorothea Lange, *Migrant
Mother* series, March 1936, as
reproduced in a promotional
sheet for *American Photo-
grapher,* late 1970s. The
famous photo, usually
captioned *Migrant Mother,
Nipomo, California, 1936,*
is on the right.

I think I recognize in his response the well-entrenched paradigm in which a documentary image has two moments: (1) the "immediate," instrumental one, in which an image is caught or created out of the stream of the present and held up as testimony, as evidence in the most legalistic of senses, arguing for or against a social practice and its ideological-theoretical supports, and (2) the conventional "aesthetic-historical" moment, less definable in its boundaries, in which the viewer's argumentativeness cedes to the organismic pleasure afforded by the aesthetic "rightness" or well-formedness (not necessarily formal) of the image. This second moment is *a*historical in its refusal of *specific* historical meaning yet "history minded" in its very awareness of the pastness of the time in which the image was made. This covert *appreciation* of images is dangerous insofar as it accepts *not* a dialectical relation between political and formal meaning, not their interpenetration, but a hazier, more reified relation, one in which topicality drops away as epochs fade, and the aesthetic aspect is, if anything, enhanced by the loss of specific reference (although there remains, perhaps, a cushioning backdrop of vague social sentiments limiting the "mysteriousness" of the image). I would argue against the possibility of a nonideological aesthetic; any response to an image is inevitably rooted in social knowledge—specifically, in social understanding of cultural products. (And from her published remarks one must suppose that when Lange took her pictures she was after just such an understanding of them, although by now the cultural appropriation of the work has long since removed it from this perspective.)

A problem with trying to make such a notion workable within actual photographic practice is that it seems to ignore the mutability of ideas of aesthetic rightness. That is, it seems to ignore the fact that historical interests, not transcendental verities, govern whether any particular form is seen as adequately revealing its meaning—and that you cannot second-guess history. This mutability accounts for the incorporation into legitimate photo history of the work of Jacob Riis alongside that of the incomparably more classical Lewis Hine, of Weegee (Arthur Fellig) alongside Danny Lyon. It seems clear that those who, like Lange and the labor photographer, identify a powerfully conveyed meaning with a primary sensuousness are pushing against the gigantic ideological weight of classical beauty, which presses on us the understanding that in the search for transcendental form, the world is merely the stepping-off point into aesthetic eternity.

The present cultural reflex of wrenching all artworks out of their contexts makes it difficult to come to terms with this issue, especially without seeming to devalue such people as Lange and the labor photographer, and their work. I think I understand, from the inside, photographers' involvement with *the work itself,* with its supposed autonomy, which really signifies its belongingness to their own body of work and to the world of photographs.[17] But I also become impatient with this perhaps-enforced protectiveness, which draws even the best intentioned of us nearer and nearer to exploitiveness.

The Sunday *New York Times Magazine,* bellwether of fashionable ideological conceits, in 1980 excoriated the American documentary milestone *Let Us Now Praise Famous Men* (written by James Agee and photographed by Walker Evans in July and August of 1936, in Hale County, Alabama, on assignment from *Fortune* magazine, but not published until 1941).[18] The critique[19] is the same as that suggested in germ by the Florence Thompson news item. We should savor the irony of arguing before the ascendent class fractions represented by the readership of the Sunday *New York Times* for the protection of the sensibilities of those marginalized sharecroppers and children of sharecroppers of forty

Walker Evans's photograph of Allie Mae Fields Burroughs appears, captionless, in Agee and Evans's *Let Us Now Praise Famous Men* (Boston: Houghton Mifflin, 1941); in that work she is called Annie Mae Woods Gudger. It also appears in *Documentary Photography* (New York: Time-Life, 1972), captioned *Tenant Farmer's Wife, Hale County, Alabama, 1936,* and in Walker Evans, *First and Last* (New York: Harper & Row, 1978), captioned *Allie Mae Burroughs, Hale County, Alabama, 1936.*

This second photo, no doubt taken at the same time as the preceding, is reproduced in Evans's *American Photographs* (New York: Museum of Modern Art, 1938), captioned *Alabama Cotton Tenant Farmer's Wife, 1936* and in *Walker Evans: Photographs for the Farm Security Administration* (New York: Da Capo, 1973), captioned *Allie Mae Burroughs, Wife of a Cotton Sharecropper, Hale County, Alabama, Summer, 1936.* There are few references to the existence of more than one "Allie Mae" with different expressions. Many writers depend on there being just one, the preceding. For example, Scott Osborne, in "A Walker Evans Heroine Remembers," *American Photographer* (September 1979), quotes Agee as calling the image "a fraction of a second's exposure to the integrity of truth."

years ago. The irony is greatly heightened by the fact that (as with the Thompson story) the "protection" takes the form of a *new* documentary, a "rephotographic project," a reconsignment of the marginal and pathetic to marginality and pathos, accompanied by a stripping away of the false names given them by Agee and Evans—Gudger, Woods, Ricketts—to reveal their real names and "life stories." This new work manages to institute a new genre of victimhood—the victimization by *someone else's* camera of helpless persons, who then hold still long enough for the indignation of the new writer to capture them, in words and images both, in their *current* state of decrepitude. The new photos appear alongside the old, which provide a historical dimension, representing the moment in past time in which these people were first dragged into history. As readers of the Sunday *Times,* what do we discover? That the poor are ashamed of having been *exposed* as poor, that the photos have been the source of festering shame. That the poor remain poorer than we are, for although *they* see their own rise in fortunes, their escape from desperate poverty, we *Times* readers understand that our relative distance has not been abridged; we are still doing much better than they. Is it then difficult to imagine these vicarious protectors of the privacy of the "Gudgers" and "Ricketts" and "Woods" turning comfortably to the photographic work of Diane Arbus?[20]

The credibility of the image as the explicit trace of the comprehensible in the living world has been whittled away for both "left" and "right" reasons. An analysis which reveals social institutions as serving one class by legitimating and enforcing its domination while hiding behind the false mantle of even-handed universality necessitates an attack on the monolithic cultural myth of objectivity (transparency, unmediatedness), which implicates not only photography but all journalistic and reportorial objectivity used by mainstream media to claim ownership of all truth. But the Right, on contradistinction, has found the attack on credibility or "truth value" useful to its own ends. Seeing people as

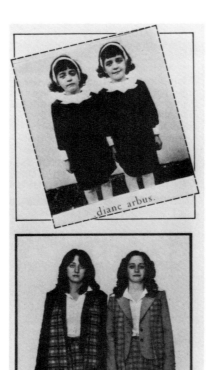

Layout from *Modern
Photography,* July 1980. The
top photo is the cover of the
Diane Arbus monograph
published by Aperture in 1972,
featuring *Identical Twins,
Roselle, N. J., 1967.* The bottom
photo is *Arbus Twins Revisited*
by Don Lokuta, 1979.

fundamentally unequal and regarding elites as natural occurrences, composed of those
best fitted to understand truth and to experience pleasure and beauty in "elevated"
rather than "debased" objects (and regarding it as social suicide to monkey with this
natural order), the Right wishes to seize a segment of photographic practice, securing the
primacy of authorship, and isolate it within the gallery-museum-art-market nexus, effec-
tively differentiating elite understanding and its objects from common understanding. The
result (which stands on the bedrock of financial gain) has been a general movement of
legitimated photography discourse *to the right*—a trajectory that involves the aestheticiza-
tion (consequently, formalization) of meaning and the denial of content, the denial of the
existence of the political dimension. Thus, instead of the dialectical understanding
of the relation between images and the living world that I referred to earlier—in
particular, of the relation between images and ideology—the relation has simply been
severed in thought.

The line that documentary has taken under the tutelage of John Szarkowski at New
York's Museum of Modern Art—a powerful man in a powerful position—is exemplified
by the career of Garry Winogrand, who aggressively rejects any responsibility (*culpability*)
for his images and denies any relation between them and shared or public human mean-
ing. Just as Walker Evans is the appropriate person within the history of street photogra-
phy to compare with Lee Friedlander, the appropriate comparison for Winogrand is
Robert Frank (who is compared with almost everyone), whose purloined images of
American life in the 1950s suggest, however, all the passionate judgments that Winogrand
disclaims.[21] Images can yield any narrative, Winogrand says, and all meaning in photogra-
phy applies only to what resides within the "four walls" of the framing edges. What can,

in Frank's work, be identified as a personally mediated presentation has become, in Szar-kowski's three "new documentarians," Winogrand, Arbus, and Friedlander, a privatized will o' the wisp:

Most of the those who were called documentary photographers a generation ago . . . made their pictures in the service of a social cause. . . . to show what was wrong with the world, and to persuade their fellows to take action and make it right. . . . A new genera-tion of photographers has directed the documentary approach toward more personal ends. Their aim has not been to reform life, but to know it. Their work betrays a sympa-thy—almost an affection—for the imperfections and frailties of society. They like the real world, in spite of its terrors, as the source of all wonder and fascination and value— no less precious for being irrational. . . . What they hold in common is the belief that the commonplace is really worth looking at, and the courage to look at it with a minimum of theorizing.[22]

Szarkowski wrote that introduction to the *New Documents* show in 1967, in an America already several years into the "terrors" and disruptions of the Vietnam War. He makes a poor argument for the value of disengagement from a "social cause" and in favor of a connoisseurship of the tawdry. How, for example, do we define the boundaries and extent of "the world" from looking at these photographers' images, and how can we be said to "know it"? The global claim he makes for their work serves to point out the limits of its actual scope. At what elevated vantage point must we stand to regard society as having "frailties" and "imperfections"? High enough to see it as a circus before our eyes, a com-modity to be "experienced" the way a recent vodka ad entices us to "experience the nineteenth century" by having a drink. In comparison with nightmarish photos from Vietnam and the United States' Dominican adventure, the work of Friedlander, Wino-grand, and Arbus might be taken as evidencing a "sympathy" for the "real world." Arbus had not yet killed herself, though even that act proved to be recuperable by Szarkowski's ideological position. In fact, the forebears of Szarkowski are not those "who made their pictures in the service of a social cause" but bohemian photographers like Brassaï and the early Kertész and Cartier-Bresson. But rather than the sympathy and almost-affection that Szarkowski claimed to find in the work, I see impotent rage masquerading as vary-ingly invested snoop sociology—fascination and affection are far from identical. A dozen years later, aloofness has given way to a more generalized nihilism.

In the San Francisco Sunday paper for November 11, 1979, one finds Jerry Nachman, news director of the local headline-and-ad station, saying:

In the Sixties and Seventies all-news radio had its place in people's lives: What was hap-pening in Vietnam? Did the world blow up last night? Who's demonstrating where? . . . Now we're on the cusp of the Eighties and things are different. To meet these changes KCBS must deliver what's critical in life in a way that's packaged even perversely. . . . There's a certain craziness that goes on in the world and we want people to understand that we can chronicle it for them.

Nachman also remarks, "Our broadcasters tell people what they saw out there in the wilderness today." The wilderness is the world, and it inspires in us, according to this view, both anxiety and perverse fascination, two varieties of response to a spectacle.

Imperialism breeds an imperialist sensibility in all phases of cultural life. A safari of im-ages. Drunken bums[23] retain a look of threat to the person. (Not, perhaps, as well as foreign prisoners [24]) They are a drastic instance of a male society, the lumberjacks or prospectors of the cities, the men who (seem to) choose not to stay within the polite

Cover of Michael D. Zettler's *The Bowery* (New York and London: Drake Publishers, 1975)

322 | 323

bourgeois world *of* (does "of" mean "made up of" or "run by" or "shaped by" or "fit for"?) *women and children.* They are each and every one an unmistakably identifiable instance of a physically coded social reality. The cynicism they may provoke in observers is far different from the cynicism evoked by images of the glitter world, which may end in a politically directed anger. *Directed toward change.* Bums are an "end game" in a "personal tragedy" sort of chance. They may be a surreptitious metaphor for the "lower class" but they are not to be confused with a social understanding of the "working class." Bums are, perhaps, to be finally judged as *vile,* people who deserve a kick for their miserable *choice.* The buried text of photographs of drunks is not a treatise on political economy, on the manipulation of the unemployment rate to control inflation and keep profits up and labor's demands down, on the contradictory pressures on the institution of the family under capitalism, on the appeal of consciousness-eradicating drugs for people who have little reason to believe in themselves.

The Bowery in two inadequate descriptive systems is a work of refusal. It is not defiant antihumanism. It is meant as an act of criticism; the text you are reading now runs on the parallel track of another descriptive system. There are no stolen images in this book; what could you learn from them that you didn't already know? If impoverishment is a subject here, it is more centrally the impoverishment of representational strategies tottering about alone than that of a mode of surviving. The photographs are powerless to *deal with* the reality that is yet totally comprehended-in-advance by ideology, and they are as diversionary as the word formations—which at least are closer to being located within the culture of drunkenness rather than being framed on it from without.

```
stewed

boiled

potted

corned

pickled

preserved

canned

fried to the hat
```

Martha Rosler, from *The
Bowery in two inadequate
descriptive systems*

adequacy followed by a withdrawal into a paranoic pout. Pointing to the existence of a received system of meaning, a defining practice, quotation can reveal the thoroughly social nature of our lives. In a society in which personal relations are characterized by fragmentation while the trend of history is toward reorganization into a new, oppressive totality in which ideological controls may be decisive, quotation's immanent self-consciousness about the avenues of ideological legitimation—those of the State and its dominating class and culture—or, more weakly, about routes of commercial utterance, can accomplish the simple but incessantly necessary act of making the normal strange, the invisible an object of scrutiny, the trivial a measure of social life. In its seeming parasitism, quotation represents a refusal of socially integrated, therefore complicit, *creativity*.

In this aspect, quotation is alienated sensibility. At certain historical junctures, quotation allows a *defeat* of alienation (alienation as psychological state, not as a structural disconnection of human beings and their labor power as described by Marx and Lukács), an asserted reconnection with obscured traditions. Yet the revelation of an unknown or disused past tradition emphasizes a rupture with the present and the immediate past, a revolutionary break in the supposed stream of history. The writing of history is always controlled by the dominant class, which selects and interprets events according to its own successes and which sees history's goal, its *telos*, as the triumph of that class. This use of quotation, that is, the appropriation of elements from the dustbin of official historiography, is intended to destroy the credibility of those reigning historical accounts in favor of the point of view of that history's designated losers. The homage of quotation is capable of signaling not self-effacement but rather a strengthening or consolidating resolve. Thus, for feminists in the past decade the resuscitation of a great variety of earlier works in all cultural fields was accompanied by energetic new production. The interpretation of the meaning and social origins and rootedness of those forms helped undermine the modernist tenet of the separateness of the aesthetic from the rest of human life, and an analysis of the oppressiveness of the seemingly unmotivated forms of high culture was companion to this work. The new historiographic championing of forgotten or disparaged works served as emblem of the *countering* nature of the new approach. That is, it served as an anti-orthodoxy announcing the necessity of the constant reinterpretation of the origin and meaning of cultural forms and as a specifically anti-authoritarian move.

Not incidentally, this reworking of older forms makes plain the essential interpenetration of "form" and "content." Yet bourgeois culture surrounds its opposition and, after initial rejection, assimilates new forms, first as a parallel track and then as an incorporated, perhaps minor, strand of the mainstream. In assimilating the old forms now refurbished, the ideological myths of the conditions of cultural production and the character of its creators are reimposed and substituted for the unassimilable sections of the newly rewritten histories that rejected or denied the bourgeois paradigms of cultural production. Today, we are witnessing the latter part of this process, in which critical and divergent elements in art are accepted but at the expense of the challenge to the paradigms of production or even, increasingly, at the expense of the challenge to institutionalized art-world power. Most particularly, there seems to be little challenge remaining to conventional notions of "success."

In general, it is through irony that quotation gains its critical force. One speaks with two voices, establishing a kind of triangulation—(the source of) the quotation is placed *here*, the quoter over *here*, and the hearer/spectator *there*—and, by inflection, one saps the

authority of the quote. Irony, however, is not universally accessible, for the audience must *know* enough to recognize what is at stake.

Irony certainly functions within the wider culture, but at present it seems to do so differently from the way it does in high art, where it is still pursued by those following from the Pop tradition. In the Pop era, quotation represented a two-faced literalism: a retying of connections to a social life beyond artistic expression that nevertheless offered a final refuge in formalism with a newly assimilated imagery. (This process has also affected some feminist quotation of styles extricated from their historically extinguished moment—it has served as a transfusion mechanism, a source of borrowings, and the same myths of individualized production have reappeared.) Pop also returned consciousness and presentness to art and artists (and intensified a tug-of-war with critics).

In the United States, the direction of Pop's quotational irony was so faintly inscribed (and so often denied) as to offer the public at large the sense of monumentalized approbation of the banal commercial commodity, that is, of its form, without *critique*—except possibly a critique of *execrable taste*. . . . or, inversely, its exultant acceptance (a version of the romantic pout). As "art," Pop may have given the public a pain (it wasn't transcendent or Beautiful) or a thrill (it acknowledged their taste for the decorative), but as a source of new merchandise, the cheap commercial "spin-offs," it was just plain fun, slightly outrageous in its brashness. Liking it was not just a way of worshipping Moloch; it was a way to fly in the face of boringness while placing oneself under the up-to-date signs of cultural power: corporate symbology.

In society at large, irony is sporadic and cathartic. It permits an outlet for relatively unexamined and sometimes only superficially understood feelings of resentment and exclusion. In high culture, the pervasive irony toward cultural production is well understood as connected to a developed critique of social structure or of the conditions of human existence. What seems culpable from the vantage point of high culture may appear whimsical, clever, or cute from the perspective of mass culture; seeing cultural elements as implicating all culture is very different from seeing them as randomly produced, isolated entities.

With quotation, as with photography, meaning is heavily weighted by the frame. Simply introducing something where it has been excluded—mass-culture imagery in an elite-culture setting (Pop) or photographs of the unphotographed poor or of subcultures—can be a radical opener, until familiarity dissipates the shock and closure is again made, with the disruptive elements now inside. Quotes, like photos, float loose from their framing discourses, are absorbed into the embracing matrix of affirmative culture (see Marcuse on this and on repressive tolerance). The irony of Pop quotation, which hardly allowed for even the sustained moral indignation that photos of the poor conceivably might, was short, for not only was no coherently critical framework provided for Pop, but even partial attempts were refused by its critics and artists. And it is even easier to admire designs from the graphic lexicon or decorations from mosque mosaics or incidental Chinese illustrations than a photo of some poor victim somewhere, no matter how familiar it has become and no matter how rich the narrative you have managed to invest it with (though in time the human content of the former photo of protest will likely raise its esteem above high-art quotation of mass-culture detritus).

Pop's irony is now nearly exhausted, but quotation is still used by artists to give form to irony and critique. "So hard to do anything original any more" betrays the dilemma of avant-garde sentiment at a time when a true avant-garde is absent and may be structurally impossible. In considering the recent critical practice in photography, we have to

differentiate art-world photography from photoworld photography. In the latter, a situational irony, external to the work, now exists as it has not before: previously, aestheticizing photographic practice, like art, was high-minded, but the past twenty years' history in the art world has made that position too stodgy. Photographers, particularly those with art-school educations, search for new looks as the omnivorous commodification of photography makes photos into art-historical material. Photos quote painting, drawing, conceptual-art diagrams, advertising, other photos, generally as a tactic of upward mobility, embracing the authority of the source and avoiding *socially* critical practice. (Even documentary photography is marked by fragmentation, subjectivization, and the distortion of images stemming from surrealism and its offshoot advertising strategies.) There is little irony intended in relation to the sources of such work (or should I say little received?): This is quotation from (or for) the aesthetically minded Right, which naturally prefers aesthetics to politics in art.

As capitalism-in-depression attempts to refurbish itself and to reimpose a business-is-king ideology that stresses competition along with rank and privilege, a predictable restructuring of the art world is under way.[26] Painting and sculpture, shepherded by dealers and surrounded by suitably adulatory critical effusions, are the preeminent art-world commodities of the era of reaction. In considering the repopularization of quotational ("neo-") expressionist and even fascist art now, much needs to be said about its relation to economic and ideological warfare, but that is beyond my concern here. Most of the quotational expressionism is lavish in its homages, though to some extent a loose Freudianized iconography has replaced mythological elements traditionally presented or tricked up as street figures. This newer work, the intensely capitalized and promoted production of Italian, German, and some American artists, ferociously attempts a return to "transcendent" art, with at best a weak and convoluted irony toward its own historical meaning. Expressionism's return, even apart from the meaning of the imagery, cannot be greeted with a consideration of the search for "authenticity" integral to its first debut. In relation to society, Lukács has provided an illuminating analysis of expressionism (in literature) in his essay of 1934, "Expressionism, Its Significance and Decline." In confronting a class-divided society in intense conflict, expressionists see only the wrenching sorrows imposed on the individual by "civilization." There is no need to take sides, only to wash one's hands of the whole thing.

As an opposition from a confused anarchistic and bohemian standpoint, expressionism was naturally more or less vigorously directed against the political right. And many expressionists and other writers who stood close to them only took up a more or less explicit left-wing position in politics. . . . But however honest the subjective intention behind this may well have been in many cases, the abstract distortion of basic question, and especially the abstract "anti-middle-classness," was a tendency that, precisely because it separated the critique of middle-classness from both the economic understanding of the capitalist system and from adhesion to the liberation struggle of the proletariat, could easily collapse into its opposite extreme: into a critique of "middle-classness" from the right, the same demagogic critique of capitalism to which fascism later owed at least part of its mass basis.[27]

One of the splashiest quotational artists draws directly on fascist iconography, dressing it in "classical modern" formal clothing. His claim to be attacking the dog-eat-dog world of corporate high finance won't do. Nazis attacked big business as well—that accounts for the "socialist" in National Socialist. Fascism commonly masquerades as populism while secretly serving big business; that's the point of John Heartfield's much-reproduced col-

lage "The Meaning of the Hitler Salute," subcaptioned "Millions Stand Behind Me" and "Little Man Asks for Great Gifts." What fascists offer the "little men" is only the chance to feel connected, through merely mythic identification, to power. Using mythic forms and exacerbating irrational doubts do not lead to progressive social transformation. Instead, they hasten people's acceptance of authoritarian, presumably patriarchal, "leadership" (subjugation).

It also won't do to deny responsibility for fascist content by projecting it onto the audience, further weighting the balance with guilt and uncertainty. The work in question, in performance, sculpture, and graphics, offers a vast monumentalization of male power—phallic columns, images of the troubled hero, the suffering god—and contorted bodies, uniforms of power, weaponry, and stark lighting. It recreates, in most blatant fashion, fascist art.

Finally, it won't do to suggest that the work embodies social critique. As analysis of Western capitalism, the label "fascist" is simply incorrect. In betraying the reality of our society (which deserves the analysis and criticism appropriate to it), this misuse of the term serves to glorify fascism, which seems intriguing and not at all unendurable. What does it mean to put fascist ideas and images center stage when there is a broad streak of adulation for them in punk-new wave and when one need only open the *New York Times* to find a full-page illustration taken straight from the fascist lexicon advertising Bergdorf's department store?

In contrast to these reactionary works, there is a much-needed practice of critical photography and text currently in the art world. It is getting feverish attention from the sectors of the critical establishment unwilling to swim with the tide of reaction. It is concerned with a critical engagement with the images of mass culture, visual and verbal, and with those of photography (and art) as a practice. It is quotational ("appropriational") and ironic. But there are serious problems with some of it, which, despite its aggressiveness and sometimes globalized claims, seems at times quite timid in relation to its own material.

Appropriation and analysis are at issue in critique. The difference between them must be appreciated. Appropriation sharply depends on context to provide the critical movement—generally, as I've remarked, through irony. Appropriative strategies do not in principle exclude either analysis or synthesis (but the ones currently receiving the most attention tend to do so). But replicating oppressive forms, whether by quoting them directly or through the fashioning of simulacra, may replicate oppressiveness. Further, the works at issue imply a totalizing or systemic critique. Implicating a whole system is logically unsatisfactory; if an assertion encompasses an entire universe, there is no vantage point outside from which to make or understand the critique. Thus, I will argue that using the language of advertising or melodrama or a simulated series of "cultural-unconscious" utterances in fact leaves their systems uncriticized and reproduces their power-seeking and anxiety-provoking gambits far too well. The work, in its stringency, is didactic in relation to other art production. Just as it locates itself logically above other art, the critical discourse needed to support it is put in the same relation to it.

Irrationalism, companion of reaction, is furthered by withdrawal from direct social analysis. Rationalism implies and fosters certitude, and doubt and ambiguity deepen social distress, as I've already noted.[28] Simulacra of ideological discourses, whether in images (say, of women) or verbal stereotypes, without analysis offer no foothold within the work but instead throw up a treacherous and contradictory dream world that encourages pro-

jection and myth. In his essay on expressionism Lukács quotes Karl Pinthus, whom he calls "one of the leading expressionist theorists":

We felt ever more clearly the impossibility of a humanity that had made itself completely dependent on its own creation, on its science, technology, statistics, trade and industry, on an ossified social order, and bourgeois and conventional customs. This recognition meant the beginning of a struggle against both the epoch and its reality. We began to resolve the surrounding reality into the unreality it is, to penetrate through the phenomena to the essence, and to surround and demolish the enemy by assault on the mind. We sought first of all to distance ourselves from our environment by ironic superiority, by grotesquely jumbling its phenomena, floating easily through the viscous labyrinth . . . , or rising into the visionary with the cynicism of the music-hall.[29]

Later in the essay Lukács remarks that "this 'essence' is . . . presented by the expressionist as the poetic reality. . . . He does this in poetry . . . by gathering together as a literary form his own inability to arrange and master the objective reality in thought, making this into the chaos of the world itself and simultaneously the sovereign act of the writer."[30]

In work based on advertising, the critique is of domination congealed into photographic images (not necessarily from ads) and language, and the presentation draws on magazine, billboard, and other display techniques. As in advertising, the relation of text to image is generally ironic: contradictory, perhaps, or revelatory. Yet there is no *particular* critique of these forms as concreted oppression, instrumentalities of selling. Advertising is merely dirtied by backwash from other critical elements in the work; although the forms are shown as constrained, they are not deeply criticized, for they carry a new, critical message. Works using television gambits suffer from the same problems. Each locates clear instances of oppressive, sometimes sensationalist, imaging, generally ones which target women or sensationalize violence, and each repeats oppressive formal strategies of the chosen industry (advertising, television) such as authoritative phrasing and type design or rapid editing, organized into an up-to-date format. Predictably, as these artists have developed their oeuvres, the work has come to seem more and more locked in fascination to its own material.

The ambivalence toward the appropriated material is evident in the form's being pressed into service of a new authoritativeness, a new mastery. This ambivalence contributes to the formalist cast of the work, for the polish may seem more powerful than the criticism. For those without a preexistent critical relation to the material, the work seems a slicked-up version of the original, a new commodity. In fact, much of this work has proved quite salable, easy to show, easy to write about, easy to sell. Epigrammatic and rhythmic, the work's effect is to tend to foreclose thought rather than to stimulate it, to replace criticism and analysis with sloganeering. No one, neither critic nor viewer, has to do the hard work of understanding the social relations alluded to in the work.

The flat refusal of "new production" (which mistakenly assumed that reproduction is no production) of some quotational artists is deeply romantic in continuing to identify creativity as the *essence* of art. This jettisons, for example, a more open-ended idea of art as stemming from and returning to lived relations. The cry of the isolated producer, the spectator of social life, represents a choice behind which lies a profound stasis. The work is immobile while critics do their work on it, "Nature" to their "Culture," female to their male (more on this later). What does it mean to reproduce well-known photos or photos of well-known artworks directly? Explanations have been inventive: removing the works from their rarified niches and making them more widely accessible (from a respectable curator); claiming them as part of our cultural unconscious (a recent *New York Times* article); exposing the commodity status of all art in the age of mechanical reproduction

(European-influenced critics); protesting the glut of existing imagery (a friend). Each explanation remains in its own domain of meanings. (The clearest explanation the artist has been able to offer has been remarks about ambivalence.)

What alternative vision is suggested by such work? We are not provided the space within the work to understand how things might be different. We can imagine only a respite outside social life—the alternative is merely Edenic or Utopic. There *is* no social life, no personal relations, no groups, classes, nationalities; there is no production other than the production of images. Yet a critique of ideology necessitates some materialistic grounding if it is to rise above the theological.

Some of the problems with the new quotational work make sense, as I've suggested, in the light of our current historical situation. The force behind its irony is not derived from a process of politicization, although it claims a politics. Consider the irony of political movements. Consider the cartoons, plays, and songs, for example, of past movements, many of which have entered official histories cut from their contexts of political ferment. The irony and parody of oppressive social institutions and their representatives contained in these works are resilient with anger and a forward motion, a resolve toward change that seems convinced of the direction of history. Most of this work stems from working-class movements, having bourgeois and petty-bourgeois allies such as intellectuals and artists. But the lack of a coherent oppositional movement now in the United States leaves artists with the easy institutional alliance that they (we), along with intellectuals and other "cultural workers," form with the controlling classes.

The critical art I have been discussing winds up traditionally modernist in its reliance (with some exceptions) on gallery and museum and critical supports. A hybrid practice, it combines the obsessiveness of (abstract) expressionism with the stringency of conceptualism (or, more properly, minimalism). Compared with the multiply inventive, directorial, and entrepreneurial activity of Andy Warhol's Pop or the self-confidently shaping intelligences of conceptual art, much of this work seems ready-made for the critic. Most of the sympathetic critics concern themselves only with art that has already found its location in commercial art galleries and museums, so that the process of legitimation is presupposed to exclude either a wider practice, a non-New York (or non-European) practice, or one that neglects or refuses commitment to the showing and selling institutions of high culture. The conservatism (and laziness) of this restricted critical practice is confirmed in its methods of intensively "working" a few artists, usually "single move" artists, most of whom provide relatively passive subjects of critical attention.

Some of the opposition to bourgeois cultural hegemony has taken on the Althusserian direction of "theoretical praxis," which claims as revolutionary the theoretical work that bares the structures of capitalist domination in the field of ideology. (Lukács stresses the theory orientation of expressionists.) However, this work remains locked within the relations of production of its own cultural field. For critics and other sympathetic producers, this functionally modernist closure reinforces their own sense of opposition to hegemonic bourgeois culture without raising difficult questions about their relation to political movements (although Althusser was a member of the French communist party even through its Stalinist period). Critics and the artists they write about engage in mutual confirmation that questions of civilization and culture must be dealt with within the universe of meaning circumscribed by the internationalized art world, mutual confirmation of the impossibility of engaging with political questions that challenge rather than simply *highlighting* power relations in society. The oppressiveness of social institutions and social relations is overstated in the art I am considering, leaving no room for oppositional human

agency—a charge that has been made against Althusser's work as well. Amid deepening uncertainty, criticism has retreated further from an "engaged" stance. The still emergent criticism deriving from the work of Jacques Derrida tends to deny any possibility of unambiguous political stands (though recently Derrida was supposedly backed against a wall by some French reporters and made to proclaim his belief in the need for social transformation), along with a denial of authorship that may paradoxically help in dusting off the view of the artist as a passively creating, disconnected figure.

The return to the trappings of genius (or, less histrionically, the lone producer) fits interestingly with questions of feminism. It is not at all accidental that most of the artists at issue are women. Women are more likely than men to be critical of existing power relations, since they have less of the power. But particularly in the highly conscious intellectual community, where feminism is still taken seriously, femaleness tends now to be the token for all markers of difference; appreciation of the work of women whose subject is oppression exhausts consideration of all oppressions. This arraying of oppressions mirrors that in the rest of society, which divides and conquers. The difference is that in the art world, race and class (for example) can be left out. This is not to say that for the art world the rest of society is obliterated. If New York is sometimes Culture to the rest of society's Nature, the world of artists and intellectuals is also sometimes Culture while the rest of culture, as either bourgeois-generated mass culture or as popular or street culture, is Nature. Nature, of course, provides setting and raw material.

The separation from, not to say contempt for, working-class and minority life and culture that many critics and intellectuals experience disappears as an issue in their championing of the female oppressed. (We need not cast blame.) Single-move art needs strong support systems, as I've said. This support can be literally patronizing: Svengali and Trilby may be too extreme a model for this relationship, but there are elements of performer and manager here, nonetheless. The dominance of critical discourse over the artist's expressive utterances is a guilt-denying dominance, for it is carried out in the logical superiority of metalanguage over language and thus exculpates the individuals involved. If the woman artist, asserting herself (and all of us?) to be a prisoner of phallocentric language, refuses to try to speak, her refusal, coupled with her continuing to seek, through ordinary art-world channels, the validation of critics, curators and buyers, confirms the image of woman as bound and impotent. The ornithological interest of some critics in the song of the caged bird fits the pattern set by previous doomed actresses and singers. One critic tempered his praise of each woman he discussed with a sobering assessment of the "weaknesses" of her approach, a strategy he has never applied to men.

Some of the new quotational work exists in relation to "the street." "The street" is interesting only in metropolitan locales with deeply divided class structure and conflict, and perhaps where the impoverished and excluded are also ethnically different. Operating in New York's closed and self-reinforcing art world but often living among its dispossessed populations, artists may identify with their neighbors but aspire to art-world success. Coming to New York is regarded as a dangerous rite of passage through which only the strong pass victorious. However deeply felt in matters of daily life, this situation becomes a fantasy drama in the matter of making art. The street and its culture become both a source of style and a theatrical setting for an art still aimed at high-culture audiences and the intermediary subcultures of young producers and supporters.

Locating art sites in impoverished neighborhoods presents a real dilemma, for the facts of social power and privilege can hardly be wished away. Neighborhood people, often kids, enter as relatively unselfconscious producers and undoubtedly gain from their experiences. But careers are built for the (mostly white) artists—careers that, in their gallery incarnations, are as docilely individualized as any. The bludgeoning of human sentiments and the truncation of social life, whose continuing vitality testifies to human resiliency under terrible conditions—conditions that activists and social critics point to as evidence of the destructiveness of capitalism—are transformed into exciting, even sensational, sources of artistic experiment and imagery, with no accompanying acknowledgment of oppression and need. That which was evidence becomes a cause for celebration. An encounter through which art audiences are satisfied that the poor are happy where they are, God bless 'em, is as supportive of the status quo as art that leaves them out.[31]

Quotation is a larger practice than I have considered here. Although some of both types, critical and mystificatory, is done by both men and women, it is evident that neo-expressionism, at least, is now (and has been) a male strategy, part of whose burden is the painful loss of individual mastery for all but a few men (and part of whose social use is "backlash"). Concomitantly, most of the socially critical, largely photographic work is made in response to the oppressive power of unauthored ideological domination as expressed in imagery of the female and logically, therefore, is done by women. Because women, in aiming for self-determination and success, have had to downplay their "expressiveness," this work is stringent and tough. Vacating the field of expression left it open for men to rush into and stake their claims (and leaving room for the feminine Mary Boone to remark entrepreneurially that men are more expressive than women and to simultaneously claim, in *People* magazine's issue for April 12, 1982, "I'll always take a great woman artist, but the museum hierarchies won't accept them").

The gutting of feminism in society makes the continuation of feminist art essential. But if women artists fit too easily into the institutional patterns of the art world, it seems plausible that feminist art will be just a competing style of the sixties and seventies and will be outdated by fashion. Repeating the images of woman bound in the frame will, like Pop, soon be seen as *confirmation* by the "post-feminist" society. We need to find a way to maintain not just a critical but a countering practice, as I mentioned at the start of these notes. Quite possibly it will be developed by those who have forged the critical practice I have considered here or by others much like them, as well as by men who refuse the kinds of rewards now offered by an art world more and more tied to the interests of those bent on control over society.

1 In England, where documentary practice (in both film and photography) has had a strong public presence (and where documentary was named, by John Grierson), with well-articulated theoretical ties to social-democratic politics, it is customary to distinguish *social documentary* from documentary per se (photos of ballerinas, an English student said contemptuously). The more general term denotes photographic practice having a variety of aesthetic claims but without involvement in exposé. (What is covered over by this blanket definition, such as the inherently racist type of travelogue, with its essentialist rather than materialist theories of cultural development, will have to remain under wraps for now.) Of course, such distinctions exist in documentary practice everywhere, but in the United States, where positions on the political spectrum are usually not named and where photographers and other artists have only rarely and sporadically declared their alignment within social practice, the blurring amounts to a tactic. A sort of popular-front wartime Americanism blended into Cold War withdrawal, and it became socially mandatory for artists to disaffiliate themselves from Society (meaning social negativity) in favor of Art; in the postwar era one finds documentarians locating themselves, actively or passively, as privatists (Dorothea Lange), aestheticians (Walker Evans, Helen Levitt), scientists (Berenice Abbott), surrealists (Henri Cartier-Bresson), social historians (just about everyone, but especially photojournalists like Alfred Eisenstadt), and just plain "lovers of life" (Arthur Rothstein). The nonsensical designation "concerned photography" latterly appears, signifying the weakest possible idea of (substitute for) social engagement, namely, *compassion,* of whom perhaps the war photographers David Douglas Duncan, Donald McCullin, and W. Eugene Smith provide the best examples. If this were a historical essay, I would have to begin with ideas of truth and their relation to the developments of photography, would have to spell out the origins of photographic instrumentalism, would have to tease apart the strands of "naturalistic," muckraking, news, socialist, communist, and "objective" photographic practice, would have to distinguish social documentary from our less defined ideas of documentary unqualified. . . .

2 Jacob A. Riis, *The Making of an American* (New York: Harper Torchbooks, 1966; originally published by Macmillan, London and New York, 1901), p. 267.

3 In quoting Jacob Riis I am not intending to elevate him above other documentarians—particularly not above Lewis Hine, whose straightforward involvement with the struggles for decent working hours, pay, and protections for, as well as for decent housing, schooling, and social dignity of, the people whom he photographed and the social service agencies intending to represent them, and whose dedication to photography as the medium with which he could best serve those interests was incomparably greater than Riis's, to whom photography, and probably those whom he photographed, was at best an adjunct to, and a moment in, a journalistic career.

Margaret Sanger, a nurse in turn-of-the-century New York, became a crusader for women's control over reproduction. She founded the American Birth Control League in the 1920s (and much later became the first president of the International Planned Parenthood Federation) and similar leagues in China and Japan. Like many women reformers, she was arrested and prosecuted for her efforts, from disseminating birth-control literature to maintaining a clinic. Many other people, including Jane Addams, founder of Hull House in Chicago, and Lillian Wald, founder of New York's Visiting Nurse Association, might be cited as dedicated reformers in this tradition of middle-class championship of the oppressed, with varying relations to the several strategies of self-help, charity, and the publication of wrongs to awaken a healing empathic response.

4 The buried tradition of "socialist photography," a defined, though no doubt restricted, practice in some parts of Europe and North America in the late nineteenth and early twentieth centuries, is being excavated by Terry Dennett (of Photography Workshop) in England. His research so far suggests that the showing of lantern slides depicting living and working conditions and militant actions were a regular part of the working-class political organizing, and references to "socialist photography" or photographers appeared in the leftist press in that period. Furthermore, the world's first news-photo agency, World's Graphic Press, seems to have had a leftish orientation. In the collection *Photography/Politics: One* (London: Photography Workshop, 1979), a start was made toward a worldwide history of the photo leagues. In relation to left photography, one must mention the illustrated magazines, the most popular of which was the German *Arbeiter Illustrierte Zeitung,* or *AIZ* ("Workers' Illustrated Newspaper"; 1924–38).

5 For a discussion of the work of Richard Herrnstein, chairman of the psychology department at Harvard University, see Karl W. Deutsch and Thomas B. Edsall, "The Meritocracy Scare," *Society* (September/October 1972), and Richard Herrnstein, Karl W. Deutsch, and Thomas B. Edsall, "I.Q.: Measurement of Race and Class?" (in which Herrnstein debates Deutsch and Edsall on some of their objections to his work), *Society* (May/June 1973); both are reprinted in Bertram Silverman and Murray Yanowitz, eds., *The Worker in "Post-Industrial" Capitalism (Liberal and Radical Responses),* (New York: Free Press, 1974). See also Richard Herrnstein's original article, "IQ," in *Atlantic Monthly* (September 1971), pp. 43–64, and Arthur Jensen, "How Much Can We Boost IQ and Scholastic Achievement?," *Harvard Educational Review,* Reprint Series No. 2 (1969), pp. 126–34. See, e.g., Samuel Bowles and Herbert Gintis, "IQ in the U.S. Class Structure," *Social Policy* (November/December 1972 and January/February 1973), also reprinted in Silverman and Yanowitz, *The Worker,* for a critique of the theorizing behind intelligence testing. There have been many critiques of I.Q.—a very readable one is Jeffrey Blum's *Pseudoscience and Mental Ability* (New York: Monthly Review Press, 1977)—and of sociobiology, exposing their ideological foundations and poor scientific grounding—critiques that haven't inhibited either enterprise.

Milton Friedman, best known of the extremely conservative "Chicago school" (University of Chicago) anti-Keynesian, "monetarist" economists, has strongly influenced the policies of the Conservative Thatcher government in England and the rightist Begin government in Israel and has advised many reactionary politicians around the world (and "los Chicago boys" laid the foundations for the brutally spartan policies of the Pinochet military regime toward all but the richest Chileans). Implicit in the pivotal conception of economic "freedom" (competition) is that the best will surely rise and the worst will sink to their proper level. That is the only standard of justice. In remarks made while accepting an award from the American Heritage Foundation, Friedman, referring to the success of his public (i.e., government- and corporate-sponsored) television series "Free to Choose," commented that conservatives had managed to alter the climate of opinion such that the series *could* succeed and proclaimed the next task to be the promulgation of "our point of view" in philosophy, music, poetry, drama, and so on. He has also recommended the dismantling of the "National Endowments" for the arts and the humanities (government funding agencies). We can expect the currency of such policies and their ideological corollaries to grow as they increasingly inform the policies and practices of rightist U.S. governments.

6 A remarkable instance of one form that such fascination may take, in this case one that presented itself as militantly chaste (and whose relation to identification I won't take on now), is provided by the lifelong obsession of an English Victorian barrister, Arthur J. Munby, which was the *observation* of women manual laborers and servants. (The souvenir *cartes de visite* of young women mine workers, at the pit head and in studio poses, suggest that some version of Munby's interest was widely shared by members of his class.) Simply seeing them dressed for work rather than watching them work generally sufficed for him, though he often "interviewed" them. Munby was no reformer or ally of feminists, but in opposing protective legislation he considered himself a champion of working-class women, particularly the "robust" ones whose company he much preferred to that of the genteel women of his class, sufferers from the cult of enforced feebleness. After a secret liaison of nineteen years with a maid-of-all-work (a low servant rank), Hannah Cullwick, Munby married her but kept the marriage secret, and although he dressed her as a lady for their journeys, they lived separately and she remained a servant—often waiting on *him*. He also insisted she keep a

diary. Munby's great interest in the new field of photography was frustrated by the fact that as in painting most aspirants had no interest in images of labor; he bought whatever images of working women he could find and arranged for others, often escorting women in work dress and sometimes using Hannah as a stand-in. He would dress her in various work costumes for photo sessions, and his diary describes how, pretending no relationship, he savored the sight of the photographer bodily arranging her poses and the degradation it imposed on her. In 1867 he took her to O. J. Rejlander, the famous painter-turned-photographer of (faked) "genre" scenes.

The huge Munby collection at Cambridge, consisting of six hundred surviving photos as well as his sketches and private papers running to millions of words, provided the material for Derek Hudson's *A. J. Munby, Man of Two Worlds: The Life and Diaries of Arthur J. Munby, 1828–1910* (London, 1972), and Michael Hiley's lavishly illustrated *Victorian Working Women: Portraits from Life* (London: Gordon Fraser, 1979). (I am profoundly grateful to Stephen Heath not only for calling Munby and his preoccupations to my attention but also for generously sharing his own research with me.)

Not in relation to photographic imagery but to the sexualization of class itself that lies behind Munby's scopophilic obsession, we note that in Victorian England, where only working-class women were supposed to have retained any interest in sexuality, gentlemen would cruise working-class neighborhoods to accost and rape young women.

7 April 1974. (I thank Allan Sekula for calling this issue to my attention.) The Smiths subsequently published a book whose title page reads *Minamata, Words and Photographs by Eugene Smith and Aileen M. Smith* (New York: Holt, Rinehart and Winston, 1975). I am not arguing for Smith's art-history-quoting, bravura photographic style. Nevertheless, and in spite of the ideological uses to which Smith's (and in this case the Smiths') work has been put in the photo world, the Smiths' work at Minamata evidently was important in rallying support for the struggle throughout Japan.

8 *Camera 35* (April 1974), p. 3.

9 Irving Penn, *Worlds in a Small Room, by Irving Penn as an Ambulant Studio Photographer* (New York: Grossman, 1974).

10 The work of Edward S. Curtis, incorporating photographs from his monumental work *The North American Indian* is now widely available in recent editions, including Ralph Andrews, *Curtis' Western Indians* (Sparks, Nev. [?]: Bonanza Books, 1962), and the far more elevated editions of the 1970s: the very-large-format *Portraits from North American Indian Life* (New York: Outerbridge & Lazard, 1972; small-format paperback edition, New York: A & W Publishers, 1975); an exhibition catalogue for the Philadelphia Museum, *The North American Indians* (Millerton, NY: Aperture, 1972); and *In a Sacred Manner We Live* (Barre, MA: Barr Publishing, 1972; New York: Weathervane, 1972). One can speculate that it was the interest of the "counterculture" in tribalism in the late 1960s and early 1970s coupled with Native American militancy of the same period that ultimately called forth these classy new editions; posters of some of Curtis's (and others') portraits served as emblems of resistance for radicals, office workers, college students, and dope smokers.

Curtis, who lived in Seattle, photographed Native Americans for several years before J. Pierpont Morgan—to whom Curtis was sent by Teddy Roosevelt—agreed to back his enterprise. (Curtis's "first contact with men of letters and millionaires," in his phrase, had come accidentally: on a mountaineering expedition Curtis aided a stranded party of rich and important men, including the chiefs of the U.S. Biological Survey and the Forestry Department and the editor of *Forest and Stream* magazine, and the encounter led to a series of involvements in governmental and private projects of exploration and the shaping of attitudes about the West.) The Morgan Foundation advanced him fifteen thousand dollars per year for the next five years and then published (between 1907 and 1930) Curtis's resulting texts and photographs in a limited edition of five hundred twenty-volume sets, selling for *three thousand dollars* (now worth over eighty thousand dollars and rising). The title page read:

The North American Indian, Being a Series of Volumes Picturing and Describing the Indians of the United States and Alaska, written, illustrated and published by Edward S. Curtis, edited by Frederick Webb Hodge [of the United States Bureau of American Ethnology], foreword by Theodore Roosevelt, field research under the patronage of J. Pierpont Morgan, in twenty volumes.

Fabulously wealthy society people, including Andrew Carnegie, Solomon R. Guggenheim, Alexander Graham Bell, Mrs. Frederick W. Vanderbilt, and the kings of England and Belgium, were

among the sets' early subscribers. But according to Curtis, over half the cost of a million and a half dollars was borne by Morgan and his estate.

Curtis dedicated himself completely to his task, and in addition to his photography and notes (and the writing of popular books, two of which became best sellers), he recorded thousands of songs on wax rolls, many of which, along with oral histories, were transcribed and published in his *magnum opus*. Curtis's fictionalized film about the Kwakiutl of Vancouver Island, British Columbia, was originally titled *In the Land of the Head Hunters* (1914) but has recently been released under the title *In the Land of the War Canoes*.

On the subject of costuming, see, for example, Joanna Cohan Scherer, "You Can't Believe Your Eyes: Inaccuracies in Photographs of North American Indians," *Studies in the Anthropology of Visual Communication* 2:2 (Fall 1975), reprinted in *Exposure* (Journal of the Society for Photographic Education) 16:4 (Winter 1978).

Curtis's brother, Asahel Curtis, was a commercial photographer and city booster in Seattle and an enthusiast of development. A book of his distinctly nonpictoralist photographs of life and especially commerce in the Puget Sound area has been assembled and published by David Sucher as *An Asahel Curtis Sampler* (Seattle: Puget Sound Access, 1973). The one brother was integrated into the system of big capital and national government, the other into that of small business and regionalism.

11 Robert Flaherty is well known for his fictionalized ethnographic films, especially the first, *Nanook of the North* (made in 1919–20, released in 1922). A catalogue of his photographs (formerly ignored) of the Inuit, with several essays and many reproductions, has recently been published by the Vancouver Art Gallery: Robert Flaherty, *Photographer—Filmmaker, The Inuit 1910–1922*, edited by Joanne Birnie Danzker (The Vancouver Art Gallery, 1980).

12 Eastman Kodak Company, *How to Make Good Movies* (Rochester, NY, n.d.).

13 Cameron's work can be found in *Victorian Album: Julia Margaret Cameron and Her Circle*, edited by Graham Ovenden (New York: Da Capo Press, 1975), and elsewhere. For Vroman's work, see *Photographer of the Southwest, Adam Clark Vroman, 1856–1916*, edited by Ruth Mahood (Ward Ritchie Press, 1961; reprinted, Sparks, Nev.[?]: Bonanza Books, n.d.), or *Dwellers at the Source, Southwestern Indian Photographs of Adam Clark Vroman, 1895–1904*, edited by William Webb and Robert A. Weinstein (New York: Grossman. It might be noted that Vroman was occasionally quite capable (as were Hine and Smith) of thrusting his work into the mold of the "traditional" Western sentimental iconographic coding of piety, humbleness, simplicity, and the dignity of labor: a photo of a mother and child is titled "Hopi Madonna"; one of a man working is called "Man with a Hoe."

14 Zwingle's story seems to derive almost verbatim from the book *Private Experience, Elliott Erwitt: Personal Insights of a Professional Photographer*, with text by Sean Callahan and the editors of Alskog, Inc. (Los Angeles: Alskog/Petersen, 1974). The strange assertion about Erwitt's gift for documentary follows an interestingly candid quotation from ad agency president Bill Bernbach (as does most of the anecdote): "Elliott was able to grasp the idea quickly and *turn it into a documentary photograph*. This was tremendously important to us because the whole success of the campaign rested on the *believability* of the photographs. We were telling people that there was a France outside of Paris, and Elliott *made it look authentic*" (p. 60, emphasis added). In repeating the book's remark that Erwitt had achieved "the ideal composition"—called in the book "the precise composition"—the focus point marked with a stone, Zwingle has ignored the fact that the two photos—the one shown in *Private Experience* and the one used by Visa—are not quite identical (and the one in the ad is flopped). Questions one might well ask are what does "documentary" mean? (a question that, for example, lay at the heart of an often-cited political furor precipitated when photographer Arthur Rothstein placed a locally obtained cow skull in various spots in drought-stricken South Dakota to obtain "the best" documentary photograph and, as FDR was traveling through the area months later, the anti-New Deal editor of the *Fargo* [N.D.] *Forum* featured one of the resulting photos [as sent out by the Associated Press, with its own caption] as "an obvious fake," implying that trickery lay at the heart of the New Deal) and how precise is a "precise" or "ideal" composition? As to the relationship between documentary and truth: The bulk of Zwingle's article is about another photo used by Visa, this one of two (Bolivian) "Indian" women that the photographer (not Erwitt) describes as having been taken during a one-day sojourn in Bolivia, without the women's knowledge, and in which "some graffiti . . . *a gun and the initials ELN, were*

retouched out to emphasize the picture's clean graphic style" (p. 94, emphasis added). The same photographer shot a Polynesia ad for Visa in San Francisco's Golden Gate Park using "a Filipino model from San Jose" who "looks more colorful in the picture than she did in real life. She was freezing" (pp. 94–95). The question of documentary in the wholly fabricated universe of advertising is a question that can have no answer.

15 Roy Emerson Stryker and Nancy Wood, *In This Proud Land, America 1935–1943, as Seen in the FSA Photographs* (Greenwich, CN.: New York Graphic Society, 1973; New York: Galahad Books, 1973), p. 19.

16 Ibid.

17 I am not speculating about the "meaning" of photography to Lange but rather speaking quite generally here.

18 Agee and Evans went to Hale County to do an article or a series on a white sharecropper family for Henry Luce's *Fortune* magazine; because Evans was employed by the Historical Section of the Farm Security Administration, it was agreed that his negatives would belong to it. When Agee and Evans completed their work (dealing with three families), *Fortune* declined to publish it; it finally achieved publication in book form in 1941. Its many editions have included, with the text, anywhere from sixteen to sixty-two of the many photographs that Evans made. A new, larger, and more expensive paperback edition has recently been published; during Agee's lifetime the book sold about six hundred copies.

It hardly needs to be said that in the game of waiting out the moment of critique of some cultural work it is the capitalist system itself (and its financial investors) that is the victor, for in cultural matters the pickings of the historical garbage heap are worth far more than the critical moves of the present, and by being chosen and commodified, by being *affirmed,* even the most directly critical works in turn affirm the system they had formerly indicted, which in its most liberal epochs parades them through the streets as proof of its open-mindedness. In this case, of course, the work did not even see publication until its moment had ended.

19 Howell Raines, "Let Us Now Praise Famous Folk," *New York Times Magazine,* May 25, 1980, pp. 31–46. (I thank Jim Pomeroy for calling this article to my attention and giving me a copy of this issue.) Raines is the chief of the *Times*'s Atlanta bureau. The article seems to take for granted the uselessness of Agee's and Evans's efforts and in effect convicts them of the ultimately tactless sin of prying. To appreciate the shaping effects of one's anticipated audience, compare the simple "human interest" treatment of Allie Mae Fields ("Woods") Burroughs ("Gudger") Moore in Scott Osborne, "A Walker Evans Heroine Remembers," *American Photographer* (September 1979), pp. 70–73, which stands between the two negative treatments: the *Times*'s and the sensationalist newswire stories about Florence Thompson (including ones with such headlines as " 'Migrant Mother' doubtful, she doesn't think today's women match her" [*Toronto Star,* November 12, 1979]. Mrs. Moore (she married a man named Moore after Floyd Burroughs's death), too, lived in a trailer, on Social Security (the article says $131 a month—surely it is $331.60, like Mrs. Thompson), plus Medicare. But unlike Thompson and Mrs. Moore's relatives as described by Raines, she "is not bitter." Osborne ends his article thus: "Allie May Burroughs Moore has endured. . . . She has survived Evans [she died, however, before the article appeared], whose perception produced a portrait of Allie May Burroughs Moore that now hangs on permanent display in the Museum of Modern Art. Now the eyes that had revealed so much in that picture stare fixedly at the violet rim along the horizon. 'No, I wouldn't change my life none,' she says." According to Raines, *that picture* is the most sought-after of all Evans's Alabama photos, and one printed by Evans would sell for about four thousand dollars. Predictably, in Osborne's story Mrs. Moore, contemplating the photo, accepts its justice, while Raines has Mrs. Moore's daughter, after her mother's death, bitterly saying how much her mother had hated it and how much unlike her it looked.

20 In the same vein, but in miniature, and without the ramified outrage but with the same joke on the photographed persons—that they allowed themselves to be twice burned—*Modern Photography* (July 1980) ran a small item on its "What's What" pages entitled "Arbus Twins Revisited." A New Jersey photographer found the twins, New Jersey residents, and convinced the now-reluctant young women to pose for him, thirteen years after Arbus's photo of 1967. There is a mild craze for "rephotographing" sites and people previously seen in widely published photos; photographers

338 | 339

have, I suppose, discovered as a profession that time indeed flows rather than just vanishing. *Mod Photo* probably had to take unusual steps to show us Arbus's photo. It is very difficult to obtain permission to reproduce her work—articles must, for example, ordinarily be *read* before permission is granted—her estate is very tightly controlled by her family (and perhaps Szarkowski) and Harry Lunn, a photo dealer with a notorious policy of "enforced scarcity" with respect to the work of "his" photographers (including Arbus and Evans). *Mod Photo's* staff photographed the cover of the Arbus monograph (published by *Aperture* in 1972), thus quoting a book cover, complete with the words "diane arbus," rather than the original Arbus print. Putting dotted lines around the book-cover image, they set it athwart rather than *in* a black border, while they did put such a border around the twin photo of 1979. The story itself seems to "rescue" Arbus at the expense of the twins, who, supposedly without direction, "assumed poses . . . remarkably like those in the earlier picture." (I thank Fred Lonidier for sending me a copy of this item.)

21 Although both Frank's and Winogrand's work is "anarchic" in tendency, their anarchism diverges considerably; whereas Frank's work seems to suggest a left anarchism, Winogrand is certainly a right anarchist. Frank's 1950s photo book *The Americans* seems to imply that one might travel through America and simply *see* its social-psychological meaning, which is apparent everywhere to those alive to looking; Winogrand's work suggests only the apparent inaccessibility of meaning, for the viewer cannot help seeing himself, point of view shifts from person to person within and outside the image, and even the *thought* of social understanding, as opposed to the leering face of the spectacle, is dissipated.

22 John Szarkowski, introduction (wall label) to the New Documents exhibition, February 28–May 7, 1967. In other words, the photographer as either *faux naïf* or natural man, with the power to point but not to name.

23 Among the many works that have offered images of drunks and bums and down-and-outers, I will cite only Michael Zettler's *The Bowery* (New York: Drake Publishers, 1975), which I first saw only after I completed *The Bowery in two inadequate descriptive systems* but which, with its photographs and blocks of text, supposed quotations from the pictured bums and from observers, can nevertheless be seen as its perfect foil.

24 Such as the photographs of Chilean detainees taken by David Burnett, which I referred to earlier.

25 Where, perhaps to hold the interest of its society patrons, who may love documentary but who also tire of it, there are increasing numbers of fashion-photography exhibitions; as I write this its two shows are of the photos of George Hoyningen-Heuné and of a collection called *Allure,* chosen by Diana Vreeland, the influential former editor of *Vogue* and "special consultant" at the Costume Institute of New York's Metropolitan Museum of Art (and coinciding with the publication of her new book with that name), whose philosophy is suggested by her account of the entree to New York's high society, which formerly was family but now is "success": "Now everything is power and money and knowing how to use both. Today, as soon as you see the name Kissinger, you know you're in the right place at the right time" (in Francesca Stanfill, "Living Well Is Still the Best Revenge," *New York Times Magazine,* December 21, 1980—an article with a shockingly exultant affirmation of wealth and great ostentation, a sign of the new regime in the United States).

26 See Martha Rosler, "Lookers, Buyers, Dealers, and Makers: Thoughts on Audience," *Exposure* 17:1 (Spring 1979). Reprinted, with afterword, in Brian Wallis, ed., *Art After Modernism: Rethinking Representation* (New York and Boston: The New Museum of Contemporary Art and David R. Godine, 1984), pp. 310–39.

27 "Expressionism, Its Significance and Decline," first published in *Internationale Literatur* 1 (1934), pp. 153–73; translated in *Essays on Realism* (Cambridge: The MIT Press, 1981), p. 87. Lukács is responding to the *return* of expressionism in the thirties and discussing its rise in the late teens.

28 The Central Intelligence Agency is well aware of the usefully "destabilizing" effect of the bizarre stories that promise chaos or catastrophe, shaking common sense or social mores. In Chile, for example, in preparation for the coup of 1973, it spread rumors and planted news items about such things as foreigners eating cats. Similar techniques were used in Jamaica—along with, it has been said, a murder campaign in Kingston—before the progressive Manley regime was voted out of office. This well-worn propaganda technique also serves such publications as the *New York Post,* for fascination and dependency also increase sales.

29 Preface to the anthology *Menschheitsdämmerung* (Berlin, 1920), p. x, quoted in Lukács, *Essays on Realism,* p. 88. Although I certainly don't accept Lukács's championing of "realistic" art as the only socially conscious and critical art, I find his analysis of expressionism to be powerfully apt, in describing not only reactionary neo-expressionist work but also some of the genuinely critical work as well.

30 Ibid., p. 105.

31 See Edit de Ak's review of John Ahearn's work in *Artforum* (November, 1982).

Permission to reproduce Irving Penn's photograph *Asaro Mudmen, New, Guinea, 1970* was refused by Condé Nast Publications, Inc. in a one-sentence rejection stating: "Unfortunately, the material requested by you is unavailable for republication." By phone their representative suggested that it was Penn who had refused the request.

Permission to reproduce a photograph of Ida Ruth Tingle Tidmore, one of Walker Evans's Hale County subjects, taken in 1980 by Susan Woodley Raines and reproduced in conjunction with Howell Raines's article "Let Us Now Revisit Famous Folk" in the Sunday *New York Times Magazine* of May 25, 1980, was refused by Ms. Raines because Ms. Tidmore was suing Mr. Raines over the content of the article. The photo requested was captioned "Ida Ruth Tingle Tidmore and her husband, Alvin, outside their mobile home, which is adjacent to Alvin's collection of junked automobiles." A small corner inset showed one of Evans's photos from *Let Us Now Praise Famous Men* and was captioned "Young Ida Ruth struck this pensive pose for Walker Evans' camera." However, the inset photo is identified in *Walker Evans: Photographs for the Farm Security Administration, 1935–1938* (New York: Da Capo Press, 1973) as Ida Ruth's younger sister Laura Minnie Lee Tengle (*sic*) (LC–USZ62–17931).

340 | 341

IN, AROUND, AND AFTERTHOUGHTS

There must be arranged a comprehensive system of exchanges, so that there might grow up something like a universal currency of these banknotes, or promises to pay in solid substance, which the sun has engraved for the great Bank of Nature.

Oliver Wendell Holmes, 1859

The Body and the Archive

On the one side we approach more closely to what is good and beautiful; on the other, vice and suffering are shut up within narrower limits; and we have to dread less the monstrosities, physical and moral, which have the power to throw perturbation into the social framework.

Adolphe Quetelet, 1842

The sheer range and volume of photographic practice offers ample evidence of the paradoxical status of photography within bourgeois culture. The simultaneous threat and promise of the new medium was recognized at a very early date, even before the daguerreotype process had proliferated. For example, following the French government announcement of the daguerreotype in August 1839, a song circulated in London which began with the following verse:

> O Mister Daguerre! Sure you're not aware
> Of half the impressions you're making,
> By the sun's potent rays you'll set Thames in a blaze,
> While the National Gallery's breaking.

Initially, photography threatens to overwhelm the citadels of high culture. The somewhat mocking humor of this verse is more pronounced if we consider that the National Gallery had only moved to its new, classical building on Trafalgar Square in 1838, the collection having grown rapidly since the gallery's founding in 1824. I stress this point because this song does not pit photography against a static traditional culture, but rather plays on the possibility of a technological outpacing of *already* expanding cultural institutions. In this context, photography is not the harbinger of modernity, for the world is already modernizing. Rather, photography is modernity run riot. But danger resides not only in the numerical proliferation of images. This is also a premature fantasy of the triumph of a *mass* culture, a fantasy that reverberates with political foreboding, especially in the context of the militant democratic challenge posed by Chartism in 1839. Photography promises an enchanted mastery of nature, but photography also threatens conflagration and anarchy, an incendiary leveling of the existing cultural order.

By the third verse of this song, however, a new *social* order is predicted:

> The new Police Act will *take down* each fact
> That occurs in its wide jurisdiction
> And each beggar and thief in the boldest relief
> Will be *giving a color* to fiction.[1]

Again, the last line of the verse yields a surplus wit, playing on the figurative ambiguity of "giving a color," which could suggest both the elaboration and unmasking of an untruth, playing further on the obvious monochromatic limitations of the new medium and on the approximate homophony of *color* and *collar.* But this velvet wit plays about an iron cage which was then in the process of being constructed. Although no "Police Act" had yet embraced photography, the 1820s and 1830s had engendered a spate of governmental inquiries and legislation designed to professionalize and standardize police and penal procedures in Britain, the most important of which were the Gaols Act of 1823 and the Metropolitan Police Acts of 1829 and 1839. (The prime instigator of these modernization efforts, the Conservative leader Sir Robert Peel, happened to be a major collector of seventeenth-century Dutch paintings and a trustee of the National Gallery.) Directly to the point of the song, however, was a provision in the 1839 act for taking into custody vagrants, the homeless, and other offenders "whose name and residence [could] not be ascertained."[2]

Although photographic documentation of prisoners was not at all common until the 1860s, the potential for a new juridical photographic realism was widely recognized in the 1840s, in the general context of these systematic efforts to regulate the growing urban presence of the "dangerous classes," of a chronically unemployed subproletariat. The anonymous lyricist voiced sentiments that were also heard in the higher chambers of the new culture of photography.

Consider that incunabulum in the history of photography, Henry Fox Talbot's *The Pencil of Nature.* Talbot, the English gentleman-amateur scientist who paralleled Daguerre's metallic invention with his own paper process, produced a lavish book that was not only the first to be illustrated with photographic prints, but also a compendium of wide-ranging and prescient meditations on the promise of photography. These meditations took the form of brief commentaries on each of the book's calotype prints. Talbot's aesthetic ambition was clear: for one austere image of a broom leaning beside an (allegorically) open door, he claimed the "authority of the Dutch school of art, for taking as subjects of representation scenes of daily and familiar occurrence."[3] But an entirely different order of naturalism emerges in his notes on another quite beautiful calotype depicting several shelves bearing "articles of china." Here Talbot speculates that "should a thief afterwards purloin the treasures—if the mute testimony of the picture were to be produced against him in court—it would certainly be evidence of a novel kind."[4] Talbot lays claim to a new legalistic truth, the truth of an indexical rather than textual inventory. Although this frontal arrangement of objects had its precedents in scientific and technical illustration, a claim is being made here that would not have been made for a drawing or a descriptive list. Only the photograph could begin to claim the legal status of a *visual* document of ownership. Although the calotype was too insensitive to light to record any but the most willing and patient sitters, it evidentiary promise could be explored in this property-conscious variant of the still life.

Both Talbot and the author of the comic homage to Daguerre recognized a new *instrumental* potential in photography, a silence that silences. The protean oral "texts" of the criminal and pauper yield to a "mute testimony" that "takes down" (that diminishes in

MUTE

William Henry Fox Talbot,
Articles of China, plate 3 from
The Pencil of Nature, 1844

credibility, that transcribes) and unmasks the disguises, the alibis, the excuses and multiple biographies of those who find or place themselves on the wrong side of the law. This battle between the presumed denotative univocality of the legal image and the multiplicity and presumed duplicity of the criminal voice is played out during the remainder of the nineteenth century. In the course of this battle a new object is defined—the criminal body—and, as a result, a more extensive "social body" is invented.

We are confronting, then, a double system: a system of representation capable of functioning both *honorifically* and *repressively*. This double operation is most evident in the workings of photographic portraiture. On the one hand, the photographic portrait extends, accelerates, popularizes, and degrades a traditional function. This function, which can be said to have taken its early modern form in the seventeenth century, is that of providing for the ceremonial presentation of the bourgeois *self*. Photography subverted the privileges inherent in portraiture, but without any more extensive leveling of social relationships, these privileges could be reconstructed on a new basis. That is, photography could be assigned a proper role within a new hierarchy of taste. Honorific conventions were thus able to proliferate downward.[5] At the same time, photographic portraiture began to perform a role no painted portrait could have performed in the same thorough and rigorous fashion. This role derived, not from any honorific portrait tradition, but from the imperatives of medical and anatomical illustration. Thus photography came to establish and delimit the terrain of the *other,* to define both the *generalized look*—the typology—and the *contingent instance* of deviance and social pathology.

Michel Foucault has argued, quite crucially, that it is a mistake to describe the new regulatory sciences directed at the body in the early nineteenth century as exercises in a wholly negative, repressive power. Rather, social power operates by virtue of a positive therapeutic or reformative channeling of the body.[6] Still, we need to understand those modes of instrumental realism that do in fact operate according to a very explicit deterrent or repressive logic. These modes constitute the lower limit or "zero degree" of socially instrumental realism. Criminal identification photographs are a case in point, since they are designed quite literally to facilitate the *arrest* of their referent.[7] I will argue in the second part of this essay that the semantic refinement and rationalization of precisely this sort of realism was central to the process of defining and regulating the criminal.

But first, what general connections can be charted between the honorific and repressive poles of portrait practice? To the extent that bourgeois order depends upon the systematic defense of social relations based on private property, to the extent that the legal basis of the self lies in the model of property rights, in what has been termed "possessive individualism," every proper portrait has its lurking, objectifying inverse in the files of the police. In other words, a covert Hobbesian logic links the terrain of the "National Gallery" with that of the "Police Act."[8]

In the mid-nineteenth century, the terms of this linkage between the sphere of culture and that of social regulation were specifically utilitarian.[9] Many of the early promoters of photography struck up a Benthamite chorus, stressing the medium's promise for a social calculus of pleasure and discipline. Here was a machine for providing small doses of happiness on a mass scale, for contributing to Jeremy Bentham's famous goal: "the greatest happiness of the greatest number."[10] Thus the photographic portrait in particular was welcomed as a socially ameliorative as well as a socially repressive instrument. Jane Welsh Carlyle voiced characteristic hopes in 1859, when she described inexpensive portrait photography as a social palliative:

Blessed be the inventor of photography. I set him even above the inventor of chloroform! It has given more positive pleasure to poor suffering humanity than anything that has been "cast up" in my time . . . —this art, by which even the poor can possess themselves of tolerable likenesses of their absent dear ones.[11]

In the United States, similar but more extensive utilitarian claims were made by the portrait photographer Marcus Aurelis Root, who was able to articulate the connection between pleasure and discipline, to argue explicitly for a moral economy of the image. Like Carlyle, he stressed the salutory effects of photography on working-class family life. Not only was photography to serve as a means of cultural enlightenment for the working classes, but family photographs sustained sentimental ties in a nation of migrants. This "primal household affection" served a socially cohesive function, Root argued—articulating a nineteenth-century familialism that would survive and become an essential ideological feature of American mass culture. Furthermore, widely distributed portraits of the great would subject everyday experience to a regular parade of moral exemplars. Root's concern for respectability and order led him to applaud the adoption of photography by the police, arguing that convicted offenders would "not find it easy to resume their criminal careers, while their faces and general aspects are familiar to so many, especially to the keen-sighted detective police."[12] The "so many" is significant here, since it implicitly enlists a wider citizenry in the vigilant work of detection. Thus Root's utilitarianism comes full circle. Beginning with cheaply affordable aesthetic pleasures and moral lessons, he ends up with the photographic extension of that exemplary utilitarian social machine, the Panopticon.[13]

Notwithstanding the standard liberal accounts of the history of photography, the new medium did not simply inherit and "democratize" the honorific functions of bourgeois portraiture. Nor did police photography simply function repressively, although it is foolish to argue that the immediate function of police photographs was somehow more ideological or positively instrumental than negatively instrumental. But in a more general, dispersed fashion, in serving to introduce the panoptic principle into daily life, photography welded the honorific and repressive functions together. Every portrait implicitly took its place within a social and moral hierarchy. The *private* moment of sentimental individuation, the look at the frozen gaze-of-the-loved one, was shadowed by two other more *public* looks: a look up, at one's "betters," and a look down, at one's "inferiors." Especially in the United States, photography could sustain an imaginary mobility on this vertical scale, thus provoking both ambition and fear, and interpellating, in classic terms, a characteristically "petit-bourgeois" subject.

We can speak then of a generalized, inclusive *archive,* a *shadow archive* that encompasses an entire social terrain while positioning individuals within that terrain.[14] This archive contains subordinate, territorialized archives: archives whose semantic interdependence is normally obscured by the "coherence" and "mutual exclusivity" of the social groups registered within each. The general, all-inclusive archive necessarily contains both the traces of the visible bodies of heroes, leaders, moral exemplars, celebrities, and those of the poor, the diseased, the insane, the criminal, the nonwhite, the female, and all other embodiments of the unworthy. The clearest indication of the essential unity of this archive of images of the body lies in the fact that by the mid-nineteenth century a single hermeneutic paradigm had gained widespread prestige. This paradigm had two tightly entwined branches, physiognomy and phrenology. Both shared the belief that the surface of the body, and especially the face and head, bore the outward signs of inner character.

Accordingly, in reviving and to some extent systematizing physiognomy in the late 1770s, Johann Caspar Lavater argued that the "original language of Nature, written on the face of Man" could be deciphered by a rigorous physiognomic *science.*[15] Physiognomy analytically isolated the profile of the head and the various anatomic features of the head and face, assigning a characterological significance to each element: forehead, eyes, ears, nose, chin, etc. Individual character was judged through the loose concatenation of these readings. In both its analytic and synthetic stages, this interpretive process required that distinctive individual feature be read in conformity to type. Phrenology, which emerged in the first decade of the nineteenth century in the researches of the Viennese physician Franz Josef Gall, sought to discern correspondences between the topography of the skull and what were thought to be specific localized mental faculties seated within the brain. This was a crude forerunner of more modern neurological attempts to map out localized cerebral functions.

In general, physiognomy, and more specifically phrenology, linked an everyday nonspecialist empiricism with increasingly authoritative attempts to medicalize the study of the mind. The ambitious effort to construct a materialist science of the self led to the dissection of brains, including those of prominent phrenologists, and to the accumulation of vast collections of skulls. Eventually this effort would lead to a volumetrics of the skull, termed craniometry. But presumably any observant reader of one of the numerous handbooks and manuals of phrenology could master the interpretive codes. The humble origins of phrenological research were described by Gall in these terms:

I assembled a large number of persons at my house, drawn from the lowest classes and engaged in various occupations, such as fiacre driver, street porter and so on. I gained their confidence and induced them to speak frankly by giving them money and having wine and beer distributed to them. When I saw that they were favorably disposed, I urged them to tell me everything they knew about one another, both their good and bad qualities, and I carefully examined their heads. This was the origin of the craniological chart that was seized upon so avidly by the public; even artists took it over and distributed a large number among the public in the form of masks of all kinds.[16]

The broad appeal and influence of these practices on literary and artistic realism, and on the general culture of the mid-nineteenth-century city is well known.[17] And we understand the culture of the photographic portrait only dimly if we fail to recognize the enormous prestige and popularity of a general physiognomic paradigm in the 1840s and 1850s. Especially in the United States, the proliferation of photography and that of phrenology were quite coincident.

Since physiognomy and phrenology were comparative, taxonomic disciplines, they sought to encompass an entire range of human diversity. In this respect, these disciplines were instrumental in constructing the very archive they claimed to interpret. Virtually every manual deployed an array of individual cases and types along a loose set of "moral, intellectual, and animal" continua.[18] Thus zones of genius, virtue, and strength were charted only in relation to zones of idiocy, vice, and weakness. The boundaries between these zones were vaguely demarcated; thus it was possible to speak, for example, of "moral idiocy." Generally, in this pre-evolutionary system of difference, the lower zones shaded off into varieties of animality and pathology.

In the almost exclusive emphasis on the head and face we can discover the idealist secret lurking at the heart of these putatively materialistic sciences. These were discourses *of* the head *for* the head. Whatever the tendency of physiognomic or phrenologic thought—whether fatalistic or therapeutic in relation to the inexorable logic of the body's signs, whether uncompromisingly materialist in tone or vaguely spiritualist in relation to certain zones of the organic, whether republican or elitist in pedagogical stance—these disciplines would serve to legitimate on organic grounds the dominion of intellectual over manual labor. Thus physiognomy and phrenology contributed to the ideological hegemony of a capitalism that increasingly relied upon a hierarchical division of labor, a capitalism that applauded its own progress as the outcome of individual cleverness and cunning.

In claiming to provide a means for distinguishing the stigmata of vice from the shining marks of virtue, physiognomy and phrenology offered an essential hermeneutic service to a world of fleeting and often anonymous market transactions. Here was a method for quickly assessing the character of strangers in the dangerous and congested spaces of the nineteenth-century city. Here was a gauge of the intentions and capabilities of the other. In the United States in the 1840s, newspaper advertisements for jobs frequently requested that applicants submit a phrenological analysis.[19] Thus phrenology delivered the moral and intellectual "facts" that are today delivered in more "refined" and abstract form by psychometricians and polygraph experts.

Perhaps it is no surprise, then, that photography and phrenology should have met formally in 1846 in a book on "criminal jurisprudence." Here was an opportunity to lend a new organic facticity to the already established medical and psychiatric genre of the case study.[20] A phrenologically inclined American penal reformer and matron of the

From Eliza Farnham,
"Appendix" to Marmaduke
Sampson, *Rationale of Crime,*
1846

174 RATIONALE OF CRIME.

B. F.

B. F. is one of the inmates of the Long Island Farms. He is partially idiotic, and the very imperfect development of the superior portion of the brain, with the small size of the whole, clearly indicates the character of his mental capacities. It affords a striking contrast to the last drawing, R. A., and is in harmony with the actual difference between the minds of the two individuals. B. F. is vicious, cruel, and apparently incapable of any elevated or humane sentiments.

APPENDIX. 175

HEADS OF PERSONS POSSESSING SUPERIOR INTELLECT.

The following drawings are introduced for the purpose of showing the striking contrast between the cerebral developments of such persons as we have been describing and those who are endowed with superior powers of intellect and sentiment.

The two male heads are taken from the busts of gentlemen distinguished for ability, though differing widely in char

women's prison at Sing Sing, Eliza Farnham, commissioned Mathew Brady to make a series of portraits of inmates at two New York prisons. Engravings based on these photographs were appended to Farnham's new edition, entitled *Rationale of Crime,* of a previously unillustrated English work by Marmaduke Sampson. Sampson regarded criminal behavior as a form of "moral insanity." Both he and Farnham subscribed to a variant of phrenology that argued for the possibility of therapeutic modification or enhancement of organically predetermined characteristics. Presumably, good organs could be made to triumph over bad. Farnham's contribution is distinctive for its unabashed nonspecialist appeal. She sought to speak to "the popular mind of Republican America," in presenting an argument for the abolition of the death penalty and the establishment of a therapeutic system of treatment.[21] Her contribution to the book consisted of a polemical introduction, extensive notes, and several appendices, including the illustrated case studies. Farnham was assisted in her selection of case-study subjects by the prominent New York publisher-entrepreneur of phrenology, Lorenzo Fowler, who clearly lent further authority to the sample.

Ten adult prisoners are pictured, evenly divided between men and women. Three are identified as Negro, one as Irish, one as German; one woman is identified as a "Jewess of German birth," another as a "half-breed Indian and negro." The remaining three inmates are presumably Anglo-Saxon, but are not identified as such. A series of eight pictures of child inmates is not annotated in racial or ethnic terms, although one child is presumably black. Although Farnham professed a variant of phrenology that was not overtly racist—

unlike other pre-Darwinian head analysts who sought conclusive proof of the "separate creation" of the non-Caucasian races—this differential marking of race and ethnicity according to age is significant in other ways. After all, Farnham's work appeared in an American context—characterized by slavery and the beginnings of massive famine-induced immigration of Irish peasants—that was profoundly stratified along these lines. By marking children less in racial and ethnic terms, Farnham avoided stigmatizing them. Thus children in general were presented as more malleable figures than adults. Children were also presented as less weighted down by criminal biographies or by the habitual exercise of their worst faculties. Despite the fact that some of these boys were explicitly described as incorrigibles, children provided Farnham with a general figure of moral renewal. Because their potential for "respectability" was greater than that of the adult offenders, they were presented as miniature versions of their potential adult-male-respectable-Anglo-Saxon-proletarian selves. Farnham, Fowler, and Brady can be seen as significant inventors of that privileged figure of social reform discourse: the figure of the child rescued by a paternalistic medicosocial science.[22]

Farnham's concerns touch on two of the central issues of nineteenth-century penal discourse: the practical drawing of distinctions between incorrigible and pliant criminals, and the disciplined conversion of the reformable into "useful" proletarians (or at least into useful informers). Thus even though she credited several inmates with "well developed" intellects, and despite the fact that her detractors accused her of Fourierism, her reformist vision had a definite ceiling. This limit was defined quite explicitly by the conclusion of her study. There she underscored the baseness shared by all her criminal subjects by illustrating three "heads of persons possessing superior intellect" (two of which, both male, were treated as classical busts). Her readers were asked to note the "striking contrast."[23]

I emphasize this point because it is emblematic of the manner in which the criminal archive came into existence. That is, it was only on the basis of mutual comparison, on the basis of the tentative construction of a larger, "universal" archive, that zones of deviance and respectability could be clearly demarcated. In this instance of the first sustained application of photography to the task of phrenological analysis, it seems clear that the comparative description of the criminal body came first. The book ends with a self-congratulatory mirror held up to the middle-class reader. It is striking that the pictorial labor behind Farnham's criminal sample was that of Brady, who devoted virtually his entire antebellum career to the construction of a massive honorific archive of photographs of "illustrious," celebrated, and would-be celebrated American figures.[24]

Thus far I have described a number of early attempts, by turns comic, speculative, and practical, to bring the camera to bear upon the body of the criminal. I have also argued, following the general line of investigation charted in the later works of Foucault, that the position assigned the criminal body was a relative one, that the invention of the modern criminal cannot be dissociated from the construction of a law-abiding body—a body that was either bourgeois or subject to the dominion of the bourgeoisie. The law-abiding body recognized its threatening other in the criminal body, recognized its own acquisitive and aggressive impulses unchecked, and sought to reassure itself in two contradictory ways. The first was the invention of an exceptional criminal who was indistinguishable from the bourgeois, save for a conspicuous lack of moral inhibition: herein lay the figure of

the criminal genius.[25] The second was the invention of a criminal who was organically distinct from the bourgeois: a *biotype*. The science of criminology emerged from this latter operation.

A physiognomic code of visual interpretation of the body's signs—specifically the signs of the head—and a technique of mechanized visual representation intersected in the 1840s. This unified system of representation and interpretation promised a vast taxonomic ordering of images of the body. This was an archival promise. Its realization would seem to be grounded primarily in the technical refinement of strictly optical means. This turns out not to be the case.

I am especially concerned that exaggerated claims not be made for the powers of optical realism, whether in a celebratory or critical vein. One danger lies in constructing an overly monolithic or unitary model of nineteenth-century realist discourse. Within the rather limited and usually ignored field of instrumental scientific and technical realism, we discover a house divided. Nowhere was this division more pronounced than in the pursuit of the criminal body. If we examine the manner in which photography was made useful by the late-nineteenth-century police, we find plentiful evidence of a crisis of faith in optical empiricism. In short, we need to describe the emergence of a truth-apparatus that cannot be adequately reduced to the optical model provided by the camera. The camera is integrated into a larger ensemble: a bureaucratic-clerical-statistical system of "intelligence." This system can be described as a sophisticated form of the archive. The central artifact of this system is not the camera but the filing cabinet.

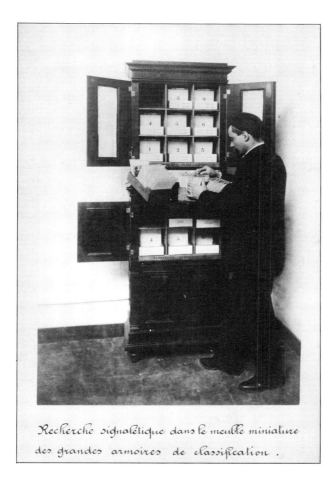

Recherche signalétique dans le meuble miniature des grandes armoires de classification.

From Alphonse Bertillon, *Service d'identification,* Exposition universelle de Chicago, 1893 (Album collection, National Gallery of Canada, Ottawa)

The institution of the photographic archive received its most thorough early articulation in precise conjunction with an increasingly professionalized and technological mode of police work and an emerging social science of criminology. This occurred in the 1880s and 1890s. Why was the model of the archive of such import for these linked disciplines?

In structural terms, the archive is both an abstract paradigmatic entity and a concrete institution. In both senses, the archive is a vast substitution set, providing for a relation of general equivalence between images. This image of the archive as an encyclopedic repository of exchangeable images was articulated most profoundly in the late 1850s by the American physician and essayist Oliver Wendell Holmes when he compared photographs to paper currency.[26] The capacity of the archive to reduce all possible sights to a single code of equivalence was grounded in the metrical accuracy of the camera. Here was a medium from which exact mathematical data could be extracted, or as the physicist François Arago put it in 1839, a medium "in which objects preserve mathematically their forms."[27] For nineteenth-century positivists, photography doubly fulfilled the Enlightenment dream of a universal language: the universal mimetic language of the camera yielded up a higher, more cerebral truth, a truth that could be uttered in the universal abstract language of mathematics. For this reason, photography could be accommodated to a Galilean vision of the world as a book "written in the language of mathematics." Photography promised more than a wealth of detail; it promised to reduce nature to its geometrical essence. Presumably then, the archive could provide a standard physiognomic gauge of the criminal, could assign each criminal body a relative and quantitative position within a larger ensemble.

This archival promise was frustrated, however, both by the messy contingency of the photograph and by the sheer quantity of images. The photographic archives' components are not conventional lexical units, but rather are subject to the circumstantial character of all that is photographable. Thus it is absurd to imagine a dictionary of photographs, unless one is willing to disregard the specificity of individual images in favor of some model of typicality, such as that underlying the iconography of Vesalian anatomy or of most of the plates accompanying the *Encyclopédie* of Diderot and d'Alembert. Clearly, one way of "taming" photography is by means of this transformation of the circumstantial and idiosyncratic into the typical and emblematic. This is usually achieved by stylistic or interpretive fiat, or by a sampling of the archive's offerings for a "representative" instance. Another way is to invent a machine, or rather a clerical apparatus, a filing system, which allows the operator/researcher/editor to retrieve the individual instance from the huge quantity of images contained within the archive. Here the photograph is not regarded as necessarily typical or emblematic of anything, but only as a particular image which has been isolated for purposes of inspection. These two semantic paths are so fundamental to the culture of photographic realism that their very existence is usually ignored.

The difference between these two models of photographic meaning are played out in two different approaches to the photographic representation of the criminal body: the "realist" approach, and by realism here I mean that venerable (medieval) philosophical realism that insists upon the truth of general propositions, on the reality of species and types, and the equally venerable "nominalist" approach, which denies the reality of generic categories as anything other than mental constructs. The first approach can be seen as overtly theoretical and "scientific" in its aims, if more covertly theoretical. Thus the

would-be scientists of crime sought a knowledge and mastery of an elusive "criminal type." And the "technicians" of crime sought knowledge and mastery of individual criminals. Herein lies a terminological distinction, and a division of labor, between "criminology" and "criminalistics." Criminology hunted "the" criminal body. Criminalistics hunted "this" or "that" criminal body.

Contrary to the commonplace understanding of the "mug shot" as the very exemplar of a powerful, artless, and wholly denotative visual empiricism, these early instrumental uses of photographic realism were systematized on the basis of an acute recognition of the *inadequacies* and limitations of ordinary visual empiricism. Thus two systems of description of the criminal body were deployed in the 1880s; both sought to ground photographic evidence in more abstract *statistical* methods. This merger of optics and statistics was fundamental to a broader integration of the discourses of visual representation and those of the social sciences in the nineteenth century. Despite a common theoretical source, the intersection of photography and statistics led to strikingly different results in the work of two different men: Alphonse Bertillon and Francis Galton.

The Paris police official Alphonse Bertillon invented the first effective modern system of *criminal identification*. His was a bipartite system, positioning a "microscopic" individual record within a "macroscopic" aggregate. First, he combined photographic portraiture, anthropometric description, and highly standardized and abbreviated written notes on a single *fiche,* or card. Second, he organized these cards within a comprehensive, statistically based filing system.

The English statistician and founder of eugenics Francis Galton invented a method of composite portraiture. Galton operated on the periphery of criminology. Nonetheless, his interest in heredity and racial "betterment" led him to join in the search for a biologically determined "criminal type." Through one of his several applications of composite portraiture, Galton attempted to construct a *purely optical* apparition of the criminal type. This photographic impression of an abstract, statistically defined, and empirically nonexistent criminal face was both the most bizarre and the most sophisticated of many concurrent attempts to marshall photographic evidence in the search for the essence of crime.

The projects of Bertillon and Galton constitute two methodological poles of the positivist attempts to define and regulate social deviance. Bertillon sought to individuate. His aims were practical and operational, a response to the demands of urban police work and the politics of fragmented class struggle during the Third Republic. Galton sought to visualize the generic evidence of hereditarian laws. His aims were theoretical, the result of eclectic but ultimately single-minded curiosities of one of the last Victorian gentleman-amateur scientists. Nonetheless, Bertillon's work had its own theoretical context and implications, just as Galton's grimly playful research realized its practical implications in the ideological and political program of the international eugenics movement. Both men were committed to technologies of demographic regulation. Bertillon's system of criminal identification was integral to the efforts to quarantine permanently a class of habitual or professional criminals. Galton sought to intervene in human reproduction by means of public policy, encouraging the propagation of the "fit" and discouraging or preventing outright that of the "unfit."

The idealist proclivities, territorialism, and status consciousness of intellectual history have prevented us from recognizing Bertillon and Galton's shared ground. While Galton has been considered a proper, if somewhat eccentric, object of the history of science, Bertillon remains an ignored mechanic and clerk, commemorated mostly by anecdotal historians of the police.

In order to explore this terrain shared by a police clerk and gentleman statistician, I need to introduce a third figure. Both Bertillon's and Galton's projects were grounded in the emergence and codification of *social statistics* in the 1830s and 1840s. Both relied upon the central conceptual category of social statistics: the notion of the "average man" (*l'homme moyen*). This concept was invented (I will argue shortly that it was actually reinvented) by the Belgian astronomer and statistician Adolphe Quetelet. Although less well remembered than Auguste Comte, Quetelet is the most significant other early architect of sociology. Certainly he laid the foundations of the quantitative paradigm in the social sciences. By seeking statistical regularities in rates of birth, death, and crime, Quetelet hoped to realize the Enlightenment philosopher Condorcet's proposal for a "social mathematics," a mathematically exact science that would discover the fundamental laws of social phenomena. Quetelet helped to establish some of the first actuarial tables used in Belgium and to found in 1853 an international society for the promotion of statistical methods. As the philosopher of science Ian Hacking has suggested, the rise of social statistics in the mid-nineteenth century was crucial to the replacement of strictly mechanistic theories of causality by a more probabilistic paradigm. Quetelet was a determinist, but he invented a determinism based on iron laws of chance. This emergent paradigm would lead eventually to indeterminism.[28]

Who, or what, was the average man? A less flippant query would be, *how* was the average man? Quetelet introduced this composite character in his 1835 treatise *Sur l'homme*. He argued that large aggregates of social data revealed a regularity of occurrence that could only be taken as evidence of determinate social laws. This regularity had political and moral as well as epistemological implications:

> The greater the number of individuals observed, the more do individual peculiarities, whether physical or moral, become effaced, and leave in a prominent point of view the general facts, by virtue of which society exists and is preserved.[29]

Quetelet sought to move from the mathematicization of individual bodies to that of society in general. In *Sur l'homme* he charted various quantitative biographies of the productive and reproductive powers of the average man and woman. For example, he calculated the fluctuation of fecundity with respect to female age. Using data from dynamometer studies, he charted the average muscular power of men and women of different ages. At the level of the social aggregate, life history read as a graphic curve. (Here was prefiguration, in extreme form, of Zola's naturalism: a subliterary, quantitative narrative of the generalized social organism.)

Just as Quetelet's early statistical contributions to the life insurance industry can be seen as crucial to the regularization of that organized form of gambling known as finance capital, so also his charting of the waxing and waning of human energies can be seen as an attempt to conceptualize that Hercules of industrial capitalism, termed by Marx the "average worker," the abstract embodiment of labor power in the aggregate.[30] And outside the sphere of waged work, Quetelet invented but did not name the figure of the average mother, crucial to the new demographic sciences which sought nervously to chart the relative numeric strengths of class against class and nation against nation.

For Quetelet the most emphatic demonstration of the regularity of social phenomena was given by crime statistics. "Moral statistics" provided the linchpin for his construction of a "social physics" that would demolish the prestige of moral paradigms grounded in free will. The criminal was no more than an agent of determining social forces. Furthermore, crime statistics provided the synecdochic basis for a broader description of the

social field. As Louis Chevalier has argued, Quetelet inaugurated a "quantitative description which took criminal statistics as the starting point for a description of urban living as a whole."[31] Chevalier has argued further that criminal statistics contributed thus to a pervasive bourgeois conception of the essentially *pathological* character of metropolitan life, especially in the Paris of the July Monarchy. Quetelet's terminological contribution to this medicalization of the social field is evident in his reference to the statistical study of crime as a form of "moral anatomy."

Quetelet refined his notion of the "average man" with conceptual tools borrowed from astronomy and probability theory. He observed that large aggregates of social data—notably anthropometric data—fell into a pattern corresponding to the bell-shaped curve derived by Gauss in 1809 in an attempt to determine accurate astronomical measurements from the distribution of random errors around a central mean. Quetelet came to regard this symmetrical binomial curve as the mathematical expression of fundamental social law. While he admitted that the average man was a statistical fiction, this fiction lived within the abstract configuration of the binomial distribution. In an extraordinary metaphoric conflation of individual difference with mathematical error, Quetelet defined the central portion of the curve, that large number of measurements clustered around the mean, as a zone of normality. Divergent measurements tended toward darker regions of monstrosity and biosocial pathology.[32]

Thus conceived, the "average man" constituted an ideal, not only of social health, but of social stability and of beauty. In interesting metaphors, revealing both the astronomical sources and aesthetico-political ambitions inherent in Quetelet's "social physics," he defined the social norm as a "center of gravity," and the average man as "the type of all which is beautiful—of all which is good."[33] Crime constituted a "perturbing force," acting to throw the delicate balance of this implicitly republican social mechanism into disarray. Although Quetelet was constructing a quantitative model of civil society and only indirectly describing the contours of an ideal commonwealth, his model of a gravitational social order bears striking similarity to Hobbes's Leviathan.[34]

Like Hobbes, Quetelet began with atomized individual bodies and returned to the image of the body in describing the social aggregate. Quetelet worked, however, in a climate of physiognomic and phrenologic enthusiasm, and indeed early social statistics can be regarded as a variant of physiognomy writ large. For example, Quetelet accepted, despite his republicanism, the late-eighteenth-century notion of the *cranial angle,* which, as George Mosse has argued, emerges from the appropriation by preevolutionary Enlighten-

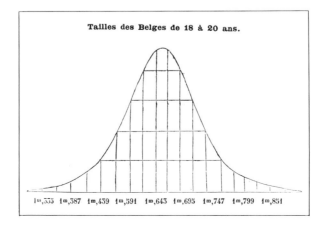

Tailles des Belges de 18 à 20 ans.

1ᵐ,335 1ᵐ,387 1ᵐ,439 1ᵐ,591 1ᵐ,643 1ᵐ,695 1ᵐ,747 1ᵐ,799 1ᵐ,851

From Adolphe Quetelet, *Physique sociale, ou Essai sur le développement des facultés de l'homme,* 1869

ment anthropology of the classicist idealism of Wincklemann.[35] Based in part on the art-historical evidence of noble Grecian foreheads, this racist geometrical fiction defined a descending hierarchy of head types, with presumably upright Caucasian brows approaching this lost ideal more closely than did the presumably apelike brows of Africans. For his part, Quetelet was less interested in a broadly racist physical anthropology than in detecting within European society patterns of bodily evidence of deviation from "normality." It is understandable that he would be drawn to those variants of physiognomic thought which sought to systematize the body's signs in terms of a quantifying geometrical schema. From Quetelet on, biosocial statisticians became increasingly absorbed with *anthropometrical* researches, focusing on both the skeletal proportions of the body and the volume and configuration of the head.[36] The inherited idealist fascination with the upright forehead can be detected even in Quetelet's model of an ideal society: he argued that social progress would lead to a diminished number of defective and inferior cases, thus increasing the zone of normality. If we consider what this utopian projection meant in terms of the binomial curve, we have to imagine an increasingly peaked, erect configuration: a classical ideal to a fault.

Certainly physiognomy provided a discursive terrain upon which art and the emerging biosocial sciences met during the middle of the nineteenth century. Quetelet's explicitly stated enthusiasm for the model of artistic practice is understandable in this context, but the matter is more complicated. Despite the abstract character of his procedures, Quetelet possessed the aesthetic ambition to compare his project to Dürer's studies of human bodily proportion. The statistician argued that his "aim had been, not only to go once more through the task of Albert [sic] Dürer, but to execute it also on an extended scale."[37] Thus visual empiricism retained its prestige in the face of a new object—society—that could in no way be effectively or comprehensively visualized.[38]

By the end of the nineteenth century, this essentially *organismic* model of a *visible* social field was in crisis. The terms of Quetelet's honorific linkage of an emergent statistics to a venerable optical paradigm were explicitly reversed. The French sociologist Gabriel Tarde argued in 1883 that "a statistical bureau might be compared to an eye or ear," claiming further that "each of our senses gives us, in its own way and from its special point of view, the statistics of the external world. Their characteristic sensations are in a certain way their special graphical tables. Every sensation . . . is only a number."[39] Here the transition is made from the prestige of the visual and the organic to the prestige of institutionalized, bureaucratic abstraction.

Tarde was a central figure, not only in the demise of organismic models of society, but also in the development of a French school of criminological thought during the 1880s. Tarde was a magistrate during his early career, and by 1894 became the head of the Bureau of Statistics within the Department of Justice in Paris, which made him the abstract overseer of the quantitative ebbs and flows of a regulated criminality. His background in legal theory and practice led him to attempt a criticism and modification of Quetelet's extreme determinism, which had absolved the criminal of all responsibility. After all, classical legal theory was not about to abandon its ideological capacity to uphold the state's right to punish criminals for their deeds. In 1890 Tarde advanced a notion of "criminal responsibility" based upon the continuity of individual identity within a shared social milieu, a milieu of "social similiarity." Tarde's psychological model of individuality assumed an essential internal narrative coherence of the self: "Identity is the permanence of the person, it is the personality looked at from the point of view of its duration."[40]

Tarde's rather nominalist approach to the philosophy of crime and punishment paralleled a more practical formulation by Alphonse Bertillon, director of the Identification Bureau of the Paris Prefecture of Police. In 1893 Bertillon offered the following introduction to his system, then in use for ten years, known variously as "Bertillonage" and the "signaletic notice":

In prison practice the signaletic notice accompanies every reception and every delivery of a human individuality; this register guards the trace of the real, actual presence of the person sought by the administrative or judicial document. . . . [The] task is always the same: to preserve a sufficient record of a personality to be able to *identify* the present description with one which may be presented at some future time. From this point of view signalment is the best instrument for the *proof of recidivation,* which necessarily implies the *proof of identity.*[41]

In effect, then, Bertillon's police archive functioned as a complex biographical machine that produced presumably simple and unambiguous results. He sought to identify repeat offenders, that is, criminals who were liable to be considered "habitual" or "professional" in their deviant behavior. The concern with recidivism was of profound social importance in the 1880s. Bertillon, however, professed no theory of a criminal type, nor of the psychic continuities or discontinuities that might differentiate "responsible" criminals from "irresponsible" criminals. He was sensitive to the status hierarchy between his Identification Bureau and the more "theoretical" mission of the Bureau of Statistics. (Bertillon was the son of a prominent anthropometrician, Louis Adolphe Bertillon, and seems to have labored mightily to vindicate himself after an inauspicious start as a mere police clerk.) He was more a social engineer, an inventive clerk-technician, than a criminologist. He sought to ground police work in scientific principles, while recognizing that most police operatives were unfamiliar with consistent and rigorous empirical procedures. Part of his ambition was to accelerate the work of processing criminals and to employ effectively the labors of unskilled clerks. He resembles in many respects his American contemporary, Frederick Winslow Taylor, the inventor of scientific management, the first system of modern factory discipline. Bertillon can be seen, like Taylor, as a prophet of rationalization. Here is Bertillon describing the rapidity of his process: "Four pairs of police officers suffice, at Paris, for the measurement, every morning between nine o'clock and noon, of from 100 to 150 men who were arrested the day before."[42] Ultimately, this was not fast enough, and therein lay a principal reason for the demise, some thirty years later, of the Bertillon system.

How did the Bertillon system work? The problems with prior attempts at criminal identification were many. The early promise of photography had faded in the face of a massive and chaotic archive of images. The problem of *classification* was paramount:

The collection of criminal portraits has already attained a size so considerable that it has become physically impossible to discover among them the likeness of an individual who has assumed a false name. It goes for nothing that in the past ten years the Paris police have collected more than 100,000 photographs. Does the reader believe it practicable to compare successively each of these with each one of the 100 individuals who are arrested daily in Paris? When this was attempted in the case of a criminal particularly easy to identify, the search demanded more than a week of application, not to speak of the errors and oversights which a task so fatiguing to the eye could not fail to occasion. There was a need for a method of elimination analogous to that in use in botany and zoology; that is to say, one based on the characteristic elements of individuality.[43]

Despite the last part of this remark, Bertillon sought not to relate individual to species, but to extract the individual from the species. Thus he invented a classifying scheme that

[handwritten margin note:] freezes and objectifies, but makes important plm effect. While maybe not labelled — photographed — they were when put in an archive.

y

ALLAN SEKULA

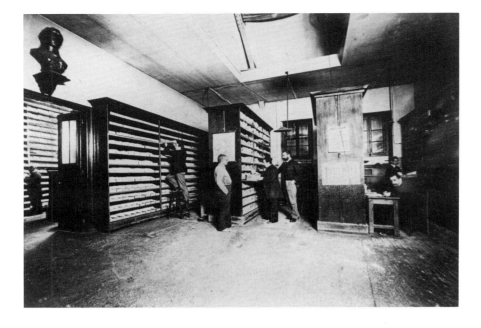

Classification cabinets, Paris Prefecture of Police. From Alphonse Bertillon, *Service d'identification,* Exposition universelle de Chicago, 1893.

was based less upon a taxonomic categorization of types than upon an ordering of individual cases within a segmented aggregate. He had failed miserably in an earlier attempt to classify police photographs according to the genre of offense, for obvious reasons.[44] Criminals may have constituted a "professional type," as Tarde argued, but they did not necessarily observe a narrow specialization in their work.

Bertillon sought to break the professional criminal's mastery of disguises, false identities, multiple biographies, and alibis. He did this by yoking anthropometrics, the optical precision of the camera, a refined physiognomic vocabulary, and statistics.

First Bertillon calculated, without a very sophisticated grasp of the calculus of probabilities, that the chance that two individuals might share the same series of eleven bodily measurements ran on the order of one in four million.[45] He regarded these eleven measurements as constant in any adult body. His signaletic notice linked this "anthropometrical signalment," recorded as a numerical series, with a shorthand verbal description of distinguishing marks and a pair of photographic portraits, both frontal and profile views.

Bertillon's second problem was the organization of individual cards in a comprehensive system from which records could be retrieved in short order. To this end, Bertillon enlisted the prodigious rationalizing energies of Quetelet's "average man." By organizing his measurements into successive subdivisions, each based on a tripartite separation of below-average, average, and above-average figures, Bertillon was able to file 100,000 records into a grid of file drawers, with the smallest subset within any one drawer consisting of approximately a dozen identification cards. Having thus separately processed 100,000 male and 20,000 female prisoners over the decade between 1883 and 1893, Bertillon felt confident in boasting that his system was "infallible." He had in the process "infallibly" identified 4,564 recidivists.[46]

Bertillon can be said to have realized the binomial curve as office furniture. He is one of the first users of photographic documents to comprehend fully the fundamental problem of the archive, the problem of volume. Given his recourse to statistical method, what semantic value did he find in photographs? He clearly saw the photograph as the final conclusive sign in the process of identification. Ultimately, it was the photographed face

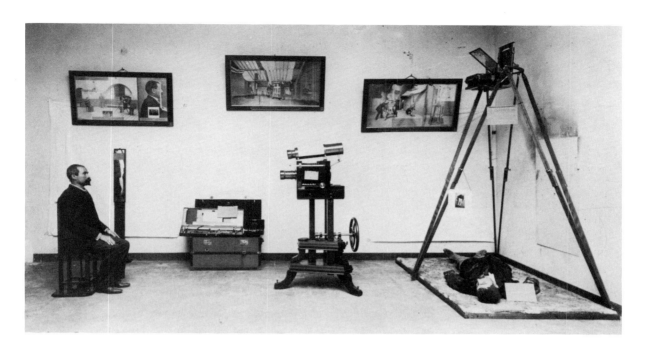

Display of apparatus, Chicago
Exposition, 1893

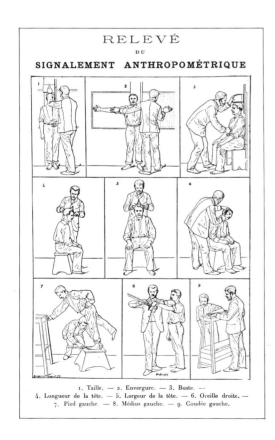

Frontispiece from Alphonse
Bertillon, *Identification
anthropométrique*, 1893

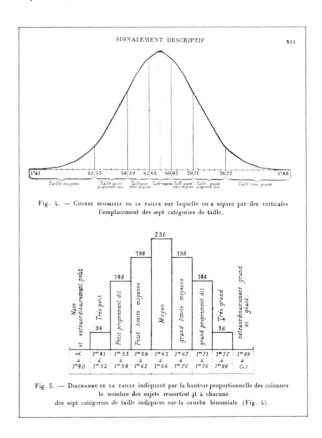

Figures from Alphonse
Bertillon, *Identification
anthropométrique*, 1893

pulled from the file that had to match the rephotographed face of the suspect, even if this final "photographic" proof was dependent upon a series of more abstract steps.

Bertillon was critical of the inconsistent photography practiced by earlier police technicians and jobbers. He argued at length for an aesthetically neutral standard of representation:

In commercial and artistic portraits, questions of fashion and taste are all important. Judicial photography, liberated from these considerations, allows us to look at the problem from a more simple point of view: which pose is theoretically the best for such and such a case?[47]

Bertillon insisted on a standard focal length, even and consistent lighting, and a fixed distance between the camera and the unwilling sitter. The profile view served to cancel the contingency of expression; the contour of the head remained consistent with time. The frontal view provided a face that was more likely to be recognizable within the other, less systematized departments of police work. These latter photographs served better in the search for suspects who had not yet been arrested, whose faces were to be recognized by detectives on the street.

Just as Bertillon sought to classify the photograph by means of the Vitruvian register of the anthropometrical signalment and the binomial curve, so also he sought to translate the signs offered by the photograph itself into another, verbal register. Thus he was engaged in a two-sided, internal and external, taming of the contingency of the photograph. His invention of the *portrait-parlé*—the "speaking likeness" or verbal portrait—was an attempt to overcome the inadequacies of a purely visual empiricism. He organized voluminous taxonomic grids of the features of the male human head, using sectional photographs. He devoted particular attention to the morphology of the ear, repeating a physiognomic fascination with that organ that extended back to Lavater.[48] But on the basis of this comparative anatomy, Bertillon sought to reinvent physiognomy in precise nonmetaphysical, ethnographic terms. Through the construction of a strictly denotative signaletic vocabulary, this project aimed for the precise and unambiguous translation of appearance into words.

For Bertillon, the criminal body expressed nothing. No characterological secrets were hidden beneath the surface of this body. Rather, the surface and the skeleton were indices of a more strictly material sort. The anthropometrical signalment was the register of the morphological constancy of the adult skeleton, thus the key to biographical identity. Likewise, scars and other deformations of the flesh were clues, not to any innate propensity for crime, but to the body's physical history: its trades, occupations, calamities.

For Bertillon, the mastery of the criminal body necessitated a massive campaign of *inscription,* a transformation of the body's signs into a *text,* a text that pared verbal description down to a denotative shorthand, which was then linked to a numerical series. Thus Bertillon arrested the criminal body, determined its identity as a body that had *already* been defined as criminal, by means that subordinated the image—which remained necessary but insufficient—to verbal text and numerical series. This was not merely a self-contained archival project. We can understand another, more global, imperative if we remember that one problem for the late-nineteenth-century police was the telegraphic transmission of information regarding suspects. The police were competing with opponents who availed themselves of the devices of modernity as well, including the railroad.

Why was the issue of recidivism so important in France during the 1880s? Robert Nye has argued recently that the issue emerged on the political agenda of Gambettist Republicans during the Third Republic, leading to the passage of the Relegation Law of 1885,

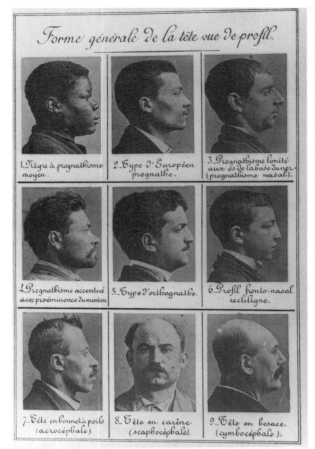

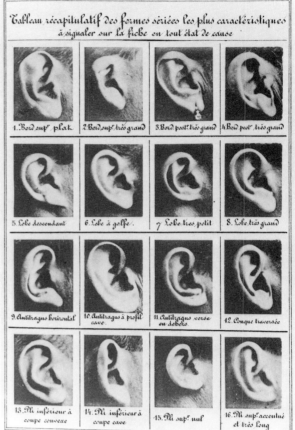

which established a Draconian policy of colonial transport for repeat offenders. The bill worked out a variable quota of misdemeanors and felonies, including vagabondage, that could lead to permanent exile in Guyana or New Caledonia. The French agricultural crisis had led to a renewed massive urban influx of displaced peasants during the 1880s. The recidivism debate focused on the social danger posed by the vagrant, while also seeing the milieu of the chronically unemployed urban poor as a source of increased criminality. Not least in provoking the fears of the defenders of order was the evidence of renewed working-class militancy in the strike wave of 1881, after a decade of peace purchased by the slaughter of the Communards. At its most extreme, the debate on recidivism combined the vagabond, the anarchist, and the recidivist into a single composite figure of social menace.[49]

Bertillon himself promoted his system within the context of this debate. Having only succeeded in identifying his first recidivist in February of 1883, he quickly argued that his binomial classification system would be essential to the application of any law of relegation. He described a Parisian working-class milieu that was undergoing what might facetiously be called a "crisis of identity." During the Commune, all city records prior to 1859 had been burned; any Parisian over twenty-two years old was at liberty to invent and reinvent an entirely bogus nativity. Furthermore, Bertillon claimed that there was an

extraordinary traffic in false documents, citing the testimony of foremen at the more "insalubrious" industrial establishments—white lead and fertilizer factories, for example—that job applicants frequently reappeared two weeks after being rejected with entirely new papers and different names.[50] In effect, Bertillon sought to reregister a social field that had exploded into multiplicity.

One curious aspect of Bertillon's reputation lies in the way in which his method, which runs counter to any metaphysical or essentialist doctrine of the self, could be regarded as a triumph of humanism. One biographer put it this way: "A man of his type inevitably found a kind of romance in a technique the aim of which was to individualize human beings."[51] Bertillon himself contributed to this "humane" reading of his project: "Is it not at bottom a problem of this sort that forms the basis of the everlasting popular melodrama about lost, exchanged, and recovered children?"[52] But in more technical and theoretical contexts, the degree to which Bertillonage actually eroded the "uniqueness" of the self became clear. Writing with a coauthor in 1909, Bertillon noted that according to the logic of the binomial curve, "each observation or each group of observations is to be defined, not by its absolute value, but by its deviation from the arithmetic mean."[53] Thus even the nominalist Bertillon was forced to recognize the higher reality of the "average man." The individual could be identified only by invoking the powers of this genie. And the individual existed *as an individual* only by being identified. Individuality as such had no meaning. Viewed "objectively," the self occupied a position that was wholly relative.

The Bertillon system proliferated widely, receiving an enthusiastic reception, especially in the United States, and contributing to the internationalization and standardization of police methods. The anthropometric system faced competition from the fingerprint system, a more radically synecdochic procedure, invented in part by Francis Galton, who had interests in identification as well as typology. With the advent of fingerprinting, it became evident that the body did not have to be "circumscribed" in order to be identified. Rather, the key to identity could be found in the merest trace of the body's tactile presence in the world. Furthermore, fingerprinting was more promising in a Taylorist sense, since it could be properly executed by less-skilled clerks. By the late nineteen-tens, the Bertillon system had begun to yield to this more efficient and less cumbersome method, although hybrid systems operated for some years.[54]

For Bertillon, the type existed only as a means for refining the description of individuality. Detectives could not afford not to be nominalists. Bertillon was not alone in this understanding of the peculiarities of the policeman's search for the specificity of crime. For example, the New York City detective chief Thomas Byrnes published in 1886 a lavish "rogues' gallery" entitled *Professional Criminals of America*. Although Byrnes practiced a less systematic mode of photography than did Bertillon, he clearly articulated the position that classical physiognomic typing was of no value whatsoever in the hunt for the "higher and more dangerous order" of criminals, who "carried no suggestion of their calling about them."[55] In Bertillon's case, the resistance to the theory of a *biologically given* criminal type was also in keeping with the general drift of late-nineteenth-century French criminological theory, which stressed the importance of environmental factors in determining criminal behavior. Thus the "French school," notably Gabriel Tarde and Alexandre Lacassagne, opposed the biological determinism of the "Italian school" of criminal anthropology, which centered on the anatomist-craniometrician Cesare Lombroso's quasi-Darwinian theory of the criminal as an "atavistic being who reproduces in his person the

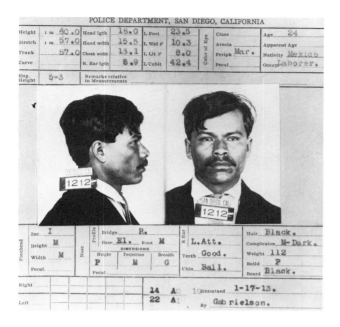

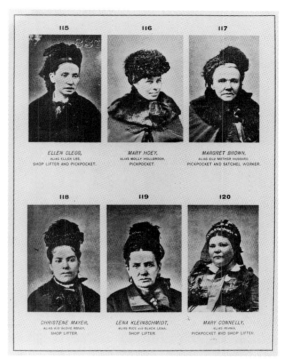

ferocious instincts of primitive humanity and the inferior animals." [56] Against this line of reasoning, Lacassagne argued that "the social milieu is the mother culture of criminality; the microbe is the criminal." [57] (In this context, it is worth noting the mutual admiration that passed between Pasteur, the microbe hunter, and Bertillon, the hunter of recidivists. [58]) The French were able to medicalize crime while simultaneously pointing to environmental factors. A range of positions emerged, some more medical, some more sociological in emphasis. Tarde insisted that crime was a profession that proliferated through channels of imitative behavior. Others argued that the criminal was a "degenerate type," suffering more than noncriminals from the bad environmental effects of urbanism. [59]

Despite the acute differences between the warring factions of the emerging criminological profession, a common enthusiasm for photographic illustration of the criminal type was shared by almost all of the practitioners, with the notable exception of Tarde, who shunned the lowly empiricism of the case study for more lofty, even if nominalist, meditations on the problem of crime. Before looking at Francis Galton's peculiar contribution to the search for a criminal type, I will note that during the 1890s in particular, a profusion of texts appeared in France and Italy offering photographic evidence of basic criminal types. Although the authors were frequently at odds with one another over the "atavistic" or "degenerate" nature of the criminal, on a more fundamental level they shared a common battle. This was a war of representations. The photograph operated as the *image* of scientific truth, even in the face of Bertillon's demonstration of the inadequacies of the medium. Photographs and technical illustrations were deployed, not only

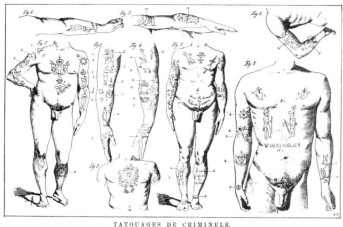

TATOUAGES DE CRIMINELS.

364 | 365

against the body of the representative criminal, but also against that body as a bearer and producer of its own, inferior representations. These texts can be seen as a battle between the camera and the tattoo, the erotic drawing, and the graffiti of a prison subculture. For Lombroso, tattooing was a particular mark of atavism, since criminals shared the practice with presumably less evolved tribal peoples. But even works that sought to demolish Lombroso's dogmatic biologism established a similar hierarchy. Scientific rationalism *looked down* at the visual products of a *primitive* criminality. This was a quasi-ethnologic discourse. Consider, for example, a work that argued against atavism and for degeneracy, Charles Marie Debierre's typologically titled *Le crâne des criminels*. This book contained an illustrated chapter treating "les beaux-arts dans les prisons" as subject matter for the psychological study of the criminal. A subsequent chapter offered a set of photographs of the severed heads of convicts, "taken one quarter of an hour after decapitation." Faced with these specimens of degeneracy, this physiognomist of the guillotine remarked: "Degroote and Clayes . . . their dull faces and wild eyes reveal that beneath their skulls there is no place for pity." Works of this sort depended upon an extreme form of statistical inference: basing physiognomic generalizations on very limited samples.[60]

This brings us finally to Francis Galton, who attempted to overcome the limitations of this sort of inferential reading of individual case studies.

Where Bertillon was a compulsive systematizer, Galton was a compulsive quantifier. While Bertillon was concerned primarily with the triumph of social order over social disorder, Galton was concerned primarily with the triumph of established rank over the forces of social leveling and decline. Certainly these were not incompatible projects. On a theoretical plane, however, Galton can be linked more closely to the concerns of the Italian school of criminal anthropology and to biological determinism in general. Com-

posite images based on Galton's procedure, first proposed in 1877, proliferated widely over the following three decades. A composite of criminal skulls appears in the albums of the 1895 French edition and the 1896–97 Italian edition of Lombroso's *Criminal Man.* Likewise, Havelock Ellis's *The Criminal,* which adhered to the positions of the Italian school and marked the high tide of Lombrosoism in England, bore a Galtonian frontispiece in its first, 1890 edition.[61]

Both Galton and his quasi-official biographer, the statistician Karl Pearson, regarded the composite photograph as one of the central intellectual inventions of Galton's career. More recent studies of Galton have tended to neglect the importance attached to what now seems like an optical curiosity.[62]

Galton is significant in the history of science for developing the first statistical methods for studying heredity.[63] His career was suspended between the triumph of his cousin Charles Darwin's evolutionary paradigm in the late 1860s and the belated discovery in 1899 of Gregor Mendel's work on the genetic ratio underlying inheritance. Politically, Galton sought to construct a program of social betterment through breeding. This program pivoted on a profoundly ideological *biologization* of existing class relations in England. Eugenicists justified their program in utilitarian terms: by seeking to reduce the numbers of the "unfit," they claimed to be reducing the numbers of those predestined to unhappiness. But the eugenics movement Galton founded flourished in a historical context—similar in this respect to Third Republic France—of declining middle-class birthrates coupled with middle-class fears of a burgeoning residuum of degenerate urban poor.[64]

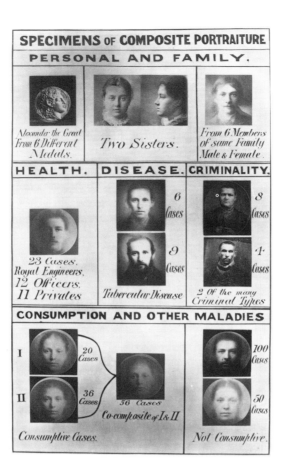

Frontispiece from Francis Galton, *Inquiries into Human Faculty*, 1883

The composite apparatus, from Francis Galton, *Inquiries into Human Faculty*, 1883

Galton's early, 1869 work *Hereditary Genius* was an attempt to demonstrate the priority, in his words, of "nature" over "nurture" in determining the quality of human intelligence. In a rather tautological fashion, Galton set out to demonstrate that a reputation for intelligence amounted to intelligence and that men with (reputations for) intelligence begat offspring with (reputations for) intelligence. He appropriated Quetelet's binomial distribution, observing that the entrance examination scores of military cadets at Sandhurst fell into a bell-shaped pattern around a central mean. On the basis of this "naturalizing" evidence, he proposed a general quantitative hierarchy of intelligence and applied it to racial groups. This hierarchy was characterized by a distinct classicist longing: "The average ability of the Athenian race is, on the lowest possible estimate, very nearly two grades higher than our own—that is, about as much as our race is above that of the African negro."[65] Eugenics can be seen as an attempt to push the English social average toward an imaginary, lost Athens and away from an equally imaginary, threatening Africa.

Galton's passion for quantification and numerical ranking coexisted with a qualified faith in physiognomic description. His writings demonstrate a remarkable parallelism and tension between the desire to measure and the desire to look. His composites emerged from the attempt to merge optical and statistical procedures within a single "organic" operation. Galton's *Inquiries into Human Faculty* of 1883 began by suggesting some of the limitations of prior—and subsequent—attempts at physiognomic typing:

The physiognomical difference between different men being so numerous and small, it is impossible to measure and compare them each to each, and to discover by ordinary statistical methods the true physiognomy of a race. The usual way is to select individuals who are judged to be representative of the prevalent type, and to photograph them; but this method is not trustworthy, because the judgment itself is fallacious. It is swayed by exceptional and grotesque features more than by ordinary ones, and the portraits supposed to be typical are likely to be caricatures.[66]

This book was a summary of Galton's researches over the preceding fifteen years. From this initial criticism of a more physiognomic stance, Galton moved directly to an outline of his composite method. The composite frontispiece and the recurrent references in various contexts throughout the book to lessons to be learned from the composites suggest that Galton believed that he had invented a prodigious epistemological tool. Accordingly, his interest in composite imagery should not be regarded as a transparent ideological stunt, but as an overdetermined instance of biopositivism.

How did Galton produce his blurred, fictitious apparitions? How did he understand them? He acknowledged at the outset of his experiments Herbert Spencer's prior proposal for a similar process of superimposition. Spencer's organismic conception of society can be seen as fertile soil for the notion of a generalized body, although in this case Spencer seems to have been drawn to the notion of a composite through a youthful fascination with phrenology.[67] But Galton was concerned also with the psychology of the visual imagination, with the capacity of the mind to construct generic images from sense data. Here he found his inspiration in Thomas Huxley. He claimed in fact that the composite photographic apparatus shared, and ultimately surpassed, the capacity of artistic intelligence to generalize. Here, as with Quetelet, one witnesses the statistician as artist manqué.

Galton fabricated his composites by a process of successive registration and exposure of portraits in front of a copy camera holding a single plate. Each successive image was given a fractional exposure based on the inverse of the total number of images in the sample. That is, if a composite were to be made from a dozen originals, each would receive one-twelfth of the required total exposure. Thus, individual distinctive features, features that were unshared and idiosyncratic, faded away into the night of underexposure. What remained was the blurred, nervous configuration of those features that were held in common throughout the sample. Galton claimed that these images constituted legitimate averages, and he claimed further that one could infer larger generalities from the small sample that made up the composites. He proposed that "statistical constancy" was attained after "thirty haphazard pictures of the same class [had] been combined."[68]

Galton made more expansive claims for his process, which he has described as a form of "pictorial statistics":

Composite pictures are . . . much more than averages; they are rather the equivalents of those large statistical tables whose totals, divided by the number of cases and entered on the bottom line, are the averages. They are real generalizations, because they include the whole of the material under consideration. The blur of their outlines, which is never great in truly generic composites, except in unimportant details, measures the tendency of individuals to deviate from the central type.[69]

In this passage the tension between claims for empirical specificity and claims for generality reaches the point of logical rupture: what are we to make of this glib slide from "they include the whole" to "except unimportant details"? In his search for a type, Galton did not believe that anything *significant* was lost in underexposure. This required an unacknowledged presupposition: only the gross features of the head mattered. Ears, for example, which were highly marked as signs in other physiognomic systems, both as individuating *and* as typical features, were not registered at all by the composite process. (Later Galton sought to "recapture" small differences or "unimportant details" by means of a technique he called "analytical photography," which superimposed positive and negative images, thereby isolating their unshared elements.[70])

Just as he had acknowledged Quetelet as a source for his earlier ranking of intelligence, so Galton claimed that the composite photograph produced an improved impression of *l'homme moyen:*

The process . . . of pictorial statistics [is] suitable to give us generic pictures of man, such as Quetelet obtained in outline by the ordinary numerical methods of statistics, as described in his work on *Anthropométrie.* . . . By the process of composites we obtain a picture and not a mere outline.[71]

In effect Galton believed that he had translated the Gaussian error curve into pictorial form. The symmetrical bell curve now wore a human face. This was an extraordinary hypostatization. Consider the way in which Galton conveniently exiled blurring to the *edges* of the composite, when in fact blurring would occur over the entire surface of the image, although less perceptibly. Only an imagination that wanted to *see* a visual analogue of the binomial curve would make this mistake, finding the type at the center and the idiosyncratic and individual at the outer periphery.

The frontispiece to *Inquiries into Human Faculty* consists of eight sets of composites. Galton describes these images as an integrated ensemble in his text, in what amounts to an illustrated lecture on eugenics. The first, upper left composite of six portrait medallions of Alexander the Great serves Galton as an introductory, epistemological bench-

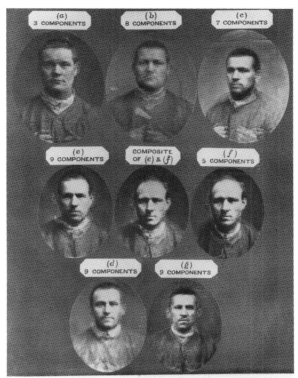

Francis Galton, *Criminal Composites*, c. 1878. Plate 27 from Karl Pearson, *The Life, Letters and Labours of Francis Galton*, vol. 2, 1924.

mark, not only to the series, but to the entire book. Oblivious to issues of style or artistic convention, Galton assumed that individual engravers had erred in various ways in their representations. The composite, according to a Gaussian logic of averaged measurements, would contain a "truer likeness." An unspoken desire, however, lurks, behind this construction. Galton made many composites of Greek and Roman portrait coins and medallions, seeking in the blurred "likenesses" the vanished physiognomy of a higher race.

Galton's next two sets of composites were made from members of the same family. With these he charged into the active terrain of eugenic research and manipulation. By exhibiting the blending of individual characteristics in a single composite image, Galton seems to have been searching for a ratio of hereditary influence. He extended these experiments to composites tracing the lineage of race horses.

The next composite was probably the most democratic construction of Galton's entire career: a combination of portraits of twelve officers and eleven enlisted men of the Royal Engineers. This was offered as a "clue to the direction in which the stock of the English race might most easily be improved."[72] This utopian image was paired with its dystopian counterparts, generic images of disease and criminality.

While tuberculosis seemed to produce a vaguely wan physiognomy, crime was less easy to type. Galton had obtained identification photographs of convicts from the Director of Prisons, Edmund Du Cane, and these were the source of his first composites in 1878. Despite this early start in the search for the biological criminal type, Galton came to a position that was less enthusiastic than that of Lombroso: "The individual faces are villainous enough, but they are villainous in different ways, and when they are combined,

the individual peculiarities disappear, and the common humanity of a low type is all that is left."[73] Thus Galton seems to have dissolved the boundary between the criminal and the working-class poor, the residuum that so haunted the political imagination of the late-Victorian bourgeoisie. Given Galton's eugenic stance, this meant that he merely included the criminal in the general pool of the "unfit."

Later, following Charles Booth's sociological stratification of the London population, Galton classified "criminals, semi-criminals, and loafers" as the worst of the eugenically unfit: the bottom one percent of the urban hierarchy. On this basis, he supported long sentences for "habitual criminals," in hopes of "restricting their opportunities for producing low-class offspring."[74]

Galton concluded the introductory sample of composite portraits in his *Inquiries* with contrasted sets of composites made from very large samples: representing "consumptive" and "not consumptive" cases. With these he underlined both the *statistical* and the *social hygenic* ambitions behind his optical process and his political program.

Galton harbored other *psychological* and *philosophical* ambitions. In his earlier essays on "generic images" he examined "analogies" between mental images, which he claimed consisted of "blended memories," and the genera produced by his optical process. Citing the Weber-Fechner Law of psychophysics, which demonstrated that relative perceptual sensitivity decreased as the level of stimulus increased, Galton concluded that "the human mind is therefore a most imperfect apparatus for the elaboration of general ideas," when compared with the relentless and untiring quantitative consistency of "pictorial statistics."[75] In *Inquiries,* he returned to this theme: "The ideal faces obtained by the method of composite portraiture appear to have a great deal in common with . . . so-called abstract ideas." He wondered whether abstract ideas might not be more correctly termed "cumulative ideas."[76] Galton's rather reified notions of what constituted thought is perhaps most clearly, if unwittingly, expressed in his offhand definition of introspection: "taking stock of my own mental furniture."[77]

The composite apparatus provided Galton with a model of scientific intelligence, a mechanical model of intellectual labor. Furthermore, this intelligence answered to the logic of philosophical realism. Galton argued that his composites refuted nominalist approaches to the human sciences, demonstrating with certainty the reality of distinct racial types. This amounted to an essentialist physical anthropology of race.[78]

It is not surprising, then, that Galton would come to regard his most successful composite as that depicting "the Jewish type." In a historical context in which there was no clear anthropological consensus on the racial or ethnic character of modern Jews, Galton produced an image that was, according to Karl Pearson, "a landmark in composite photography": "We all know the Jewish boy, and Galton's portraiture brings him before us in a way that only a great work of art could equal—scarcely excel, for the artist would only idealise from *one* model."[79] This applause, ominous enough as it is, takes on an even more sinister tone in retrospect when one considers the line of influence that led from Anglo-American eugenics to National Socialist *Rassentheorie.*[80]

Galton's composite process enjoyed a wide prestige until about 1915. Despite its origins in a discourse of racial essentialism, the composite was used to make a variety of points, some of which favored "nurture" over "nature." For example, Lewis Hine made a

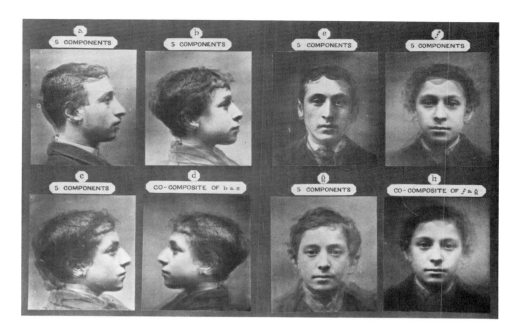

Francis Galton, *The Jewish
Type*, 1883. Plate 35 from
Pearson.

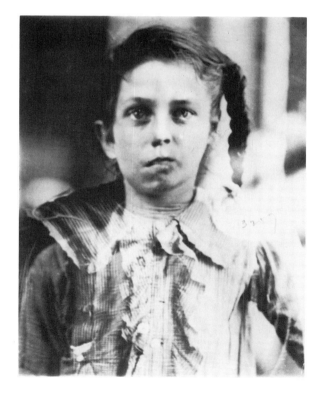

Lewis Hine, composite
photograph of child laborers
employed in cotton mill, 1913
(National Gallery of Canada,
Ottawa)

number of crude composite prints of girl mill-workers in 1913, in what was evidently an attempt to trace the general effects of factory working conditions on young bodies. And, in a curious twist, the book that provided the conclusive refutation from within criminology of Lombroso's theory of the innate criminal with the telltale skull, Henry Goring's *The English Convict,* opened its attack with a comparison between composites of freehand drawings and composites of tracings from photographs of criminal heads. The former has been used by Havelock Ellis to make his physiognomic case in *The Criminal.* The discrepancy between these and the tracings revealed a great degree of caricature in Ellis's pictures.[81] With both Hine and Goring, a faith in the objectivity of the camera persisted. However, with the general demise of an optical model of empiricism, Galton's hybridization of the camera and the statistical table approached extinction. Photography continued to serve the sciences, but in a less grandiose and exalted fashion, and consequently with more modest—and frequently more casual—truth claims, especially on the periphery of the social sciences.

In retrospect, the Galtonian composite can be seen as the collapsed version of the archive. In this blurred configuration, the archive attempts to exist as a potent single image, and the single image attempts to achieve the authority of the archive, of the general, abstract propositions. Galton was certainly a vociferous ideologue for the extension and elaboration of archival methods. He actively promoted familial self-surveillance for hereditarian purposes, calling for his readers to "obtain photographs and ordinary measurements periodically of themselves and their children, making it a family custom to do so."[82] His model here was the British Admiralty's voluminous registry of sailors. Here again, eugenics modeled itself on the military. Galton founded an Anthropometrical Laboratory in 1884, situated first at the International Health Exposition, then moving to the Science Museum in South Kensington. Nine thousand visitors were measured, paying three or four pence each for the privilege of contributing to Galton's eugenic research.[83]

Although married for many years, Galton left no children. Instead, he left behind an immense archive of documents. One curious aspect of Karl Pearson's massive pharaonic biography of Galton is its profusion of photographic illustrations, including not only Galton's many photographic experiments, but also a kind of intermittent family album of more personal pictures.

Eugenics was a utopian ideology, but it was a utopianism inspired and haunted by a sense of social decline and exhaustion. Where Quetelet had approached the question of the average with optimism, finding in averages both a moral and an aesthetic ideal, Galton's eugenicist hope for an improved racial stock was always limited by his early discovery that successive generations of eugenically bred stock tended to regress back toward the mean, and "mediocrity."[84] Thus the fantasy of absolute racial betterment was haunted by what must have seemed a kind of biological entropy.[85] Later, in the twentieth century, eugenics would operate with brutal certainty only in its negative mode, through the sterilization and extermination of the Other.

What can we conclude, finally, about the photographic problems encountered and "solved" by Bertillon, the nominalist detective, and Galton, the essentialist biometrician? The American philosopher and semiotician Charles Sanders Peirce, their contemporary, made a useful distinction between signs that referred to their objects indexically and those that operated symbolically. To the extent that photographs are "effects of the radiations from the object," they are indexical signs, as are all signs that register a physical trace. Symbols, on the other hand, signify by virtue of conventions or rules. Verbal lan-

guage in general, and all conceptual thought, is symbolic in Peirce's system.[86] Paradoxically, Bertillon, in taming the photograph by subordinating it to the verbal text of the *portrait parlé,* remained wedded to an *indexical* order of meaning. The photograph was nothing more than the physical *trace* of its contingent instance. Galton, in seeking the apotheosis of the optical, attempted to elevate the indexical photographic composite to the level of the *symbolic,* thus expressing a *general law* through the accretion of contingent instances. In so doing, Galton produced an unwitting caricature of inductive reason. The composites signified, not by embodying the law of error, but by being rhetorically annexed to that law. Galton's ambition, although scientistic, was not unlike that of those other elevators of photography, the neosymbolists of the Photo Secession. Both Galton and Stieglitz wanted something more than a mere trace, something that would match or surpass the abstract capabilities of the imaginative or generalizing intellect. In both cases, meaning that was fervently believed to emerge from the "organic" character of the sign was in fact certified by a hidden framing convention. Bertillon, on the other hand, kept his (or at least his underlings') eye and nose to the ground. This made him, in the prejudiced and probably inconsequential opinion of one of his biographers, Henry Rhodes, "the most advanced photographer in Europe."[87] Despite their differences, both Bertillon and Galton were caught up in the attempt to preserve the value of an older, optical model of truth in a historical context in which abstract, statistical procedures seemed to offer the high road to social truth and social control.

The first rigorous system of archival cataloguing and retrieval of photographs was that invented by Bertillon. Bertillon's nominalist system of identification and Galton's essentialist system of typology constitute not only the two poles of positivist attempts to regulate social deviance by means of photography, but also the two poles of these attempts to regulate the semantic traffic in photographs. Bertillon sought to embed the photograph in the archive. Galton sought to embed the archive in the photograph. While their projects were specialized and idiosyncratic, these pioneers of scientific policing and eugenics mapped out general parameters for the bureaucratic handling of visual documents. It is quite extraordinary that histories of photography have been written thus far with little more than passing reference to their work. I suspect that this has something to do with a certain bourgeois scholarly discretion concerning the dirty work of modernization, especially when the status of photography as a fine art is at stake.[88] It is even more extraordinary that histories of social documentary photography have been written without taking the police into account. Here the issue is the maintenance of a certain liberal humanist myth of the wholly benign origins of socially concerned photography.[89]

Roughly between 1880 and 1910, the archive became the dominant institutional basis for photographic meaning. Increasingly, photographic archives were seen as central to a bewildering range of empirical disciplines, ranging from art history to military intelligence.[90] Bertillon had demonstrated the usefulness of his model for police purposes, but other disciplines faced significantly different problems of image cataloguing. An emergent *bibliographic science* provided the utopian model of classification for these expansive and unruly collections of photographs. Here again Bertillon was prescient in his effort to reduce the multiple signs of the criminal body to a textual shorthand and numerical series. At a variety of separate but related congresses on the internationalization and standardization of photographic and bibliographic methods, held between 1895 and 1910, it was

recommended that photographs be catalogued topically according to the decimal system invented by the American librarian Melvil Dewey in 1876. The lingering prestige of optical empiricism was sufficiently strong to ensure that the terrain of the photographable was still regarded as roughly congruent with that of knowledge in general. The Institute for International Bibliography built on the universalist logic of the eighteenth-century encyclopedists. But appropriate to the triumphal years of an epoch of scientific positivism and the early years of bureaucratic rationalization, a grandiose clerical mentality had now taken hold.[91]

The new scientific bibliographers articulated an operationalist model of knowledge, based on the "general equivalence" established by the numerical shorthand code. This was a system for regulating and accelerating the flow of texts, profoundly linked to the logic of Taylorism. Is it surprising that the main reading room of that American Beaux-Arts temple of democratic and imperial knowledge, the Library of Congress, built during this period of bibliographic rationalization, should so closely resemble the Panopticon, or that the outer perimeter of the building should bear thirty-three "ethnological heads" of various racial types?[92] Or is it any more surprising that the same American manufacturing company produced Bertillon cabinets, business files, and library card catalogue cabinets?[93]

Photography was to be both an *object* and *means* of bibliographic rationalization. The latter possibility emerged from the development of microfilm reproduction of documents. Just as photographs were to be incorporated into the realm of the text, so also the text could be incorporated into the realm of the photograph. If photography retained its prestige as a universal language, it increasingly did so in conjunction with a textual paradigm that was housed within the library.[94]

The grand ambitions of the new encyclopedists of photography were eventually realized but not in the grand encyclopedic fashion one might have expected. With the increasing specialization of intellectual disciplines, archives tended to remain segregated. Nonetheless, the dominant culture of photography did rely heavily on the archival model for its legitimacy. The shadowy presence of the archive authenticated the truth claims made for individual photographs, especially within the emerging mass media. The authority of any particular syntagmatic configuration was underwritten by the encyclopedic authority of the archive. One example will suffice. Companies like Keystone Views or Underwood and Underwood serially published short pictorial groupings of stereograph cards. Although individual sequences of pictures were often organized according to a narrative logic, one sees clearly that the overall structure was informed not by a narrative paradigm, but by the paradigm of the archive. After all, the sequence could be rearranged; its temporality was indeterminate, its narrativity relatively weak. The pleasures of this discourse were grounded not in narrative necessarily, but in archival play, in substitution, and in a voracious optical encyclopedism. There were always more images to be acquired, obtainable at a price, from a relentlessly expanding, globally dispersed picture-gathering agency.[95]

Archival rationalization was most imperative for those modes of photographic realism that were instrumental, that were designed to contribute directly or indirectly to the practical transformation or manipulation of their referent. Can any connections be traced between the archival mode of photography and the emergence of photographic modernism? To what degree did self-conscious modernist practice accommodate itself to the model of the archive? To what degree did modernists consciously or unconsciously resist or subvert the model of the archive, which tended to relegate the individual photogra-

Walker Evans, *License-Photo Studio, New York, 1934 (Lower East Manhattan, Baxter Street)*. Plate 1 from *American Photographs*, 1938. (Collection, The Museum of Modern Art, New York)

pher to the status of a detail worker, providing fragmentary images for an apparatus be-yond his or her control? Detailed answers to this question are clearly beyond the scope of this essay. But a few provisional lines of investigation can be charted.

The protomodernism of the Photo Secession and its affiliated movements, extending roughly to 1916, can be seen as an attempt to resist the archival mode through a strategy of avoidance and denial based on craft production. The elegant *few* were opposed to the mechanized *many*, in terms both of images and authors. This strategy required the osten-tatious display of the "honorific marks of hand labor," to borrow the phrase coined by the American sociologist Thorstein Veblen in 1899.[96] After 1916, however, aesthetically ambi-tious photographers abandoned the painterly and embraced pictorial rhetorics much closer to those already operative within the instrumental realist and archival paradigms. Understandably, a variety of contradictory attitudes to the archive emerge within photo-graphic discourse in the 1920s. Some modernists embraced the archival paradigm: August Sander is a case in point. Others resisted through modernist reworkings of the antiposi-tivism and antirationalism of the Photo Secession: the later Stieglitz and Edward Weston are obvious examples.

In many respects the most complicated and intellectually sophisticated response to the model of the archive was that of Walker Evans. Evans's book sequences, especially in his 1938 *American Photographs,* can be read as attempts to counterpose the "poetic" structure of the sequence to the model of the archive. Evans began the book with a prefatory note *reclaiming* his photographs from the various archival repositories that held copyright to or authority over his pictures.[97] Furthermore, the first photograph in the book describes a site of the archival and instrumental mode's proliferation into the spaces of metropolitan daily life in the 1930s: *License-Photo Studio, New York, 1934.* We now know that Evans was fascinated with police photographs during the period in which he made the photographs

in this book. A terse topical list on "New York society in the 1930s" contains a central, telegraphic, underlined inscription: "*This project get police cards.*"[98] Certainly Evans's subway photographs of the late 1930s and early 1940s are evidence of a sophisticated dialogue with the empirical methods of the detective police. Evans styled himself as a flaneur and late in life likened his sensibility to that of Baudelaire. Though Walter Benjamin had proposed that "no matter what trail the *flâneur* may follow, every one will lead him to a crime,"[99] Evans avoided his final rendezvous. This final detour was explicitly described in a 1971 interview in which he took care to distinguish between his own "documentary style" and a "literal document" such as "a police photograph of a murder scene."[100] He stressed the necessary element of poetic transcendence in any art photograph of consequence. The elderly Evans, transformed into the senior figure of modernist genius by a curatorial apparatus with its own archival imperative, could no longer recognize the combative and antiarchival stance of his earlier sequential work. Evans was forced to fall back on an organicist notion of style, searching for that refined surplus of stylistic meaning which would guarantee his authorship and which in general served to distinguish the art photographer from a flunky in a hierarchy of flunkies.

With the advent of postmodernism, many photographers have abandoned any serious commitment to stylistic transcendence, but they fail to recognize the degree to which they share Evans's social fatalism, his sense of the immutability of the existing social order. Modernism offers other models, however, including more militant and equally intelligent models of photographic practice. Consider Camille Recht's reading of the photographs of Eugène Atget, a photographer of acknowledged import in Evans's own development. Recht comments on interior views "which remind us of a police photograph of a crime scene" and then on "the photograph of a worker's dwelling which testifies to the housing problem." For Recht, the proximity of a "nuptial bed and an unavoidable chimney flue," provided grimly comic testimony of everyday life in an exploitative social formation.[101] This emphasis on the telling detail, the metonymic fragment that points to the systemic crimes of the powerful, would be repeated and refined in the writings of Walter Benjamin.[102] Our tendency to associate Benjamin with the theory and practice of montage tends to obscure the degree to which he built his modernism from an empiricist model, from a model of careful, idiosyncratic observation of detail. This model could argue both for the photographer as *monteur* and for the photographer as revolutionary spy or detective, or, more "respectably," as critical journalist of the working class.

This essay could end with this sketch of modernist responses to the prior institutionalization of the instrumental realist archive. Social history would lead to art history, and we would arrive at a safe archival closure. Unfortunately, Bertillon and Galton are still with us. "Bertillon" survives in the operations of the national security state, in the condition of intensive and extensive surveillance that characterizes both everyday life and the geopolitical sphere. "Galton" lives in the renewed authority of biological determinism, founded in the increased hegemony of the political Right in the Western democracies. That is, Galton lives quite specifically in the neo-Spencerian pronouncements of Reaganism, Thatcherism, and the French National Front.[103] Galton's spirit also survives in the neoeugenicist implications of some of the new biotechnologies.

These are political issues. As such, their resonance can be heard in the aesthetic sphere. In the United States in the 1970s, a number of works, primarily in film and video, took an aggressive stance toward both biological determinism and the prerogatives

of the police. Martha Rosler's video "opera" *The Vital Statistics of a Citizen, Simply Obtained* (1976) retains its force as an allegorical feminist attack on the normalizing legacy of Quetelet and Galton. Other, more nominalist, works took on the police at the level of counter-testimony and counter-surveillance. I am thinking here of a number of documentary films: Howard Gray and Michael Alk's *The Murder of Fred Hampton* (1971), Cinda Firestone's *Attica* (1973), and the Pacific Street Film Collective's *Red Squad* (1972). These examples tend to be forgotten or overlooked in a contemporary art scene rife with a variety of what can be termed "neophysiognomic" concerns. The body has returned with a vengeance. The heavily expressionist character of this return makes the scientist and racialist underpinnings of physiognomy seem rather remote. In photography, however, this lineage is harder to repress. In one particularly troubling instance, this returned body is specifically Galtonian in its configuration. I refer here to the computer-generated composites of Nancy Burson, enveloped in a promotional discourse so appallingly stupid in its fetishistic belief in cybernetic truth and its desperate desire to remain grounded in the optical and organic that it would be dismissable were it not for its smug scientism. For an artist or critic to resurrect the methods of biosocial typology without once acknowledging the historical context and consequences of these procedures is naive at best and cynical at worst.[104]

In the interests of a certain internationalism, however, I want to end with a story that takes us outside the contemporary art scene and away from the simultaneously inflated and deflated figure of the postmodernist author. This anecdote might suggest something of the hardships and dilemmas of a photographic practice engaged in from below, a photographic practice on ground patrolled by the police. In 1967 a young Black South African photographer named Ernest Cole published a book in the United States called *House of Bondage.* Cole's book and his story are remarkable. In order to photograph a broad range of South African society, Cole had first to change his racial classification from black to colored, no mean feat in a world of multiple bureaus of identity, staffed by officials who have mastered a subtle bureaucratic taxonomy of even the offhand gestures of the different racial and ethnic groups. He countered this apparatus, probably the last *physiognomic* system of domination in the world, with a descriptive strategy of his own, mapping out the various checkpoints in the multiple channels of apartheid.

Cole photographed during a period of relative political "calm" in South Africa, midway between the Sharpeville massacre of 1960 and the Soweto students' revolt of 1976. At a time when black resistance was fragmented and subterranean in the wake of the banning of the main opposition groups, he discovered a limited, and by his own account problematic, figure of resistance in young black toughs, or *tsotsis,* who lived lives of petty criminality. Cole photographed *tsotsis* mugging a white worker for his pay envelope as well as a scene of a white man slapping a black beggar child. And he regularly photographed the routine passbook arrests of blacks who were caught outside the zones in which they were permitted to travel. As might be expected, Cole's documentation of the everyday flows of power, survival, and criminal resistance got him into trouble with the law. He was questioned repeatedly by police, who assumed he was carrying stolen camera equipment. Finally he was stopped after photographing passbook arrests. Asked to explain himself, he claimed to be making a documentary on juvenile delinquency. Sensing his criminological promise, the police, who then as now operated through a pervasive system of informers, invited him to join the ranks. At that point, Cole decided to leave the

Eugène Atget, plate 12 from
Lichtbilder, 1930

Metrical photograph and
planimetric sketch, from A.
Bertillon and A. Chervin,
Anthropologie métrique, 1909

country while he still could. *House of Bondage* was assembled from the negatives he smuggled out of South Africa. Since publishing his book in exile, Cole has disappeared from the world of professional photojournalism.[105]

The example of Cole's work suggests that we would be wise to avoid an overly monolithic conception of realism. Not all realisms necessarily play into the hands of the police, despite Theodor Adorno's remark, designed to lampoon a Leninist epistemology once and for all, that "knowledge has not, like the state police, a rogues' gallery of its objects."[106] If we are to listen to, and act in solidarity with, the polyphonic testimony of the oppressed and exploited, we should recognize that some of this testimony, like Cole's, will take the ambiguous form of visual documents, documents of the "microphysics" of barbarism. These documents can easily fall into the hands of the police or their intellectual apologists. Our problem, as artists and intellectuals living near but not at the center of a global system of power, will be to help prevent the cancellation of that testimony by more authoritative and official texts.

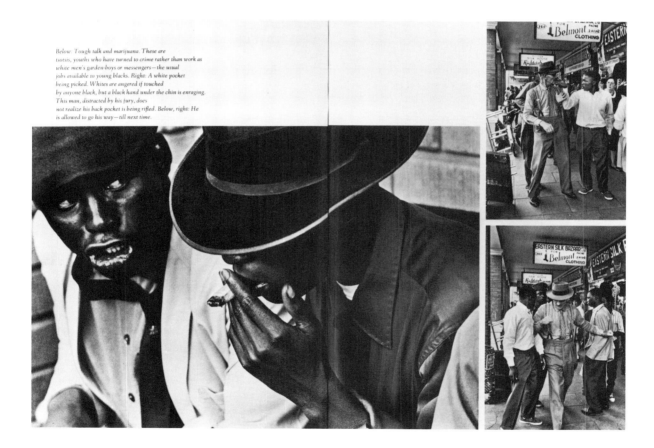

Below: Tough talk and marijuana. These are tsotsis, youths who have turned to crime rather than work as white men's garden-boys or messengers — the usual jobs available to young blacks. Right: A white pocket being picked. Whites are angered if touched by anyone black, but a black hand under the chin is enraging. This man, distracted by his fury, does not realize his back pocket is being rifled. Below, right: He is allowed to go his way — till next time.

From Ernest Cole, *House of Bondage, 1967*

First published in *October* 39 (Winter 1986). Earlier versions of this essay were presented at the National Gallery of Canada, Ottawa, October 2, 1982, and at the College Art Association Annual Meeting, New York, February 13, 1986. This version was completed with the assistance of a Visiting Senior Fellowship at the Center for Advanced Study in the Visual Arts, The National Gallery of Art, Washington, D.C., Summer 1986.

1 Quoted in Helmut and Alison Gernshiem, *L. J. M. Daguerre* (New York: Dover, 1968), p. 105 (italics in original).

2 The Metropolitan Police Act, 1839, in *Halsbury's Statutes of England,* vol. 25 (London: Butterworth, 1970), p. 250. For a useful summary of parliamentary debates on crime and punishment in the nineteenth century, see *Catalogue of British Parliamentary Papers* (Dublin: Irish University Press, 1977), pp. 58–73. On the history of the National Gallery, see Michael Wilson, *The National Gallery: London* (London: Philip Wilson Publishers, 1982).

3 William Henry Fox Talbot, *The Pencil of Nature* (1844; facsimile edition, New York: Da Capo, 1968), pl. 6, n.p.

4 Ibid., pl. 3.

5 The clearest of the early, optimistic understandings of photography's role within a new hierarchy of taste, necessitating a restructuring of the portrait labor market along industrial lines, can be found in an unsigned review by Elizabeth Eastlake, "Photography," *Quarterly Review* 101:202 (April 1857), pp. 442–68.

6 See Michel Foucault, *Discipline and Punish: The Birth of the Prison,* trans. Alan Sheridan (New York: Pantheon, 1977) and *The History of Sexuality, Volume I: An Introduction,* trans. Robert Hurley (New York: Pantheon, 1978).

7 Any photographs that seek to identify a *target,* such as military reconnaissance photographs, operate according to the same general logic. See my 1975 essay "The Instrumental Image: Steichen at War," in *Photography against the Grain: Essays and Photo Works, 1973–1983* (Halifax: The Press of the Nova Scotia College of Art and Design, 1984).

8 The theoretical ground for the construction of a specifically *bourgeois* subject can be found in Hobbes's *Leviathan* (1651). C. B. Macpherson has argued that Hobbes's axiomatic positing of an essentially competitive individual human "nature" was in fact quite specific to a developing market society, moreover, to a market society in which human labor power increasingly took the form of an alienable commodity. As Hobbes put it, "The *Value* or WORTH of a man, is as of all things, his Price; that is to say, so much as would be given for the use of his Power: and therefore is not absolute; but a thing dependent on the need and judgement of another" (Thomas Hobbes, *Leviathan* [Harmondsworth: Penguin, 1968], chap. 10, pp. 151–52. See Macpherson's introduction to this edition and his *Political Theory of Possessive Individualism: Hobbes to Locke* [London: Oxford University Press, 1962]).

While it would be farfetched to present Hobbes as a theorist of the "bourgeois portrait," it is interesting to note how he defined individual autonomy and its relinquishment through contractual obligation in terms of dramaturgical metaphors, thus distinguishing between two categories of the person, the "Author" and the "Actor" (*Leviathan,* chap. 16, pp. 217–18). The analogy between symbolic representation and political-legal representation is central to his thought. (An amusing history of portrait photography could be written on the vicissitudes of the Hobbesian struggle between photographer and sitter, both in the actual encounter and in the subsequent reception of portrait photographs.)

Furthermore, the frontispiece to *Leviathan* took the form of an allegorical portrait. The commonwealth, or state, is literally embodied in the figure of a sovereign, an "artificial man," whose body is itself composed of a multitude of bodies, all of whom have ceded a portion of their indi-

vidual power to the commonwealth in order to prevent the civil war that would inevitably result from their unchecked pursuit of "natural" appetites. Thus the "body" of the Leviathan is a kind of pressure vessel, containing explosive natural forces. This image is perhaps the first attempt to diagram the social field visually. As such, it has a definite, if usually indirect, resonance in nineteenth-century attempts to construct visual metaphors for the conceptual models of the new social sciences.

9 "The utilitarian doctrine . . . is at bottom only a restatement of the individualist principles which were worked out in the seventeenth century: Bentham built on Hobbes" (Macpherson, *Political Theory of Possessive Individualism,* p. 2).

10 Jeremy Bentham, "A Fragment on Government" (1776), in Mary P. Mack, ed., *A Bentham Reader* (New York: Pegasus, 1969), p. 45.

11 Quoted in Helmut Gernsheim, *The History of Photography: From the Camera Obscura to the Beginning of the Modern Era* (New York: McGraw-Hill, 1969), p. 239.

12 Marcus Aurelius Root, *The Camera and the Pencil* (1864; reprint Pawlett, VT: Helios, 1971), pp. 420–21.

13 The Panopticon, or Inspection House, was Jeremy Bentham's proposal, written in 1787, for an architectural system of social discipline, applicable to prison, factory, workhouse, asylum, and school. The operative principles of the Panopticon were isolation and perpetual surveillance. Inmates were to be held in a ring of individual cells. Unable to see into a central observation tower, they would be forced to assume that they were watched continually. (As Hobbes remarked over a century earlier, "the reputation of Power is Power.") The beneficial effects of this program were trumpeted by Bentham in the famous opening remarks of his proposal: "Morals reformed—health preserved—industry invigorated—instruction diffused—public burdens lightened—Economy seated, as it were, upon a rock—all by a simple idea of architecture" (John Bowring, ed., *The Works of Jeremy Bentham,* vol. 4 [London: Simpkin, Marshall, 1843], p. 49). With Bentham the principle of supervision takes on an explicit industrial capitalist character: his prisons were to function as profit-making establishments, based on the private contracting-out of convict labor. Bentham was a prototypical efficiency expert. (On these last two points see, respectively, Gertrude Himmelfarb, "The Haunted House of Jeremy Bentham," in *Victorian Minds* [New York: Knopf, 1968], pp. 32–81; and Daniel Bell, "Work and Its Discontents," in *The End of Ideology: On the Exhaustion of Political Ideas in the Fifties* [Glencoe, IL: Free Press, 1960], pp. 227–74.)

For Foucault, "Panopticism" provides the central metaphor for modern disciplinary power based on isolation, individuation, and supervision (*Discipline and Punish,* pp. 195–228). Foucault traces the "birth of the prison" only to the 1840s, just when photography appears with all of its instrumental promise. Given the central optical metaphor in Foucault's work, a reading of the subsequent development of disciplinary systems would need logically to take photography into account. John Tagg has written a Foucauldian account of the "panoptic" character of early police and psychiatric photography in Britain. While I am in frequent agreement with his argument, I disagree with his claim that the "cumbersome architecture" of the Panopticon became redundant with the development of photography ("Power and Photography: Part 1, A Means of Surveillance: The Photograph as Evidence in Law," *Screen Education* 36 [Winter 1980], p. 45). This seems to accord too much power to photography and to imply that domination operates entirely by the force of visual representation. To suggest that cameras replaced prisons is more than a little hyperbolic. The fact that Bentham's plan was never realized in the form he proposed has perhaps contributed to the confusion; models are more easily transformed into metaphors than are realized projects. Once discourse turns on metaphor, it becomes a simple matter to substitute a photographic metaphor for an architectural one. My main point here is that any history of disciplinary institutions must recognize the multiplicity of material devices involved—some literally concrete—in tracing not only the importance of surveillance, but also the continued importance of confinement. After all, Bentham's proposal *was* partially realized in the cellular and separate systems of confinement that emerged in the nineteenth century. At least one "genuine" panopticon prison was constructed: the Stateville Penitentiary in Illinois, built between 1916 and 1924. (For works on early prison history, see D. Melossi and M. Pavarini, *The Prison and the Factory: Origins of the Penitentiary System,* trans. Glynis Cousin [London: Macmillan, 1981]; David Rothman, *The Dis-*

covery of the Asylum: Social Order and Disorder in the New Republic [Boston: Little, Brown, 1971]; and Michael Ignatieff, A Just Measure of Pain: The Penitentiary in the Industrial Revolution, 1750–1850 [London: Macmillan, 1978]).

Certainly prison architecture and the spatial positioning of prisons in the larger environment remain matters of crucial importance. Especially in the United States, where economic crisis and Reaganite judicial tough-mindedness have lead to record prison populations, these are paramount issues of what is euphemistically called "public policy." In fact, the current wave of ambitious prison building has led to at least one instance of (postmodern?) return to the model of the Panopticon. The new Montgomery County Detention Center in Virginia was designed by prison architect James Kessler according to a "new" principle of "podular/direct supervision." In this scaled-down, rumpus-room version of the Panopticon, inmates can see into the central control room from which they are continually observed (see Benjamin Forgey, "Answering the Jail Question," The Washington Post, August 2, 1986, pp. G1–G2).

14 For earlier arguments on the archival paradigm in photography, see Rosalind Krauss, "Photography's Discursive Spaces: Landscape/View," Art Journal 42:4 (Winter 1982), pp. 311–19, reprinted in this volume; and Allan Sekula, "Photography between Labour and Capital," in B. Buchloh and R. Wilkie, eds., Mining Photographs and Other Pictures: Photographs by Leslie Shedden (Halifax: The Press of the Nova Scotia College of Art and Design, 1983), pp. 193–268.

15 John [sic] Caspar Lavater, Preface to Essays on Physiognomy Designed to Promote the Knowledge and the Love of Mankind, vol. 1, trans. Henry Hunter (London: J. Murray, 1792), n.p.

16 Quoted in Louis Chevalier, Labouring Classes and Dangerous Classes in Paris during the First Half of the Nineteenth Century, trans. Frank Jellineck (London: Routledge, 1973), p. 411.

17 In addition to Chevalier's book just cited, see Walter Benjamin's 1938 essay, "The Paris of the Second Empire in Baudelaire," in Charles Baudelaire: A Lyric Poet in the Era of High Capitalism, trans. Harry Zohn (London: New Left Books, 1973), pp. 35–66. See also Judith Wechsler, A Human Comedy: Physiognomy and Caricature in Nineteenth Century Paris (Chicago: University of Chicago Press, 1982). For specific histories of phrenology, see David de Guistino, Conquest of Mind: Phrenology and Victorian Social Thought (London: Croom Helm, 1975); and John Davies, Phrenology: Fad and Science (New Haven: Yale University Press, 1955).

18 Lavater, vol. 1, p. 13.

19 Davies, p. 38.

20 On the history of the illustrated psychiatric case study, see Sander Gilman, Seeing the Insane (New York: J. Wiley, 1982).

21 Eliza Farnham, "Introductory Preface" to Marmaduke Sampson, Rationale of Crime and its Appropriate Treatment, Being a Treatise on Criminal Jurisprudence Considered in Relation to Cerebral Organization (New York: Appleton, 1846), p. xiii.

22 For a reading of the emergence of this system in France, see Jacques Donzelot, The Policing of Families, trans. Robert Hurley (New York: Pantheon, 1979). Donzelot seems to place inordinate blame on women for the emergence of a "tutelary" mode of social regulation. For a Marxist-feminist critique of Donzelot, see Michelle Barrett and Mary McIntosh, The Anti-Social Family (London: New Left Books, 1982).

23 Sampson, p. 175.

24 See Madeline Stern, "Mathew B. Brady and the Rationale of Crime," The Quarterly Journal of the Library of Congress 31:3 (July 1974), pp. 128–35; and Alan Trachtenberg, "Brady's Portraits," The Yale Review 73:2 (Winter 1984), pp. 230–53.

25 On this point see Michel Foucault, "Prison Talk," in Power/Knowledge: Selected Interviews and Other Writings, 1972–1977, ed. Colin Gordon (New York: Pantheon, 1980), p. 46.

26 Oliver Wendell Holmes, "The Stereoscope and the Stereograph," Atlantic Monthly 3:20 (June 1859), p. 748. For a more extensive treatment of this issue, see my 1981 essay "The Traffic in Photographs," in Photography against the Grain, pp. 96–101.

27 François Arago, letter to Duchâtel, in Gernsheim, Daguerre, p. 91.

28 See Ian Hacking, "How Should We Do the History of Statistics?" Ideology and Consciousness 8 (Spring 1981), pp. 15–26; and "Biopower and the Avalanche of Printed Numbers," Humanities and Society 5: 3–4 (Summer–Fall 1982) pp. 279–95.

29 Adolphe Quetelet, *A Treatise on Man and the Development of His Faculties,* trans. R. Knox (Edinburgh: Chambers, 1842), p. 6.

30 Karl Marx, *Capital: A Critique of Political Economy,* vol. 1, trans. Ben Fowkes (London: New Left Books, 1976), pp. 440–41.

31 Chevalier, p. 10.

32 Adolphe Quetelet, *Lettres sur la théorie des probabilités* (Brussels: Académie Royale, 1846). Published in English as *Letters on the Theory of Probability,* trans. O. G. Downes (London: Layton, 1849). See also Georges Canguilhem, *On the Normal and the Pathological,* trans. Carolyn Fawcett (Boston: Reidel, 1978), pp. 86–104.

33 Quetelet, *Treatise on Man,* p. 100.

34 See note 8. Of course, Quetelet's extreme determinist view of the social field was diametrically opposed to the contractual model of human relations advanced by Hobbes.

35 See George Mosse, *Toward the Final Solution: A History of European Racism* (New York: Fertig, 1978), pp. 17–34.

36 See Adolphe Quetelet, *Anthropométrie, ou mesure des différents facultés de l'homme* (Brussels: Muquardt, 1871). Quetelet suffered from aphasia after 1855, and his later works tend to be repetitious and incoherent (see Frank H. Hankins, *Adolphe Quetlet as Statistician* [New York: Columbia University Press, 1908], pp. 31–32). On the intersection of anthropometry and race science, see Stephen Jay Gould, *The Mismeasure of Man* (New York: Norton, 1981).

37 Quetelet, *Treatise on Man,* p. v.

38 Here are some ways in which Quetelet's position in relation to idealist aesthetic theory become very curious. The "average man" can be regarded as a bastard child of Kant. In the "Critique of Aesthetical Judgement" Kant describes the psychological basis of the construction of the empirically based "normal Idea" of human beauty, arguing that "the Imagination can, in all probability, actually though unconsciously let one image glide into another, and thus by the concurrence of several of the same kind come by an average, which serves as the common measure of all. Every one has seen a thousand full-grown men. Now if you wish to judge of the normal size, estimating it by means of comparison, the Imagination (as I think) allows a great number of images (perhaps the whole thousand) to fall on one another. If I am allowed here the analogy of optical presentation, it is the space where most of them are combined and inside the contour, where the place is illuminated with the most vivid colors, that the *average size* is cognizable; which, both in height and breadth, is equally far removed from the extreme bounds of the greatest and smallest stature. And this is the stature of a beautiful man" (Immanuel Kant, *Critique of Judgement,* trans. J. H. Bernard [London: Macmillan, 1914], pp. 87–88). This passage prefigures not only Quetelet but also—as we shall see—Galton. However, Kant was careful to respect differences between normal Ideas of beauty appropriate to different races. On an empirical level, he constructed no hierarchy. Furthermore, he distinguished between the empirically-based normal Idea, and the "Ideal of beauty," which is constructed in conformity with a concept of morality. Quetelet can be accused of unwittingly collapsing Kant's distinction between the normal Idea and the Ideal, and thus fusing aesthetics and morality on a purely quantitative basis, preparing thus the ground for Galton's plan for the engineering of human reproduction.

 Although Kant's more general proposal for a science of the human species based on the model of the natural sciences was known to Comte, Quetelet, "a stranger to all philosophical speculation," seems never to have read Kant (Joseph Lottin, *Quetelet, statisticien et sociologue* [Louvain: Institut supérieur de philosophie, 1912], p. 367).

 Quetelet's persistent likening of his project to the work of the visual artist can certainly be taken as emblematic of the fusion of idealist aesthetics with Enlightenment theories of social perfection. More specifically, however, Quetelet's evocations of art history—which extended to the measurement of classical sculpture and to long chronological tables of artists who had dealt with problems of bodily proportion—can be seen as a legitimating maneuver to ward off accusations that his strict determinism obliterated the possibility of a human creativity based on the exercise of free will. (It was also an attempt to compare the average bodily types of "ancients" and "moderns.") Thus Quetelet colors his gray determinism with a self-justifying hint of romanticism. But this maneuver also converts the visual artist into a protoscientist, linking Quetelet to the emerging

discourse of artistic realism. (See his *Anthropométrie,* pp. 61–169. In this work Quetelet constructed a visual diagram of the biographical course of an average body type from infancy to old age, based on anthropometrical data.)

39 Gabriel Tarde, "Archaeology and Statistics," in *The Laws of Imitation,* trans. Elsie Parsons (New York: Henry Holt, 1903), pp. 134–35 (this essay first appeared in the *Revue philosophique,* October 1883). In an extraordinary passage of the same essay Tarde compares the graphical curve for criminal recidivism with the "curve traced on [the] retina by the flight of [a] swallow," metaphorically linking within the same epistemological paradigm the work of Bertillon with that of the physiologist Etienne Jules Marey, chronophotographer of human and animal locomotion (ibid., p. 133).

40 Gabriel Tarde, *Penal Philosophy,* trans. Rapelje Howell (Boston: Little, Brown, 1912), p. 116.

41 Alphonse Bertillon, *Identification anthropométrique; instructions signalétiques* (Paris: Melun, 1893), p. xiii. I have modified the translation given in the American edition, *Signaletic Instructions,* trans. R. W. McLaughry (Chicago: Werner, 1896).

42 Alphonse Bertillon, "The Bertillon System of Identification," *Forum* 11:3 (May 1891), p. 335.

43 Ibid., p. 331.

44 Alphonse Bertillon, *L'identité des récidivistes et la loi de relégation* (Paris: Masson, 1883), p. 11.

45 Bertillon, *Identification anthropométrique,* pp. xvii–xviii.

46 Ibid., pp. xxi–xxiii, lxxiv.

47 Alphonse Bertillon, *La photographie judiciare* (Paris: Gauthier-Villars, 1890), p. 2 (my translation).

48 In 1872 O. G. Rejlander suggested that photographs of ears be used to identify criminals ("Hints Concerning the Photographing of Criminals," *British Journal Photographic Almanac* [1872], pp. 116–17). Carlo Ginzburg has noted the coincidence of Bertillon's attention to the "individuality" of the ear and Giovanni Morelli's attempt to construct a model of art-historical authentication based on the careful examination of the rendering of the ear by different painters ("Morelli, Freud, and Sherlock Holmes: Clues and Scientific Method," *History Workshop* 9 [Spring 1980], pp. 5–29).

49 See Robert Nye, *Crime, Madness, and Politics in Modern France: The Medical Concept of National Decline* (Princeton: Princeton University Press, 1984), pp. 49–96. Although Nye mentions Bertillon's project only in passing, I have relied upon his social history for an understanding of the politics of French criminology during the late nineteenth century. A more directly relevant study of Bertillon, Christian Pheline's *L'image accusatrice* (Paris: Cahiers de la Photographie, 1985), unfortunately came to my attention only after this essay was going to press.

50 Bertillon, *L'identité des récidivistes,* pp. 2, 5.

51 Henry Rhodes, *Alphonse Bertillon: Father of Scientific Detection* (London: Abelard-Schuman, 1956), p. 83.

52 Bertillon, "The Bertillon System of Identification," p. 330.

53 A. Bertillon and A. Chervin, *Anthropologie métrique* (Paris: Imprimerie Nationale, 1909), p. 51 (my translation). The same text drolly likens the shape of the binomial curve to that of a "gendarme's hat."

54 Bertillon noted that his system was adopted by 1893 in the United States, Belgium, Switzerland, Russia, much of South America, Tunisia, the British West Indies, and Rumania (*Identification anthropométrique,* p. lxxxi). Translations of Bertillon's manuals of signaletic instructions appeared in Germany, Switzerland, England, and Peru, as well as the United States. On the enthusiastic American reception of the Bertillon system, see Donald Dilworth, ed., *Identification Wanted: Development of the American Criminal Identification System, 1893–1943* (Gaithersburg, MD: International Association of Chiefs of Police, 1977). The IACP promoted the general adoption of Bertillonage by the geographically dispersed and municipally autonomous police forces of the United States and Canada, and the establishment of a National Identification Bureau in Washington, D.C. This office was absorbed into the Federal Bureau of Investigation in 1924. (Canada adopted Bertillonage with the Criminal Identification Act of 1898.) Starting in 1898, a quasi-official monthly publication of the IACP, called *The Detective,* carried Bertillon measurements and photographs of wanted criminals. This publication provides a reasonable gauge of the ratio of reliance by American police on the Bertillon and fingerprint systems over the next twenty-five years. The British resisted Bertillon's method, largely because the fingerprint system was of British origin. Nonetheless, regulations were established in 1896 under the Penal Servitude Act of 1891 for the photographing, fingerprinting,

and Bertillon measurement of criminal prisoners (Great Britain, *Statutory Rules and Orders* [London: H. M. Stationary Office, 1896], no. 762, pp. 364–65). By 1901, however, the anthropometric sig-nalment was abandoned.

Bertillon and Galton traded jibes at their respective systems. Bertillon faulted Galton for the difficulties encountered in classifying fingerprints ("The Bertillon System of Identification," p. 331). Galton faulted Bertillon for his failure to recognize that bodily measurements were corre-lated and not independent variables, thus grossly underestimating the probability of duplicate measurements (Francis Galton, *Memories of My Life* [London: Methuen, 1908], p. 251; see also his "Personal Identification and Description," *Journal of the Anthropological Institute* 18 [May 29, 1888], pp. 177–91).

The two men's obsession with authorship may have been a bit misplaced, however. In "Morelli, Freud, and Sherlock Holmes" (cited in note 48, above), Carlo Ginzburg has suggested that the whole enterprise of rationalized criminal identification rested on the *theft* of a more popular, con-jectural form of empiricism, grounded in hunting and divining. Sir William Herschel had appro-priated fingerprinting in 1860 from a usage customary among Bengali peasants under his colonial administration. The source of police methods in what Ginzburg describes as "low intuition" was obliquely acknowledged by Bertillon in a passage in which he argues for a rigorously *scientific* po-licing, while invoking at the same time the distinctly *premodern* image of the hunter: "Anthropol-ogy, by definition, is nothing but the natural history of man. Have not hunters in all times been interested in natural history? And, on the other hand, have not naturalists something of the hunter in them? No doubt the police of the future will apply to their particular form of the chase the rules of anthropology and psychology, just as the engineers of our locomotives are putting in prac-tice the laws of mechanics and thermodynamics" ("The Bertillon System of Identification," p. 341). Ginzburg has proposed a model of observation and description that is more open to multi-plicity and resistance than that advanced by John Tagg, who subsumes all documentary within the paradigm of the Panopticon (Tagg, "Power and Photography," p. 55).

55 Thomas Byrnes, "Why Thieves are Photographed," in *Professional Criminals of America* (New York: Cassell, 1886), p. 53.

56 Cesare Lombroso, "Introduction," to Gina Lombroso-Ferrero, *Criminal Man* (New York: Putnam, 1911), p. xxv.

57 Quoted by Nye, p. 104.

58 Rhodes, p. 190.

59 See Nye, pp. 97–131.

60 Charles Marie Debierre, *Le crâne des criminels* (Lyon and Paris: Storck and Masson, 1895), p. 274. The other important illustrated works are by members of the Italian school: Lombroso's revised French and Italian editions of his 1876 *L'uomo delinquente* included separate albums of illustrations (Paris: Alcan, 1895 and Turin: Fratelli Bocca, 1896–97). The plates of criminal types in these albums were taken from materials prepared for Enrico Ferri, *Atlante antropologico-statistico dell'omici-dio* (Turin: Fratelli Bocca, 1895).

61 Havelock Ellis, *The Criminal* (London: Walter Scott, 1890).

62 The exception is David Green, "Veins of Resemblance: Photography and Eugenics," *The Oxford Art Journal* 7:2 (1984), pp. 3–16.

63 See Ruth Schwartz Cowan, *Sir Francis Galton and the Study of Heredity in the Nineteenth Century* (New York: Garland, 1985).

64 See Gareth Stedman Jones, *Outcast London: A Study in the Relationship between Classes in Victorian Soci-ety* (Oxford: Clarendon, 1971).

65 Francis Galton, *Hereditary Genius* (London: Friedman, 1978), p. 342.

66 Francis Galton, *Inquiries into Human Faculty and Its Development* (London: Macmillan, 1883), pp. 5–6.

67 Galton acknowledged Spencer in an 1878 paper read before the Anthropological Institute, ex-tracted in ibid., p. 340. Spencer's previously unpublished 1846 proposal for producing and super-imposing phrenological diagrams of the head, "On a Proposed Cephalograph," can be found as an appendix to his *An Autobiography,* vol. 1 (New York: Appleton, 1904), pp. 634–638. Like Quetelet, Spencer appears not to have read Kant on the notion of an average type, or on any other topic for that matter (see David Wiltshire, *The Social and Political Thought of Herbert Spencer* [Oxford: Oxford University Press, 1978], p. 67). Spencer's organismic defense of a hierarchical social division of labor is articulated in a review of the collected works of Plato and Hobbes: "The Social Orga-

nism," *The Westminster Review,* n. s. 17:1 (January 1860), pp. 90–121. This extended metaphor goes so far as to compare the circulation of blood with that of money (p. 111). On the connections between Spencerian social Darwinism and eugenics, see Greta Jones, *Social Darwinism and English Thought* (Sussex: Harvester, 1980).

68 Galton, *Inquiries,* p. 17.

69 Francis Galton, "On Generic Images," *Proceedings of the Royal Institution* 9 (1879), p. 166.

70 Francis Galton, "Analytical Photography," *Nature* 18 (August 2, 1890), p. 383.

71 Francis Galton, "Generic Images," *Nineteenth Century* 6:29 (July 1879), p. 162. In the related, previously cited paper "On Generic Images," Galton stated that Quetelet was the first to give "the idea of type" a "rigorous interpretation" (p. 162). Ruth Schwartz Cowan has argued, following Karl Pearson, that Quetelet was of no particular import in Galton's development as a statistician; but Cowan is interested in Galton's position as a statistician in the lineage of hereditarian thought and not in his attempt to negotiate the merger of optical and statistical methods. That is, Cowan prefers to define biostatistics as a science which began with Galton, a science having no prehereditarian precursor in Quetelet (see *Sir Francis Galton,* pp. 145–200).

72 Galton, *Inquiries,* p. 14.

73 Ibid., p. 15.

74 Francis Galton, *Essays in Eugenics* (London: Eugenics Education Society, 1909), pp. 8–9, 62.

75 Galton, "Generic Images," p. 169.

76 Galton, *Inquiries,* p. 183.

77 Ibid., p. 182.

78 Galton, "Generic Images," pp. 163–64.

79 Karl Pearson, *The Life, Letters and Labours of Francis Galton,* vol. 2 (Cambridge: Cambridge University Press, 1924), p. 293.

80 On the role played by eugenics in Nazi racial policy, see Allan Chase, *The Legacy of Malthus: The Social Costs of the New Scientific Racism* (Urbana: University of Illinois Press, 1980), pp. 342–60.

Galton was asked to make the composites in 1883 by Joseph Jacobs, who was attempting to demonstrate the existence of a relatively pure racial type of modern Jew, intact despite the Diaspora. For the portraits, Jacobs recruited boy students from the Jews' Free School and from the Jewish Working Men's Club in London. Galton and Jacobs both agreed that a racial type had been produced, but they disagreed profoundly on the *moral essence* of that type. Galton, the great quantifier, met his imaginary Other: "The feature that struck me most, as I drove through the . . . Jewish quarter, was the cold scanning gaze of man, woman, and child. . . . I felt, rightly or wrongly, that every one of them was cooly appraising me at market value, without the slightest interest of any other kind" ("Photographic Composites," *The Photographic News* 29:1389 [April 17, 1885]). Jacobs responded to Galton's anti-Semitism with a more honorific reading of the composites, suggesting that "here we have something . . . more spiritual than a spirit. . . . The composite face must represent this Jewish forefather. In these Jewish composites we have the nearest representation we can hope to possess of the lad Samuel as he ministered before the Ark, or the youthful David when he tended his father's sheep" ("The Jewish Type, and Galton's Composite Photographs," *The Photographic News* 29:1390 [April 24, 1885]). Thus Jacobs counters Galton's myth of the Jew as the embodiment of capital with a proto-Zionist myth of origins. (On the medical and racial stereotyping of Jews in the late nineteenth century, and the Jewish reaction, see Sander Gilman, "The Madness of the Jews," in *Difference and Pathology: Stereotypes of Sexuality, Race, and Madness* [Ithaca: Cornell University Press, 1985], pp. 150–62).

81 Henry Goring, *The English Convict: A Statistical Study* (London: H. M. Stationery Office, 1913). Lombroso's theoretical fixation with convict head size had already been undercut within physical anthropology by Franz Boas. See his 1910–13 essay, "Changes in Bodily Form of Descendants of Immigrants," in *Race, Language and Culture* (New York: Macmillan, 1949), pp. 60–75.

82 Galton, *Inquiries,* p. 43.

83 Pearson, *Life, Letters and Labours,* vol. 2, p. 357.

84 Galton, *Hereditary Genius,* pp. xvii-xviii.

85 On the cultural resonance of the concept of entropy in the nineteenth century, see Anson Rabinbach, "The Body without Fatigue: A Nineteenth Century Utopia," in Seymour Drescher et al., eds., *Political Symbolism in Modern Europe: Essays in Honor of George Mosse* (New Brunswick: Transaction Books, 1982), pp. 42–62.

86 Charles Sanders Peirce, *The Philosophical Writings of Peirce,* ed. Justus Buchler (New York: Dover, 1955), pp. 99–119.

87 Rhodes, p. 191.

88 Compare Josef Maria Eder, *History of Photography,* trans. Edward Epstean (New York: Columbia University Press, 1945), with Beaumont Newhall, *Photography: A Short Critical History* (New York: Museum of Modern Art, 1938). Eder, very much part of the movement to rationalize photography during the first decade of this century, is quite willing to treat police photography as a proper object of his narrative. Eder in fact wrote an introduction to a German edition of Bertillon's manual (*Die gerichtliche Photographie* [Halle a. S.: Knapp, 1895]). Newhall, on the other hand, wrote a modernist history in 1938 that privileged technical photography, including First World War aerial reconnaissance work, without once mentioning the use of photography by the police. Clearly, Newhall found it easier to speak of the more glamorous, abstract, and chivalrous state violence of early air power than to dwell on the everyday state violence of the police.

89 An exception would be Sally Stein's revisionist account of Jacob Riis, "Making Connections with the Camera: Photography and Social Mobility in the Career of Jacob Riis," *Afterimage* 10:10 (May 1983), pp. 9–16.

90 Compare Bernard Berenson, "Isochromatic Photography and Venetian Pictures," *The Nation* 57:1480 (November 9, 1893), pp. 346–47, with Fred Jane, "Preface," *Fighting Ships* (London: Marsten, 1905–6), p. 2. However different their objects, these texts share an enthusiasm for large quantities of well-defined photographs.

91 The Institut International de Bibliographie, founded in 1895 with headquarters in Brussels, campaigned for the establishment of a *bibliographia universalis* registered on standardized filing cards. Following Dewey, the Institute recommended that literature on photography be assigned the seventh position within the graphic arts, which were in turn assigned the seventh position within the categories of human knowledge. The last subcategory within the classification of photography was to hold photographic prints. See the Institute's following publications: *Manuel pour l'usage du répertoire bibliographique de la photographie établi d'après la classification décimale* (Brussels, copublished with the Société Française de la Photographie, 1900); *Code pour l'organisation de la documentation photographique* (Brussels, 1910).

92 I am grateful to Daniel Bluestone for pointing out this latter architectural detail. For a contemporary description of the heads, see Herbert Small, *Handbook of the New Library of Congress* (Boston: Curtis and Cameron, 1901), pp. 13–16.

93 See the following catalogues published by the Yawman and Erbe Mfg. Co.: *Card Ledger System and Cabinets* (Rochester, NY, 1904); *Criminal Identification by "Y and E": Bertillon and Finger Print Systems* (Rochester, 1913); and *"Y and E" Library Equipment* (Rochester, 192?).

94 On early microfilm, see *Livre microphotographique: le bibliophoto ou livre à projection* (Brussels: Institut International de Bibliographie, 1911). On the more recent conversion of the photograph from library-document to museum-object, see Douglas Crimp, "The Museum's Old/The Library's New Subject," *Parachute* 22 (Spring 1981), pp. 32–37 (reproduced in this volume).

95 This suggests that the historiography of photography will have to approach the question of an "institutional mode" in different terms than those already developed for the historiography of cinema. See, for example, Noël Burch, "Film's Institutional Mode of Representation and the Soviet Response," *October* 11 (Winter 1979), pp. 77–96.

96 Thorstein Veblen, *The Theory of the Leisure Class: An Economic Study of Institutions* (New York: Modern Library, 1934), pp. 163–64.

97 Walker Evans, *American Photographs* (New York: Museum of Modern Art, 1938).

98 Reproduced in Jerry Thompson, ed., *Walker Evans at Work* (New York: Harper and Row, 1982), p. 107.

99 Walter Benjamin, "The Paris of the Second Empire in Baudelaire," in *Charles Baudelaire,* p. 41.

100 Leslie Katz, "Interview with Walker Evans," *Art in America* 59:2 (March-April 1971), p. 87.

101 Camille Recht, introduction to Eugène Atget, *Lichtbilder* (Paris and Leipzig: Henri Jonquières, 1930), pp. 18–19 (my translation).

102 See Benjamin's 1931 essay "A Short History of Photography," trans. Stanley Mitchell, *Screen* 13:1 (Spring 1972), p. 25.

103 For an example of the high regard for Galton among contemporary hereditarians, see H. J. Eysenck's introduction to the 1978 edition of *Hereditary Genius* previously cited.

104 See Nancy Burson et al., *Composites: Computer Generated Portraits* (New York: William Morrow, 1986).

105 Ernest Cole (with Thomas Flaherty), *House of Bondage* (New York: Random House, 1967). For the account of Cole's own struggle to produce the pictures in the book, I have relied upon Joseph Lelyveld's introduction, "One of the Least-Known Countries in the World," pp. 7–24.

106 Theodor Adorno, *Negative Dialectics,* trans. E. B. Ashton (New York: Seabury, 1973), p. 206.

Douglas Crimp, co-editor of the journal *October,* was the recipient of the 1988 Frank Jewett Mather Award for Distinction in Art Criticism. He is the editor of *AIDS: Cultural Analysis/Cultural Activism* (The MIT Press, 1988) and the author of *On the Museum's Ruins* (forthcoming from The MIT Press in 1990).

Christoper Phillips is an associate editor at *Art in America,* and he has taught at the International Center of Photography, New York; Tisch School of the Arts, NYU; and Parsons School of Design. He is the editor of *Photography in the Modern Era: Documents and Critical Writings 1913–40* (Metropolitan Museum of Art, 1989).

Benjamin H. D. Buchloh teaches twentieth-century and contemporary art history in the School of Architecture at the Massachusetts Institute of Technology. A collection of his essays will be published by The MIT Press in 1990.

Abigail Solomon-Godeau is a photography critic and art historian. She has published extensively in journals such as *Afterimage, Art in America, Camera Obscura, October,* the *Print Collector's Newsletter,* and *Screen.* A book of her collected essays, *Photography at the Dock,* is forthcoming from the University of Minnesota Press.

Catherine Lord is dean of the School of Art at the California Institute of the Arts, where she teaches in the art and photography programs. She is a former editor of *Afterimage,* and her writings on feminism, photography, and cultural politics have appeared in *Views, Exposure,* the *Independent,* and the *Feminist Review.* She has received a fellowship in video criticism from the New York State Council on the Arts.

Deborah Bright is an artist, writer, and assistant professor of art at the Rhode Island School of Design. She has published widely, and has exhibited her work recently at the Houston Center of Photography, the Minneapolis College of Art and Design, and the Museum of Contemporary Photography. A monograph on her work, *Deborah Bright: Textual Landscapes,* was published in 1988.

Sally Stein is a cultural historian who writes primarily about the history of photography and the modernization of print media. Co-author of *Official Images: New Deal Photography* (1987), she teaches in the History of Art Department, University of California, Riverside.

Jan Zita Grover is a historian working as a medical editor on an AIDS project in San Francisco. For the past four years her writing has focused on the cultural politics of AIDS. In 1989 she curated the exhibition *AIDS: The Artists' Response* for Ohio State University.

Carol Squiers is a writer and curator who specializes in photography. She contributes a regular column on photojournalism to *Artforum* and has also written for *Vogue, Vanity Fair, Art News, Aperture,* and *Interview,* among other publications. She is an associate editor of *American Photographer* and has recently edited *The Critical Image: Essays in Contemporary Photography* (1990).

Esther Parada, a professor of photography at the University of Illinois at Chicago, is an artist and critic with a special interest in Latin America. Her writings have appeared in such journals as *Afterimage, Exposure,* and *Aperture.* She has exhibited widely in the United States, Latin America, and Europe and was the recipient of National Endowment for the Arts Photography Fellowships in 1982 and 1988.

Richard Bolton is an artist and writer who teaches in the Visual Arts Program at the Massachusetts Institute of Technology. His writings have appeared in numerous journals and books, and he has exhibited widely. He is also the editor of "Media & Society," a series published by the University of Minnesota Press.

Rosalind Krauss is co-founder and co-editor of *October* and a professor of art history at Hunter College in New York City. She is the author of *The Originality of the Avant-Garde and Other Modernist Myths* (1985), *Richard Serra/Sculpture* (1986), *L'Amour Fou: Photography and Surrealism* (with Jane Livingston, 1985), and many other books and articles.

Martha Rosler is an artist and writer who teaches at Rutgers University and in the Whitney Independent Studies Program. She recently co-produced the videotape *Born to Be Sold: Martha Rosler Reads the Strange Case of Baby S/M* with Paper Tiger Television; she also organized "If You Lived Here. . . ," a series of exhibitions and forums on homelessness and housing. She is the author of *Martha Rosler: 3 Works* (The Press of NSCAD, 1981).

Allan Sekula is a photographer and critic, and director of the photography program at the California Institute of the Arts. He is the author of *Photography against the Grain: Essays and Photo Works 1973–1983* (The Press of NSCAD, 1984).

Note: Italicized page numbers indicate illustrations